THIS BOOK IS THE PROPERTY OF:

STATE	
PROVINCE	Book No. ___
COUNTY	Enter information
PARISH	in spaces
SCHOOL DISTRICT	to the left as
OTHER	instructed

ISSUED TO	Year Used	CONDITION	
		ISSUED	RETURNED
••••••••••••••••••••	••••••••••••	••••••••••••••	••••••••••••••
••••••••••••••••••••	••••••••••••	••••••••••••••	••••••••••••••
••••••••••••••••••••	••••••••••••	••••••••••••••	••••••••••••••
••••••••••••••••••••	••••••••••••	••••••••••••••	••••••••••••••
••••••••••••••••••••	••••••••••••	••••••••••••••	••••••••••••••
••••••••••••••••••••	••••••••••••	••••••••••••••	••••••••••••••
••••••••••••••••••••	••••••••••••	••••••••••••••	••••••••••••••
••••••••••••••••••••	••••••••••••	••••••••••••••	••••••••••••••
••••••••••••••••••••	••••••••••••	••••••••••••••	••••••••••••••

PUPILS to whom this textbook is issued must not write on any page or mark any part of it in any way, consumable textbooks excepted.

1. Teachers should see that the pupil's name is clearly written in ink in the spaces above in every book issued.
2. The following terms should be used in recording the condition of the book: New; Good; Fair; Poor; Bad.

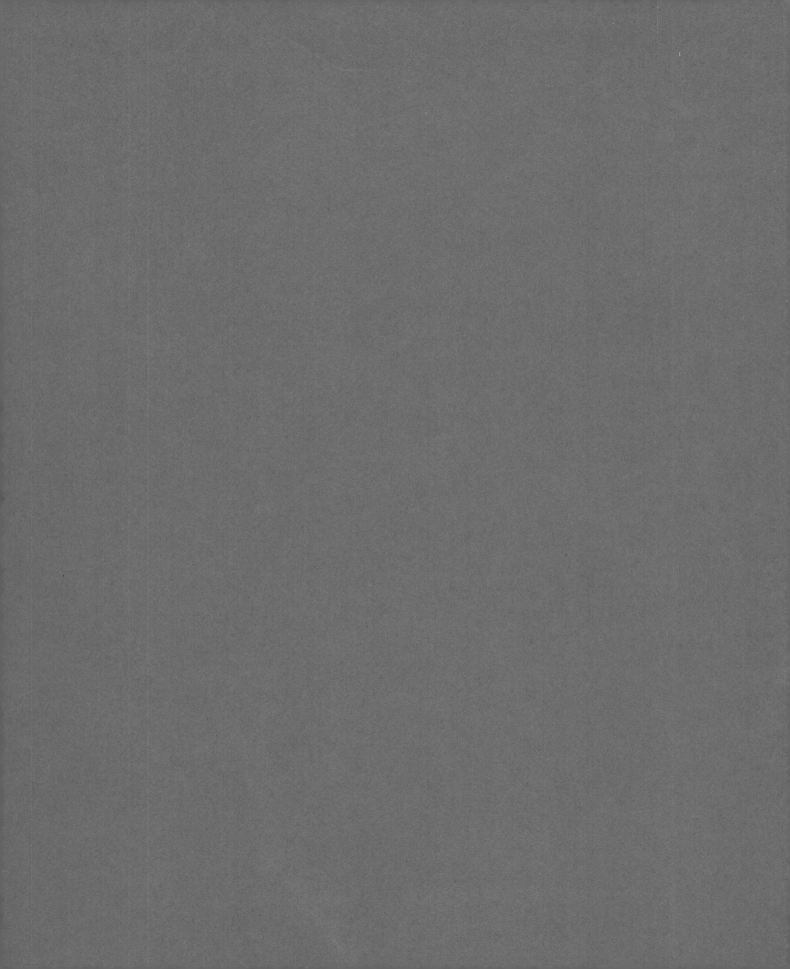

Discovering Art History

SECOND EDITION

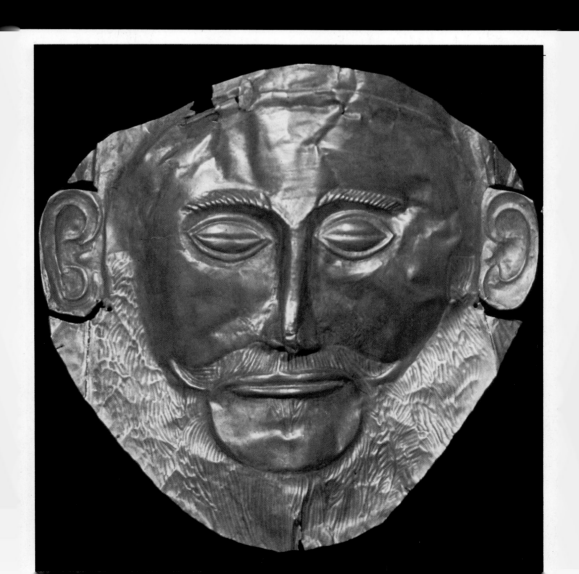

LD F. BROMMER

AUTHOR, ARTIST

ES, CALIFORNIA

hl

ONAL SCHOOL

NG

Davis Publications, Inc.

WORCESTER, MASSACHUSETTS

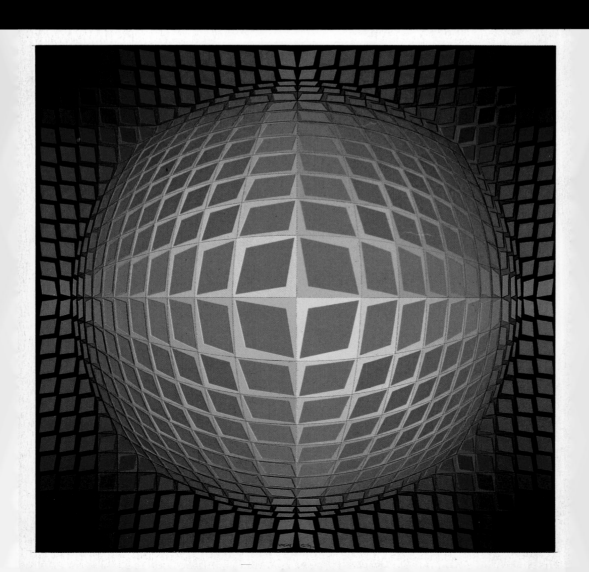

Discovering Art History

SECOND EDITION

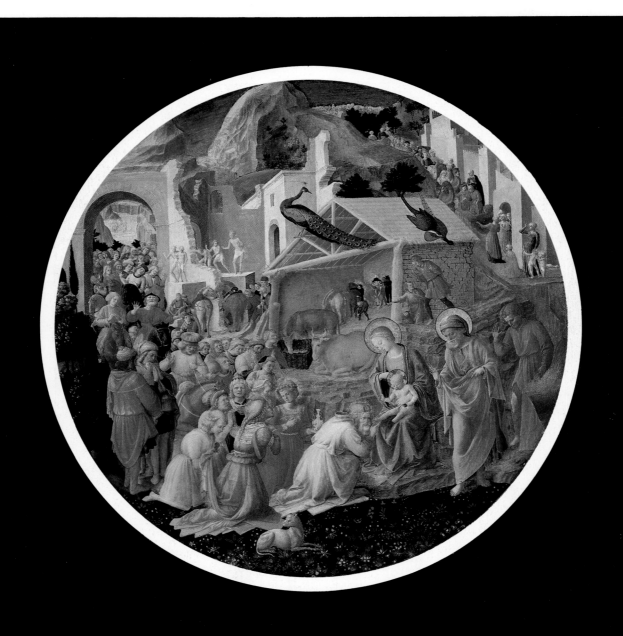

To Georgia ...
who has shared hundreds of trips
to museums, galleries, and places of architectural interest ...
and shares my enthusiasm for the arts.

Copyright 1988
Davis Publications, Inc.
Worcester, Massachusetts, U.S.A.

Printed in the United States of America

Library of Congress Catalog Card Number:

ISBN 0-87192-190-1

Graphic Design: Penny Darras Maxwell

10 9 8 7 6

Cover:
Mask of King Tutankhamen, 1352 B.C.
18th dynasty. Gold with precious stones
and glass, life sized. Thebes. Cairo
Museum, Egypt

Page 1:
Funeral mask about 1500 B.C. Beaten
gold, about 30 cm high. Royal Tombs,
Mycenae. National Archaeological
Museum, Athens

Page 2:
VICTOR VASARELY. *Vega-Kontosh-Va*, 1971.
Tempera on panel, 65 x 65 cm. Los
Angeles County Museum of Art, gift of
Mr. and Mrs. Donald Winston

Page 3:
FRA ANGELICO and FRA FILIPPO LIPPI.
Adoration of the Magi. Tempera on wood,
137 cm diameter. National Gallery of Art,
Washington D.C., Samuel H. Kress
Collection

Preface

It is well known that art is a universal language. Despite differences in speech, customs, and lifestyles, people can readily enjoy and appreciate the art of other cultures. Imagine standing in front of a painting such as *The Second of May, 1808* by the Spanish master, Francisco Goya. A group of viewers think and talk in English about the horses, the figures, the action, and perhaps the story behind the painting. Then other visitors arrive and discuss these matters in French, Italian, or Japanese. Although Goya only spoke Spanish, everyone can "read" his visual communication. The visual arts, like music and dance, are an exciting universal language to be seen, studied, and understood by all.

This book explores mostly Western—European and American—art. The major part of the text is arranged in chronological (historical) order—from prehistoric to art of the 1980s. Throughout Western art, one style has followed another, sometimes expanding on and sometimes reacting to previous periods. By following this progression through its various phases, contemporary movements, such as Neo-Expressionism or Abstraction, may be understood more easily.

While the cultural heritage of the Western world is deep and fascinating, the art of other cultures is also important. For this reason, the book offers a brief overview of art from the non-Western world—including Asia, Africa, and Islam. At times, these works have been similar to, different from, or more advanced than those of the West. To develop such an awareness, the basic material presented in Chapter 4 is expanded to include visual expressions from other parts of the world, also presented at the end of each chapter on Western art. Wherever possible, relationships between the art of the West and other cultures are pointed out.

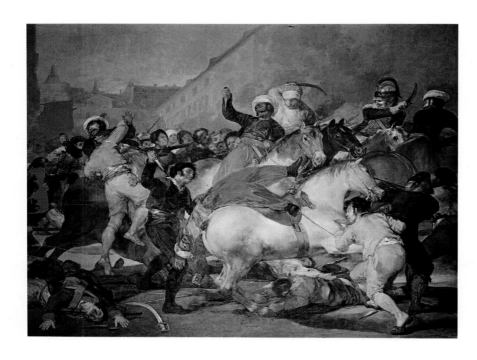

Francisco Goya. *The Second of May, 1808*, 1814. Oil on canvas, 273 × 342 cm. Prado Museum, Madrid

Before unfolding the history of art, it is important to know what art is about. The materials artists use and the kinds of subject matter they portray are discussed in several introductory chapters. Some attention is also given to how artists design their works to be aesthetically pleasing and how trends in art develop. After this initiation to the world and work of the artist, the rest of the text becomes more meaningful.

This book presents a variety of art forms and shows some of the best examples available. All of the work will not appeal to everyone. Yet, it will encourage an appreciation of different styles, of the special features of each style, and of the various ways artists can express themselves. Understanding what artists, past and present, are trying to communicate, is an exciting process. Each artist has a different approach or vision. During some periods of history, the artist wanted to imitate nature; at others to make a personal statement. Both goals are valid. The aim of most artists is not to imitate things and nature but to interpret them—to make personal statements about their subjects. There is a story about the French artist, Henri Matisse, who was in a gallery when some visitors were talking about his work which was on exhibit. A woman said about one of his paintings: "That girl's arm is too long." "Madame," Matisse said, "that is not a girl. It is a painting." By learning to understand what artists are trying to say, viewers will enjoy many kinds of works.

The best way to learn about art is to look at-it. Thumb through the text to notice the wide variety and types of expression—paintings, architecture, sculpture, and crafts. It is always better to see the actual works and buildings, but often such trips are impossible. Pictures will have to do the job.

At the end of each chapter are a series of individual projects that will help you dig into the various disciplines or areas of art—to make personal statements about the subject. Art can be divided into four major areas for study: 1) *Art History* (which this texts treats in detail); 2) *Art Criticism* (or the analysis of art products); 3) *Aesthetics* (the study of beauty and how we personally react to art); 4) *Art Production* (the making of art). The individual projects at the end of the chapters will help you understand and work with these disciplines of art and will assist you in making personal decisions about art.

In the back of the text is a pronunciation guide. A glossary, or list of definitions, describing artistic movements and styles, also appears here. (These terms are italicized the first time they are used in the main text.) Consult these guides often and use these new terms and names in class discussion. This practice leads to discovering and remembering paintings and sculptures, trends and places, people and their work.

Contents

Part One
The World and
Work of the Artist

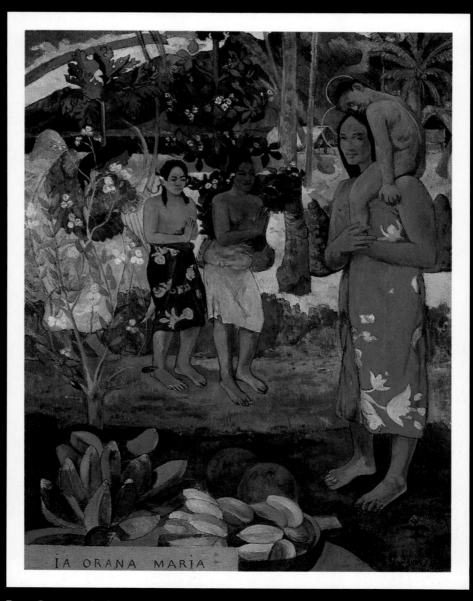

Paul Gauguin. *Ia Orana Maria*, 1891. Oil on canvas, 113 × 87 cm. The Metropolitan Museum of Art, New York.

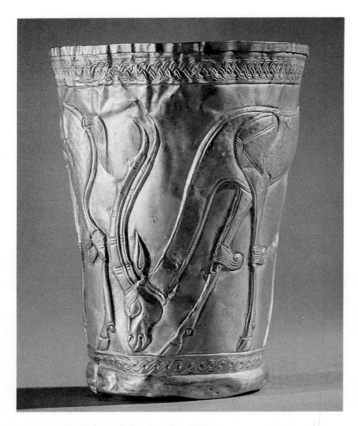

Ceremonial cup, about 1000 B.C.
Northwest Iran. Gold, 11 cm high.
Los Angeles County Museum of Art

Nobleman Plaque, late 17th Century.
Benin Culture, Nigeria. Bronze, 48 ×
18 cm. Los Angeles County Museum
of Art

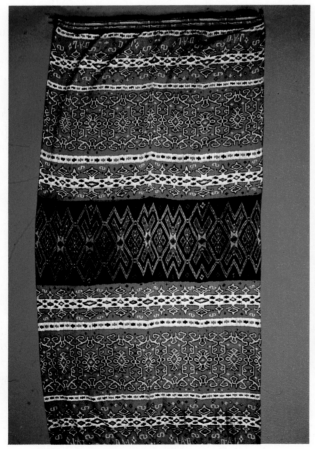

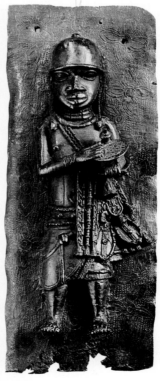

Blanket, 1930–1950. Sumba Culture,
Indonesia. Cotton, warp ikat, supple-
mentary border, 249 cm long. Los
Angeles County Museum of Art

1 Learning About Art

ART IS PERHAPS humanity's most essential, most universal language. While art communicates its messages through visual images rather than through words, we use words to describe the images, reactions, sensations and feelings we have about objects of art.

All the images in this book are concerned with art. Museums around the world are filled with objects called art. Some people spend time and money to search for works of art that will please them and add to their enjoyment of life. Contemporary artists continue to make images and objects that are called art. Hundreds of books and magazines are filled with pictures and descriptions of fascinating objects: paintings, buildings, drawings, pottery, weavings, sculpture, prints and other things we call art. And yet, some observers ask seriously, "What is so special about that chair, vase, painting or wood carving? Why is it called art?"

It is impossible to establish a definition of art that will please everyone. The term is broad; each age of humanity has different ideas about it, and each art historian has his or her favorite definition. While we may not be able to define art to everyone's satisfaction, we can define some of the standards by which art is evaluated. When an object is placed before a group of people, how do they come to agree it is a work of special quality? What criteria or guidelines do they use to make a judgement? How do they evaluate works that are new and different? And how can you learn to approach a work of art—your own, your peers' or a work in a museum or gallery—and say to yourself, "This is an outstanding painting. It is well designed, shows good use of color and pattern, and treats its subject imaginatively." How can you learn to think beyond "I like it" or "I don't like it" and be able to give real reasons for your preferences?

Evaluating Works of Art

We generally base our evaluation of works of art on such criteria as craftsmanship, design, aesthetic properties, and how well the works reflect the societies in which they were created.

CRAFTSMANSHIP

A craftsperson is someone who is skilled in the use of materials and tools and produces well-made objects of above average quality. The finely crafted ceremonial cup from northwest Iran was made about 3000 years ago, and displays rare skill in planning and execution. It was made from a thin sheet of gold and the design was probably hammered from within, against a wooden mold. The gazelle is beautifully stylized and designed to fit the space comfortably. All the details are carefully planned and executed, and no cracks appear, even after this tremendous length of time. All these features tell us that the piece was made with great care and a mastery of materials and tools.

AESTHETIC PROPERTIES

Each work of art has certain *properties* that belong to it. By analyzing them, we can see what makes the work unique.

Sensory properties are the elements of art (see pages 50–57) that we can recognize by using our senses: the use of *line*, the choice and blending of *colors*, the variety of *values*, *shapes* created by color and line, the *texture* of an object, the suggestion of *space*, and the *form* or *mass* of something three-dimensional.

Formal properties are the principles of art (see pages 58–63) that help us see how artists organize the ele-

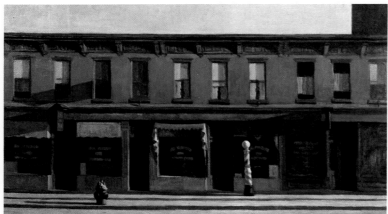

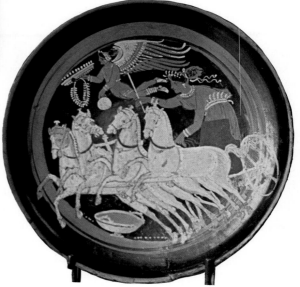

EDWARD HOPPER. *Early Sunday Morning*, 1930. Oil on canvas, 89 × 152 cm. The Whitney Museum of American Art, New York, gift of Gloria Vanderbilt Whitney

Plate, 400–300 B.C. Hellenistic Greece. Terra cotta with polychrome slip, 30 cm diameter. Hermitage Museum, Leningrad

ments of art to express their ideas effectively. If we are able to analyze the *unity, balance, contrast, rhythm, pattern, emphasis* and visual *movement* in works of art, we can determine how all parts of a composition work together well.

The weaver of the Indonesian blanket used line, shapes, color and texture and showed a knowledge of design principles (pattern, rhythm, unity, balance and contrast) in the creation of an object that reflects the values of her cultural heritage. Even though we may not understand all of the symbolism, we can appreciate both the *geometric* and *abstract* designs as well as the blanket's superb craftsmanship.

Technical properties are the media, tools and equipment used to make the work of art. Ceramics, oil painting, bronze casting and charcoal drawing all rely on different technical skills. The figure of the nobleman from the Benin culture of Nigeria was designed and cast in bronze, a technique learned from the Ife people, Benin's neighbors during the Middle Ages. Studying and working with various media can help us make value judgements about the quality of artists' techniques.

Expressive properties are the characteristics of an artwork that cause us to respond to it with feeling and emotion. Paintings, for example, might express moods of tension, relaxation or sadness through color, metaphor, symbolism or design. Ideas, ideals, social criticism, religion, hope and compassion can be communicated through art. Edward Hopper's painting, *Early Sunday Morning,* expresses some of the artist's feelings about his society. How do you respond to it? How does it make you feel? How do you think the artist created these feelings in you?

REFLECTION OF SOCIETY

Artworks also reflect the times in which they were created. *Artisans* often provide or confirm information about early cultures. For example, the *Hellenistic Greek* plate reflects many of the values of late Greek society: moral, religious, decorative, political, aesthetic, and functional considerations. The maker of the plate shaped it to fit the expectations of his client while decorating it in the style of the day with materials not used in earlier periods of Greek pottery manufacture. The piece combines information about the artisan's society with high quality design and craftsmanship. The artisan's choice of subject reflects his understanding of Greek mythology, relating the activities of men to the gods.

Identifying Works of Art

Paintings and sculptures can easily be identified as works of art, but often a bowl, blanket or other utilitarian object is also called art. Such objects have been

preserved by collectors or *connoisseurs* who appreciate their appearance, craftsmanship or message. Other objects have been preserved by the societies in which they were produced, being buried with the dead, enshrined in temples or hung on walls in special rooms or vaults. Thus, if a society placed high value on a crafted object, that fact alone may cause it to be considered an object of art today. An item is not art just because it is old, but its age is one of many factors taken into consideration.

In the art historian's search for pieces that are good examples of the craftsmanship, aesthetic properties and societal background of a culture, certain objects stand out as *paradigms*. These are classic examples which seem to reflect the highest quality work. While paradigms are photographed and studied extensively, one should realize that many other fine examples of art from around the world may exist in local museums, university collections and private homes, and may be of as high a quality as any paradigm or example shown in art history books.

Why Do People Create Art?

Why do people create? Why do they bother carving, painting, or doing hours of painstaking finishing on an object? The reasons that people in the past have made objects of great beauty may include functional considerations, religion, politics, education, aesthetics, and humanity's inborn desire to create.

UTILITY

Utility is a term that describes the role of objects made primarily to be useful. Nearly all societies have had the need to make eating utensils and storage vessels which have been formed from clay, basketry, leather, or metals. The storage jar of basketry created by a Western Apache artisan is meant to be utilitarian. Yet the intricate craftsmanship, the attention to ornamentation, and the overall design indicate that greater value was placed on this basket than the simple function of storage. Similarly, clothing not only protects the wearer but indicates social rank and individual taste. Architectural forms not only provide shelter but enclose spaces for worship, living, or public assembly, and are specifically designed and decorated to enhance those functions. Objects from the Western culture made for functional purposes, yet having artistic qualities, include furniture, glassware, machinery, automobiles, office buildings, airplanes, pens, and lamps.

RELIGION

Religious and superstitious beliefs and activities have inspired the creation of temporary and permanent objects to aid in worship. Supernatural attributes have been ascribed to phenomena in nature such as the movement of stars, the rising and setting of the moon and sun, tidal activities, flooding rivers, and the habits of animals. *Mystical* worship is aided in many cultures through the use of magical designs and *mandalas*, the creation of good luck charms or *fetishes*, the ritual dis-

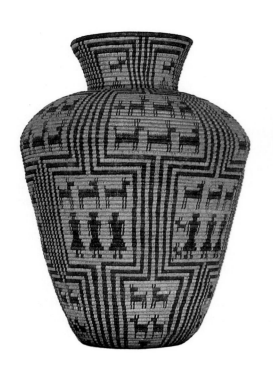

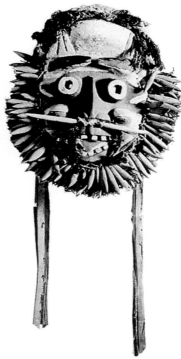

Storage jar, Western Apache. Reed, 91 cm high. Texas Memorial Museum, The University of Texas, Austin

Poro Society mask. N'Gere Peoples, Ivory Coast, Africa. Wood, fiber, and fur, about 46 cm high. Baltimore Museum of Art, gift of Mr. and Mrs. Leonard Whitehouse and Dr. and Mrs. Bernard Berk

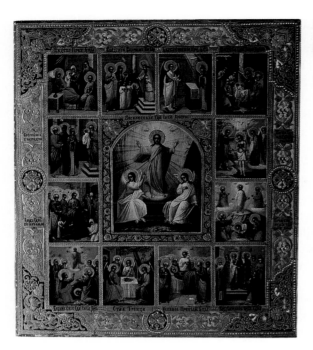

Russian Icon, late 19th Century. Tempera on panel, 36 × 30 cm. Collection, Joseph Gatto

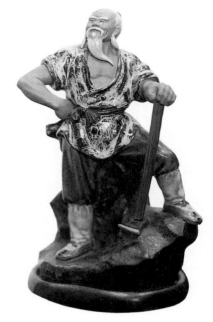

Foolish Old Man, 1979. Shek Wan, China. Stoneware, 30 cm high. Collection of Mr. and Mrs. David Schollard, Hong Kong

play of sacrifices in symbolic or ornamental containers on specially designed altars, and the unique ornaments and coverings of priests and worshippers. The Poro Society mask was worn by dancers "possessed" by the spirit of the object. The mask is meaningless until given life by the ceremony, when it is no longer an inanimate object but a real force, an abode of power, and a controller of life.

The beautifully decorated Russian *icon* was made to remind the viewer of the life, suffering, death, resurrection and heavenly reign of Jesus Christ. Wonderful craftsmanship is combined with religious conviction to create an image that is essentially meaningful, but also decorative.

Objects may be made to represent a god and to remind the worshiper of that spirit's power, divinity, omniscience, or humanity. Gods are often depicted as *anthropomorphic* or *theriomorphic*, but when these objects themselves become the focus of worship, they are called *idols*, no longer representing an image of the god but becoming an actual god to the worshipper. Many beautiful and impressive objects have been made as gifts to the gods by worshippers in cultures as primitive as *aborigines* and as sophisticated as the Classical Greeks. Copies of holy writings may be elaborately printed in specially ornate *script* and bound or protected in cases or bindings of leather, precious metals, and jeweled designs. Structures for the worship of gods range from neolithic *cromlechs* to elaborate cathedrals, temples, and artificial mountains.

POLITICS

Political art is aimed at influencing both friends and enemies. The building of large castles and fortified cities in feudal times has been both defensive and offensive. *Battlements, crenelations,* and *turrets* may be both beautiful and ominous. Images of the ruler painted or carved into walls and towers have been used to perpetuate myths of the awesome power of a king. Today, satire and humor as well as honest criticism often form the basis for propaganda as seen in the political cartoon, critical painting, or billboard poster. A subtle use of propaganda in art appears in the Chinese statue of the *Foolish Old Man*. This image was produced in clay and visualizes a story cited by Mao in 1945. A man wanted to move two mountains so he would have a better view from his doorway. Everyone thought him crazy, but with hoe in hand, he began digging. He worked till he died, when his sons and grandsons carried on the work until eventually (to the consternation of his old opponents) the mountains were gone. The political message is that through great determination, much can be accomplished, and the foolish old man symbolizes that concept in a physical form—much like an *allegorical* figure.

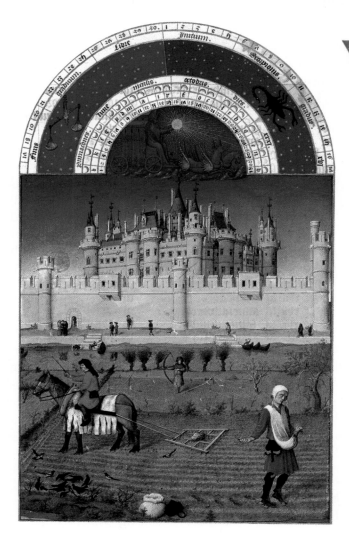

THE LIMBOURG BROTHERS. *October*, from *Les Très Riches Heures du Duc de Berry*, 1413–1416. Musée Condé, Chantilly, France

ROBERT SWAIN. *Untitled*, 1968. Acrylic on cotton duck, 268 cm per side. Collection, Stephen S. Schwartz

INFORMATION/HISTORY

The use of art to teach assumes great importance in cultures where there is no written language or where the literacy rate is low. The passing on of information about moral values, mythological and historical foundations, folk tales, and religious traditions has been accomplished by paintings, sculptures, stained glass windows, and symbolic abstract designs. Sometimes these are only understood by people living in that culture. Oral traditions are thus reinforced in a physical way with the visual recording of heroes, gods, or even instructions on how to make wine, make love, or worship properly.

The miniature painting and book illustration made by the Limbourg brothers in France in 1416 allows us to see the activity of farmers in October. This single painting of a twelve-part series shows clothing styles, farm equipment, a scarecrow and the castle of the nobility (actually a "portrait" of the Gothic Louvre). The unhappiness of the farm worker sowing winter grain shows in his sad expression.

AESTHETICS

The creation of an object just to be pleasing to sight and touch (as people think of most art today) has not always been a conscious process. *Aesthetics* is the term used to sum up the search for beauty—for a feeling of balance, proportion, and pleasing arrangement; for a tasteful mixture of plain surface with textured or ornamental areas; for thought provoking subject matter; and for a conscientious use of materials to achieve good craftsmanship and permanence. In such objects, it is obvious that the designer/artist/craftsperson has put forth a supreme effort to create a work pleasing to the eye and stimulating to the imagination. Other motives of manufacture are secondary. For example, Robert Swain's painting may evoke many types of thoughts to viewers, regardless of their backgrounds. And by adding a title, like *Untitled*, the possible connotations are limited only by the imagination of the viewer, who is expected simply to look and enjoy.

Artists and craftspersons become specialists in the processes that everyone possesses—the awareness of environment, the sensitivity to design, and the desire to work with materials to make physical records of thoughts and observations. To generalize about artists, it is possible to say that they are curious, enjoy beauty, seek order and design, desire to contribute to the body of knowledge within their society, and have original ideas which they want recorded permanently for future generations. As suggested earlier, they also have messages they wish to communicate about their views on religion, politics, education, moral values, or beauty. Finally, many have excellent skills, a sense of humor, and an ability to edit and present their observations in unique ways. Such a diversity of human ideas will be revealed in later sections.

The Discovery and Preservation of Art

ARCHAEOLOGY

Now that a general approach to art and artists has been established, it is important to explore an area that is of vital significance to art historians—*archaeology*. Archaeology is the unearthing and study of evidences from past cultures which have been hidden from human eyes for centuries. Much of the ancient material seen in this book, such as statues, coins, and even buildings, was dug from its earthly grave and brought to society's attention by trained archaeologists. Many of these items are now preserved in museums and universities. Archaeologists also play a key role in giving Americans an insight into the roots of their culture. By identifying ancient *civilizations* and studying their technical and aesthetic developments, archaeologists can trace the early influences on American culture.

Archaeologists unearth a variety of objects and fragments from past civilizations. Jewelry, trinkets, and coins are often found. Vases, ceramics, sculpture, and carvings are discovered. Paintings, glassware, utensils, and writings are also found. Often, the objects are damaged. Bits of broken pottery (shards) are thus put back together and sculpture is repaired. Archaeologists' findings also go beyond specific objects to suggest what house construction or city planning was once like. Walls, courtyards, rooms, and even streets have been uncovered.

Today archaeology is in fashion. Everyone knows of the glamorous objects of gold and beautiful craftsmanship found in King Tut's tomb in Egypt. However, archaeological items are not usually discovered so easily. They are located after hard, plodding, detective work. Ancient works of art do not just pop out of the desert sands and trip some passerby. Research is needed to find a probable site for some undiscovered city or culture and then the digging starts.

To determine if a site is a worthwhile place for archaeological research, cores are drilled to identify the materials under the surface. Once a likely place is found, the digging and removing of the earth is dreadfully slow. Nothing must be disturbed or broken and all the earth must be sifted for tiny bits of pottery or jewelry. Today, countries guard their excavations with great care so vandals cannot steal potential treasures. Every item uncovered is catalogued, referenced, and photographed—even broken bits of jewelry or pottery fragments. Objects are dated by scientific means (carbon 14 count) or by their historical associations. Archaeology formerly implied digs and treasure, but today it suggests research, analysis, and a scientific approach to cultural detective work. But there is always the chance of some extraordinary and fascinating find.

In 1977 Soviet and Afghan scientists, working a dig near Afghanistan's northern border, uncovered the grave of a nobleman covered with pieces of gold. Nearby graves revealed more gold objects: bracelets, beads, pins, rings, daggers, clasps, and pendants. Before winter set in they uncovered another grave with so many golden artifacts that they covered it up and returned to it the following year, after the ground had thawed. For 2000 years these tombs had not been discovered. They date from a culture that lived there from 100 B.C. to 100 A.D. around the time of Christ. A stunning part of the discovery is that the objects of art reveal the combined influences of Greek, Bactrian, Roman, Indian, and Chinese cultures. It was not known before this discovery that these cultures were ever united in one place on earth. One pendant shows Bactrian rams' heads, Chinese dragons, and Mesopotamian animals on the same piece of work. Although a find like this is spectacular, the day to day work of archaeologists all over the world continues to tediously uncover the elements of ancient/cultural sources.

In the Valley of Teotihuacan, north of Mexico City, Cortez and his army defeated 200,000 Aztec warriors in a mammoth battle in 1520. Already at that time, the Pyramids of the Sun and Moon were partially covered with debris, earth, and shrubs. They had been abandoned nearly a thousand years earlier. Today, one can walk through magnificent streets, climb towering pyr-

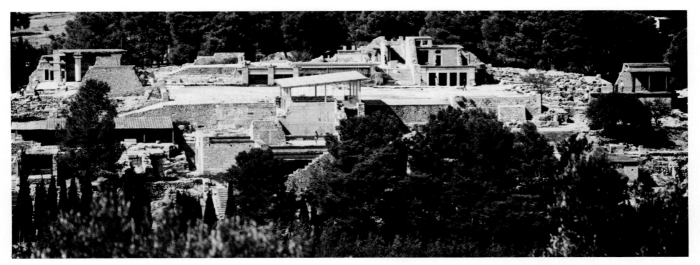

Knossos. The Palace of Minos, 1800–1600 B.C. Crete

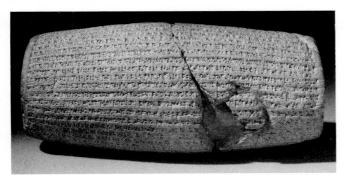

Cyrus Cylinder, about 535 B.C. Persian. Terra cotta, 20.3 cm long. British Museum, London

amids, and stroll in great courtyards. Archaeologists have uncovered much of the original city of Teotihuacan but are continuing the work every day. The impressive structures are there to see while the art objects have been taken to the Archaeological Museum in nearby Mexico City. Although scientists can uncover such great cities, they cannot yet determine why they were evacuated and left to the destructive elements of nature.

At the beginning of this century, Arthur Evans excavated a gigantic mound of earth at Knossos in Crete and was the first person to approach such a task in scholarly fashion. He was also a controversial archaeologist because he attempted to reconstruct parts of the palace based on paintings of it found in the ruins. Others considered this an unscientific approach, yet his contribution to the field of archaeology was great.

Every once in a while, writings will be uncovered which add to the historical knowledge of the place and the people. The *Cyrus Cylinder,* for example, was found in the inner walls of the city of Babylon. Written

in Babylonian, it commemorates the building operations of Cyrus II (559–530 B.C.) since he had captured Babylon in 539 B.C. It also reveals that the Persian conquest of the city was welcomed by the inhabitants as a means of liberation from former oppressors.

Sites around the world have revealed glimpses into past great civilizations: The Ming Tombs in China, Pompeii and Herculaneum, The Athenean Acropolis, The Roman Forum, Persepolis, Niniveh, Ur, Memphis, and Monte Alban. More will be uncovered in the future and every time a new discovery is made, our understanding of world culture is enriched.

APPROACHES TO ART HISTORY

It should be apparent now that archaeology is an invaluable aid to the study of art history. Art historians, such as this author, who believe that the present can only be understood by investigating the past, profit from the work of archaeologists. An archaeologist, for example, unearths and identifies an example of a major art form. Art historians then determine how the piece represents an advance in creative thinking and if and how it influenced the work of later artists.

Art historians have not always adopted this approach. To the ancient Greeks, the history of art was combined with the history of other kinds of technology that showed a gradual progression toward perfection. They believed perfection was reached about 250 B.C. when they had imitated nature ideally, and they called their style "Classic"—the standard for all time to come. During the Middle Ages, nobody thought about the history of art, but during the Renaissance, the lives

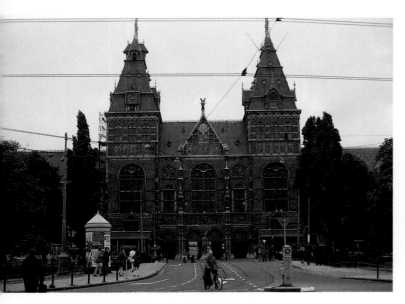

Rijksmuseum. 1885. Amsterdam

and work of artists were described by Giorgio Vasari in his book, *Lives of the Painters, Sculptors and Architects.* He arranged them chronologically and again ended with the "Classic" style of Michelangelo and Raphael. Nature had been reproduced perfectly again!

The study of art history became formalized with the establishment of art schools or *academies* in the late 1800s. The work of artists was analyzed and categorized and put into certain periods or styles. Superb examples of these various categories became the ideal for each. The present system of studying art was thus evolving. Trends were traced and styles were followed. Eras were outlined and influences were noted. Art was not only the product of artists and a source of great enjoyment, but had become the target for study and scholarship. Today, in order to understand the current development of art, art historians look back to determine how the past influences the artists of the 1980s.

MUSEUMS

When people want to hear good music they go to a concert hall, and when they want to see art they go to a museum. This seems simple enough, but it was not always so. Throughout history, artists have created their work for patrons and collectors, not for museums. Paintings and sculpture were held in the great family collections of kings and queens, nobles and wealthy families. Palaces and castles of Europe and Asia were crammed with objects of art, but the common people never got to see them. The revolutions of

the eighteenth and nineteenth centuries changed all that. When monarchies tumbled, the fabulous collections of art were taken over by the new governments which then had to figure out orderly ways for the people to view their new treasures. The Palace of the Louvre in Paris became the Museum of the Republic in 1793, and many other royal buildings in Europe followed suit. Sometimes new structures were designed to house combined collections too large to fit existing spaces.

The Rijksmuseum in Amsterdam, for example, was built in 1885 especially to house a growing collection that was bulging the walls of its former home. As the collection grew by gifts and purchases, other items of less importance were sold. In this way, collections expand and grow and are cut back down to size again, principally to fit the available space.

Sometimes museum buildings are architectural works of art in themselves. The fifteenth century Topkapi Palace in Istanbul is a magnificent structure of great historical and architectural interest. It now contains the fabulous collection of jewelry, ceramics, furniture, and the relics of sultans and the Ottoman Turkish Empire. Although not designed as a museum, it is a worthy setting for such a collection.

Many European art collections have been accumulated by kings and heads of state while others have been endowed by wealthy donors. Many collections in America belong to the cities (Museum of Fine Arts in Boston) or counties (Los Angeles County Museum of Art) or the nation (National Gallery in Washington, D.C.). Works of art were given to the collections by individuals or groups of people as outright gifts, loans, or bequests purchased

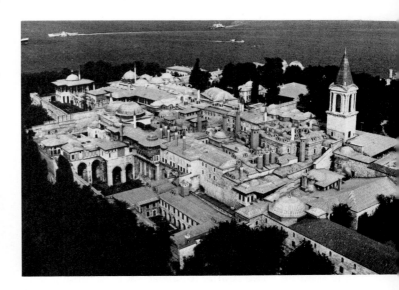

Topkapi Palace. 15th century. Istanbul

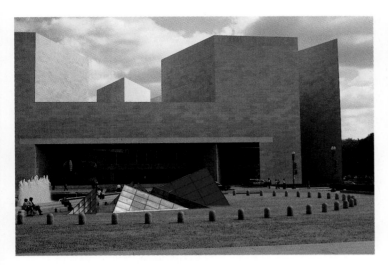

I. M. Pei. East Building, National Gallery
of Art, 1978. Washington, D.C.

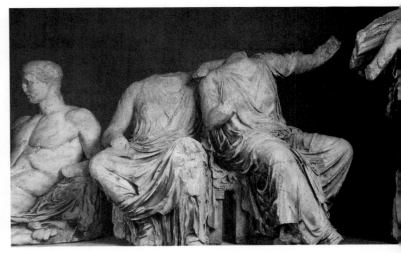

Parthenon sculptures, 432 B.C. British Museum, London

with funds from donated estates. In this way American collections have grown in the past century to equal many older collections around the world.

The collection of art in the National Gallery in Washington, D.C. belongs to the people of the United States. Most of the paintings and sculptures it contains were donated by individual collectors to enhance our cultural heritage. In 1978 a magnificent new wing was added to the Classical main building. Designed by I.M. Pei, it is a unique architectural design, conceived to hold large works of art in marvelous open spaces, but also to exhibit works in intimate surroundings (*See* p. 459). It contains a comprehensive art library, study and research areas, and large meeting or display areas. It supplements and completes a growing and dynamic center for visual art in the nation's capital.

In Asia, Europe, and America there are also individual collections that have been made available for public use. Often the owners buy or build their own museums, fill them with their own collections, and open the doors to visitors. The Solomon R. Guggenheim Museum in New York, for example, was designed by Frank Lloyd Wright and contains changing displays from the Guggenheim collection. Norton Simon, J. Paul Getty, and Henry Clay Frick are other wealthy collectors who have enriched America's cultural heritage in the visual arts.

A few individual museums can be found around the world—collections of a single artist displayed in a building provided by a city or the family. Examples include the Edvard Munch Museum in Oslo (city owned), the Fernand Leger Museum in Southern France (family owned), and the Rodin Museum in Paris (the artist's former home).

The primary function of museums is to display works of art for the enjoyment of both casual observers and students of art and culture. Various collections preserve artifacts of past civilizations which contribute to the public's understanding of the history, anthropology, and sociology of these groups. The British Museum in London features the Elgin Marbles, sculptures from the Parthenon in Athens. The Louvre in Paris has a special room to display Rubens' huge paintings of the life of Marie de' Medici. Only in a museum could such large, important, and valuable works be seen. But most museums have other functions also.

Education is of great concern and groups of school children and adults can hear lectures and see TV, movie, and slide programs to aid their understanding of art. Some museums even send out movies and programs to assist schools and other programs in their work. Many museums also sponsor public music programs.

Museums in various parts of the country and other parts of the world often work cooperatively to arrange special exhibits for their patrons. Several museums worked together to bring the treasures of King Tut's tomb from the Egyptian Museum in Cairo to America. As a result of other joint efforts, the latest Chinese and Greek tomb findings, and treasures from Mexican and Soviet museums have also "toured" America. Some large museums and collections also sponsor exhibits from their collections that travel to smaller regional or municipal museums. In this way, the collected works of art can be enjoyed by many more people and regular museum visitors get a chance to see works from distant collections.

A program of art restoration and repair is essential to

most large museums. Paintings need cleaning and often some kind of restoration work. The science of formulating pigments, matching paints and repairing canvas, bronze, and marble is quite exacting. Photography of art is essential to assure its authenticity, and every major painting is X-rayed to record the underpainting and characteristic use of brush and pigments by the artist. This procedure aids in identification, helps prevent frauds, and leads to an expanded knowledge of older painting techniques.

Museums can also control humidity and temperature so valuable works of art on wood or canvas do not dry out or age too rapidly. Light can also be controlled so unnecessary fading is kept to a minimum. The care of great works of art is in good hands and will benefit generations to come if the museums use their expertise to protect them and yet keep them on public display.

How We Study Art

Art covers a broad spectrum of ideas and expression. It is a beginner's attempt at watercolor; the graceful design of a table; the Statue of Liberty; a tiny piece of jewelry. Clothes, cars, textbooks and television scenery are imagined and designed by artists, and their designs affect the way you live.

Art is all around you. Do you always see it? Probably not. And you probably don't understand all of what you *do* see. But the more you learn about art, the more you'll notice, and the more you notice, the more you'll understand. Understanding things helps you enjoy them and respond to them in new ways.

To grasp the various aspects of art, we can break its study into four components: criticism, aesthetics, history and production. While we might isolate these four areas for study, we must use all four of them together to fully appreciate and understand a single work of art.

Art Criticism is analysis. It is explaining and judging works of art. It is discovering how the artist used art elements such as line, color and texture. It is determining how the artist used balance, pattern, emphasis and other art principles to arrange the parts of the work. It is sensing how the artist used media and tools to create the work. And it is also trying to understand what the artist might have meant to say in the work. In this way we analyze the artwork's sensory, formal, technical and expressive qualities, as we've already discussed.

Aesthetics is a term that refers to our personal responses to works of art. Why do we like some visual images and dislike others? Why do we feel more comfortable with some works than with others? We each respond differently to visual images, because we each have a different set of personal experiences on which our responses are based. You say, "I like that painting because. . . ." and your reasons will be your aesthetic response to the painting.

Art History provides the setting and context for a work of art and helps us understand the artist and the circumstances in which the work was made. Artworks reflect the times and cultures of the people who produced them. Art history provides a kind of timeline that shows how art has developed from early human history to the present. It also shows how artists have been influenced by previous artistic styles, by technology and social change and the like, and how those influences show up in their artwork. Art history adds personality to works of art and helps us see artists and their times in the work they have done. We understand today's art more fully when we can trace its development through time.

Art Production is the creation of art. This process requires tools, media and technical ability. It involves learning to look carefully, use the materials you choose, make decisions, solve problems, learn about design, interpret what you see and feel, and criticize your own efforts. Through production and studio experiences, you'll learn to appreciate the ability, knowledge and skill of fine artists and craftspeople. By handling clay, mixing colors, working with composition, using brushes, carving wood or building a model, you'll enter the working world of artists and begin to understand some of the visual and technical problems they encounter daily.

The integration of art history with aesthetics, criticism and production provides us with the opportunity to study art from four viewpoints. We learn to base our own aesthetic judgements on several criteria. None of these four components stands alone. However, their combined study will enrich and clarify the total concept of art.

At the end of most chapters in the book you will find three groups of Independent Study Projects: *Criticism/ Analysis; Aesthetics/Personal Sensitivity;* and *Production/ Studio Experiences.* Because art history is dealt with throughout the book, no specific projects are listed under that heading. The projects are structured to deal with art history as it relates to each of the other components in the study of art.

Analysis

1. Art, design and visual images affect our lives in many ways every day. Make a list of things you use daily that artists have designed. Organize your list into general categories such as transportation, clothing, artwork, advertising, entertainment, etc.

2. Write a brief analysis of an art object illustrated in Chapter 2 (painting, sculpture, crafted object, etc.). Use the discussions on pages 11, 12 and 20 as a guide, and list sensory, formal, technical and expressive properties, mood and aesthetic qualities of the artwork. Explain why you think it was created, and why you like or dislike it.

3. Select three objects from your home which have some relationship to design (such as a cup, painting, quilt or lamp) and write descriptions of them. Then analyze their artistic merits (sensory, formal and technical properties). What is good about them; what could be improved?

Aesthetics

4. The artwork seen in most museums was created for other purposes and locations and not for museum spaces. In the palace at Versailles, however, paintings and sculpture can be seen in the spaces for which they were created. In the photograph below, visitors are viewing huge paintings of French historical subjects. How does this display differ from most museums? How did the architects provide effective lighting? How have the architectural details produced a unified setting for the art? How is viewing space provided for visitors? Would such paintings be as effective in a smaller room? Write a short paper answering these questions.

5. Locate archaeology books or magazine articles (*National Geographic,* for example) that deal with parts of the world associated with your ethnic or religious roots. After some research, write a brief report on your findings. Has much archaeology been discovered? Are excavations still going on? What are some of the *major* findings? What are future projections for possible archaeological finds?

6. It is often said that peoples' aesthetic choices are based on the total of their visual experiences. List things you have *seen* and *felt* that made an important impact on you at the time. Your list might include trips, television shows, teachers, books, movies, etc. that have made you more visually sensitive and aware of your environment. Explain how you think these experiences have affected your personal sensitivity.

Studio

7. Make an arrangement of three art-related objects, similar to a museum display. Bring objects from home or gather some from around school (toy, painting, weaving, sculpture, jewelry, etc.). Make labels for each object, including as much of the following information as possible: artist's name, title of the object, date it was made, from which country or state it came, physical description (medium, color, size [in inches and metric]), where you obtained object, and owner.

8. Using back issues of *National Geographic* or *Archaeology,* etc., clip pictures of archaeological activities, such as digging, sifting, reconstructing, photographing, drawing, plotting, etc. and make a display chart illustrating steps that archaeologists use to find, identify and classify objects.

9. Make a poster (using ink, markers or tempera paint on heavy drawing paper or poster board) that illustrates the elements and principles of design. Use your imagination to present the concepts clearly, so they can be easily understood by others. Several different posters might be designed for this project.

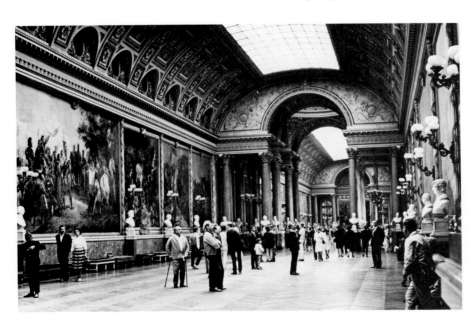

Interior, Palace of Versailles, 1670. France

2 The Visual Communication Process

As ARTISTS AND CRAFTSPERSONS are trying to communicate something in visual language, viewers should make an effort to learn about their subjects, methods, and styles. This chapter therefore explores four areas: Subject Matter (what the artist is talking about), Media (the tools and materials of the artist), Crafts (making useful items attractive), and Design (the structure of visual communication). While each of these areas could be discussed in book length, a condensed, visual presentation will be offered here. The verbal descriptions, which accompany the visual examples, are short and point up only the major emphasis. With this brief background, the rest of the text should be much more meaningful.

Subject Matter: What the Artist Is Saying

If a person was given a pencil and told to draw something, his or her probable reaction would be a question: "What should I draw?" If the person was told to draw a body, a bird, or a house, that would be the subject matter. Most artists use *things* as their subjects, things such as people, apples, objects, or animals. Others use ideas such as war, love, loneliness, or joy. Still others are concerned with the scientific or mathematical aspects of art, design, and proportion which become their subject matter.

Artists not only need subjects but also must have something to tell about them. They need a reason to paint a landscape or to sculpt a person. This reason may be as simple as liking the color of green grass or as personal as wanting to show the unalterable order of the cosmos in every landscape. A woman may be sculpted because she is beautiful, but could also be painted to show her character or her influence on her fellow humans. Throughout history, and especially in the last few decades, artists' attitudes toward subject matter have changed drastically, as the last chapters reveal.

Subjects are numerous and personal ways of treating them are almost endless. Several examples, all from Western art, will now be presented so that a comparison can be made within a restricted framework. Almost all works are paintings so that there will be a common ground for such comparison. Usually only one example is shown in each category, but many more could be included to make the ideas and comparisons complete.

NARRATIVE SUBJECTS

In narrative paintings, the artist is telling a story, and Pieter Bruegel of Flanders was a master story teller. All parts of his painting contain bits of peasant life and little insights into further stories. Bruegel lived in an urban area but loved to go into the country and paint the activities of peasant farm life. This jolly gathering is typical of his work. One can easily find the bride, but where is the groom? As Bruegel tells his own story of the wedding, he interweaves many subplots. What are they?

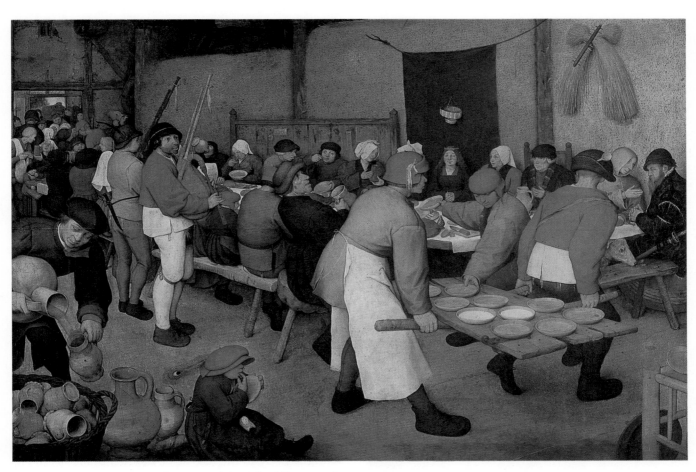

PIETER BRUEGEL. *Peasant Wedding*, 1566. Flemish. Oil on panel,
113 × 162 cm. Art History Museum, Vienna

EUGENE DELACROIX. *The Abduction of Rebecca,* 1846. French. Oil on canvas, 100 × 82 cm. The Metropolitan Museum of Art, Wolfe Fund

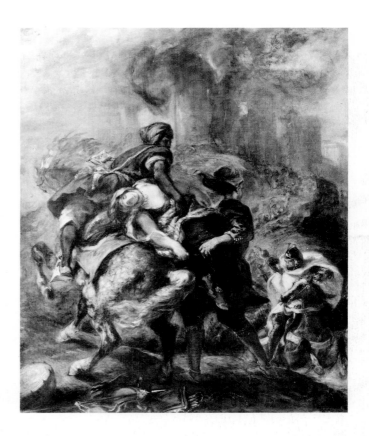

REMBRANDT VAN RIJN. *The Descent from the Cross*, 1651. Dutch. Oil on canvas, 143 × 111 cm. The National Gallery of Art, Washington D. C., Widener Collection

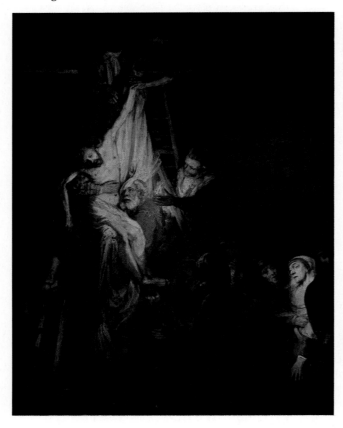

LITERARY SUBJECTS

Painters may use literary sources to get ideas for their paintings. Many have used Bible stories as their subjects, but Delacroix here uses a theme from Sir Walter Scott's book, *Ivanhoe*. The romantic nature of Scott's writing appealed to Delacroix and he used slashing brush strokes to create a swirling, active, and colorful painting. The painting is the artist's but the subject is the author's. This painting can be read as it appears, as a dramatic abduction, or in other ways. By knowing the literary source, *Ivanhoe*, one recognizes this event as part of a larger story—a literary detail.

RELIGIOUS SUBJECTS

Any religious figure from any religion can be the subject of a work of art. Biblical history provides Christian subjects for artists such as Rembrandt, who shows the dead Christ being let down from the cross. The men struggle with the body in the half-light, but Rembrandt's artistic spotlight is beamed at the figure of Christ and at his mother, Mary, at the right. What is Rembrandt telling the viewer about the event and the people?

LANDSCAPES

Landscapes are paintings of the natural environment, but they were not always popular subjects for artists. In eighteenth century England, people wanted to have their portraits painted, and Gainsborough made a handsome living doing just that. But he really wanted to paint nature and did, on a limited basis, for his own interest. All artists who enjoy painting in the sunlight or working with elements of the natural environment owe a debt of gratitude to Gainsborough, who advanced the idea that nature should not just be a backdrop for human beings but could be a subject itself. Ironically, he never painted outdoors. This painting was done in his studio where he first made a model of the scene using sponges and moss and then painted it according to his recollections.

CITYSCAPES

Views of city streets, plazas, courtyards, buildings, and activities taking place in the urban environment are called cityscapes. Most of these paintings have been done in the twentieth century, but Corot produced this early view of Venice in 1834. Corot, a realist painter, portrays an authentic scene from the times. He does not tell a story nor does he reveal his feelings about Venice. He simply depicts what he saw, in about the same way a photographer would take a picture of the place to send to a friend.

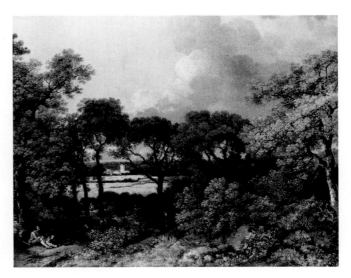

THOMAS GAINSBOROUGH. *View of Dedham*, 1750. English. Oil on canvas, 63 × 78 cm. Tate Gallery, London

JEAN BAPTISTE CAMILLE COROT. *View of Venice, the Piazzetta seen from the Quay of the Esclavons*, 1834. French. Oil on canvas, 47 × 69 cm. The Norton Simon Foundation, Los Angeles

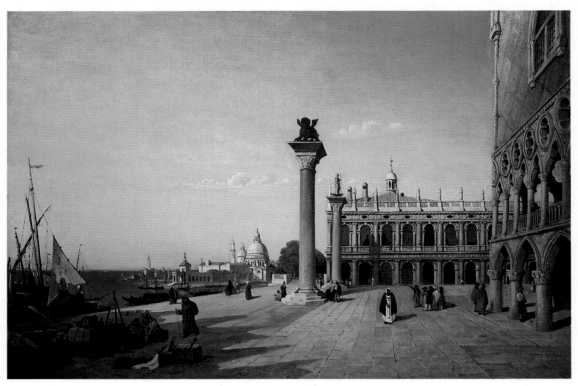

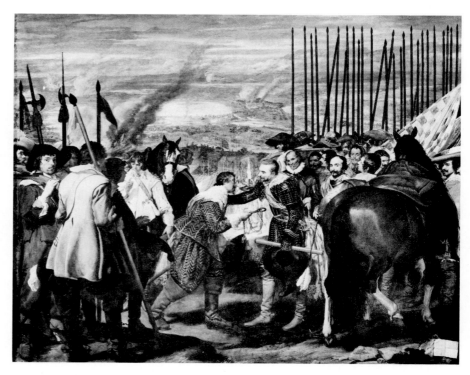

DIEGO VELAZQUEZ. *Surrender of Breda*, 1634–1635. Spanish. Oil on canvas, 307 × 365 cm. Prado Museum, Madrid

PETER PAUL RUBENS. *Judgement of Paris*, about 1629. Flemish. Oil on Panel, 145 × 195 cm. National Gallery, London

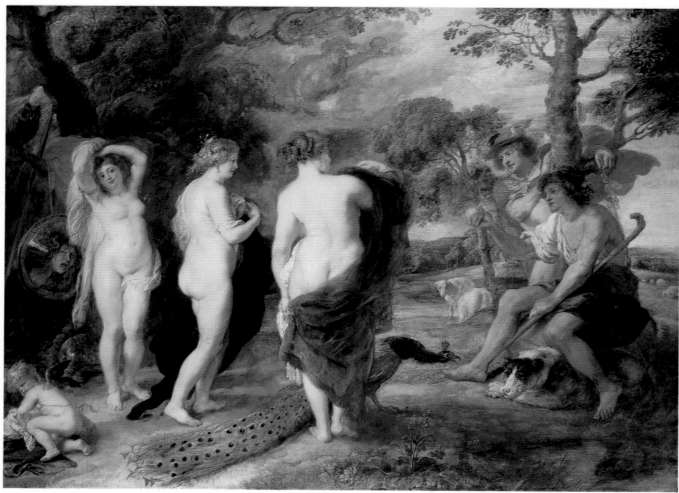

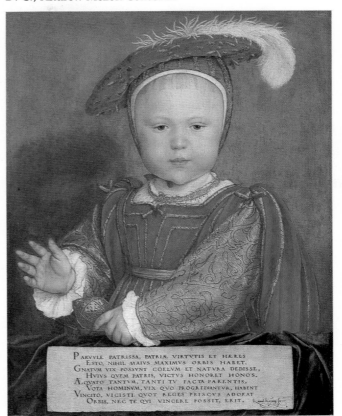

HISTORICAL SUBJECTS

Historical subjects have usually been painted on large canvases, probably to lend importance or to memorialize an event. The walls of the Capitol building in Washington, D.C. are lined with historical paintings in which battles, victories, treaties, or skirmishes are the subjects. In this work, the Dutch general is handing over the key to the city gate of Breda to the Spanish general. Velazquez did not actually see the event take place, but he did talk to many of the victorious officers and included their portraits in the painting. He also found out from them what the scenery was like, how the Dutch were dressed, and how they acted in defeat. As with all historical subjects, the artist must research the topic before creating the painting.

THE FIGURE

The human figure was first used as an artistic motif by the Greeks who saw their gods as perfect human beings. During the Middle Ages, such subjects were abolished by the church and it was not until the late Renaissance that Michelangelo, Titian, and others revived the figure as a painting subject. From then on, artists have considered the figure a supreme subject. They appreciated the human body as both an aesthetic and sensuous form. Rubens loved to paint human flesh and he often used tales from mythology as his motif. Here, Paris is judging a mythological beauty contest, but the three female figures are Rubens' real subject. He shows us front, side, and back views in a dazzling display of ingenuity and painting technique.

THE PORTRAIT

Portraits come in a variety of sizes and shapes but have one thing in common—they are paintings of people. The people may be alone or in groups, young or old. They may pose formally or informally and may be set against a solid background or in the natural environment. The artist may depict the full figure, from head to toe, or only the bust, the upper body. If the painting is of a person and is meant to look like the person, it is a portrait. Holbein, one of the world's greatest portrait artists, painted Prince Edward VI for his father, Henry VIII. The pose is rather stiff and formal; the clothes are regal; and the inscription tells Edward to emulate his father in all things. Unfortunately, Edward died before he could become England's king.

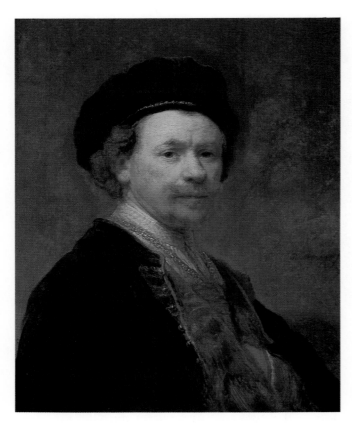

REMBRANDT VAN RIJN. *Self-Portrait*, about 1636. Dutch. Oil on panel, 64 × 51 cm. The Norton Simon Foundation, Los Angeles

SELF-PORTRAITS

Many artists make pictures of themselves, called self-portraits. Looking into a mirror, Rembrandt painted this image of himself when he was about thirty years old. The life of this Dutch artist can be traced in his many self-portraits which he did at various times in his life. As his looks changed and matured, so did his painting style. Vincent van Gogh and Albrecht Dürer are two other artists who made many paintings of themselves. Most other artists try it once or twice, probably when they are changing their styles, want to try a new technique, or cannot afford to pay a model to pose for them.

GENRE SUBJECTS

Genre painting refers to subjects of normal, everyday activities which are carried out by ordinary people. A king and queen riding in a royal carriage is not a genre subject, but a poor family riding on the local public transportation is. Farmers working in the fields, children in school, people sitting in a cafe, or a woman peeling potatoes are genre subjects. Daumier shows us a grandmother, mother, and little child in the light, and another boy in the shadows. Each has his or her own thoughts as the car bumps along its way. Although the train is crowded, each person seems rather alone—one of the plights of urban society. Daumier tells us much more than the title of the painting indicates.

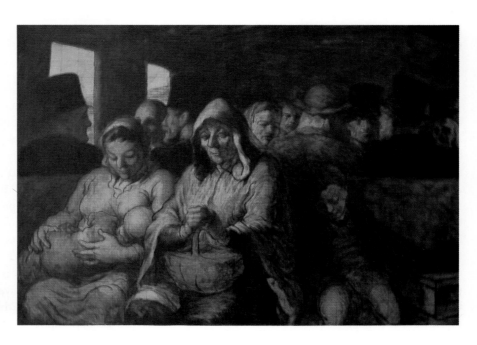

HONORE DAUMIER. *The Third Class Carriage*, 1862. French. Oil on canvas, 65 × 90 cm. The Metropolitan Museum of Art, New York, The H. O. Havemeyer Collection

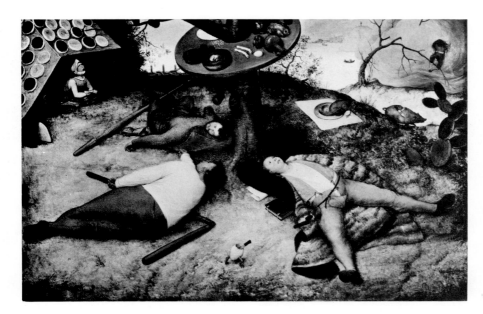

PIETER BRUEGEL. *Land of Cockayne*, 1567. Flemish. Oil and and tempera on panel, 51 × 78 cm. Pinakothek, Munich

SOCIAL COMMENT

Some artists want to make visual statements about their society or the world. They may criticize national leaders, churches, neighbors, wars, or political oppression. Pieter Bruegel often made satirical comments about his contemporary society. *Land of Cockayne* was a place of overindulgence in a Flemish fable, a fool's paradise where people become slaves to their own appetites of various types. Bruegel cleverly adds a peasant, cleric, soldier, and nobleman to the scene, all of whom have lost the battle with self-control. Three have overeaten to the point of passing out. Bruegel's visual language is a provocative and satirical way of commenting on self-interest and selfishness in his society—and is more potent than a sermon.

STILL LIFE

A still life is a painting of inanimate objects—things which cannot move. Items, such as bottles, bowls, fruit, flowers, and cloth, often appear in these works. The objects are usually arranged by the artist on a table top in the studio. This arrangement is also called a still life or may be referred to as a set-up. Still life paintings can be elaborate, as in the Flemish Baroque (*See* p. 303), or simple, as in Chardin's work. Chardin often includes small still lifes in his genre paintings of people. In his *Still Life With Plums*, the arrangement of common objects in a pyramidal composition makes them seem solid and important.

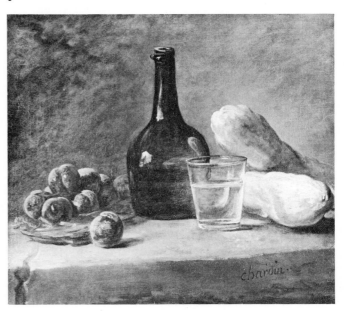

JEAN BAPTISTE-SIMEON CHARDIN. *Still Life with Plums*, 1758. French. Oil on Canvas, 41 × 50 cm. The Frick Collection, New York

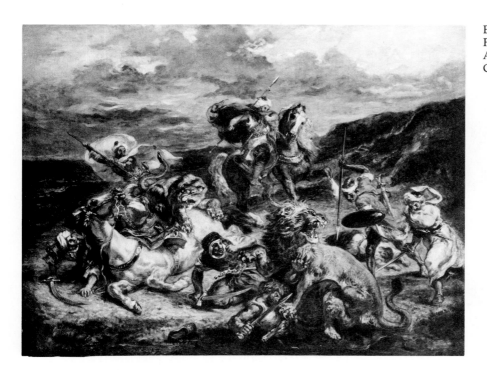

EUGENE DELACROIX. *The Lion Hunt*, 1861. French. Oil on canvas, 76 × 98 cm. The Art Institute of Chicago, Potter Palmer Collection

ANIMALS

Artists are often intrigued by animals. The Chinese, Indians, and Egyptians have portrayed birds and mammals with great skill, both in realistic and stylized versions. Animals have been used in paintings to symbolize fidelity, love, or cunning. Exotic animals, those from distant countries, have been favorite material for artists, and when private zoos were fashionable (from the late Renaissance to the nineteenth century), artists used such animals for models. Delacroix was fascinated with lions and lion hunts because they idealized his own romantic spirit. He had to study the anatomy and bone structure of both horses and lions to be able to create this powerful and dramatic work. Yet, his watercolor sketches of small kittens were sensitive and delicate.

EXPRESSION

While some artists paint what they see when looking at their subject matter, others, like El Greco, include their feelings about the subject. When personal and emotional feelings are added to a work, it is an *expressionistic* painting. El Greco lived in Toledo, Spain, where he painted primarily religious works. But here he paints a cityscape from the hill on the opposite side of the river. Using greens and blues in various values and mixtures, he gives his city a distinct personality. Sparkling under a super-charged sky, the city seems vibrant and full of excitement, yet mysterious and rather lonely.

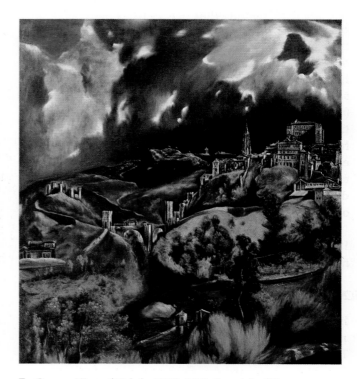

EL GRECO. *View of Toledo*, 1600–1610. Spanish. Oil on canvas, 121 × 108 cm. The Metropolitan Museum of Art, New York, bequest of Mrs. H. O. Havemeyer

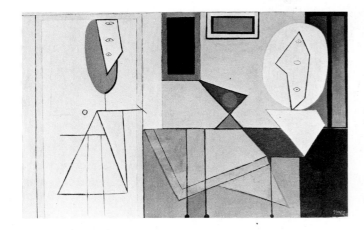

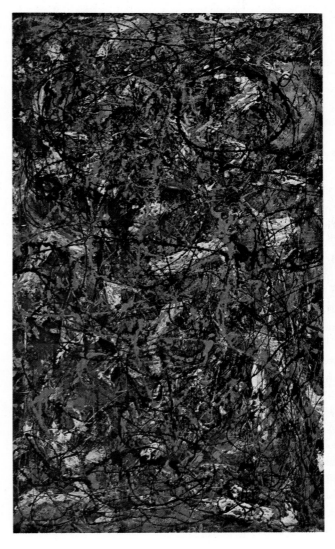

PABLO PICASSO. *The Studio*, 1927–1928. Spanish. Oil on canvas, 150 × 231 cm. The Museum of Modern Art, New York, gift of Walter P. Chrysler, Jr.

JACKSON POLLOCK. *Full Fathom Five*, 1947. American. Oil on canvas, 130 × 77 cm. The Museum of Modern Art, New York, gift of Peggy Guggenheim

ABSTRACTION

Abstraction is the simplification of subject matter into basic and often geometric shapes. When the simplification process dominates the visual subject, it can be thought of as the subject matter itself. Picasso here uses his studio as a starting point. He depicts a table as simplified shapes, an object that may be a sculpture (*right*) as a whitish oval, and a container (*center*) as two triangles. Pictures are on the back wall and the artist and his easel are at the *left*. While viewers may identify these elements, the painting is first and foremost an abstract arrangement of lines, shapes, and colors. The abstracted design was far more important to Picasso than the studio objects.

Notice that the artist in the picture has three eyes. What may Picasso be suggesting about the visual awareness of artists?

NON-OBJECTIVE PAINTING

In the late nineteenth century, artists gradually created more abstract works. However, their art, like Picasso's *The Studio*, still presented recognizable objects. Even Cezanne, who stated that the painting was more important than the subject matter, included identifiable forms. During the early twentieth century, some artists painted fully abstract works, composed of only color, shape, and line. When artists, such as Jackson Pollock, began a painting, they did not think of trees and people but of color and line. Today, such non-objective painting is common.

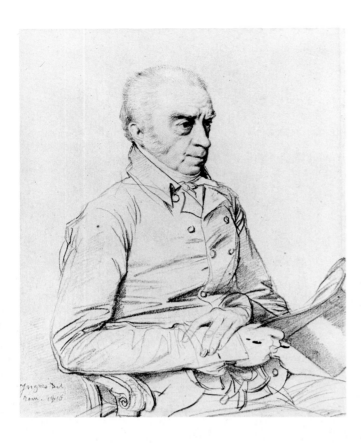

Jean Auguste-Dominique Ingres. *Thomas Church*, 1816. French. Graphite on paper, 19 × 16 cm. Los Angeles County Museum of Art, Loula D. Lasker Estate Fund

Media: The Tools and Materials of the Artist

Once the artist has chosen the subject matter, a decision must be made about what material or medium to use. The subject can be drawn, painted, printed, or sculpted. There are a wide variety of media for each area. Drawings can be done with dry media, such as pencil, charcoal, and wax crayon, or with wet media, such as ink, wash, and brush. The same type of variety is available to artists in the painting, printmaking, and sculpting media.

Recently, there has been a vast array of new media in the art stores. While traditional media are still popular, artists enjoy the experimentation process it takes to master new materials. The final chapters of this book will discuss the often surprising materials and methods used by contemporary artists.

Several, but not all, media are described in this section. Each medium produces unique effects. Note that most captions in this text include the materials used by the artist, such as "oil on canvas," "tempera on panel," "bronze," or "etching and engraving." The medium is listed first, then the surface or *ground* on which it is placed, and then the size of the work. Canvas, wood panels, and paper are grounds for the various two-dimensional media.

DRAWING MEDIA

Pencil The pencil has always been one of the most versatile drawing tools, tracing its history back to the Roman stylus, a silver pointed tool which made delicate lines. Lead had been used to make lines, but in 1795 the French inventor, Conté, found a way to mix graphite and clay—the modern pencil was born. It can be used for quick sketches and for detailed drawings. Ingres' portrait drawing of Thomas Church combines many pencil techniques in one work. There are quickly sketched lines and heavy, firm lines. The shaded areas on the body were done with broad, flat strokes while the face was finished with careful shading under great control. Ingres was a master draftsman and the pencil was his favorite drawing medium (*See* p. 338).

Charcoal The soft, grainy quality of charcoal is evident in Seurat's drawing done on textured paper. Charcoal is a soft, black substance, made by burning all organic materials from twigs and sticks. It can be compressed into sticks, like chalk, so that the ends and sides can both be used. It can also be used in pencil form, wrapped in wood. Charcoal smudges easily and is used primarily as a sketching material. Seurat used the broadside of a charcoal crayon to capture quickly the pose he wanted. Without outlining, he pressed harder in some places to get the desired value variation. Value is the lightness and darkness of a color. The three basic values, when sketching, are: light, half tone, and dark. Look at Seurat's painting, *Sunday Afternoon on The Island of La Grande Jatte* (*See* p. 378), to find this sketched figure in final form.

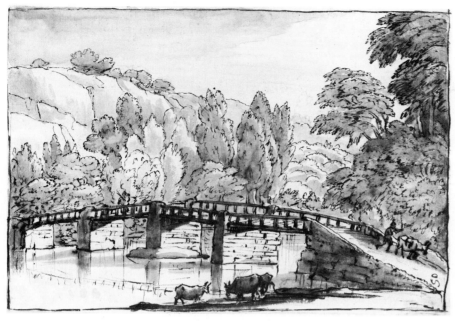

Claude Lorraine. *Wooded Landscape with Bridge.* Pen and wash, 22 × 32 cm. Norton Simon Inc. Foundation

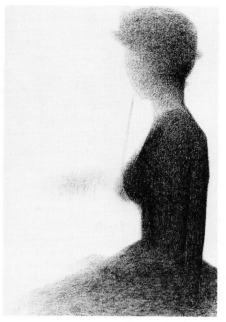

Georges Seurat. *Seated Woman*, about 1885. French. Charcoal on paper. The Museum of Modern Art, New York

Mary Cassatt. *Sleeping Baby*, about 1910. American. Pastel on paper, 65 × 52 cm. Dallas Museum of Fine Arts, Munger Fund

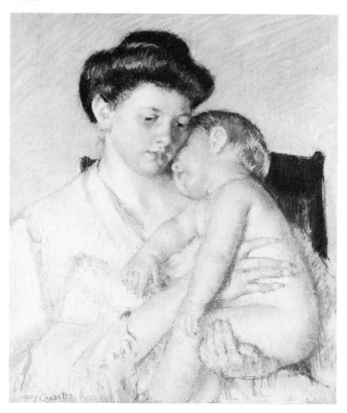

Pen and Wash When India ink is applied undiluted, it makes a solid black area; when it is mixed with water, it produces a soft gray. The more water that is added, the lighter gray are the *washes*—a term used to describe the dilution of inks with water. In this landscape sketch, Claude Lorraine made some quick lines with black chalk and then began to draw with a quill pen and ink. After many lines were added, he brushed in the wash areas with light, medium, and dark washes. He used this sketch and similar ones as the subject matter for oil paintings done in his studio.

Pastel Oil pastels are a dry material, almost like colored chalk, which are applied to a paper or canvas ground. Creating with oil pastels is halfway between drawing and painting. The final result usually looks like a colored drawing and is often called a painting. Mary Cassatt was equally adept at pastels and oil painting. Her pastel, *Sleeping Baby*, has delicate shading, light value colors, and a sketchy, dry-textured quality—all characteristic of this soft, chalky medium. The subject matter of mother and child in a casual, loving relationship is a favorite of the artist.

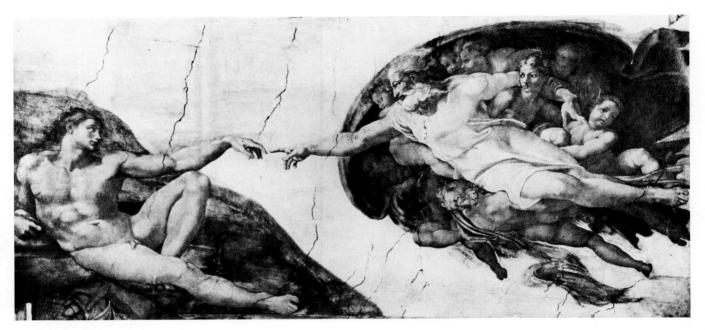

MICHELANGELO. *Creation of Adam*, 1511. Italian. Detail of ceiling fresco. Sistine Chapel, The Vatican

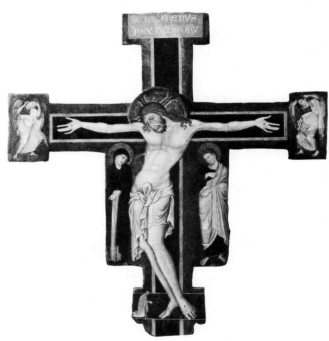

MASTER OF SAN FRANCESCO. *Crucifixion*, about 1280. Italian. Tempera and gold on wood. Philadelphia Museum of Art, the Wilstach Collection

PAINTING MEDIA

Fresco Fresco is one of the oldest painting media and one of the most difficult to master. From ancient Greece and Rome to Renaissance Italy, frescoes have been used to decorate walls and ceilings. During the Renaissance, Michelangelo painted the magnificent ceiling frescoes in the Sistine Chapel. In the fresco process, the surface to be painted is first covered with a coat of rough plaster which is allowed to dry. The day the painting is to be done, fresh, smooth plaster is put over only the area to be covered that day. While still wet, colors mixed with thinned plaster are painted on, binding themselves into the fresh plaster. Only small portions can be painted each day and no corrections are made by going back over previous work. Try to imagine Michelangelo, lying on his back atop a huge scaffold, working for several years with this process over his face.

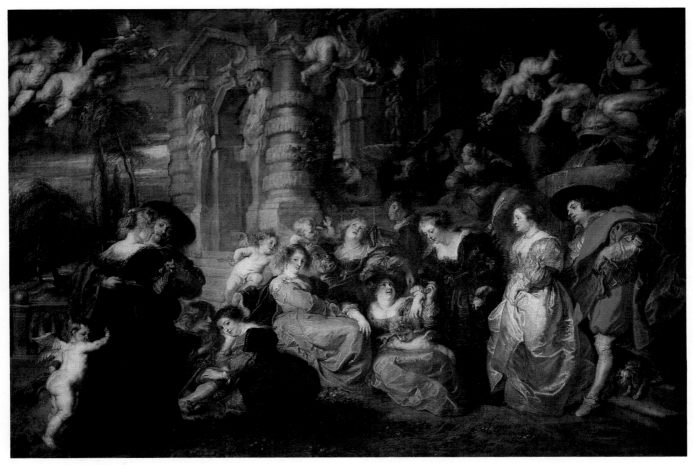

PETER PAUL RUBENS. *Garden of Love*, about 1633. Flemish. Oil on canvas, 197 × 281 cm. Prado Museum, Madrid

Tempera The word tempera is familiar to most students because the paint used in elementary school is often a form of tempera called poster paint. As early as ancient Egypt, artists have used various forms of tempera paint. Some, such as the painter of this thirteenth century cross, used egg yolk as the binding agent to stick the colored *pigment* to the wooden panel. Often, pure gold was added to egg yolk to form the background for paintings of the Middle Ages. Since egg tempera dries quickly, small brushes are used to work on very small and detailed areas with tiny strokes. Building up layers of transparent color over each other creates a richly colored, luminous surface. In later years, oil was sometimes mixed with the egg tempera. Finally, a paint, which used only oil as the binding agent, was developed. Tempera paints can also be made by combining the colors with casein glue to make a chalky paint similar to poster paints.

Oil Oil painting became popular when artists needed to work on larger surfaces with larger brushes. Oil colors are pigments bound to a surface of wood or canvas with either linseed or poppy oils. The paint is usually thinned with turpentine to make it spreadable and takes much longer to dry than tempera. It can be applied in thick, buttery layers *(impasto)* or in thinned washes or *glazes*, almost like watercolor. The variety of techniques is tremendous and Peter Paul Rubens was a master of the medium. By using glazes of color mixed with varnish, he was able to make the tints of flesh and satin material glow in his paintings. With the innovation of canvas as a ground, oil paintings could become huge in size. Rubens took advantage of this advance in his many gigantic works. Deep darks and brilliant lights offer the ultimate range of value contrasts in a painting medium used more than any other in the history of art.

Watercolor Although watercolor has been used since ancient Egypt, it has come into its own only recently as a major painting medium. Many artists have used the medium as a sketching technique prior to making oil paintings in their studios. However, Albrecht Dürer, a Renaissance artist, regarded watercolor as an important medium of expression in and of itself. Although watercolor became popular with artists and hobbyists in nineteenth century England, it did not gain the stature of a major painting medium until Winslow Homer, an American artist, became famous. Homer thought of his watercolors as finished works, instead of as sketches, and exhibited them as such. The binding agent in watercolor is gum arabic, a water soluble adhesive that sticks the pigments to paper. The colors are mostly transparent, and opaque white is often shunned by watercolorists, who use the white of the paper as part of their transparent painting technique. Gouache and casein paints are opaque watercolor preferred by some artists for their excellent covering characteristics.

WINSLOW HOMER. *After the Hunt*, 1892. American. Watercolor on paper, 48 × 63 cm. Los Angeles County Museum of Art, Paul Rodman Mabury Collection

RICHARD ANUSZKIEWICZ. *Iridescence*, 1965. American. Acrylic on canvas, 152 × 152 cm. Albright-Knox Art Gallery, Buffalo, gift of Seymour H. Knox

Acrylic In the last half of the twentieth century many new painting media have been explored. Acrylics are among the most popular. Instead of using natural materials for binders, acrylic paints use polymer emulsions which can adhere pigments to almost any surface—masonite, canvas, glass, paper, cardboard, or wood. Thinned with water and easy to clean up, acrylics dry rapidly and can be applied heavily like oils and transparently like watercolors. Their versatility has made them extremely popular, especially for some of the hard-edged techniques which require absolute control and quick drying. Richard Anuszkiewicz worked on canvas but needed rulers, masking tape, measuring devices, acrylic paints, and brushes to create his glowing statement. The central square seems to glow as it floats in its colorful and lineal environment.

ALBRECHT DÜRER. *Four Horsemen of the Apocalypse*, about 1498. German. Woodcut, 39 × 28 cm. German National Museum, Nuremberg

PRINTMAKING MEDIA

Woodcut The various printmaking techniques began as a way to furnish art to the masses at reasonable prices. Even though many copies are made by the artist, each is signed and numbered, and the edition is kept to a limited number of copies, thus ensuring that the value will remain constant. When parts of a flat block of wood are cut away and ink is rolled onto the remaining raised area, the surface can be printed to reveal a mirror image of the original cut-out design. Albrecht Dürer was the first noted artist to turn to woodcut as a major medium and his style demanded incredible skill to cut from wood. Over four hundred years later, Germans again turned to the woodcut as a means of expression. Ernst Ludwig Kirchner, in keeping with twentieth century artistic feeling, did not want his woodcuts to look like pen and ink drawings, but like cut-out wood—jagged, rugged, and splintery.

ERNST LUDWIG KIRCHNER. *Head of Ludwig Schames*, 1917. German. Woodcut, 58 × 26 cm. The Museum of Modern Art, New York, Abby Aldrich Rockefeller Fund

REMBRANDT VAN RIJN. *Saint Jerome in an Italian Landscape*, 1653. Etching and drypoint, 26 × 21 cm. Los Angeles County Museum of Art

Intaglio While woodcuts are printed from the flat surface of a block, intaglio prints are made from the lines or crevices in a plate. The printmaker produces the design on a metal plate, usually zinc or copper, by making lines and scratches in the plate. These indentations can be made by applying acid (etching), by scratching (drypoint), or by removing thin V-shaped strips with a tool called a burin (engraving). Ink is forced into these grooves by rubbing and the rest of the plate is wiped clean. To transfer the image, the paper is dampened and placed against the plate in a press. Under great pressure, the dampened paper picks up the ink from the grooves and the image is made. Rembrandt's intaglio print combines etching and drypoint to produce an incredible variety of lines and dark areas. *Intaglio* refers to the ink being transferred to paper from *below the surface*.

Lithograph Lithographs may appear textured, flat, black and white, or full color. Toulouse-Lautrec made many large prints that were used as posters on the kiosks of Paris to advertise cafes, bars, and nightclubs. In this lithograph, he shows a printmaker making a lithographic print and a woman client checking it for accuracy. A lithograph or "stone writing" is made by drawing a design on a limestone slab with a greasy crayon or ink. Then water which will adhere only where there is no greasy substance, is spread over the stone. A large brayer is then used to roll greasy ink onto the surface. As grease will not mix with water, the ink only sticks where there is no water. The image is now ready to be reproduced. As Toulouse-Lautrec's print demonstrates, a sheet of paper is put over the slab and run through a lithographic press. This process is difficult to master. When several colors are used, each one has to have its own stone, and colors are printed one over the other.

Serigraph The newest of the printmaking media is *serigraphy* or silk screen printing which developed largely in the United States. It requires a screen of silk or a similar material, stretched on a frame. A stencil is attached to the silk and ink is forced through the stencil with a rubber squeegee. The open parts of the stencil allow the ink to pass through onto the paper or other printing surface below. Many colors can be used, but a separate stencil is needed for each one. A painterly effect can be produced if glue stencils are used. If a hard edge is desired, paper or lacquer stencils are employed. Andy Warhol's print has been placed on canvas and is as large as one of his paintings. Each of the four colors has its own stencil and the colors are flat and unshaded. In this print the result seems mechanical and commercial, which is exactly the way he wanted it to appear.

Henri de Toulouse-Lautrec. *L'Estampe Originale*, 1893. French. Lithograph. The Metropolitan Museum of Art, Rogers Fund

Andy Warhol. *Campbell's Soup Can*, 1964. American. Silk-screen on canvas, 90 × 61 cm. Leo Castelli, Inc.

SCULPTURE MEDIA

Marble Sculptors work in a number of ways: by cutting away (subtractive), by putting parts together (additive), by forming with hands (modeling), and by producing from a mold (casting). One of the earliest forms of art was carving figures from wood or soft stone. This book contains many examples from all over the world. Marble is an excellent sculptural material because it can be polished to a glass-like finish or left rough and textured. Michelangelo sculpted this powerful version of Moses from a single block of stone. He first made many drawings to see how the figure would look from all sides and then proceeded to chisel away until the statue was formed. Earliest carvings were stiff and uninteresting in their poses, but Michelangelo knew how to make a single figure dynamic by having it turn in several directions and by carving the folds with great depth and fullness.

Auguste Rodin. *The Thinker*, 1879–1889. French. Bronze, 71.5 cm high. National Gallery of Art, Washington, D.C., gift of Mrs. John W. Simpson

Michelangelo. *Moses*, about 1515. Italian. Marble, 2.33 m high. Church of St. Peter in Chains, Rome

Bronze Large bronze sculptures like *The Thinker* are made by the lost-wax process (called *cire perdue*, in French, and *investment casting*). Ancient Chinese, Egyptians, Greeks, Ife, and Benin people were expert at this complicated process. When Rodin started this sculpture he first modeled it in plaster (sometimes he used clay). Then he made a negative, gelatin piece-mold of it. The mold was cut and removed from the original plaster model. This piece-mold was then reassembled and the inside coated with a thick layer of melted wax, as thick as the finished bronze would be. Rodin now had a hollow, wax model which he packed with a core of foundry sand which would become the inner support for the bronze when it was poured. He removed the piece-mold again to retouch the wax. Wax rods were added as vents and the entire figure then encased (invested) in a heat resistant plaster or clay. Metal pins were inserted to keep the core in place. The entire investment was heated to dry the plaster and melt out the wax (lost-wax). Molten bronze was poured into the space where the wax used to be. When the investment was broken apart, the bronze rods were cut off, the sand inside shaken out, and the surface cleaned and finished. Several such castings can be made from the original plaster or clay model.

Wood Wood is a very versatile sculpture material and can be used in both subtractive carving and in additive constructions. It can be carved and nailed, filed and drilled, sanded and glued. Artists from ancient times to the present have made creative use of wood because of its warm feeling and attractive color and grain. Claes Oldenburg likes to take ordinary objects and enlarge them to monumental size. In this version of the *Giant Three-Way Plug*, he uses various forms of wood (boards, strips, plywood sheets) to recreate a common household item in gigantic size. This one is made to hang from the ceiling, but he has also made gigantic plugs from Cor-Ten steel (to sink partially in the earth) and stuffed vinyl material (to hang as soft sculpture).

Steel An entire book could explore the sculpture media of the second half of the twentieth century. Chapter 17 presents some of its variety, but not all can be included there. When sheet steel could be cut and welded together, it gave sculptors who enjoyed the additive processes a new material to use. Alexander Calder is famous because of his fascinating *mobiles*—metal constructions that are made to move in soft breezes (*See* p. 446). But he also assembled flat steel cut-outs to make non-movable structures which he called *stabiles*. Often they are interesting arrangements of abstract shapes. But this one, resembling a gigantic spider, has a fitting title.

Many more media in each of the areas could be studied. The past examples, however, provide an idea of the variety and some of the visible characteristics of artists' materials.

CLAES OLDENBURG. *Giant Three-Way Plug*, 1970. American. Wood, 148 cm high. The Detroit Institute of the Arts

ALEXANDER CALDER. *Black Widow*, 1959. American. Sheet steel, 2.34 m high. The Museum of Modern Art, New York, Mrs. Simon Guggenheim Fund

Byzantine book cover, 6–7th centuries. Syrian. Gold, rock crystal, and ruby, 23 cm high. William Rockhill Nelson Gallery of Art, Kansas City

Craftsmanship is often used to convey the value or importance of an object. The craftsperson who made this beautifully designed book cover undoubtedly thought highly of the text. He could have simply bound it in leather or have tooled a few simple designs in the leather to make it more attractive. Instead, valuable materials and superb craftsmanship were employed to make the cover special. Gold thread was woven to make the outside border, and a round slab of rock crystal was cut and polished for the center design. A Greek cross of gold was riveted to the crystal and a ruby was mounted at the center. The degree of craftsmanship indicates that the book was highly regarded and was produced by a sophisticated culture. The culture was advanced both for the quality of the work and the value it placed on the written word.

In this book, there are many examples of crafts from a wide variety of cultures. All objects were crafted by hand and most were made for utilitarian purposes. During the first half of the twentieth century, Western society almost eliminated hand-made crafts from its culture as machine-made objects were in greater demand. Since the 1950s, however, there has been renewed interest in crafts because they are unique objects in a standardized, technological age. Many societies have not been interrupted by mechanization and have continued their traditions of crafts and craftsmanship from earliest beginnings to the present.

Clay Before humans learned to weave cloth, they wore animal skins and made objects of clay. Clays of various types are dug from the earth and when formed, dried, and fired become extremely durable. Earliest examples were *flash-fired* in open pits, but later work was heated more carefully in primitive *kilns*. Today, gas- or electric-fired kilns can be controlled carefully to create just the right temperatures, atmospheres, and cooling off times for each type of clay.

Clay bodies vary from coarse clays and terra-cotta (softest) to stoneware and to porcelain (the hardest). Terra-cotta is fired at lower temperatures while porcelain needs extremely high heat to vitrify (fuse) the material. Fine china is made of such porcelain clays.

CRAFTS: MEDIA & FORMS

In primitive cultures, people hand-crafted objects for the daily activities of cooking, carrying, and storing; for personal adornment; and for seeking the favor of their gods or some supernatural forces. In trash heaps and digs around the world, archaeologists have uncovered pots, baskets, tools, utensils, ornaments, idols, weapons, and decorative objects. Since these humble beginnings, crafts have become more decorative, carefully designed, and durable. The sophistication of these crafts has been a valuable aid in determining the cultural advancement of a particular society.

First and most important to the craftsperson is the usefulness of an object and its functional design. Then the piece may be decorated to suit the owner. The Comanche Indian cradle board was first designed to hold a baby while the mother was busy with her daily tasks. After the design proved useful, the cradle boards were decorated to make them more appealing, colorful, and mystical. This was done by sewing beads to the material to form various protective symbols or patterns and by tooling the leather and carving the wood.

Ku-shaped vase, 1796–1820. Porcelain, 37 cm high. Chinese. Los Angeles County Museum of Art, gift of Mr. and Mrs. Harvey S. Dye

GERTRUD AND OTTO NATZLER. Vase, 1963. American. Glazed ceramic, 22.5 cm high. Los Angeles County Museum of Art, gift from Rose A. Sperry Revocable Trust

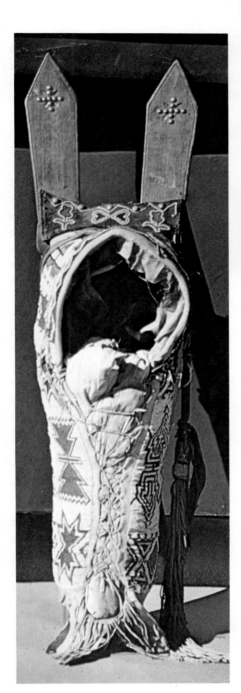

Comanche cradle board. American Indian. Wood, leather, fabric. Texas Memorial Museum, University of Texas at Austin

Many Greek and Roman vases exhibit excellent craftsmanship. However, the finest ceramic work was done by Chinese *potters,* and many Chinese kilns became famous because they produced work for the Imperial courts. The Ku-Shaped vase of porcelain is from the early nineteenth century. The potter produced a traditional vase form and decorated it beautifully with traditional designs and motifs.

Contemporary ceramists work in a time-tested manner. Moist clay can be formed by hand in a variety of ways or can be formed into a shape on a *potter's wheel,* a process called throwing. Forming and finishing are the two important phases of all clay work. After the clay is trimmed and allowed to dry slowly, it is given a bisque firing (preliminary firing) in the kiln at a low temperature of about 900° C. When cool, the object can be colored by applying glazes (made of various mineral ingredients) and refired at a high temperature of about 1290° C for stoneware and porcelain. The end product has a durable, shiny, colored finish such as the vase created by Gertrud and Otto Natzler. One forms the clay and the other creates the unique glazes that they use in their work. The beautifully textured surface is the result of a glaze that crystalizes, melts, runs, and fissures in places because of the combination of minerals contained in it.

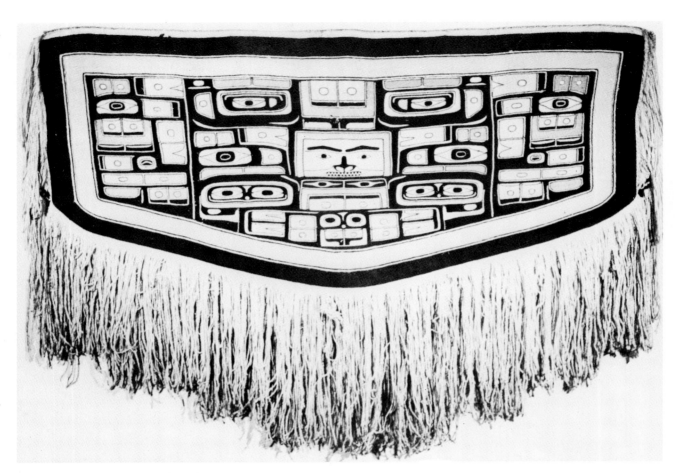

Blanket. Tlingit. Cedar bark and wool,
172 cm wide. Whatcom Museum of
History and Art, Bellingham,
Washington, Hauberg Collection

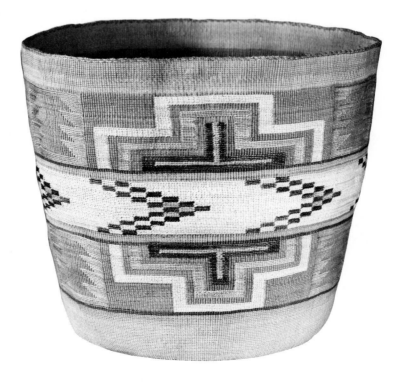

Basket, about 1890. Tlingit. American
Indian. Spruce root, 40.5 cm high.
William Rockhill Nelson Gallery of Art,
Kansas City

JOAN MIRO. *Femme,* 1978. Spanish Tapestry, 10.5 × 6.04 m. National Gallery of Art, Washington, D.C., gift of Collectors Committee

Fibers The early processes of weaving and *twining* resulted from a need for containers, clothing, and protective coverings for walls and floors. Materials were available to twist, knot, twine, and loop into forms that helped to meet these basic needs. At a later time, weaving was developed—the process of making textiles on some type of loom. Today, people take fabrics for granted and do not appreciate the gradual developments that led to the machine production of needed goods. But there are still many hand-weavers working today, using fibers and looms to produce unique fabrics.

The basket was twined from spruce roots by a member of the Tlingit Indian tribe in Southern Alaska. It is wonderfully crafted and the design is beautifully incorporated into the twining process. The blanket was also crafted by someone from the same tribe, using cedar bark and dyed mountain goat's wool. The traditional design is a bear (the head is in the center) with faces marking each important joint. It is as if the bear were symbolically dismembered and spread out for the viewer to see.

Contemporary fiber artists, such as Joan Miro, have developed the craft into an art form. Dyed and natural wools and synthetic fibers of many thicknesses and textures have been woven, knotted, tied, and stitched to create his wonderfully colored and textured design, *Femme.* While crafts are usually designed to be utilitarian, Miro has taken the craft technique and used it to create a work of art—solely for aesthetic not practical use.

Tapestries, carpets, brocades, stitchery, and fabrics of many types could be shown here. Many will be found in other parts of the book illustrating a universal craftsmanship with fibers. Today's fiber artists are weaving sculptures and environments, which is a long way in time and culture from early basketmaking attempts.

Glass Glass is such a common item today that it is difficult to think of it as a precious material. Yet the Egyptians used glass and precious gems in jewelry, and it was an important part of King Tutankhamen's burial mask.

Glass is formed by fusion in a heated kiln. It is compounded of silicates (plain glass is made of silica, soda, and lime), and other materials are added to provide clarity, opacity, hardness, or color. In its molten state glass can be formed with tools into solid objects, rolled out into flat sheets, blown with human breath into rounded and hollow forms, or formed into desired shapes in molds. After it is formed and cooled, designs can be cut into it with diamond-edged wheels and tools. Decorations can be etched with acids or sand-blasted with powdered abrasives. Glass can also be painted with special materials which can be fused to the glass by refiring in a kiln.

The glass bottle made by an Egyptian craftsperson about 3350 years ago is a beautiful example of superb craftsmanship. It probably held valuable perfume or other precious oils for a wealthy nobleman or his wife.

From the precious objects of Egyptian, Greek, and Roman times, glass gradually became more plentiful as the working processes became standardized and commercialized. In early American history, several centers for making glass bottles, dishes, vials, compotes, and goblets were established. The crafted glass products shown here were made around Sandwich, Massachusetts on Cape Cod. The formulas for obtaining certain colors in glass making were guarded secrets, handed down from father to son.

Other glass-related crafts include the making of stained-glass windows (*See* pp. 218–19), a craft that enjoys great popular revivals from time to time. Solid glass sculptures and decorative paper weights are other glass items created by craftspersons. *Enamels* are bits of ground colored glass that are adhered to metal and fused in a kiln. Several examples are included elsewhere in the book. Besides keeping the rain on the outside of windows, glass is also a valuable and popular medium for craftspersons.

Hand-blown and mold-made glass, 18-19th centuries. American. Glass Museum, Sandwich, Massachusetts

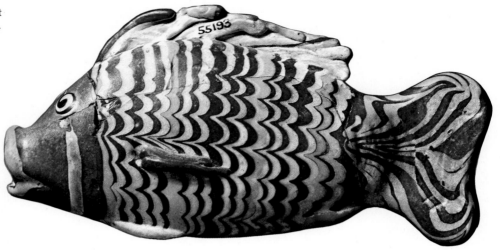

Glass bottle shaped like a fish, about 1370 B.C. Egyptian, from el Amarna. Glass, 14 cm long. British Museum, London

Jewelry Millions of pieces of jewelry have been made by excellent craftspersons around the world and any one of them could be used as an example. In nomadic societies, wealthy families invested in jewelry or other portable items. As noblemen and rulers in later years acquired great wealth, their collections of jewelry grew until fine jewelry, gems, and wealth became synonymous. Simple jewelry, on the other hand, can be made of any material that enhances personal appearance—string, seeds, or basic metals like copper. It satisfied the need for personal adornment in primitive societies.

Goldsmiths and gem cutters often must work together to create jewelry of striking beauty. The Spanish goldsmith, who crafted this pendant, used metal gold to form the basic shapes, wires, and chains. The green gems are emeralds and the black stones are onyx, making the entire item very valuable.

Pendant, in the form of a caravel, 16th century. Spanish. Gold, emerald, and onyx. The Hermitage Museum, Leningrad

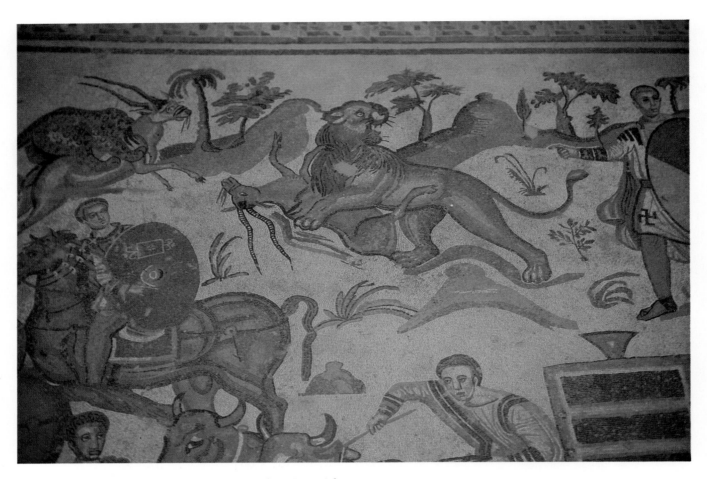

Hunting scene, 3-4th centuries. Roman. Mosaic from Imperial
Villa at Casales, Sicily

Mosaics Mosaics can be made of glass (Byzantine and
Venetian glass), stone (various colored marble bits), bits
of ceramic tile, pieces of wood, or even seeds and paper.
The walls and ceilings of early Christian churches were
lined with mosaics of colored glass and even glass con-
taining gold. Bits of glass *(tesserae)* were embedded in
plaster or cement to make designs and pictures that glit-
tered in the light of passing candles. Ancient Romans
put thousands of incredibly small pieces of marble to-
gether to create wall decorations that were polished until
smooth as glass (*See* p. 173). They also lined the floors of
many buildings with mosaics of scenes or designs, such
as this one at a villa in Sicily. The floor was in a hunting
lodge and illustrated many techniques for hunting, cap-
turing, and killing various animals and birds. Often
mosaic sidewalks in front of Roman shops contained
symbols or pictures of the type of business found inside.

Furniture Furniture, like glass, is taken for granted.
Craftspersons working with wood have produced such
astounding results that they have often signed their
pieces as painters and sculptors do. Like the other crafts,
furniture can be as simple and stark as a Quaker chair or
as elaborate as a complicated painting or mosaic. The
commode seen here has a veneered decoration of tulip-
wood, burr wood, and satinwood. When bits of veneer
(thin slices of wood) are cut and fitted into intricate de-
signs such as this, the craft is called *marquetry*. A fitted
and shaped marble top together with gilt-bronze
mounts complete this marvelous work.

Contemporary craftspersons are working with metal,
glass, plastics, leather, fibers, and wood to create furni-
ture for offices, homes, and public spaces, using modern
production methods and finishing techniques.

Metalwork Craftspersons working with metals have been producing work for their societies ever since bronze could be worked. As with other crafts, the competence of the craftspersons provides a good indication as to the sophistication of the society and its level of technology. Working in gold, silver, copper, bronze, iron, steel, and aluminum, artisans have created their metal magic for centuries. Paul de Lamerie was considered England's greatest silversmith in the early eighteenth century. The silver sconces were heated and beaten into shape, then tooled, burnished, formed, and polished until finished. The elaborate style is called Rococo and many of the designs and techniques in these works were unique with de Lamerie.

Other metal objects and crafts are presented throughout this text. Most crafts were made to be useful and not simply to look at and enjoy. Some, however, are of such high quality that their aesthetic value outweighs their usefulness—and they must be called art.

PAUL DE LAMERIE. Pair of Wall Sconces, 1725. English. Silver-gilt, 56 cm high. Los Angeles County Museum of Art, promised gift of Mr. and Mrs. Arthur Gilbert

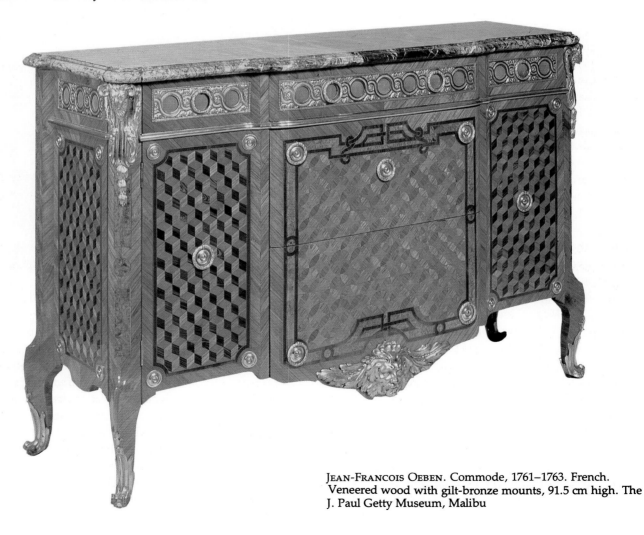

JEAN-FRANCOIS OEBEN. Commode, 1761–1763. French. Veneered wood with gilt-bronze mounts, 91.5 cm high. The J. Paul Getty Museum, Malibu

Design: The Structure of Art

The craftsperson working in Java or India has probably had no formal training in art nor has the Eskimo stone carver had a course in design. The Ife mask maker and the German manuscript illuminator of the Middle Ages did not formally study the elements and principles of design. Yet they all have produced excellent work that seems well planned and carefully designed. Most artists and craftspersons have an innate sense of design so that when they work on a painting, sculpture, or ceramic piece, they intuitively know what is right and comfortable. After centuries of looking at paintings, sculptures, crafts, and buildings, art historians and theoreticians have discovered that certain aspects of good art are repeated. They call these features, DESIGN.

Design is really the structure of art—the grammar of visual language. Just as verbal language needs structure to make it understandable and effective (random words strung together are confusing), visual language needs structure to make it comprehensible. The elements of design are the vocabulary with which artists work; the principles of design are the grammar, suggesting how these elements can be used most effectively. These features are rarely used in isolation. Artists usually use all the elements and principles in concert to produce an effective visual statement.

Look at El Greco's painting of *St. Martin and the Beggar.* The subject matter is a narrative account of St. Martin meeting a naked, starving beggar and giving him his own cloak for protection. The oil painting of the horse, two figures, and landscape are painted in the individual style of El Greco, who is discussed later in the section on the Renaissance period. El Greco used all the elements of art in this composition. It is easy to find *line* in the work. The horse is a white *shape.* The beggar is shaded so he seems to have three-dimensional *form.* The costume of St. Martin has a different *texture* than the horse. There are light, dark, and medium *values* of color shown in this reproduction. The *colors* used (green and blues) are predominantly cool. Deep *space* is indicated because of the small scale of the distant town. These elements (line, shape, form, texture, value, color, and space) are the vocabulary of the artist—the things with which every artist works. But what about the grammar?

When El Greco structured this composition, he had to decide where to place each part to make it most effective. The parts are in *balance* because there is just about the same visual activity and weight on both sides of the central axis. Because of the limited use of

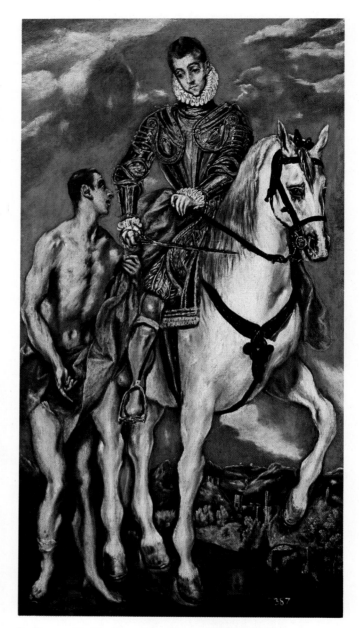

EL GRECO. *St. Martin and the Beggar*, 1597–1599. Oil on canvas, 194 × 103 cm. National Gallery of Art, Washington, D.C., Widener Collection

color and the elongated distortion that El Greco uses throughout, the painting has a sense of *unity. Emphasis* is placed on the good deed of giving to the poor and on the dominant blue-green color. There are many *contrasts:* between light and dark, textured and smooth areas, and rich and poor. The flickering light El Greco creates causes elongated shapes to be repeated in the painting, forming a *pattern* of lights and darks. He controls viewers' eyes so that they always end their visual *movement* at the face of St. Martin, the center of inter-

est. The repeated vertical shapes develop a sense of *rhythm* in the painting. These principles (balance, unity, emphasis, contrast, pattern, movement, and rhythm) are the grammar of the artist—the ways that he/she can best use the elements to create a pleasing composition.

An important aspect of art criticism involves analyzing a work of art to find the elements of art (or elements of design) in the work. We might also analyze how the principles of art (or principles of design) were used to structure the elements successfully. Some of the elements and principles may sometimes not be evident in a particular work, but most of the time you should be able to find them and judge how effectively they were used.

These elements and principles will be explored more fully in this section. Some artists are more conscious of design in their work than others, but all must use the elements and principles. The terms describing these elements and principles will appear often hereafter, but only a few paintings will be discussed in detail as to their design and composition.

KINDS OF QUESTIONS TO ASK

When studying and analyzing a work of art, it is helpful to ask a few questions. These examples can help you make up your own questions about the content and properties of the work.

Content can be determined by asking: What is the work about? What is the major theme? Are there minor themes?

Sensory properties can be found by asking: Where are lines and shapes used? Are colors bright or dull? Which color dominates? Is texture evident?

Formal properties can be noted by asking: Where is the center of interest—the area of emphasis? Are colors or shapes repeated? How is balance achieved and felt? What kinds of contrast can you see? Is the work unified? How?

Technical properties can be noted by asking: What medium is used? How large is it? How did the artist use the material to express his idea? Are the wood grains used effectively? Are brush strokes important to the work?

Expressive properties can be emphasized by asking: How is mood established? What does the painting tell us? How did the artist feel about the subject? How do I feel about it? Are there implications here of social or religious significance?

The discussions and descriptions on the following pages will help you use such questions to understand art more completely.

THE ELEMENTS OF DESIGN

The elements of design are everywhere, not just as paintings or sculptures. Lines are seen everyday. They can be two-dimensional like those on a sheet of writing paper or three-dimensional like the branches of a tree or the cracks in a rock. A good exercise is to look for lines around the room and then to look at a photograph or a painting to find lines there also.

If a line on paper wanders around and finally crosses itself, the enclosed area is called a shape. Shapes have only two dimensions. They can be geometric (triangle, circle, square, or rectangle) or organic (free form, irregular, pear shaped, amoeba-like).

A form is three-dimensional and encloses volume. Like shapes, forms can be geometric (cubes, pyramids, boxlike, cones), irregular, or free form (eggs, pears, horses, people, bottles). Sculptors and potters work with form while painters work with shapes, often trying to shade them to make them look like forms. Every physical object people see has a form and every picture of those objects has shape.

Value refers to the light or dark quality of a color or shape in a painting. Black is the darkest value; white is the lightest. When a basic red color is mixed with white, its value is lightened; if black is added, its value is darkened. Look at El Greco's painting again and notice the dark values, light values, and middle values. If a painting were all dark values it would be difficult to read. Most successful paintings have a contrast of values; the stronger the contrast the more dramatic the painting seems. Sometimes it is difficult to see the light or dark quality of color, but a black and white photograph will show you immediately the various values in the painting.

The surfaces of things have texture. Sandpaper, wool cloth, leather, and asphalt have textures. A painting may have to simulate textures by using color and value contrasts to make the surface *seem* textured.

Space is where people live. The volume of air around us is negative space—space not occupied by solid forms. But space also refers to the illusion of depth in a painting or drawing. Real space is three-dimensional while space in a painting is two-dimensional. Leonardo da Vinci believed that true art makes the viewer feel three-dimensional space on a two-dimensional surface.

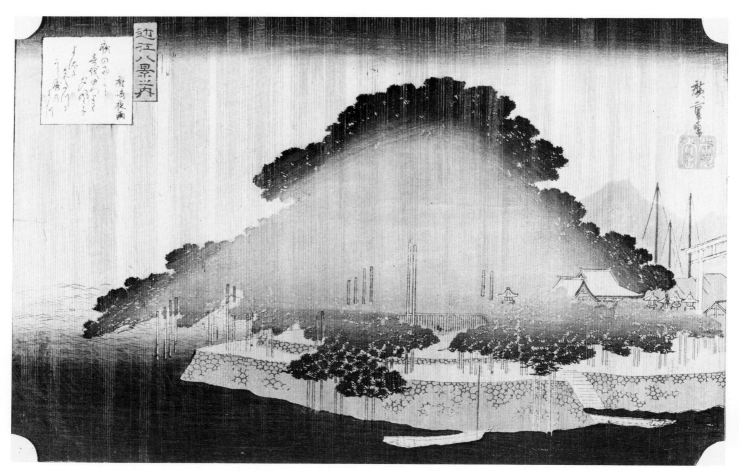

UTAGAWA HIROSHIGE. *Night Rain on Kirasaki Pine*, 1834. Japanese. Woodblock print, 23 × 36 cm. Los Angeles County Museum of Art, gift of Mr. and Mrs. Nathan V. Hammer

Line A marvelous variety of line is cut into the woodblock and printed by Hiroshige. Some lines are thin or thick; continuous or interrupted; straight or curved; vertical, horizontal, or diagonal; geometric or organic. Even *calligraphic* lines can be seen in the signature, description, and *chops* in the upper corners of the print. Some lines are massed together to create gray or textured areas while others are used singly or in pairs. Some lines are black while others are colored in the original print. Each color used on this print required a separate, cut block. Over fifteen separate blocks were used to get the final result in some of these prints.

Shape Although Diego Rivera is noted for his expressionistic murals in Mexico's capital and other cities, he studied for a time in Europe and learned the cubist style of painting from Pablo Picasso. The tilted table top, the rearranged perspective, and the simplification and abstraction of objects is typical of the cubist style. Rivera used shape as the dominant element in his design. Some shapes are organic, others geometric. The hard edges and sharp breaks between values and colors make it easy to see the different shapes. Shape and design were more important to Rivera in this painting than a realistic representation of the objects on the table. Value contrast is also very important, otherwise one would not be able to pick out the various shapes.

James Rosati. *Untitled*, 1978. American. Steel, about 3.5 m high. National Gallery of Art, Washington, D.C., gift of Collectors Committee

Diego Rivera. *Still Life—Bread and Fruit*, 1917. Mexican. Oil on canvas, 116 × 89 cm. Los Angeles County Museum of Art, gift of Morton D. May

Aristide Maillol. *The River*, 1939–1943. French. Lead, 209 cm long. Norton Simon Inc. Foundation, Los Angeles

Form Looking at the two sculptures, one cast in lead and one of welded steel, it is easy to see which has geometric forms and which has organic forms. Form, the volume or mass that objects have, is the most important art element for sculptors. The human body may sometimes be rendered in geometric forms, but Maillol's style is *representational* and his figure is rather realistic, although somewhat *stylized*. Proportion of the parts is important to such a work, regardless of the pose or attitude. Rosati welded planes of steel together to create his angular forms. Even though they are geometrical, he produced forms for which there are no names. Light is important to both pieces, emphasizing the roundness of Maillol's forms and defining the sharp edges and flat planes of Rosati's.

Nicholas de Staël. *Landscape in Vaucluse, No. 2*, 1953. French. Oil on canvas, 64 × 81 cm. Albright-Knox Art Gallery, Buffalo, gift of Seymour H. Knox Foundation Inc.

Texture Nicholas de Staël greatly simplified the landscape of Vaucluse so that only shapes and colors remain. The shapes perhaps remind one of cliffs and trees, sky and water, or perhaps other elements of the landscape. When the French artist put down his oil paint on canvas, he wanted to use another element of design besides color and shape—texture. One can immediately see the texture in this work: it actually exists. The paint was buttered onto the canvas with a painting knife, like a small spatula. The artist may not have used a regular brush at all on this *impasto* surface. It appears that he also added textural material to his paint, materials like sand and sawdust. Rubbing one's hand over this painting, even with eyes closed, reveals the coarse textural quality of the surface.

Simulated Texture Although the surface of Gustav Klimt's painting looks more textured than de Staël's, it is not. Its surface is relatively smooth as the textures are simulated. The surface is painted to look like texture but in reality it is not. Klimt was a master at creating unusual and convincing textures. Flat surfaces often appear textured because of the value contrasts the artist used. Usually, paintings have a variety of simulated textures so the surface is not monotonous, but Klimt gives us little relief. The viewer is overpowered by the dense forest of uniform texture. Klimt and de Staël both enjoyed texture for its own sake. The two paintings are not representations of real textures in nature but are abstracted works which emphasize texture.

Gustav Klimt. *The Park*, before 1910. Austrian. Oil on canvas, 110 × 110 cm. The Museum of Modern Art, New York, Gertrud A. Mellon Fund

Space: Perspective Over the years, artists have devised ways of showing depth or space in a painting—a process called *perspective*. If two objects overlap on a flat surface, one is clearly behind and the other is in front. A sense of depth is created. But painters also use *aerial perspective* to show depth. In Turner's painting, the bright haze hides distant details and one's eye reads the mountains as being far away. The darker values are up close and the lighter values are far away; the colors also are more intense up close while the edges become softer farther away. Turner used all these features to help the viewer feel the deep space at Montreux.

Canaletto used *linear perspective* to help the viewer experience the space he saw at Venice. All parallel lines run toward invisible vanishing points which are off the canvas. With mathematical precision, the artist depicts the diminishing size of arches, columns, and people as they recede. In both paintings there is a strong feeling of depth or space, yet each artist used different means.

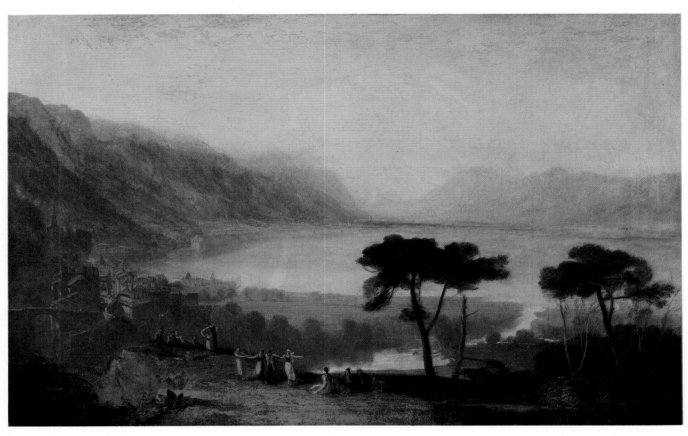

JOSEPH MALLORD WILLIAM TURNER. *Lake Geneva from Montreux*, 1810. English. Oil on canvas, 103 × 163 cm. Los Angeles County Museum of Art, Adele S. Browning Memorial Collection

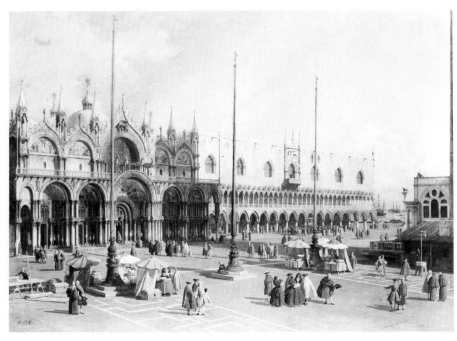

CANALETTO. *The Square of St. Mark's*, about 1730. Italian. Oil on canvas, 115 × 154 cm. National Gallery of Art, Washington, D.C., gift of Mrs. Barbara Hutton

COLOR WHEEL

Francisco Zurbarán. *Still Life with Lemons, Oranges and a Rose*, 1633. Spanish. Oil on canvas, 59 × 105 cm. The Norton Simon Foundation, Los Angeles

Color　Color is the one phase of art that is also a science. Some artists often disregard the scientific aspects of color but others use all the scientific approaches they can in their abstract use of color. There are three terms that artists use in talking about color: hue, value, and intensity. *Hue* is the name of the color—yellow is a hue. *Value* is the dark or light quality of a color—pink is a light value of red because white has been added to it. *Intensity* is the brightness or saturation of a color—the pure color is most intense; if one adds its *complement* and grays it, it is less intense.

The color wheel is a good place to begin learning about color. There are three *primary hues* (red, yellow, and blue) and from these, all other colors can be made. If two primaries are mixed together, a secondary color is produced (red and yellow make orange). If a primary and secondary color are mixed together an intermediate color is created (blue and green make blue-green). Colors directly opposite on the color wheel are *complementary colors* (yellow and violet). If they are mixed together, the original hue is grayer and less intense. A little green mixed with red will lessen the intensity of red and make it a grayed or muted color.

Hues containing red and orange are *warm colors,* and hues containing green or blue are *cool colors.* Warm colors seem to advance or come forward while cool colors seem to retreat or go back into a painting. Shadows are often painted with cool colors and sunlight with warm colors.

Painters also refer to the local color of objects, which is the color they are when lit by uniform, white light. However, if two colored objects are next to each other, each will also contain reflected colors (those absorbed from surrounding objects) as well as its own local color. If the source of light is colored, the local color will change. For example, if a yellow replaces white as the only light source, the objects will take on a yellowish hue, not at all like their color in white light. Think of how the colors in nature change when the sunset casts an orange hue over everything.

Color is the most important art element for the painter, and generally a lesser concern to printmakers and sculptors. How artists have seen color in nature has greatly determined their painting techniques and styles.

Artists can also use color to create a mood. For example, purple looks cool and mysterious. Mood colors are often used by expressionist painters to emphasize their feelings toward a person or place.

Value　The light and dark values in Zurbarán's still life can be readily identified in both the black and white print and the color reproduction. In the black and white print the middle values are gray whereas in the color reproduction they are variations of the dominant hues. Colors have values also, and the artist has used them to create a feeling of form—of three-dimensionality. The rounded lemons and oranges look like they take up volume and space because of their gradual value changes from light to dark. If value changes are sudden, they indicate a sharp edge like the rims of the plates and cup. The cup appears rounded because of its shading or change in value. The still life has a dramatic impact because of the strong value contrasts from deepest dark to lightest light. Paintings that have mostly light values are called *high-keyed* and those of mostly dark values, *low-keyed.*

PRINCIPLES OF DESIGN

The principles of design describe the general ways in which artists arrange the parts of their compositions (or sculptures, pots, blankets, weavings, buildings, or woodcuts). These organizers are balance, unity, emphasis, contrast, pattern, movement, and rhythm.

The principles are never used in isolation but always in concert. A design may use balance to achieve equilibrium, but it may also contrast certain areas, emphasize one part of the design, achieve rhythm and movement, or produce an overall pattern. One principle may dominate, but when an overall unity is achieved, all the principles have probably been employed. Look again at El Greco's painting of *St. Martin and the Beggar* to see how these principles work together.

While there are many ways to use the elements to achieve each design principle, only a few can be explored here. Most of the principles will be found in the following examples, although only one will be discussed and emphasized in each work. Readers may want to return to this section often to reinforce their understanding of design terms and dynamics.

Balance: Symmetrical Symmetrical (or formal) balance is a roughly even distribution of visual weight or activity on each side of a central axis—like two equally sized children on a teeter-totter. Most paintings are not perfectly balanced symmetrically as one side would be a mirror image of the other. Antoine Watteau's *Italian Comedians* comes close. The white-clad figure is dead center, in front of a centered doorway. The massed figures on each side are about the same in size. The lower figures on the left are balanced by the heavy drapery on the upper right. Note the distribution of light values across the canvas and the importance of the flowers on the steps in creating the visual balance.

Balance: Asymmetrical Asymmetrical balance means that larger masses on one side of the painting may be balanced by smaller, contrasting, or more intensely colored parts on the other side. The asymmetrical painting is informally balanced and is usually more exciting than a formally balanced composition. It is sometimes difficult to see the balance in such a design, but if the overall effect is comfortable, it is probably properly balanced.

ANTOINE WATTEAU. *Italian Comedians*, 1720. French. Oil on canvas, 64 × 76 cm. National Gallery of Art, Washington, D.C., Samuel H. Kress Collection

EDGAR DEGAS. *Mademoiselle Malo*, 1877. French. Oil on canvas, 81 × 65 cm. National Gallery of Art, Washington, D.C., Chester Dale Collection

WINSLOW HOMER. *The Carnival*, 1877. American. Oil on canvas, 51 × 76 cm. The Metropolitan Museum of Art, New York, Lazarus Fund

In Degas' painting, the face is on the right side of center. The two light-valued hands are on the left side. The bulk of the body is about equally balanced, although the shapes are different. The other light values also work to achieve balance. The bits of white flowers on the left side are balanced with the light values of the chair on the right. In many of Degas' ballet paintings, his asymmetrical balance is much more complex (*See* p. 370). By covering first one half and then the other half of this painting, the viewer can see how different they are. Yet the composition seems balanced and comfortable.

Unity Unity combines the principles of design and the physical aspects of a painting to create a single, harmonious work. It can be compared to the bringing together of all instruments, tonal movements, and chords to make a single beautiful passage of sound. Artists can use various means to achieve unity. Consistency is achieved in three ways in Turner's dramatic painting of the great London fire: (1) values are mostly high-keyed; (2) feathery brush strokes appear throughout; and (3) all forms are rendered abstractly. A limited palette of yellows and oranges also insures color unity because all the hues are related.

Homer's subject and methods of obtaining unity are quite different from Turner's. In *The Carnival*, Homer uses a single strong light source, entering from the left.

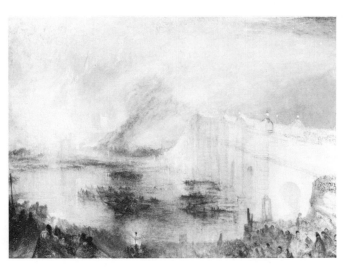

JOSEPH MALLORD WILLIAM TURNER. *Burning of the Houses of Parliament*, 1835. English. Oil on canvas, 92 × 123 cm. Philadelphia Museum of Art, The McFadden Collection

The colors on the carnival figures are more intense than the muted background hues. The figures are therefore dominant while the background is subordinate. The figures also contain more detail and value contrasts than the background. The central three figures are strongest and all eye movement in the painting is directed to them and eventually to the act of sewing up the torn costume—the center of interest. A strong repetition of vertical shapes establishes a rhythm that unifies the work; but there is also a secondary horizontal movement, established by the fence and the ground shadows, which tie the verticals together. The little girl on the left is placed to delicately balance the asymmetrically arranged elements. Finally, the visual story or narrative helps to unify the subject matter and therefore the painting.

JAN VERMEER. *Officer and Laughing Girl*, 1655–1660. Dutch. Oil on canvas, 50.5 × 46 cm. The Frick Collection, New York

Emphasis Emphasis is the way of developing the main theme in a work of art. It answers the question: "What is the artist trying to say?" The answers can be obvious or obscure. Artists may emphasize one or more of the art elements—such as color, line, or texture—and subordinate the rest. Artists may also emphasize a particular subject or concept—symbolism, daily life, material magnificence, or historical fact. Genre painters emphasized the situation of the common people while Rococo painters emphasized the playfulness and frivolity of French court life.

Jan Vermeer emphasizes light in his work. The natural light entering from the open window floods the wall, girl, and table. Vermeer also depicts the various reflected lights and different intensities of shadow. The room, officer, and girl are simply props for Vermeer's beautiful study of light. Compare Vermeer's approach to those of the artists discussed. Winslow Homer emphasizes his figures by subordinating the background while Turner emphasizes the swirling fire by practically eliminating all else in the painting.

Contrast If all parts of a painting were alike, it would be monotonous and the viewer would lose interest quickly. To avoid monotony and to make the painting as visually interesting and exciting as possible, artists use contrasts of various kinds. In Tiepolo's painting of the wise men visiting Mary and the Christ child, he used many contrasts. It is easy to find contrast of light and dark values which, of course, accompany the contrast in color between warms and cools. Soft, curving shapes of fabric contrast with the hard edges of the building. Small sized areas of light or dark contrast with large shapes. Textured areas contrast with smooth. Earthly elements contrast with heavenly; richness contrasts with poverty; youth contrasts with age. There are even ethnic contrasts in the people represented. Vertical movement contrasts with horizontal. The entire structure of the painting, which is designed and painted superbly, revolves around contrasts, controlled by the arbitrary use of light and shadow at the personal direction of the artist. The abstract portrait by Jacques Villon is remarkably like Tiepolo's painting in design. This similarity is revealed

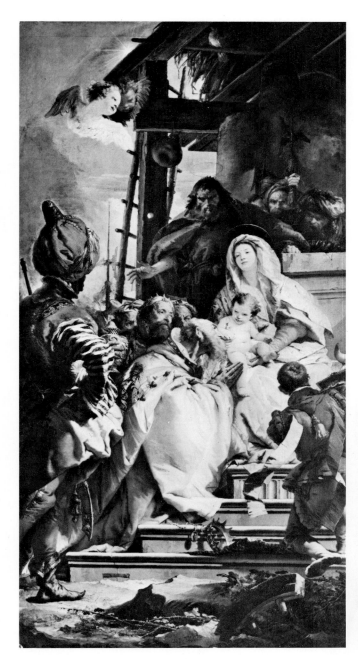

GIOVANNI BATTISTA TIEPOLO. *Adoration of the Magi*, 1753. Italian. Oil on canvas, 366 × 209 cm. Alte Pinakothek, Munich

JACQUES VILLON. *Portrait of Mlle. Y. D*, 1913. French. Oil on canvas, 130 × 89 cm. Los Angeles County Museum of Art, gift of Anna Bing Arnold

quickly by studying both paintings with squinted eyes. Although Tiepolo's style is more representational, Villon's use of contrasting art elements is about the same. The contrast of light and dark is readily apparent. Note also the similar contrasts of size and shape in both works. Textures subtley contrast with the angular and curved shapes.

As Villon was working solely with abstract shapes and ideas, his chief focus was on the design and arrangement of elements. An interesting project is to analyze how Villon used the other principles of design in arranging the shapes and colors in his composition.

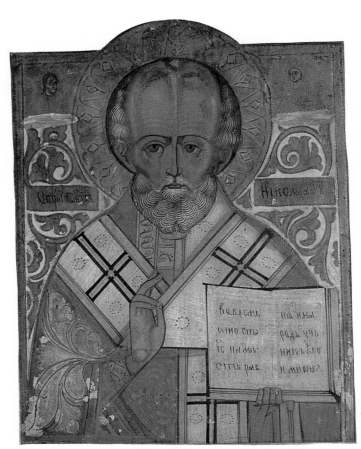

Unknown icon painter. *Saint Nicholas*, 19th century. Russian. Egg tempera on wood, 35 × 25 cm. Collection of Mr. and Mrs. Joseph Gatto

Pattern Pattern can be produced by the repetition of motifs, colors, shapes, or lines in a painting, sculpture, or craft. Islamic art and many works from ancient or primitive cultures rely heavily on pattern. The Russian craftsperson who designed this sacred icon for someone's home relied heavily on pattern to fill both *positive* and *negative areas*. Notice the repetition of linear motifs in the halo and even in the beard and hair. Designed patterns using leaves as the motif fill background space. The robe itself has line and dot patterns which are repeated. A large percentage of the surface is therefore patterned. Cultures or artists favoring symbolism over reality tend to rely heavily on pattern to decorate spaces in their crafts or art.

Movement Visual movement in art directs the eyes of the viewer through the work to a center of interest. Van Dyck's painting is a wonderful example because it inevitably directs all eye movement to the left side and to the glowing figure of Delilah. Samson is being dragged

ANTHONY VAN DYCK. *Samson and Delilah*, about 1628. Oil on canvas, 143 × 253 cm. Art History Museum, Vienna

David Alfaro Siqueiros. *Portrait of a Woman*, 1934. Mexican. Oil on masonite, 151 × 78 cm. Los Angeles County Museum of Art, gift of Morton D. May

of design to lead viewers around his exciting composition until they get to the place he wanted them to notice first, last, and continually—the beautifully painted Delilah.

Rhythm Rhythm is established in a painting or other work of art when elements of the composition (such as curves, angles or vertical or horizontal lines) are repeated. Repetitions can occur at either regular or irregular intervals. Rhythm and movement, like rhythm and pattern, are inseparable. In Siqueiros' painting of the woman clasping her hands, there is strong movement up to and around her face, where the haunting eyes become the center of interest. Siqueiros repeats the gently curving shapes in regular intervals to create a strong rhythmic beat to the movement. He emphasizes the roundness of the folds so that they almost appear to be made of metal or concrete instead of cloth. Notice how the fingers and the hair repeat the rhythm established in the folds. Siqueiros has taken an ordinary subject and created a lesson in the principles of design.

Conclusion

It is important to remember that almost every element and every principle of design could be discussed with every piece of art in the book. However, this approach would become monotonous and would merely make art history a technical study. Most artists learn these concepts of organization and work with them for a while until they become a natural part of their being. Some artists dismiss the principles or deliberately avoid one or more of them to emphasize a point in their visual communication. Artists before the nineteenth century did not have these principles outlined for them or taught in classes. Yet their work adheres closely to them. Most of the principles were derived by looking back at the work of artists who designed their painting spaces intuitively or analytically to make the best and most organized statements possible.

violently away from Delilah but eye movement keeps going back to her. Follow the areas of light values on legs and arms, and notice how they direct movement to the left. Squinting also reveals that dark value areas also seem to move to the left. The eyes of almost all of the figures are looking at Delilah and even her little puppy is curved to lead the viewer's eyes to her. Her light valued flesh is contrasted dramatically with the black background, forming a perfect center of interest for the asymmetrically balanced composition. Her crinkly robes also form a contrast with the massive dark bodies of the men. Van Dyck has used all the elements and principles

Analysis

1. Look through the text and select five pieces of art that *emphasize* one of the design elements. Under the headings of line, shape, form, texture, color, space and value, list the works by *title, artist* and *medium.* Or, make a similar chart of five works of art that emphasize each of the *design* principles (balance, unity, pattern, movement, rhythm, emphasis and contrast).

2. Portraits have always been an important way to show how people appear to others. There are many *reasons* to make portraits (personal, illustration, advertising, identification, business). Clip from magazines, five portraits done in each of the following ways: drawing, painting, sculpture and photography. For each of them, make a caption and list their probable purpose or use. Tell whether you think the portrait is effective.

3. Some artists emphasize the elements and principles of design in their art while others are more concerned with personal feelings about their subjects. In American artist Edward Hopper's painting, *Lighthouse Hill,* identify where he used the elements of art (line, shape, texture, form, value and space). Then analyze how he handled the principles of design (balance, emphasis, pattern, contrast, unity, movement and rhythm). In an oral presentation or videotape, share your analysis with the class. Although Hopper was careful about his design, was he still able to develop a mood in the painting? How does *Lighthouse Hill* make you feel? What can you tell about the place and the artist by looking at this painting?

Aesthetics

4. Design is a part of every handmade or manufactured object. Sometimes design is determined by aesthetics (appearance), function, trial and error or indifference. Select three objects from the artroom or from home which you think are well designed (they look pleasing and seem to perform their intended functions well). If they are small, you may set up a display illustrating good design. Select three objects which, in your opinion, are poorly designed. Discuss your reasons for liking or disliking the design in each object.

5. Nature photographers, landscape painters and landscape architects all work with nature. Write a paper describing how their work is similar and how it is different. Perhaps you can illustrate your project or present it as a videotaped documentary.

6. Write a short essay on: Why my past visual experiences influence my current taste in art and my selection of well-designed objects.

Studio

7. Use tempera paints to make a color wheel that is different in design from the one on page 56. Look through magazines and select color advertisements in which the *dominant* hues are very similar to each of those in your color wheel. Arrange a poster to effectively display your project.

8. Explore some of the tools and media that artists use. Find out the difference between a camel hair and bristle brush, fine and coarse tooth papers, canvas and masonite, and plaster and clay. In an oral presentation or video program, demonstrate such media and grounds to the class.

9. The text illustrates sixteen kinds of subject matter. Look through magazines and select advertisements and/or illustrations (photographs) that illustrate any *twelve* of these subjects. Label each of them and make a notebook, chart or slide/video presentation to share your findings.

EDWARD HOPPER. *Lighthouse Hill*, 1927. Oil on canvas, 72 × 100 cm. Dallas Museum of Fine Arts, gift of Mr. and Mrs. Maurice Purnell

Part Two
Trends and Influences in World Art

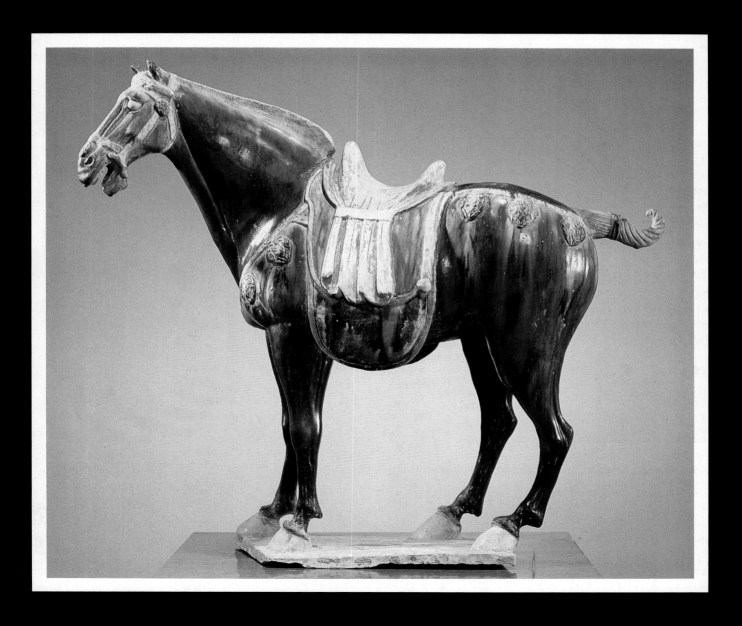

Glazed horse, 618–906. Tang Dynasty, China. Los Angeles County Museum of Art

Gravel garden, raked in circular patterns, 1979. Nanzenji
Temple, Kyoto, Japan

3 Looking for a Common Denominator

OBJECTS OF ART from around the world present a wide diversity of styles, functions, subject matter, and usage of materials. Despite this diversity, there are amazing similarities in the way people throughout history have used materials to form objects. Often, societies separated by thousands of miles have produced nearly identical art.

In subject matter, there are many remarkable similarities found in isolated cultures such as the use of animal and human *motifs*. These show up on similar types of pottery, architecture, or jewelry. Upon further reading, and critical analysis, many of these recurring themes will become obvious.

Geometric Patterns

One basic design quality, common to all the world's societies, is the use of geometric motifs. Particularly in the early development of a society, people have had a fascination with regular, rhythmic hard-edge patterns and have used them to ornament their artistic products. Spirals, checkerboards, wave patterns, and abstract key designs are some examples. Such decorations are found in the pottery of such widely separated cultures as ancient Persia, the Indus Valley civilization, the Archaic and Classic periods of Ancient Greece, native American tribes, and the early Chinese dynasties.

The cloth woven by many cultures is not merely fabricated to protect the individual from the weather but is often composed of colored threads woven into rhythmic patterns. Clothing of the ancient Inca civilization, the contemporary Iban tribes of Borneo, and Greek and Roman peoples of antiquity all utilize overall or geometric border patterns in their ornamentation.

Another use of geometric patterns is found in the *mandala*, a symmetrical design which symbolizes an understanding of the supernatural. Hindu and Buddhist symbols represent the universe in graphic designs. A circle may enclose a square with a god symbolized within the enclosure. Native Americans often represent gods or their respect of the earth in the geometric designs decorating their shelters, hunting garb, or sand paintings made by medicine men or *shamans*. Abstract geometric forms are created by Zen priests in Japanese Temple grounds, where gravel is raked in patterns that aid in meditation.

Floor plans of buildings or complexes of structures often represent more than mere efficient use of spaces and passageways. They are laid out to symbolize the order of the universe, such as at the Egyptian funerary district of Giza or at the complex of towers and cloisters at *Angkor Wat* in Cambodia. Single buildings, such as a Christian cathedral, graphically represent symbols in stone, brick, mortar, and floor plan.

Animal Designs

Humans have always been close to nature, having to depend upon plants and animals for their essential needs. Throughout history, craftspersons have used animals to represent the gods, to symbolize humans' relationship with nature, and to express people's fascination with dependence upon the animal world. The universal acceptance of animal motifs can be seen in the use of fish, which are found decorating bowls in native American, Chinese, and Thai pottery. Fish are also found on the mosaic floors of early Christian basilicas and in the paintings of the twentieth century German Expressionist, Max Beckmann. In American cul-

El Castillo. Pyramid temple, late 12th century. Toltec-Maya Culture. Chichen Itza, Mexico

Vase, about 700–800. Mayan. Slateware pottery, 19.5 cm high. William Rockhill Nelson Gallery of Art, Kansas City, gift of Peter I. Hirsch

ture, the eagle symbolizes nationalism and courage, and the bear represents strength. Wild animals, such as lions and birds of prey, are found in the art of Persia, on ancient Greek vases, and in the weavings of North and South American tribes. Domesticated animals are used in the motifs adorning drinking vessels from Mycenae to China.

While geometric pattern and animal styles seem to represent two divergent attitudes of decoration, many single objects have been decorated with both styles. These pieces indicate *transitional* periods when tastes were changing from geometric to animal styles.

Human Figures

People are the most important aspect of the environment. More is known about their thoughts, feelings, and physical activities than about any other component of the environment. Representations of humans in art have taken just about every form imaginable, from Peruvian hollow clay water vessels in the form of bodies to Michelangelo's exacting anatomical sculptures.

Human activities of every kind have been depicted on the walls of ancient Egyptian, Indian, and Mayan structures. People have carved monumental images of themselves, such as the huge likeness of the Roman Emperor Constantine or the United States' presidents on Mount Rushmore. Conversely, minute images of people appear in the art of Tibetans, the miniature

paintings of Islam, and the *icons* of the Orthodox Christian church.

Nude males and females have been used to portray the beauty of the human form or the creative power of God, as well as humanity's sensuous and sexual nature. Elaborately clothed figures depict wealth, social standing, and cultural tastes. The most highly individualized example of human design, the facial portrait, has been executed in every conceivable material.

A combination of all these features can be seen in the Mayan vase. The facial portrait is both realistic and symbolic. The artist understood anatomy, yet there is some stylization in the musculature and position. Emotion is strong. A combination of geometric motifs is used to complete the design.

Architecture

Civilizations have expended tremendous energy in the construction of monumental architecture. Artificial mountains, glorifying both people and their gods, can be found in many societies. Examples are found in the *ziggurats* of ancient Mesopotamia and in the pyramids of the Egyptians, Mayans, and the central Javanese. Castles of feudal Japan and Indian Hindu temples are other forms of this mountain-building trend.

Vertical structures have fascinated the imagination of architects throughout the world. Towers of stone have soared hundreds of feet into the sky. Ancient tribes erected stone *monoliths* called *menhirs* in locales as far apart as Laos and Sardinia. The ancient Egyptians carved tall needles of granite known as *obelisks* upon which they carved historical records. Chinese and Japanese constructed *pagoda* towers which function both as watch towers and Buddhist memorials. Soaring spires and towers of Gothic cathedrals also exhibit civilizations' obsession with the vertical. Today architects erect towers of steel and glass, perpetuating this ancient trend.

Cross-Cultural Influences

While some trends in the pattern of art around the world have developed in total isolation, there are many instances where one culture has affected another. This process of influence may have occurred through peaceful means, as in the Chinese and Buddhist influences upon Japanese culture. In some cases, one culture has actively sought out the aesthetic and technological expertise of another, such as the Roman reliance on Greek sculptors

Osaka Castle, late 16th century. Osaka, Japan

and techniques, and the Inca respect for *Paracas* and *Nazca* culture.

Ironically, military violence sometimes has been used to either attain the aesthetic treasures of another society or to insure a cultural infusion into a less creative people. For instance, the Japanese invaded Korea in the late sixteenth century, captured Korean potters and transported them to the southern Japanese island of Kyushu for the crafting of tea ceremony items. The Mongol invasion of China in the thirteenth century, however, did not cause a cultural upheaval. The Mongols encouraged Chinese potters to produce the now famous blue and white ware, not for their own taste but as an export item with which to raise revenue throughout their far-flung empire.

In the cultural world, influence is usually subtle, and the influence of one culture upon another reveals itself slowly as styles and techniques intertwine. Traders, missionaries, military expeditions, cultural missions, and diplomatic envoys have all helped to introduce and spread the styles and motifs of one culture to another. Osaka castle, built in Japan in the late sixteenth century, is a good example. Chinese culture had been first introduced into Japan in 552. Slowly, Chinese ideas of curved roofs, high *plinth*, and symmetrical arrangement had become part of Japanese aesthetics. European traders in Japan in the 1500s taught the Japanese about fortifica-

The Alhambra, 13–14th centuries. Granada, Spain

tions built in medieval England. When civil war broke out in Japan, warlords combined these influences into the unique structure seen here, one both defensible and beautiful.

Aesthetic and cultural influences may be introduced very quickly into a society, and almost overnight, styles and tastes change. The Mediterranean world changed dramatically after the rapid and militant spread of Islam in the seventh and eighth centuries. Such structures as the *Alhambra* palace in Spain reflect this radical shift in styles from a native to an imposed tradition. The new style of round arches, latticework, tilework, courtyards, and reflecting pools has become a mark of Spanish and Mediterranean architecture, strongly influencing architecture in much of Hispanic America and of the Southwestern United States.

Technology has often been imported. The use of bronze suddenly appeared in China during the *Shang* dynasty. The Chinese do not appear to have possessed the understanding of the lost-wax casting process until it

was somehow taught to them. This could have come from Central Asia, from the Indus Valley, or possibly from early advanced cultures in Northern Thailand. However it was learned, the Chinese quickly expanded the possibilities of this medium, producing such excellent works as the Mongolian figure holding two birds of *jade*.

Ideas for forms, shapes, and subjects also have been borrowed. Many twentieth century artists have received inspiration from the art of peoples who had never heard of Renaissance perspective, photo-realism, or the color wheel. Picasso was greatly influenced by the sculpture of African tribal peoples, and Gauguin went to Tahiti hoping to see the world through the eyes of unaffected peoples. The French Impressionists of the mid-1800s were inspired by the woodcuts of the Japanese who depicted the world with a different use of perspective and color. Chinese silks and porcelain set off an *eclectic* and *Baroque* taste in seventeenth century Europe known as *chinoiserie*. This style influenced the interior decoration

of Versailles and the ceramics of *Delft* and *Nevers*. Chinese pottery shapes were emulated by Koreans of the Koryu era who directly reproduced the *mei-ping* shape vase seen here. However, they also developed their own unique method of ornamenting the piece, by painting colored slip clay into scratched areas, a process known as *mishima*.

As new aesthetic ideas enter a culture, they often evoke a number of responses. People may embrace the new idea as a fad or may reject it if it is associated with military presence or the dominance of a rival government or religion. More often, after a society is exposed to new ideas, it absorbs them into its own existing culture. This homogenization process often results in some of the most interesting of all artwork. The art reflects not only the different components, but the struggle of artists and craftsmen to weld together seemingly divergent influences. The finest examples of this process are seen in the colonial world—in locations such as Mexico, where Europeans introduced their aesthetic traditions into a native area. The result was often *eclectic*. Local images and decorative motifs were combined with Renaissance architecture or Romantic painting to produce a stimulating combination of ingredients.

In studying the art of various cultures, it becomes apparent that people everywhere share a sense of aesthetics. They have a feel for arrangement and rhythm, color and pattern, pleasing shape, and visual balance. In a broader sense, a society's aesthetics reveals itself in the messages of its paintings, crafts, and sculptures. Art reveals the complexity and variety of the human personality. It demonstrates the numerous relationships of individuals with each other, with society at large, and with environmental and supernatural forces. While art forms vary stylistically from culture to culture, their general messages can be understood by all.

Mongolian Youth, 3–4th centuries B.C. late Zhou period, China. Bronze figure with jade birds, 29 cm high. Museum of Fine Arts, Boston, Maria Antoinette Evans Fund

Mei-Ping vase, 12th century. Koryo dynasty, Korea. Ceramic with celadon and mishima decoration, 31 cm high. Museum of Fine Arts, Boston, bequest of Charles B. Hoyt

HENRY MOORE. *Reclining Figure Single Leg*, 1976–1977. Granite, 185 cm long. Collection of the artist

HUGO ROBUS. *Despair*, 1927. Bronze, 30 cm high. Whitney Museum of American Art, New York

Emotion vs. Intellect: The Continuing Struggle for Expression

In all societies and at all times in history, two extremes of visual expression have been possible: a completely emotional approach with no concern for design and reason and a completely intellectual approach with no room for feelings and emotions. People are able to match those artistic extremes at each end of the scale—some being very emotional while others are very cool and aloof. Most people have both qualities although one may be more dominant. The kind of art that an individual enjoys (expressionistic or carefully designed) can indicate to some degree which way that person's interests lie. If artists work according to their natural feelings, they will express themselves in either one of the directions, although few can be found at either of the extremes. Most artists have had to try several approaches to visual expression before they feel comfortable working in their own natural way.

The art of various periods often seems to share these characteristics. In Western art there seems to be a repeating cycle of dominance and repression—emotional content is important for a while and then design becomes more important and emotion of less importance. Each seems to lie in wait while the other is more important and when the time is right again, emerges as the dominant attitude in art and expression.

Features of an intellectual or classic approach are: an emphasis on design and composition; a cool, analytical approach to the subject; the use of rules; an emphasis on neat, clean arrangements and proper proportions; and

an excellence of realistic drawing. Aspects of an emotional or romantic approach to art are: an active and colorful interpretation of the subject; the required participation of the viewer; violent movement; distortion; bright and vivid colors; a strong interest in nature; and a personal approach to the subject.

Henry Moore's sculpture demonstrates an intellectual approach to three-dimensional form whereas Hugo Robus' piece suggests a romantic approach. Although both works have similar rounded forms, the two artists had completely different purposes in mind when working. Henry Moore abstracted the human figure until only forms remain to suggest the original source. This abstracting process is an intellectual one and the finished product is cool and beautifully worked, exactly the way the artist wished it to look, without emotional overtones or hidden meanings. While the smooth curves may elicit a vague feeling of calm or sensuousness, they do not prompt a specific, overwhelming emotional response. The beauty of the form is appreciated chiefly for what it is, not for what it suggests.

The Hugo Robus sculpture is quite small, yet has a feeling of great size. It also has rounded forms and is somewhat abstracted, but the important difference is that it has an emotional content which cannot be ignored. The title, *Despair*, adds an expressionistic tag to the work. Viewers can feel the work's intended emotional content without knowing the title. In short, both artists used the human form as the subject, yet each

treated it with a different emphasis. Both use abstracted forms, yet one reflects a more intellectual and design-oriented approach while the other emphasizes feeling and emotion and an expressionistic approach.

A look at other works of art produced since Greek times will help clarify the dominance of one style of art over the other in a cyclical arrangement. It must be remembered that the repressed element was always waiting for a change in the cultural winds, and some artists were always working in a style that was not popular at the time. Two thousand years ago the cycles rotated slowly, often taking hundreds of years to change. Then the time span was shortened, until today they exist side by side. One style may be popular for only a year or two at a time, and the complete dominance of one over the other as a national trend is almost non-existent. Both tend to exist simultaneously.

Sometimes as one phase of a cycle came to an end, a period of transition occurred in which the other quality began to emerge. At other times a sudden almost physical reaction against the waning style occurred and the succeeding style became dominant instantly.

A simplified chart will demonstrate the cyclical development and dominance of either the intellectual or emotional approaches to art. Such a generalization is not totally accurate but will help explain why Romantic painters looked back to Baroque artists for ideas and why Neo-classic artists studied Greek and Roman art for aesthetic ideas akin to their own.

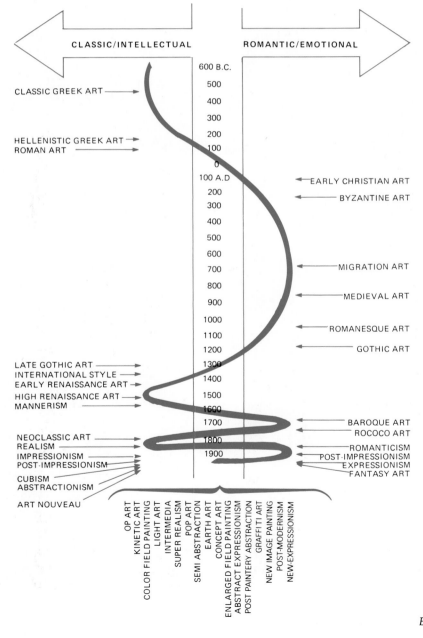

A brief look at some examples of art from different places and various periods will highlight how much the styles have in common. Emotional art is always expressionistic and is usually a strong personal statement by an

JEAN-AUGUSTE-DOMINIQUE-INGRES. *Madame Moitessier*, 1851. French, Neoclassic. Oil on canvas, 147 × 100 cm. National Gallery of Art, Washington, D.C., Samuel H. Kress Collection

RAPHAEL. *Madonna and Child with the Baptist and St. Nicholas of Bari*, 1506. Italian, Renaissance. Oil on wood, 209 × 148 cm. National Gallery, London.

JOSEF ALBERS. *White Line Square*, 1966. American, Classical Abstraction. Lithograph, 52 × 52 cm. Los Angeles County Museum of Art

JEAN METZINGER. *Tea Time*, 1911. French, Cubism. Oil on wood, 76 × 70 cm. Philadelphia Museum of Art, Louise and Walter Arensberg Collection

artist, regardless of time and subject. Intellectual art always appears cool and carefully designed. Many of these examples may contain both qualities at the same time, but one dominates the other.

ROMANTIC-EMOTIONAL-EXPRESSIONISTIC

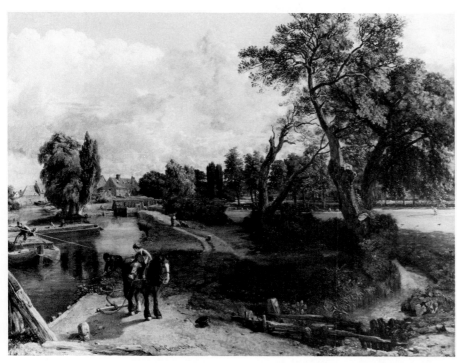

John Constable. *Flatford Mill*, 1817. English, Romanticism. Oil on canvas, 102 × 127 cm. Tate Gallery, London

Mathis Grünewald. *The Small Crucifixion*, 1510. German, Renaissance. Oil on wood, 62 × 46 cm. National Gallery of Art, Washington, D.C., Samuel H. Kress Collection

David Alfaro Siqueiros. *Echo of a Scream*, 1937. Mexican, Expressionism. Duco on wood, 122 × 91 cm. The Museum of Modern Art, New York, gift of Edward M. M. Warburg

Willem de Kooning. *Woman II*, 1952. American, Abstract Expressionism. Oil on canvas, 150 × 109 cm. The Museum of Modern Art, New York, gift of Mrs. John D. Rockefeller

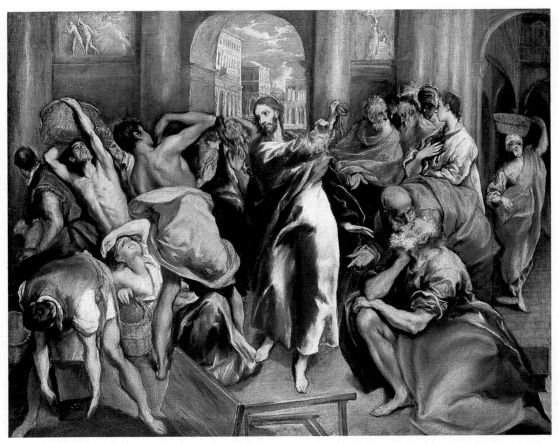

El Greco. *Christ Driving the Moneychangers from the Temple*, 1600. Spanish. Oil on canvas, 106 × 130 cm. National Gallery, London

Style

INDIVIDUAL STYLE

Artists throughout history, if they have developed in an environment free of rules and directives, have worked out their own personal styles. Regardless of their early teachers or other powerful influences, their styles are as individual as their handwriting. Individual style is the result of all the environmental influences, the teachers, and the exposures to art of the past, and the friends and aesthetic influences that affect the artist. These influences can cause changes in methods, subject matter, and approaches to art. Often, the style of an artist changes during a lifetime of such influences and during periods of experimentation. Rembrandt van Rijn, Joseph Mallord William Turner, Jean-Baptiste-Camille Corot, and Pablo Picasso are some examples of artists with changing individual styles.

The work of El Greco is immediately recognizable because of his distinctive style—a concentration on Biblical subject matter; an elongated distortion of the figures, writhing movement, and powerful value contrasts that

create flamelike lights and darks. Hundreds of artists illustrated in the book can be similarly identified by characteristic features of their work. It is impossible to fully understand the development of individual style because it is so intricately interwoven with each artist's unique personality. As you become more analytical in your study of art, your critical evaluations will include the awareness of style and stylistic differences.

PERIOD STYLE

The art work in this book has been grouped together in various chapters because it has similar characteristics. Art of certain periods is often alike. Egyptian art, for example, was determined by a rigid set of conventions which caused strikingly similar images for 2500 years. While some styles lasted for centuries, others endured for only decades or less. Within one period, a dominant style may undergo subtle changes. The Italian Renaissance, for example, can be broken up into early, high, and manneristic periods. Despite differences, these indi-

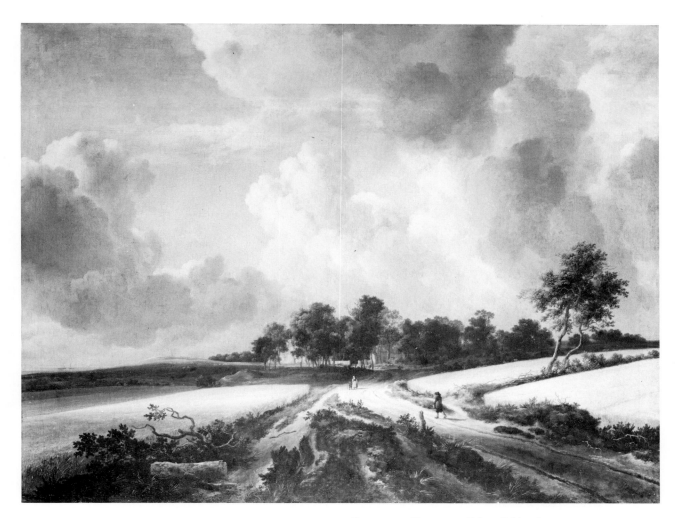

JACOB VAN RUISDAEL. *Wheatfields*, about 1660. Dutch. Oil on canvas, 100 × 130 cm. The Metropolitan Museum of Art, New York, bequest of Benjamin Altman

vidual styles are sufficiently alike to be grouped together for study.

Jacob van Ruisdael's painting *Wheatfields* is characteristic of both the artist and the Baroque period in the Netherlands. Many artists painted such nature scenes with turbulent skies, small human figures, and carefully controlled light. The long Baroque period in Europe also has certain characteristics which allow it to be studied as a unit. Despite variations, all styles seem to fit into the large pattern of artistic development called Baroque.

Architecture of various periods also can be identified by specific characteristics. The view of Vienna shows several outstanding buildings. The two most obvious are the domed structure in the foreground and the towering cathedral. The dome and other architectural details set that building in the Baroque period while the forms, details, spires, and vertical emphasis of the cathedral place it in the Gothic period. An expert would be able to name periods for most other buildings seen in this photograph.

View of downtown Vienna, Austria. St. Peter's Church in the foreground, St. Stephen's Cathedral in the background

Style | 77

NATIONAL STYLE/REGIONAL STYLE

Sometimes a country has a national style. It is not part of any period style but evolves gradually over a long time. Probably arising from older forms of native culture, it often has ethnic overtones and may be part of a country's political movement. Mexican artist Diego Rivera emphasizes traditional peasant activities in *Flower Day*. His style is rooted in ancient Mexican styles but has a modern feeling. The forms are rounded, monumental, and simplified. They are presented in uncomplicated but crowded arrangements which create a feeling of great strength and power. The style Rivera developed became the foundation for several generations of Mexican artists who still work in a similar manner. Many Mexican-American artists base their own styles on what has become a Mexican national style.

During the first half of the twentieth century in the United States, a number of regional styles developed throughout the country. They often evolved from the influence of a single, strong local artist or a group of people working in similar styles and techniques (*See* Chapter 15).

RAPHAELLE PEALE. *After the Bath*, 1823. American. Oil on canvas, 74 × 61 cm. William Rockhill Nelson Gallery of Art, Kansas City

DIEGO RIVERA. *Flower Day*, 1925. Mexican. Oil on canvas, 147 × 121 cm. Los Angeles County Museum of Art

TECHNIQUE STYLE

A certain type of painting may emerge in several periods. It may be based on a particular technique or presentation of subject matter. One of these technique styles is *trompe l' oeil*—the French term for "fool the eye." An object painted in this style is so lifelike that viewers think it is real. Raphaelle Peale, an early nineteenth century American, painted a towel with such realism that people were tempted to pluck it from the canvas in order to see the nude figure behind it. There have been other trompe l'oeil painters in every generation since, and in the late 1970s and early 1980s a style called *Super Realism* carried on this tradition. Such technique styles bridge many periods but often do not become dominant enough to be part of the mainstream of art activity.

In the history of art, there are many styles. Some are obvious while others are subtle. Although art communicates in a universal language, the styles that characterize individuals, countries, regions, and periods may vary drastically. Each develops a style best suited to its needs.

Analysis

1. Go to your school or city library and study books on single artists (such as Rembrandt, El Greco, Paul Klee, Wassily Kandinsky, etc.). Make notes on characteristic features of their styles. Look especially for changes in style from early to later work. Discuss your findings in either visual, written, oral or video reports.

2. Neo-classic designs are popular in architecture. Identify buildings in your community which use Greek columns, capitals, pediments and domes (see Chapter 6 for illustrations). List them or photograph them for a display about architectural influences in your community.

3. Geometric pattern is the dominant feature of the Navajo shoulder blanket woven in the early nineteenth century. Identify all of the various geometric shapes and make an illustrated chart of your findings.

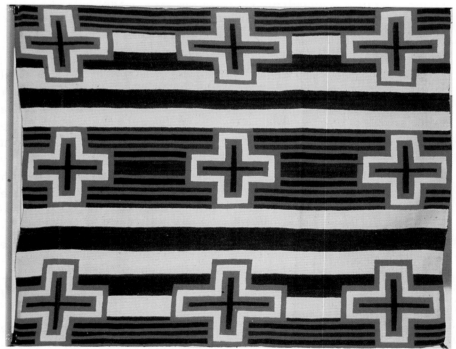

Navajo blanket (Chief pattern). 1890–1900. Millicent A. Rogers Memorial Museum, Taos, New Mexico

Aesthetics

4. Nature has always been an important source for artistic concepts and products. How do artists use nature? Is interpretation and symbolism ever involved? What might such artists be trying to express? Answer these questions in the form of an essay, video documentary or oral presentation (you may wish to use your own sketches, slides or prints of artwork to illustrate your project).

5. Study the illustrations on pages 74–75. Write a short paper discussing the general differences between classic and romantic styles. Then write a paragraph explaining which style you like better, and why.

6. San Xavier del Bac in Tucson is a mission church begun by Father Kino which shows evidence of Hispanic influences on many architectural styles in America. Find illustrations in magazines that demonstrate these Hispanic influences in American architecture. Make a combined visual and verbal presentation. Or trace the development of this style from Spain to Mexico to the United States.

San Xavier del Bac, exterior rear view. Completed 1797. Tucson, Arizona

Studio

7. Use tempera paints or colored pencils to make your own geometric *border pattern*. Look at examples in this or other books for ideas, but create your own patterns using crosses, squares, circles, triangles, rectangles, ovals, lines, etc. Make at least three repetitions (using stencils) to emphasize the pattern.

8. Select an artist whose work you enjoy and analyze the *style* of the artist. Using watercolor or construction paper, make a painting or collage of *exactly* the same subject, but in a different style (flat, abstracted, monochromatic, outlined, or your own style). You might use pen or brush and ink to finish your study.

9. Use tempera paint to create *two* small, simple still lifes (23 × 30 cm) of the same arrangement of three items. Make one painting in a carefully designed style and another in an expressionistic style. Study such styles on pages 74–75 and in other parts of the book before you begin your project.

4 Non-Western Art and Cultural Influences

Non-Western art includes the great civilizations of India, China, and Southeast Asia. It encompasses the kingdoms of Africa below the Sahara Desert; the tribal societies of Africa, Asia, and America; and the complex ancient civilizations of South and Meso-America.

Before surveying the art of these cultures, it is important to explore the broad ways in which non-Western art differs from Western art. The distinctions arise in two general areas: (1) religious and political influences and traditions and (2) media and design (terms discussed in Chapter 2).

Religion

Three major formal religions have evolved in Africa and Asia—*Hinduism, Buddhism,* and *Islam.* Every civilization also developed more primitive religious practices, usually based on worshipping nature and natural phenomena—such as the planets, animals, and the processes of fertility and reproduction. These various relationships with the supernatural have greatly influenced the native art of these cultures.

The art forms may at first have no meaning to Westerners. Asian and African art presents images and symbols *(iconographs)* of religious, cult, or moral ideas alien to the Judeo-Christian tradition. While much Western art depicts Christ and his followers, Asian art presents many images of Buddha, "the Enlightened One," as the example from Java shows.

A more complex example is this carved wooden figure from an African tribe. Anthropoligical study reveals that this male figure is actually a guardian, meant to protect its owner from evil and sorcery. In short, he

is a symbol that "performs" a specific function. A closer look at the three major religions will provide other examples of non-Western imagery.

HINDUISM

Hinduism originated in ancient India over a long period of time. By the sixth century B.C., it was believed that the individual could identify with universal powers through the gods *Brahma* (The Creator), *Vishnu* (The Preserver), and *Siva* (The Destroyer). As the art reveals, each god is depicted with a distinct set of iconographic objects. For example, Brahma appears in white robes and rides a swan. From his four heads (he is often shown this way) spring the Vedas (sacred books) which he carries along with a scepter. Vishnu holds a discus, conch shell, mace, and a lotus. Siva is often entwined in snakes and wears a headdress of skulls, but at other times he dances in a circle of fire, and is a combination of older mythological figures from India's prehistory and of Hinduism.

Hinduism gave order and hierarchy to the universe and to the structure of society. The universe was divided into three zones—earth, middle space, and sky. Animals and human forms were often used to depict the powers and truths within these three zones. *The Descent of the Ganges* is a carving in India which uses dancing and active human figures to represent the source of life. This massive work seems to center on the elephant forms which are symbolic of the power of nature; particularly for their mythological ability to call upon the clouds to produce rain. Nature is symbolized by the gigantic elephants as being much more powerful than humanity, and the gods more important than humans. The differ-

Buddha and Attendants. 9th century.
Carved on the Loro Jongrang Temple,
Java, during the Pallava Dynasty

*The Descent of the River Ganges from
Heaven*, 10th century. Live rock carving
at Mamallapuram, India

Standing male figure. Songyre People.
Zaire, Africa

Jizo Bosatsu, 12th Century, late Heian Period, Japan. Wood, 146 cm high. Los Angeles County Museum of Art, gift of Anna Bing Arnold.

Nyoirin-Kannon (Bodhisattva), 645–647. Nara period. Bronze. Oka-Dera Temple, Nara, Japan

ent *registers* may correspond with social *castes* ruled over by a king with divine power.

BUDDHISM

Buddhism emerged in the sixth century B.C. as a Hindu reform movement, preached by *Gautama* Buddha. Through years of meditation he became enlightened and preached charity to all creatures, the equality of all beings, and the practice of moderation. He essentially reformed Hinduism without discarding the Hindu gods. In the second century B.C., a complex form of Buddhism developed, known as *Mahayana* Buddhism, which preached the salvation of souls and the important role of *bodhisattvas*. These saints were believers who achieved enlightenment like Buddha but who chose not to enter Nirvana (eternal life), wishing instead to help struggling mortals. The most popular of these bodhisattvas is *Avaloketisvara*, known in China as *Guan Yin*, and in Japan as *Kannon*. This "Goddess of Mercy," with a meditative countenance and a reassuring confidence, is symbolically represented upon a *lotus* seat. The lotus, a water lily, symbolizes purity.

The Buddhist cult of Jizo Bosatsu was introduced into Japan in the 8th Century, and was extremely popular from 900–1300. Jizo is a compassionate diety concerned with the needs of suffering humanity and is the patron saint of children. He is usually shown as a simple monk. This carving is made of joined wood blocks, and the artist used the wood grains to enhance the contours of the figure. The serene look on the Jizo reflects the gentle grace of the late Heian style.

An Indian Hindu epic, known as the *Ramayana*, is a series of stories concerning the legendary king *Rama*, who was unjustly deprived of his kingdom. Various episodes concern Rama's birth, his marriage to the beautiful *Sita*, her capture by the devil *Ravana*, and Rama's rescue of Sita and his land. The Ramayana was adopted by the Buddhists and later even became part of Islamic heritage. Its value is in its basic teaching: good prevails over evil. Scenes from this tale are painted and sculpted on temples, shrines, palaces, and courts throughout Asia, and each country has its own subtle version of this universal tale of the Hindu-Buddhist world.

Two Men Converse in a Landscape. A Folio from a Shah Nama, 16th century. Sultanate period, India. Watercolor on paper, 21 × 13 cm. Los Angeles County Museum of Art, gift of Doris and Ed Wiener

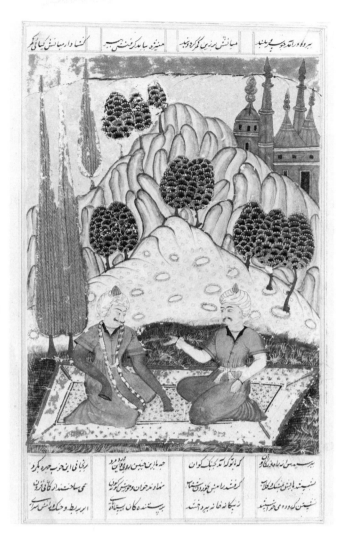

ISLAM

Much of Asia is dominated by *Islam* which acknowledges the existence of one god who has revealed himself to humans through the *Koran,* the scriptural writings of the prophet *Mohammed.* Mohammed received his revelations in Mecca, a city in Saudi Arabia, during the seventh century. He preached that the way to Allah lies through learning the sacred writings and in service to him. Mohammed's followers spread his message to the Middle East, Northern Africa, China, and the Malay archipelago. The key to Islam's success has been its ability to modify itself to blend with local beliefs and yet retain its emphasis on scripture and the law.

Islamic art concentrates on geometric and floral patterns known as *arabesques* which embellish simple interiors of courts and *mosques.* Religious sculptures could not depict human figures, but miniature paintings were made of men and women as illustrations for tales about successful Islamic rulers, their loves, and their adventures. This example is a single page or folio from a Shah Nama (Book of Kings), a popular illustrated history. Islamic buildings are typified by the use of pointed arches, elaborate filigree, and onion-shaped domes.

While these three main religions have motivated most of the artistic production in Asia, local beliefs have also had their impact. Among them are *Daoism* and *Confucianism* in China; *Shintoism* in Japan; and the worship of natural phenomena and mysticism in the islands and highlands of Asia and the Pacific. Art and architecture of ancient American kingdoms and native American peoples (ancient inhabitants of Mexico, Meso-America, and South America) are also founded on naturalism and mystic spiritualism. Images in the American tradition (both continents) are stylized, with a Classic sloping forehead and the use of much symbolism. The manuscript (codex) is a strong statement about Mixtec society, including their ceremonial dress, their use of the jaguar head as a religious symbol, frontality in human representation, and the playing of a ceremonial game with a rubber ball.

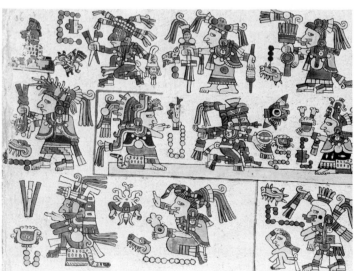

Souche Nuttar Codex, one of forty-eight sheets, 14th century. Mixtec culture, America. Drawing and painting on deerskin, 18 × 25 cm. British Museum, London

Taj Mahal, 1632. White marble. Agra, India

Politics

Politics has had an important impact upon the type of art produced in non-Western cultures. Most societies were governed by a king or ruler who was placed in an unapproachable position from his subjects. Chinese and Japanese emperors and *Inca* and *Aztec* rulers had a near mystical connection with the sun. Javanese and Khmer rulers were "god-kings" who were not seen in the flesh by their subjects but were represented in symbolic monumental architecture. Although the ruler was remote from his subjects, his influence was felt by all. He generally controlled the type of art created in a culture. As a result, an object is now catalogued according to the ruler's name or period. For example, it may come from the *Song* dynasty, the *Momoyana* period, or the *Sialendra* era.

Song China was ruled by men who placed high value on the visual and performing arts. Momoyana Japan was ruled by a military shogun who stressed castle architecture and weaponry. The Sialendras were Buddhists who expressed their enthusiasm in sculpture and monumental architecture among the terraces of Java. Whereas the Song emperors encouraged craftspeople to learn from the past and create new techniques, some rulers disdained the accomplishments of their predecessors. For example, during the Mughal period in India, sculpture and architecture were destroyed, and a new brand of austerity in the arts was introduced with Islamic preferences.

While the new tradition was alien to the local Hindu and Buddhist religions, it added a new aesthetic quality to local artistic traditions, as exemplified by the Taj Mahal, built by Shah Jahan to memorialize his beloved wife. He used 20,000 workers to construct a mausoleum based on Islamic concepts but decorated with native Hindu materials, motifs, and craftsmanship. Pointed arches (Islamic) are filled with perforated white marble grilles (Hindu). Arabesques and chevrons (Islamic) are done with inlaid, semi-precious stones (Hindu technique).

Art was used by rulers in still more ways. When the leader of a culture was militant, the implements of war became art forms symbolizing power. Many objects became court or *Imperial* art. Chinese, Vietnamese, Khmer, and Thai kings, for example, patronized royal ceramic "factories" which produced excellent wares for use by the sophisticated court. The finest products were automatically the property of the emperor or king.

Artistic objects were also recognized as valuable commodities which could be traded overseas for other prized items. These products were known as *export wares*. The same Asian rulers who sponsored Imperial wares allowed the second-rate ceramics, silks, and lacquer wares of their patronized factories to be traded for products such as exotic foods and spices, rare woods, and minerals. These trade wares often gained a reputation in their

Lidded bowl and *bottle,* 14th Century. Sawankhaloke Kiln, Thailand (Siam). Glazed ceramic, each 11 cm high. Collection of Mrs. L. C. Saunders, Hong Kong

Crush the Gang of Four! Political poster, 1977. About 1.5 × 2 m. Guilin, China

own right, such as the two objects of trade pottery, made for export by Chinese potters in 14th Century Siam. Art objects were often exchanged by ambassadors and royal emissaries as gestures of respect and good will and showed off the technological and aesthetic advancement of the home court. Persia and China, for example, greatly appreciated their mutually exchanged products. Many other royal courts amassed huge collections of art from "tribute" states and from friendly peoples throughout their spheres of influence.

Trade also had another impact on art. Ideas and techniques spread as items were exchanged between non-Western and European cultures. Beginning in the fifteenth century, Europeans—first the Portuguese, then the Dutch, Spanish, English, and French—began trading at ports such as Goa, Bombay, Hong Kong, and Nagasaki. The Europeans not only acquired artistic objects for their home countries but carried goods from one part of Asia to another, facilitating cultural exchange in ceramics, painting, sculpture, and architecture. In some instances, the local art was overwhelmed by newly imported styles; in some, there was a peaceful and unique blending of Eastern and Western ideas and motifs; and in others, local artisans rejected the new influences, adhering to time-tested techniques and subjects.

Finally, rulers have determined the nature of art by using it as political propaganda. Modern China, for instance, has used art to depict the latest goals of the Communist party leadership. This poster was painted in 1977 during the height of the criticism of the "Gang of Four." These leaders were blamed for the ills of the country and are shown being crushed by a team of workers representing the farmers, factory workers, and soldiers who make up the workforce of China. The heroes (those now in control) are always shown as huge, powerful figures who appear clean and idealistic. Monumental statues of Chairman Mao were seen all over China, while huge sculptures and posters of Lenin adorn locations in the Soviet sphere of influence.

Media

Technology and choice of media in non-Western cultures is often similar to Western craftsmanship. Materials such as stone, brick, wood, paint, and clay are used. However, Westerners paint on canvas or paper while Oceanic tribes paint on bark and the Chinese have used glass and silk as their ground. American Indians have painted on hide, wood, stone, and textiles. Technological processes such as lost-wax casting among such peoples as the *Shang* dynasty of China and the *Benin* culture of Nigeria far outclassed their contemporaries in Europe. While bronze is permanent, many choices of materials in non-Western art include perishable items such as feathers, flowers, leather, grass, bark, and shells.

Western painters tend to work within the limitations of a frame, but Chinese and Japanese painters, working on screens and scrolls, can tell their entire story by adding more sections to the screen or rolling the scroll out for several more meters. In China and Japan artists used lacquerware, a unique medium they could first build up and then carve, sculpt, and/or paint.

Perspective

Perspective is the Western term for showing realistic spatial relationships of objects in drawing or painting. Westerners' generally use overlapping planes and have lines converging at a vanishing point to show distance. (*See* p. 55 and p. 316, for example.) In some Chinese and Japanese art, receding lines remain parallel and do not converge. Thus, the eye moves back into the picture but does not eventually meet one or two specific vanishing points.

Asian artists often depict great distance by showing three planes: a foreground, a middle distance, and a far distance, each *parallel* to the picture plane. For example, one may see a plain, then trees, then mountains, each painted separately, not overlapping. As the viewer's eye leaps from one distance to the next, the vastness of nature is felt. Furthermore, objects are often enveloped in mist or cloud to further suggest spaciousness.

Westerners, particularly artists in the High Renaissance and late nineteenth century, used hazy atmospheric effects to show distance (*See* pp. 244, 350). And Japanese painters, influenced by Western art in the late nineteenth century have used both linear and aerial perspective. However, as described, there are general differences in Western and non-Western ways of depicting depth.

Finally, some non-Western artists, such as those of the Orient and Africa, believe that the front and side view of an object can be presented simultaneously or that "X-ray" views of internal parts can be seen at the same time as the exterior. The artist thus depicts more than the surface of things.

Color

Over the centuries, Western artists have changed their minds about using color in their paintings. Roman artists easily used realistic colors, but Byzantine painters (around the sixth century) used colors as symbols (gold for heaven, white for purity, etc.). Renaissance artists again tried to obtain realistic color representation in their painting. Impressionist painters dabbed in color as it was reflected from objects and approached it almost scientifically. And Expressionists used color to symbolize feelings and emotions, employing reds, oranges, greens, and blacks with great intensity.

In Oriental painting, color is arbitrary. Chinese painters were happy producing monochromatic scrolls. Color was often used only for accents and emphasis, but line was much more important than color. The Oriental woodcut artist did not worry about how colors looked in shadows or half-light. Colors were kept flat and were not used to describe form, only to show the flat shapes of things. Color and value were not used together.

Both perspective and color were approached differently in the East and the West. An understanding of these approaches helps distinguish between the two art heritages and allows one a deeper insight into non-Western art.

INDIA

Hindu and Buddhist religious systems have dominated the art of India for over 2500 years. At times, these two religions have vied with each other, producing distinct sculpture and architecture. At other times, they have co-existed, resulting in architecture and imagery simultaneously Hindu and Buddhist in character. India has also received outside cultural influences at various times, but all have eventually been absorbed into the unique Indian style.

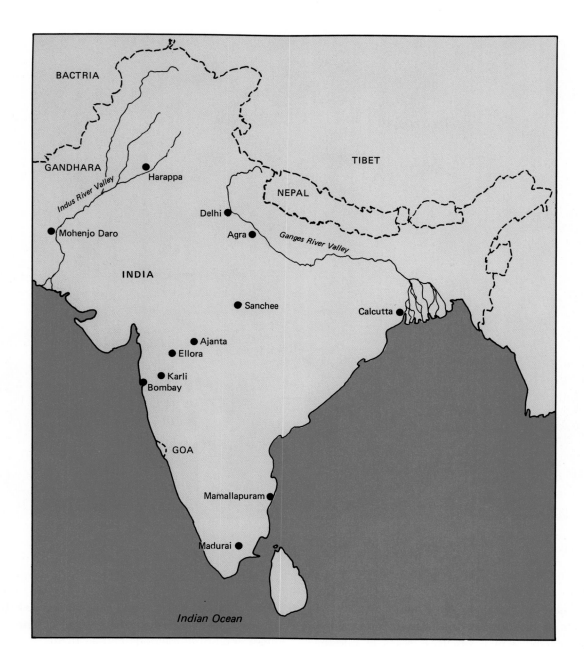

Indian Ocean

INDUS VALLEY CIVILIZATION

The earliest Indian culture is known as the *Indus Valley Civilization,* a sophisticated society existing until 1500 B.C. It was located along the river banks in what is modern Pakistan, stretching about two thousand kilometers, from Harappa to Mohenjo-daro. Visible evidences of this mysterious people are the bronze and stone animal sculptures and small personal stone seal stamps which were used as signatures on official documents. The people built temples honoring popular water gods and created ceramic bowls rubbed with *resin* and decorated with geometric and animal motifs.

THE MAURYAN ERA

A long era, known generally as the *Ganges Civilization,* followed. For a thousand years there was little evidence of Indian civilization. It was during this "Vedic Era" that many aspects of Brahmanic belief became formalized in the Hindu writings known as the *Vedas.* By the latter half of the second century B.C., however, King Asoka, who converted many subjects to Buddhism, had large columns built, upon which were inscribed Buddhist exhortations. The columns were topped with magnificent seated lion sculptures, which have become the mark of Asokan art.

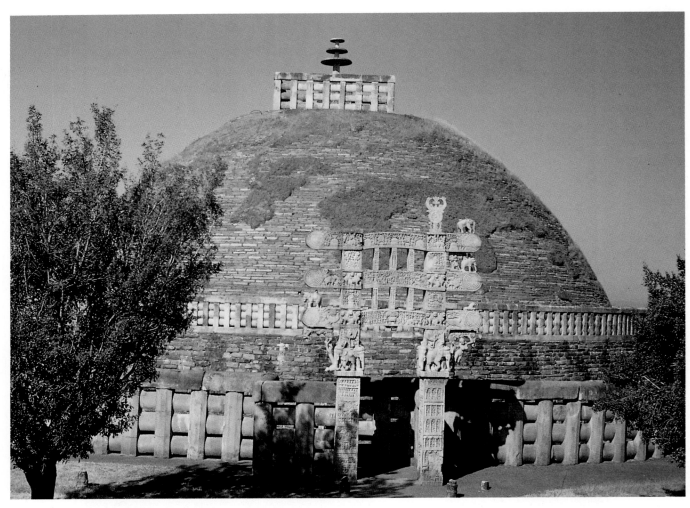

Stupa I, 2nd century B.C.–1st century A.D. solid masonry.
Sanchee, India

Asoka's descendents, the Mauryans, constructed the first objects of Buddhist architecture—round mounds known as *stupas,* which contained relics of Buddha's body. A stupa was surrounded by a wall, and believers on pilgrimages were aided in their appreciation of Buddhist teachings by reading relief carvings on the walls and gateways. The small railed balcony atop the structure is the *harmika,* topped with stylized umbrellas symbolizing the thirty-three higher heavens of Mahayana Buddhism.

THE GANDHARA ERA

Buddhists produced their first significant sculpture under the influence of the *Hellenistic* (Greek) kingdoms in Bactria and *Gandhara.* Greeks had established themselves in Northern India and Pakistan after 326 B.C. with the conquests by Alexander's armies. Knowledge of Greek sculptural methods and aesthetics was the foundation for the first images of Buddha. The mark of these sculptures is their Western facial and body types. The colossal head of Buddha, made of *stucco,* shows a Greek-style face, except for the half-closed treatment of the eyes. The hair is formed in a style reminiscent of Hellenistic Greek figures of Apollo. Distinct motifs were developed to show Buddha's sacred nature: elongated ear lobes, the *ushnisha* coil of hair protruding from the back of the head, and the third eye, or *urna,* which symbolized his omniscience.

Under the Gandhara school of art, the first Indian cave temples were cut into hillsides of *live rock.* The form of these cave sanctuaries resembles earlier wooden constructions, except that they were hewn from solid rock.

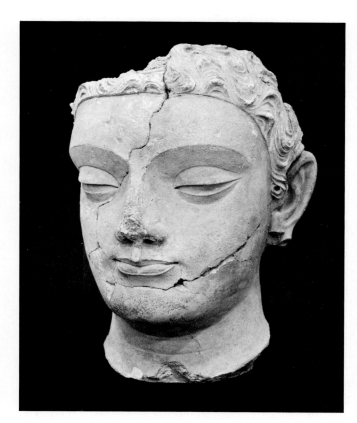

Colossal Head of Buddha, 2-3rd centuries. Gandhara school, India. Stucco, 70 cm high. Los Angeles County Museum of Art, Leo Meyer Collection

THE GUPTA ERA

Greek motifs in Indian art declined and a new, distinctly Indian, style emerged with the rise of the *Gupta* era in 320. The Gupta is regarded as the golden age of Buddhist Indian art. Kings such as Chandragupta II (375–414) were patrons of the arts. Drama, literature, painting, sculpture, and architecture flourished. Many beautiful and elaborate cave temples were carved and painted at Ajanta and Elloura, where Buddhist and Hindu iconography and themes were intermixed. Distinctly Indian figures decorate these temples with bodies that no longer show Greek-style anatomy, but are rounded and voluptuous and lack a characteristic Western look.

THE MEDIEVAL PERIOD

Hinduism experienced a revival toward the end of the Gupta era. From the ninth to the sixteenth centuries, political division produced a variety of kingdoms flourishing simultaneously. One kingdom, known as the *Pallava*, in Southeastern India, produced large free-standing temples cut from live-rock at Mamallapuram. The monolithic structures with multi-storied roofs preserve in solid stone the square towers developed by Hindu architects. The temple is symmetrical, and the building complex represents order in the universe as well as providing pathways used by worshippers in accomplishing their rituals. Images of Nandi, the bull (foreground), symbolize the rejuvenator god, Siva. In-

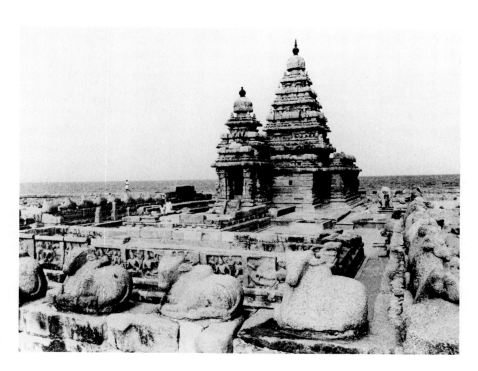

Shore Temple. 7–8th centuries. Mamallapuram (Mahabalipuram), India. Pallava style, Live rock

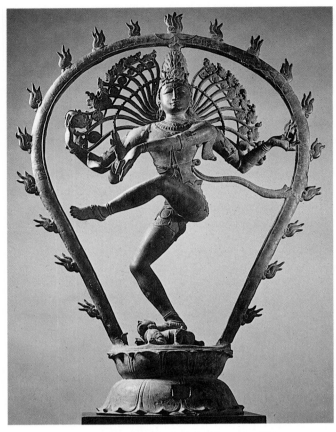

Siva, Lord of the Dance, Performing the Nataraja, 10th century. Chola dynasty, India. 76 cm high. Los Angeles County Museum of Art

Meenakshi Temple. Madurai, India, 17th century. Brick and stucco, painted in polychrome

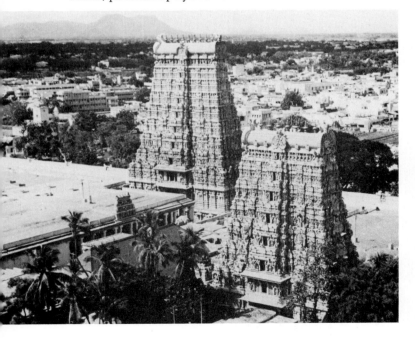

dian architectural influences can be seen in many areas of Southern Asia, particularly in Indonesia.

The Pallavas also produced massive towered gateways called *gopura*, placed at entrances to temple complexes. The two gopura of the Meenakshi Temple are in the sacred southern city of Madurai. Known as *Dravidian* style, it is synonymous with Southern Indian architecture to this day. Each level of the rectangular and pyramidically-tapered tower is filled with sculptured and painted panels from Hindu mythology.

Bronze casting of high quality in the lost-wax method was practiced by another medieval kingdom, the *Chola*. Such images as Siva dancing the *nataraja*, or dance of reincarnation, illustrate the minute and accurate detail of these figures. Graceful movement is depicted in metal that would be impossible to portray in stone, and the flame-encrusted *halo* shows a remarkable and delicate use of line and shape.

THE MUGHAL PERIOD

The final phase of traditional Indian art arrived with the successive waves of Moslem invasions between the twelfth and sixteenth centuries. Akbar formed the mighty *Mughal* Empire to reunite the divided medieval kingdoms into a single, great unit. Although he was a patron of the arts, Islamic attitudes were generally antagonistic to the complex Hindu-Buddhist symbolism and figure sculpture. Many temples were destroyed in the Mughal's attempt to stamp out imagery, and he replaced them with mosques and beautiful palaces of symmetrical simplicity. Mughals brought with them a style evolved in their Persian domains, a style mixed with Indian ideas. Mosaics of stone and ceramic decorated the floors and walls in arabesque patterns of leaves, flowers, and geometric motifs. Most famous of the structures from Mughal India is the Taj Mahal (*See* p. 84).

Typical of Mughal art was the production of fine small objects in enamel, mother-of-pearl, glass, or metalwork. Miniature paintings were made on palm leaves and paper. Here earthly rulers (never deities) were portrayed with faces often in profile and much attention given to bodily ornament. The arrival of European influences came with Portuguese, Dutch, French, and British traders. While they introduced Neoclassical architecture and encouraged a revival of Islamic motifs, the basic Hindu heritage of India still dominates the culture of the subcontinent to this day.

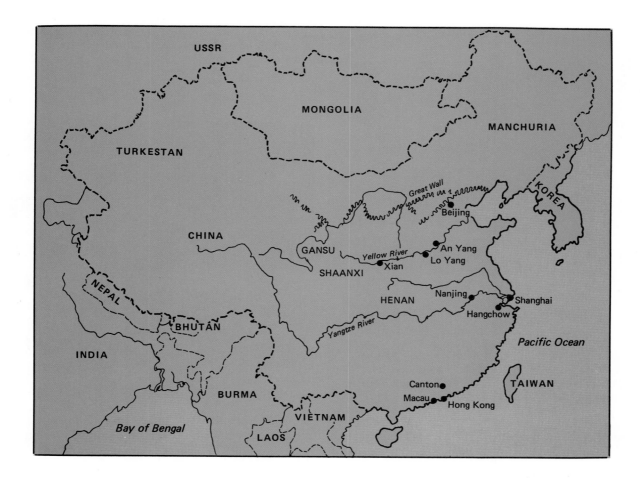

China

Often claimed to be the oldest continuing civilization, China's culture developed first along the valley of the Yellow River and later in much of northern and eastern China. Rulers were regarded as the sons of heaven, with a mandate to rule the Chinese while other nations came to pay tribute. Many cultural and geographic differences between the Chinese north and south of the Yellow River were overcome by the common teachings of *Daoism* and *Buddhism,* and the written language which was the same, regardless of local dialect.

Early Chinese art centered on animals and on the everyday lives of the people. Humans took on new dimensions with the coming of Buddhism. The Chinese was still a farmer and fisherman, but he was also a contemplative, studious being relating to the ancestors of his past and projecting his dreams into the future. In Chinese art, humanity did not become the conqueror of nature, but rather took its rightful place in it. Humans become insignificant figures against the vastness of their natural surroundings. The art of writing becomes difficult to separate from painting, for in *calligraphy* there is

an evolution of rhythm, similar to that in music. Line evolves as the dominant aspect of Chinese art.

Ancient neolithic tribes in China are known by the types of pottery unearthed in Henan, Gansu, and Shaanxi provinces. Black fired pottery and stone implements identify the *Long Shan* culture while red pottery typifies the *Yang Shao* culture. Designs were often stamped into the clay while other hand-built and wheel-thrown pottery was burnished smooth and decorated with geometric or curvilinear designs in black *slip*.

In the Long Shan culture, there is evidence of the carving of a very hard, semi-translucent stone known as *jade*. From green, brown, or white nephrite and jadeite, craftspeople have carved ritual objects which the Chinese believed to have spiritual and medicinal qualities. The use of jade is found continually from stone-age China to the present.

During the *Xia* culture (1800–1500 B.C.), the first evidence of *pictographic* writing appeared as picture drawings on the bones of animals. Flat bones and tortoise shells were apparently used as tablets upon which mes-

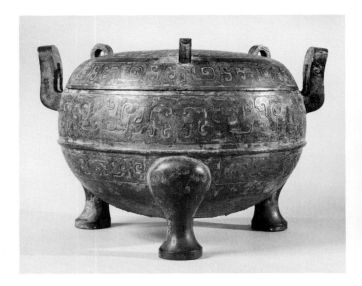

Jar with cover, 5–3rd century is B.C. Late Zhou dynasty, China. Pottery with glass paste, 12 cm high. Museum of Fine Arts, Boston, Charles B. Hoyt Collection

Covered ting, 5th century B.C. Zhou dynasty, China. Bronze, 34 cm high. Los Angeles County Museum of Art, gift of Mr. and Mrs. Eric Lidow

sages to the gods were written. The tribal *shaman* heated the bone until it cracked, then interpreted the fractures as the god's answer to the message. These objects are known to archaeologists as *oracle bones.*

SHANG DYNASTY

The bronze age in China corresponds with the *Shang* and *Zhou* periods, from about 1600 to 221 B.C. The center of the Shang culture was at the walled city of An Yang where many "industrial" settlements produced fine hand and wheel-made, gray pottery. Coatings of a glasslike *glaze* on the pottery heralded the beginnings of modern ceramics. Clay models of buildings were made as part of the elaborate funerals designed for royalty, and sculpture was produced in ivory, stone, and jade. Most significantly, high quality bronze weapons and sacrificial vessels were made by the lost-wax process by 1100 B.C. It is thought that the Chinese did not discover this method but somehow learned it from another civilization. Ritual food, water, and wine containers for ancestor worship and ceremonial weapons were decorated with stylized linear spiral motifs. The covered *ting* shows the use of fine surface ornamentation on a ritual three-legged vessel. The fine textures of swirls and rice grains inside the meandering bands are known as *diapers* and are found throughout Chinese art, filling spaces in lac-

querware carvings and porcelain painting. Designs were often symbolic of clouds, thunder, and fierce animal forms. Ownership of bronze meant wealth and power and has been cited as one origin of the class system in Chinese history.

Toward the end of the bronze era, political chaos and division brought about the evolution of sophisticated weaponry. During the era, a disgruntled civil official named *Confucius* taught a social system based on respect for parents, ancestors, clan, state, and emperor. His ideas formed the basis for the retrospective, stable, scholarly, and continuing nature of Far Eastern culture. Another philosopher, Lao Zi, taught that humanity needed to exist in harmony with the forces of nature, and his philosophy became known as *Dao* or "The Way," the basis of Daoism.

ZHOU DYNASTY

Pictographic symbols became more stylized and elaborate during the Zhou period, and painting made its first appearance while ceramics continued to become more sophisticated. Glasslike glazes were used to create intricate geometric designs on some ware, and glass paste was melted on the surface of porous clay bodies to form geometric patterns as in this covered jar made of stoneware. The brightly colored original glass has faded to soft pastel hues.

Cavalryman and Saddle Horse, Qin Dynasty (221–210 B.C.). Terra cotta, life-size. Xian, China

House model, 206 B.C.–221 A.D. Han dynasty. Polychromed pottery, 132 cm high. William Rockhill Nelson Gallery of Art, Kansas City

QIN DYNASTY (CHIN)

The Chinese north of the Yang Zi (Yellow River) were united for the first time in 221 B.C., forming the short-lived *Qin* dynasty, during which the system of written characters was standardized. Pottery objects were made especially for use in tombs; and burial suits of jade segments were tied together in the belief that the jade would preserve the body. The most important revelation in recent Chinese archaeology was the discovery in 1974 of a buried pottery army, found in underground vaults near Xian. Created as an imperial bodyguard to serve the emperor in afterlife, an army of over 7,000 life-size soldiers and horses were sculpted in clay.

Most significant, however, was the architectural feat of combining a number of existing protective walls in northern China into the *Great Wall,* a massive fortification 3971 kilometers long, 6 meters wide, and 7.8 meters high, designed to keep out the nomads of Mongolia and Manchuria (*See* p. 177).

HAN DYNASTY

The succeeding *Han* dynasty (206 B.C.–220 A.D.) was the second longest in Chinese history and provided the climate in which many traditions, practices, and artistic motifs became established. Han rulers united several territories and the "Silk Road" connected the capital at Chang-An (Modern Xian) with Syria and Rome. Toward the end of the dynasty, Buddhism was brought by missionaries from India, where it originated, and from Indo-China.

The Han period provides the first record of Chinese architectural practices, not from actual buildings but from clay models created for burial in tombs. Such models show roofs with large overhanging eaves, curved and flat clay tiles, and the inward orientation of Chinese building. Houses, temples, and palaces all employed a similar pattern: the use of one or more courtyards, with rooms facing that space.

Han culture was as sophisticated as the contemporary Romans in the West. Ceramic sculptures and functional objects were made for ritual and daily usage. A technique of attaching preformed clay sculptural decorations onto pottery, known as *sprigging,* produced vessels ornamented with frieze panels and handles with animal forms. Glazes containing lead were developed, which enabled Chinese potters to use bright and varied colors. Cosmetic boxes, cups, and many other shapes were made and decorated in red and black lacquer, and were often *inlaid* with silver or mother-of-pearl. The silk industry flourished, producing woven and embroidered cloth which was colorful, elegant in appearance, and delightfully smooth and cool to the touch. Not only popular with the wealthy in China, these items were exported to royal courts throughout Asia and the Mediterranean world.

Mural painting continued in tombs, and frescoes of scenes from daily life were created. Lifesize stone or clay figures lined the "spirit path" leading to these tombs, and more clay figures of sacrificial men and horses were placed inside.

SIX DYNASTIES ERA

Although invaders overtook the Han dynasty, the ensuing period (256–589) was one of growth and change in China. Buddhism spread with zeal, and Daoism, a strong religion based on a simplistic return to nature, emerged in the south. Stupa architecture merged with local Chinese watchtower forms to produce the *pagoda*, an odd-storied monument thought to give protection to residents within its view. Cave temples and monasteries were hollowed out of rock and embellished with huge carved images of Buddha and bodhisattvas.

Paintings on scrolls of silk and paper first appeared, which enabled scholars to enjoy a long narrative without having to view the entire work at once. Figures were painted against plain backgrounds in a non-stylized naturalism, showing action and overlapping planes, as in the portrait of the Emperor Hsuan Ti by the painter Yen Li-pen. Note the undefined depth of the scene, emphasized by an absence of background and the lateral placement of the figures. Notice the difference between the sense of depth shown in this painting (one part of a series of thirteen groups on a single scroll), and the painting done by Rembrandt (*See* p. 312), who created a powerful feeling of depth and space. This handscroll is one of the great paradigms of early Chinese figure painting. (See p. 86 for a comparative discussion).

TANG DYNASTY

Chinese culture and art reached a golden age during the Tang (618–906) and Song (960–1260) dynasties and developed a complex and cosmopolitan nature which has not been equaled since. Buddhism flourished and "paradise cults" of believers, anticipating a happy afterlife, commissioned millions of images of Buddha. The development of woodblock printing would eventually lead to the printing of Buddhist scriptures and the world's first encyclopedia.

The Tang rulers established a great capitol at Chang-An (modern Xian), an international metropolis of two million people. Many temples were built, and codes of architectural principles evolved, stipulating proportional relationships for all parts of these wooden structures. Multi-storied brick pagodas were constructed throughout the realm. Tang Buddhist missionaries introduced Chinese art, architecture, and writing into Japan in 552.

Sculpture and ceramics flourished as large tomb figures, glazed in a profusion of colors, were manufactured in factories and sold to wealthy families. They often were in the form of a horse, a symbol of wealth and loyalty to the emperor, and were glazed in "three-color" glaze. Sensitive figurines of court women and musicians were painted in subtle colors, reflecting a demure quality with all the calm of Classical Greek sculpture.

Most Tang sculpture was religious, especially Buddhist images, which evolved from early imported Gandharan Indian models into a fully "Chinese" style. However, in 845 Buddhism and other religions were banned because of their feared political and financial influence. Life under the Tang was sophisticated, with a stress on Confucian values of education, respect for family, and the growing bureaucracy. *Academies* were learning centers where scholars developed ideas about the aesthetics of painting and the evolving art of *calligraphy*—the painting of expressive and beautiful written characters. Painting became the pastime of men who belonged to the social elite and different "schools" of painting emerged, one stressing monumental landscapes, another favoring natural still lifes of plants and animals, and a third dealing with expressive images of Buddhist saints.

SONG DYNASTY

After the empire collapsed in 906, the country was in turmoil until reunification by the Song in 960, when rulers sought to recreate the glorious politics and culture of the Tang. It was the golden age of landscape painting. Painters in the north stressed bird and flower subjects while painters in the south emphasized bamboo, a plant symbolic to the Chinese of scholarship and wisdom. *Connoisseurship* evolved because of a growing wealthy urban population who could afford to collect art and pursue their romantic interests in the glories of earlier art.

A high point in Chinese ceramic technology was reached during the Song. *Feldspathic* glazes made use of mineral colorants, and deliberate crackling techniques in the glaze were used to give the appearance of great antiquity to delicately formed clay vessels. Many pieces were created for use in the tea ceremony of the Chan Buddhists. *Celadon,* an iron-green glazed ware, so resembled the appearance of precious jade that it was ascribed the same spiritual and medicinal qualities.

Sculpture, while still tied to Buddhism, developed a natural appearance very different from earlier stiff Indian-influenced figures. The seated *Guan Yin,* the goddess of mercy, rests in a casual pose, covered with the typical elegant drapery and ornament of a bodhisattva.

Architecture of the Song period reflects the strict architectural rules developed under the Tang. Northern ar-

YEN LI-PEN. *The Thirteen Emperors*, detail of Emperor Hsuan Ti of 569–582, 7th century. Handscroll, ink, and colors on silk, 51 cm high. Length of entire scroll, 5.1 m. Museum of Fine Arts, Boston, Ross Collection

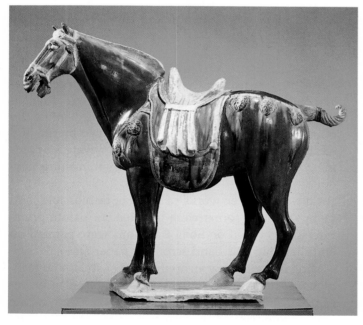

Glazed horse, 618–906. Tang dynasty, China. Ceramic with three-color glaze, 74 cm high. Los Angeles County Museum of Art, gift of Mr. and Mrs. Felix Guggenheim

Kuan-Yin, about 12th century. Song dynasty. Polychromed wood, 115 cm high. Museum of Fine Arts, Boston, Henry Edward Wetzel Fund

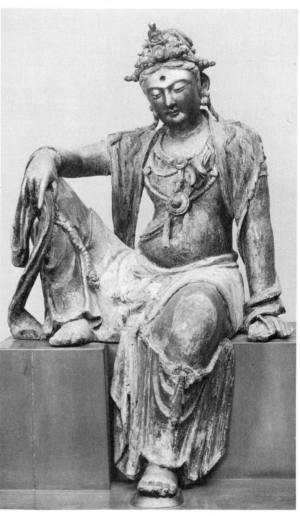

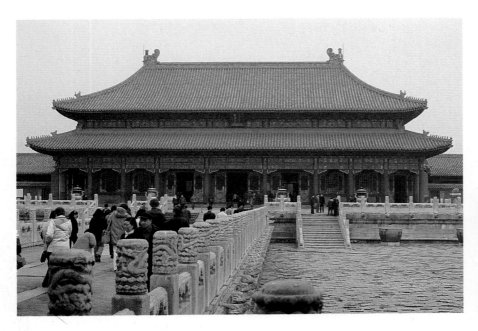

Hall of Supreme Harmony, Imperial Palace, Beijing. Ming Dynasty, begun 15th Century.

Tripod Incense Burner, early 15th Century, Ming Dynasty. Cloisonné enamel on bronze, 12 × 13 cm. Los Angeles County Museum of Art

chitecture was solid and monumental in appearance, with double roofs of tile dominating the exterior of wooden pillars and beams. Groups of naturalistic and stylized animals ornament roof ridges, and *polychromatic* designs in paint cover upper columns and beams of the interior. Southern architecture, while not codified into manuals, evolved into a more flamboyant style with exaggerated upturned eaves, less complex support systems for roofs, and the use of ceramic panels depicting mythological or operatic scenes on rooftops.

YUAN DYNASTY

Although the Mongol or Yuan dynasty (1279–1368) overpowered the Song, the mainstream of Chinese culture was so strong that the reign of the Khans was marked by support of the established culture rather than by any attempt to impose Mongol values. It was during this era that Marco Polo visited "Cathay" and returned to Venice to write glowing reports of Chinese urban life.

Perfecting the technology of porcelain, potters produced high-fired pure white ware, which was elegantly shaped and decorated. Bold decorative floral motifs had developed under the Song, and now potters used imported Persian cobalt to create similar designs in blue. Known as *"blue-and-white,"* the objects were made for the Imperial court.

MING DYNASTY

When the *Ming* dynasty (1368–1644) came to power, it again tried to restore the glories of traditional China. The Imperial Palace in Beijing (called "The Forbidden City") was started in the early 15th Century on the site of ancient palaces. It was often destroyed by fire and earthquakes but always rebuilt and renovated according to its original plans. Its many buildings are now open to visitors.

Collecting older works of art was fashionable, and many older art forms were imitated. In painting, nature scenes based on Song traditions were painted on both hanging and hand scrolls of paper and silk.

Ming ceramics saw an abundance of styles and techniques. Blue-and-white ware was produced in profusion for both local and overseas markets. Many white pieces were painted with colorful enamels and refired at lower temperatures to produce *overglaze enamels* of brilliant colors. Cloisonné enamel techniques were perfected, and enamels were applied to bronze surfaces to create exquisite decorative vessels. When Portuguese traders established a trading center at Macau in 1557, strong contacts with European tastes began to influence southern Chinese silk and ceramic industries and export wares made especially for these foreign tastes.

Ming buildings basically repeated Song construction techniques and are the major surviving evidence of Chinese architecture.

Ceramic rooftop decoration (scene from a local opera), about 1820. Rooftop, Ap Lei Chao Temple, Hong Kong

Three Chinese clan temples. Cantonese and Fukienese settlers, late 19th century. King Street, Georgetown, Penang, Malaysia

QING DYNASTY

Tribes from Manchuria conquered the Ming in 1644, and building styles continued without much alteration. The Chinese carried their architectural practices overseas. At Penang in Malaysia, for example, this row of clan temples resembles southern Chinese architecture. Notice the upturned eaves and the decorative panel that rests on the ridge of the roof. The small temple has highly decorative and complex forms at the corners of the glazed tile roof.

The Manchu, or Qing, dynasty (1644–1911) was regarded by the Chinese as barbarian. They absorbed and emulated Chinese culture, and their royal palace in Beijing imitated earlier Chinese palaces. Elaborate ornamentation, coloring, tile work, and *coffered* ceilings are a type of *Baroque* interpretation of earlier architectural ideas. Rooftop ornaments of glazed clay showed national symbols or local stories, like the roof ridges shown above. Painting continued to be the main form of expression of the literary class. Imperial kilns were revitalized and produced multi-colored wares with floral, landscape, or *heraldic* designs in styles known to Western collectors as "*Famille Verde*" and "*Famille*

Rose." Celadons and blue-and-white ware continued to be produced with refined technology.

European tastes and Chinese technology merged in the production of elegantly flamboyant furniture, lacquerware, jade carving, textiles, and jewelry. Popularly adopted in Europe, and known as *chinoiserie*, the romantic appeal of Chinese goods was a part of the exotic tastes of the *Regency* era in England. By the mid-nineteenth century, trade flourished through Hong Kong and along the China coast, expediting the export of Chinese culture and art objects around the world.

During the middle of the twentieth century, art schools were shut down by the government and artists were forced to work in communes as ordinary laborers. This was intended to eliminate art as an anti-government threat and to direct all attention to the production of food and needed supplies. In the 1970s, as China's borders were opened to the outside world, artists were again allowed to work and students could again attend art schools. In the 1980s, the government still had control over artistic production, but artists were beginning to express themselves more freely.

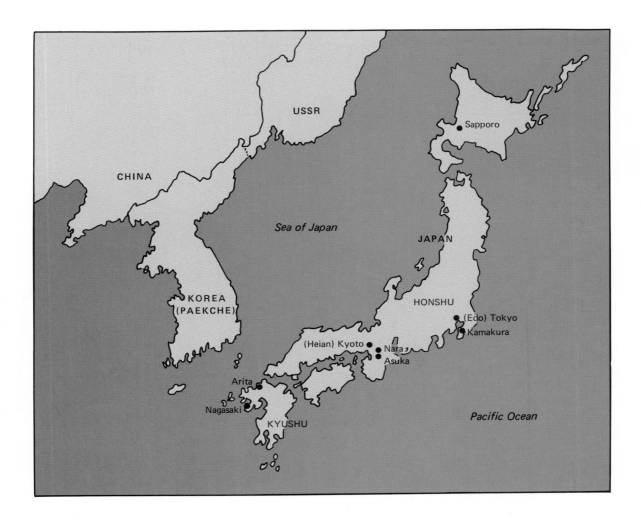

Japan

Japanese culture is the product of long periods of isolation from outside cultural influences, followed by eras of contact with other cultures. Three of the most far-reaching influences on Japanese art were Chinese and Korean from the seventh to ninth centuries; Chinese and European in the sixteenth century; and the final opening of Japan to the West following 1868.

The general characteristics of Japanese art are simplicity of form and design, attentiveness to the beauty of nature, and subtlety. The infusions of outside cultural ideas usually stimulated a Baroque development in the arts, with ornamentation and elaborate refinement. These Baroque phases were followed by periods of artistic reaction, during which simplicity and renewed attentiveness to natural design were stressed.

JOMON AND YAYOI CULTURES

The neolithic *Jomon* culture dates as far back as 5000 B.C. when simple undecorated food vessels were made of red clay. By 2000 B.C., colored slip was used to create animal and human abstract patterns, and by 200 B.C., the *Yayoi* culture from Korea and Kyushu overtook the Jomon society. Unique to this culture were pedestaled clay bowls, plates, and unglazed ceramic cylinders with human or animal forms sculpted in their upper parts, set up around gigantic tomb mounds. In addition to these *haniwa* figures, the late Yayoi culture also produced bronze cast objects from about 300, reflecting a technological importation from post-Han China.

The area around present day Kyoto came to be the center of political power. A statue of Buddha was sent to

Horyu-ji temple complex, begun 607. Asuka, Japan

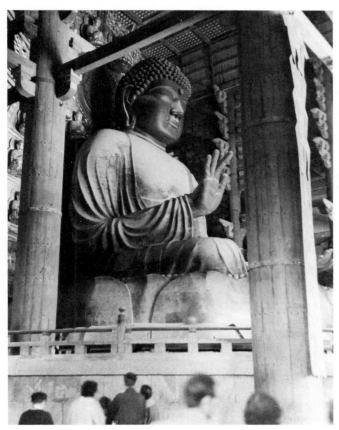

Great Dibutsu (Buddha), 8th century. Bronze, 21.6 m high. Todai-ji temple, Nara

the Japanese court from the Korean kingdom of *Paekche* in 552. It was the beginning of Japan's acceptance of Buddhism and with it Chinese and Korean cultural influences.

ASUKA PERIOD

Asuka became the Japanese capital from 538 to 645, giving its name to an era during which Buddhist missionaries, scriptures, and beliefs were welcomed. Confucian ideals of government organization accompanied these Chinese and Korean imports, and soon the Japanese ruler was even regarded as the son of heaven. Older Japanese religious beliefs known as *Shinto* (the way of the gods) continued to influence Japanese thought, particularly its *shamanistic* practices and its veneration for ancestors. Sui and Tang Chinese architecture were emulated in the building of the first Buddhist structures, the Horyu-ji temple at Asuka. The main hall and an adjacent pagoda still exist as the oldest wooden structures in the world (from 607). These buildings are also regarded as a faithful reproduction of Chinese architecture of the Tang, exhibiting a graceful atmosphere as well as structural honesty in the exposure of beams and brackets.

NARA PERIOD

When the capital was moved to nearby *Nara*, a new era began (646–784). Furniture, paintings, pottery, lacquer, and architecture were based on Chinese ideals, and the court sponsored elaborate production and collection of art, including works from China and Persia. Buddhism became firmly entrenched, and huge temples and monasteries were constructed of wood in the Chinese style. Buddhist images were made of *terra cotta, lacquer,* and bronze. The largest, a 53 foot high, 700 ton, bronze *Dibutsu,* is housed in the largest wooden temple in the world, the Todai-ji.

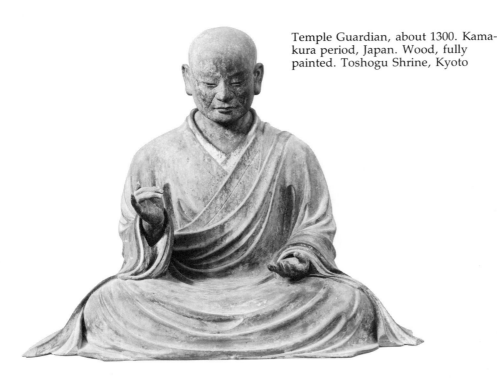

Temple Guardian, about 1300. Kamakura period, Japan. Wood, fully painted. Toshogu Shrine, Kyoto

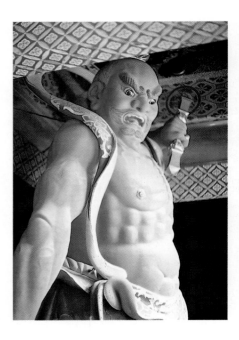

Koshun (Sogyo Hachiman), 1328. Kamakura period, Japan. Wood with crystal eyes, 82 cm high. Museum of Fine Arts, Boston, Marie Antoinette Evans Fund

HEIAN PERIOD

Heian (the modern city of Kyoto) was designated as the capital in 784, and its name has been given to the Golden Age of Japanese art, lasting until 1192. An energetic royalty continued to maintain close ties with China until internal upheavals resulted in the breaking of ties in 898. This meant that developing Japanese culture was not independent of Chinese influence.

Yamato-e painting evolved during the later Heian period. Decorative horizontal scrolls expressed Japanese tastes, sentiments, and nationalistic feelings through the use of long narratives. Chinese influence declined, and temples and gardens were asymmetrically arranged with buildings, ponds, and rock forms signifying the harmony of humanity with nature.

Buddhism had split into a number of factions or sects. One of these sects, the Shingon, stressed the veneration of images and figures of gods with multiple heads and hands. Amida cult Buddhists carved peaceful images, stressing spiritual sincerity and the belief in a rebirth in the Western paradise of Amida Buddha. Wooden buildings of subtle proportions were constructed in natural settings, often near water.

KAMAKURA PERIOD

A military government replaced the Heian government, and the capital was moved to Kamakura from 1192 to 1338. Fashion and taste in the new capital were at odds with the cultural heritage of Kyoto. The Kamakura military lords continued to accept Buddhism which gave a spiritual basis for the knightly virtues of courage and fidelity. Many early Nara temples were restored after the civil wars, and a huge bronze Buddha was cast (See p. 226). Influenced by Song sculpture, Kamakura images represent the last great flowering of naturalism in Japanese sculpture, creating portraits of Buddhist monks in wood, such as the image of Koshun. In contrast, ferocious temple guardians of great size were also carved in wood, and then painted to prevent intervention by evil spirits.

During the Kamakura era, Zen Buddhism from China gained popularity in Japan. It was to have a far-reaching cultural impact, promoting spiritual exercises, meditation, and a simple monastic lifestyle. These aspects appealed to the shogun ruler and his samurai warriors. Paintings stressed portraiture, battle scenes, and incidents taken from everyday life, or depicted torments in hell, illness, and suffering. They were often created in the hope of gaining religious converts. Potters who studied Song ceramic methods established kilns in Seto and other southern centers, leading to a native Japanese ceramic tradition. The objects produced there became a mainstay in the later development of the Zen-inspired tea ceremony.

Kano paintings inside audience room of Nijo Castle, Kyoto. about 1603

MUROMACHI AND MOMOYAMA PERIODS

Kyoto was re-established as the capital in 1338, initiating the *Muromachi* era which lasted until 1578. The warrior class patronized the arts, creating an ostentatious court life. As a contrast to their incessant warfare, tranquil landscaped gardens provided respite with their peaceful arrangements of natural and architectural elements. Spiritual peace was also available in the *Noh* (dramas), *cha-no-yu* (tea ceremony), *ikeband* (flower arranging), and the appreciation of individual works of art displayed within special alcoves known as *tokonoma*.

Muromachi painting was dominated by the Chinese ink style, known also as *sumi-e*. Although usually done on absorbent rice paper in quick confident strokes, the style was used on sliding door panels and screens by a family of painters named Kano. Their style of painting was later used during the Momoyama era (1573–1615) to embellish rooms in large castles built by feudal war lords. Paintings of trees and nature scenes appear to be viewed through the pillars, adjacent to the *tatami*-matted floor. The influence of Portuguese, Dutch, and English traders appears in the stone castles of this period, which exhibit European building techniques and Chinese concepts of fortification (*See* p. 284).

EDO PERIOD

European and Christian influence was banned in 1612 as Japan again closed itself to the outside world and the capital was moved to Edo, modern Tokyo, (1615–1867). A prosperous middle class arose as the warrior class declined. After 1868, the *Meiji* Restoration, Japan opened itself to Western influences in political, social, and cultural areas that quickly made it a progressive and modern state.

In the *Edo* period decorative painting continued while a unique style of *genre* painting evolved, known as *ukiyo-e*. Ukiyo-e art, for the most part, is celebratory. It features colorful images of daily life, fashionable courtesans, and actors from the popular *kabuki* theater. These paintings were later adapted to the woodcut process. By the end of the era multi-colored prints were being produced by over 200 artists and marketed to the middle class at very low prices. Among the best examples is Utagawa Hiroshige's *Night Rain on Kirasaki Pine*, part of a large series of prints (*See* p. 52).

MODERN PERIOD

Non-Japanese painting techniques, notably oil painting, were first introduced by the *Jesuits* and later encouraged under the Meiji era. *Ming* and *Qing* ceramics influenced Japanese pottery production, leading to "Imari" and "Kutani" wares which are brightly surfaced and boldly colored porcelain. Contemporary artists in Japan continue to reflect their tradition of assimilation without surrendering the native Japanese heritage of simplicity, elegance, and use of natural materials.

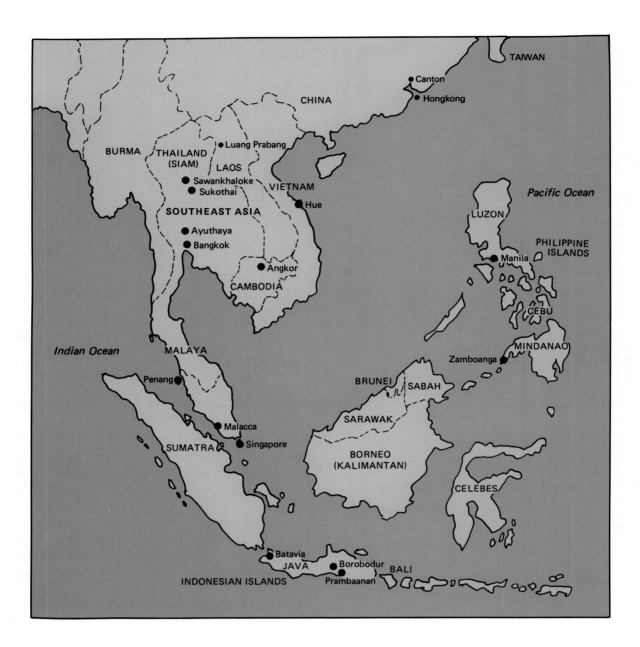

Southeast Asia

Southeast Asia is a geographic zone where cultural influences from various sources have met, mingled, coexisted, or dominated each other, since the days of the Roman empire. The two dominant influences have come from India and China.

Several coastal areas became *Indianized* as early as the first century. Adopting Hindu and Buddhist faiths, rulers developed a form of government and social pattern known as the *deva raja* concept. In this god-king cult, the ruler became the model for society and had the blessings of the gods in his earthly rule.

God-kings in Cambodia perpetuated their divine image through the construction of immense national temples which later served as their mausoleums. Worshippers of the king were his subjects who lived around the *wat* so they could be close to the abode of the god. The god-king temples reflect strong Hindu influence in the tall stone towers covered with sculptures of Hindu and local religious heroes. Small niches inside the temple were filled with stone or bronze images of deities. The finest examples of god-king temples are Angkor Wat, built about 1150, and the Bayon at Angkor Thom. The

Angkor Thom. Sculptured faces of Jayavarmin VII, about 1190. Cambodia

Borobodur. Ambulatory on third level. Scenes from the Ramayana in stone relief, about 850. Shailendra dynasty. Java

Bayon features the head of King Jayavarman VII depicted as the Bodhisattva *Lokeshvara* on towers throughout the temple complex.

Buddhist influences most strongly affected areas of Burma, Thailand, Sumatra, and Central Java. Bronze and clay images were created by artisans of the *Sri Vijaya* kingdom, a strong political power. Buddhism reached its greatest political height with the *Shailendra* kingdom in ninth century Java. There architects created one of the seven wonders of the ancient world in the artificial cosmic-mountain known as *Borobodur*. This ten-level pyramid shaped stupa symbolically represents the cosmos through bas-relief carvings on the lower six layers. The lowest of these levels represents hell and eternal torment and was apparently so grotesque that the Shailendras themselves covered the images with tamped earth ramparts. The next five layers represent humanity's earthly adventures. Walkways on each square level are lined with carvings of tales from the *Ramayana* which teach righteous living through the example of Rama. Sculptures show a realistic understanding of body proportion, overlapping planes to show depth, graceful movement in the figures, and historical records of clothing, architecture, and even shipbuilding styles. Four round layers finish off the top of the stupa, representing the supernatural element. At the apex of Borobodur is a large solid stupa similar to the original one at Sanchee in India.

Buddhism declined in Java with the fall of the Shailendras in 856 but dominated the cultures of Burma, Sri Lanka, Cambodia, Thailand, and Vietnam. Burmese art and architecture reached a high point in the twelfth century with the construction of many bell-shaped stupa-temples in the capital city of Pagan. This influence entered Cambodia and became intermixed with older Hindu traditions. Buddhist images were cast in a unique style with facial features distinctly Cambodian. In the example pictured here, a *niche* has been created for the Buddha incorporating the Hindu kala-makara, a serpent-like creature which devours and reproduces time. The flames, embellishments, decorations and tiny figures are part of Buddhist and Hindu iconography.

Distinctive Thai art and architecture originated in the late 1200s with the formation of the first Thai kingdom at *Sukothai* in the northern Chao Phraya valley. Bronze casting technology and ideas about architecture and sculpture came from the Khmers and from remnants of the *Dvaravati* kingdom in far southern Thailand. Stupas were constructed in the style of the Ceylonese, Burmese, and Khmers, and immense images of Buddha were formed in clay, brick, and stucco, often covered with gold leaf.

The king of Thailand, Ram Kamhaeng, with the assistance of the emperor of China, established a royal pottery works. While the products of these and succeeding potters may not possess all the technical perfection of Imperial Song and Yuan ceramics, the Thai potters did create distinctive celadon glazes. Thai equivalents of blue-and-white were made, using local materials, to form exquisite designs which reflect the taste and traditions of the Thais. One such example is the covered box produced at the *Sawankhaloke* kilns near Sukothai about 1400.

Buddha Enthroned, 10th century. Khmer. Bronze. Kimbell Art Museum, Fort Worth, Texas

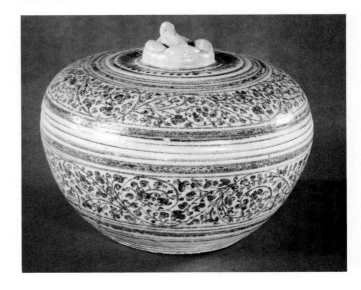

Covered box. Sawankhaloke kilns, Thailand, 14–15th centuries. Stoneware with underglaze iron, 14 cm high. Los Angeles County Museum of Art

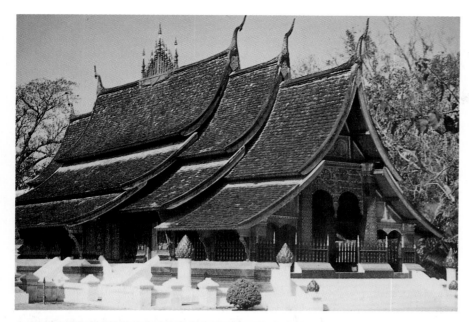

Wat Xieng Thong (The Chapel). Luang Prabang, Laos

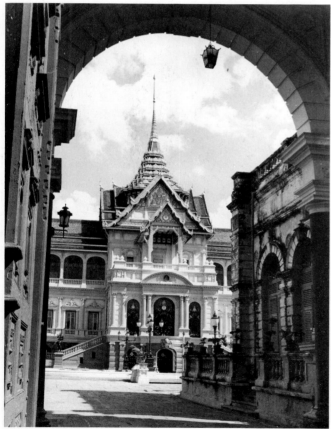

Royal Palace, exterior view, 19th century. Bangkok, Thailand

European Neoclassic traditions first influenced Thailand during the reign of King Narai (1657–88). Later, when Bangkok became the Thai capital, architecture, like the Royal Palace, blended Asian and European influences. The European influence can be seen in the rusticated base, the segmentally-arched portico, and the Classical columns and windows. The roof, however, is distinctly Thai and is topped with spirelike forms, known as *chedis*.

Chinese culture has directly influenced a much smaller area of Southeast Asia. When Vietnam became independent from China in the tenth century, the court at Hue emulated Chinese culture in its bronze castings and in the construction of Buddhist temples. This influence carried over into areas of neighboring Laos. The resulting Buddhist architecture, as seen in Wat Xieng Thong, is a mixture of Chinese (concave roof), Thai (overlapping roof lines), and local Lao traditions (decorative detail), and is a beautiful example of cultural accommodation in architecture.

When Islam became established in coastal Malaya and Indonesia between the ninth and fifteenth centuries, artists and architects produced distinctive *mosques,* elaborate bronze weaponry (the wavy-edged *kris* dagger) and printed fabrics known as *batik*, made from wax stencil dying processes. The elegant and sophisticated court life required well-crafted bronze utensils and bejeweled royal objects. Court musicians played the *gamelon*, an or-

chestra of drums, wooden wind instruments, and sets of turned bronze gongs, all highly ornamented with geometric and curvilinear abstract patterns.

When colonial powers arrived in Southeast Asia in the sixteenth centuries, there were two cultural results. First, Portuguese, Dutch, and British settlers brought Neoclassic tastes with them. Local peoples were impressed and incorporated some Western ideas into their art and architecture. Second, British and Dutch officials often provided financial support for local sultans in Malaya and Indonesia who, as a result, devoted much time and newly acquired wealth to reviving traditional art forms and creating opulent courts.

Oceania and Highland Asia

Stretching from the upper headwaters of the Mekong, Irriwaddy, and Chao Phraya rivers south to Australia and east to Polynesia, a vast disparate cultural area exists in which some of the world's most symbolic artwork has been produced. Indigenous tribes located in pockets throughout this area have traditions of sculpture, weaving, architecture, and pottery that are distinctive in form, style, and symbolism. Many tribes have had little or no

contact with the "outside" world and have developed artistic styles in connection with *animistic* practices, unique to their own cultures. Other peoples are part of larger cultural entities, most notably those within the *Oceania* area, which is sub-divided into *Micronesia, Melanesia,* and *Polynesia.*

Highland tribes of the Southeast Asian peninsula separated themselves from the mainstream of lowland cultures at various times throughout history. The various tribes have produced similar, but distinctive, art forms. Houses built on stilts and using steeply sloping roofs of thatch are typical. Symbolic painting and sculpture is usually employed to represent mystic forces over the unknown powers of nature, such as the highly stylized curvilinear designs of paintings which were often a part of panels found inside the communal *longhouses* of Borneo. A preference for animal and geometric symbolism and symbolic pattern, rather than perspective, is typical of painting throughout the region.

Mystic designs are often empowered with spiritual energy. Nonetheless, as indigenous peoples have become part of modern states and have experienced the meeting with more technological cultures, their artwork has reflected new subject matter in their world. The woven blanket shown here is filled with mystic and *to-*

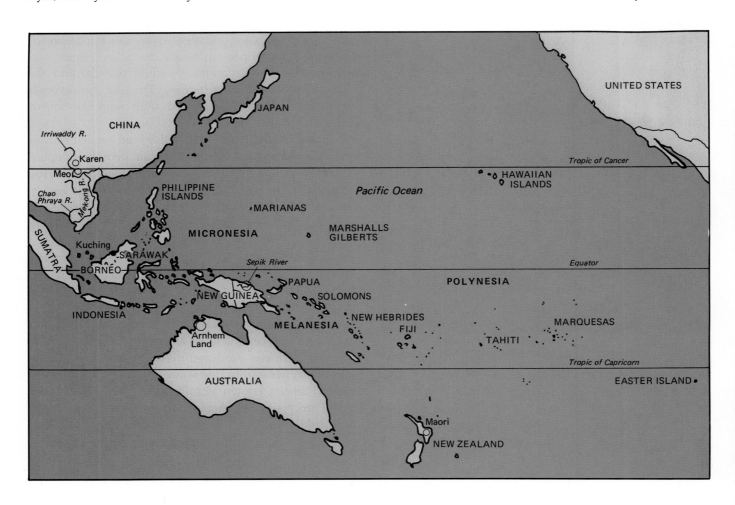

Gableboard painting. Kenyah Tribe, Sarawak, East Malaysia. Vegetable dyes and earth colors on wood. Sarawak Museum, Kuching

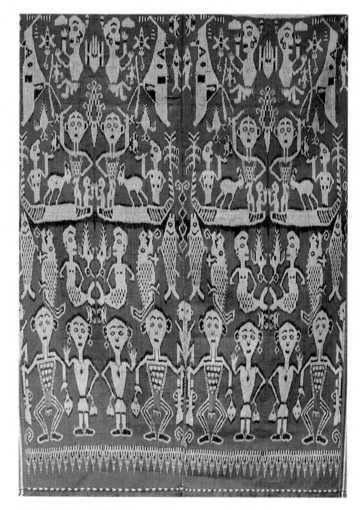

temic symbols. The alligator is a common motif in Oceanic art, but the introduction of the synthetic bird in the form of an army helicopter indicates that these people are open-minded and can easily add new images to their iconographic heritage.

Peoples of the highlands share many artistic similarities with Oceanic peoples of the Pacific. Their objects are created, not for their aesthetic beauty, but for their functional purposes—primarily religious items for the cults of gods, ancient chiefs, worship of ancestors, and *cult magic*. Their pottery is also similar; it is hand-made, impressed with geometric patterns, then *flash-fired* in open fire pits.

Most Oceanic art is sculptural, primarily in the form of *masks*. These are used by cult groups to decorate ceremonial huts or as objects of worship. Used in rituals, the mask possesses the wearer, who loses his or her own identity and becomes the spirit of the ancestor or spirit embodied in the mask. In a similar way, life and power is given to spears, boats, and eating utensils through mystic or animal motifs carved onto these objects.

Wood, commonly used sculptural material of Highland and Oceanic peoples, is carved with curved axes, sharks' teeth, shell splinters, sea urchin spines, and bits of sharp stones. Stone sculpture is much less common, found only in Polynesia where it is usually chipped out of volcanic rock. Almost no sculpture of either material is known in Micronesia, which has a less-developed artistic tradition. Painting is used to embellish carved

Blanket. Iban Tribe, Sarawak, East Malaysia. Cotton and vegetable dyes, 81 × 123 cm. Collection of Mr. and Mrs. David Kohl

Male ancestral figure. Sepik River, Papua, New Guinea. Wood colored with earth pigments.

Carved wall panel from Maori Meeting House, late 19th century. Dominion Museum, Wellington, New Zealand

wooden images and masks, especially in Melanesia. Ancient examples of sculpture are rare since the materials quickly deteriorate, and most work found today is less than one hundred years old.

Papua, New Guinea has one of the strongest artistic traditions in Melanesia. Basically a peasant art, the stress is on bright colors in ornamenting objects for ancestor worship. Ancestral figures are carved from wood in sizes from three inches to three feet in height. The use of paint embellishes the ancestral figure with white highlights and reddish brown paint, which supposedly looks like blood, in an attempt to guarantee the continued existence of the soul of the deceased. *Totemism* is also common in Melanesia where masks, statues, and other cult worship objects are used to identify kinship.

Tribal art of the Sepik river in northern Papua marks a high achievement in native art. A broad intermixture of island, coastal, and mountain cultures have produced woodcarvings of great variety in subject matter and free expression. Detailed and well-carved wooden images are embellished with shells, dogs' teeth, feathers, animal hair, and paint or colored earth, similar to the practices of sub-Saharan tribes in Africa. Images are either ancestral masks, ceremonial masks, or fertility images.

Polynesian art is far more aristocratic. Masks, carvings, and even boats represent sophisticated cult worship of gods and chiefs. Often ancient migration leaders are immortalized in a type of hero worship. The stress is not on bright colors but rather on the use of the grain of the wood. In contrast to Melanesian practice, masks are not considered as the permanent dwelling of spiritual forces but assume powerful worship force only when surrounded by ritual.

Unique in the art of Oceania, stone sculpture is found at Polynesian places of worship and as foundations for

houses and tombs. Stunning examples of stone carving are the monumental ancestral images in volcanic rock on Easter Island and the stylized figures of the Marquesas Islands.

Woodcarving is common throughout Polynesia, from Hawaii to New Zealand. Intricately carved bas relief panels distinguish the houses of New Zealand's tribal *Maori* chiefs and priests. Like the totem pole of Northwest American tribes, this wooden carving depicts a tribal ancestor as a warrior with his tongue thrust out in defiance of his enemies. The small figure between his legs represents later tribal ancestors. Notice how only half of the figures are depicted—a distinctive feature of Oceanic art. The lattice panels of dyed vegetable fibers on each side of the carving are abstract representations of natural forms.

Tattoo work on the human body originated in the Marquesas. In an under-the-skin dying process taking years, men's bodies are covered in traditional geometric designs which appear to be symbolic and mystic.

Australian *aboriginal* culture shares stylistic and media similarities with Oceanic and Highland peoples. Living throughout the arid regions, they have produced a tradition of painting on flattened bark, which is usually placed on the inside of their temporary shelters. Kangaroos, birds, fish, snakes, tortoise, and alligators are common subjects. As seen in the example from Western Arnhem land, an "X-ray" effect is used to depict internal organs, simultaneously showing two aspects of the same subject. Designs of humans, mammals, birds, reptiles, and fish are also abraded, pecked, or hammered into the surface of rock outcroppings. It is common to find geometric designs carved into earth or trees as part of initiation ceremonies and *walkabouts*.

The vast heritage of this entire region has only been "discovered" in the twentieth century and has so far been more closely studied by anthropologists than by art historians.

Aboriginal rock paintings. Gunqinggu group, Western Arnhem Land, Australia

The World of Islam

Islam has directly influenced the cultures of Europe, Africa, and Asia from Spain to the Philippines. Its indirect effect on the arts of America are seen in the architecture of the Southwest and the craft traditions of South America. Typical of Islamic art is the use of round and pointed arches, ceramic tile, complex systematic ornamentation, and the near absence of human and religious forms.

Arab culture, from which Islam grew, produced no monumental architecture or painted images. These semi-nomadic peoples valued small, portable objects with rich decoration. Arabic script became highly regarded, since it was the language through which *Allah* had chosen to reveal his messages to the prophet Mohammed. These inspirations were written in the *Koran*, and a whole style of art developed around the *calligraphic* attention given by devoted scribes in recopying that sacred text.

In metalwork, pottery, carpet making, and architecture, Islamic art reveals itself as an art of ornamentation. Swirling plant form designs known as *arabesques* were used to ornament objects. Imaginative, stylized designs were based on *Kufic* script, plant forms, and geometric patterns. These fill spaces on manuscript pages, copper containers, ceramic vessels, weapons, and the walls of holy buildings like The Dome of the Rock, in Jerusalem (*See* p. 192). Usually, no prominent center of interest is obvious. Instead, symmetry and tranquility seem to be the desired goal.

The major architectural form in Islam is the *mosque*, or temple. Originally, the mosque had to have one wall facing Mecca, marked by a niche known as the *qibla*. Towers known as *minarets* were used by *muezzins* to call the faithful to prayer. Mosques in Spain centered on elaborately arched courtyards, with rows of columns facing the open space in front of the qibla. A second style

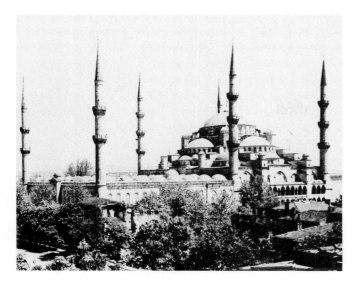

Blue Mosque of Ahmet I. 1617. Istanbul

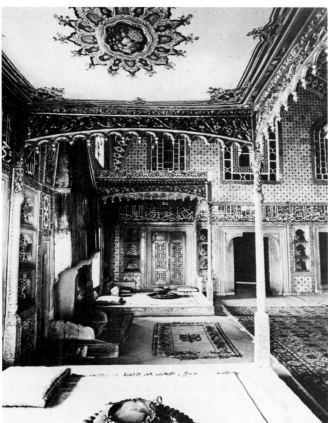

Interior, Topkapi Palace, begun 1462. Istanbul

of mosque emerged in Turkish and Persian areas, known as the *madrasah* or teaching mosque (also spelled *medresa*). It was still open to the sky, but the courtyard was walled in with a large semi-vaulted room opening into the courtyard from each of the four surrounding walls. This created an essentially cruciform (cross) floorplan. The third style of mosque, created by the Ottoman Turks, was based on the Hagia Sophia in Constantinople. Combining the *madrasah cruciform* plan with the domed enclosed spaces of Byzantine architecture, such examples as the Blue Mosque display a rhythmic yet structural use of domes to enclose a spacious interior. Small windows in the *drum* of the dome allow shafts of light to enter the *faience*-tiled interior, producing a mystic atmosphere.

Religious and political leadership in Islamic societies were combined in one person, usually known as the *caliph* or *sultan*. Palaces for these men and their courts took various forms but invariably featured elaborately ornamented interiors. The Alhambra in Spain (*See* p. 70) and Topkapi Palace in Turkey (*See* p. 18) testify to Islamic creativity. The room illustrated from the Topkapi Palace shows the use of Arabic calligraphy on the walls, faience wall tile, geometrically *traced* windows, and colorfully-patterned carpets. The *dais* for sitting is bordered by twisted columns supporting a patterned canopy, which contains a *medallion* filled with realistic fruit.

Sculpture, particularly of humans or of God, is expressly prohibited in Islamic tradition. If an artist created a figure, he or she would be acting like God, a presumption no *Muslim* would want to make. A few sculptured animal forms were made with an understanding that images were permitted if they were small enough so that they cast no shadows.

Painting was not originally part of the Arab tradition, and few pictorial works appeared in Islamic courts until the *Mongol* era. During the thirteenth century, the region from Persia to China benefited from contact with the sophisticated culture of the Song. Chinese paintings were so influential that lotus, phoenix, dragon, and

MAQSUD KASHANI. *The Ardabil Carpet*, 1540. Safavid dynasty, Persia. Wool, 716 × 396 cm. Los Angeles County Museum of Art, gift of J. Paul Getty

Unique to Central Asia is the creation of beautiful and colorful rugs, carpets, and textiles of wool or silk. They are often regarded as the highest achievement of Islamic craftsmanship and design, combining painstaking knotting techniques with intricate symmetric and symbolic patterns. *The Ardabil Carpet* combines a design of sanctuary lamps with floral motifs to give the barefooted worshipper a visual as well as tactile experience.

Potters created elegant forms and glazes, using *lustre, enamels,* and *faience* techniques for decorating ceramics with Islamic motifs, which add rich color and texture to the inexpensive base materials. Turkish utilization of Chinese motifs were found during and following the Mongol interlude, producing drinking containers, bowls, and dishes such as the Isnik platter. Chinese floral designs (three peonies and two tulips) in the central panel are surrounded by stylized cloud patterns painted in cobalt. The designer was probably influenced by imported Chinese porcelain as seen in the lobed rim and Chinese motifs. The colors (blue, red, green, turquoise and black) are Turkish additions to the traditional Ming blue and white.

Metalsmithing reflects the ability of Muslim artisans to render materials into intricate forms of beauty. The Persian bracelet features rows of golden birds complete with tiny beaks, wings, and feather patterns. Its rhythmic alignment is in harmony with theories of symmetry and regularity typical of Islamic culture.

Throughout all geographic areas touched by Islam, an appreciation of the crafts can be seen. Carved woodwork, crystal, bronze, textiles, and weaponry provided a format for ornamentation. Regardless of media, size, or function, Islamic arts remain true to the philosophical foundations of the culture—objects are a witness to the order of creation and to the believer's submission to Allah's will.

cloud motifs began to appear in manuscripts and decorative arts. Paintings such as *The Battle of Alexander with the Dragon* show both a Chinese subject matter and painting technique new to the Arab world, where stylized mountains and trees create an environment similar to Song landscapes. The sweeping curves of the mountains seem to turn back on the scene, adding drama and power to the action. While the borders are Arabic, the faces Middle Eastern, and the compacted space is Islamic, the action pose of the central horse and rider and the landscape features show the influence of Chinese art but do not imitate it. A vast quantity of painting on palm leaves, cloth, and paper was created by various Islamic dynasties throughout the realm, reflecting unique regional tastes and motifs (*See* title page).

The Battle of Alexander with the Dragon, 14th century. Mongol period in Persia. Gouache on paper, 18 × 29 cm (detail). Museum of Fine Arts, Boston, Ross Collection

Dish with lobed rim and flaring body, 1550–1560. Isnik (Nicaea), Turkey. Tin-glazed faience, 34 cm diameter. Los Angeles County Museum of Art, Nasli M. Heeramaneck Collection

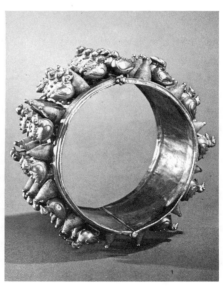

Bracelet, 10–11th centuries. Persia. Gold, 5 × 13 cm. Los Angeles County Museum of Art, Nasli M. Heeramaneck Collection

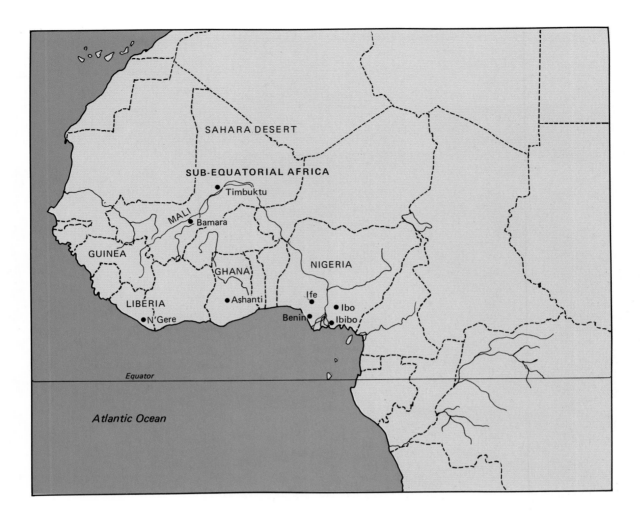

Sub-Equatorial Africa

South of the Sahara Desert, there are three distinct types of societies: (1) nomadic tribes in the desert and steppe regions; (2) sedentary farming cultures in the savanna and rain-forest fringe areas; and (3) ancient, sophisticated kingdoms of Nigeria and the Guinea coast. While all three have separate art traditions, their art is similar in attention to craftsmanship, general use of non-permanent materials, use of geometric abstraction, and religious orientation.

Religion is the dominant force in African tribal life and society. Each individual's spiritual counterpart seems to spill out of his or her own body shell and interrelates with the spirits of all other individuals. Spirits are everywhere, uniting the whole human race in a harmonious whole with the visible and invisible universe. Ancestors are thought to still exist, and a strong bond unites individual and clan with each other, and with the deceased.

Religion greatly determines the nature of Sub-Equatorial African art forms. It is most often manifested in *masks* and sculpture—ancestor or *cult figures, fetishes,* and *reliquary* figures. The wandering tribes of the semi-arid regions do not produce sculpture, as their roaming lifestyle does not permit the accumulation of material possessions. However, they do create masks for religious ceremonies.

A much more permanent and long-lived tradition of sculpture and masks is present among the agricultural tribes of the tropical savanna regions. Masks are used in ritual ceremonies to embody spiritual forces. Some are used in ritualistic dances, such as the wooden one from a tribe in French Guinea. While wearing the mask, the dancer ceases to be himself and becomes the spirit of the mask. From an artistic point of view, this object is slightly stylized. Geometric and naturalistic shapes combine to represent a recognizable human face. By

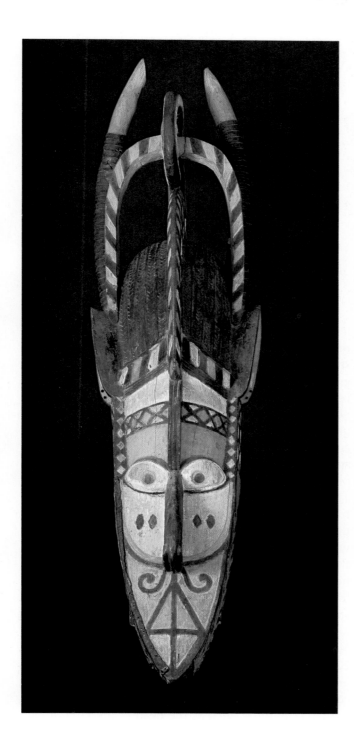

Antelope headdress. Bamara Tribe, Mali

Wooden images from the Bamara tribe of Mali show another type of mask, worn as a headdress. Carved of wood and painted sparingly with white paint, the mask (the image of antelopes) takes on a *surreal* appearance in its disproportion, geometric simplicity, and contrast of textures. Masks may also serve other functions. Deformity masks represent the results of diseases, and ancestor masks are the abode of deceased relatives.

Ancestor or cult figures are full-body images kept in homes. As part of the daily ritualistic routine, the family presents offerings to them. Sometimes these figures indicate social rank within the tribe or may function as fertility gods. They may be carved in the form of stools, wherein *caryatid* figures support the seat. Other cult figures may be carved holding an offering bowl or as mother and child figures.

contrast, other masks only faintly resemble natural forms. The wart-hog masks of the *N'Gere* people of Liberia are highly stylized representations, employing a wide range of materials in their construction. Wood, paint, fabric, tin, cotton cord, fiber, cloth, and woolen ornaments are combined with nails and even cartridge cases in a *primitive assemblage* which accentuates the mysticism of the mask (*See* p. 13).

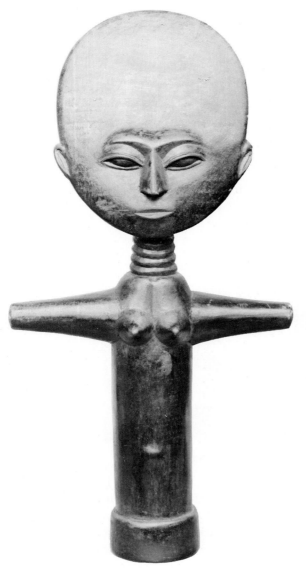

Akua Iba doll, 19–20th centuries.
Ashanti culture, Ghana. Wood, 30 cm
high. British Museum, London

Fetish figures, designed to hold a set of ingredients endowed with mystical powers, are human forms to which many types of materials can be affixed, such as rope, string, feathers, or shells. *Reliquary figures* are carved guardians which stand above basket receptacles for ancestral remains. Especially in these figures, art historians note an obvious *geometric stylization* of human anatomy, using concave and convex surfaces, cylinders, cubes, and cones to symbolize (not represent) the guardian spirits. The Akua Iba doll of the Ashanti tribe, for example, mixes geometric forms with realistic facial motifs.

In contrast to the nomadic and sedentary agricultural tribes, the aristocratic kingdoms of Nigeria created art that did not reflect the tastes of common people but of wealthy kings and courtiers. Royal craftspersons were on the king's "staff" and produced ceremonial sculpture, household ornamental panels, and artifacts used in daily living: bowls, stools, textiles, pottery, and musical instruments.

Kingdoms flourished as early as 500 B.C., when the *Nok* culture created large *terra cotta* figures. Nearly 2000 years later, an advanced society flourished in western Nigeria known as the *Ife*. Their most significant accomplishment was the production of very naturalistic human sculptures, such as the head of the king or *oni*, cast in bronze by the lost-wax method. All facial features in Ife sculpture are anatomically accurate, even to the bone structure beneath the skin. Holes allowed the application of real hair to give the original an even more life-like appearance. While many people once felt that Ife artists learned their sculptural naturalism and technology from outside sources, most scholars now agree that Ife sculpture represents the culmination of the aristocratic style, which is far different from the art of the savanna tribes.

Oni (King) of Ife, 12–14th centuries. Bronze, 37 cm high (lifesize). British Museum, London

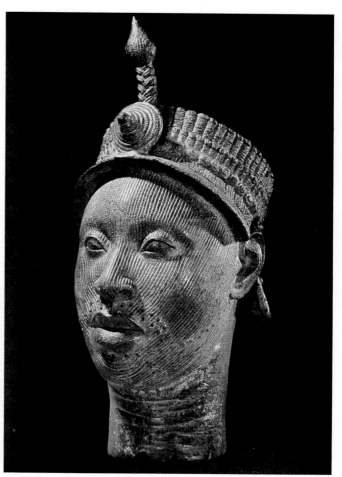

Flute player, 15–16 centuries. Benin culture, Nigeria. Engraved bronze, 62 cm high. British Museum, London

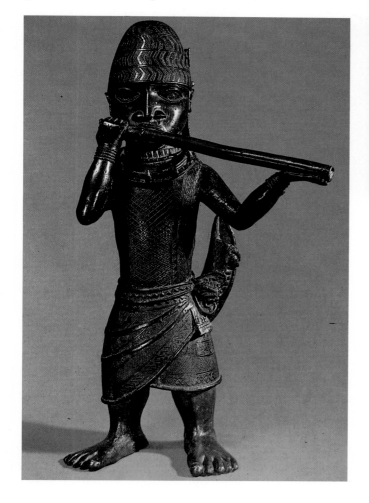

Ife craftsmen taught artisans of the neighboring *Benin* kingdom the techniques of naturalistic bronze casting in the fifteenth century. Figures such as the flute player show the Ife and Benin use of a head-to-body proportional ratio of one to four. Massive and realistic feet and legs contrast with the delicacy of the textures of cloth and helmet. (Other Benin casting can be seen on p. 10.)

African art was "discovered" by Westerners near the end of the last century. Picasso, Matisse, and other artists were influenced by the geometric qualities and abstract forms of African sculpture. Many European and American artists have emulated African art for its refreshing and simplified forms yet have failed to realize that the works were *not* produced as aesthetic statements reflecting a search for beauty. One can appreciate African art most by regarding it as generally intuitive and symbolic. People created these works to secure a relationship between themselves and unknown forces. Their art springs from a thought process unfamiliar to the Western world.

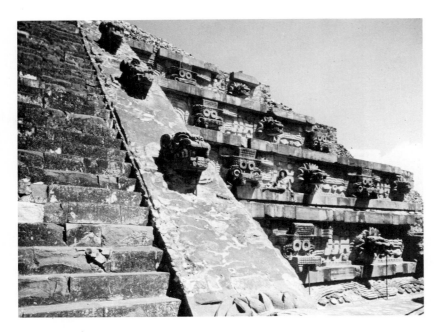

Funeral urn, 600–800. Teotihuacan, Mexico. Painted clay, 60 cm. high. National Museum of Anthropology, Mexico City

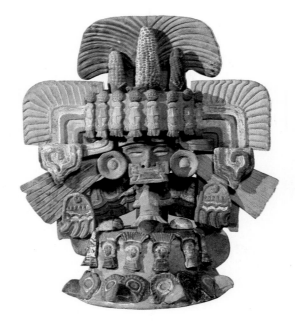

Pre-Columbian Art

Civilizations in America flourished long before their "discovery" by Columbus and their conquest by the Spanish. These ancient Americans can be distinguished by two geographic regions: (1) Mexico and Middle America (known culturally as Meso-America) and (2) the coastal and highland areas of Peru and adjacent areas (known as Andean). Here people produced architecture, sculpture, weaving, and ceramics of high quality, technically and stylistically very different from Western traditions.

In architecture, there was no knowledge of the true arch, so openings were created by *corbelling*. As a result, no large openings or interior spaces are found in pre-Columbian art. Stone masonry was of the highest quality, creating earthquake-proof temples and palaces made of fitted polygonal stones which were locked and *bonded* into massive walls. Temples were pyramidal in shape, often built of earthen mounds faced with finely fit stone or sculptured *adobe* (*See* p. 68). One or more sides of these temples were fitted with an immense stairway. Carved mythological heads depicting deities such as *Quetzalcoátl*, the feathered serpent of *Teotihuacan*, were cut and fit into the slopes.

Sculpture throughout the Americas was religious, with heads or full figures of gods carved in low or high relief. Very often, human or animal forms became highly stylized, and animal-human gods were carved with the type of symbolism seen on the Temple of Quetzalcoátl or in the clay funeral urn made by the *Zapotec* people of Oaxaca. The motifs seen here—jewelry, headdress, facial simplification, and ornamental dress—are repeated throughout much of ancient American sculpture.

Ceramics were a significant product of nearly all American cultures. Potters did not possess knowledge of the wheel, but their hand-made work was technically excellent, with thinly made walls and surfaces painted with colored clay slips. *Terra cotta* clays were *burnished* with polished wooden cylinders to produce shiny non-glazed

wares. *Chimu* potters of Peru produced black wares by firing with an oxygen-deficient *reduction* atmosphere in the kiln. Typically, pottery was made for use in ritual and burial, and pots were often broken to "release" the spirit when buried with the dead. The interesting "stirrup"-shaped vessels have handles which bridge both sides of the pot, and are hollow to form a spout through which liquids were poured. Shapes included human heads, a variety of animal forms, and even fish, as seen in the *Mochica* vessel.

Stirrup vessel in the shape of a fish. Mochica culture, Peru. Hand-formed clay, 24 cm high. Ohara Museum of Art, Kurashiki, Japan

Burial mantle, 300 B.C.–300 A.D. Paracas Necropolis culture. Alpaca fibers, embroidered, 246 × 171 cm. Los Angeles County Museum of Art

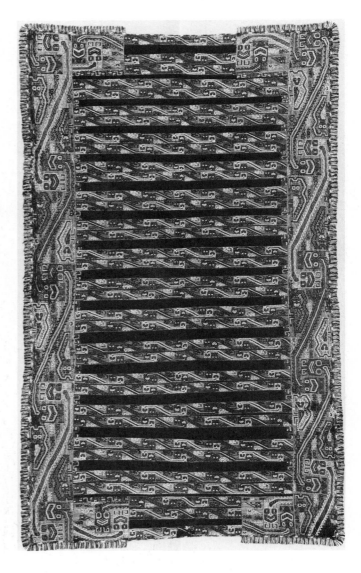

Fabrics of cotton, wool, feathers, or strips of hide and fur were produced throughout ancient America. Much has been lost because of the perishable nature of the materials, but weaving traditions date back to at least 1500 B.C. in coastal Peru where the *Paracas Necropolis* culture produced the finest of all ancient American fabrics. The example shown here was woven of alpaca fibers and includes stylized heads, crocodile motifs worked into geometric patterns, and a regularity of design repetition which marks this burial mantle as a paradigm of the weavers' craft.

Metallurgy originated with the early cultures. Gold was associated with the sun, and silver with the moon. Tin, copper, lead, and alloys were also used to make jewelry, death masks, whistles, and ritual objects. Smiths hammered, shaped, *soldered, inlaid, filigreed*, and cast these materials with lost-wax and in open molds.

MESO-AMERICA

The most ancient culture in Meso-America is the *Olmec* culture, centered along the Gulf of Mexico from as early as 2000 B.C. to about 200 A.D. The Olmecs affected the religious, political, and artistic practices throughout the region and carved huge *monolithic basalt* sculptures of faces which mixed human and catlike creatures. The jaguar became symbolic of the gods and was pictured in various forms of art.

Other ancient Mexican cultures included the *Nayarit* and *Colima* on the west coast. Their ceramic sculptures provide information about daily life. The example shown illustrates a ceremonial rubber-ball game played in a clay court. These games must have had religious significance as courts are found connected with the temples of later Meso-American cultures.

"Classical" Meso-American civilization dates from about 200 to 900. During this era, the *Teotihuacáns* built a huge stone temple-city for the use of pilgrims, yet the common people lived in *wattle-and-daub* huts (*See* p. 118). Mayan civilization also emerged during this period, constructing similar pyramidal temples throughout Yucatan and much of Middle America. Frescoes were painted at Bonompak depicting life-size human figures involved in ceremonies and processions. *Zapotec* culture, noted for its ornamental clay funerary urns and incense burners, also flourished at this time.

The post-Classical era saw the rise of imperial states, as first the *Toltec,* then the *Aztec* nations controlled Middle America. At Tula, the Toltecs built one of the few temples to use columns, which were carved in the form of warriors and spearthrowers. Enjoying a pinnacle of power in the later 1400s the Aztec centered their empire at Tenochtitlan, continuing the artistic traditions of the Mixtecs and Toltecs. Aztec sculptors produced bas relief calendar stones illustrating the days of the week as well as Aztec history. Unique to this era is the development of *codices* or illuminated manuscripts painted on bark paper or deerskin parchment. Humans are shown with sloping foreheads and slanted eyes which date back to the Olmecs, testifying to the cycle of cultural influences in Meso-America (*See* p. 83).

Machu Picchu. Overall view, late 15th century. Inca culture, Peru

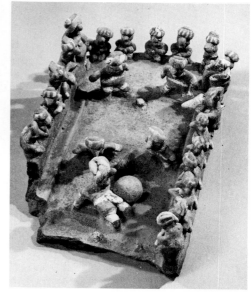

Ceremonial ball game, 100–300. Nayarit culture. Ceramic, white on red slip, 33 × 20 cm. Los Angeles County Museum of Art, Proctor Stafford Collection

ANDEAN

Andean civilizations trace their common origins to the *Chavin* culture of the Peruvian highlands. A stylized feline deity motif originated there which recurs many times in Andean art as a symbolic version of the jaguar. Stirrup-shape pottery vessels found in later Peruvian cultures were first made here, as were early examples of well-fitted stonework architecture.

The Chavin era gave way to an "experimental" period about 500 B.C., marked by the use of geometric decorations in pottery and weaving. The south coast *Paracas* culture flourished, producing thin sculptured pottery vessels in the stirrup tradition, covered with thick *resin* pigments. Weavings of the Paracas were the finest of all ancient American fabric art. Other coastal cultures, such as the *Mochica* and *Chimu,* constructed large pyramidal temples of adobe during this era.

From about 100 to 900, a "master craftsman" period has been identified, during which pottery production in coastal areas reached a high point in quality. Mochica potters produced naturalistic animal shaped vessels, using *incised* designs, *appliquéd* and pressed ornaments,

and painted patterns. South coast *Nazca* potters used polychromatic decorations of bold design and color to ornament their thin, highly polished wares.

From 900 to 1200, Andean artists produced well-fitted masonry gateways covered with stylized anthropomorphic bas reliefs. The urban Chimu kingdom reached its peak of power about 1200 and was notable for: fine silver and gold cups and masks; adobe-faced temples ornamented with naturalistic birds, fish, and geometric abstract motifs; and Mochica-influenced pottery.

About 1440, the *Inca* conquered the region, creating the final "imperialist" period, and utilized the artistic achievements of former kingdoms for its own purposes, much like the Romans did in Europe. The capital at Cuzco and other cities were well planned communities, on *grid-iron* patterns, where central *plazas* contained public buildings and temples. Late in the Inca era, walled fortresses were built near centers like Pisac and Machu Picchu. Despite hasty construction, huge stone blocks were expertly fitted and locked into *megalithic* structures which have withstood invasions and earthquakes. They stand today as a testimony to the engineering skill of the Andean civilization.

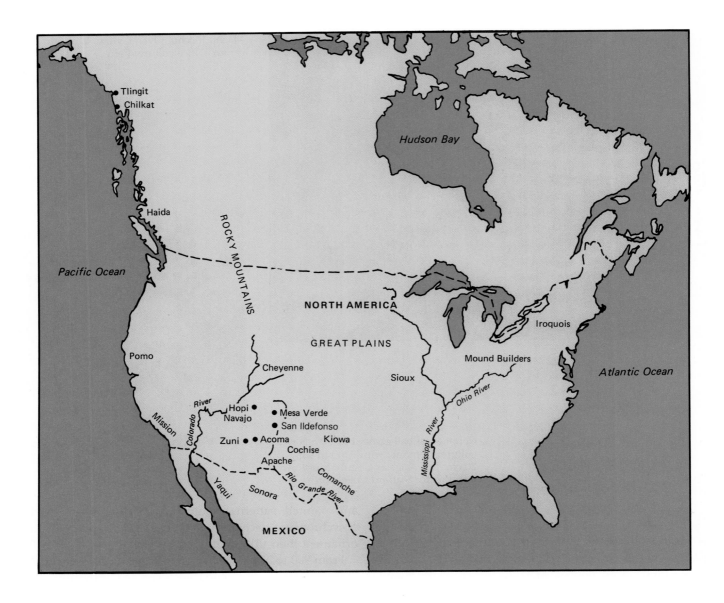

Native America

Native Americans have created ceremonial and functional objects of high craftsmanship and symbolic beauty since neolithic times. Characteristics include an appreciation for the materials of nature; a level of artistic sophistication similar to that of late neolithic cultures worldwide; a close relationship with the spirit world; a pictographic symbolism employed on *artifacts* from pottery to pipes; and an advanced level of craftsmanship in the production of folk art.

North America has supported a diverse population. The sub-Arctic area was peopled by nomads who lived in conical bark or hide shelters, and made crafts of bark, skin, and wood. In the Eastern woodlands, farming tribes lived in *palisaded* villages of bark-covered houses and produced pottery, baskets, and crafts of wood, shell, and copper. Great Plains Indians were grassland hunters living in *tipis,* bark houses, or multi-family earth lodges and produced fine beadwork, skin-and-feather work, pottery, and basketry. Tribes of the arid Southwest organized into either *pueblos* of farmers or single family houses of semi-nomadic herders. Known for their pottery and weaving, they have been able to maintain an on-going tradition of fine craftsmanship through their silverwork and ceramics. California peoples survived on acorns and hunting, producing fine basketry for cooking and storage. Coastal groups, known as the *Mission In-*

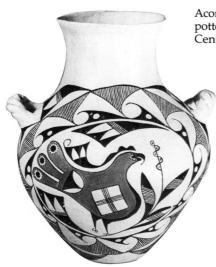

Acoma vase. Bird design. Polychrome pottery, 36 cm high. The Indian Art Center of California, Studio City

MARIA MARTINEZ and JULIAN MARTINEZ, 1929. Black vase. Polished pottery, 15 cm high. The Indian Art Center of California, Studio City

San Ildefonso water jar. Polished pottery, 38 cm high. The Indian Art Center of California, Studio City

dians, constructed Franciscan-style adobe churches with red tile roofs. Alaskan and Northwest fishermen lived in villages of large plank houses where complex clan associations supported an advanced artistic development in wood sculpture and weaving.

The *mound builders* of eastern America created huge earthen platforms by carrying earth in baskets and tamping it into flattened terraces. One of the largest of these is at Cahokia, Illinois, a complex of eighty-five mounds. The pyramid is over 30 meters high, 300 meters long, and over 200 meters wide.

Ancestors of the Pueblo peoples in the Southwest built communal apartment houses under the protecting ledges of massive cliffs. By 700 stone and adobe were used to build square dwellings with only a few windows or T-shaped doorways high up on the walls, accessible only by retractable ladders. Thus, the *pueblo* could be defended, much like a fort with round towers aiding in this function. In front of every pueblo were round subterranean *kivas* (meeting rooms), roofed with domes of twigs, thatch, or fitted stone, with interiors of painted ceremonial designs. Remains of the Great Pueblo are found at Mesa Verde in Chaco Canyon, New Mexico; Canyon de Chelly, Arizona; and other sites. Contemporary pueblos continue the tradition in the Southwest.

Dwellings of other native Americans were usually less grand than those of the Pueblo peoples. Hunters of the Plains region relied on the portability of the *tipi,* a dwelling of rawhide stretched over a conical framework of long poles. Decoration was significant, and painting on the hide included designs representing the forces of nature with which Indians identified. Sun, rain, animals, spirits, and *mandala* patterns were all rendered with earth colors and animal dyes.

Pottery traditions of native American peoples are exceptional for their fine craftsmanship and design. The earliest North American pottery was created by Eastern peoples about 2200 B.C. The potter's wheel was not used, but clay was slowly formed into symmetrical shapes using the coil method of building the form up ring by ring. Forms were sometimes enlarged and shaped by using paddles. No glaze was used, but pots were partially waterproofed by burnishing—a process of polishing with smooth rocks or wood before the pot was completely dry. Decorations were stamped, incised, or engraved into the surface, and often *slip* of various colors was painted onto the *leather-hard* clay.

Most shapes of native American pottery reveal their function as containers for food storage or cooking, such as the Acoma vase, decorated with polychrome slip design. Its slender neck, secure handles, and animal design suggest its uses. In 1919 Maria and Julian Martinez of New Mexico began the production of black polished pottery. This pottery is made of clay that fires to a black finish after it is burnished until it shines. No glazes are used in this process. Designs are then painted (sometimes carved) on the elegant forms after polishing. A striking effect is achieved as the painted areas appear dull black on the polished surface. Note this interaction on the upper body of this vase. Women make the basic ware, then men paint it, an unusual departure from the common Indian practice where women make the pot from start to finish.

Painting ca.. ue traced to ancient rock carvings found in at least forty-three states. The *petroglyphs* are, in some instances, 5000 years old, and the designs were probably *abraded* as part of ritual puberty, hunting, fertility, or worship practices. Images of puma, serpents, bighorn,

Navajo rug, 1850–1880. Wool. The Indian Art Center of California, Studio City

owls, whales, and human figures are stylized in what seems to be the beginnings of a written language. Carved patterns were often highlighted with color from clay, minerals, charred bone, or plant pigments, and resemble the works of ancient tribes in Europe (*See* p. 194).

Since 1875, Indian artists have been using Western media and techniques to depict their heritage. Rituals, ceremonies, and folkways are presented in paint, such as the "Mud Bath Ceremonial" painted by George Keahbone, a Kiowa from Oklahoma. The flat background, an absence of modeling in the figures, and stylized motifs like hoofprints, leaves, and shields, show the relationship with traditional designs found in sand paintings, pottery decoration, Kiva, and ancient rock paintings.

Southwestern weaving traces its unique use of the *loom* back to Cochise and Mogollon cultures, about 300 B.C. Clothing and blankets are created by innovative weave patterns known as the basket, tapestry, diagonal twill, or diamond twill weaves. The Navajo rug of wool has distinct designs which represent both the tribe and the individual woman who wove it.

Related to textile weaving is the more ancient craft of basketry, first practiced about 9000 years ago by peoples needing cooking containers. One of three methods is used in their manufacture—*plaiting, twining,* or *coiling.* Not only are the fibers of grass, bark, root, or hemp woven into fine, often water-tight containers, but dyed or naturally colored strands are incorporated to create rhythmical geometric patterns and representations of animals like the *thunderbird* (*See* p. 13). Each region has produced fine work, but the outstanding baskets of the California *Pomo* peoples are regarded as the most excellent in both craftsmanship and decoration.

Metalworking has been practiced in copper since 3000 B.C. By 1200, Southeastern peoples made ceremonial plaques of eagles and costumed dancing warriors. The mound builders of Ohio hammered copper ornaments into snake heads, birds, fish, and headdresses. Silver was introduced by Europeans and was beaten into jewelry by the *Iroquois, Oneida,* and others in the early nineteenth century. *Cheyenne* and *Sioux* created hairplates, buckles, armbands, and harness trappings during the same period. The *Navajo,* destined to become the finest of all American silversmiths, learned smithing from the Mexicans. Old silver dollars were hammered into *squash-blossom* necklaces and hollow beads or *cast* into jewelry forms. *Zuni* specialized in beautiful settings

Haida totem pole. Tlingit Indians of Southeast Alaska

GEORGE KEAHBONE. *The Mud Bath Ceremonial.* Department of Interior Gallery, Washington D.C. Denman Collection of Indian Art

GEORGE KEAHBONE. *The Mud Bath Ceremonial.* Department of Interior Gallery, Washington D.C. Denman Collection of Indian Art

for clusters of turquoise while *Hopi* silversmiths created new techniques by adding shell and coral to their pieces.

While most of the creative energy of native Americans went into seemingly functional objects, the wood sculpture of the Northwest Indians represents a contrast. Ritual carvings represent the finest sculpture, and the *totem poles* and house posts of the *Haida* depict supernatural and legendary characters and animals associated with certain tribes or clans. Other native Americans practiced sculpture on ritual masks, effigy figures, utensils, and the Navajo *kachina* dolls.

Hispanic and Other Colonial Arts

In the sixteenth century European voyagers introduced the Western world to Asia, Africa, and the Americas. For religious or political reasons, these travelers either checked or conquered political powers to establish European colonies in these newly "discovered" lands. By opening trade centers, they sent exotic goods—such as spices, silks, ceramics, and Oriental treasures—to Europe. These items eventually influenced art and taste in the West.

Colonial art forms also developed. A generally predictable pattern emerges in the history of all colonial arts. In the first phase, the colonialists usually isolate themselves in a small enclave, building European structures and trying to live as the "folks back home." Intermixing of European and native cultures occurs when Europeans need large numbers of buildings, furniture, pottery, or paintings. Local craftspeople are employed for these jobs and their aesthetic heritage begins to enter the works made for the colonialists. Eventually a hybrid style emerges in which the objects bear some resemblance to each parent influence yet exhibit a distinct creative form and style.

Europeans also wanted to convert native peoples to Christianity. As priests and *padres* worked toward this mission, they needed to reinterpret their faith so that the natives could understand the European concept of God and salvation. Christ, His mother, Mary, and other saints

Miagao Church. Iloilo, Philippines

Pieta, 17th century. Polychromed wood, 25 cm high. Philippines. Collection of Mr. and Mrs. L. C. Saunders, Hong Kong

were depicted as local people and even dressed in regional styles. Carvings of the *pieta,* such as this Philippine example, are perhaps naive in concept but have an emotional quality.

Architecture is the dominant art form produced by colonial societies, and its phases of transition can be readily identified. *Hispanic* churches, for example, display easily distinguishable styles of structure, ornamentation, and *facade* arrangements, reflecting the strong influence of Spain and Portugal.

Early Hispanic priests brought their heritage of *Moorish* architecture, known as *mudéjar*—a combination of Islamic, Gothic, and Renaissance styles, characterized by the use of round arches, brick construction, and tile roofs. The *plateresque* style, popular in Spain at the time of colonial expansion, introduced a profusion of elaborate swirling relief ornament. Churches in South America, Mexico, Cuba, Puerto Rico, and the Philippines combined these styles into buildings which provided both worship space and military fortification against heathens and pirates. The Miagao church (Philippines) is built with heavy *buttresses* that are delicately ornamented, while relief carvings on the facade portray St. Christopher amidst papayas, coconuts, and other local flora. Churches like this reflect the unique combination of Western styles, built by local labor under the

supervision of a European, and ornamented in local folk-style.

In the later seventeenth century, Baroque and Rococo styles were imported to such colonial centers as Lima, Quito, Copacabana, and Manila by the Spanish. Portuguese colonizers used similar styles in Brazil, Goa, and Macau. Wealthy viceroyalties like Peru and Mexico were able to support ostentatious displays in a colonial style known as *churrigueresque.* Ornate sculpted decoration became an essential element in the heritage of the Hispanic world. In addition, centers like Potosi and Mexico City supported wealthy communities where collectors amassed objects of ivory, silver, textiles, and ceramics imported from the Orient, adding to the proliferation of eclectic influences in the colonies.

The American Southwest witnessed another stage in the modification of Hispanic architecture. Franciscan *friars* and padres established a chain of missions to Arizona and California Indians beginning about 1769. Learning from local traditions in this arid region, they built their churches and dormitories of sun-baked adobe. Walls were thick, pierced with only a few small windows, which resulted in cool interiors. Ornamentation in white *stucco* was added sparingly. Mission San Luis Rey (founded by Junipero Serra) illustrates the *Mission Style,* wherein heavy towers and an elegantly raised

San Luis Rey Mission. 1811. San Luis
Rey, California

Two vases of terra cotta, 17–19th cen-
turies. Mexico. *Right*, Chinese shape
with Islamic pattern; *Left*, glazed with
polychrome majolica

espadaña gable will give the facade the impression of being much more majestic than the interior height would suggest. The church at San Xavier del Bac in Arizona is another fine example of mission architecture. White surfaces contrast with the decorative balustrades and the sculpted stucco facade (*See* p. 79).

Sculpture in the Hispanic world centered on figures of the Madonna, Christ, and wealthy local patrons. Ivory was imported from Asia via Manila and carved in Peru or Mexico. Often, designs show Oriental facial features, indicating that sculpture was also imported directly from China to the colonies. Painted sculptures of religious figures like the Philippine Madonna or the risen Christ were produced by the thousands.

Massive carved and gilded walls, known as *retables* or *reredos,* stood tall behind the altars of colonial churches. Usually carved of wood, they were designed as icono-

graphic displays for the local parish. Small niches often enclosed a valued sculpture, painting or scene from the Bible. Priests who designed these retables and needed church furniture contracted the actual carving, painting, and gilding to native craftspeople who interpreted their instructions in the local style.

The Spanish encouraged local pottery traditions, and introduced their preference for European and Oriental shapes, the potters wheel, and colorful glazes. Low-firing *majolica* glazes produced *pastel hues* over earthenware clay, appealing to the design sense of local craftspeople. Designs first imitated blue-and-white Spanish patterns, but later, Oriental designs were painted in polychrome like the Chinese porcelain brought by the Manila galleons.

Metalsmithing thrived on the silver mined in the Americas. Coins known as "pieces of eight" were

minted at Potosí for the Spanish crown. Tableware, crucifixes, altars, plaques, tankards, and vases were forged, soldered, and formed for the use of religious orders and private families. Designs reflected an integration of Baroque and native aesthetics.

Hispanic painting was inspired first by the *heraldic* insignias on flags and sails of the Spanish ships. As European painting turned to Baroque expression, the colonialists tried to have that style copied. But poor canvas and inferior paint kept artists from achieving the same greatness of their European counterparts.

When the British began their colonial expansions, they introduced the *Neoclassic* style which stressed Greek capitals, curved and triangular *pediments, colonnades, cupolas*, and a much more angular style than that found in the Hispanic world. English colonial architecture in Asia and America resulted from this *Palladian* style and was practiced enthusiastically by such architects as Thomas Jefferson (*See* Chapter 12).

The Dutch established themselves at South Africa, Batavia, and New Amsterdam (New York), in the early seventeenth century. Their architectural influence is still visible in parts of New York today. French, German, Danish, Russian, and American colonial empires date from later periods. Although they never had the same cultural impact as in the Hispanic world, there are German cathedrals in Shanghai and Russian forts in California. Such physical remains of humanity's political and cultural interactions contribute to America's rich and diverse artistic heritage.

INDEPENDENT STUDY PROJECTS

Understanding Patterns of World Art
Some of the many ways in which one can look at a work of art have been described in the first chapters of this book. Now that you have experienced the wide and diverse nature of art beyond the Western tradition, you may be able to see some common factors in world art. The thoughts, comparisons, and questions raised here are representative of one approach to the appreciation of world art—discovering what is similar, not what is different. By using the resources of the first four chapters, what informed conclusions can you develop using these questions and pictures on the next two pages as a guide?

Analysis

1. Many artistic influences, styles and motifs were used to create this enthroned deity from India. Write a descriptive paragraph about this image, using some of your newly acquired art-related vocabulary to describe the different images, surface treatments, patterns and iconographical motifs.

Tara with Attendants (Buddhist Altarpiece), 8–9th centuries. Madhya Pradesh, Sirpur, India. Bronze with copper and silver inlay, 38 cm high. Los Angeles County Museum of Art, The Nasli and Alice Heeramaneck Collection

Assyrian army crossing a river on inflated skins, about 859 B.C. Nimrud, ancient Kalhu. Gypsum, low relief, each man about 43 cm long. British Museum, London

Lion, 618–906. Tang dynasty, China. Marble, 30 cm high. William Rockhill Nelson Gallery of Art, Kansas City

Stag, 1000 B.C. Amlash, Persia. Bronze, 25 cm high. William Rockhill Nelson Gallery of Art, Kansas City

2. Three sculptures of animals are shown here. Much can be learned from them in terms of the accuracy of the representations, the technology of the culture that produced them and their cultural heritage. Assuming that none of these pieces were made to be simply decorative, what may have prompted their creation? Why are animals a popular motif in art around the world? Two of these works are much more stylized than the third, yet each involves some degree of stylization. Which do you think is most stylized and why? Which is least stylized? Write several paragraphs, analyzing the stylization in each of the three pieces.

3. Choose one of the five topics listed below, research it and write a one-page paper discussing:
 1) The effects of colonization on the arts of Asia and the Americas.
 2) The importance of masks in tribal use in Africa.
 3) The use of trade as an important element in the spread of aesthetic influences in Asia.
 4) The shaman as a powerful influence on the cultures of various Asian or African peoples.
 5) Several ways in which Western and non-Western art seem to differ.

Studio

4. Roll ceramic clay into long coils and place on top of each other to form a vase or bottle. Roll a flat piece for the base, and use slip (clay thinned with water) as binding material. Smooth the surface with a stick or flat stone. Allow piece to dry slowly. When "leather hard," trim it and carve designs into the surface. Look at hand-built pottery examples in this chapter or in other art or ceramic books. Ask your ceramics teacher for help with glazes, engobes and decorative techniques, as well as the firing process. Bisque ware can be glazed or painted with acrylic paints to simulate native American work or the ceramic ware of other cultures.

5. Clay can also be used to make stylized sculptural forms similar to the Teotehuacan figure on page 118. You might simulate such a design or update it, making it "meaningful" to late twentieth century society.

6. Study several kinds of masks and try to understand why they were made. Use papier-mâché to form a stylized mask that will fit on your head. Use tempera or acrylic paint to decorate it. Use traditional African or New Guinea masks as models, or make your own design.

7. Use tempera paint and/or watercolor to make a design (on paper) of a blanket or rug in one of the cultural styles described in this chapter (Islamic, Andean, Navajo). You may wish to research other books or encyclopedias before beginning. Or make up your own design, in the *style* of those cultures mentioned.

8. Use watercolor to paint in the style of the Islamic or Mixtec illustrations on page 83. Use present day subjects, but paint in one of the cultural styles depicted. Draw your image carefully before you start to paint it.

Aesthetics

9. In writing, describe a trip you might take in an area of Southeast Asia, Japan or India. Describe your impressions of the art and architecture of the region, much as Marco Polo described China. A single day from a diary might provide enough material for your project.

Temple of Chichen Itza, Mexico, 12th century

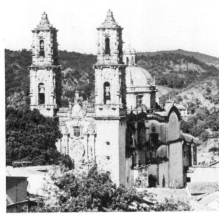

Church of Santa Prisca, 1751. Taxco, Mexico

10. Religion has been a major inspiration for many of the objects and structures that we think of as *art* today. These two structures represent architectural traditions of religious art in Mexico. What religion does each represent? What artistic heritage does each represent? How did their use as a place of worship differ? Can you think of other places where two or more strong religious traditions exist side by side? Write a paper on your personal feelings and reactions to the idea that religion influences art and architecture.

11. Three distinct human images are shown here, representing three diverse traditions and materials. What design elements are common to all three? What is the mood of each? Why might each have been created? Which involve distortion as a design technique? Which images are originally part of the culture from which they came, and which are derived mainly from an outside culture? Which of the three do you personally prefer, and why? Write a paper describing your feelings about each.

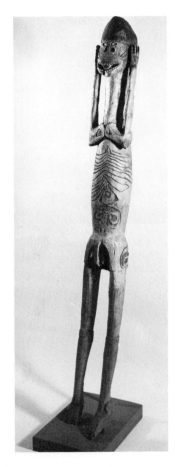

Cooks Bay Figure. Asmat Tribe, New Guinea. Wood, 141 cm high. Baltimore Museum of Art, gift of the Hecht Co.

Amedeo Modigliani. *Head,* 1915. Limestone, 57 cm high. The Museum of Modern Art, New York, gift of Abby Aldrich Rockefeller

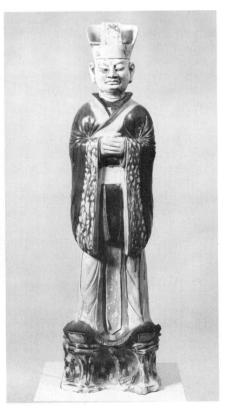

Court Official, 618–906. Tang dynasty, China. Ceramic with three-color glaze, 115 cm high. Los Angeles County Museum of Art, gift of Leon Lidow

Part Three
Art in the
Western World

5 The Seeds are Planted: Beginning of Western Art

It is not easy to pinpoint the beginning of art. The origins may be in the cave paintings of Africa, Spain, or France; may not have been discovered yet; or may be lost forever. However, it is interesting to note that among the earliest known groupings of human beings, there were two recognized occupations: hunters and artists.

The Earliest Beginnings

The hunters of the Paleolithic era (prior to 10,000 B.C.) prowled the hill country of what is now Western Europe, searching for bison, elephants, bear, deer, horses, and other wild creatures. The artists, undoubtedly chosen because of their talents, drew and painted the animals in startling realism and action. The reasons are unclear. Were the drawings a sort of magic way to help the hunters find and kill their prey? Were they merely decorative representations of the creatures in their environment? Or were they documentations of major hunting expeditions?

Whatever the reason, the artists were extremely competent at *stylizing* their work, simplifying it and eliminating extraneous detail. The animals are beautifully simplified and their characteristic features are emphasized and recorded. They are almost always seen in profile (viewed from the side) while they vary in their activity from standing to running to jumping.

The first cave paintings were discovered in 1870 by a small girl who was exploring a cavern at Altamira in Spain. When she looked up at the ceiling of the cave and saw a herd of wild bison charging across it, her excitement must have been overwhelming. Painted in several colors, they had been preserved by the dry air of the cave for over ten thousand years. The colors were made from the various hues of earth (red, yellow, brown, violet) and lampblack (soot) from the lamps used in the cave. They were probably applied to the walls with mats of moss or hair. Some colors seem to have been sprayed through tubular bones onto the walls.

In 1940 several small boys discovered similar paintings in a cave at Lascaux in central France. These paintings have been dated at about 15,000 B.C. and contain herds of horses and cattle, often drawn over each other. Other caves in France have revealed clay sculpture in low relief and carvings in cave walls of animals and human forms, all dating from about the same time.

Not only can Spain and France claim such wonderful cave art. Marvelous examples have been found in Sicily and Tassili in the Sahara Desert of Africa. These African caves reveal not only that humans lived in this area, now completely sand, but that before 4000 B.C. there was abundant water and vegetation sustaining many animals and people. Often domesticated animals are shown being herded by people.

These ancient cave paintings, however, may not be the oldest forms of art. Round and bulging female figures have been discovered in many places in Europe and western Asia. The *Venus of Willendorf* was found in Austria and is dated as about 25,000 years old. Although obese to contemporary thinking, this bulbous figure suggests abundant fertility and a plentiful supply of food—the two all-important needs to perpetuate society. The name of "Venus" was given by modern discoverers and does not have any connection with the later Roman goddess.

The sculptor who carved the bison was skilled in taking advantage of the natural form of the found material. The turned-back head is an elegant adaptation

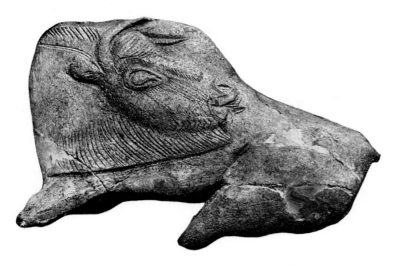

Bison, about 10,000 B.C. Reindeer antler, about 10 cm long. Museum of Natural Antiquities, St.-Germain-en-Laye, France

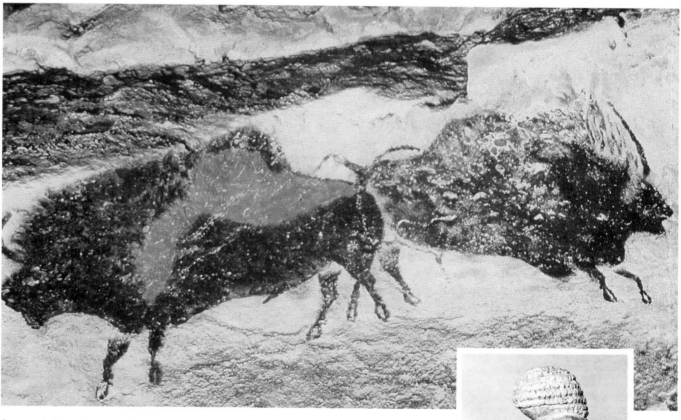

Cave painting. Lascaux, France

Venus of Willendorf, about 25,000 B.C. Limestone, 11 cm high. Museum of Natural History, Vienna

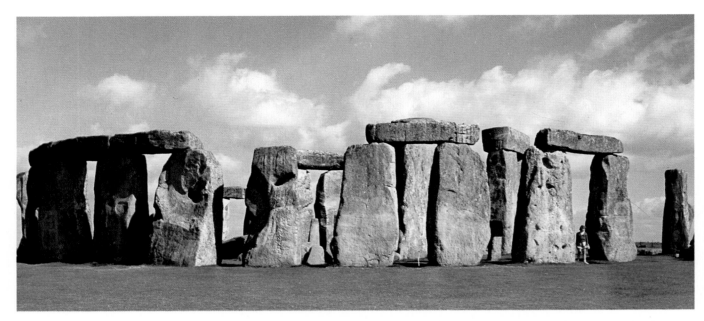

Stonehenge, about 2000 B.C. Height about 4.1 m. Salisbury Plain, England

Fortifications and circular tower, about 7500 B.C. Jericho, Israel

to existing contours. Because the piece is broken off, its original use cannot be determined.

Architecture became a vital concern to ancient peoples of the Neolithic era (New Stone Age, 8000–3000 B.C.). Once humans began to cluster together outside of caves, they herded cattle, raised simple crops, and formed communities. Protection from the elements was provided by simple structures of grass, mud-bricks, and even stone. Protection from enemies was often provided by walls around the settlement. Recent excavations have uncovered a town of mud-brick at Jericho in southern Israel, that dates from 8000 B.C. A rough stone wall, surrounding the village, has been dated at 7500 B.C. The walls are twelve feet high and a stone tower reaches to thirty feet—the world's earliest stone fortification. Other recent finds have revealed cities in Turkey dating back to 6500 B.C. Archaeologists continue the search for still further examples of ancient cultures.

Several huge stone monuments have survived. Built on the site of two earlier constructions, *Stonehenge*, on the Salisbury Plain in England, is a round grouping or *cromlech* of gigantic stones, constructed about 2000 B.C. The stones, some weighing fifty tons, were dragged for more than twenty miles to be trimmed and stood on end. The *lintels* were curved slightly to fit the circular plan. Apparently a ritual site, Stonehenge was constructed to indicate the solstices and equinoxes of the calendar year, and probably the times for planting, harvest, and religious ceremonies.

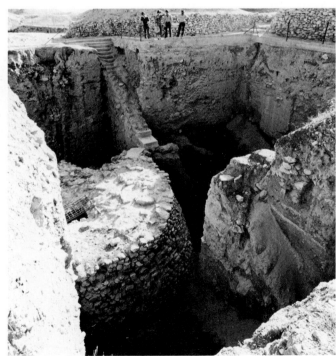

Fortifications and circular tower, about 7500 B.C. Jericho, Israel

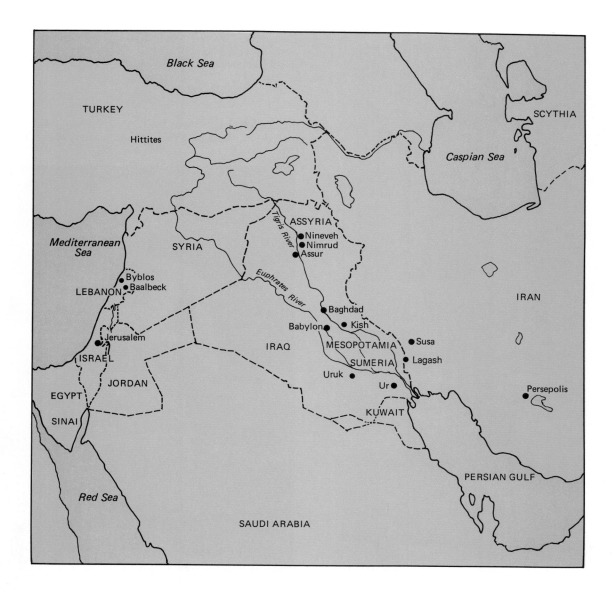

The Ancient Near East: Mesopotamia

In Mesopotamia, between the Tigris and Euphrates rivers in what is now the country of Iraq, a great civilization arose. On this wide, flat, and fertile expanse of land, the Sumerians established their first city-states about 3500 B.C. Their origin is unknown, but they settled in the southern part of the plain, near the Persian Gulf. Many of our contemporary social and political activities can be traced directly to Sumer. Cuneiform writing, record keeping, schools, democracy (they had a bicameral, representative government), the use of the vault and arch and the wheel–all originated in Sumer. The Sumerians used mud-brick for their buildings as wood and stone were not readily available. Most of these structures have been destroyed, with only foundations remaining.

Every city-state had its own god, and the priests seemed to be the *secular* rulers. Because no hills were present on which to build temples, the Sumerians constructed huge mountains of sloping platforms of earth faced with mud-brick and sometimes fired brick. These mammoth structures are called *ziggurats*. The oldest was built before 3000 B.C.,but the most famous was probably the biblical Tower of Babel—now destroyed.

Some of the art of Sumeria has been uncovered in the royal cemetery of Ur, where archaeologists have found statues, panels, and other artifacts. *The Goat and the Tree* is a statuette of wood, overlaid with gold, silver, inlaid shell, and colored stones (lapis lazuli) and shows a ram eating from a flowering tree. One of a pair, which were probably supports for an offering table, this charming work was done about 2600 B.C., about the time the Egyptians were constructing their pyramids.

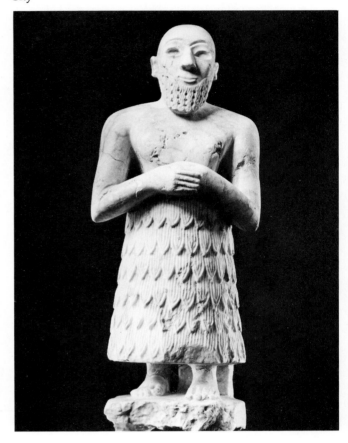

The Goat and the Tree, about 2600 B.C. Sumerian. Wood, overlaid with gold, silver, shell, and lapis lazuli, 46 cm high. Royal Cemetary, Ur. British Museum, London

Praying Nobleman, about 2600 B.C. Sumerian. Alabaster, 36 cm high. Mari. William Rockhill Nelson Gallery of Art, Kansas City

Much of Sumerian sculpture, carved from various stones, was in the form of praying figures. The eyes in all the figures are very large (windows to the soul), and there is a characteristic stylization in their poses and clothing. Each has a rounded form and hands folded in a prayerful attitude.

The musical instrument, a *lyre*, made of silver and decorated with an inlay of shells and stones, was also found in the royal cemetery of Ur. The kind of culture that was developing here about five thousand years ago was obviously quite sophisticated.

Lyre, about 2600 B.C. Sumerian. Wood, overlaid with silver, shell, and colored stones, 98 cm high. Royal Cemetery at Ur. British Museum, London

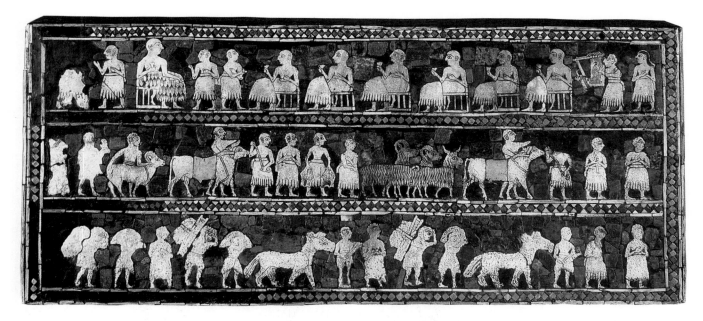

Look carefully at the *Peace Standard of Ur,* also found in the cemetary at Ur. The exact purpose of the work is unknown but it is a mosaic-like panel of shell and colored stones. The upper row shows the king (larger than the others) and courtiers at a feast. Notice the musician at the right, playing a lyre. The other two rows depict people bringing gifts or tribute to the king. A similar panel was also found, showing the people of Sumeria at war.

In about 2300 B.C. a Semitic-speaking people, the Akkadians, moved in from the north and conquered the Sumerians. Striving to dominate the entire world, their rule, however, was not long-lasting, and the Sumerians regained their autonomy gradually. The most important of the New Sumerian rulers was *Gudea*, of whom there were many statues. The one shown here is only partial, but is carved in diorite, a very hard, imported black stone. The pose is relaxed and worshipful, with muscles and facial features sculpted carefully.

After several centuries of warfare, the Babylonians emerged in 1700 B.C. as the masters of Mesopotamia. Their first leader was *Hammurabi,* a powerful figure, who composed a generally humane code of laws inscribed in stone. The Hittites defeated the Babylonians in 1595 B.C. and in turn were overrun by a succession of warring peoples.

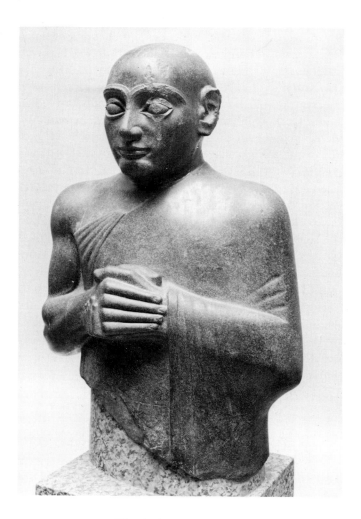

Gudea of Lagash, about 2255 B.C. Neo-Sumerian. Diorite with traces of gilt, 74 cm high. British Museum, London

Winged Genius, about 875 B.C. Assyrian. Alabaster, 236 cm high. The Palace of Ashurnasirpal II. Los Angeles County Museum of Art, gift of Anna Bing Arnold

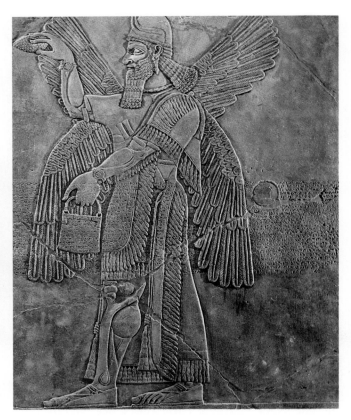

Dying Lioness. from Nineveh (Assyria). c. 650 B.C. Limestone, height of lion 35 cm. British Museum, London

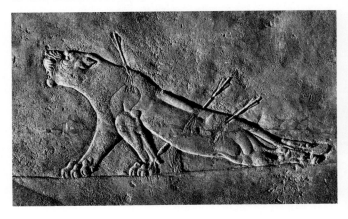

About 900 B.C., Mesopotamia was overwhelmed by the powerful Assyrians who descended on the plains from the north. They expanded their control as far away as Egypt and built marvelous palaces in the northern parts of the plain. Stone from nearby mountains was used to line these huge structures; the walls, carved in *low relief,* showed the exploits of the kings. The sculptors were superb craftsmen who could create a feeling of depth on a very shallow surface.

In 539 B.C. the Persians brought an end to the Assyrian empire. Under King Darius, they built huge palaces such as the one at Persepolis. Magnificent spaces were filled with great columns and atop each of the hundred columns, in a huge central room, was a pair of sculpted bulls, the symbol of power. Although carved from limestone, the bulls were probably covered with silver, gold leaf, and lapis lazuli.

The Persians remained dominant in this area until Alexander the Great toppled them in 331 B.C., thus uniting the Greek culture with the one that had slowly developed in the land between two rivers—Mesopotamia.

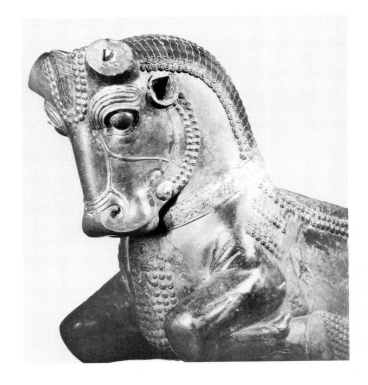

Bull capital, about 486–423 B.C. Persian. Limestone, 71 cm high. Persepolis. William Rockhill Nelson Gallery of Art, Kansas City

Egypt

About the same time that tribes were grouping together to form cities along the Tigris and Euphrates Rivers, similar communities were forming along the Nile River in Egypt. (Cities were also being created along the Indus in India and the Yellow River in China.) Slowly, complex cultures developed in both the upper (southern) and lower (northern) parts of the great Nile Valley. These communities consisted of soldiers, slaves, priests, scribes, artists, craftsmen, farmers, and herdsmen.

Succeeding generations learned to make bricks, to use sails on the water and wheels on land. They harnessed animals to help with heavy work, trained donkeys to carry people, and discovered ways to separate copper from ores and forge it into tools sharper than flint. And by 2000 B.C., they combined copper with tin to make bronze.

The Nile Valley is protected from invaders by huge mountains to the south, vast deserts on both sides, and the Mediterranean Sea to the north. In such a protected environment, separated from the rest of the developing world, the Egyptians evolved a unique way of life and a style of art which remained almost unaffected by other cultures for several thousand years. Sumerian, Babylonian, and Assyrian influences filtered into Egypt only occasionally through the corridor of the northern Sinai peninsula to the northeast. The surrounding and protecting deserts and mountains also provided the stone, ores, and gems which artisans used in creating works of art.

From the earliest times (in the Pre-Dynastic period) Egyptian craftsmen were honored and their products admired. Some works, such as pottery, paintings, tools, and small carvings, remain to be examined. Still, relatively little is known of these early peoples and their work.

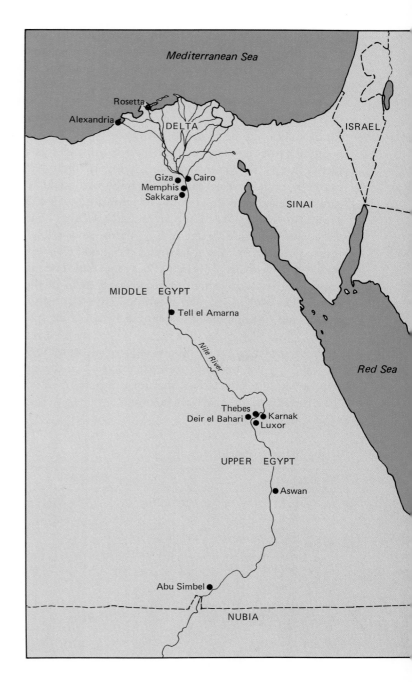

Egypt's recorded history begins about 3100 B.C. with the unification of the delta and valley areas into a single kingdom. The first ruler of this united kingdom was Menes who set up his capitol at Memphis. After several *dynasties,* a system of writing with picture-symbols (*hieroglyphs*) developed and allowed the following cultural evolution to be recorded as history.

Egypt's early civilization flourished as a result of its effective kings. Egyptians enjoyed living in their Nile-centered homeland so much that they wished to live forever. This desire for a happy eternity (afterlife) led to a prolific development of tomb art and architecture. Historians owe their knowledge of Egyptian society solely to these monuments. The tombs and pyramids were constructed so that the god-kings (Pharaohs) had food, servants, art, and equipment to accompany them in their second lives. Thus, a great wealth of Egyptian art was buried and, if not looted or stolen, is available for study today.

The first pyramid was constructed as a successor to the low, rectangular building tombs (*mastabas*) of the predynastic kings. King Zoser, the most important ruler of the Third Dynasty, asked the architect Imhotep to build his memorial tomb on a rock ledge at Sakkara, west of Memphis. Imhotep, the first artist in history whose name is known, built a solid stone structure of six huge steps rising about 65 meters in the desert air. The body of Zoser was buried in a room carved about 25 meters below ground, directly under the pyramid, which was surrounded with many other structures, mastabas, and walls to complete the funerary district. The step pyramid at Sakkara was the first huge stone structure built on earth, and the architect Imhotep was deified for his work. The time was about 2600 B.C.

During the Fourth Dynasty, pyramid building reached a climax in the three great structures at Giza. Hundreds of thousands of men were used to construct these rock mountains. The stones (some weighing over 40 tons!) were floated on rafts across the Nile valley during flooding season and hauled to the edge of the desert. Here, with a meticulous precision that astounds people today, men placed the stones to create the vast pyramids. Only levers and rollers were employed by the workers, who constructed huge earthen ramps on which to raise the stones: a mammoth undertaking, including tremendous organization and planning.

Egyptian History

PERIODS	B.C.	DYNASTIES	CAPITAL	HIGHLIGHTS
Pre-Dynastic	7000–3100			scattered communities, utilitarian crafts
Early Dynastic (Archaic Period)	3100–2686	1st and 2nd Dynasties	Memphis	Egypt unified, first cities, agriculture
Old Kingdom	2686–2185	3rd to 6th Dynasties	Memphis	written language, pyramids, sun god Re
First Intermediate Period	2181–2040	7th to 19th Dynasties		anarchy, civil war
Middle Kingdom	2133–1786	11th and 12th Dynasties	Thebes	tombs and temples, Osiris is leading god
Second Intermediate Period	1786–1567	13th to 17th Dynasties	Delta area Thebes (17th)	anarchy, Hyksos Kings, use of chariots
New Kingdom	1567–1085	18th to 20th Dynasties	Thebes	Luxor, Karnak, temples, Valley of Kings, Abu Simbel, rock-cut tombs
Post Empire	1085–333	21st to 30th Dynasties	Independence only in 26th Dynasty (663–525)	anarchy, foreign domination by Libya, Nubia, Assyria, Persia
Ptolemaic Period	332–30		Alexandria	Alexander the Great, Ptolemies (Greek influence), Cleopatra (Roman influence)

SOURCE: Based on chronology in *The Cambridge Ancient History,* rev. ed. Cambridge Univ. Press, New York.
NOTE: Dates shown may not coincide exactly with those in other sources because many key dates have been lost in the countless struggles, clashes, crises, assassinations, and foreign incursions that have plagued Egypt. As a result, chronologies by scholars vary.

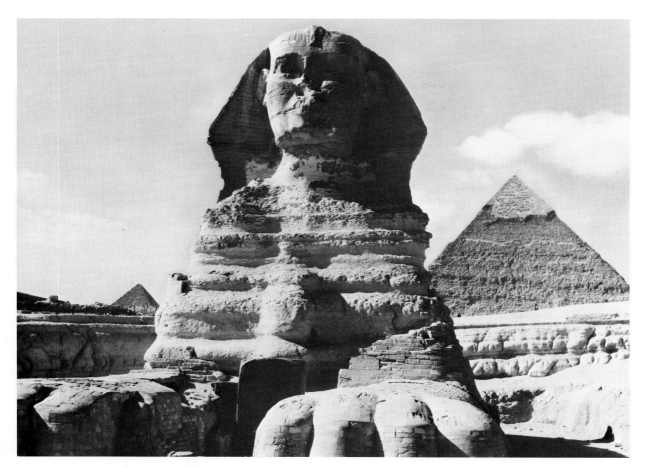

The Pyramid of Cheops and The Great Sphinx, about 2530 B.C. 4th dynasty. Giza

Iмнотер. Step pyramid of King Zoser, about 2600 B.C. 3rd dynasty. Sakkara

The largest of the great pyramids was built for Cheops about 2570 B.C. It covers about thirteen acres and is 276 meters on each side of the base. It is 176 meters high and was the tallest structure in the world, until modern skyscrapers pierced the skies some forty-five hundred years later. Cheops' pyramid contains over two million blocks of limestone, most weighing over two and a half tons. Originally it was faced with polished limestone to reflect the sun, creating a glare which must have dazzled Egyptians for many miles around. The stones were cut so accurately that, even today, it is difficult to find a place where a knife blade can be forced between two surfaces. The burial chamber for the mummy of Cheops is located in the heart of the pyramid.

At the same site, two other large pyramids were constructed, one for Chefren (2530 B.C.) and one for Mycerinus (2500 B.C.). Many smaller pyramids and other structures surrounded the three mammoth pyramids, and all were guarded by the Great Sphinx, a 36 meter high figure carved from the rocky ledge. With the body of a lion and head of Chefren it sat with great majesty for centuries, only to be damaged by Muslim vandalism and the sandblasting winds of the Sahara.

The statues unearthed in and near the great pyramids are of three types: standing, seated, and sitting on the floor. The carving of the standing figures of *Mycerinus and His Queen* was cut from a single block of slate. The artist would draw the standing couple on all four sides of the block and begin carving toward the center. The resulting figures have a stylized and formal appearance—arms rigid, faces looking straight ahead, and left foot slightly forward. There are no open spaces piercing the block; arms and legs are attached, or *engaged* to adjoining surfaces. Because the figures are facing and looking straight ahead, one describes their poses as *frontal*. Their faces are carefully sculpted to describe the actual features of the king and queen, but the bodies are stylized—that is, they are ideal bodies and not accurate depictions of the king and queen.

The seated sculpture of *Katep and His Wife* was carved from limestone and painted for added realism. The figures were also treated with *frontality* and *stylization*, characteristics found in most Egyptian art. Katep is not a king but a nobleman, and the sculpture is an example of the non-official art of the common people. The eyes are painted on, whereas the eyes of Pharaohs often contain stones or inlaid quartz.

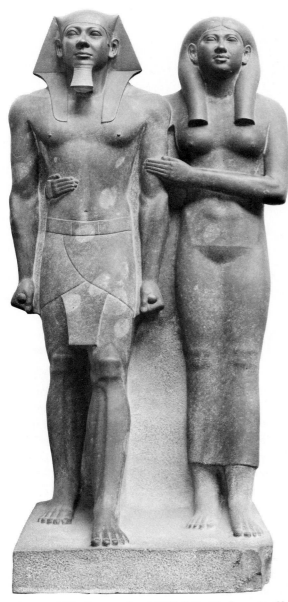

Mycerinus and His Queen, about 2470 B.C. 4th dynasty. Slate, 142 cm high. Giza. Museum of Fine Arts, Boston

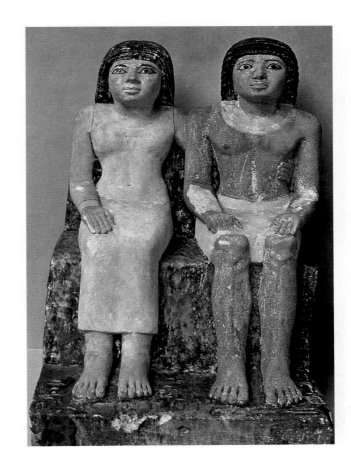

Katep and His Wife, about 2563 B.C. 4th dynasty. Painted limestone, 47 cm high. Near Memphis. British Museum, London

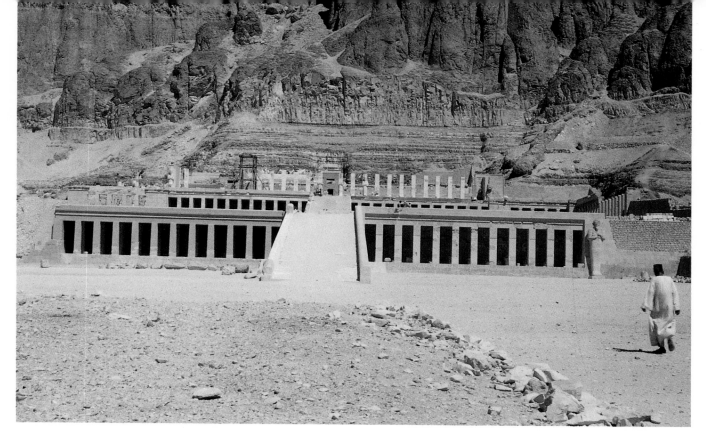

Funerary Temple of Queen Hatshepsut, at Deir el Bahari,
about 1480 B.C. 18th dynasty

Seated Scribe, about 2400 B.C. 5th dynasty. Painted limestone,
53 cm high. Sakkara. Cairo Museum, Egypt

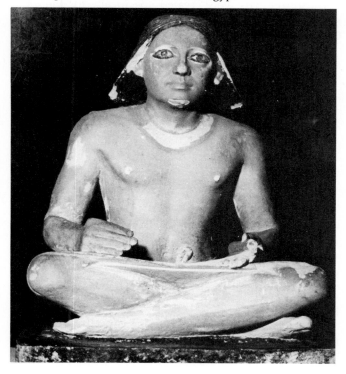

The *Seated Scribe* sits cross-legged on the floor and is ready and eager to transcribe a message. The pose is idealized but the face again has been carved to present a realistic appearance. Like artists and craftsmen, scribes who could write the language held honored positions in Egypt.

Besides sculptures in the round, the walls of Old Kingdom tombs were covered with painted relief sculptures showing various activities of the persons buried there, as well as workers and relatives. The artist crammed every possible space from floor to ceiling with some kind of sculpture, drawing, or painting.

The Middle Kingdom followed a period of anarchy and divided rule, in which various powerful lords controlled Egypt. The princes of Thebes finally grew powerful enough to establish a comparatively peaceful rule which lasted for two dynasties (11th and 12th).

Architecture shifted from pyramids to the construction of funerary temples built near Thebes. These were designed to hold the mummies of the rulers and were constructed so that part was cut into the cliff and part was built outside. The temple built by Queen Hatshepsut, although constructed later, was built according to these Middle Kingdom architectural styles.

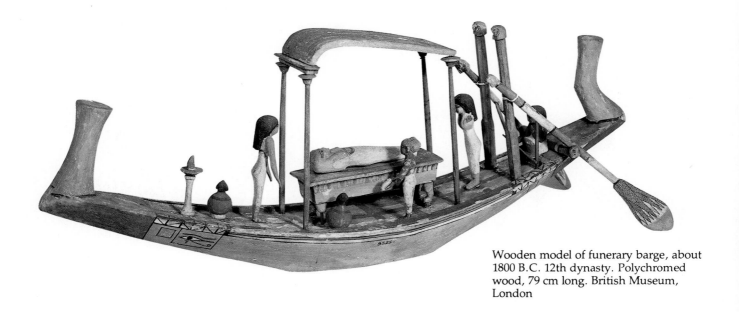

Wooden model of funerary barge, about 1800 B.C. 12th dynasty. Polychromed wood, 79 cm long. British Museum, London

Art continued to flourish in the Middle Kingdom, with craftsmen still holding an honored position in society. One can get an excellent idea of Egyptian life and culture from the many models carved throughout the country's history. Craftsmen carved wood into figures, boats, weapons, and other items which were painted to create an illusion of reality. The wooden funerary barge is typical of boats which were buried with the dead, to be used as transportation in the afterlife. Beneath the canopy lies the mummy, accompanied by two women mourners, a priest, and the helmsman. The painted eye at the front of the barge would help guide the craft without mishap.

The Second Intermediate Period followed the Middle Kingdom. The Hyksos Pharaohs (Shepherd-Kings from some place in Asia) invaded Egypt and ruled for 150 years. During this time, there was no harmony in the land. These outside rulers, however, did introduce Egypt to such things as the horse, chariots, wheels, and weapons of war.

About 1567 B.C. the princes of Thebes overthrew these invaders and established the New Kingdom. More powerful than ever, Egypt became an empire, with lands controlled far beyond her own borders. Not only did the kingdom flourish, but artists and architects grew in skill and creative expression. This revival in art covers a vast range of styles, from rigid and traditional approaches to brilliant inventiveness. Huge monuments were built, but tiny decorative figures were also carved.

One of the outstanding architectural works to survive is the funerary temple of Queen Hatshepsut, built in 1480 B.C. against and into the cliffs at Deir el Bahari.

Made of terraced walls, colonnades, sculptured reliefs, passageways, and large open terraces, it was placed alongside the Middle Kingdom tomb of Mentuhotep. The Queen, often strapping a false beard to her chin and wearing men's clothing, spent much of her reign constructing the temple. Her behavior was typical, however. Rulers began constructing their tombs as soon as they were crowned.

All the great structures have been associated so far with tombs and burial, but during the Eighteenth Dynasty temples were created specifically for the worship of gods and the homes of priests. Among the greatest was the Temple of Amun at Karnak. Here a huge complex of buildings included *pylons,* courtyards, a *hypostyle hall* and minor halls, chambers, and passages. The hypostyle hall was the most dramatic structure, consisting of 135 columns that created a forest-like feeling. In the view seen here, only several of the many columns are seen. There were sixteen rows across the front alone. The central columns were about 21 meters high and were capped with open-flower capitals; the other capitals were in the shape of lotus buds, as shown. The columns were carved from top to bottom with relief sculptures and were then painted. Stone *lintels* were placed atop the columns to create a sheltering roof while the higher central columns allowed windows to be used to flood the interior with light. Because the lintel stones were of such great weight, the columns needed to be kept close together to prevent the stone slabs from breaking. Any such structure, with many columns supporting the roof (and not much open space inside), is called a hypostyle hall.

Greenfield Papyrus, about 1080 B.C. 21st dynasty. 49 cm high.
British Museum, London

Temple of Amun, Karnak, about 1530 B.C.

During the New Kingdom, many other huge temples and complexes were built, attesting to the skill of the architects and the power of the priesthood. But other arts also flourished. The *Greenfield Papyrus* is an illuminated manuscript that reveals some important characteristics of Egyptian art in all ages. In the center, Shu (god of atmosphere) raises the body of Nut (goddess of sky). His arms are supported by two ram-headed gods, while Geb (god of earth) lies on the ground. In the lower right corner is the daughter of the high priest and her soul (human-headed bird) for whom this Book of the Dead was drawn. The drawing is sensitive and beautifully done. The figures are placed in *registers* (layers), and many of the gods are in the form of animals. Notice that the figures are shown so the legs, arms, and faces are in profile, but the upper body is turned toward the viewer. If you could see the faces clearly, you would notice that the face is in profile, but the eye is looking directly at the viewer. This method of stylistically depicting the figure is called *frontality* and is related to the frontal pose found in sculptures. *Descriptive perspective* can also be seen, in which the more important figures are shown larger than the less important ones. The careful design and placing of figures to fill almost all available space is also characteristic of Egyptian painting and wall sculpture.

Dancing Girls at a Banquet, about 1400 B.C. 18th dynasty. Wall painting, portion shown is 61 cm high. Thebes. British Museum, London

The tomb painting of a banquet scene shows guests being entertained by two female dancers, a musician, and three singers who are clapping in rhythm. The words of the song are shown directly above the singers. The guests are painted in the register directly above (one can see their feet and legs). Is there something in this painting that is very un-Egyptian? Several figures are shown facing frontward, where they are usually shown in profile. The artist was attempting to paint realistically, rather than stylistically. Usually the artists worked with formulas that they knew very well, and did not depict people as they actually looked.

Glass was an important technological discovery in Egypt and was considered quite precious. The many-colored glass bottle in the shape of a fish was probably used to hold perfume (*See* p. 47).

While the stylization of art seems to characterize most of Egypt's art, there was a time during the reign of Akhenaten (Eighteenth Dynasty) that realism became dominant. The king built the largest private home in the world at that time at Tell el Amarna; changed his name and declared a single new supreme god in Aten, the sun; and, most importantly, declared himself Aten's representative on earth, and a god himself. He also stressed a realistic approach to art, of which the sculpture of his wife, Nefertiti is a superb example. The portrait is delicate and sensitive and shows a marvelous knowledge of the structure of the human head. Actually, Akhenaten's artists are known to have taken molds from human faces and bodies to study the structure and create carvings of anatomical perfection. The sculpture of Nefertiti, a most beautiful woman, was left abandoned in the artist's studio after the death of the king.

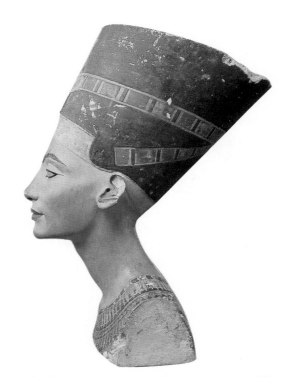

Queen Nefertiti, about 1360 B.C. 18th dynasty. Painted limestone, 51 cm high. El Amarna. States Museum, Berlin

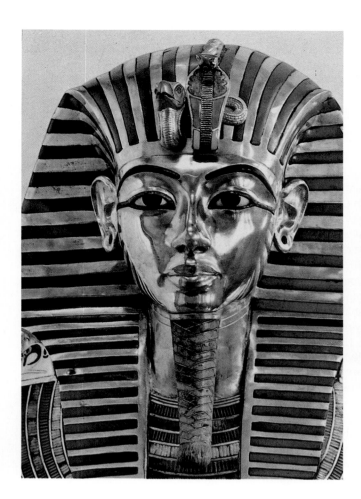

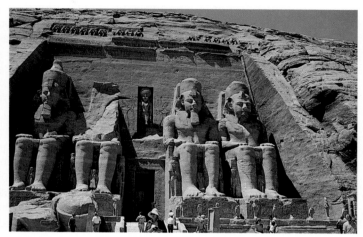

Mask of King Tutankhamen, 1352 B.C. 18th dynasty. Gold with precious stones and glass, life sized. Thebes. Cairo Museum, Egypt

Ramses II, about 1257 B.C. 19th dynasty. Sculpted from cliff, each about 21 m high. Abu Simbel

Akhenaten's successor was his nine-year-old relative, Tutankhaten, who was guided by advisors to move the capital back to Thebes, to reinstate the worship of Amen, and to change his name to Tutankhamen. Although he ruled for only nine years, he is Egypt's most famous king because of the wealth of art objects found in his tomb. Over the years, Egypt's kings realized that the large burial structures only invited thievery of their buried treasures—crimes that had been going on for centuries. Now the rulers were secretly cutting their burial chambers into rock cliffs and disguising the entrances. Even these were found and rifled—all except one: that of Tutankhamen, whose tomb entrance was hidden by the debris from a later tomb.

In the young king's burial chambers, discovered in 1922, were the mummy of the king and countless objects of great beauty and value. The body of the boy-king was extraordinarily well-protected. It was placed within three successive coffins, which in turn were put within four gilt-wood shrines—each larger than the former. The innermost coffin was of solid gold (weighing over a ton!) and was encrusted with precious stones. Resting on the

head of the mummy itself was the solid gold mask shown here. Gold was everywhere: statues, thrones, chairs, boxes, jewelry, ornaments, chests, and tools. Cloth, bottles, and paintings were also found. The treasures of Tutankhamen's tomb give a small idea of the wealth and majesty of the many other kings of Egypt.

With the end of the Eighteenth Dynasty, art again returned to traditional stylization. Ramses II (Nineteenth Dynasty) ruled for sixty-seven years and had a multitude of statues of himself placed throughout the land. His temple at Abu Simbel is the most famous. Four figures of himself are carved directly out of the standing cliff while the temple itself recedes into the stone wall. This space was for priests only. Notice the relative size (importance) of the queen and other relatives as expressed in the descriptive perspective. The construction of the Aswan Dam in recent years caused this site to be flooded permanently. To preserve it, the entire temple and the four mammoth sculptures were cut apart, lifted to the plain above and reassembled under the direction of American engineers. Such an effort exemplifies the important the rest of the world places on the art of ancient Egypt.

4000

Sumer	Pictograph writing (3500); Wheeled carts (3500); Potter's wheel (3250)
Egypt	Sailboats (after 3500); First burial in mastabas
China	Yang Shao and Long Shan cultures, handbuilt pottery, and painted clay figures (7000–4000 B.C.)
Southeast Asia	Ban Chiang culture, bronze castings, and slip-painted pottery (c4200 B.C.)

3000

Sumer	Cuneiform writing (2900); Bronze tools; Building of ziggurats; Abraham in Ur
Egypt	Hieroglyphic writing (3000); Step pyramids (2700); Smooth pyramids, sphinx
Greece	Cycladic civilization trades with Spain (2200); Minoan culture on Crete
China	Xia culture (2180–1750); Oracle bones; Wheel thrown pottery; Class society
Eastern Europe	Scythian civilization in Steppes; Metal work in animal style (to 500)

2000

Mesopotamia	Assyrian civilization; Hammurabi (1760); Development of mathematics and astronomy
Egypt	Bronze tools and weapons; Rock-cut tombs; Moses (c1300); Tutankhamen (c1250)
Mediterranean	Minoan civilization (1700–1500); Decline of Cycladic civilization
Greece	Dorians invade (c1100); Rise of Mycenaeans; Beehive tombs; Fortified acropolis
Hittites	Capital at Hattusas; Conquest of Babylon (c1550); Iron tools and weapons
India	Indus valley grid-pattern cities (2500–1500); Aryan invasion; Ganges civilization
Americas	Mother cultures; Olmec in Mexico (c2000); Chavin culture in Peru (c1500)

1000

Turkey	First coinage invented by Lydian culture of Asia Minor (c700)
Syria	Alphabet (c1000); Jonah visits walled city of Nineveh (c860)
Palestine	Kings David and Solomon (died 926); Prophets; Jerusalem destroyed by Babylon (586)
Greece	Iliad and Odyssey written (750); First Olympics (776); Greek democracy (510)
India	Gautama (563–483) founds Buddhism; Vedic era and sacred Hindu texts (to 600)
China	Chou dynasty (1027–256); Bronze vessels; Confucius (551–479); Lao Zi (604–531)
Italy	Roman Republic established (509); Etruscans defeated
Americas	Geometric period in Tarascan, Nayarit, and Colima cultures (Mexico); Paracas in Peru (500 B.C.)

500

ART OF OTHER CULTURES

This figure is typical of those found in the Aegean tombs, dating from twenty centuries before Christ. Its simplicity and sytlization make it acceptable as a fine sculpture today. It has very little modeling and was made to lie down in the tomb.

Handbuilt vessels were created with very thin walls and perfect symmetry, and were decorated with clay slip by the farming peoples of northern China. The small-footed design and the use of bold, curvilinear decoration is strikingly similar to the octopus patterns painted by the potters on Crete at about the same time. The potters, however, lived about 8000 miles apart.

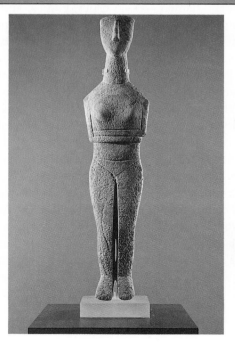

Cycladic figure, about 2200 B.C. Marble, 88 cm high. Los Angeles County Museum of Art, gift of Anna Bing Arnold

Slip-painted earthenware jar, about 1600 B.C. Yang Shao culture, late neolithic period, Gansu province, China. Fung Ping Shan Museum, University of Hong Kong

All was not work and hunting in Ur in third century B.C. Undoubtedly, as this gaming board suggests, ancient peoples enjoyed some leisure time in their active schedules. Each player had seven counters which were stored inside the board, making it a portable unit.

Gaming board, about 2600 B.C. Ur. Wood and mosaic of bone and colored stones, 29.8 cm long. The British Museum, London

INDEPENDENT STUDY PROJECTS

Analysis

1. Many existing Egyptian wall paintings have been found in the tombs of noblemen as well as those of Pharoahs. List as many characteristics of Egyptian art as you can find in the wall painting below which `shows a hunter and his family in the marshes.

2. Write a news article, based on your own research, on the discovery of King Tutankhamen's tomb in 1922; or on the finding of a new cave filled with prehistoric paintings.

3. The Egyptian style of art remained virtually unchanged for several thousand years, while during the last two thousand years Western art has changed dramatically. What may be

Wall painting, 1400 B.C. 81.3 cm high. Thebes. British Museum, London

some of the reasons for these phenomenons? If you were a fine craftsperson, would you choose to live in Egypt in 1990 BC or in America in 1990 AD? Why?

Aesthetics

4. Write an essay discussing the importance of art in the development of Egyptian civilization. Include ideas such as historical documentation, visual history, art as decoration, art as writing, celebration, family history, cultural documentation, symbolism, religion, life after death, etc. Why were artists considered essential to Egyptian culture and life?

5. Compare and contrast the following sculptures: Cycladian figure (ancient Greece, page 148), praying nobleman (Sumer, page 136) and the seated scribe (Egypt, page 143). Consider their uses, stylization, naturalness, size, attention to detail, decoration, materials, etc.

6. By looking at the objects recovered from archaeological sites in Sumer (see pages 136–137) what can you tell about the life-style and cultural development of the Sumerian people? Write a column describing several cultural events for a Sumerian newspaper.

Studio

7. Construct a scale model of a pyramid, temple or ziggurat. Plans may be found in books on ancient archaeology or in an encyclopedia. Use cardboard and/or papier-mâché to make the construction, and paint it to look like stone. Include some figures in the model to indicate relation to human scale.

8. Paint a large piece of corrugated cardboard (at least 100 cm long) with a coat of flat white paint (gesso or latex house paint). When dry, draw part of an Egyptian-style wall painting on it, using either an Egyptian theme or a theme based on a day in your own life (or combine them). Paint the scene with tempera or acrylic paints, and tear the edges of the panel to suggest part of a ruined wall painting.

9. If you have the space on your campus, mark off the dimensions of Cheops' pyramid to give you the feeling of the size of these gigantic architectural structures. Outline the shape with string or position classmates along the way. Make a sketch to show its size in comparison to your campus.

6 Our Roots are Deep: Greek and Roman Art

Two DISTINCT CIVILIZATIONS developed after those of Mesopotamia and Egypt. One was in Crete and is termed Minoan (after Minos, the Cretan king), and the other is called Mycenaean (after the city of Mycenae). Both were considered mythical until their cities and art were unearthed by archaeologists in the late nineteenth century. The two civilizations existed on what was later to become Greek soil. Their discovery helps substantiate the historical basis for the poems of Homer and establishes a foundation for Greek culture which follows.

Minoan Art

Dates and names are indefinite, but several cultural centers developed on the island of Crete, the most important of which was the huge complex at Knossos called the palace of Minos. It was a luxurious group of multi-storied buildings with many rooms, running water, a sewage system, theater, storerooms, terraces, and elaborate quarters for the rulers (*See* p. 17). It was built of masonry and had downward tapering wooden columns which were destroyed but which have been partly reconstructed from paintings found on the walls. Many *frescoes* decorated the interior of the palace, filling the spaces with color and life. The palace was not fortified (naval power protected the island) and was so elaborate and complex that it lived on in Greek legend as the labyrinth of the Minotaur. Ceramic ware, found here and in Egypt (result of a trade network), has helped date this lost culture at about 1600 B.C.

No temples have been found, and religion seems almost non-existent. Sculpture was small and, like the frescoes, probably decorated the living quarters of merchant rulers. The *Snake Goddess*, carved from ivory and decorated with gold bands, may be the goddess of an unknown religion or simply a daring young woman playing with snakes. Daring exploits seem to have been much admired by the Minoans who painted one fresco showing young people turning cartwheels over a charging bull.

Bulls seem to be an important element in the Minoan culture. This small head of a bull is really a ritual vase. It is carved from a hard stone, has eyes of rock crystal, and has graceful horns of gold which contrast with the delicate lines incised into the rock.

The Minoan civilization came to an abrupt halt. The people disappeared with no one really knowing what happened. Perhaps future archaeologists will answer this question.

Mycenaean Art

A civilization similar to the Minoan developed on the mainland. It centered around the most important settlement, Mycenae. Many relationships between the two developing cultures are evident in their art, but no specific historical reference ties them together.

Mycenaean palaces were hilltop fortresses of many rooms, surrounded by walls of enormous stone blocks so large that later Greeks thought them to be the work of the Cyclopes, a mythical race of one-eyed giants. The main gate at Mycenae (The Lion Gate) is topped by a huge triangular-shaped stone slab on which are carved two standing lions flanking a Minoan-type column. Notice

Bull Dance, from the Palace at Knossos. Fresco, c. 1500 B.C. Height, including border, 80 cm. Archaeological Museum, Heraklion, Crete

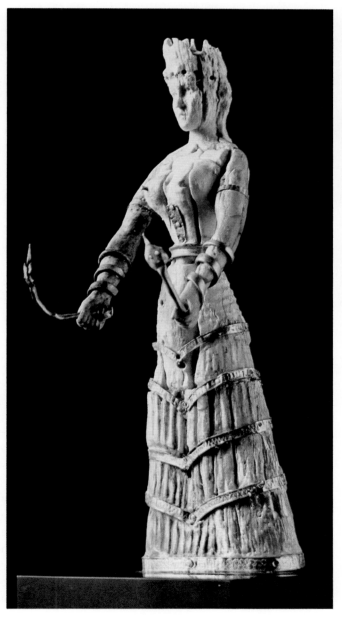

Bull's Head, about 1550–1500 B.C. Steatite with inlaid shell, rock crystal, and gold. Knossos. Archaeological Museum, Heraklion, Crete

Snake Goddess, about 1550. Ivory and gold, 16 cm high. Knossos. Museum of Fine Arts, Boston, gift of Mrs. W. Scott Fitz

Lion Gate at Mycenae, about 1250 B.C. Limestone relief, sculpture about 3 m high

Funeral mask about 1500 B.C. Beaten gold, about 30 cm high. Royal Tombs, Mycenae. National Archaeological Museum, Athens

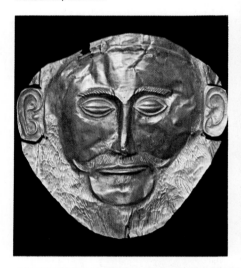

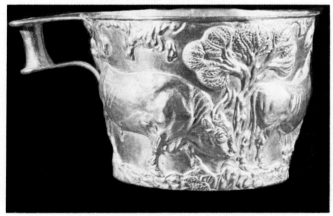

Vaphio Cup, about 1500 B.C. Gold, about 9 cm high. Laconia. National Archaeological Museum, Athens

the massive stone block that acts as a lintel over the opening and the way in which the other large blocks are cut to fit exactly together.

In 1876, excavations at Mycenae uncovered beehive tombs of massive proportions and sunken royal graves containing a dazzling array of objects in gold, silver, and other metals. The *Funeral Mask* is a thin sheet of beaten gold, probably intended to cover the face of a deceased ruler of about 1500 B.C.

Other gold work from this time (1500 B.C.) include the two *Vaphio Cups* (one is shown here) from a grave in Laconia. The lively reliefs on these beautifully crafted works illustrate several ways the Mycenaeans had of capturing wild bulls. Recently, several ivory sculptures and some paintings have been uncovered, but still little is known of the development of Mycenaean history and culture, which was abruptly terminated about 1100 B.C. when the Dorians invaded from the north.

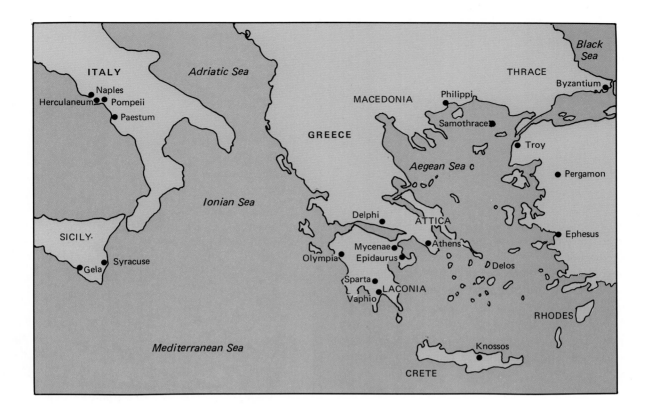

Greek Art

Following the Dorian occupation, the people of Greece returned to a nomadic life where art and learning were nearly abandoned. Even writing was forgotten during this four-century dark age (1100–700 B.C.). Gone was the joyful expression of the Minoans and the realistic art of the Mycenaeans. Instead, a severe geometric style, using black lines, dots, circles, and swastikas developed. Animals and humans were stylized into almost sticklike figures.

Gradually, in the eighth century, Greek civilization underwent changes. City states emerged and trade with eastern Mediterranean lands influenced the art of Greece (it has been termed the Orientalizing period), and the black lines on vases changed into shapes that represented people and animals. A new alphabet was developed and the Archaic period in Greek history was underway.

Greek culture was unique as its art and literature reveal. While the art of previous cultures remained almost unchanged for long periods of time, Greek art evolved steadily or matured over a period of seven hundred years. The Greeks were anthropocentric (human beings were all-important) and their gods were *anthropomorphic*. Gods were shown a bit larger than real people, and

Major Periods in Greek Art

800–600 B.C.	Geometric and Orientalizing periods
600–480 B.C.	The Archaic period
480–323 B.C.	The Classic period
	480–450 B.C. Severe Classicism
	450–404 B.C. The Age of Pericles
	404–323 B.C. Late Classical or Pre-Hellenistic
323–150 B.C.	Hellenistic period

though often more perfect than mortals, they still were not absolutely perfect. The human form was considered beautiful, perfectly balanced, and harmonious. When gods were sculpted or painted, they were shown in perfect human form. This often meant that the nude figure was needed to show ultimate perfection and harmony.

Proportion, balance, and unity were key ideas to the Greeks. Buildings, sculpture, and even life itself needed to be harmonious or they were considered barbarian. Beauty was the essence of this thinking. Everything had its ideal form, which was therefore beautiful. In later periods, the art that developed in this cultural atmosphere was greatly involved with the striving for such ideal beauty.

Greek artists worked in a cultural environment that encouraged art of all types. They were free to experiment and innovate as long as they worked toward the common goal of beauty and harmony. They could even sign their works. How does this differ from the artistic climate through most of Egypt's history?

Unfortunately, most of the art of Greece has been lost. Wars, invasions, and neglect have caused the destruction, burial, and deterioration of huge numbers of works, but some excellent examples are available for study and perhaps more will be found. There are also Roman copies to examine (some of which are good) and writings of Greek and Roman scholars that describe works which are now non-existent. Despite the losses, aspects of Greek culture, medicine, government, mathematics, and philosophy are evident in Western civilization. As several other sections of this book reveal, Greek ideas influenced the development of many phases of Western art.

PAINTING

The Greeks were proud of the large and colorful paintings decorating their walls, but not even one exists today. Therefore, people study the paintings on the many vases found in museums around the world. Early vases of the Archaic period are of red clay and have black figures and decorations painted on them. The hydria from Attica—a large jug for carrying water from the community fountain—is a black-figured vase that has lines scratched into the areas of black to suggest details. The painting on this vase illustrates its use in daily life. Notice the carved animal heads functioning as spouts on the fountains and the chariot decoration on the shoulder of the vase. The artist is unknown but is called the A.D. Painter, and other works of a similar style are attributed to him.

Another hydria of a later date (410 B.C.) shows a great change in technique and style. The background is now

THE A.D. PAINTER. Attick Black-figured Hydria, about 520 B.C. 52 cm high. Museum of Fine Arts, Boston, William Francis Warden Fund

The Battle of Issus, about 100 B.C. Marble mosaic, about 3.2 m wide. Roman copy of Greek painting, Pompeii. National Museum, Naples

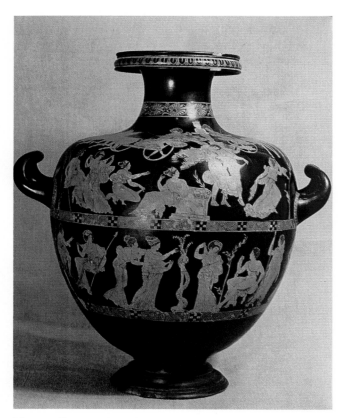

MEIDIAS PAINTER. Red-figured Hydria, about 410 B.C. 52 cm high. British Museum, the Hamilton Collection, London

painted black and brush lines can be drawn freely on the red figures to show exacting detail and a variety of lines. A kind of perspective is shown by having some figures higher than others. Two scenes, both familiar stories, are painted by the artist/potter, Meidias, who signed the vase. The upper register shows the rape, or carrying away, of the daughters of Leucippus, and the lower register shows Heracles in the garden of the Hesperides. Traces of white, brown, and gold have been added to suggest form and depth on this red-figured hydria.

The sophistication of later Greek painting is revealed in *The Battle of Issus*, a Roman mosaic (of marble chips) which is a copy of a Hellenistic wall painting of about 315 B.C. Only four colors (red, yellow, white, and black) are used in the mosaic and probably in the original painting, since many Greek artists used the same limited palette. The subject is the victory of Alexander the Great over Darius and the Persian army. Alexander, on the left, is partly obliterated because many of the stone tessarae are lost. However, the overlapping figures, the rounded forms created by shading, the foreshortening, the complicated composition, the marvelous detail, and the accurate anatomy of both horses and men are exciting and advanced achievements in visual presentation. Subsequent Hellenistic painting retained the natural appearance of people and animals which characterized the Classic period, but added excitement, action, and emotion. Both the original concept (Greek) and the mosaic technique (Roman) are to be admired.

Kouros, about 600 B.C. Marble, 185 cm high. The Metropolitan Museum of Art, New York, Fletcher Fund

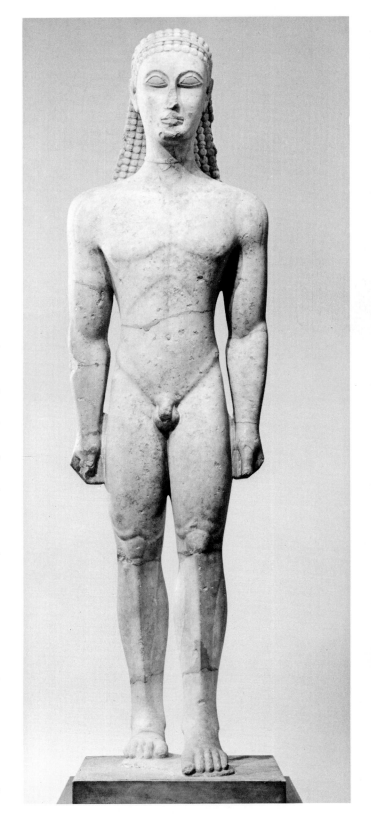

SCULPTURE

Sculpture best exemplifies how Greek art developed beyond earlier forms. Early work of the Archaic period was limited to two subjects: standing figures of young men and women. The sculpture of a young man was called a *Kouros* and was of a nude youth about life size who either represented Apollo or an ideal athlete. Early figures were stylized, all appearing to be idealized and not of specific people, and recall some Egyptian sculptures. They face toward the front, have the left foot slightly forward, and both arms are held rigidly at their sides. Kneecaps are sharply carved, and a faint smile is on their faces. The smile is so evident that it has been termed an *Archaic smile*. The hair is stylized into small ringlets that fall in a blocky mass to the shoulders. The major difference from Egyptian sculpture, however, is in the freestanding of the figure. Openings are seen between arms and side, but more startling (for that time) is the lack of supports to hold up the figure at the legs. Egyptian work had part of the original stone block still clinging to the figure for support. Now, the Kouros stood free.

Over a period of only seventy-five years, the stylization of the early Kouros changed to a more natural and realistic representation of the human figure. Greek artists were now sculpting what they saw and observed rather than creating idealized forms from memory.

The female figure, or *Kore*, was a freestanding clothed figure of an idealized young girl. There were several variations in clothing, depending upon the areas where the sculptors worked. The Kore figures were painted, as were most Greek sculptures, to appear more natural. Although people are used to seeing the natural white of the marble, the original Greek versions were painted and brightly colored. Notice the folds of cloth, the long braided hair, the traces of color left on the work, and the traces of an Archaic smile.

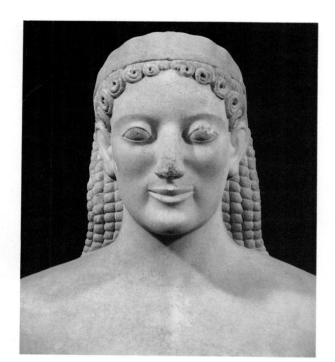

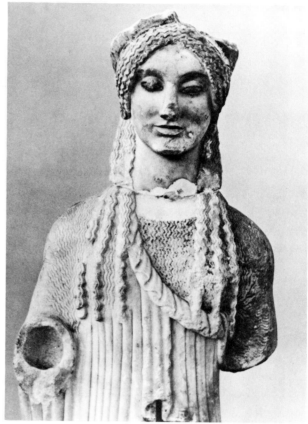

Kouros (detail), about 525 B.C. Marble, 194 cm high (complete sculpture). National Archaeological Museum, Athens

Kore (detail), about 525 B.C. Marble, 91 cm high (complete sculpture). Acropolis Museum, Athens

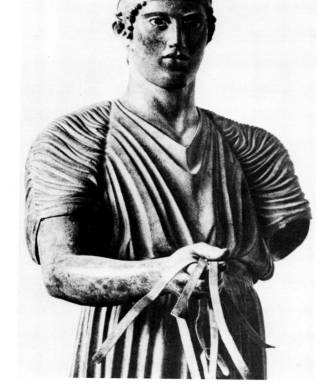

Charioteer of Delphi (detail), about 470 B.C. Bronze, 180 cm high (complete figure). Archaeological Museum, Delphi

In the early part of the Classic period (after 480 B.C., following the defeat of the Persian fleet at Salamis) the Greeks enjoyed a period of peace in which the arts flourished. Individualism of ideas, thoughts, and artistic representation was honored. The *Charioteer of Delphi* is typical of the changes that took place. The figure is cast in bronze and is the earliest of the few remaining Greek bronzes. The rest were destroyed, lost, or melted down for later ammunition or weapons of war. The charioteer was originally polished, with eyes of glass paste and lips and eyelashes of inlaid copper. In most later bronzes of Greece and Rome, these features are now missing and dark holes remain for the lost eyes. The cloth folds, muscles, and facial features are natural, and the Archaic smile is replaced by a dignified look of calm and self-control, which symbolizes a classical balance of emotion, personality, and physical ability. The features and pose are a bit rigid and severe compared to the sculpture that follows.

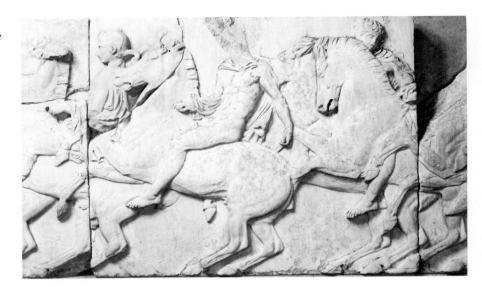

Mounted Procession (detail), 432 B.C. Marble, 106 cm high. North frieze of the Parthenon. British Museum, London

Three Goddesses, about 435 B.C. Marble, over lifesize. East pediment of the Parthenon. British Museum, London

The Age of Pericles was the culmination of the Classical period in Greek sculpture and architecture. Athens was safe and prosperous, and the arts were admired and loved as never before and seldom since. The decoration of the Parthenon was the most ambitious sculptural program undertaken by the Greeks. Both east and west pediments were filled with over-lifesize statues; there were ninety-two *metopes* sculpted in relief; and a continuous *frieze* ran for over 175 meters around the top of the wall of the *cella*, which contained a huge statue of Athena. All the sculptures were produced in a period of twelve years by a team of sculptors under the direction of Phidias. Many of the works were later destroyed, but in 1801 Lord Elgin collected most of what remained, sending them back to England for safekeeping.

The pediment sculptures filled the flat triangular areas at each end of the Parthenon and were designed to fit the spaces exactly. The *Three Goddesses* (from the east pediment) have remained as a group. The fascinating drapery is startling in the way it seems to cling to the bodies and is no longer stylized or severe, but falls in natural folds and creases. These folds are calculated to create visual movement and lead the viewer's eye over the bodies and to the central event in the pediment composition, the birth of Athena.

The frieze around the inner wall depicts a procession, occurring once every four years, in which the youth of Athens pay tribute to Athena. The relief sculpture shows a multitude of figures and horses; one of the most impressive sections depicts horses and riders, sometimes four abreast. To sculpt this much depth in the shallow space of a few inches took all the skill that the Classical Greek sculptors could muster. Anatomy, movement, rhythm, and a convincing suggestion of space are all handled with superb control. The figures closest to the viewer are most round; the second and third layers are shallower; and the background is flat. Originally, the frieze, like other parts of the Parthenon, was brightly painted.

Dying Gaul, about 230–220 B.C. Roman marble copy of bronze original, lifesize. Pergamon. Capitoline Museum, Rome

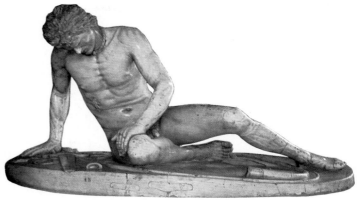

LYSIPPUS. *Victorious Athlete Crowning Himself (The Getty Bronze)*, about 330 B.C. Bronze, lifesize. The J. Paul Getty Museum, Malibu

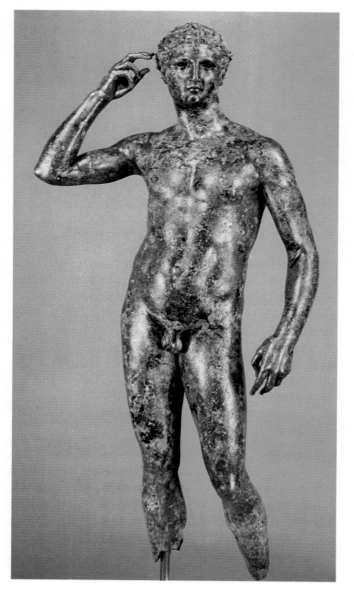

The Peloponnesian War disrupted the glory of Classical Greece, and the fourth century saw a subtle change in the sculpture. Several Greek artists were recorded in the writings of the time, among them Lysippus. A bronze figure, attributed to him, has recently been found in the Mediterranean Sea. Known as the Getty Bronze, it is a victorious athlete crowning himself with a laurel wreath. Lysippus made the heads of figures slightly smaller and the bodies more slender. Notice the slight S-curve of the body caused by the centering of weight on the figure's right leg. The left leg is relaxed and non-supportive. Facial features, hands, and muscles are exact in their detail, and the hair seems unruly and natural for an athlete. The lower legs and feet are missing, but this hardly detracts from the excellence of the figure and its natural feeling. Lysippus became the official sculptor of Alexander the Great and his court.

After Alexander's death, the empire was divided into sections and ruled over by some of the conqueror's generals. The art of this Hellenistic period became more concerned with action and emotion. In Classic art, these elements would have been kept under complete control.

The Dying Gaul is a Roman copy in marble of a Greek bronze of this time. It is lifesize and shows the struggle of a wounded man about to die. The sculptor noticed the differences in the ethnic features of face and hair that characterized the Gauls. The figure leans heavily on his arms because his legs no longer can help him move. There is agony in the pose and in the face of the warrior. Death seems very real and not as heroic as it might have been shown several centuries earlier.

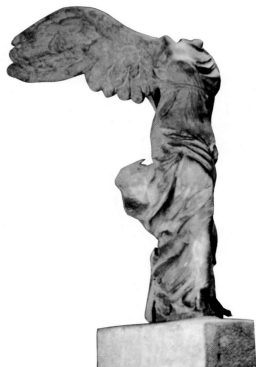

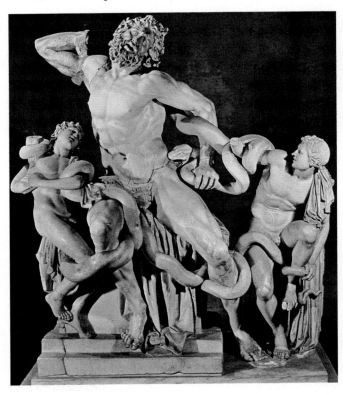

Nike of Samothrace, about 190 B.C. Marble, 244 cm high. The Louvre, Paris

HAGESANDROS, POLYDOROS and ATHENODOROS OF RHODES. *Laocoön and His Two Sons (The Laocoön)*, Late 2nd century B.C. Marble, 214 cm high. Vatican Museum, Rome

The *Nike of Samothrace* is perhaps one of the greatest of Hellenistic sculptures. Carved about 200 B.C., it is the symbol of Winged Victory, her great wings spread wide as she lands on the prow of a ship. The force of the wind whips the drapery into wonderfully animated folds. Because of this effect, the space around the Nike, in front and behind her, become important parts of the sculpture itself—a concept that will not be used again for many centuries.

The Laocoön is a group sculpture signed by the three artists from Rhodes and characterizes the emotional expression of Hellenistic art. The writhing bodies are meant to evoke horror and pity. Laocoön, a priest of Troy, and his two sons were violently killed by two serpents as a punishment for warning his people against the Trojan horse. Michelangelo was later influenced by the sculpture, as were others, yet today people may feel the entire group is too melodramatic.

Alongside the drama of suffering, Hellenistic sculptors continued to create works in the traditional ideal of classic beauty. The *Aphrodite (Venus) of Melos* is a good example. The artist succeeded in using marble to contrast the softness of flesh with the rich texture of heavy drapery. Feminine beauty and warmth are conveyed through the fully developed, carefully rounded, three-dimensional form.

In many Greek sculptures, the arms, heads, and wings were carved from separate pieces of marble and attached to the torso with metal pins. When they were moved or knocked over in earthquakes or wars, these appendages were often broken and lost. Thus, many of the sculptures seen today are without some of these parts. Besides large and impressive works, Greek sculptors created a vast number of small bronzes as home decorations, and also designed coins and beautiful jewelry.

ARCHITECTURE

As in Greek sculpture, it is not difficult to notice the progressive development of Greek architecture from heavy and ponderous in the Archaic period to light, airy, and refined in the Classic period. Public building in Greece is characterized by temples since no palaces or fortresses were constructed. The earliest versions were of mudbrick, wood, and thatched roofs, so naturally none are in existence today. However, the style of these earlier

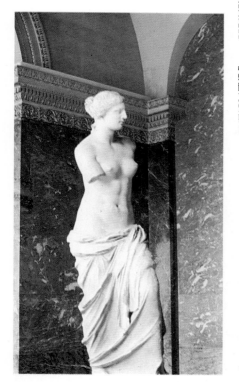

Aphrodite of Melos (Venus de Milo), about 150–100 B.C. Marble, about 201 cm high. The Louvre, Paris

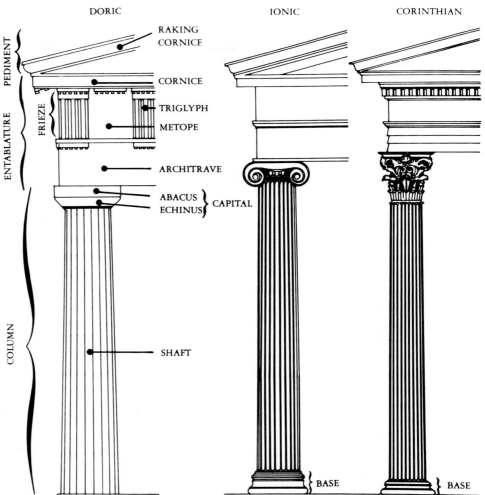

Doric, Ionic, and Corinthian Orders. Reproduced by permission of Harcourt Brace Jovanovich, Inc. from *Art in Perspective: A Brief History* by Henri Dorra

works was later translated into the first stone structures. Since the public was generally not allowed into the temples, architects designed impressive exteriors.

The concern of the Greeks for harmony and proportion was also carried into their architecture. They saw public buildings as organic units (like human beings or plants) that must be organized into orderly arrangements of parts. This attitude led to definite sytems of construction which were called "the orders." The *Doric order* developed in mainland areas; the *Ionic order* evolved in the islands and the coast of Asia Minor; and the *Corinthian order* was used in Hellenistic times and later in Roman civilization. The orders consisted of detailed rules for construction, based on proportions and an integration of the parts of the buildings. They were a means of breaking down complex forms into simple units that made up the whole.

In the Doric order, for example, the shaft of the column rests on the topmost step. It tapers toward the top in a slightly swelling curve, which is more noticeable in some earlier temples. Atop the shaft is the capital which has a round cushion-like molding topped by a square block. Resting on the capitals are three members: *architrave, frieze,* and *cornice*. The architrave is the lintel that stretches horizontally above the columns. The frieze consists of oblong panels (*metopes,* often carved) and square blocks with upright channels (*triglyphs*). The crowning member of the superstructure is the cornice, whose wide flat band casts a shadow on the frieze below. The flat triangular space under the cornice is the pediment, which was often filled with sculpture. Look at the early Doric temples at Paestum (a Greek colony in Italy, south of Naples) and at the later Parthenon. Compare them, noticing the refinement that took place as the styles developed.

The Ionic order is much lighter and more delicate than the Doric. The columns are set on a base, and are more slender, with capitals decorated with a spiral motif. The frieze is continuous and the superstructure is lighter in appearance.

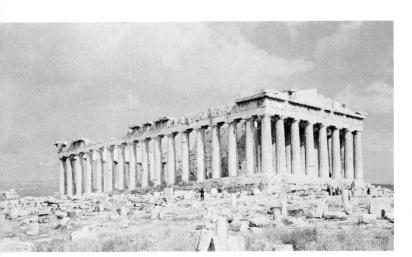

Kallikrates. Temple of Athena Nike, about 425 B.C. The Acropolis, Athens

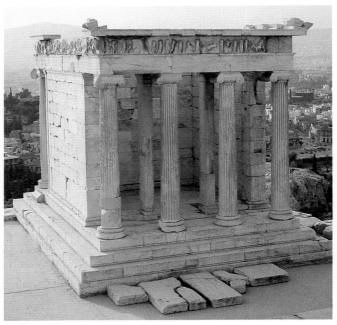

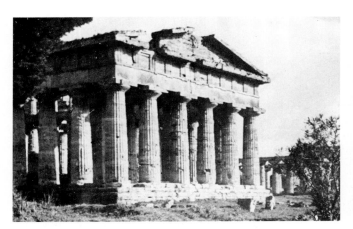

The Temple of Poseidon, about 460 B.C.; "The Basilica" (Temple of Hera I, at right), about 550 B.C. Paestum, Italy

All of these temples, many of which are still standing in part, were constructed without mortar or cement. The stones were cut so exactly that they fit together precisely. Sometimes, metal rods were used as dowels to hold one block in place above another. The columns were built up of several *drums* and had *flutes* cut in after they were erected.

Archaic Doric temples were powerful structures, heavy in appearance. The *Temple of Hera* (called "The Basilica") at Paestum was built about 550 B.C. and has very heavy columns that bulge and taper toward the top. The capitals are huge and flat. The drums are easily detected and the *stylobate* is low to the ground. The Temple of Poseidon, finished about 460 B.C., is extremely well preserved and has columns spaced a bit farther apart. They are also thinner and have smaller capitals, adding to a feeling of greater height. Upon close observation, a set of double columns (one above the other) that raise the roof line slightly can be seen inside the

temple. These surround the *cella*, a room where the statue of the god was kept.

The Doric style reached maturity during the Classical period in the Parthenon in Athens. The architects, Iktinus and Kallikrates built it from 448 to 432 B.C., a short time for so huge a project. It is the central building of the Athenean Acropolis, which contains several other temples and Classic structures. Compare it with the temple of Poseidon at Paestum. It is larger, but seems less massive. Proportions have been carefully readjusted: the columns are more slender; the slightly curved tapering (or *entasis*) of the columns is less pronounced; capitals are smaller and less flaring; space between columns is wider; and the cornice projects less. The stylobate is higher and is slightly convex. The columns lean slightly inward and the corner columns are closer to their neighbors than the rest of the columns. All these visual refinements help give the structure a feeling of great harmony, balance, and organic unity. The ruins of the building (it was greatly destroyed during several wars) are clean marble, but originally many areas were

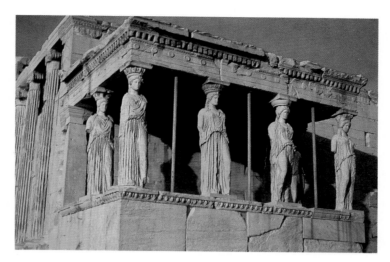

The Porch of the Maidens, the Erechtheum, about 421–405 B.C. The Acropolis, Athens

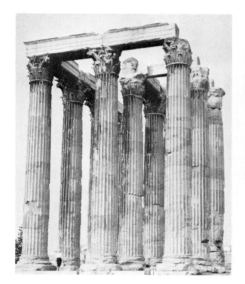

COSSUTIUS. Temple of the Olympian Zeus, about 174 B.C.–2nd century A.D. Athens

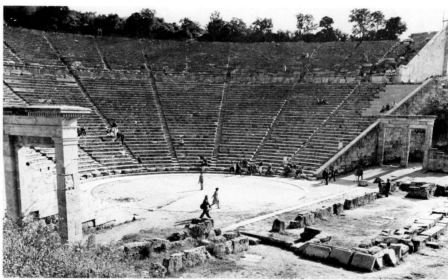

The Theater at Epidaurus, about 350 B.C.

painted, especially where sculptures were present. The cella contained a huge statue of Athena.

Although most Ionic temples were built away from the mainland of Greece, the Acropolis in Athens contains several excellent ones. The *Temple of Athena Nike,* built from 427 to 424 B.C. is a fine example of a small Ionic building. The *Erechtheum* (421–405 B.C.) is a large and more complex structure. Columns are quite thin, tall, and delicate in appearance, with scroll-like capitals. The *Porch of the Maidens* uses six feminine figures (*caryatids*) instead of columns to support the architrave.

Corinthian columns were used in the *Temple of Olympian Zeus* in Athens, begun in 174 B.C., but not com-

pleted until the Roman emperor Hadrian had it finished in the second century. The towering columns are crowned with decorative capitals of acanthus leaves. Only a small portion of the huge temple remains today.

The Greeks were also interested in drama and music and constructed theaters in the larger cities. These were open-air, rounded structures that were placed into the sloping sides of hills. Constructed of carefully tiered stone seats with aisles and walkways, they had a round stage area which was called the orchestra, backed by a low building (scene) which formed the setting for the action. All these features are in the theater at Epidauros which is still used for dramatic productions today.

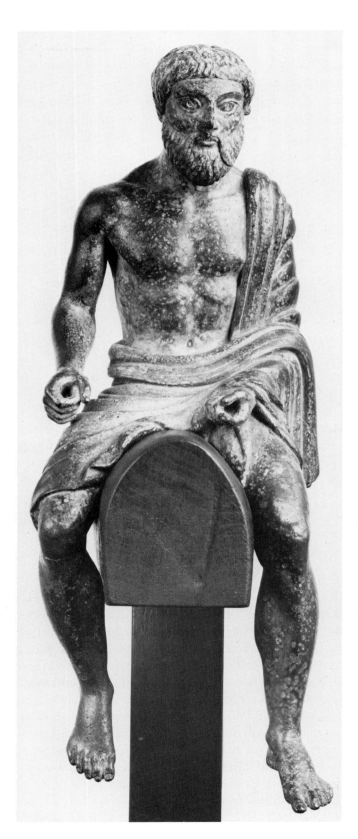

The Rider, about 450–425 B.C. Bronze, 27 cm high. Etruscan, found at Comacchio, Italy. Detroit Institute of Arts

Etruscan Art

As stated earlier, the Greeks had established cities on the southern part of the Italian peninsula by the sixth century B.C. (Paestum, for example). The central part of the peninsula was inhabited at this time by the Etruscans, whose origin and background are shrouded in mystery. For four hundred years (seventh through third centuries B.C.) they controlled much of central Italy, and many of their towns continue to live in the form of cities today. Even the region of Tuscany retains part of the Etruscan name.

The Etruscan culture borrowed much from its Greek neighbors to the south, but its architecture, sculpture, pottery, and painting were about a century behind the more advanced Greeks. The Etruscans used the arch in important places (such as city gates) while the Greeks used it mainly in substructures and kept it hidden. The Etruscans' use of bronze in sculpture and other decorative items was much admired (even by the Greeks). The elaborately decorated burial places are the chief source of knowledge about this culture because the former towns are under present day cities and are extremely difficult to excavate.

The Rider is a small, solid cast bronze sculpture, the horse is missing. It, like most other Etruscan sculpture, was probably modeled after a Greek original. The rider sits stiffly upright and wears a short toga which the Romans later adopted. A considerable understanding of anatomy was necessary for the artist to sculpt a figure with such convincingly realistic features.

Roman Art

Between the Etruscans on the north and the Greeks on the south, a city-state was established in the eighth century B.C. that was to grow to a magnitude of unbelievable proportions. These people, the Romans, eventually threw off the Etruscan yoke, expanding their control in every direction to eventually dominate the Western world. To these places the Romans took their laws, religion, customs, their extraordinary ability to organize, and the Latin language. From their conquered peoples, they absorbed the cultures that existed and borrowed from them to make up the complex structure of Roman culture and art.

The Romans admired Greek sculpture and brought many pieces back to decorate their villas. They also brought back Greek sculptors to work at home and to make careful copies of many Greek sculptures. Although much of Roman art was *eclectic*, they used original portrait sculpture to honor their emperors and perpetuate their features and greatness. The Roman interest in portrait sculpture, especially the bust (head and upper torso) is an important contribution to world art. Most of the work prior to the first century B.C. has been lost, but there is a wide variety of sculptural expression since then to study.

Portrait of a Lady, 69–96. Marble, 64 cm high; *The Roman Legislator*, about 125. Marble, 42 cm high. William Rockhill Nelson Gallery of Art, Kansas City, Nelson Fund

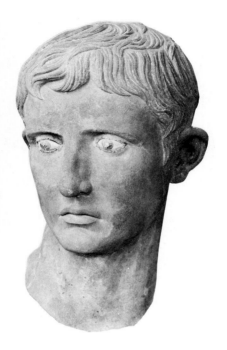

Head of Augustus, 27 B.C.–14 A.D. Bronze, 47 cm high. Found at Meroe, Sudan in 1910. British Museum, London

The *Head of Augustus* was part of a large full-length figure probably sculpted in Alexandria, Egypt. It is cast in bronze and has eyes of glass paste. It is striking in its realistic appearance and individualized expression and is certainly not an idealized figure. Such sculptures allowed Roman subjects throughout the vast empire to know how their ruler looked, while today the camera assumes that job.

Other sculptures of a later date show the emphasis on realism in portrait busts of Roman people. *Portrait of a Lady* is carved in marble and probably was done as a commission to decorate the home of the subject. Notice the style of the coiffure and the acanthus leaf ornament at the base, features which help archaeologists date such works. The bust of the *Roman Legislator* illustrates the naturalism that developed in the later Roman style. The wrinkled and sagging skin of the aging legislator is emphasized but not idealized.

Relief sculptures were used to record important events in the lives of Roman emperors. Domitian dedicated a huge arch to commemorate his brother Titus' capture of Jerusalem. A person walking along the Sacred Way in Rome, passing through the arch, can see two relief panels decorating the interior. *Triumph of Titus* is one which shows a royal procession that is carved deeper in space

than the reliefs of the Parthenon. Many of the parts of the horses and people are carved in the round (some have been broken off) while other parts, by contrast, are carved in low relief against the background.

The *Column of Trajan* is a splendid marble cylinder that rises to a height of over 40 meters, including the pedestal. It was originally topped by a bronze statue of Trajan but now holds a statue of St. Peter. The base of the column is carved into a giant laurel wreath. In a spiral relief some 215 meters long, the exploits of Trajan's Dacian campaigns are carved as a narrative history in stone. The column is hollow and originally contained an urn with the ashes of the emperor.

In the piazza (square) atop the Capitoline Hill, once the center of Roman government, stands a bronze *Equestrian Statue of Marcus Aurelius,* one of Rome's best emperors. It is the only well-preserved equestrian statue (horse and rider) from antiquity to survive and has been imitated often. Michelangelo, who designed the piazza and the surrounding buildings in the Renaissance, placed the statue here at the request of the Pope who thought it was of Constantine, the first Christian emperor. The size of the figure is large in comparison to the horse, a characteristic of such Roman works. The bearded emperor looks out on the world, his right arm in a typical Roman

Column of Trajan, 106–113. Marble, 40 m. high. Rome

Equestrian Statue of Marcus Aurelius, 161–180. Bronze, over lifesize. Piazza del Campidoglio, Rome

oratorical gesture. The horse is superbly sculpted, showing that the artist had immense knowledge of the bone and muscle structure of horses. The balance is superb, with all the weight of the cast bronze evenly distributed over the three supporting legs.

The head of *Constantine the Great* is part of an enormous sculpture that once was placed in his basilica. Head, arms, hands, legs, and feet were of marble, and the drapery was probably of bronze plates over a masonry frame. The colossal head and neck are superbly modeled, but the eyes, which seem to be fixed on some spot above our heads (perhaps on eternity) seem overly large. Such large eyes are common in the art of the early Christian period which follows shortly. The eyes of such late Roman sculptures were carved so that shadows provided the definition of iris and pupil rather than painting them on the marble.

Constantine the Great, about 330. Marble, head about 2.5 m high. Palace of the Conservatori, Rome

Aqueduct in Segovia, Roman, probably
Augustan Era. 30 m high. Spain

ARCHITECTURE

The Romans made their greatest contribution to art in architecture—the area in which their influence is most strongly seen. At first they borrowed elements from the Etruscans, Greeks, and the people of the Near East, but they combined them into unique architectural statements. With the huge numbers of people in Rome, they needed large structures that could hold multitudes; with the use of concrete (a mixture of mortar, gravel, and rubble) they were able to build huge structures of enormous proportions. Concrete surfaces were covered with a facing of brick, stone, marble, or a thin coating of plaster that was visually attractive, but which has disappeared from most buildings and ruins today.

The Romans constructed secular buildings and public works that spread from one end of their world to the other. Bridges, roads, aqueducts, arenas, and public forums were built where previous cultures had spent their efforts on temples, palaces, burial places, and fortresses. Romans did not invent the arch, vault, dome, or concrete, but they used these structural elements and materials to far greater advantage than previous cultures. Their architecture was a creative achievement of the highest order, and in construction, planning, and engineering they had no peers. They erected the first structures in history with vast interior spaces—buildings which are impressive because of size and practicality rather than aesthetic feeling.

The *arch* and *vault* became essential parts of monumental Roman architecture and formed the basic construction units for sewers, bridges, and aqueducts. Rome had eleven aqueducts supplying 350 million gallons of water a day from distant mountains. The oldest one dates from 312 B.C., but aqueducts were constructed all over the Roman Empire, wherever water had to be brought across valleys and into cities. The aqueduct in Segovia (Spain) still stands in the center of the city. A double-storied marvel of construction, it is built of carefully cut and placed stones without mortar (dry-jointed) except for the very top band which carried the water. It contains 128 arches, is about 30 meters high at the center, and is still usable and in almost perfect condition.

The *Pont du Gard* near Nimes, France is a triple-storied aqueduct built of stone (without mortar) and bridges the gorge of the Gard River. It and the aqueduct are typical of the types of structures which the Romans built in the outreaches of their empire.

The arch was also used to bridge water and carry traffic across rivers. The *Ponte Fabrico* is the oldest bridge in Rome (64 B.C.) still in daily use. It is built of concrete, brick, and stone and spans the Tiber River with two large arches, each 26 meters wide. Much larger Roman bridges, however, can be found in other parts of Europe. Roman roads that tied the empire together and crossed such bridges were masterpieces of engineering in themselves and are still visible in parts of Europe.

Theater of Herodes Atticus, 2nd century. Athens

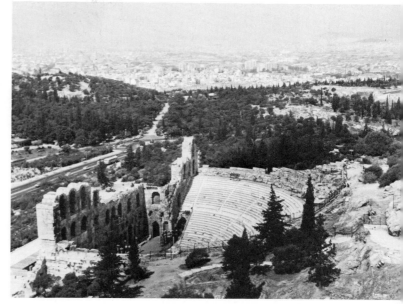

Possibly the grandest of all Roman structures is *The Colosseum* in Rome, an *amphitheater* (double theater—really two theaters placed face to face) of enormous size. This first elliptical building in the world was used for combat, mock naval battles, and various contests that entertained Roman citizens. Fifty thousand Romans could be held in the marble-seated interior. Concrete arches, walls, and vaults that were over several kilometers of passageways were covered with marble or decorative plaster. The outer wall (over 57 meters high) went completely around the structure and supported poles from which an awning could be stretched to protect spectators from sun or rain. Statues filled the arched niches around the outside, and a heavy wooden floor covered layers of cells below, in which gladiators and animals were held. The inside floor area (almost 100 meters long) could be flooded and used as a shallow lake for mock naval battles. Three emperors were involved in the amphitheater's construction (72–80): Vespasian, Titus, and Domitian. Unfortunately, the Colosseum has been damaged by later citizens and architects who used it as an instant quarry for marble when constructing other buildings. Other amphitheaters were constructed in every major city of the empire. Many are in such excellent condition that they are still used today for performances and bullfights.

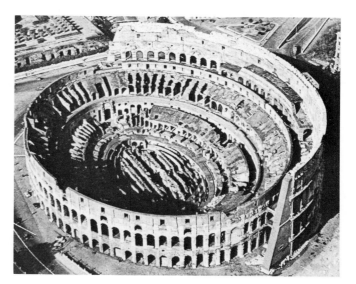

The Colosseum, 72–80. Rome

Roman theaters differed slightly from those of the Greeks. The round Greek orchestra was partially cut, and a raised stage area was constructed behind it. The performance was given from the stage, and important spectators were seated in the orchestra. The seating was in a semi-circle rather than in the two-thirds circle of the Greeks. Theaters were often freestanding rather than placed in a concave hillside. The 5000-seat Roman *Theater of Herodes Atticus,* built on the side of the Acropolis in Athens and once roofed with cedar wood, illustrates some of these points. It is still in use today.

GIOVANINI PAOLO PANINI. *Interior of the Pantheon*, about 1750. Oil on canvas, 128 × 99 cm. National Gallery of Art, Washington D.C., Samuel H. Kress Collection

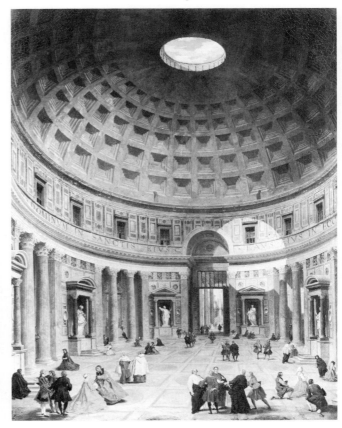

The Pantheon, about 118–125. Rome

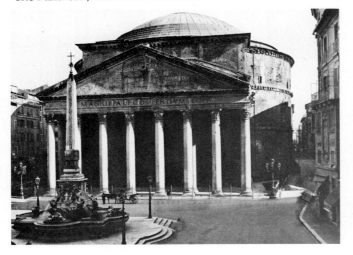

Romans also built huge structures that were completely enclosed and held large numbers of people; the most startling and creative is *The Pantheon*. Built to honor all the gods, it is of a revolutionary style. A huge dome (an exact hemisphere on the inside) rests on a mammoth drum, creating an interior space that is overwhelming to experience. The floor space is 47 meters in diameter, and the top of the dome is 47 meters above the floor. The concrete *coffered dome* is thin at the top and thickens as it reaches for the walls, which are massive enough (over 6 meters thick) to support the tremendous weight. A single round, eyelike opening (oculus) at the top, 9 meters in diameter, is the only source of light. Any rain that falls through it is carried away by an elaborate underground drainage system. The interior of the drum area is covered with marble columns and decorations. Some of Italy's great artists and composers were later buried here. The once-gilded, huge bronze doors on gigantic hinges are still original, placed there by the Romans. A colonnade of Corinthian columns, carved from single blocks of stone, dominates the entrance and is topped by a Greek-style pediment. The dome was originally covered with gilded bronze plates.

The Romans also built gigantic structures to house their baths. The *Baths of Caracalla* contained several pools of various temperatures, libraries, offices, meeting rooms, conversation areas, and spaces for recreation. The interior of the concrete structure was roofed with vaults that spanned enormous spaces. Large meeting halls, called *basilicas*, were part of the civic center in each city. They will be discussed in the next chapter since many were later converted into churches.

Several emperors built large triumphal arches to commemorate their greatest achievements. The *Arch of Constantine*, celebrating Constantine's assumption of power, is actually a large building with three arches through it. Many of the statues on it came from other monuments in Rome and were combined with some original work to complete the monument. The Colosseum can be seen in the background.

Romans loved to discuss things—politics, the weather, battles, history, art, trade business, or gossip. Their *forums* provided a space in their cities for these discussions. The *Forum Romanum* is one of many in Rome and contained temples, state buildings, open spaces, basilicas, and monuments, with the Via Sacra

The Arch of Constantine, about 312–315. Rome

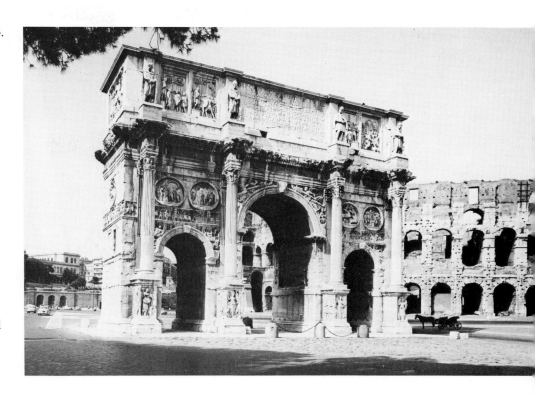

Plan of the Pantheon. From *Art in Perspective*, by Henri Dorra, published by Harcourt Brace Jovanovich, used by permission.

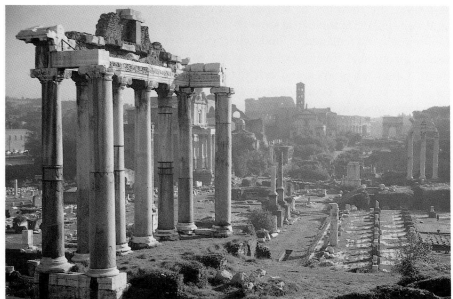

Forum Romanum, constructed over several centuries. Rome

(Sacred Way) passing through it. At a later time it became a valley full of rubble from the ruins and a garbage dump for the citizens, but was later excavated as it is seen today. At the far end is the Arch of Titus and beyond that is the Colosseum.

City planning was another phase of civic engineering at which the Romans excelled. Cities were equipped with sewers, running water, city squares, shopping streets, residential areas, public baths, gymnasiums, sports arenas, theaters, temples, paved streets, warehouses, and beautiful homes. Homes were often two stories high, built around atriums, and contained gardens and fountains. Pompeii (covered with volcanic ash from Mt. Vesuvius in 79) and Herculaneum (covered with a wall of mud at the same time) have been excavated to reveal urban centers of great sophistication and

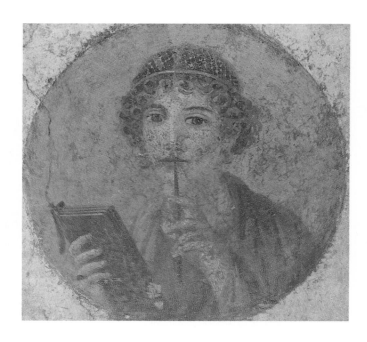

PAINTING

Both the Etruscans and the Greeks made paintings which the early Romans copied. Yet, since none of the Greek and only several of the Etruscan paintings have survived, the extent of their influence on Roman artists cannot be determined. Paintings were used to decorate and color the interiors of houses. Still lifes, portraits, landscapes, and mythological subjects are found on walls in Pompeii, Herculaneum, and other excavated cities where a complete covering of ash or dirt has preserved them. Often landscapes and architectural scenes were painted to serve as "open windows" to provide a feeling of greater space in small rooms. Portraits were sometimes painted on walls to record how members of the family looked. All Roman wall paintings were done in fresco, a method of using a watercolor medium on wet plaster. Entire plaster covered walls were frescoed to look like marble and wood paneling or were gaily decorated with flowers and vines, almost like wallpaper. *The Woman Playing the Cithara* is a decorative wall fresco, in which the woman and child have a feeling of individuality yet seem slightly idealized. They may possibly be portraits as the poses are casual and intimate and the figures are shaded to create a comfortable feeling of depth. Roman painters had mastered several types of *perspective* to create the illusion of depth in a painting.

The girl in *Portrait of a Young Girl* is from a wall in a Pompeian house. She holds a stylus to her lips as if thinking about what to write in the book. The painting may possibly be a commemorative portrait of a girl who died young and whose family wished to remember her. In the part of Egypt dominated by Rome, another medium, *encaustic*, was used by artists to paint portraits of people who had died and whose likenesses were placed over their faces when buried.

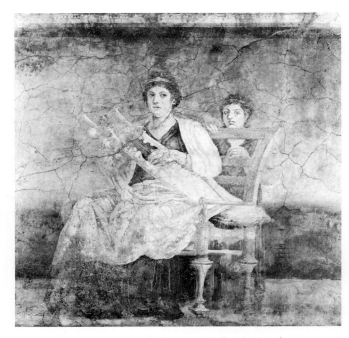

Woman Playing a Cithara, before 79. Wall painting from Boscoreale. Fresco, 2 m high. The Metropolitan Museum of Art, New York, Rogers Fund

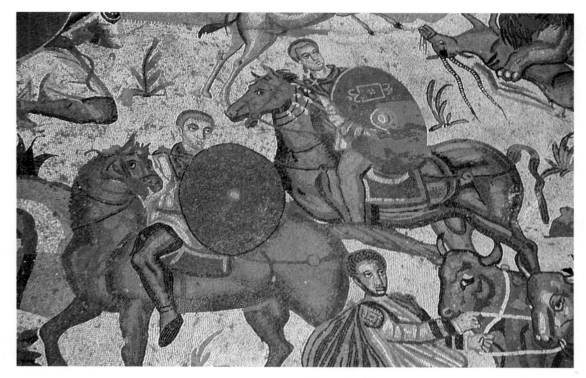

Hunter, 3–4th centuries. Mosaic, section shown about 4 m high. Imperial villa excavations, Casale, Sicily

MOSAICS

While the Greeks had used colored stones to create mosaic designs, the Romans excelled in this art. Small bits of marble were cut, polished, and fitted together to make an image. Floor mosaics, such as those at Casale in Sicily, were made of pieces one to two centimeters across. The owner of this hunting lodge had all the floors of many rooms and hallways covered with scenes of hunting, like these riders on horseback. Many types of animals as well as fighting and killing scenes are portrayed (*See* p. 48).

Wall mosaics were done with more care and used much smaller stones, many less than a millimeter in diameter. When done, the entire surface was polished to feel like a smooth sheet of glass. The artist of the wall mosaic, *Doves*, reveals a limited knowledge of space perception. While his shading of values is excellent, his perspective drawing is not. The frame and border also are done in the same mosaic technique, where stones are so tiny that 150 are used in every square centimeter.

The Battle of Issus, previously described, is a mosaic from the House of the Faun in Pompeii and is a brilliant example of mosaic art. Huge in size for a mosaic, its subject matter and execution are extremely complex. The grading of colors and values to create rounded forms is difficult when the colors and values must be found in natural stones (*See* p. 155).

Doves, 2nd century. Mosaic, 85 cm high. From villa of Emperor Hadrian at Tivoli. Capitoline Museum, Rome

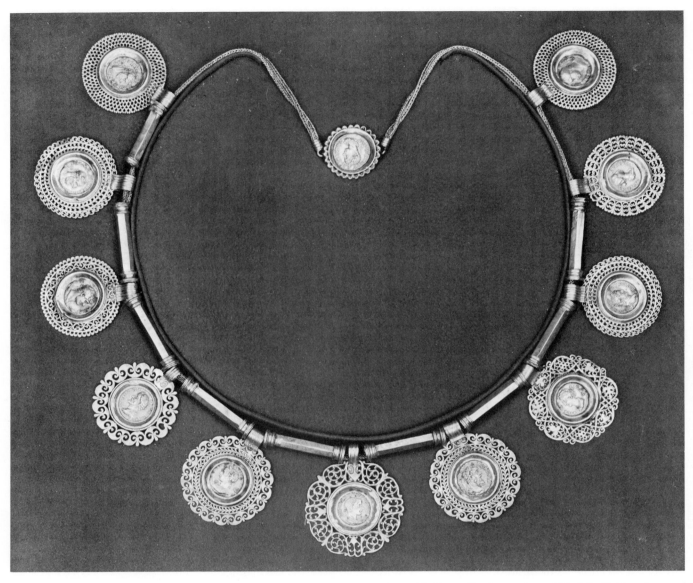

Necklace with Eleven Pendants, about 238–243. Gold and Roman coins, 76 cm long; medallions 3–4 cm in diameter. From Alexandria, Egypt. William Rockhill Nelson Gallery of Art, Kansas City, Nelson Fund

JEWELRY

Earrings, bracelets, pendants, rings, combs, mirrors, belts, and necklaces were plentiful among the Romans, and many have been found in burial sites and excavations. Roman coins also have been found all over Europe. The *Necklace with Eleven Pendants* is worked in gold and was found near Alexandria in Egypt. The openwork is delicate and detailed and enframes imperial coins of ten emperors, the latest being Gordianus III Pius. Archaeologists can therefore date the work at the time of or after this emperor, 238–243.

500

Middle East	Palace at Persepolis, Persia (500); Enameled walls, Susa; Jerusalem rebuilt (c445)
Africa	Nok culture flourished in Nigeria
Egypt	Incorporation into Achaemenian, Ptolemaic, and Roman empires in succession
Greece	"Golden Age" in Athens; Socrates (469–399), Aristotle (384–322); Alexander the Great
Rome	Defeat of Carthage in Punic Wars (261–241); Acquisition of Spain (201)
China	Chou dynasty to 256; Great Wall unified (221–210); Early mural tomb decoration
India	Mauryan kingdom (322); Greek colony at Bactria, Alexander in India; King Asoka (272–232)
S.E. Asia	Dong Son culture in Viet Nam (500–200); Menhirs erected on Plain of Jars in Laos
Americas	Olmecs (850–150) Jade carving, terra cotta vases; Cochise and Mogollon cultures

200

Middle East	Hasmonaean dynasty liberates Palestine from Rome (166–63)
Greece	Hellenistic world spreads Greek culture; Pergamon Altar in Asia Minor (181–159)
Rome	Expansion of empire; Beginning of Pax Augustus (31 B.C.–235 A.D.); Ovid, Cicero, etc.
China	Han dynasty (202 B.C.–220 A.D.); Invention of paper, systematic history, Fu poetry
Korea	Paekche kingdom founded in 18 B.C.
India	Domed stupa built at Sanchee; Buddhist rock-cut chapels at Karle; Painted frescoes
Americas	Pyramids of Tlapacoya (200); Olmec, Satopec in Mexico; Paracas, Mochica in Peru

1

Palestine	Life and teachings of Christ; Journeys of Paul (40–64); Jerusalem destroyed (70)
Rome	Invention of glass blowing; spread of Christianity; Nero (54–68); Pantheon
China	Cont. of Han dynasty; Buddhism from India (67); First census; Early lacquer work
India	Madhya, Pradesh, and Sanchee cultures; Buddhism expands
Americas	Zapotec and Monte Alban II cultures (200 B.C.–200 A.D.); "Mound Builders" in Ohio Valley

100

Rome	Ptolemy (astronomer), Galen (physician); Emperors Hadrian and Marcus Aurelius
China	Han dynasty; Calligraphy official script (175); Export silk; Roman envoy (166)
India	Mahayana Buddhism develops and separates from Hinayana Buddhism
Americas	Monte Alban II (–200); Superb fabrics by Paracas Necropolis weavers in Peru

200

Middle East	Shapur I, Sassanian king of Persia
China	Han empire divided into "Six Dynasties" era (220–589); Bamboo slip books written
India	Hellenism in North India; Gandhara produced first images of Buddha on Greek models
Rome	Hadrian's wall in England; Baths of Caracalla, Rome; Baalbek in Lebanon
Americas	Totonac and Zapotec cultures thrive in Mexico; Mochica, Nazca: master crafts in Peru

300

ART OF OTHER CULTURES

Stirrup-spout vessels were first designed in the Americas during the Chavin culture, about 800 B.C. The stirrup of this fine example of Mochica art (coastal valleys of Northern Peru) serves as both handle and spout. Utilitarian ware in the form of human figures were common in the Andes region.

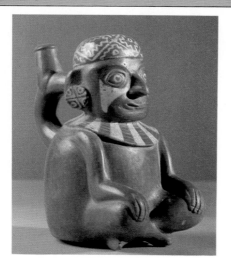

Stirrup-Spout Vessel, Seated Man. Peru, Mochica culture, about 200 B.C. Ceramic, 18 cm high. Amano Museum, Lima

175

Wine jar, 2nd century. Han Dynasty, China. Glazed earthenware, 43 cm high. Los Angeles County Museum of Art, gift of Nasli M. Heeramaneck

China was the first civilization to develop waterproof permanent ceramic glazes. The secret lay in compounding natural glass (silica) with low-melting lead oxide flux so that the coating would melt and adhere to the clay body. Such vessels were treasured highly. They were used in religious ceremonies and as royal gifts and trade items with other powerful kingdoms in Asia and the Mediterranean world.

For several centuries, scattered tribes in northern China had been busy constructing defense barriers across mountain passes. About 220 B.C. hundreds of thousands of laborers were conscripted to link these shorter walls together into a single massive wall that stretched along the entire border of the country. As Chinese influence extended, the wall was lengthened to about 3975 kilometers and was regarded as impenetrable. It was refaced with stone and brick during the Ming dynasty (15th and 16th centuries). A testament to the grand size of this architectural work is that it was the only earthly element that the astronauts on the moon could recognize. The Great Wall has recently been repaired again in places where tourists have access to it.

This large black stone was found by a French officer building fortifications in the Rosetta delta area of the Nile River in 1799. It contained a priestly decree in three scripts (hieroglyphs, demotic, and Greek) but in only two languages (Egyptian and Greek). The Greek text was used in the deciphering of the hieroglyphs and the demotic script. Its translation opened the way for the scientific study of Egyptian archaeology.

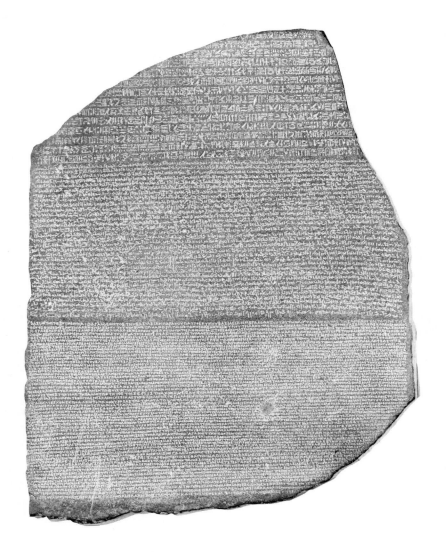

The Rosetta Stone. Egypt, 196 B.C. Basalt, 112 cm high. The British Museum, London

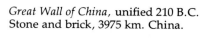
Great Wall of China, unified 210 B.C. Stone and brick, 3975 km. China.

INDEPENDENT STUDY PROJECTS

Analysis

1. To get an idea of the scale of well-known buildings from this era, measure off the sizes of the Pantheon, Parthenon, the Circus Maximus or other ancient Greek or Roman buildings on your athletic field. Pace them off after establishing the length of your normal walking stride. Outline the measurements with stones, chalk marks or string. They might be overlapped to show comparative sizes. You might also lay out the dimensions of some of today's buildings to compare the sizes.

2. Greek architecture is distinctive in its use of certain motifs and orders. Locate buildings in your town that use some of these motifs. Write a descriptive paragraph about a house, courthouse, museum or other public building. Use the proper terms for the various parts. If no such structure is available, work from a photograph of the United States Capitol.

3. Compare and contrast (in as much detail as possible) the Roman Colosseum with a major stadium in your own area, or in another U.S. city. Use dimensions, seating capacity, numbers of gates and entrances, variety of uses, and/or other means of comparison. Illustrations or diagrams would help make your written or oral presentation more interesting. Use encyclopedias for your research.

Aesthetics

4. Concepts of beauty change with time, as seen in the way the Greeks presented the sculptured figures of the ideal male athlete. Using illustrations from old magazines, present a picture essay on changing styles. For example, how has our idea of a beautifully designed automobile changed through the years? Or think about styles of women's clothing, airplanes, hair styles, homes, etc.

5. The realism of Roman sculpture (and Hellenistic Greek sculpture) was very popular with Renaissance artists, since they too were striving for naturalistic realism. Many sculptures had been buried by Roman noblemen in their efforts to save them from barbarian destruction. Imagine that you are an Italian newspaper reporter in 1450, and a farmer's plow has just uncovered a Roman sculpture outside your village. Write the headline and article that describe the event, the sculpture and the excitement.

6. Write an essay that explores the changes in Greek sculpture from Classic style to the later Hellenistic style. Discuss the characteristics of each, and describe the subtle and evident changes of character. Use examples if you wish. Which of the two styles seems most attractive to you? Why?

Studio

7. Roman artists were masters of the mosaic medium. Experiment with this technique by using small color chips (tesserae) to make a design or picture. Cut colored construction paper or magazine colors into 1 cm squares or irregular chips. Draw the outline of your subject on a 46 × 61 cm piece of chip board or corrugated cardboard. Glue the tesserae in place.

8. Use thinned tempera paint to paint a pastel, "fresco-like" portrait of yourself or a member of your family. In Roman times, this would be painted directly on a wall of your house. Research a bit to find typical Roman poses, decorations and colors, and adapt them to our present day culture.

9. Greek vase painting depicted scenes from Greek mythology, and the urns were made as gifts for the gods. Design Greek-style vase paintings of American mythology, depicting folk tales such as Paul Bunyan, Big Foot, Casey Jones or the exploits of Betsy Ross, Daniel Boone, Davey Crockett or Junipero Serra. Use Greek vase shapes, or paint these stylized scenes on such typical 20th century containers as plastic bottles, gallon wine jugs, etc. Acrylic paint will stick to most surfaces.

The Good Shepherd. Ceiling fresco, Early 4th century.
Catacomb of Saints Peter and Marcellinus, Rome

7 Religious Conviction: Early Christian, Byzantine, Migration, and Islamic Art

THROUGHOUT ROMAN HISTORY, the conquered peoples of Greece, Egypt, and other nations were not forced to adopt the religious beliefs of the empire. If they made a yearly offering to the Emperor, they were then free to worship their own gods. In this atmosphere of religious complexity, the followers of Jesus Christ, the Christian Church, spread their teachings. By the time the empire was ready to collapse, Christianity was the best established and most widely accepted religion.

Because all the art of Christianized Europe during the Middle Ages, and much of the art of the Renaissance is based on Christian teachings, it is important to review the basic tenets of Christianity.

Jesus was born among the Jews. Their God had communicated with them for centuries through His prophets and Old Testament writings and had given them laws (commandments) by which to live. Obeying these laws was the only way to please Him. But Jesus said that to love God and other human beings was more important than to keep those laws. To His followers He was God's Son, the Savior of the world, whose coming was predicted in the Old Testament. People who believed in Him would be raised at the end of time to spend eternity with Him in heaven. This salvation was not only for Jews, but for all who believed, and Jesus' followers were eager to carry this message through their missionaries to all parts of the empire.

Early Christian Art

In Italy, Rome became the center of Christian activities, with both St. Peter and St. Paul preaching the gospel of salvation through belief in Christ. For a time the Christian religion was outlawed, and believers were perse- cuted and blamed for many of the troubles in the empire. In order to escape torture and death, they often inhabited the tunnel-like *catacombs* outside Rome, places of complete safety and seclusion. Here they met for worship, celebrated their sacred rites, buried their dead, and even lived at times in complete protection.

Among the first Christian art known to exist are the frescoes that decorate the ceilings and walls of chapels located in the catacombs. On plastered surfaces a new kind of image was painted—not a realistic or natural one (such as the Romans painted) but figures and objects suggesting people and events of religious importance. These paintings are *symbolic*. At first symbols were borrowed from the Romans around them: Juno's peacock became the symbol for immortality; the phoenix for Christ's resurrection; Phaeton's chariot for Elijah's chariot; and the pastoral god Aristaeus became the Good Shepherd.

The ceiling fresco in the Catacomb of Saints Peter and Marcellinus show Christ as *The Good Shepherd* in the center (Christ had often spoken of himself as the good shepherd who gives his life for his sheep). As in other very early Christian art, he is shown as a beardless Roman youth, carrying a sheep on his shoulders. In the half-circles are several parts of the story of Jonah, an Old Testament prophet whose life was a symbol of Christ's life, death, and resurrection. At the left Jonah is thrown from the ship; on the right he emerges from the whale; and at the bottom he is safe again on dry land. Perhaps the missing section showed him in the belly of the whale. The story was also a great comfort to the Christians as it showed God's protection, care, and deliverance, even for them. The standing figures with their hands raised in prayer are symbols of church members while the circle itself represents the dome of heaven.

Notice the cross formed by the bands used as connecting lines. Although first shunned as evil and deathly, the cross later became the dominant Christian symbol. Realism was not the goal of these artists since they simply wanted to communicate a religious thought or idea. This concept changed the course of art for several centuries.

When the Emperor Constantine became a Christian and the Edict of Milan (313) favored Christianity as the official religion, the small houses that served as meeting places for church members were no longer sufficient. Rooms that held large numbers of worshipers were needed, and the Roman basilicas seemed to fit the requirements. The basilica plan seemed ideally suited for the Christian worship service because the congregation could sit and listen to the explanations of the deacon. When the first Christian church building was constructed (St. John Lateran, in Rome), it thus followed the general plan of the basilica.

This plan called for a long brick building with a timber roof. Connected to the front of the structure was an *atrium* (a courtyard) with a covered walkway around it. Entrances were at the rear of the building on the corners.

The *nave*, or central part of the basilica, was for the worshipers and was flanked by *side aisles*, separated by a row of columns, usually taken from heathen temples. Windows were located above the columns to flood the interior with light. The *apse* was a semi-circular area at the front of the nave that was covered with a half-dome. The *altar* was placed on the raised portion of the apse and always had a canopy or *baldachin* over it. This was made of carved and painted wood or stone.

Separating the nave from the apse was a so-called triumphal arch, symbolizing the victory of Christ over eternal death. Later basilicas had *bemas* or *transepts* (See diagram) that added interior space to accommodate larger crowds and a greater number of clergy. *Crypts* were sometimes placed under the raised apse to provide burial space for bishops or church leaders. Often a freestanding bell tower (*campanile*) was erected near the front of the basilica. The general plan, enlarged and elaborated as time passed, became the basis for European cathedrals of later centuries. About forty of the original three hundred basilicas are still standing, although all have been rebuilt and redecorated after destructive fires.

The greatest basilica was Old St. Peter's in Rome, which was torn down during the Renaissance to make way for the current huge basilica of St. Peter's in the Vatican. Slightly later, *St. Paul's Outside the Walls* was erected. It too was destroyed by fire but was rebuilt according to old plans, paintings, and drawings. The interior view shows the highly decorated character of all

APSE

DOUBLE SIDE AISLES

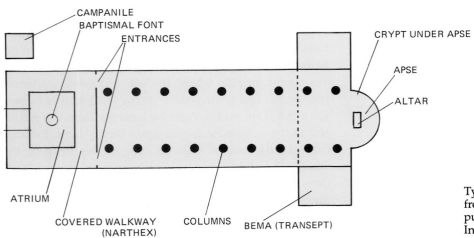

CAMPANILE
BAPTISMAL FONT
ENTRANCES
CRYPT UNDER APSE
APSE
ALTAR
ATRIUM
COVERED WALKWAY (NARTHEX)
COLUMNS
BEMA (TRANSEPT)

Typical basilica plan. Upper diagram from *Art in Perspective*, by Henri Dorra, published by Harcourt Brace Jovanovich, Inc., used by permission

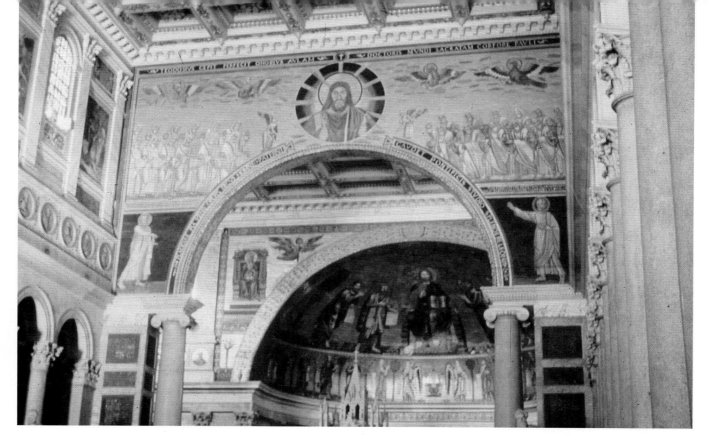

St. Paul Outside the Walls. Interior view, begun 368, reconstructed 1823. Rome

St. Apollinare in Classe. Exterior view, 470. Ravenna

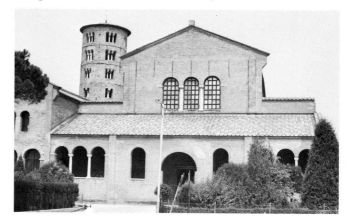

Christian basilicas. Mosaics of colored glass and gold cover the walls, creating a shimmering and sparkling surface. The eighty granite columns in four rows direct the view toward the triumphal arch (also covered with mosaics) and toward the apse where the altar and its baldachin are seen. Even the floor is decorated with inlaid marble designs.

The plain brick exteriors were in direct contrast to the glittering interiors—symbolic of the richness of the spirit compared to secular matters. *The Basilica of St. Apollinare in Classe* in Ravenna has such an exterior which gives no hint of the mosaic-covered walls inside. Note the campanile that stands by itself near the basilica.

Some *rotundas* and their central-plan structures were also used for churches, but the basilica plan was most often found in early Christian towns.

Fresco painting, done in the Roman style but using Biblical themes, was used in some basilicas instead of mosaics. Only slight fragments, however, remain today. *Illuminations* or illustrations, like those of early Christian books and scrolls, also decorated the basilicas. These storytelling or narrative paintings, almost like miniature murals, illustrated, enhanced, and clarified the written words of the Bible.

St. Tecla and the Beasts, 5th century. Coptic, Upper Egypt. Limestone, 65 cm in diameter. William Rockhill Nelson Gallery of Art, Kansas City, Nelson Fund

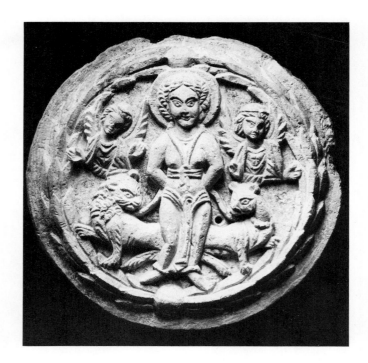

The Good Shepherd, 3rd century. Marble, half lifesize. Rome. Lateran Museum, Rome

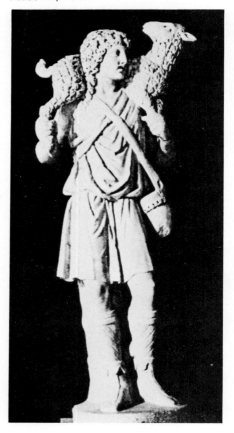

Little sculpture was produced in the early Christian church, and much of it has been destroyed. Coffin-like boxes of stone, called *sarcophagi* (one is a *sarcophagus*), used as caskets for burial, were carved completely in relief. This was a Roman development, but the subject matter on the Christian sarcophagi was religious and again symbolic rather than realistic.

The Good Shepherd is a freestanding sculpture in the Roman style which was adapted as a Christian symbol of Christ the Good Shepherd. It is one of the last Christian works with a naturalistic rather than a symbolic form. At first Christ was depicted as a Roman youth, but later, in the fifteenth century, as a dark bearded man with the haunting eyes of a shepherd from Syria.

The relief sculpture of *St. Tecla and the Beasts* is a work done for the Coptic Christians in Upper Egypt. St. Tecla, a Christian of the first century was converted through the preaching of St. Paul. She survived many tortures for her faith, including flames of fire and wild beasts in the arena. The fifth century artist seems to portray this subject because the angels near St. Tecla protect her from the menacing lions. Such images gave spiritual strength to the early Christians of distant Egypt or other remote lands.

The gold glass disc, showing the *Apostles Peter and Paul*, was probably the bottom of a drinking cup. These cups were special gifts for marriage or baptism, were

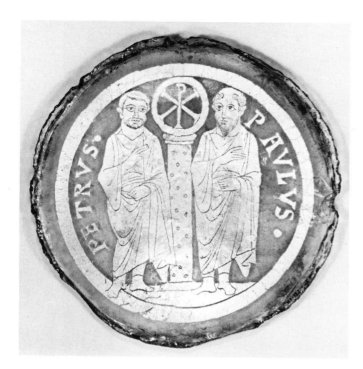

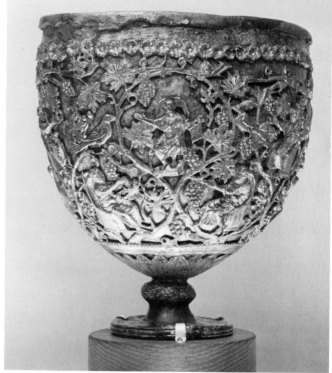

Apostles Peter and Paul, 4–5th centuries. Gold glass, 10 cm in diameter. Rome. Cloisters Collection, Metropolitan Museum of Art, New York, Rogers Fund

Chalice of Antioch, 350–500. Silver and gilt, 19 cm high. Syria. Cloisters Collection, Metropolitan Museum of Art, New York

used by the owners during their lifetimes, and were buried with them at their death. Some discs were even mounted in the walls over the burial places. This one shows the two apostles as they were depicted for centuries after: Peter with a short, rounded, and curly beard and Paul with a balding head and long, pointed beard. The column between them supports a monogram of Christ, the superimposed Greek letters X and P (chi and rho) which are the first two letters of the Greek word for Christ. It is not known exactly how the gold glass was made since the technique is lost. Gold leaf was probably cut, drawn into, and then embedded between two layers of fused glass.

The *Chalice of Antioch* consists of an inner plain silver cup set into an ornately carved silver and gilt openwork shell. The carved and footed shell contains two figures of Christ (one on each side); one is youthful and the other more mature. Apostles, animals, and birds are woven into a network of vines, branches, leaves, and grapes— all symbolic of Christ and his work. The eagle on one side, like the rosettes at the top, are signs of immortality.

Christian artists also created wall hangings and carvings in ivory. All worked in symbolic rather than realistic styles. Other crafts were also explored by these artists, and all work was meant to enrich the spiritual lives of the owners rather than to enhance their material possessions.

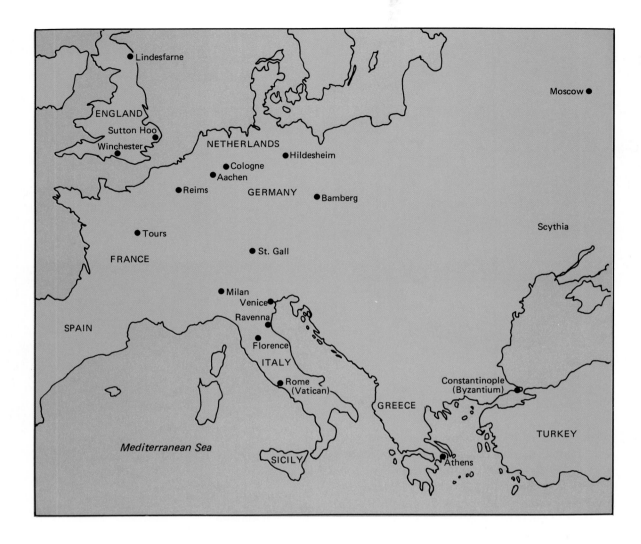

Byzantine Art: A Shift to the East

After the death of Constantine, the Roman Empire was split into Eastern and Western Empires. By this time the city of Rome had lost its tremendous power. It was sacked in 410 by the Visigoths, threatened by the Huns under Attila in 452, and sacked again by the Vandals in 455, leaving the once proud citadel of Western culture in virtual ruin. Rome became only a provincial town and after another period of chaos, all of Italy was devastated. The unrest continued in the west (Latin Roman Empire), and under the bishop of Rome (the pope) *monasteries* were established as a refuge from worldly disorder. For example, the Benedictine order (established by St. Benedict) was charged with the responsibility of copying and preserving important religious manuscripts and papers.

In 527 Justinian ascended the throne of the Eastern Roman Empire (Byzantine Empire), the capital of which

was Constantinople (formerly Byzantium). Justinian recaptured most of southern Italy and established Ravenna on the east coast as the new center of power. Justinian's reign began the Golden Age of Byzantine culture and art.

The number of important and beautiful church buildings constructed in Ravenna in the fifth and sixth centuries is amazing. All are plain brick on the outside and look ordinary, but inside they are encrusted with brilliant Byzantine mosaics. Roman mosaics had been of polished, colored stone, but Byzantine mosaics were made of brightly colored glass *tessarae* pressed into wet plaster. They were not evened out or polished so the irregular surface glitters with reflected light as candles or visitors pass by.

San Vitale in Ravenna is a large octagonal church, constructed with a central plan, having a dome over the center. Mosaics, under the arches and on almost every

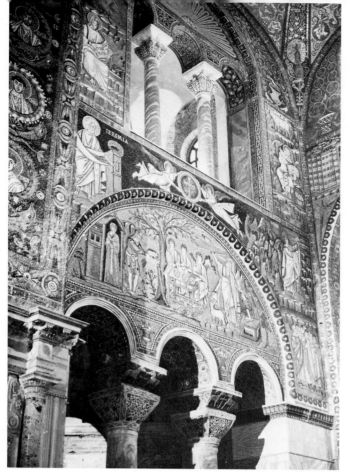

San Vitale. Interior, central wall, about 525–547. Ravenna

available surface, illustrate Biblical and some contemporary events. The semi-circle contains two stories from the life of Abraham. Notice how the capitals of the columns differ in their design from the orders of Greece and Rome.

The mosaic of *Emperor Justinian and Attendants* is an example of a contemporary subject in San Vitale. The emperor, with a halo around his head, is telling people that he is God's holy representative on earth and is therefore holy himself. The figures are generally stylized yet several of the faces are quite individualistic and are probably portraits. The bodies of these tall, slim figures disappear under the stylized costumes, and large eyes stare from small, almond-shaped faces. Their feet do not seem to touch the ground as they look directly ahead. They seem unable to move as if posing for a photograph. Note again the monogram of Christ, similar to that on the gold glass circle containing the likenesses of St. Peter and St. Paul. High officials, soldiers, and priests surround their emperor, all of whom sparkle today as they did in the sixth century. They are seen against a background of gold glass tessarae (gold leaf embedded in glass) which symbolizes the holiness and perfection of heaven and eliminates any earthly geographical associations. The use of gold for this symbolic purpose is a recurring characteristic of Byzantine art.

Emperor Justinian and Attendants, about 547. Mosaic, about lifesize figures. San Vitale, Ravenna

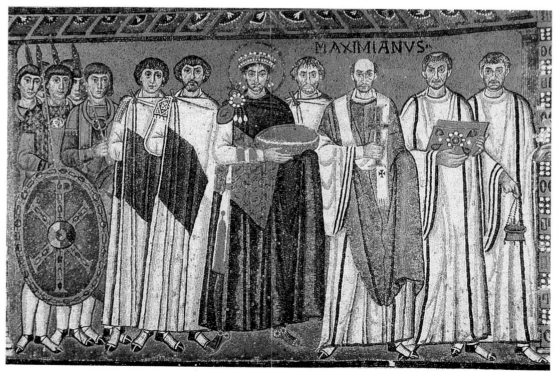

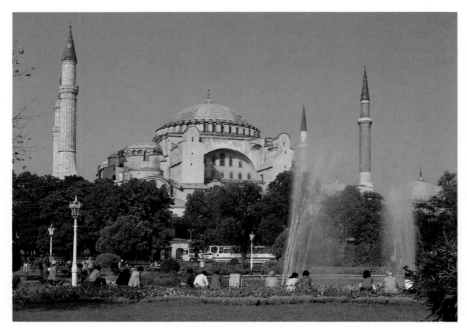

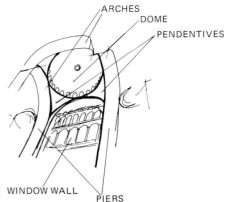

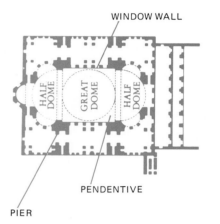

Anthemius of Tralles and Isidorus of Miletos. Hagia Sophia. Exterior, about 532–537. Istanbul

A sketch of the interior dome and pendentive structure of the Hagia Sophia, together with a diagram of the floor plan of the huge structure.

The culmination of art in the early Christian era was reached in Constantinople during the sixth century—the First Golden Age of Byzantine Art. Following a revolt in 532, Justinian rebuilt the city, including the large basilica. *Hagia Sophia* (Church of Holy Wisdom) is a monumental structure of completely original design, created by two architects Anthemius of Tralles and Isidorus of Miletos. The unique design combines a long open space (like a basilica) and a centralized dome (like a rotunda). The structural challenge was to place a huge round dome on square supporting walls. The dome of the Pantheon rested on a round drumlike structure, but supporting all parts of a circle by a square had not been solved aesthetically by this time. The diagram shows how the problem was solved. Four concave spherical triangles (pendentives) are supported by four *piers*.

These units form four arches on the walls and create a continuous circle at their top edge, on which the dome rests. The pendentives provide a graceful transition from square base to round dome, and with the four piers carrying the weight, allow the walls to remain open under the arches. With a row of arched windows at its base, the dome creates the visual sensation of floating above. Pendentive and dome construction replaced earlier clumsy attempts to solve the structural problem, and became a

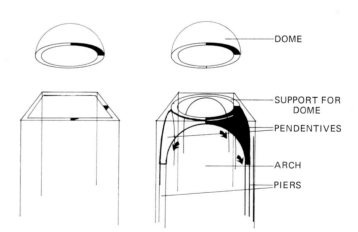

If a round dome is placed on a square base, (as at left) only a small part of the dome will be supported by the existing walls. If arches are placed in the four walls (as at right) and the circle of the dome rests on the four arches, a pendentive is formed in the four corners. The massive weight of the dome is supported by this spherical triangle which transfers the thrust to the four huge piers which support it.

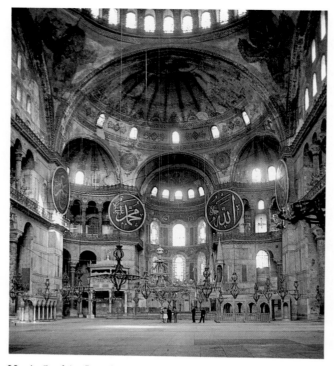

Hagia Sophia. Interior

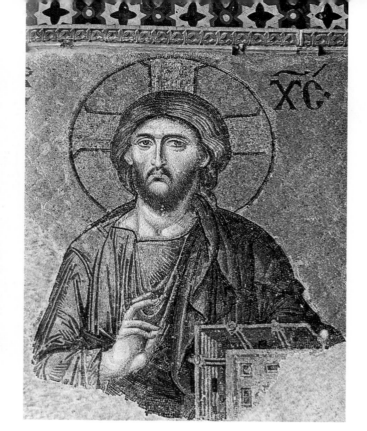

Christ between the Virgin and Saint John the Baptist (detail), 1261. Mosaic, southern gallery. Hagia Sophia, Istanbul

characteristic construction technique of later Byzantine churches, Renaissance domed buildings, and domed structures in America and the rest of the world. Against the huge domed cube in the center, rest two half-domed forms that give the interior its longitudinal axis. From the outside Hagia Sophia seems to be a mountain of masonry that reaches its apex at the top of the flat dome, about 60 meters above the city. The *minarets* were added in 1453 when the Moslems conquered Constantinople and changed the church to a mosque. By covering the minarets with one's fingers, one can see how it originally looked.

The exterior of the Hagia Sophia does not prepare one for what will be seen and felt inside. The space is overpowering: eighty meters long, forty meters wide, with the inside of the dome almost 50 meters above the floor. The church was the largest interior space in the world at that time. Originally the interior walls were completely covered with Byzantine mosaics of brilliant colors and gold. Eyewitnesses tell of feeling that the entire golden dome was hanging from heaven by a chain and that, among the glittering mosaics, they were walking the very streets of heaven. This mammoth work was completed in less than six years—an incredible feat, considering the new type of construction, the gigantic size, and the lack of modern machinery.

Arcades and galleries open onto the main space on two levels adding to the feeling of enormous space (*See above*). Light floods the interior from many windows, although more existed in the original structure. When the Moslems converted the church to a mosque, all the mosaics were either scraped from the walls or covered with plaster because their religion did not permit any likenesses of people. Over the plaster, geometric designs were painted, completely changing the character of the interior space. Skilled workers have recently uncovered many of the mosaics while others are completely destroyed or yet to be uncovered. Today Hagia Sophia is not used for worship, but is a huge museum of Byzantine art.

As in Ravenna, the Byzantine glass tessarae are placed irregularly, causing a glittering visual sensation as the viewers walk below. The mosaic of Christ is only a small section of a larger wall on which He is placed between John the Baptist and the Virgin Mary. Christ was shown earlier as a stern judge, but here He has a compassionate and loving look. His face is realistically done, although His robes are still stylized and unnatural. Done in 1261, this is the last mosaic work completed in Hagia Sophia. It was uncovered from its plaster tomb in 1933.

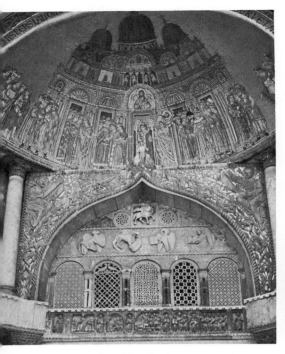

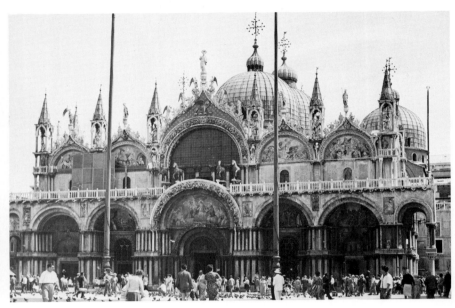

St. Mark's. Mosaic above one entrance.
Venice

St. Mark's. Venice, begun 1063

The Iconoclastic Controversy disrupted the growth of Byzantine culture after 726 and caused a split in the church between the image-destroyers (*iconoclasts*) and those who wished to retain images in the church. No art was produced for over a hundred years, and much of what had been created earlier was now destroyed. During these hectic times, the cross came into use as a symbol for Christ. The year 843 heralded the Second Golden Age of Byzantium or the Byzantine Renaissance.

No Byzantine structure rivaled Hagia Sophia in any way, although smaller churches used many of the features developed in its construction. Eastern European churches continued the architectural style begun here. The plan usually was of a Greek cross (four arms of equal length) contained in a square with the apse in one of the arms and a central dome resting on a square base. Often the dome was set on a cylindrical drum that raised it high above the roof line and the interior of the dome contained the figure of Christ Pantocrater (ruler of the world) set against a gold background.

The largest and most lavishly decorated church of the Second Golden Age is St. Mark's in Venice, begun in 1063 and built to hold the body of St. Mark, brought from Alexandria. It has the typical Greek cross plan, but here each arm has a dome of its own as well as the usual central dome. The exterior has many mosaics and 2,643

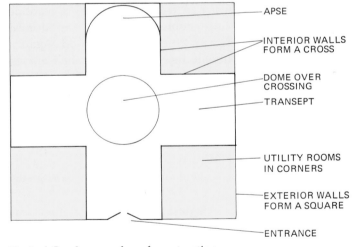

Typical Greek cross plan of construction

APSE

INTERIOR WALLS
FORM A CROSS

DOME OVER
CROSSING

TRANSEPT

UTILITY ROOMS
IN CORNERS

EXTERIOR WALLS
FORM A SQUARE

ENTRANCE

colored marble columns brought from Constantinople by Crusaders. The interior is completely covered with brilliant mosaics of both Byzantine and Venetian glass.

The half-dome mosaic over one of the five entrances shows St. Mark's in its original form—unadorned with the later additions of pictorial mosaics and Gothic spires. The four horses over the main entrance are still there and were also brought from Constantinople. They are probably original Greek bronzes from about 300 B.C.

The Archangel Michael, 5th century. Part of an ivory diptych, 42 cm high. British Museum, London

Byzantine architecture, like the Eastern Orthodox faith, spread over Eastern Europe and into the center of Russia. Often churches were constructed of wood rather than brick, but the interiors still glowed with images called *icons*. These mosaics and paintings are of saints and apostles. The most famous of the Russian churches is the Cathedral of St. Basil, located across Red Square from the Kremlin. While Moscow contains many Byzantine style buildings and churches, St. Basil's is unique and fantastic. Built during the rule of Ivan the Terrible, it has a large number of onion-shaped domes surrounding a central tentlike structure. The brilliantly painted domes and walls create a fairy-tale appearance that is both joyful and impressive.

Monumental sculpture did not exist in Byzantine culture, but small architectural sculptures often decorated the interiors of churches. Most were either destroyed or lost during the Crusades as they were being carried back to Europe. Small ivory relief panels also were carved, such as *The Archangel Michael*, part of a *diptych* (two pieces hinged together). The figure floats above the steps and seems weightless. The space seems shallow behind him, but the drapery seems to recall that of Greece or Rome, from which this figure is not far removed in style and concept. It is an excellent adaptation of the Classic style to Christian ideas and needs.

Enthroned Madonna and Child, 13th century. Egg tempera on panel, 122 × 77 cm. National Gallery of Art, Washington D.C., gift of Mrs. Otto H. Kahn

Some *mural* painting was done near the end of the Byzantine Empire, but more painting effort was spent on icons, painted on wooden panels. Icons were often used as worship centers in homes, but the best decorated the interiors of the churches, especially the large screen (*iconostasis*) that separated the holy sanctuary from the nave of the Byzantine church. Artists used *egg tempera* as their medium, even combining gold with the medium to produce brilliant backgrounds for the figures. The *Madonna Enthroned* is typical of this style of work. Gentle faces and hands are quite realistically done (a Roman influence), although their poses are symbolic. The robes do not seem real but appear flat, having folds that resemble sunbursts (an Oriental influence). There are attempts at *foreshortening* but they are carried out incorrectly. Still, in keeping with Byzantine tradition, the meaning is much more important than an accurate depiction of reality. Icon painting continued to be important for centuries in all areas where the Eastern Orthodox church was present (See p. 62).

Byzantine art remained expressionistic (colorful and emotional), two-dimensional (with a flat appearance, lacking great depth), and symbolic (reluctant to give saints and holy figures a truly human appearance).

Craftspersons often decorated churches and the objects used in worship. Wrought iron was often incorporated into the construction of the iconostasis in churches, and brilliantly colored *enamels* were fused to metal surfaces on crosses, boxes, and chalices used in various rites.

Pre-Romanesque Art: Migrations and Islamic Art

Europe, between the fifth and tenth centuries, was setting the stage for Romanesque, Gothic, and later Renaissance expression. Peoples were moving about the continent, some freely and some under duress. The present countries of Europe were in embryonic stages, and the Christian church was in turmoil. The migrating peoples (often called barbarians) were mobile societies and needed to carry their art and treasures with them, which they did in the form of necklaces, beads, pins, pendants, rings, buckles, purses, and trappings for their horses.

The Lock for a Purse makes use of garnets, glass, enamel, and gold, and was mounted on a slab of ivory. It was found in England (at Sutton Hoo) in a ship-burial place and was probably owned by a powerful ruler. Several influences can be seen: the Oriental decorations at the top (abstract and geometric) and the barbarian preoccupation with animal forms. The two outside groups show wild pigs attacking a man, while the inner groups show two birds of prey seizing two ducks.

Animal motifs were common in decoration and de-

Lock for a purse, first half of 7th century. Gold, garnets, glass and enamel, 19 cm long. From Sutton Hoo, England. British Museum, London

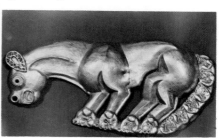

Crouching Panther, 6th century B. C. Scythian. Gold, 29 cm long. The Hermitage, Leningrad

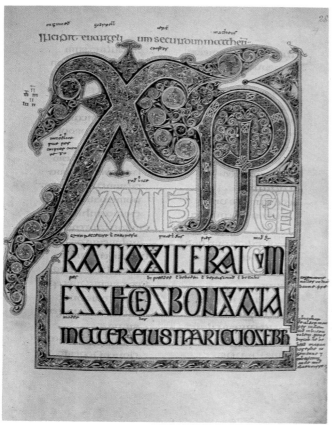

X-P (Chi-Rho) Page. From *Lindisfarne Gospel Book*, 698–721. Miniature on parchment, 24 × 20 cm. Lindesfarne, England. British Museum, London

sign. Some of this influence stemmed from the Russian steppes to the east where the *Scythians* had created stunning gold objects of great beauty. The *Crouching Panther* and similar works greatly influenced the migrating peoples of pre-Christian times and eventually the tribes looking for permanent homes in Europe in the fifth and later centuries.

Abstract and geometric designs were also fascinating to Pre-Romanesque artists. Using letters, flowers, and geometric motifs, monks in secluded monasteries decorated pages of Scripture and other writings with infinite detail. The *Lindisfarne Gospel Book*, illustrated between 698 and 721 in Christianized Great Britain, is a volume of many *vellum* pages. The page shown here is the beginning of the Gospel of St. Matthew and displays X-P (chi rho), a contraction of the Greek name for Christ. It is beautifully interlaced with abstract and geometric designs of minute detail, yet hidden in the curves and swirls are serpents, dragons, and other fantastic animals.

Charlemagne, Frankish king (786–814) and emperor of the West (800–814), was chiefly responsible for a short revival of interest in classical studies, art, and language. Under his direction, the Palatine Chapel was built in Aachen, Germany. Its rotunda plan followed the design of San Vitale in Ravenna and was copied later in several other German churches. Monasteries were constructed to preserve the learning of the past and to reproduce pages from Scripture and other holy writings.

Some pages of these manuscripts have figures and narrative decoration while others are simply words with no illustrations. Amid the abstract and geometric art of the time, the monks kept figurative drawing and paint-

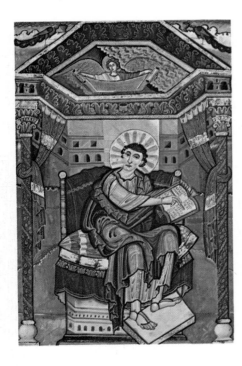

St. Matthew the Evangelist. From the *Gospel Book*, Rhineland, about 800. Miniature on parchment, 36 × 24 cm. British Museum, London

ing alive by creating *miniatures* on small pages. Their efforts bridged the span between Roman and Romanesque art. *St. Matthew the Evangelist* was painted during Charlemagne's reign in Rhineland (now Germany). St. Matthew is writing his Gospel as he works in a Classical setting. The painting reflects the Roman Classical interest in mathematics, architecture, and perspective drawing. The canopy and building are similar to the central plan structure of both San Vitale in Ravenna and Charlemagne's Palatine Chapel.

While parts of Europe were struggling under barbarian influences and/or trying to establish a foundation for future artistic development, Islam was taking over great areas of North Africa and the Near East. With rapidity that rivaled the conquests of Alexander in earlier centuries, Egypt, Syria, Palestine, Mesopotamia, and Persia had fallen to the Muslims by 662, only thirty years after the death of Mohammed. By 732 the Muslims had reached India and Afghanistan in the east and Spain, Portugal, and southwestern France in the west. The study of numbers, algebra, botany, and medicine were encouraged by the Arabs. Since the Muslim religion prohibited the use of human figures, they continued to emphasize geometric arabesques and abstract motifs in their art.

Architecture, particularly the construction of mosques for worship took several directions. New buildings were constructed or old Christian basilicas and churches were made over into mosques. In Jerusalem over the top of the rock mountain on which Abraham attempted to sacrifice his son Isaac (and from which Mohammed was to have left this earth) Muslims from many countries built *The Dome of the Rock*. This oldest Islamic monument (begun about 643) has an octagonal base, and many columns inside support the golden dome. The building is Byzantine in its rotunda form and was designed for this one particular spot and not copied elsewhere. The slightly pointed dome of wood was overlaid with lead and gilded with gold, but today it reflects the brilliant sun from an anodized aluminum surface. The exterior of the mosque is covered with brightly glazed ceramic tiles, although originally it contained mosaics of Byzantine glass.

The earliest huge Muslim building for congregational purposes is *The Great Mosque at Damascus*, built from 705 to 711. It made use of existing Christian and Roman structures and incorporated the existing square towers into the first Moslem minarets. From these minarets, people were called to prayer several times a day. The huge sanctuary has many columns to support the roof, measures about 160 by 100 meters, and still contains some of the original mosaic decoration as well as a monument to St. John the Baptist. From some of these early structures, architects developed the style of construction and decoration that typified the mature development of later Islamic architecture. Other early Islamic mosques can be found in North Africa, Iraq, Turkey, Mesopotamia, Egypt, and Spain.

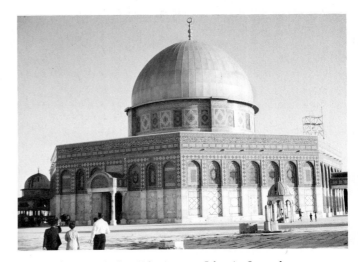

Dome of the Rock, late 7th century. Islamic. Jerusalem

300

Rome	Constantine; Division of empire (476); St. John Lateran built; Diocletian's palace
China	Political chaos; Buddhist cave temples; Neo-Daoism; Ku K'ai-chih, master painter
India	Rise of Gupta; Beginning of Golden Age (320–600); Indian orchestra visits China
Americas	Totonac culture in Mexico; Also Teotihuican, Colima, Nayarit, and Zapotec cultures

400

Middle East	Importation of silk cultivation from China; Qal at Saman, Syria
China	Invention of stirrup; Indian-style Buddhist images; Landscape poetry of Hsieh Ling-yun
Korea	Paekche and other kingdoms; Gilt bronze castings; Buddhist court arts
India	Live rock temples at Ajanta (400–700); Hindu temple architecture begun
Americas	Teotihuican culture (frescoes, pyramids, sculpture); Colima culture; Monte Alban
Europe	St. Augustine; St. Patrick in Ireland; Italy invaded by barbarians; Ostragoths

500

China	Calligraphy is art form; Buddhist "Paradise Cults"; Sui dynasty (589–618)
Middle East	Mohammed, prophet of Islam (570–632)
S.E. Asia	Khmers conquer Funan; Worship of Harihara; Kingdom of Dvarvati in So. Thailand
Japan	Asuka court (552–645); Korean Buddhism imported; Influence of Chinese art
Europe	Benedictine order; Hagia Sophia built; Lombards in Italy; Persian Wars

600

Middle East	Mohammed flees to Medina, dies (632); Koran written; Beginning of Islamic conquests
China	Tang dynasty established; First cast iron; wood block printing invented
Korea	Silla kingdom unites Korea; Buddhist class system modeled on Chinese system
Japan	Horyu-ji temple complex built at Nara; Yakushi-ji built (680)
Europe	St. Augustine in England; Scots Christianized; Caedomon is first English poet
Americas	Monte Alban terra cotta sculptures; Mayan culture at Palanque; Toltec culture

700

Middle East	Papermaking from China; Great Mosque at Damascus; Found city of Al-Mansur
China	Tang dynasty—glazed and unglazed funerary figures; Ta Ming palace
Japan	Capital at Nara (710) and Kyoto (794); Great Dibutsu and Todai-ji built at Nara
India	Freestanding Pallava architecture at Mahabalipuram (715); Rock-cut temples, Ellora
S.E. Asia	Kalasan temple and Dieng culture on Java; Indianization of Java complete
Europe	Muslims take Spain, stopped at Tours (732); Mosque at Cordoba; Beowulf written
Americas	Mayan culture, terra cottas; Quetzalcoatl temple (770–829); Mixtec records; Pueblos in U.S.

800

Middle East	Arabs capture Palermo, Sicily; Great Mosque built at Samarra (847)
China	Tang dynasty; "Diamond Sutra Scroll," oldest printed work (868)
Japan	Heian period (794–1185); Yamato-e painting; Hōōdō of Phoenix Hall built at Uji
India	Medieval period, political division; Mooktesvara temple at Bhuvanesvara (900)
S.E. Asia	Mountain stupa at Borobodur; Hindu Prambanan temples; Angkor; Sri Vijaya, Sumatra
Europe	First church organ at Aachen (822); Vikings raid England; Charlemagne
Americas	Monte Alban (zenith of Zapotec culture); Murals painted at Bonampak

900

Middle East	First windmills; Use of water power; Tomb of Ishmael Samanid at Bokhara (907)
China	Song dynasty (960–1279); architecture formalized; Landscapes by Ching hao & Kuan T'ung
Korea	Koryo kingdom (918–1392) promotes Golden Age; Celadon and sunggam pottery
Japan	Heian period; Pagoda of Daigo-ji in Kyoto (951); Refined court arts developed
India	Classic "sikhara" temples, Lingaraja; Dilwara shrine at Mount Abu; Tanjor temple
Europe	Vikings in France; Otto the Great, Germany; Russia becomes Orthodox; St. Sophia, Kiev
Americas	Pueblos in U.S.; Post-classic period in Mexico; Tiahuanaco culture in Andes, Peru

1000

Ladies of the Court Playing Polo, late 7th–early 8th centuries. China, Tang dynasty. Pottery with traces of polychrome, each 28 cm high. William Rockhill Nelson Gallery of Art, Kansas City

The sophistication of Tang culture far surpassed any society in the late eighth century. Elegance and grace typified the court life of a landed aristocracy. To perpetuate such a refined existence, articles for daily life (paintings, clothing, and sculptures of this quality) were buried with the wealthy for use in an afterlife.

Buddha, 7th century. Japan, Nara period. Bronze, 64 cm high. Kofuku-ji Museum, Nara, Japan

This hollow-cast bronze image was made during the early years of Japanese Buddhism and reflects a combination of influences: naturalism, stylization, and an esoteric and ethereal countenance. The spiritual enthusiasm of Nara, Japan was responsible for the fantastic number of Buddhist images, monasteries, and temples throughout the Yamato plain.

Newspaper Rock (detail), about 700. Petrified Forest, Arizona. Abraded stone, about 60 cm high.

Nomadic tribes on the North American continent made rock carvings for almost 5000 years. These stone pictures or *petroglyphs* are stylized pictures which seem to depict hunting, fertility, and other ceremonial activities in a simple, straightforward way. While the advancement of this neolithic culture was not nearly as technologically advanced as Tang, Nara, or Mexican civilizations, its written communication has a sophistication and honesty all its own.

Analysis

1. *Christ Enthroned* is a cloisonné enamel on gold in the Byzantine style (10th–12th centuries) and is about 16.5 cm high (Metropolitan Museum of Art, New York, gift of the Estate of Mrs. Otto M. Kahn). To make the brightly colored design, ground colored glass was melted and fused to small metal panels. The colors were kept separate and precisely shaped by low thin walls or wires of gold, called "cloissons." This piece reveals the technical proficiency and keen design sense of the medieval artisan. Write a detailed description of this work, emphasizing the characteristics of Byzantine art as you see them here.

2. Compare and contrast the depiction of human features by the craftspersons of Byzantium (in the cloisonné enamel) and their contemporaries in China (in the polo-playing ladies) and Japan (in the face of Buddha). Use terms such as stylization, naturalism, simplification, form, iconography, shape and line in your written or oral presentation.

3. The concept of an *atrium*, which formed a courtyard at the entrance of a basilica, can be traced back to ancient Greek houses. What was its purpose in both of these cases? In what form is the concept of the atrium being used in homes and commercial structures today? What are its structural and environmental advantages and its aesthetic benefits? Write a brief analysis answering these questions.

Aesthetics

4. Imagine you are on one of the crusades that entered Constantinople in the Middle Ages. Write a letter to a friend back home in England describing what you saw and how you felt as you approached and entered the Hagia Sophia for the first time.

5. Study the Byzantine style of representing figures on pages 187, 190 and here (as well as other books). Write a paper, explaining why they were shown in this stylized way. Conclude with a paragraph expressing your own personal reaction to these representations. Do you like them as they are? Why or why not? If you designed your own representation of Christ, the Madonna or other religious figures, what changes would you make?

6. Write a paper on what is meant by symbolism, and why the early Christian church made such extensive use of it in its art. Then compare or contrast religious symbolism with that of contemporary visual iconography (corporate symbolism or logos). Compare their intent, use, visual impact, connotation, significance, personal identification and response, etc.

Studio

7. Using the diagrams and photographs in this chapter, make a cardboard model (use tagboard or lightweight cardboard) of a basilica. You may wish to make the roof removable and paint the interior to look like it is brightly decorated with mosaics.

8. Use papier-mâché to build up a model of a dome supported by pendentives. You might use pieces of wood for support, and half a rubber ball for the dome.

9. Using tempera or watercolor, copy a page from a medieval manuscript to learn the intricate detail required for such work; or translate a fairy tale or contemporary event (sports, religious, social, political) in manuscript illumination style.

10. Early Christian and Byzantine artists often carved relief medallions and panels (pages 182, 189) in stone or ivory. Roll out a flat piece of clay and carve a low relief sculpture in medallion or panel form. Use a school or personal event as your subject.

8 Courage and a Growing Awareness: Romanesque and Gothic Art

DURING THE TIME of Charlemagne, and later of Otto I of Saxony, some efforts to pull Europe out of the Dark Ages were well organized while others were feeble and useless. Finally, the eleventh century arrived. The threat of Islam had waned, the Viking raids had subsided, eastern tribes were held in check, and Christianity unified efforts and ideas on the continent. Monasteries were sanctuaries for the scholarly, but they also began to exert influence in business and the social services. The more learned and creative monks of the tenth and eleventh centuries prepared the way for the intellectual ferment of the Gothic age. Romanesque art, based on a new religious fervor, sprang up all over Western Europe at the same time. The Crusades, organized to recapture the Holy Land for Christendom, moved huge numbers of people back and forth across Europe, bringing back the influences of Oriental and Byzantine art.

Towns, depopulated and almost empty during previous years, began to grow again, along with a revived interest in commerce and trade. A new middle class emerged (between peasants and landholders) made up of craftsmen and merchants. Countries, as known today, and central governments did not exist. There was only a system of feudal overlords. Romanesque art, which emerged from this context also lacked a dominant style, unified features, and direction. The art was primarily religious, and major efforts were directed toward constructing churches and carving sculpture to decorate them.

Romanesque Art

The name *Romanesque* was coined in the nineteenth century to cover all art from Roman times until the Gothic period. Today, with greater understanding of post-Roman Europe, its use is limited to the eleventh and twelfth centuries in western Europe. The beginnings and ends of the period vary in different localities.

The number of churches still standing after almost a thousand years is remarkable. They are scattered all over western Europe but most are in France, Germany, and Italy (coincidentally the heart of the Holy Roman Empire). The churches were built of carefully cut local stone, which varied in color and texture from place to place. The entrances were usually at the west end with the direction of worship toward the east (and symbolically toward Jerusalem). They are huge, with *crossings* (the place where nave and transept intersect) that are often topped with towers or *lanterns*. These intersecting spaces produced the shape of a *Latin cross* with one arm longer than the other three.

Ambulatories were built around the apse to allow for large processions. Often small chapels were added to the outside of these ambulatories to hold *relics* brought back in the Crusades and/or to be small worship spaces. Interior columns, separating nave from side aisles, seemed to continue to the roof, and broke the side walls up into a series of rectangular units that created a strong feeling of rhythm as one looked down the nave.

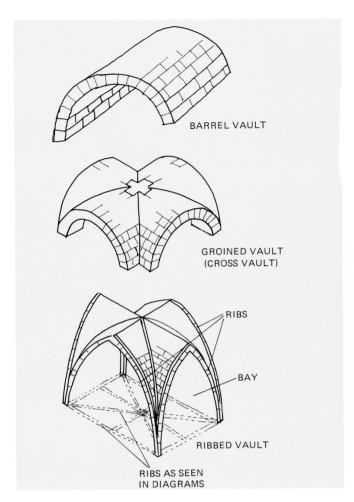

BARREL VAULT

GROINED VAULT
(CROSS VAULT)

RIBS

BAY

RIBBED VAULT

RIBS AS SEEN
IN DIAGRAMS

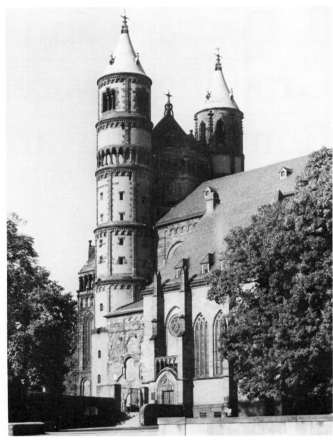

Worms Cathedral, about 1016–1181. Worms, Germany

The wooden roofs of previous ages were replaced by masonry barrel vaults which eliminated the danger of fire and produced better acoustics. The stone vaults, similar to those used by the Romans, were extremely heavy as they spanned the naves and produced tremendous outward thrust, requiring massive *buttresses* and thick walls for support. Groined vaults (cross vaults) were often used to stabilize the naves or to add strength over the side aisles. Interior Romanesque space was not nearly as tall as later Gothic space because the problem of weight and thrust was simply too difficult to overcome with existing engineering skills. Windows were kept small so as not to weaken the walls and therefore the entire structure. Hence, interiors were quite dark and had a rather heavy feeling.

Rounded arches, also a Roman feature, were used over windows and over inside and outside niches containing sculpture. They also appeared in arcades, supports, and side aisles. Other geometric forms found in architecture were cubes, cylinders, half-cylinders, hemispheres, rectangles, and cones.

Towers were often used, sometimes at the front corners, sometimes at the crossings, and sometimes freestanding (campaniles). To accommodate a larger clergy and more ritual, the apse area was greatly enlarged and included a *choir,* an area for the singing clergy. To hold the burial spaces for high ranking clergy and other important personages, large crypts were built under these raised areas.

When a monastery accompanied a church, the complex of buildings was called an *abbey.* A *cloister* with an arcaded ambulatory usually connected the church with the living quarters of the monks. Structures that were the home church of *bishops* contained a special chair or throne for these ecclesiastical leaders—a *cathedra,* and such church buildings were called *cathedrals.* Churches that do not contain such chairs cannot be correctly called cathedrals, no matter how beautiful or large they may be.

As a result of the vast number of new ideas and constant adjustments necessary in construction, Romanesque architecture was a dynamic art form. It was always

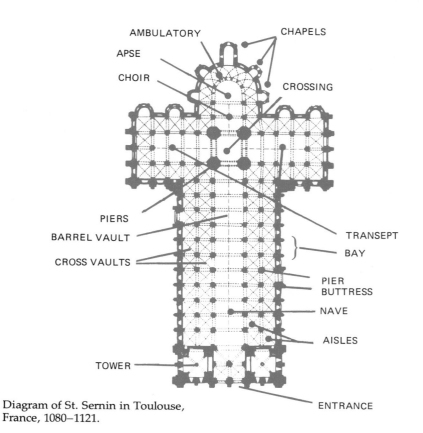

Diagram of St. Sernin in Toulouse, France, 1080–1121.

Diagram labels:
AMBULATORY
APSE
CHOIR
CHAPELS
CROSSING
PIERS
BARREL VAULT
CROSS VAULTS
TRANSEPT
BAY
PIER BUTTRESS
NAVE
AISLES
TOWER
ENTRANCE

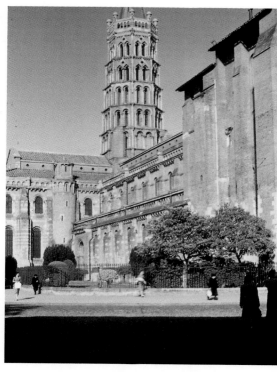

Saint-Sernin, about 1080–1120. Toulouse, France

changing to meet new situations and often changing with the employment of a new architect. A few examples will provide a basic understanding of this architecture—its variety and characteristic features.

The Worms Cathedral typifies Romanesque architecture in Germany. Based on earlier structures built during the reigns of Charlemagne and Otto the Great, it tends to be heavy and fortress-like, making use of strong geometric forms. The entrance is on the side through a later Gothic addition (*See* photo), and the church has an apse on each end, as do several other German Rhineland churches. The towers resemble the turrets used in castles and are repeated at the other end of the building.

The exterior view of Saint-Sernin in Toulouse, France shows a huge tower over the crossing and an exterior view of one arm of the large transept. This structure was a pilgrimage church—that is, it was built to hold huge multitudes of travelers on their way to sacred shrines. A large apse and ambulatory, many small chapels, and double side aisles helped control the crowds that moved through the church.

The interior of Sainte-Madeleine at Vezelay exhibits some expected Romanesque features as well as some surprises. By using groined vaults rather than single barrel vaults, the architect was able to open large windows in the clerestory, allowing light to flood the interior.

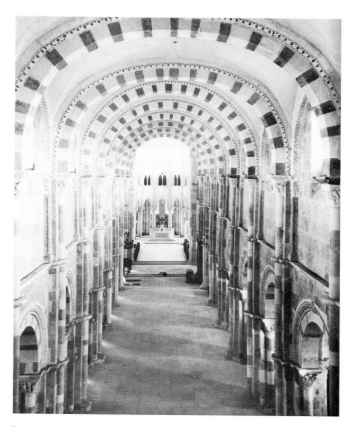

Interior, Sainte-Madeleine, about 1104–1132. Vezelay, France

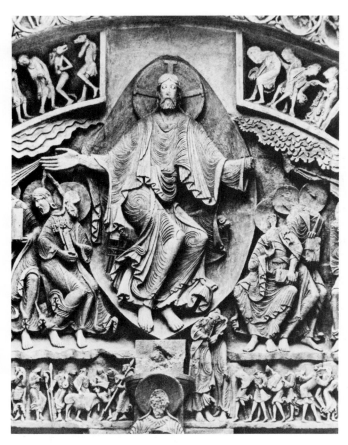

Detail, Sainte-Madeleine. Central part of central tympanum

whole composition seems agitated and frenetic. The thin, gaunt appearance of Christ and other honored people was a sign of holiness because it symbolized poverty and hunger, both virtues at this time in Christian history.

Notre-Dame-la-Grande in Poitiers, France is a low and wide church with a barrel-vaulted interior that is heavy and dark, due to the small windows. The exterior has more sculpture than many Romanesque churches, especially the west facade which contains fourteen large sculpted figures in niches formed by round arches and stumpy columns. Directly above the entrance is a frieze of many figures illustrating the mystery of Christ's birth and work. Taller columns are bunched at the corners and lead upward to cone-shaped helmets which were added at a later time, and which do not seem to belong to the rest of the church. A heavy tower seems to sit on the roof at the crossing, and it too is capped with a cone-shaped top. The church is smaller than many others of the time and has only one portal. The flanking arches are decorative and not functional.

Italian Romanesque architecture was brighter, more colorful, and more highly decorated than contemporary buildings north of the Alps. The grandest in central Italy is the complex at Pisa, made up of the cathedral, the baptistry, and the campanile. All built of white marble with horizontal bands of inlaid green marble, they are set off by the huge green lawn that surrounds them. The campanile—the famous Leaning Tower—started leaning during early construction and efforts were made, unsuccessfully, to straighten it. A definite bend can be noted in the tower as a result. Settling causes further tilting each year and even extreme efforts have not stopped its continued leaning toward eventual destruction. The cathedral is built on a Latin cross plan with an apse at each end of the transept and a pointed dome crowning the crossing. As in other cathedrals of the area, the facade consists of tiers of superimposed arcades which are echoed in *blind arcades* down the sides of the church. The interior has been strongly influenced by Early Christian basilicas, with rows of columns and a wooden roof. The baptistry is a freestanding building, similar to others in the Tuscan area of central Italy. Built only for the purpose of elaborate baptism ceremonies, its dome and upper sections were completed in Gothic times. Note how the simple blind arcading in the lower level contrasts with the elaborately carved decorations in the upper sections. The structure has a unique pear-shaped interior that follows the contour of the dome and has remarkable acoustic properties.

Even with the added strength of the groined vaults, the church had to be reinforced from the outside with flying buttresses during Gothic times. The compound *piers* (many columns massed together) have sculpted capitals of white limestone. The striking two-color effect, created by using soft golden limestone and light pink granite blocks in the piers, is a direct influence of the Islamic mosques built in Spain. The brightly lit choir is a later Gothic renovation.

The glory of Vezelay is its set of three sculptured portals opening into the nave and side aisles from the *narthex*. They are relief sculptures, but are carved almost in the round (*See* detail). The central *tympanum* contains the *Mission of the Apostles,* Christ sending his disciples to preach to the entire world, a fitting subject for a church from which many Crusades departed. The huge figure of Christ is placed in a *mandorla,* his knees turned in a zig-zag position. From his hands (one is missing) stream rays of light to the apostles who are all shown with objects that symbolize them, their work, or their martyrdom. The drapery seems almost Byzantine and the

Notre-Dame-la-Grande, about 1162–1271. Poitiers, France

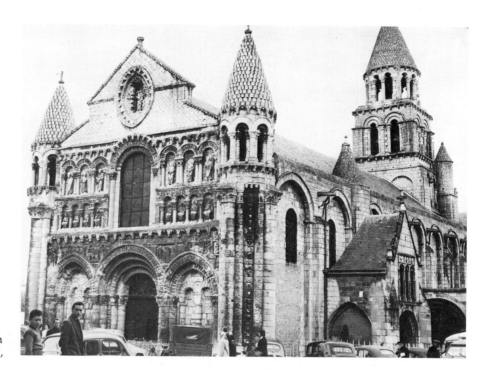

Baptistry (begun 1153), Cathedral (begun 1063), and Campanile (begun 1174). Pisa, Italy

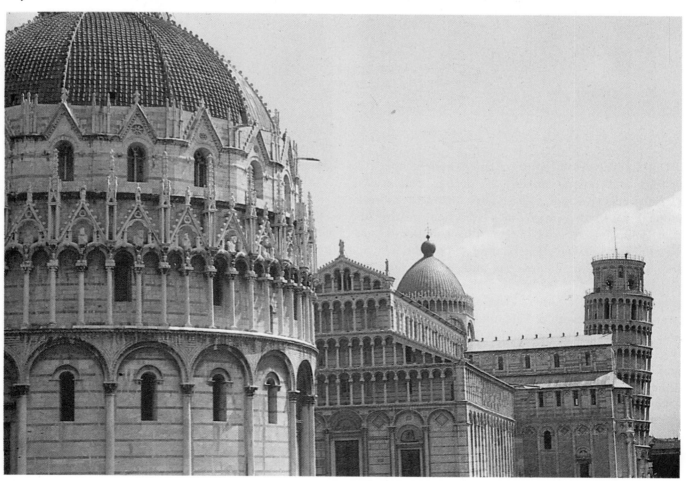

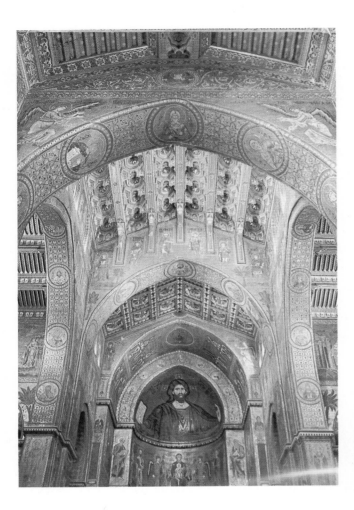

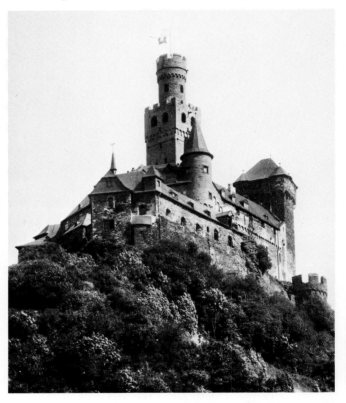

Interior, Cathedral of Monreale, 1174–1182. Monreale, Sicily

Marksburg, 12th century. Braubach, Germany

During the twelfth century, Romanesque Sicily had a distinct and unique mixture of people: part native Sicilians, part Greeks (descendants of ancient Greek settlers), Muslims (former conquerors from nearby Africa), French-speaking Normans (the conquerors and current rulers), Italians (from central and southern Italy), and Byzantines (from Ravenna and Turkey). The architecture that developed carried all of these influences and was unlike any other. The Cathedral of Monreale, located on a hill south of Palermo, is a spacious church with a highly decorative exterior. The inside, however, is a fantastic blend of Roman columns, Byzantine mosaics, and a timber roof of brightly painted Islamic designs. The color and richness is almost overwhelming, especially after viewing the simple and sedate Romanesque churches of northern Europe. The mosaics are in narrative form, telling the story of the Bible, and climaxing in the huge figure of Christ Pantocrater which fills the slightly pointed half-dome in the apse. This dome and the slightly pointed arches are styled after pointed Islamic domes and arches.

Most construction effort was spent on cathedrals where much of the labor was donated by pious Christians, from every level of society, eager to help earn their way into heaven. Powerful secular rulers, who wished to protect themselves from their enemies, constructed strong fortresses for themselves and their knights in France, Germany, England, Italy, and Spain. The majestic Marksburg castle is typical of twelfth century fortifications in Germany. Standing on a cliff, 150 meters above the Rhine River, its main tower reaches another 40 meters into the air. Still intact, the castle resembles churches of the period in its towers, cones, thick walls, stone materials, and small windows. Conversely, some features of the castle, notably a central plan, defensible walls, enduring construction, and austere and solemn appearance, can be found in the churches. Obviously, the same architects were involved in both types of construction.

MASTER OF PEDRET. *Virgin and Child Enthroned*, about 1130. Fresco, about 3 m high. The Metropolitan Museum of Art, New York, The Cloisters Fund

SCULPTURE, PAINTING, AND CRAFTS

Sculpture, like all Romanesque art, was associated with the church and was designed to help the laity understand the great leaders and teachings of the church. Most of it was part of the structure itself: capitals of columns, tympanum sculpture, work around portals or figures placed in niches, similar to those already noted at Vezelay and Poitiers. Still other places for sculpture were around the altars and in the crypts of some churches. The facade of San Zeno in Verona, Italy is very plain except for the ambitious marble sculpture in the tympanum and flanking the single portal and the bronze relief sculptures on the door itself. Among the subjects treated are Biblical scenes, allegories of the months, figures of saints, zodiac signs, and scenes from the life of St. Zeno. The two lions supporting the columns are a typical feature of Italian Romanesque churches and represent a vigilant church, prepared to defend its doctrines and beliefs.

Generally, most Romanesque sculpture is elongated or distorted, emphasizing a frenzied movement and a fear of an all-powerful God. Many figures seem emaciated to emphasize their poverty and therefore holiness. Such work is *expressionistic* because it places emphasis on a strong emotional response rather than a natural appearance.

Manuscript illumination continued through the Gothic period with monks carefully copying the words of Scripture and embellishing them with fanciful lettering and Biblical illustrations. Usually these were painted on parchment and colored with tempera, inks, and pure gold.

Painting took on added importance with frescoes used to decorate some interior spaces, especially in Spain and Italy. Churches in the north were too dark, and the

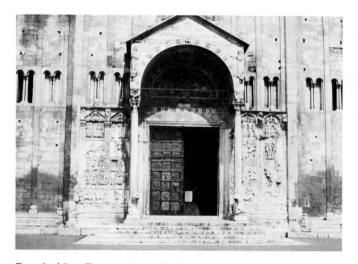

Portal of San Zeno, 1120–1138. Verona, Italy

weather was too damp to use the fresco technique effectively. Although most frescoes have been destroyed, some remain in excellent condition. The *Virgin and Child Enthroned* was painted by the Master of Pedret (an unknown artist) in a small church in the Pyrenees Mountains of Spain. Such work in a large cathedral would have been destroyed during renovation or modernization, but many of these works in small churches remained untouched. The Virgin and Child are rendered symbolically as in Byzantine art. They are placed in a mandorla (an almond-shaped form) to signify heaven and are flanked by the archangels Michael and Gabriel. The painting was originally on the semi-dome of the apse, but with modern techniques the entire fresco was removed and placed on a flat surface, prior to the destruction of the church.

God Creating Eve from the Rib of Adam, about 1182. Mosaic. Monreale Cathedral, Sicily

The Battle of Hastings, detail of the Bayeux Tapestry, about 1073–1083. Wool embroidery on linen, 51 cm high. Town Hall, Bayeux, France

As in the Byzantine tradition, mosaics decorated the interiors of some Italian churches. The Cathedral at Monreale is practically an illustrated Bible. One of the sections high on the wall shows *God Creating Eve from the Rib of Adam*. The figures are outlined and stylized but do not appear symbolic because they are shown as individuals in natural poses. There is even an attempt to portray the natural environment, with trees, mountains, rocks, and shrubs to indicate the Garden of Eden. Yet, the gold background of earlier Byzantine mosaics persists, probably because the workmen were familiar with such techniques (*See* ceiling mosaic in baptistry, Florence, on title page).

In some Romanesque churches, particularly in central and northern Europe, the small windows were filled with a new art form that would reach fantastic proportions in the Gothic period. Artists learned to mix color with glass to produce amazing jewel-like sheets which were cut and placed into designs held together with lead channels. Stained glass allowed artists to use still another medium to enrich the interiors of their churches.

Soon after the Battle of Hastings, Bishop Odo of Bayeux (France) commissioned the marvelous illustration of William the Conqueror's invasion of England in 1066. It is a wool embroidered frieze seventy meters long and fifty-one centimeters high that decorated the Bayeux Cathedral. It is a documentation of the battle, with soldiers, horses, weapons, shields, towns, animals, invasion fleets, and even a running commentary in Latin words. It is called the *Bayeux Tapestry* but is really a richly embroidered panel and not a true tapestry. This small section shows Bretons, Normans, and Europeans on horseback converging on Harold's personal troops. The ranks are so tightly packed that the dead cannot fall. Notice the variety of weapons used as Harold's men fight valiantly though in vain: battle axes, javelins,

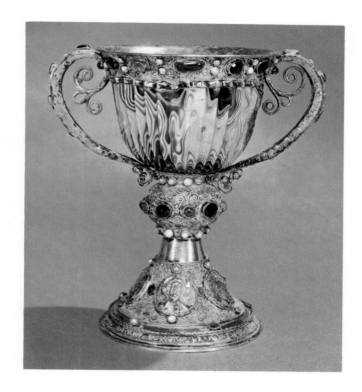

Chalice of Abbot Suger of Saint-Denis, about 1140. Sardonyx, gold, silver-gilt, gems, and pearls, 19 cm high. National Gallery of Art, Washington D.C., Widener Collection

Gothic Art

The twelfth and thirteenth centuries saw a massive shift in the population of Europe. People moved from the countryside into towns which grew in size to become cities with businesses, commerce, schools, and trade. Cathedrals became the religious, cultural, and social centers of the growing cities and cathedral schools and universities replaced the monasteries as learning centers. Fresh ideas and technical knowledge were spawned in these cities. From this newly found freedom emerged Gothic art and, more particularly, Gothic architecture.

The word *Gothic*, like Romanesque, is a misnomer, having nothing to do with the barbarian Goths of the fifth century. But Renaissance Italians, looking down on twelfth and thirteenth century art as barbarian, called the style Gothic, a term of ridicule. Today, Gothic art is synonymous with the new energy and dynamic style that started at the royal abbey of Saint-Denis, outside Paris in 1140. No previous style of art can be pinpointed to a single date, but the Gothic style began when Abbot Suger started to enlarge and redesign his small church to accommodate the many pilgrims who were visiting the chapel.

Abbot Suger wished to construct a church that was as beautiful and richly decorated as possible because anything less would be unsuitable for God's house. His main concern was light as it symbolized the presence of God. He greatly enlarged the apse of his church, providing an ambulatory for the pilgrims, and designed huge windows that let in great quantities of light

hurling spears, stones, and crossbows. The border above the scene is purely decorative while the one below shows dead soldiers, animals, and discarded weapons, all part of the story.

Other works were also crafted, but generally in the service of the church. The *Chalice of Abbot Suger* is created from an ancient Roman cup, carved from a single piece of sardonyx, and has a twelfth century gilt silver mounting studded with precious stones and pearls. The chalice has a rugged beauty that resembles the craftsmanship of the barbarian peoples of earlier years. Yet it was made for Abbot Suger of Saint-Denis in Paris, one of the originators of the Gothic style. He wished to use only the best, most precious, and most beautiful things in the service of God, and thus established a new trend in church art. The chalice was admired so much that it was used by French kings for three hundred years.

Ghent, Belgium. Three houses, three architectural styles: Romanesque, Renaissance, and Gothic

Ghent, Belgium. Center of the city. St. Nicholas (13th century). The Belfry (12th century), St. Bavon (14th century), and civic buildings

through stained glass. He thus developed an architecture of supports, not of walls. Columns and piers supported the vault, windows replaced walls, and Gothic architecture was born. Heavy Roman-type vaults and massive post-and-lintel construction were suddenly obsolete.

From Saint-Denis, the Gothic architectural style moved to Chartres, Paris, and the rest of northern France, then to England, Germany, and all of northern Europe and finally filtered into Italy, inspiring a building boom of unprecedented proportions. The three buildings in Ghent are not churches but houses that illustrate the evolution of architectural style over a long period of time. The building on the left is Romanesque; it has heavy, small windows, rounded arches, and a plain facade. The house on the right is Gothic: it is lighter and more delicate in feeling, has large window spaces and elaborate decoration on the facade. Although round arches were still used, they have been made elaborate with stone carving, called *tracery*. The central house is of Renaissance style: it demonstrates a balance between windows and wall, between plain and decorated areas of the facade, has a Classical post-and-lintel construction and a quieter, more refined appearance.

Another view of Ghent provides a look at the central part of a Gothic city. Without automobiles, the two churches, a freestanding belfry, and the civic buildings would appear as they did in the fourteenth century.

Unity is the key word in Gothic architecture. Interiors and exteriors belong together and are similarly dec-

Cathedral of Chartres, about 1142. City setting. France

orated—the first time in history that they receive equal emphasis. Structure, aesthetics, purpose, and meaning are fused together to present an organic whole or a unified structure. This unity is sometimes a wondrous accomplishment, considering that the buildings often took several generations to complete, requiring several architects and thousands of workers. Construction times were lengthy, and many of the churches were never completed according to their original plans.

There are several features that characterize Gothic construction. There is an overall feeling of verticality as architects tried to make the interiors as high as possible, as if reaching toward heaven. The nave of the Amiens Cathedral is over 42 meters high. Ribbed cross vaults of several types added stability and strength and allowed for huge glass walls at the *clerestory* level, over the side aisles. Pointed arches provided greater height and more open area even though the spacing of the supporting columns was the same. The height-to-width ratio in round arches is about 2 to 1, but in pointed arches can be 3 to 1. The pointed arches also changed the thrust of the vault to a more vertical direction, and with the addition of *flying arches* and *tower buttresses,* transferred that thrust not to the walls but to the massive towers outside

the structure, thereby eliminating the need for solid, thick walls. The flying arches reached over the side aisles and allowed light to enter unhindered through the clerestory windows. There are at least three (sometimes five) main portals in the facade. A huge round window (*wheel window* or *rose window*) was often placed over the main portal or at the ends of the transepts. All of these features are found in most Gothic construction, but the most important is unity: the way all elements work together to present an integrated and organic unit.

The best remaining example of early Gothic construction is Chartres Cathedral (Saint-Denis has been greatly changed over the years). The photograph reveals the size and importance of such churches in their communities. Begun as a Romanesque church, it incorporated many new ideas from Saint-Denis, especially the need for huge window walls of stained glass, which remain virtually intact. The two towers were built fifty years apart, the plainer one first and the more elaborate one later. The Latin cross plan can be noticed from the roof structure, and a huge rose window can be seen at the end of the transept. Flying arches are seen, especially over the apse. Some of the sculpture and the beautiful windows of Chartres will be discussed later in this chapter.

Exterior, Notre Dame. Paris

Notre Dame, nave, about 1163–1250. Paris

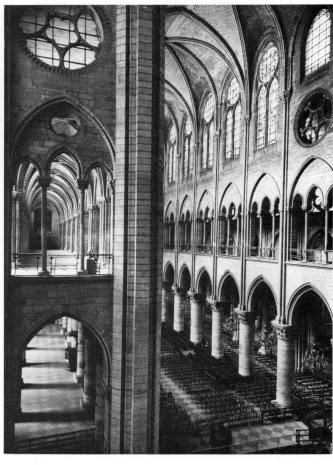

On a small island in the heart of Paris is perhaps one of the best known of all Gothic cathedrals, Notre Dame. Begun in 1163 and worked on for about a hundred years, it was never finished, since the two square towers at the front were originally to be the bases for impressive spires. The interior view from the transept shows the use of the pointed arch and ribbed vaults. The clerestory windows are huge and reach up to the roof, allowing light to flood the vault itself. Over both double side aisles is a gallery through which monks, nuns, and priests walk while in prayer. The heavy, rounded columns seem Romanesque but are integrated well into the overall construction. The thin, engaged columns extending to the vault add a feeling of lightness and help develop a visual rhythm on the side walls.

Remarkably, the openings in the galleries, the huge windows, and the lower openings between the columns leave little bearing wall to hold up the great weight of the massive stone vault. By looking at the exterior view, one can see how this is possible. Reaching over the side aisles and over the ambulatory of the choir and apse, flying arches (buttressed with towers at the outside of the church) lean against the walls at a point between the windows where the vault starts on the inside. The thrust of the vault is absorbed by the arches and buttresses in a way as to be functional as well as aesthetic. The exterior view also shows the huge rose window at the end of the transept and the immense choir, used for all the clergy and the pageantry of the Paris cathedral. The delicate tower over the crossing was added at a later date.

Although there are many other cathedrals that can be used as examples, two other French churches are especially interesting. Reims Cathedral has an interior arrangement similar to Notre Dame in Paris, with an immense choir that takes up about half the length of the building. The kings of France were often crowned here so the space needed for the pageantry was extremely large. But the west facade of the Reims Cathedral is fascinating. Solidity and heaviness have been replaced by openings and lightness. You can actually see through the facade (on the second level over the outside portals) to the flying buttresses of the nave. The towers are not solid at all but are carved stone openings of delicate tracery. Over each portal, the usual carved tympanum is replaced

by a window, also with stone tracery. Only at the third level is the facade solid and here it is full of carved niches holding full-figure, sculpted portraits of French kings. The rest of the facade is full of sculpture: in the portals, over the portals, in other niches, and on platforms. Each pinnacle is carved with knobs and protrusions to create a delicate and airy feeling. The towers were designed to hold huge spires, which were never built. The human figure at the bottom creates a sense of scale for the size of the cathedral.

In Amiens Cathedral, Gothic architectural style reached its climax. The soaring effect of the interior is dramatically overpowering. The ribbed columns, rising uninterrupted from floor to vault, seem much too slender and graceful to hold up the heavy, stone vault. The clerestory windows are immense, separated only by the thin columns, and create the visual sensation of the vault floating without support above the glass. These windows together with the tracery openings of the middle level gallery (triforium) and the large arched spaces below, almost eliminate the feeling of any walls at all—the ultimate goal of Abbot Suger when he started to work on his church in Saint-Denis. The view is from the choir toward the entrance with the rose window (12.1 meters in diameter) above the main portal. By looking at the ribs in the vault, one can see where the transept crosses the nave. A view directly up at the cross vaults reveals the incredible amount of glass and the small visible columns that support the stone vault.

West facade, Cathedral of Reims, about 1225–1299. France

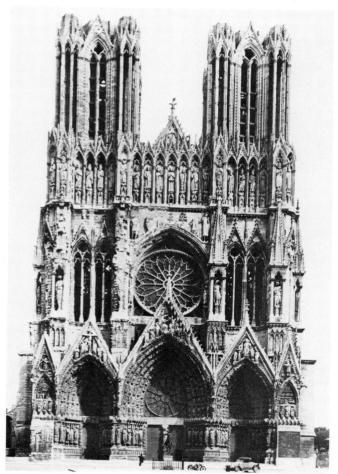

Interior, Cathedral of Amiens. Cross vaulting.

Interior of nave, Cathedral of Amiens, begun about 1220. France

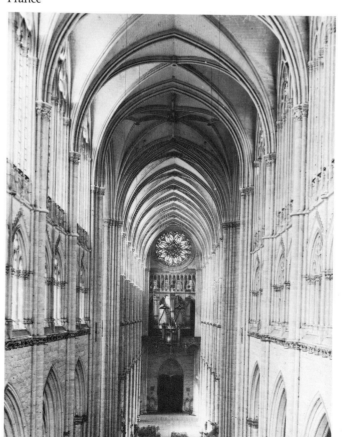

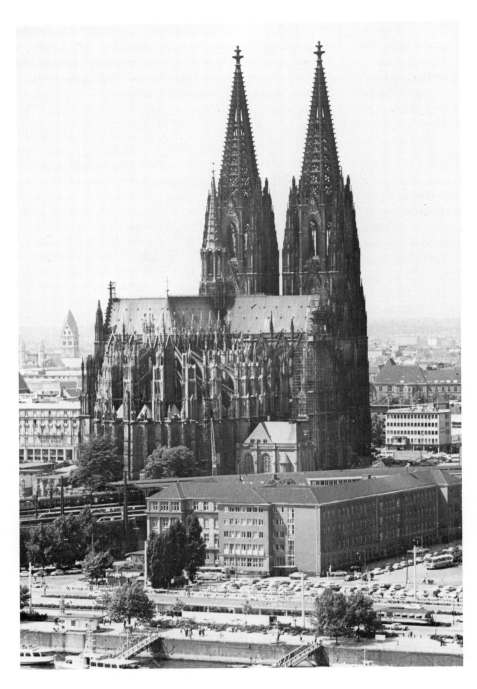

Cathedral of Cologne, 1248–1322. Germany

In Germany, the cathedral erected at Cologne is the largest in the country. Built to resemble French cathedrals in plan, it was not a popular design in Germany. Later builders designed churches with high side aisles and wide interior spaces called *hallenkirche* or hall churches. But the architects and builders of Cologne succeeded where many French builders had failed—in the construction of the spires. Two huge masses of stone tracery, so open that one can see through them, stand at the facade and dominate the skyline of Cologne. They are both massive and delicate, heavy and light as they reach heavenward. The ring of flying buttresses surrounding the choir appears to be a forest of stone. Notice the height of the towers and the mass of the structure when compared to the large buildings around the cathedral, which is built on the site of an old Roman town on the Rhine River. This cathedral continues to dominate the skyline of Cologne, even today.

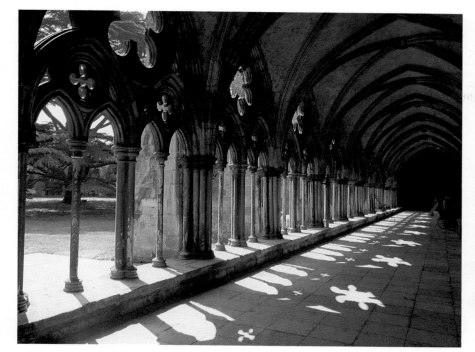

Cloister, Salisbury Cathedral

Fan vaulting. Chapter House, Salisbury Cathedral

Across the channel in England, the Gothic style spread rapidly, dotting the countryside with spires and square towers, calling attention to structures that combined French ideas and Norman influences. Compared to French cathedrals, the Salisbury Cathedral is low and wide, since the builders did not desire a soaring effect. Sculptures fill the horizontal bands of the screenlike facade and only a few flying buttresses can be seen. The tower over the crossing is Salisbury's crowning achievement. It reaches over 122 meters into the English sky, but is solid and not highly sculptured when compared to continental steeples, and is in keeping with the purity of the Norman building style.

A beautiful cloister is attached to the Salisbury cathedral. Notice the garden through the carved tracery arches of the covered walkway. Massed columns and ribbed cross vaults are characteristic features of the early Gothic style in England. In later English Gothic architecture, the ribbing becomes extremely decorative, as in the vault of the Chapter House of the Cathedral at Wells. Here small clustered columns seem to be transformed into ribs for the vault and create a feature called *fan vaulting*. So elaborate was the rib work done at a later time that the final style of Gothic art in England is called *Flamboyant Gothic*.

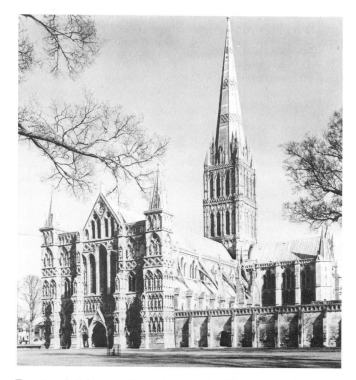

Exterior, Salisbury Cathedral, begun in 1220. England

Cathedral of Florence, 1296–1436. Italy

Cathedral of Siena, begun about 1288. Italy

In Italy, only Milan Cathedral has the feeling of French Gothic, with other cathedrals taking on a distinctive Italian flavor. Florence Cathedral, a massive marble structure dominating the city, was designed in 1296 by Arnolfo di Cambio. Its main feature, the huge octagonal dome as wide as the nave, was not added until the Renaissance architect Filippo Brunelleschi finished it in 1436. Windows are small, and the feeling is horizontal rather than vertical. Inlaid marble panels match the exterior of the Romanesque baptistry across the street. Large wall spaces were needed in Italy to accommodate their favorite fresco painting technique, therefore large windows, so important in France and Germany, were kept to a minimum. The white bell tower was designed by the painter Giotto in 1334 and completed after his death.

Siena Cathedral is a zebra-striped marble church with an elaborate facade covered with statuary and mosaics. A dome and lantern stand over the crossing and the campanile with its interesting window arrangement pierces the sky. The striping continues in the interior which also has a magnificent marble inlaid floor with dozens of narrative illustrations. Even the exterior pavement is decorated with inlaid marble. Except for the time in history and the builders' desire to construct beautiful sanctuaries for the glory of God, most Italian Gothic churches have little in common with French Gothic style to the north.

Although the construction of cathedrals dominated the building activity of the Gothic period, municipal buildings also were erected in major cities all over Europe. Some appear to be like churches while others have used the features of Gothic construction in different ways. Like the cathedrals, all the buildings shown here are still in use after six hundred years or more, attesting to the skill of the architects, engineers, and masons.

The Palazzo Publico is the city hall of Siena, Italy and its 100-meter-high bell-tower is the highest in the country. Towers of similar style dot the Tuscan landscape, but Siena's is the proudest and most beautiful. Begun by Sienese merchants in 1288, the building's lower story is of stone while the rest is brick. Only part of the structure is seen here, but the arches (round inside of pointed) and the porch are typical of the Sienese Gothic style. Part of the beautiful city square (piazza) can be seen in the foreground.

In Venice, the Palazzo Ducale (Doge's Palace) is a lacey network of marble with a large arcade on the first level and open gallery or triforium on the second level, similar to the interior wall plan of a French Gothic cathedral. On the top story only small windows pierce the walls, but the colored pattern in marble keeps this level from seeming too heavy. The lower columns seem to be sunk in the ground but they were not always so. The three steps on which they rest have now sunk with the subsiding Venetian ground level. The building has a very unified feeling and from its surface reflects light and color, two natural ingredients that will continue to fascinate Venetian artists for centuries.

Palazzo Publico, begun 1288. Siena, Italy

Palazzo Ducale, 1340–1424. Venice, Italy

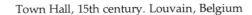
Town Hall, 15th century. Louvain, Belgium

Belfry of the City Hall, 1376–1482. Bruges, Belgium

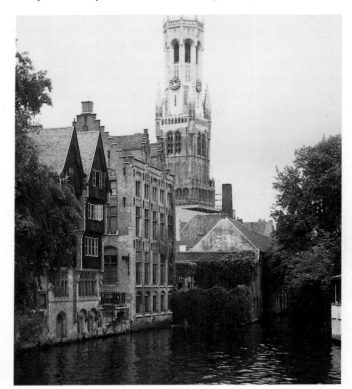

In northern Europe, municipal buildings vie with cathedrals for ornateness and beauty. The town hall of Louvain, Belgium is built in the flamboyant Gothic style of the fifteenth century. It has an elaborate surface which sparkles with reflected light. There is hardly a square meter of uncarved or undecorated surface and the incredible amount of stone tracery produces a lace-like feeling in many places.

The Belfry in Bruges, Belgium is an enormous brick and stone tower begun in 1376 but not completed until the octagonal portion was added in 1482. It dominates the small city which contains many other Gothic buildings, and its carillon of 47 bells (27 tons) can be heard for miles around. It is similar to many Gothic belfries constructed in the fourteenth century in the Low Countries but is larger than the rest.

SCULPTURE

The revolutionary changes in Gothic architecture were duplicated in the evolution of sculpture from Romanesque decoration to important individual works, and a revitalization of the Classic sculptural tradition. The change was slow but constant as artists were given the freedom to work with increasingly natural human, animal, and plant forms. The rigid symbolism of Romanesque sculpture gave way to a new awareness of the natural world.

Early Gothic sculpture began at Saint-Denis, but the earliest existing examples are on the west facade of Chartres, done about 1150. The three portals are filled with sculpture on the tympana, in the archivolts, and on the door *jambs*. The *Four Ancestors of Christ* are from the

Jamb statues. St. Stephen, Empress Kunigunde and Emperor Henry II, about 1235–1240. Sandstone. Bamburg Cathedral, Germany

Four Ancestors of Christ. Jamb statues, about 1150. Stone. Cathedral of Chartres, France

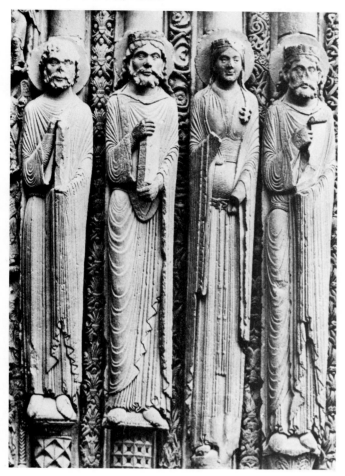

Toothache. Capital from south transept, Wells Cathedral, about 1250. Stone. Wells, England

central door jamb and are extremely elongated. The drapery is still stylized and flat, often just chiseled lines. The statues appear to be part of the columns and have a Romanesque quality seeming to lack the ability to move. In spite of the early date, there is some individualization of the faces. The feet seem to be floating over the sloping platforms instead of resting on them.

The figures on the door jamb of the Bamberg Cathedral illustrate the change that had occurred by the late Gothic period. Carved in sandstone about 1235 and almost casual in their stance, they seem to be free of the columns and are sculpted in the round. Their faces are individual, each having a different expression. The drapery is loose and the folds are fully carved. The naturally proportioned bodies beneath the garments seem actually there and almost capable of movement. Their feet rest naturally on flat pedestals. They simply have a more natural look because the artist was free to sculpt without the previous restrictions which the church imposed.

Not all sculpture in churches was religious in subject matter. Contemporary people and events often shared cathedral space with saints. The man with a toothache is from the capital of a column in the transept of the cathedral in Wells, England.

Virgin and Child, about 1475. Limestone, 90 cm high. From castle of Gisors, near Rouen. William Rockhill Nelson Gallery of Art, Kansas City

TILMAN RIEMENSCHNEIDER. *Three Helpers in Need*, about 1494. Lindenwood, 53 cm high. The Metropolitan Museum of Art, New York, The Cloisters Collection

The highest Gothic expression in Spain occurred in magnificent altarpieces which were really carved screens that separated the altars from the windows behind them. The incredible detail in the Toledo Cathedral altarpiece was designed by Peti Juan, but carved in wood by artists from Holland, France, Germany, and Spain. The figures illustrate fifteen events in the life of Christ and are painted in brilliant color. There is a multitude of other painted figures, and the entire altar is woven together with incredibly detailed carvings of Gothic spires, needles, platforms, and canopies which are covered with gold. It is an elaborate and decorative way of presenting the New Testament happenings to Toledo's churchgoers.

The *Virgin and Child* are from the private chapel of a castle near Rouen, France. Carved from limestone and originally painted, they are carved completely in the round—to be viewed from all sides. They have broken away from the architecture and stand on their own as a work of art, not as part of a cathedral, chapel, or column. The pose and the drapery are natural and there is a delightful interplay between the child and his mother, something that is quite human. The cycle of Classic-Roman-Early Christian-Romanesque-Gothic-Classic will be full and complete with the next step—the Renaissance.

While many artists and craftspeople of the Middle Ages worked anonymously (in the tradition of subordinating their fame and working for the glory of the church), several became well known because of their extremely fine work. Among them are Tilman Riemenschneider of Germany and Claus Sluter of Holland. Riemenschneider was the last of the great altarpiece carvers of Germany, specializing in elaborate and detailed wood sculpture. *Three Helpers in Need* is part of a larger group of fourteen figures carved for a church altar in Würzburg, Germany. The three are Sts. Christopher, Eustace, and Erasmus. All fourteen were saints that were turned to for help in times of pestilence, tragedy, storm, sickness, and travel. Such saints were easily identified by medieval people because the symbolism was well known: Christ on the shoulder of St. Christopher (his head and hand are unfortunately missing), St. Eustace with his knightly attire, and St. Erasmus with the spindle around which his entrails are wrapped because he was believed to have been martyred by disembowelment. The compact group is carved in lindenwood and is unpainted. Only a few masters like Riemenschneider could attain such realism in carving wood that their work need not be painted. The complex interweaving of line and form in the folds of cloth and the placement of the figures are characteristic of the artist's work. It creates a rather restless feeling that is repeated in the expressive, somber faces and the long hands and fingers. Although done about 1494 while the Renaissance was exploding in Italy, it is Gothic in form and content because northern Europe adhered to the Gothic style far longer than Italy.

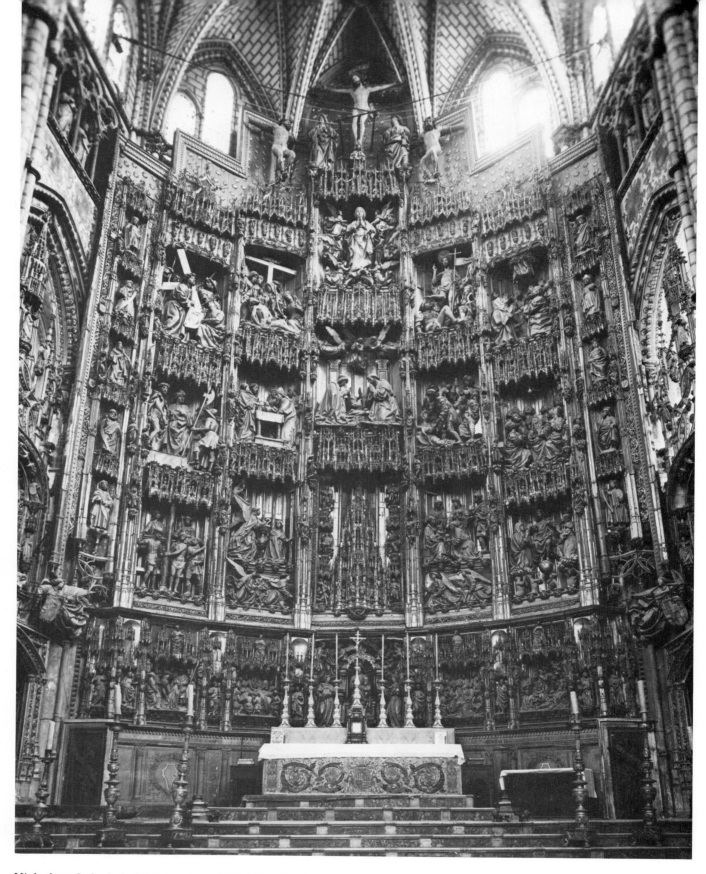

High altar. Cathedral of Toledo, about 1498–1504. Wood, paint, and gold. Spain

Although Claus Sluter was born in Holland, his greatest work was done in France, particularly at Dijon for the Duke of Burgundy. Sluter brought new zest and ultimate realism into Gothic sculpture. His work is so strong and his style so individualistic that it could be placed in the Renaissance period. *Moses with Two Prophets* is a masterful statement in marble. The facial expression is intense and powerful—more than merely natural. Moses has returned from Mt. Sinai with the tablets of the law in his right hand. The horns on his head had become a traditional symbol for the prophet as he returned from facing God (a symbol derived from an errant translation of the Old Testament story). His full and parted beard and the lush, flowing robes create a dynamic rhythm and visual movement that leads up to the expressive face. The sculpture was part of a large carved monument, much of which has been lost. Because only the fountain part remains, it is known as the *Well of Moses*.

CLAUS SLUTER. *Moses with Two Prophets*, 1395–1404. Marble, figures about 2 m high. From the *Well of Moses*, Carthusian Monastery of Champmol, Dijon, France

STAINED GLASS

The entire twelfth and thirteenth century cathedral in the north became a framework to hold stained glass, which would have pleased Abbot Suger. The techniques of producing glass sheets with brilliant color were initiated during the Romanesque period, but they reached their peak in the magnificent windows of Gothic structures. The glowing colors are achieved when light passes through the glass which can be cut to fit the shapes the artist requires. A full scale line drawing (called a *cartoon*) was first put on a large board, then sheets of glass placed over it and cut according to the lines. These pieces were then put together like a giant jig-saw puzzle, and later held in place with I-shaped lead strips, soldered in place. Carved stone tracery or iron bars were used as supports to hold the entire window flat when set upright in place. Before assembly, paint was applied in certain places to create shading, lines, and details, and the individual pieces were fired in a *kiln* to harden the pigment.

Reds and blues dominated Gothic color schemes, although many other colors also were used. These deep hues darkened the interiors of churches causing the windows to glow like huge jewels. Much original glass has been destroyed, but the remains indicate that the windows were brilliantly colored visual teaching aids for the church.

The huge rose window (13 meters in diameter) and the lancet windows below are from the south transept of Chartres Cathedral. One of four rose windows in the church, this one features Christ at the center while the lancets symbolize the evangelists, writers of the New Testament. The dark spaces between the medallions that make up the rose window are carved stone that appear as silhouettes from the inside.

The single large window from Chartres is from the upper level and shows St. Denis presenting his red banner to the knight who donated the window to the church. This interesting custom of showing the donors in the work they contributed, often with saints, Christ, or the Virgin Mary, was used in forty windows at Chartres. It also occurred in many paintings of the period and even later in the Renaissance. In this window

Rose windows and lancets, 13th century. Stained glass, diameter of rose window, 13 m. Cathedral of Chartres, France

St. Denis and Jean-Clement, 12th century. Stained glass. Cathedral of Chartres, France

one can see some of the lines and shading that were painted onto the glass, although it is often hard to distinguish the painted lines from the lead lines.

The incredibly complex windows in Sainte-Chapelle in Paris are the ultimate in Gothic architectural decoration. Built by Louis IX (later known as St. Louis) in 1243, the small chapel has no side aisles and no flying buttresses. But the windows are magnificent. They are huge for the size of the small chapel and extend from several meters above the floor in single panels to the vault. Nowhere else is the feeling so strong that the glass is holding up the vault because the columns between the windows seem so thin and fragile. The pieces of glass are cut very small and illustrate Bible stories in the medallions. Those at the top become so small that viewers have difficulty reading the detailed pictures. In sunlight, all details are blurred by the brightness and the entire chapel seems to glow with brilliant color.

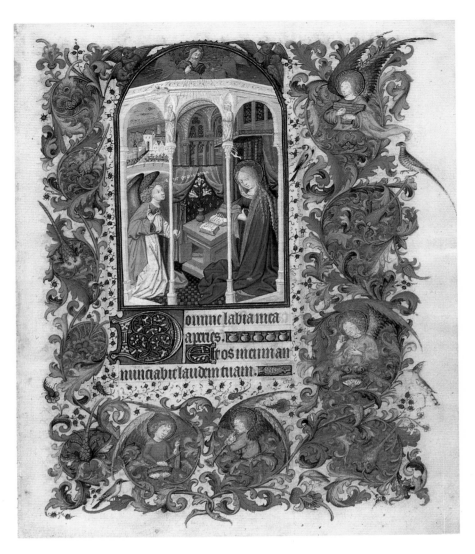

Annunciation Page from French *Book of Hours*, 1440. Tempera and gold on parchment. Huntington Art Gallery, Pasadena

LATE GOTHIC PAINTING

Because the huge stained glass pictures took over the task of illustrating the Bible in northern European cathedrals, architectural painting was kept to a minimum. Some altarpieces were painted, but most French religious painting was restricted to manuscript illumination. *The Annunciation* page from the French *Book of Hours* (1440) is an extremely complex and interwoven decoration of angels playing instruments surrounding an illustration of the scene. The angel Gabriel is telling the Virgin Mary that she will be the mother of Christ. In the single illustration one can see a tiny landscape outside and a cathedral-like setting inside; God the Father (at the top) presides over all the events. The words are Mary's response to the angel. The fantastic border includes flowers, leaves, scrolls, birds, and fanciful designs.

The page from a vellum choir book was painted in tempera and gold leaf by Nicolo da Bologna in Italy.

Many late Gothic illustrators were not monks or nuns but talented lay people working in studios such as Nicolo's in Bologna. Many illustrations were also for non-religious and civil books. This page has a large initial P in which Christ's ascension is illustrated. Notice the figures along the shaft of the P and the four-line staffs for the square notes. Choir members chanted part of the service from such pages.

An exciting departure in Italian painting took place in the thirteenth century because of a change in the religious ceremony of the church. Until then the mass had been celebrated with the priest behind the altar, facing the people (as it is done again now). But the priest's position was changed so that he faced the altar from the front, thus freeing the space behind and above it for large works of art. Large painted crucifixes of wood began to appear in this space. They were painted with egg tempera, a technique discussed earlier in the book.

NICOLO DA BOLOGNA. Detail from a choir book, artist lived 1330–1401. Tempera and gold on vellum, 74 × 53 cm. Los Angeles County Museum of Art, gift of Anna Bing Arnold

A similar format to the one used by the Master of San Francesco was followed (*See* p. 34). Christ is shown with his body in an S-curve, his head tilted forward, and an expression of pain on his face. Here, Mary and St. John flank the main shaft of the cross with supporting angels on each side arm. The words above are Latin stating that Christ is the King of the Jews. The small figure at Christ's feet is probably the patron who commissioned the work. Christ was always at the center, but other figures could be at the side in similar crucifixes. In Italy, such crosses over altars gradually gave way to figures of the Virgin and the Christ Child painted on large wooden panels.

Giotto (1267–1337) When Giotto was a boy of ten, he was tending his father's sheep and spent much of his spare time making drawings of them. One day an Italian gentleman from Florence saw the young boy working on his drawings and went to Giotto's father to ask permission to make the boy one of his apprentices. The gentleman was Cimabue who was one of the most respected painters in Florence from 1272 to 1302. Giotto's father was honored to have his son study with the master and sent him happily to Florence where Giotto would soon revolutionize Medieval painting. Florence, readying itself to become a leading center of the Renaissance, was already vigorous, dynamic, and experimental, unlike other Italian cities of that time. Here Giotto went to work, to become recognized in his own day as one of the great men of Florence—the one who revived the art of painting from nature. Giotto's paintings may not seem revolutionary today, but since Roman times, no one had tried to paint from nature because everything was meant to be symbolic.

Giotto's *Madonna and Child* was probably part of a large altarpiece for a church in Florence. Suddenly the two figures are not symbols but real people—solid, heavy, and three-dimensional under the robes. The faces and hands are shaded with darker values to appear rounded—not flat. The folds in the cloth also are depicted realistically. The figures are not painted flat on the gold background but seem to stand in front of it as rounded forms. Finally, the Christ Child, holding his mother's finger while reaching for the flower in her hand, is acting tenderly and naturally. The halos are

GIOTTO. *Madonna and Child*, between 1320 and 1330. Tempera on wood, 86 × 62 cm. National Gallery of Art, Washington D.C., Samuel H. Kress Collection

GIOTTO. *Lamentation* (or *The Pieta*), 1305–1306. Fresco. Arena Chapel, Padua

more like decorations on the background than floating circles about the heads of the figures. Compare this image with the Byzantine icon painting, *The Virgin and the Child Enthroned* (*See* p. 190).

Giotto's masterpiece is a series of forty major paintings. Working between 1305 and 1306 in a private chapel in Padua, not far from Venice, Giotto illustrated the lives of Christ, the Virgin, and her family. In the Arena Chapel, so called because it was built on the site of a Roman arena, he used the fresco technique to fill the walls with three bands of powerful paintings and a judgment day scene on the entrance wall. The *Lamentation* (or the *Pieta*), one painting in the series, appears to

be enacted on a shallow stage by a group of real people. The figures are in active, natural poses: leaning, holding, sitting, and bending. They are monumental and solid, with large folds in their robes suggesting weight and mass. Notice how the shading creates a sense of roundness and natural light coming from above. Giotto studied people's hands carefully as those of St. John's reveal, whose right hand reaches back into space in the center. Finally, a hint of natural landscape and sky (not a gold background) enhances the reality of the event.

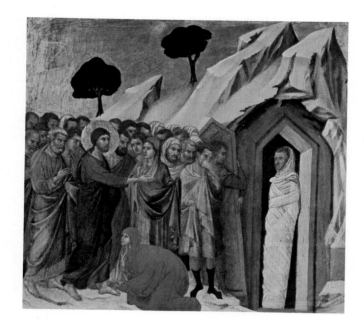

DUCCIO. *Christ Raising Lazarus from the Dead.* Tempera on panel, 43 × 46 cm. Kimbell Art Museum, Fort Worth

The center of interest in the painting is Christ who has been taken down from the cross and is being held by several figures. His mother Mary grieves as she searches his lifeless face. Sorrow is expressed on every face as Giotto wants the viewer to experience this emotion. Sorrow and grief have probably never been painted so forcefully up to this time. The angels even weep as they tumble overhead.

The composition of *Lamentation* is asymmetrically balanced. A huge rock form leads the viewer's eyes diagonally across the painting directly to Christ's face. There are many other shapes and lines that also lead there. The bare tree in the upper right, separated from the figures, helps create a feeling of desolation. It also recalls a legend known by all at the time: the Tree of Knowledge in Eden withered when Adam and Eve sinned and would come back to life when Christ fulfilled his work of redeeming humanity.

Giotto was responsible for many other frescoes in several churches in Italy (Assisi and Florence, for example) and was also the designer of the campanile next to the cathedral in Florence. Giotto's students continued his techniques but with less power and waning conviction. Giotto's spirit and ideas on painting would normally place him in the Renaissance, but it was almost a century before that searching and dynamic era would begin.

Duccio (Active 1278–1319) In the town of Siena, a short distance from Florence, the Byzantine tradition remained a strong influence into the fourteenth century, although some drastic changes were made. Duccio, asked to paint a large altarpiece for the cathedral of Siena, worked on it for three years. When it was finished, a holiday was declared. The artist and his masterpiece were paraded through the city, from his studio to the cathedral, accompanied by the ringing of church bells and the blare of trumpets. The altarpiece, called the *Maesta (Madonna in Majesty)* was freestanding, about four meters wide, and painted on both sides. The front contained Mary and the Christ Child as large central figures, surrounded by several dozen apostles, prophets and saints, each individualized to a great degree. Such a work had never been seen before. The back side was covered with dozens of panels, illustrating the life of Christ. Painted in tempera, they were much more detailed than Giotto's large frescoes at Padua.

In one of Duccio's panels, from the Maesta, *Christ Raising Lazarus from the Dead,* a crowd of people surround Christ who now has lost his symbolic robes but not his halo. Faces are individualized and the overlapping bodies suggest spatial depth. Although there seems to be a single light source to create the forms of faces and figures, there are no shadows cast on the ground. Duccio's figures are wonderfully detailed, sensitively drawn, and excitingly colored. They are not as massive as Giotto's and yet they seem to have weight. Small brushes were used in the tempera technique, allowing Duccio to create great detail in such small works, a trait he acquired while painting miniatures in his earlier years. Many of his paintings of Christ contain part of the Sienese landscape and the city itself—a delightful mixing of time and place.

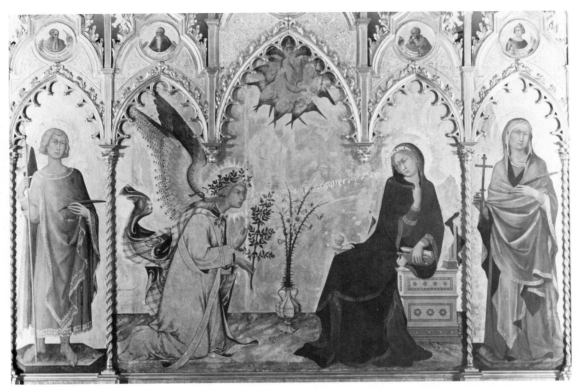

SIMONE MARTINI. *Annunciation*, 1333. Tempera and gold on panel, 270 × 300 m. Uffizi Gallery, Florence

Simone Martini (about 1284–1344) Duccio's pupil, Simone Martini, made a further break with Byzantine tradition. Working in Naples for the French king, he picked up some ideas, techniques, and styles from the French Gothic painters. *Annunciation* is a panel painting over three meters wide with carved wood decoration that almost seems to be a condensed French Gothic facade. The angel Gabriel is dressed in a magnificent gold brocade robe and the Virgin's blue mantle has a deep gold border. This concern for fabric detail and beautifully drawn line is a direct influence of Simone's contact with French artists of the time. Byzantine art portrayed spiritual beauty rather than such material magnificence. The angel's message, "Hail thou that art highly favored, the Lord is with thee," is carved into the wood background which is of burnished gold. Mary recoils from the message in a natural and graceful way, not with symbolic gestures. The two saints were added by the artist's brother-in-law Lippo Memmi. The last four years of Simone's life were spent in Avignon, France, painting frescoes in the Papal Palace.

Ambrogio Lorenzetti (1285–1348) The sculptural solidity of Giotto's work, the architectural space of Duccio's, and the elegance of Simone Martini's are combined in the work of the Lorenzetti brothers, Pietro and Ambrogio. On a fifteen-meter wall of the Palazzo Publico in Siena, Ambrogio painted a fresco representing *The Effects of Good Government in the City and Country*—a panorama too vast to present in one photograph. The left half, seen here, portrays life in the city; the country portion of neat fields and industrious peasants is to the right, outside the gate and walls, and is the first truly convincing landscape in Italian art. The architectural detail of Siena is amazingly real with a variety of buildings, squares, and streets. In the upper left corner one can recognize the cathedral dome and the campanile. Workmen are even constructing a large house in the upper central part while orderly and richly dressed Sienese throng the streets below the terraced city. Beneath the three arches of one building are a shoe shop, a school with a seated teacher and pupils, and a wineshop—all operating smoothly under the guidance of good government. An accompanying mural also shows the effect of bad government on the city and country. Details of clothing, architecture, and commerce are so carefully transcribed that scholars use Ambrogio's murals as a source-book for fourteenth century Tuscany. The artists and the city of Siena appeared ready to jump into the Renaissance, but it was not to be. The Black Death

AMBROSIO LORENZETTI. *Allegory of Good Government: The Effects of Good Government in the City and Country*, 1338–1339. Portion of fresco seen is 3.9 × 7.3 m. Palazzo Publico, Siena

(bubonic plague) swept Europe in 1348, killing half to two-thirds of the population of Florence and Siena (including the Lorenzetti brothers) and delaying the natural development of Italian art.

Gentile da Fabriano (1370–1427) There seems to have been a steady exchange of ideas, themes, and techniques between the artists of Tuscany and those of central France. By the end of the fourteenth century, French and Italian Gothic styles had merged into an International style that was a stronger influence on painters than on sculptors. Claus Sluter was the foremost sculptor in this style (*See* p. 218), and French painters, such as the Limbourg brothers, expanded the painting tradition in the north.

The greatest Italian painter of the International style was Gentile da Fabriano who, like Simone Martini, exchanged ideas with French artists. Gentile's tempera painting of *The Coronation of the Virgin* is a superb example of the style. Under the blessing of the Holy Spirit (the dove) Christ places the tiara on the Virgin Mary, establishing her as the Queen of Heaven. All this is accompanied by singing angels shown in smaller size (less important) in the corners. The gold background, decorative halos, and the smaller size of the angels suggest Byzantine influences, but the figures are certainly of the International style. The skillful rendering of the richly colored and patterned fabrics, the extreme care taken with natural details, and the flowing folds in the garments are typical of the style and of Gentile's work. Never before has cloth taken on such richness and sheen. There is weight to the figures but the illusion is not carried out in the pattern on the floor. The world was still one step from the Renaissance—one step from a true three-dimensional feeling in painting.

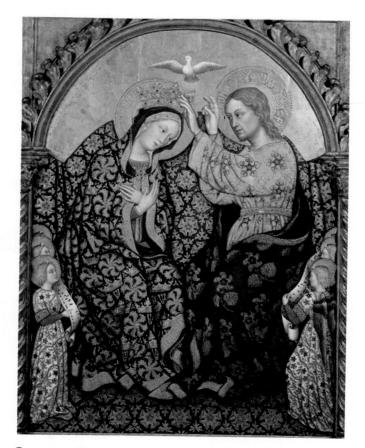

GENTILE DA FABRIANO. *Coronation of the Virgin*, about 1420. Tempera on panel, 93 × 64 cm. The J. Paul Getty Museum, Malibu

1000

Islamic world	Seljuk Turks develop cruciform mosque; Hariri, scholar and poet
China	Song dynasty (porcelain, celadon); Classical Renaissance; Painter Li Kung-lin
Japan	Heian period (to 1185); Phoenix Hall of Byodoin temple at Uji (1053)
India	Medieval period; Khandariya temple; Modhera and Mysore temples; Gujarat shrines
Europe	Leif Ericson to North America; Battle of Hastings; First crusade
Americas	Toltecs dominate Meso-America; Mixtecs united; Period of Tiahuanaco in Andes

1100

Islamic world	Ayyubids rule Egypt; Moors build Giralda Tower and Alhambra; Omar Khayyam writes
China	Song dynasty ends in north, continues in south; Painting academy; Jun and Dzu ceramic
Japan	End of the Heian period (1185)
Korea	Continued Golden Age of Koryo dynasty; Refined arts and crafts
India	Gopuram gateway towers in Mysore; Alampur temple; Vidyashankara temple, Sringeri
S.E. Asia	Angkor Wat completed (1152); Chams defeat Khmers; Buddhist Burmese Golden Age
Africa	Ife culture casts bronze; Terra cotta sculptures made by Yorubas
Europe	Universities at Bologna (1150) and Oxford (1167); Peter Abelard; Magnetic compass
Americas	Toltec, Maya, Aztec cultures; El Castillo built; Imperialist civilizations in Peru

1200

Islamic world	Cifte Minare (1253); Ince Minare (1258); Blue-and-white pottery; use of numerals
China	Yuan dynasty (Mongols in China, Genghis and Kublai Khan); Marco Polo
Japan	Kamakura period (1192–1333); Military shoguns; Great Buddha of Kamakura
India	Temple to the Sun at Orissa; Great Mosque at Ajmer; Rise of Delhi sultans
S.E. Asia	Thais unite under Ram Kamhaeng (Sukothai kingdom); Emissary to Mongol court
Europe	Magna Carta (1215); Mongols in Russia; Dante Aligheri; St. Francis of Assisi
Americas	Inca empire in Peru (1200–1530); Late Nazca and peak of Chimu cultures (1200–1300)

1300

Islamic world	Madrasah of Sultan Hasan, Cairo; Muslims into India; Mamluks rule Syria
China	Yuan dynasty ends; Ming established (1368–1644); Blue-and-white procelain improved
Japan	Kamakura period becomes Namboko-cho era (1336–1392); Kinkakuji at Kyoto
S.E. Asia	Sukothai sacked, Ayutthya established (1350); Majapahit kingdom on Java (1331–1364)
Africa	Ife culture thrives; Production of terra cotta sculpture
Europe	Black death; *Decameron* by Boccaccio; Chaucer; Papacy in Avignon
Americas	Imperial Aztec culture builds Tenochtitlan (1325–1344); Inca empire expands

1400

ART OF OTHER CULTURES

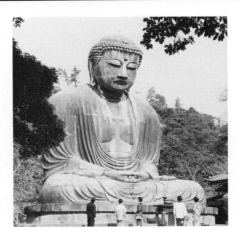

Great Buddha of Kamakura, 1252. Kamakura period, Japan. Cast bronze, 12.8 meters high

To demonstrate that their new capitol was equal to the old Imperial city at Kyoto, the new Kamakura rulers in Japan commissioned the casting of a Buddha image equal in magnitude to the Great Dibutsu at Nara. A tidal wave swept away the surrounding wooden temple long ago, and now the immense casting has the sky for a canopy. Buddhism played a significant role in unifying Japan. During the Kamakura era, new sects, stressing meditation and salvation, influenced the rising samurai class.

Nestorian Christians came to Chang-an and Canton as early as 655, during the Tang dynasty. One of the most unique products of their culture are the bronze crosses. They were produced for hundreds of years—even long after the official persecution of Christians in 845.

Nestorian Cross, 1280–1368. Yuan dynasty, China. Bronze, 7.5 cm across. Fung Ping Shan Museum, University of Hong Kong

This piece was probably made for a Central Asian mercenary soldier on duty in China when the Mongols were incorporating China into their far-flung empire.

After the Siva-worshipping Angkor kings were routed in 1177, the new Khmer king, Jayavarman VII, rebuilt the glories of the Angkor era in the form of a Buddhist temple complex known as the Bayon. Jayavarman commissioned two major projects: (1) huge facial portraits of himself for the exteriors of over forty towers, and (2) historical relief panels showing the attack on his prede-

cessors by the Chams. This panel from the historical series was made by a refined bas-relief technique superior to the contemporary relief carvings on early Gothic buildings in Europe.

Processional Scene from the Bayon Temple, Angkor Thom, late 12th century. Cambodia. Sandstone

INDEPENDENT STUDY PROJECTS

Analysis

1. Study Giotto's painting, *Madonna and Child* (page 221). It was done in the artist's transition period and shows evidence of the coming Renaissance naturalism as well as aspects of Byzantine influence. Under the headings of Byzantine and naturalistic influences, list as many aspects of each as you can find.

2. The dimensions of many Gothic cathedrals are overwhelming. The German cathedral at Cologne has a 46-meter-high nave and 152-meter-high towers. Devise a visual presentation that will graphically compare the size of several buildings in your community with this gigantic Gothic structure. You can also find out the length and width of several cathedrals (from the encyclopedia) and plot them in your neighborhood or on school grounds.

3. Use photographic or video cameras to prepare a visual documentary (bulletin board display, slide show or video program) on:
1) Romanesque and Gothic influences in local architecture.
2) Contemporary stained glass craftspeople and their art.

Aesthetics

4. Using slides or prints, prepare a visual presentation or an illustrated essay comparing one of the following:
1) A Claus Sluter sculpture with one by Michelangelo (next chapter) and with a Romanesque portal sculpture.
2) A basilica floor plan with a late Gothic plan. (Consider size, shape, organization and purpose.)
3) Romanesque and Gothic exterior facades, interior naves or portal sculptures.

5. Arrange a print or slide show that illustrates the changing concept in figure painting (or sculpture) from Greek to Gothic times. Cite dates and describe stylistic changes.

6. What is good and not good about the church's domination of art in the Middle Ages? Discuss examples. What were the alternatives available to people at that time? Write a paper comparing the role of the church in the art of the Middle Ages and in the art of contemporary society. Write a concluding paragraph describing in which culture you feel more comfortable. Explain why.

Studio

7. Using the diagrams on page 198, cut pieces of lightweight cardboard to form models of the various vaults used by Romanesque builders. Or, research and build models of typical Gothic vault construction.

8. The Bayeaux Tapestry (page 204) commemorated an historic event. Using tempera paint and a roll of shelf or kraft paper, several class members can commemorate an important school or community event.

9. Roll out a slab of clay (30 cm high) and cut it into the shape of a typical Gothic cathedral front (see page 209). Use clay tools to make your own facade design. After bisque firing, stain the surface with thinned acrylic paint.

10. Using diagrams or illustrations in encyclopedias or other reference books as a guide, carefully draw a partial side wall plan (interior) of a Gothic cathedral. Use tag board or lightweight cardboard, and then cut out all the window spaces and structural openings to reveal how light and delicate these gigantic structures were in their design.

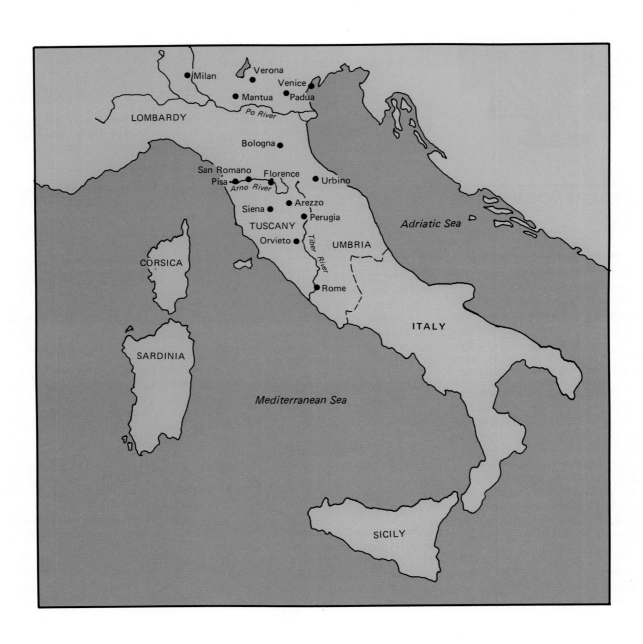

9 The Rediscovery of Humans and Their Environment: The Italian Renaissance

THERE WERE NO BOOMING CANNONS or blaring trumpets to signal the coming of the Renaissance. The people did not carry banners or signs announcing its presence. It was not an instantaneous explosion of artistic and scientific energy after a thousand years of silence. Instead, it was a slowly developing set of ideas that gradually made people aware of themselves, their place in the environment, and their ability to create grand and beautiful works. In fact, it is often difficult to distinguish between works of art classified as "Late Gothic" and those as "Early Renaissance." As the last chapter demonstrated, the bold steps of Giotto, Ambrosio Lorenzetti, Claus Sluter, and others were all on the verge of Renaissance thinking and reasoning.

Renaissance is a French word for *rebirth*. The Italian word is similar (*rinascità*) and was used at the time to signify a new age of developing achievement. It was the first time that people living in a new phase of artistic development were conscious of it themselves. At least the upper strata of society realized it, though peasants and commoners were not aware of much change.

There had been several attempted revivals or small "rebirths" of Classic tradition during the Middle Ages—Carolingian, Ottonian, Byzantine, and even Romanesque and Gothic. But the tremendous changes of the fifteenth century cannot be attributed simply to a revival of interest in Classical antiquity, although it was both springboard and activator. The discovery (or rediscovery) of the world and of humanity was the key. Renaissance thinking established that the world was created for humans, not for God who did not need it. A human being is the most perfect work of God; the body is so beautiful that Christians and pagans alike represent their deities in human form. Human intelligence seems limitless, and comprehension needs to be tried and tested. The works of humans have value in themselves and not only in the service of the church. Arts, science, wisdom, knowledge, and the earth itself are to be used in the service of humanity. This philosophy is *humanism*. It was the secular doctrine of the Renaissance and co-existed in most people's minds with the religious doctrine of Christianity. How the Italians reconciled these two philosophies will be seen later in the chapter.

Renaissance artists were not suddenly relieved of the religious commitments of their Romanesque and Gothic predecessors. They still designed churches and decorated them with brilliant painting and sculpture. Stained glass windows were phased out as a church decoration, and the printed book replaced manuscript illumination. Patronage of the arts (financing the artist and his work) shifted from the church alone to a balance of individual and religious support. This change produced a new market for work that was not exclusively religious in nature—works such as individual portraits, landscape printings, and nude studies. These subjects were all part of God's earthly creation and therefore worthy of artistic presentation. The revival of interest in Greek and Roman philosophy, language, literature and art, together with the growing interest in humanism, propelled Renaissance art into a rapid development.

Versatility was a key to Renaissance greatness. Many of the artists were also writers, such as Alberti, Ghiberti, Albrecht Dürer, and Leonardo da Vinci. Many were scientists also, studying such subjects as geology, botany, anatomy, geometry, and mathematics. Artists often worked in more than one medium and studied Classical literature and the arts. They designed peaceful paintings and weapons of war, church interiors and bridges, city plans and fortifications, sculptures and canals. They explored the scientific aspects of art, such as proportion,

anatomy, and perspective. Artists even dissected cadavers to learn about the structure of human muscles and bones. Such knowledge made the figures they drew, painted, and sculpted more realistic.

Artists in the Middle Ages (even up to the early fifteenth century) were considered craftspeople and belonged to the artisan guilds. They were simply employees in the workshops of their patron, the church. The Renaissance brought a change in that the artists became part of the princely society, working for individual, wealthy patrons. They signed their names to their works of art and were known for the individual creations they produced. By the sixteenth century they were often individuals of great social stature, wealth and influence—artists such as Michelangelo, Raphael, and Titian.

In Italy, this remarkable growth in the arts took place in a setting of political and economic instability, a situation completely different than the age of Pericles. Wars, rebellions, and feuds both inside the church structure and among the various republics, the Papal states, and the duchy of Burgundy threatened the continuity and steady development of the Renaissance. Yet the arts flourished in this disruptive and competitive environment. When the political situation was settled and the republics lost their freedom, the Renaissance came to an end.

The Early Renaissance in Italy

Led by the Medici family of bankers and wool merchants, Florence warded off the dukes of Milan in 1429 and became the political and intellectual leader among Italian cities. Florence became the "new Athens," a city of great cultural achievements and of inhabitants full of energy and ambition. Despite threats to the city's safety, the people embarked on programs to finish the cathedral, build beautiful doors for their baptistry, line the streets with magnificent homes, and plan a city of great beauty.

ARCHITECTURE

Filippo Brunelleschi (1377–1446) Typical of the artistic genius of the Renaissance, Brunelleschi was a goldsmith, sculptor, mathematician, clock builder, and architect. Trained as a sculptor, he discovered scientific perspective: a way of accurately showing three-dimensional buildings or objects on a flat sheet of paper. But his greatest achievement was in architecture where he initiated a new style of building.

After a stay in Rome, where he spent time accurately measuring all the ancient Roman buildings, Brunelleschi returned to Florence in 1417 to design and construct the mammoth dome over the cathedral. His innovative techniques were astounding at the time. The dome was built as two shells, one inside the other, ingeniously linked with ribs and supports so that each helped support the other. The simple proportions of one part to another give a feeling of order to the finished dome. It does not seem huge until it is seen in distant view of the cathedral and the city (*See* p. 212). Usually ramps were used to lift building materials to such height, but Brunelleschi designed a system of hoists which eliminated the need for ramps and scaffolding. He showed succeeding generations of architects that technical problems can be met with scientific approaches and innovative solutions. This was a new concept in the building

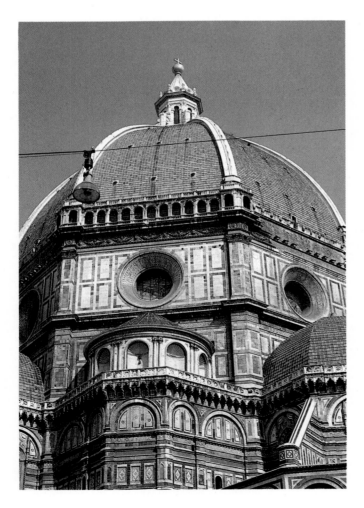

FILIPPO BRUNELLESCHI. Dome, Cathedral of Florence, 1420–1436

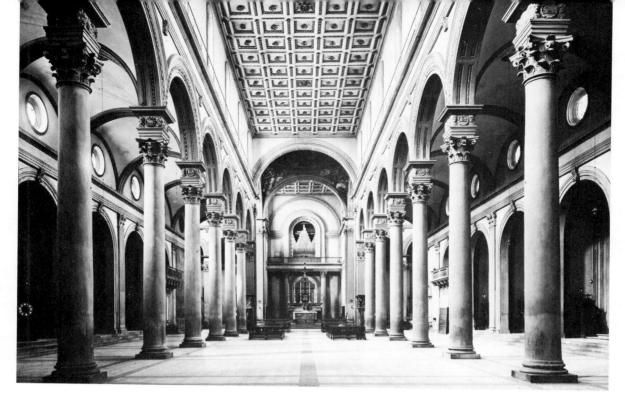

FILIPPO BRUNELLESCHI. Nave and choir, San Lorenzo, 1421–1469. Florence

MICHELOZZO. Exterior, Palazzo Medici-Riccardi, begun 1444. Florence

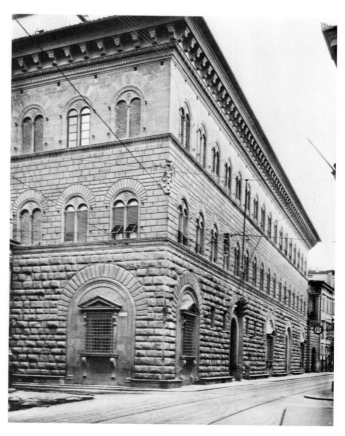

trades which had usually looked to previous structures for such help in solving problems.

Basic geometrical shapes and simple proportions were favorite devices of Brunelleschi, as they were for the Greeks and Romans. While Gothic interiors had become decorative and elaborate, Brunelleschi simplified. In the Church of San Lorenzo, built for the Medici family, he went back to the basilica plan for a simple framework. Lines are clean and walls are uncluttered. He used the square in the coffered ceiling and on the floor as points of visual measurement and as a means of emphasizing the geometry in his design. Contrasted with previous Gothic flamboyancy and movement, Brunelleschi's work tends toward cool and static perfection—a drastic change. His experience in measuring the ancient Roman buildings had helped him arrive at the conclusion that discipline of thought, clarity of design, the proportion of one part to another, and a constant awareness of regular visual rhythm are essential to fine architecture.

Michelozzo (1396–1472) Cosimo de Medici commissioned Michelozzo to design and construct a building for both the family banking business and a residence. The architect built the *palazzo* (in Italian, a large city building) on an almost square plan with a huge interior courtyard not noticeable from the outside. The plan and fortress-like style became the model for several centuries of Florentine construction. The three stories are each different in surface treatment and details, and diminish

in height from bottom to top. The bottom story is cased in rough-hewn (*rusticated*) stones, the second in smooth stones grooved at the edges, and the top in unbroken masonry. The large projecting cornice is derived from the entablatures of ancient Roman temples. Other Classical features can be noted: the round arches and the small Corinthian columns that divide each window. The lower windows were formerly doors for the Medici banking offices; they were later designed and added by Michelangelo. Buildings similar to this one can be seen on many of the streets of Florence today and are still occupied by Florentine offices and residences.

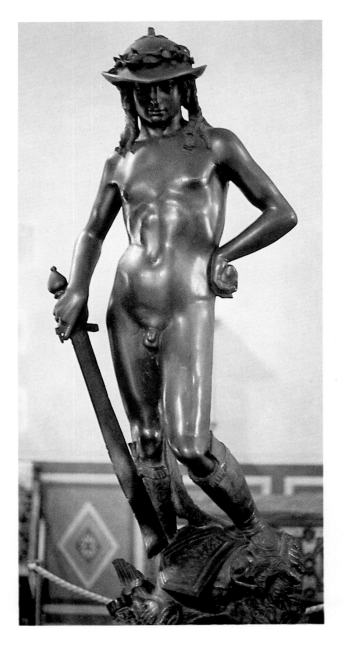

DONATELLO. *David*, 1430–1432. Bronze, 159 cm high. National Museum, Florence

SCULPTURE

In the early fifteenth century in Florence sculptural activity flourished. While the painters were still working on altarpieces and frescoes in the churches, the sculptors were commissioned to create works for exterior niches. Sculpture not only contributed to civic enrichment but provided images of pride, dignity, and self-reliance—attitudes essential to a republic fighting for its independence. Although painting dominated the art of the late Renaissance, sculpture led people into Renaissance style and thinking. Thirty-two lifesize or over-lifesize statues were placed in Florence in a short time.

Donatello (1386–1466) In a city where competition was keen among the artists, Donatello emerged as the greatest sculptor of his time and as one of the greatest ever to live. His work was a combination of Classic style and Renaissance expression. He used the *contraposto* of the Greeks to suggest action, but the facial expressions show the determination and self-sufficiency of the Renaissance. His figures seem capable of movement and can easily be removed from their locations to stand on their own. Although most were sculpted to stand in niches, they are no longer part of the architecture. Throughout the Renaissance and the following centuries, many of Donatello's figures, sculpted in both marble and bronze, looked out over the daily life of the Florentines.

Among his outstanding later works, his bronze *David* is unique. It was the first lifesize, freestanding nude statue since ancient times and must have seemed revolutionary. It stands in a classic contraposto, its body in a slight s-curve with its weight firmly carried by the right leg. The youth's relaxed left foot toys with the severed head of Goliath. The body of the young David is wiry and smooth and its gently swelling muscles contrast vividly with the crisp, straight edge of the sword and the shaggy head below. Donatello's faces are usually very expressive, but David's seems calm and serene—almost Classical—while the face of Goliath is horrifying. Commissioned by Cosimo de Medici, it was designed to be viewed from all angles and to stand free of any wall or niche. David's head is crowned with contemporary fighting headgear and a laurel wreath—another combination of ancient and contemporary traditions. Throughout the Middle Ages, David's victory over Goliath was symbolic of Christ's victory over sin and

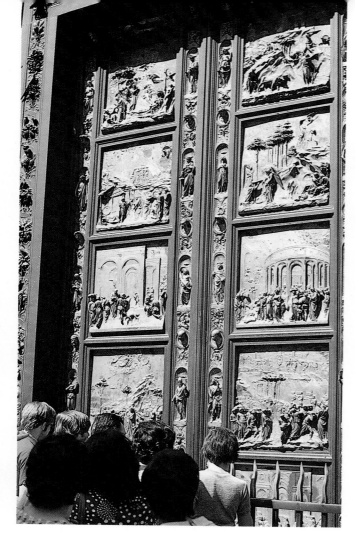

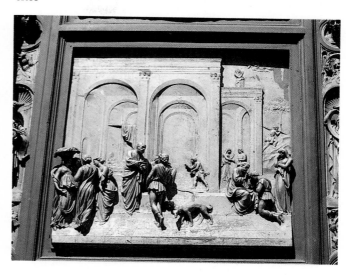

Lorenzo Ghiberti. *Gates of Paradise*, 1425–1452. Gilded bronze relief. Baptistry, Florence

Lorenzo Ghiberti. *The Story of Jacob and Esau* (detail, baptistry doors), 1425–1452. Gilded bronze relief, 80 × 80 cm. Florence

death, yet to the Florentines it became symbolic of the victory of the small and self-sufficient over the brute force of much larger opponents.

Donatello was called to Padua in 1443 and commissioned to sculpt a huge equestrian statue to place before the Basilica, where it still stands. The subject was a Venetian general, nicknamed *Gattamelata* ("Honeyed Cat"), who had died before the artist arrived in Padua. Undoubtedly drawing his ideas from the Classic statue of Marcus Aurelius in Rome, Donatello's bronze creation is huge in size and mounted on a high pedestal. The horse is gigantic but is controlled by the domineering will of its rider, whose face is a powerful and idealized portrait of the general. The visual rhythms are beautifully coordinated, from the arched tail to the arched flank to the arched neck. Three legs seem to support the gigantic weight while the fourth hoof toys with a cannon ball. It was the first large equestrian statue of the Renaissance and the first over-lifesize horse and rider since ancient Rome.

Lorenzo Ghiberti (1381–1455) Following an intense competition with many artists (including Brunelleschi) the twenty-one-year-old Ghiberti won the commission to design and sculpt the north doors of the baptistry in Florence. The two doors took over twenty years to complete, and the twenty-eight panels illustrate stories from the New Testament as well as other figures. They were received so well that Ghiberti was commissioned to do the final set of doors on the east side, which was to become his masterpiece. Later called *The Gates of Paradise* by Florentines, they were very different from the previous work. Instead of so many small panels, Ghiberti divided the space into ten large, square panels. Rather than using stagelike space as before, he adopted pictorial space and one point perspective (originated by Brunelleschi) which produced convincing depths on a relief surface. Look particularly at the panel with the arches, *The Story of Jacob and Esau*, and notice how the space creates an illusion of reality. The size of figures diminish as they recede in space; parallel lines lead to a single vanishing point; and detail becomes simpler as it gets farther away. Several of the closer figures seem to project out in space in front of the panel. While his first doors contained remnants of Gothic sculpture, these doors are truly works of Renaissance art and thinking. In Ghiberti's own words: "I did my best to observe the correct proportions, and endeavored to imitate nature as much as possible. . . ." The doors are cast bronze, covered with gold.

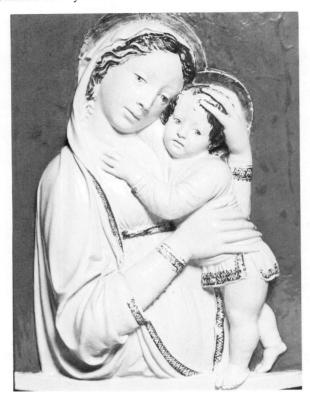

LUCA DELLA ROBBIA. *Madonna and Child*, 15th century. Glazed terra-cotta, 81 cm high. The Detroit Institute of Arts, gift of Founders Society from Octavia W. Bates Fund

Luca della Robbia (1400–1482) Although marble and bronze were the primary sculpture materials used in the Renaissance, Luca della Robbia's favorite material was glazed terra-cotta or clay. Although he was considered a master in marble at an early age, he gave it up in favor of clay relief figures, a process which he pioneered and developed into a successful family enterprise. The *Madonna and Child,* typical of his work, is glazed white with traces of color in the trim and hair. His figures combine sweetness and solemnity, characteristics that made his work extremely popular. Often multi-colored garlands of fruit and flowers decorate his reliefs, adding the touch of nature and realism which he enjoyed.

PAINTING

Almost a hundred years had passed since Giotto painted his magnificent and daring frescoes on the chapel walls in Padua. His followers attempted to continue his style but Italian painting was still dominated by the Byzantine influences of the Late Gothic artists in Siena. The International style had invaded Italy when Gentile da Fabriano (*See* p. 225), just returned from Burgundy, brought a new realism to Florence in the painting of a beautiful nativity. Two years later, a young man painted a chapel wall in Florence, and Renaissance painting was underway. Although innovations in architecture and sculpture had led the way by several years, painting would soon become the dominant art form of the Renaissance.

Masaccio (1401–1428) Only twenty-seven years old when he died, Masaccio revolutionized the art of painting when he was in his mid-twenties. He had studied the International style of Fabriano and combined its visual perspective and fascination with texture with the monumental forms of Giotto to initiate Renaissance painting in Florence. His *Tribute Money*, a fresco in the church of Santa Maria del Carmine, is one of only several paintings done by the young genius before his untimely death. The story is taken from the Bible and illustrates three succeeding events at the same time. Christ and his disciples are confronted by a Roman tax collector and asked to pay tribute to Caesar (the central group of figures), and Christ is sending Peter to the lake. Peter goes to the Sea of Galilee and finds the tribute money in the mouth of a fish (at left) and pays the tax collector (at the right). Although the story probably helped the government convince the Florentines to pay taxes in support of their war against Milan, it is not the depicted event that is important.

Masaccio has used light as never before in a painting. It is not difficult to see that there is a single source of light coming from the right side. Notice how it brightens up the right part of every figure and casts a dark shadow on the left sides. It seems to make the forms of rounded legs, massive folds, expressive faces, and three-dimensional bodies occupy real space. No longer is there any indication of flatness or invented light. The light is real. To add to the illusion of reality in the chapel painting, the figures appear to be illuminated by the light from the window just to the right of the painting.

Where Giotto's painting had a depth of only several feet, as on a stage, Masaccio's depth seems endless. Look past the figures to the lake, to the diminishing trees, and over several ranges of hills to the bluish sky. The parallel lines of the building converge to a single vanishing point above the head of Christ, whose face was used as a model by painters for many years. The halos still persist, but the bodies are no longer of the Middle Ages. They are solid and sculptural, convincing and natural, and seem to exist under the naturally falling folds of heavy cloaks.

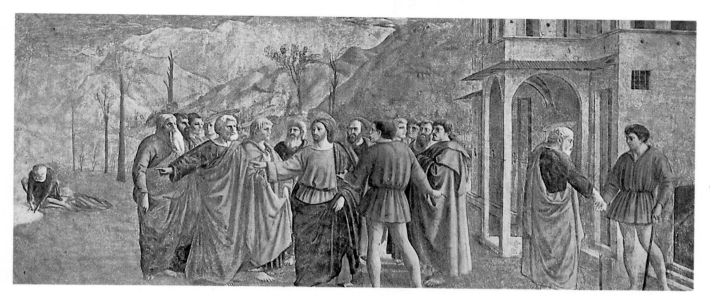

MASACCIO. *Tribute Money*, 1427. Fresco, Brancacci Chapel, Santa Maria del Carmine, Florence

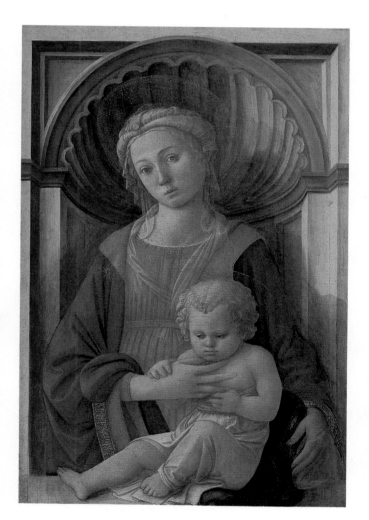

FRA FILIPPO LIPPI. *Madonna and Child*, 1440–1445. Tempera on panel, 80 × 51 cm. National Gallery of Art, Washington D.C., Samuel H. Kress Collection

Fra Filippo Lippi (1406–1469) Because of his early death, Masaccio had no pupils and therefore no one to carry on his style, thus leaving a gap in the evolution of Renaissance painting. As a young monk, Filippo watched Masaccio at work in the chapel and decided to become a painter. He painted religious subjects such as madonnas, annunciations, and nativities but used real people as models. He followed the lighting and perspective of Masaccio's work but incorporated the delicacy and detail of Fabriano's. In his *Madonna and Child* he places the two beautifully drawn figures before a shell-like niche which is convincing in its depth. Careful attention to light and shadows is essential to the correct modeling of the figures, and the faces of both mother and child are sensitively done. The almost transparent, gauzelike cloth so marvelously painted by Filippo will appear again in the work of his pupil, Botticelli.

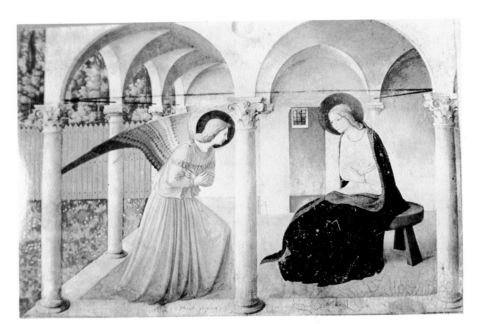

FRA ANGELICO. *The Annunciation*, 1440–1450. Fresco. Monastery of San Marco, Florence

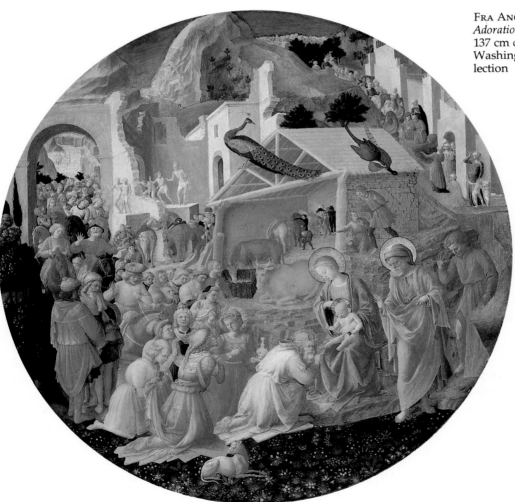

FRA ANGELICO and FRA FILIPPO LIPPI. *Adoration of the Magi*. Tempera on wood, 137 cm diameter. National Gallery of Art, Washington D.C., Samuel H. Kress Collection

ANDREA DEL CASTAGNO. *David*, 1450. Tempera on leather, 115 × 77 cm. National Gallery of Art, Washington D.C., Widener Collection

Fra Angelico (1400–1455) Before Guido de Pietro entered the Dominican order and changed his name to Fra Angelico ("Fra" means "Brother"), he was already a painter in the Late Gothic tradition. He became a prior or high ranking administrator of the Monastery of San Marco in Florence and filled its walls with lyrical frescoes, such as *The Annunciation*. The figures of the angel Gabriel and the Virgin Mary seem tender and frail compared to the powerful work of Masaccio or Giotto, whom Angelico admired. They are placed in an arched and vaulted porch which is painted in careful perspective. The landscape to the left gives a glimpse of the artist's interest in nature.

Landscape painting, at which Fra Angelico was the Florentine master, also appears in the *Adoration of the Magi*, a *tondo* painted in tempera on wood. It is the work of both Fra Angelico, who left it unfinished when he went to Rome, and Fra Filippo Lippi who finished it. It reflects the past in its decorative color and line but also foretells the future of Renaissance painting. Mary and the Christ Child are the focal point around which the painting revolves. A richly dressed group of wise men together with hordes of other figures in fine clothing are paying them homage. Although not accurate in every way, the perspective of the artists shows great depth of space. The introduction of nearly naked figures of boys watching the procession hints at the future Florentine fascination with figure painting while the animals and people in the stable foretell the painting of common, everyday subjects. The landscape elements of flowers, trees, mountains, and sky indicate a Renaissance mind interested in nature. In this single painting we see a farewell to the Middle Ages and a welcome to the Renaissance.

Andrea del Castagno (1417–1457) At mid-fifteenth century, the painters of Florence had solved the problems of making their subjects appear three-dimensional and solid. The next step was to show people in motion, and Andrea del Castagno was the first artist to do it successfully. Although he painted several frescoes, his *David* is painted in tempera on a leather shield used to lead processions in Florence. Two events are present in this painting. One, David's slaying of Goliath, has been achieved and the other, David's hurling of a stone with a sling, is anticipated. The juxtaposition of the two events is important. David is a strong athlete, tense and energetic. The presence of Goliath's head at his feet and his disheveled appearance convince the viewer that David will succeed in his present venture. The landscape shares the exuberance and vitality of the figure as it is painted with the same care for detail.

PAOLO UCCELLO. *The Battle of San Romano*, 1445. Tempera on panel, 182 × 321 cm. National Gallery, London

Paolo Uccello (1397–1475) Perspective was of such great concern to Paolo Uccello that he once made a linear diagram of a seventy-two-sided polyhedron. His fascination with this scientific aspect of painting is seen in *The Battle of San Romano*, one part of a three-panel painting now in three separate museums. It was once a continuous work in the Medici Palace. The foreground becomes a stage for the main action as riders joust with each other—left and right, into the picture plane and out. The horses are plump and artificial looking as they prance on the stage. The landscape near San Romano in the Arno Valley is distant and contains many small figures. The fallen warrior is also in perspective as Uccello has used foreshortening to create the feeling of the body pointing toward the viewer. There is no ferocity in the battle, as Castagno might have shown it. Instead, the complex composition is a study in pattern, contrasting values, and perspective.

Piero della Francesca (1420–1492) Although spending several years studying in Florence (around 1439) Piero left that center of Renaissance art to do all his important painting in other cities. He was an apt student and easily incorporated the findings and styles of Masaccio and Castagno (form), Fra Angelico (light), and Brunelleschi and Alberti (scientific perspective). In fact, Piero also wrote an extensive book describing methods of working with perspective and proving its geometric exactness. His painting has a cool and severe character, almost like the classical severity of Greek sculpture. His figures possess no warmth, being unemotional and scientifically accurate. The light in his paintings seems to be at a low angle, like early morning, and produces solid and rounded forms. But the poses and facial expressions produce a "frozen-in-action" feeling rather than the agitated natural action of Castagno. Regardless of the subject, emotion was of no concern because Piero placed prime emphasis on the design of his pictorial space and the mathematics needed to design that space effectively. In this respect, he is closely related to many contemporary artists who work in the area of abstraction and mathematical precision.

Piero della Francesca's masterpiece is the huge wall of the Church of San Francesca in Arezzo, dealing with the story of *The Legend of the True Cross*. Several tiers of paintings relate the entire story, with the discovery itself shown in the example. On the left side, the cross of Christ is found by Helena, the mother of Constantine the

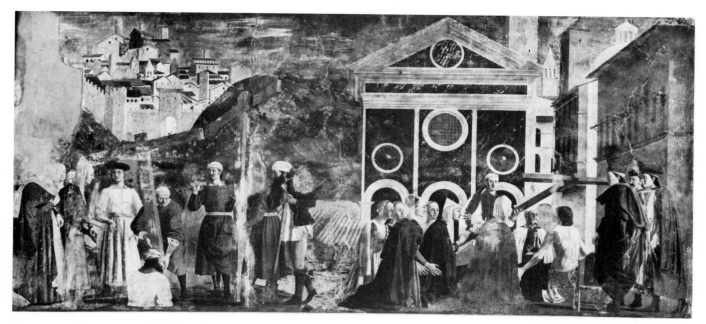

PIERO DELLA FRANCESCA. *The Discovery and Proving of the True Cross*, about 1453–1454. Fresco. Church of San Francesco, Arezzo, Italy

PIERO DELLA FRANCESCA. *The Nativity*, about 1470–1475. Tempera and oil on panel, 123 × 122 cm. National Gallery, London

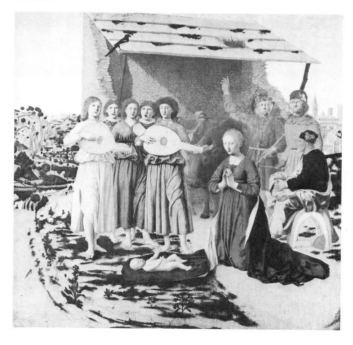

Great, while on the right, it is proved the True Cross by the miracles of healing it causes. Even though such a discovery would normally cause tremendous joy and excitement, Piero's figures are cool and calm. Notice how buildings of Italian design appear in the background because Piero did not know how buildings in Palestine looked over a thousand years earlier. The lighting of the scene produces solid forms while accurate perspective, both linear and aerial, creates a feeling of great depth in space—both characteristics of the artist's work.

Piero painted *The Nativity* later in his life. The angels, clustered together, are intent on their singing and do not seem to see the Christ Child and Mary. Notice that the halos have disappeared in the final humanizing of sacred persons. Joseph sits at the right, almost uninvolved in the happenings, while the shepherd points to the sky, probably telling of the angel choir he and his companion have seen and heard. All, except Mary, seem to ignore the Christ Child. The small ruined shed separates the figures from the busy background, a distant landscape on the left and an Italian cityscape on the right. Again, Piero positions everything precisely. The cow and the donkey fit exactly into the space left for them. The forms are beautifully rounded by the light and the cloth drops in elegant folds. Perhaps Piero had contact with northern European artists because this work is done in a combination of tempera and oil paint on a panel, a technique probably first begun in Flanders.

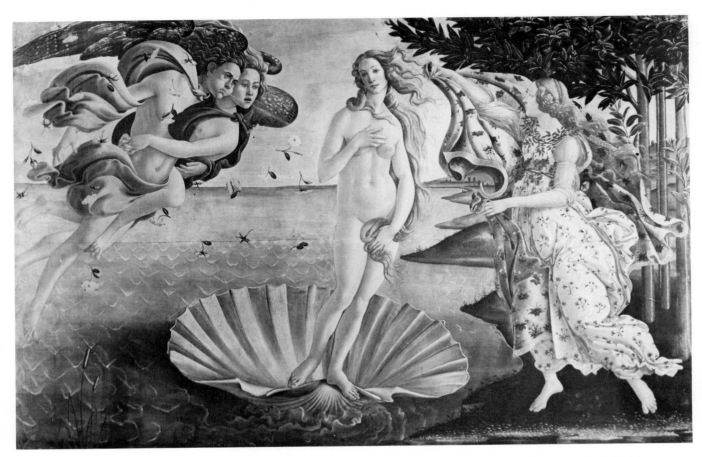

SANDRO BOTTICELLI. *Birth of Venus*, after 1482. Tempera on canvas, 175 × 280 cm. Uffizi Gallery, Florence

Sandro Botticelli (1145–1510) In the last third of the fifteenth century, few of the founders of the Renaissance were still living. The Florentine struggle for survival had eased, and living among the patricians was luxurious. Artists continued exploring aspects of Renaissance thought: a scientific appreciation of nature and the human body and a tendency toward the poetic and unreal subject matter of allegories and myths. Yet, there were internal political and religious problems. Savonarola condemned the ruling class and the Medici family. Intellectuals and artists, led by Lorenzo the Magnificent (head of the Medici family and leader of Florence), struggled to reconcile Classical philosophies with the Christian religion. This development is called *Neoplatonism,* and the leading painter of the group was Sandro Botticelli.

Botticelli's huge painting of the *Birth of Venus* clearly illustrates what the Neoplatonists were trying to rationalize. Venus, the goddess of love, rises from the sea and emerges from a shell. On the left, West Winds, looking like puffing angels, push her toward land. The figure on the right is Spring, ready to toss a robe around Venus' unclothed body. The scene enacts traditional mythology, which of course was not accepted by the Christians. Yet, Neoplatonist artists, like Botticelli, justified the subject as worthwhile because it was a metaphor for many Christian thoughts. Venus, like the Virgin Mary, is a source of "divine love" through which humans are linked with God. Venus, the water, and Spring could symbolize Christ, baptism, and John the Baptist: Baptism, like the birth of the celestial Venus, signifies the rebirth of humanity. Renaissance intellectuals thus looked to this rebirth and desire to reach new spiritual heights as a likely common ground for pagan myth and the Christian religion.

Botticelli was a master of delicate lines. The windblown hair of Castagno's *David* is carried to extremes by Botticelli, whose figures and fabrics are beautifully drawn. The figures seem outlined with an extremely fine line. The colors are pale and with the floating appearance of the figures add to the unreality of the subject. Notice the stylized waves in the sea, and the spring flowers blown by the wind. The painting appears as a delightful

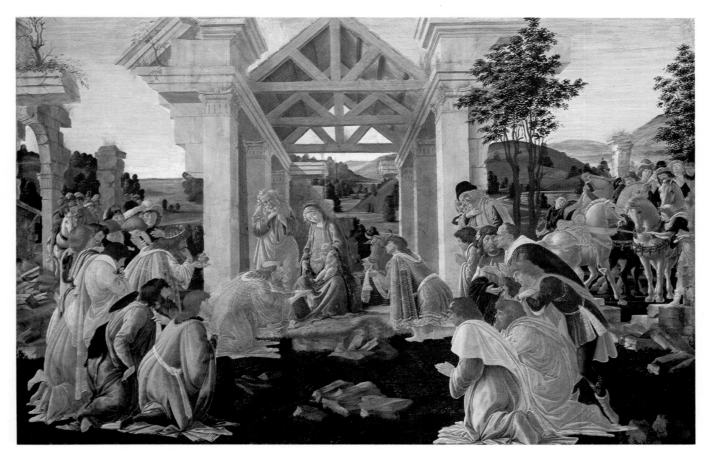

Sandro Botticelli. *The Adoration of the Magi*, early 1480s. Tempera on panel, 70 × 104 cm. National Gallery of Art, Washington D.C., Andrew Mellon Collection

fantasy but to the artist it was a serious and philosophical work. It is one of the first Italian works on canvas instead of wood panel. Botticelli used gold to heighten the color of hair and robes and to add a feeling of elegant refinement so desired by Lorenzo the Magnificent and his followers.

Botticelli's work, *The Adoration of the Magi*, reveals another characteristic of some late fifteenth century painting. While the Holy Family receives guests in the shadow of ancient Roman buildings, the wise men and a large company of others are actually portraits of Italian contemporaries, each painted with exacting detail. A concentric rhythm develops, starting at the center and radiating to the outer edges—calm at the center and active at the outside. Beyond the complex arrangement of figures, again outlined with delicate sensitivity, Botticelli presents the serene Italian countryside. Botticelli's scene is elegant and luxurious, especially when compared to Masaccio's and Giotto's treatments or to the events as they took place in the Bible. Shortly after this painting was finished in the early 1480s, Botticelli joined the ranks of Savonarola's followers (who condemned the Medicis and their pagan thoughts) and painted strictly religious subjects with power, emotion, and spiritual force.

Botticelli was not alone in his painting activity at the end of the century. Florence, Rome, and other Italian cities enjoyed the works of artists such as Ghirlandaio, Perugino, and Signorelli, all of whom worked outside the Neo-Platonist circle and painted for the middle classes and/or the church.

During the early fifteenth century in northern Italy, Venice became a dominant economic and political power, but its art remained a blend of Byzantine and Gothic styles. Fabriano, Uccello, Filippo Lippi, and Castagno visited and worked for short times and influenced native Venetian artists to a small extent, but Donatello's eleven-year stay in Padua revolutionized Venetian art. Perspective, form, anatomy, and the classic traditions, so common by now in Florence, were combined with the Venetian fascination for color and texture to produce a dynamic and exciting style that finally outshone Florence in its richness of expression.

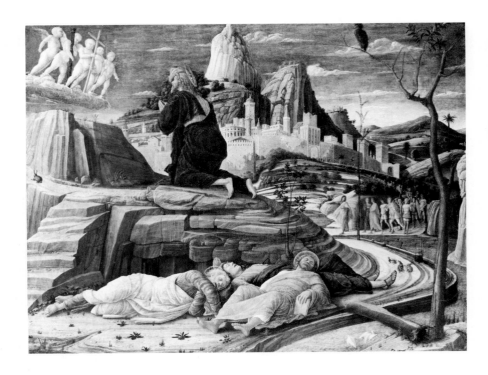

ANDREA MANTEGNA. *The Agony in the Garden*, about 1455. Tempera on panel, 80 × 63 cm. National Gallery, London

Andrea Mantegna (1431–1506) Already a polished artist when only seventeen, Mantegna learned much from the Florentine artists who visited northern Italy. He soon mastered form and anatomy and excelled in working with perspective, especially foreshortening. Earlier artists had painted scenes with figures as though the viewer were looking directly at them, regardless of their location on the wall. The bottom of Masaccio's *Tribute Money*, for example, is three meters from the floor, yet the reproduction shows the eye level about the middle of the work, an impossible location from which to actually view it. Mantegna painted such scenes so that the eye level was below the lower frame and one looked up at the figures.

Study the perspective in *The Agony in the Garden*, painted in Mantua when Mantegna was only twenty-four. The eye level is a horizontal imaginary line between the feet of Christ and the heads of the sleeping disciples. The group of soldiers, led by Judas, is on this line. The city of Jerusalem (with Italian features), the angels who comfort and fortify Christ, and the mountains are above it. The figure in the foreground whose feet face the viewer is extremely foreshortened and beautifully drawn.

Halos are still used, but the natural world of the Renaissance can be seen in the rabbits, birds, the variety of plants, the geologic formations, and landscape common to northern Italy. The colors of the tempera work are glowing and alive even though the convincingly drawn figures are like sculptures, carved from the very stone upon which they rest.

Giovanni Bellini (1430–1516) The master painter of Venice in the last part of the fifteenth century was Giovanni Bellini whose entire family seemed very artistic and whose sister married Mantegna. Bellini was greatly influenced by his brother-in-law in his early years of painting. Then with the arrival of the oil painting technique in Italy, he developed a richness of color and depth of value unequaled in Italy at the time. One of his later works, *St. Francis in Ecstasy*, is a dramatic landscape painting in which the figure of St. Francis seems almost insignificant. The forms are a bit softer than Mantegna's and the light a bit more luminous. St. Francis has a more natural appearance and is not as sculptural as the figures of Mantegna. Animals, plants, rocks, and the Italian hilltowns are painted in perfect perspective. The saint, removing his shoes (see lower right corner) stands in ecstasy as he observes the absolute wonder and beauty of God's creation and receives the stigmata—the signs of Christ's suffering and death (the nail marks on hands and feet). Every part of the painting is meticulous in its detail, but because of the careful observance of scientific perspective, the depiction of depth, and the luminous light, the scene contains a naturally unified feeling.

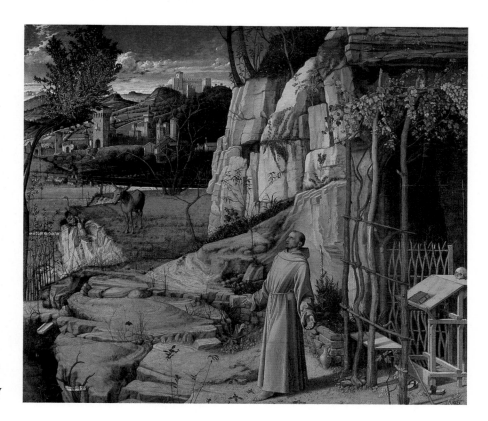

GIOVANNI BELLINI. *St. Francis in Ecstasy*, about 1485. Oil and tempera on panel, 123 × 140 cm. The Frick Collection, New York

The extreme detail and the use of oil paints show the influence of contemporary painters in Flanders in northern Europe, painters whose work was undoubtedly brought to Venice at the time. In his portrait of *The Doge Leonardo Loredan*, Bellini eliminated his beautiful landscapes and concentrated on the facial features of the Doge, elected at age sixty-five to be the leader of the Venetian Republic. The sensitive face is beautifully captured by the artist who allows light from the left to softly model the forms. Like Flemish artists, Bellini has superbly painted the luxurious brocade cloth of the Doge and contrasted the softly lit figure with the darkened and flat background. The artist signed his name as though it were on a bit of paper stuck on a piece of frame.

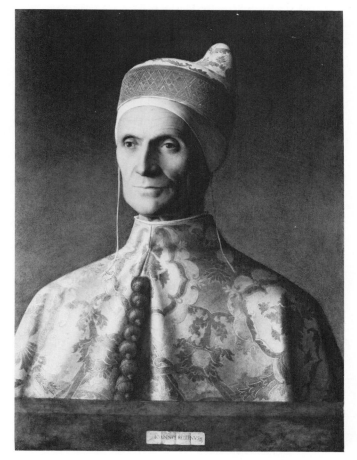

GIOVANNI BELLINI. *The Doge Leonardo Loredan*, 1502. Oil on panel, 61 × 45 cm. National Gallery, London

The High Renaissance

The year 1492 was crucial in Italy—not because Columbus sailed to the New World (not many people heard about that) but because Lorenzo the Magnificent died in Florence. His death weakened the government of the city, and several years later the Medicis were expelled and the republic restored. France marched into the peninsula and occupied Milan. Julius II became pope, began cleaning up the corruption in the church, and organized an army to resist the French. For twenty-five years, artists of the High Renaissance carried forth the ideals of Florence and Rome amid the constant threat of foreign domination. Perhaps the artistic giants of the time were compensating spiritually for the lack of Italy's physical unity and might. Sculpture, architecture, and painting were powerful and heroic, even though the land was near collapse. The art generated in this atmosphere influenced European art for at least three centuries as this crop of genius-artists often disregarded the rules which had determined the art of the developing Renaissance and let their feelings dictate their styles. They were thus more expressionistic than their predecessors who had relied on formulas, scientific perspective, ratios, and proportions to structure their work. When these giants died, the Renaissance in Italy died with them.

Leonardo da Vinci (1452–1519) If the "Renaissance man" was to be knowledgeable in all things, then Leonardo was it! He is mostly known as a painter, although the artist from Vinci left only a dozen or so works. His great equestrian sculpture had been destroyed before it was completed. He designed magnificent buildings that were never constructed. But he also invented fantastic machines for both peacetime and war, was an engineer, musician, physicist, botanist, anatomist, geologist, geographer, and aerodynamic engineer. Not only was he interested in these fields but was considered an expert in all of them; he left ten thousand pages of drawings, ideas, sketches, and notes, all written left-handed in reverse, or mirror image. Many of the things he began were never completed because once the major problems were solved, his fertile mind

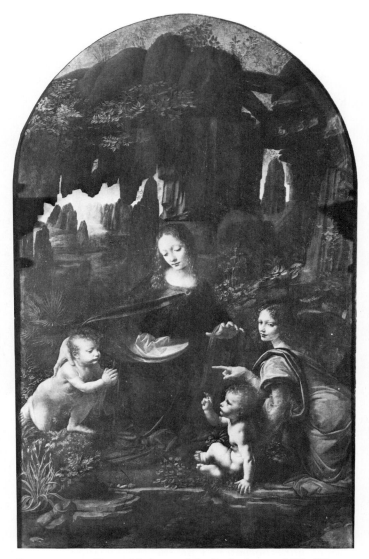

LEONARDO DA VINCI. *Madonna of the Rocks*, begun 1483. Oil on panel (transfered to canvas), 200 × 122 cm. The Louvre, Paris

was already working on the next several projects. Leonardo considered painting the supreme form of art. He felt that to create a convincing illusion of space on a two-dimensional surface was the essence of great art. To sculpt, he said, was simply to copy nature, to paint is to be "Lord and God" of the subject and art, a point on which he and Michelangelo never agreed. He understood and used the principles of scientific perspective and based his paintings on them but altered the rigid structure to fit the needs of the composition and its dramatic effect.

Leonardo created most of his work away from Florence. *Madonna of the Rocks* was painted in Milan for the

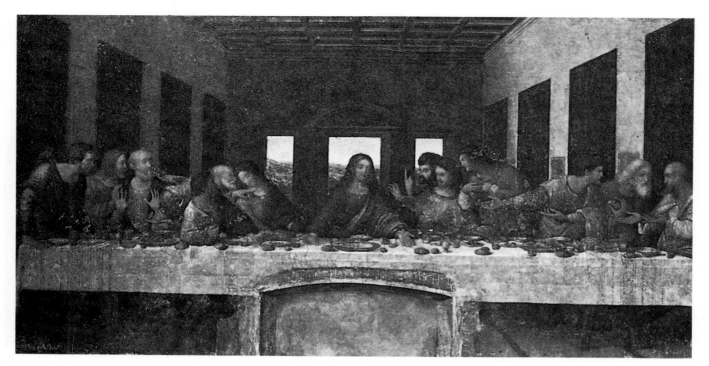

LEONARDO DA VINCI. *Last Supper*, 1495–1498. Oil and tempera on plaster. Refectory, Santa Maria della Grazie, Milan

Duke of Sforza and is the earliest of two almost identical subjects painted by the artist. The figures form a triangular composition with Mary's face at the apex. Mary raises her hand in protection of the Christ Child who blesses the infant John the Baptist at the left. The angel points to John who is worshiping the Christ Child. The wonderful sweetness and grace of the faces became a characteristic of Leonardo's work. For a genius of Leonardo's scientific nature, it may seem strange that his paintings are not scientific at all but are rather expressions of humanity and emotional feeling. Leonardo leads the viewer from one figure to another, but the viewer's eyes finally come to rest on the face of Mary. Notice the geological formations of rocks, kept mostly in dark shadow. Light forms emerge from this dark background to create a dramatic contrast of values. Such an extreme contrast of dark and light values is called *chiaroscuro*. Painting in oil, Leonardo concentrated on details of figures, cloth, texture, plants, and rocks, much as the Flemish painter Van Eyck had done (*See* next chapter). The hazy light, shimmering between the craggy rocks, creates a feeling of great depth. The arched top was necessary to fit the space above an altar where the work was placed.

While in Milan, Leonardo painted the *Last Supper* on the wall of the dining hall of the monastery of Santa Maria della Grazie. He shows the reaction of Christ's followers when he said to them, "One of you shall betray me!" Clustered in groups of three which establish a balanced composition, they react in shock and amazement. Each group is a finished composition in itself, and all are used to direct the visual movement toward Christ at the center. The perspective lines also lead to a point on Christ's head, to which the window frame adds importance. Leonardo's ever-present landscape is visible through the three windows, creating the further illusion of depth and space. Always an experimenter, Leonardo painted for several years on the dry plaster wall with an oil and tempera mixture. Tragically, it began peeling almost immediately so that few people ever saw the work as Leonardo conceived it. It was in such poor condition that, at one time, it was considered so unimportant that a door was hacked through the wall and part way up into the painting (see result at center, bottom of illustration). During World War II, Milan was heavily bombed and the building was almost completely destroyed, except for the sand-bagged wall on which the painting existed. After removing the protective bags and scaffolding, the painting was miraculously intact. All modern methods have been used to try to restore and save it, but its present condition, although better than in years gone by, is still only a shadow of the original work.

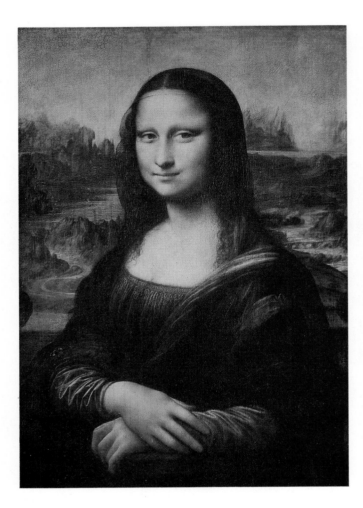

Leonardo da Vinci. *Mona Lisa*, 1503–1506. Oil on panel, 77 × 53 cm. The Louvre, Paris

Leonardo's last years were spent travelling where he saw how young Michelangelo and Raphael were using the principles he established. Trips to Florence, Rome, and Milan finally ended when he went to France (taking *Mona Lisa* and several other paintings with him) to live in the household of King Francis I. He painted little at the end and spent much of his time working on scientific ideas, many only recently rediscovered.

Michelangelo Buonarroti (1475–1564) The artistic genius of Michelangelo dominated the High Renaissance, and his long life caused his work to be influential in the Late Renaissance and beyond. Born of a poor family and sent at age six to live in the country with a stonecutter's family, he loved to use hammer and chisel and to draw. Returning to Florence, he knew he wanted to be an artist and when he was thirteen his father finally allowed him to study with Ghirlandaio, where he learned the art of fresco painting. After a short time, Michelangelo was accepted by Lorenzo de Medici into his school for sculptors and was treated as a son in the Medici household. Here he studied with Bertoldo, a pupil of Donatello, and went to school with Lorenzo's three sons, developing an intense interest in Greek and Roman culture. Such paganism was denounced by the Dominican friar Savonarola, who condemned the Medici and their Neo-platonist friends to hellfire. Michelangelo heard these thunderous sermons and the moral conflict between his love of human beauty and anatomy and his fear of God's punishment for sin was to haunt him for the rest of his life.

His earliest masterpiece, the *Pieta*, was done in Rome about 1500 and is a work of profound Christian feeling. The almost nude body of Christ is held on the lap of his mother Mary, who does not grieve sorrowfully over her son but accepts his death as the necessary fulfillment of humanity's salvation. Her youthful face probably was Michelangelo's way of saying how she, like the church, is ageless and timeless. The anatomical accuracy of Christ's body was undoubtedly the result of dissections performed by the artist in Florence. The folds of drapery and the feeling of flesh are superbly handled, and the sculpture is polished completely in the style of the Early Renaissance. In his later works, parts are often left in roughly chiseled condition and contrasted with polished areas. The work was carved from a single block of marble and signed later by the artist on the band across Mary's chest. The seated mother of Christ is overly large when

Milan fell to the French in 1499. Leonardo left for Venice and Mantua and finally returned to Florence where he accepted a commission for a great battlescene to be painted in the city hall, the Palazzo Vecchio. He began work on *The Battle of the Anghiari* and outlined it on the wall, only to leave it unfinished to return to Milan at the call of the French. For a century, the outlined drawing was hailed as a masterpiece, but only his sketches and a copy by Peter Paul Rubens remain. While working on the plans for this powerful work, Leonardo painted a portrait of the wife of one of his Florentine friends, a painting that became known as *Mona Lisa*. The woman sits in a relaxed position in front of a typical Leonardo landscape—a scene in which distant hills and mountains are partially obscured by a light haze (called *sfumato* in Italian), an effect that allowed Leonardo to create a feeling of enormous depth. The slightly sad smile on the face of Lisa Giocondo seems somehow familiar if one has seen other paintings by Leonardo, such as the *Madonna of the Rocks*.

MICHELANGELO. *Pieta*, 1499–1500. Marble, 174 cm high. St. Peter's, Vatican, Rome

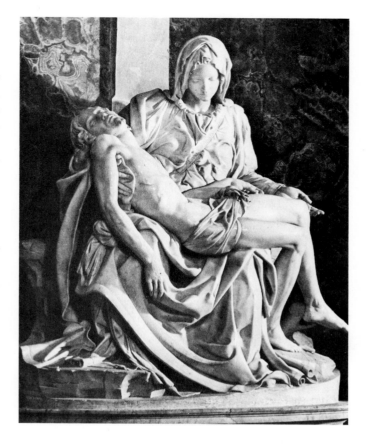

compared to the body of her son. The proportions may be incorrect according to nature, but Michelangelo was concerned with the overall appearance and visual effect of the pyramidal composition rather than with exact proportions.

Michelangelo would look at a block of stone in front of him and envision a figure inside. He would sketch that figure from every possible angle and finally, as he carved, felt as though he were releasing it from a prison of stone. When he returned to Florence in 1501, such a huge block was waiting to be carved. The block was already famous before Michelangelo began to work on it. Nicknamed "The Giant," the rather thin, 4.5-meter-high marble had been cut into during the 1460s. Now the challenge was Michelangelo's. The city fathers of Florence wanted a sculpture of David to symbolize the spirit of their city, and it had to be carved from this block. When finished, it was placed in the main square in front of the Palazzo Vecchio, only several feet from the spot where Savonarola was executed several years earlier. If the friar had still controlled the morality of Florence, such a nude sculpture would not have been allowed. Mi-

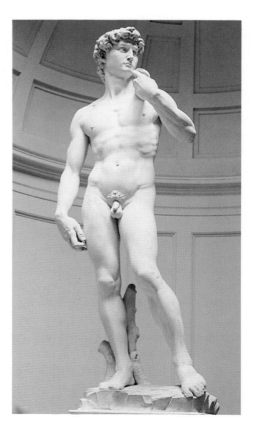

chelangelo's heroic *David* goes far beyond imitating nature. It is huge in size and superhuman in its muscular perfection. The young boy of the Bible has a manly body and an expression that is angry and defiant. The empty sling drapes over his left shoulder and a round stone is cradled in his huge right hand. He stands relaxed but ever alert, a god-like being, half Apollo and half Hercules. It is the epitome of Michelangelo's belief that human beauty is the outward indication of divine spirit. As a result, at only twenty-nine, Michelangelo was declared the greatest sculptor in Italy. The original work is now protected indoors at the Academy in Florence while a duplicate is standing in the original location in the piazza.

In 1505 Pope Julius II called Michelangelo to Rome to design his monumental tomb of forty over-lifesized figures to be placed in St. Peter's, which was then being built. Because of innumerable interruptions, including the painting of the Sistine Chapel, the work was scaled down until only three of the original sculptures were

MICHELANGELO. *David*, 1501–1504. Marble, about 4.8 m high. Gallery of the Academy, Florence

used, and the tomb was placed in a small church in Rome. The sculpture of *Moses* is now the dominating feature of the tomb, although it was carved to be on the second level in the original design (*See* p. 40). An incredibly powerful figure, Moses seems ready to burst into action from his seated position. The tables of the law are only a prop as Michelangelo awes the viewer with the rippling muscles and stern glare of the prophet. Hair, beard, and cloth, all deeply carved, share the dynamic power and intensity of the figure which seems ready to battle the world in defense of God's newly-given law. Michelangelo had studied many ancient sculptures as they had been uncovered by 1503 and derived from them further knowledge of Classical sculpture techniques and the powerful representation of human forms.

In 1508 Michelangelo interrupted work on the tomb of Pope Julius II to accept the commission to paint the ceiling of the *Sistine Chapel,* the private chapel of the popes. Although he did not consider himself a painter, the artist undertook the tremendous task of decorating the ceiling of the forty-meter-long room with paintings of the twelve apostles of Christ. Michelangelo vastly expanded that idea until practically the entire Old Testament was visualized. The central area contains four large and five smaller scenes that span the Biblical time from *Creation* to the *Drunkenness of Noah Following the Flood.* Large figures of prophets and sibyls who foretold the coming of Christ occupy spaces around this central core. In the triangular lunettes between them appear forty generations of the ancestors of Christ, and in the large corner sections are scenes of *David and Goliath, Judith and Holofernes, The Crucifixion of Haman,* and the *Brazen Serpent,* all stories that prefigure the work and salvation of Christ. Separating these important events and figures are painted architectural elements and hundreds of figures (over 400 in all) that seem to be carved in stone. Using very few assistants, Michelangelo completed the monumental task in only four years.

One of the most dramatic scenes on the ceiling is the *Creation of Adam,* portrayed at the exact moment when God charged Adam with the spark of life (*See* p. 34). God the Creator seems a veritable dynamo of energy as he swirls through the heavens, enveloped in a billowing lavender-gray mantle and surrounded by wingless angels. Under his trailing left arm, Eve awaits her own creation and looks curiously toward Adam. God reaches forth his energy-charged hand to the waiting finger of an expectant Adam, himself rather limp but ready to burst into life and become "a living soul."

The ceiling was painted while Julius II was at war with France, valiantly trying to keep Rome safe from invasion.

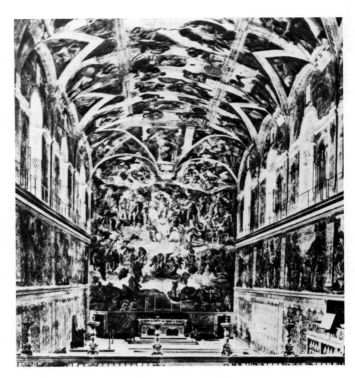

MICHELANGELO. Interior of Sistine Chapel, showing ceiling fresco and the *Last Judgment*, 1508–1512. Vatican, Rome

By 1534 the effort had sapped both the church and the city of their wealth and work on St. Peter's had come to a halt. Michelangelo had been working in Florence and was called back to Rome by Pope Clement VII and asked to paint a gigantic *Last Judgment* on the end wall of the Sistine Chapel. He filled in several windows and covered up some other frescoes, including part of his own ceiling, to make room for the immense creation. Between 1536 and 1541 he labored on the wall, producing an incredible work of the horror of hell and the reward of eternal life in heaven—the very conflict that dominated his personal faith.

Starting at the lower left, the bodies and souls of the dead are united and ascend to the judge, the dramatically powerful figure of an avenging Christ. He is surrounded in heaven by saints, martyrs, and believers while Mary sits under his right arm which is raised to dash unworthy souls out of Paradise. In the lower right portion, wicked sinners, their eyes reflecting the horror they anticipate, are dragged down by demons into hell. Charon drives the damned off his boat as it crosses the River Styx. The 15 × 13.3-meter wall is covered with heavy figures, distorted with their struggles, much as Michelangelo's mind was torn with his own spiritual battles. The figures are no longer the same as those he

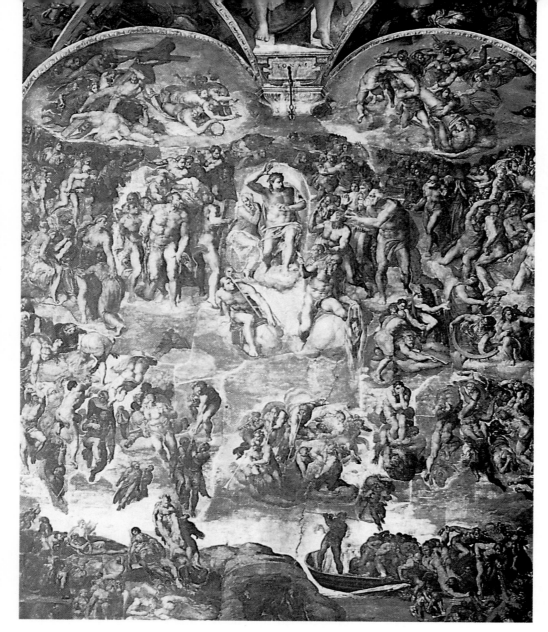

MICHELANGELO. *Last Judgment*, 1536–1541. Fresco, 15 × 13.3 m.
Sistine Chapel, Vatican, Rome

painted on the ceiling and they reflect the change in his attitude. He had begun to realize that physical beauty changes with age and reflects the struggles of life and of the spirit, and he often emphasized these changes in his later work. All the figures were completely nude when Michelangelo finished the wall, but later Counter-Reformation morality led to the request that one of his pupils paint bits of swirling cloth where needed to prevent offending viewers' sensibilities. The power of the painting was evident when it was first shown, as dozens, including the pope himself, fell to the floor in fervent prayer.

In 1546 the seventy-one-year-old artist was in poor health and yet accepted without salary the commission to finish the construction of St. Peter's. He had designed other architectural structures in Florence (the Medici Chapels) and went to work immediately on the huge basilica, untouched for so long that trees were growing from the huge arches. Donato Bramante was the original architect and had died while construction was under way. His plan was altered slightly by Michelangelo. Although he retained the shape of the Greek cross, he redesigned the exterior, built the rear of the church, and designed the enormous dome which was completed

MICHELANGELO. Dome of St. Peter's, 1546–1564. The Vatican, Rome. The facade was designed by Carlo Maderno (1606–1612).

after his death. The exterior walls took on a sculptural quality that produces an upward thrust toward the dome. The hemispherical dome of Bramante's design was replaced by a high, pointed, double-shelled dome (like Brunelleschi's) placed on a tall drum. The heavily sculpted lantern completes the upward visual movement of the walls, drum, and dome and is crowned by a large cross. The largest dome in the world rests on four pendentives and four huge piers inside the church. Although the nave was lengthened later and a new facade was added, the imprint of Michelangelo can be easily detected in the present basilica.

Working on sculptures until six days before he died, Michelangelo—recognized by his contemporaries as "the greatest man ever known to the arts"—said on his deathbed, "I regret that I am dying just as I am beginning to learn the alphabet of my profession."

Raphael Sanzio (1483–1520) The spirit of the High Renaissance reaches its peak in the work of Raphael. The sculptural quality of Michelangelo, the grace and feeling of Leonardo, and the detail and light of his first teacher, Perugino, are combined in Raphael's paintings which are masterpieces of balance and harmony. While Michelangelo was a solitary genius with nothing to live for but art, Raphael (several years younger) enjoyed the social whirl of Rome and the adulation of many admirers. After working in Urbino with Perugino for several

years, Raphael came to Florence in 1505, where Michelangelo and Leonardo had already established the foundations of the High Renaissance. They were too busy with large commissions to satisfy the wants of the merchants, and Raphael happily filled the gap. For eager patrons, he painted numerous flattering portraits and popular Madonnas, one of the first being now called *The Small Cowper Madonna* (named for Lord Cowper who once owned it). The wistful expression on Mary's face shows the influence of Perugino; the firmly drawn figures, the solid forms, and the contrasting values show Leonardo's influence. But the combination is Raphael's. The plump Christ Child, who like Mary exhibits northern Italian characteristics, lovingly embraces his mother. Raphael reintroduces the halo as a delicate gold line, probably at the request of his patrons. The landscape includes the church of San Bernardino in the outskirts of Urbino, Raphael's home town. It is one of dozens of Madonna subjects painted by the artist.

Raphael went to Rome in 1508 at the invitation of the pope and immediately became a popular figure. Because Michelangelo was occupied with his tremendous commissions, Raphael was sought after for more portraits and Madonnas and was court painter in the Vatican until his early death at thirty-seven.

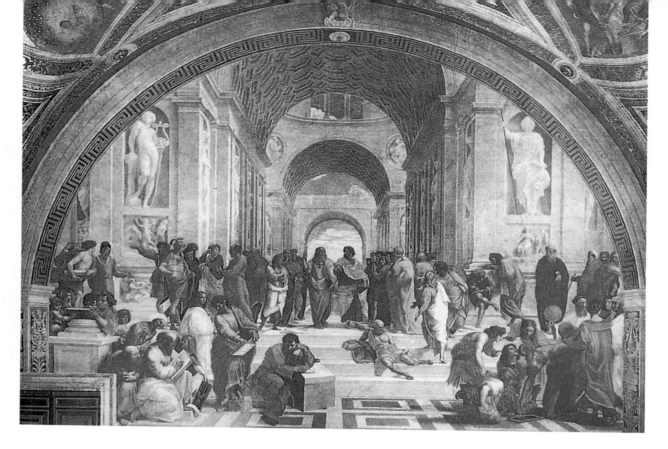

RAPHAEL. *School of Athens*, 1510–1511. Fresco. Stanza della Segnatura, Vatican, Rome

At the bequest of Pope Julius II, Raphael worked from 1509 to 1511 on large frescoes in the Stanza della Segnatura (Room of Signatures, where official papers were signed). The arched format fits the wall space in the room where the four subjects on the four walls are: *The Disputation over the Sacrament; The School of Athens; Parnassus;* and *Prudence, Force and Moderation. The School of Athens* is probably his masterpiece, as it embodies perfectly the spirit of the High Renaissance. Again, the sculptural quality, the individual poses, and the grouping of the figures in an architectural setting are influences of Michelangelo who was painting his ceiling only a few meters away. Yet the balance and composition are reminiscent of Leonardo's *Last Supper*. The result is a synthesis that is Raphael at his best. The architectural setting is dramatic and in harmony with the number and placement of the figures, and it suggests the interior of the incompleted St. Peter's. The architectural perspective

RAPHAEL. *The Small Cowper Madonna,* 1505. Oil on wood panel, 59.5 × 44 cm. The National Gallery of Art, Washington D.C., Widener Collection

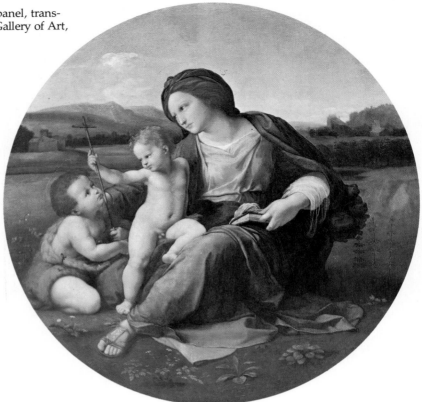

RAPHAEL. *The Alba Madonna*, 1510. Oil on wood panel, transfered to canvas, 94.5 cm diameter. The National Gallery of Art, Washington D.C., Andrew Mellon Collection

leads the viewer's eyes to a vanishing point between the heads of the two main figures, Plato and Aristotle, who are deep in conversation. Socrates, Pythagoras, and Euclid can be seen, but all are actually portraits of contemporary persons. Bramante, Michelangelo, and Leonardo (Plato) are included, as are many others, and Raphael includes himself as a bystander. All the masters of Classical Greek thought, science, and art are in animated conversations, yet they are portraits of High Renaissance contemporaries situated in a contemporary Christian structure—Raphael's superb way of balancing pagan Classicism and Renaissance Christianity in one monumental work.

The Alba Madonna (so named because it was in the collection of the Duke of Alba in Spain) was painted in 1510 and reflects the influence of Michelangelo who was then working on the Sistine ceiling. *Tondo* paintings require extremely fine balance in order to keep them from seeming to roll like a wheel, and Raphael used the most stable composition available, the triangle. The three solid forms of Mary, John the Baptist, and the Christ Child are firmly resting on the ground and yet are related to the surrounding landscape which has a feeling of great depth. Raphael guides the viewer's eyes easily around the balanced composition, from Mary's leg, her

left arm, shoulder, and face which looks at the cross and at John. The artist uses many devices (value contrast, direction of eyes, and composition) so that visual movement is directed to come to rest on the cross. He includes the concept of Christ's life, death, and salvation in a painting which seems outwardly to be just another Madonna painting. Here again, Raphael has created a balance between form (the composition) and content (the meaning). Leonardo's sfumato can be detected in the portrayal of deep space, clear light, and the Italian landscape. The foreshortened leg of Mary, her pose, and the sculptural quality of her robes are reminiscent of Michelangelo, but the sensitive faces, graceful gestures, and the balance of all elements are Raphael's.

After his early death in 1520, Raphael was buried in the Pantheon in Rome, and the era of the High Renaissance, begun with Leonardo's *Last Supper* twenty-five years earlier, came to an end. Although Michelangelo lived many years after Raphael had died, his continually developing style places his later work in the Late Renaissance and Mannerist traditions. Although Michelangelo and Leonardo were the geniuses of the High Renaissance, it was the balance brought about by Raphael that was imitated and admired by artists in succeeding generations.

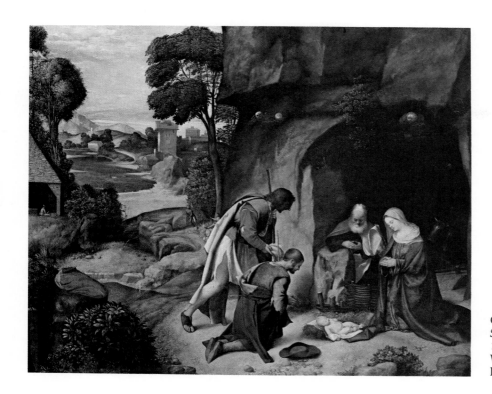

GIORGIONE. *The Adoration of the Shepherds*, about 1505. Oil on panel, 91 × 111 cm. National Gallery of Art, Washington D.C., Samuel H. Kress Collection

NORTHERN ITALIAN ART

After the death of Raphael, the sixteenth century saw a shift in the dominance in art from Florence and Rome to Venice in northern Italy. The one exception was Michelangelo, who remained the solitary genius in central Italy until his death in 1564. But Venice gradually took over the leadership in painting, building on the foundation laid down by Giovanni Bellini and benefiting from the discovery of flexible resins that made painting on canvas possible.

Giorgione da Castelfranco (1477–1510) Although living and working a very short lifetime and leaving only a relatively small number of paintings, Giorgione made some dramatic innovations in painting that pushed Venetian art to the forefront in Europe. Early Renaissance artists had thought of painting as colored drawings with definite contours, modeled in light and shade to suggest relief. Fifteenth century painters realized that individual figures and objects are not seen separately but together, creating interesting groupings that react with their surroundings. Yet each part was shown as crystal clear, such as in Botticelli's *Adoration of the Magi*.

Giorgione changed this bright light that picks up all details to a soft, misty sunlight that helps blend all parts of a composition together, creating a strong visual unity. Bellini (in his last works) and Titian both shared in this revolutionary development. *The Adoration of the Shepherds* takes its compositional development from Bellini's *Ecstacy of St. Francis,* but the colors and values are muted for a more unifying effect. Two shepherds have come to the stable-cave to worship the Christ Child lying before Mary and Joseph. While a fairly bright light brings out the details in the principal figures, Giorgione used chiaroscuro in the cave and a soft golden light to illuminate the middle and far distance. He loved to paint landscapes, and the upper left portion of the painting is not only an environment for the subject but a jewel of a landscape painting in itself. Notice the overcast sky which softens the light and eliminates harsh contrasts and sharp shadows. Notice also how the dark shadows on Mary and Joseph blend into the darks of the cave and how the middle values of the shepherds blend into the middle gray values around them. By squinting, one can see how the figures seem to melt into the values around them. With these techniques Giorgione conveyed his special feelings or moods about his subjects. While Michelangelo and Raphael excelled in creating form, Giorgione mastered mood in painting.

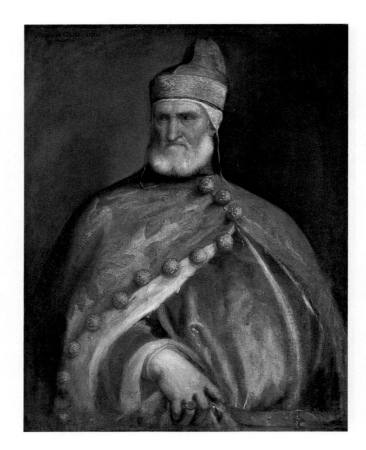

TITIAN. *Doge Andrea Gritti*, about 1540. Oil on canvas, 133 × 103 cm. National Gallery of Art, Washington D.C., Samuel H. Kress Collection

Titian (1490–1576) The artistic giant of Venice, comparable to Michelangelo in Florence and Rome, was Titiano Vecelli, known as Titian. Studying with both Giovanni Bellini and Giorgione, he shared their belief that color and mood were more important in painting than line and scientific accuracy. His painting methods were innovative. He often painted his figures in bright colors over a red-painted background, which added a warmth to the entire work. After it was dry, the surface was painted with as many as thirty or forty glazes (transparent mixtures of color and medium) over everything, toning down the bright colors and unifying the surface. Preferring not to smooth out the surface paint, he allowed brush strokes to remain visible and let the soft edges of his figures blend into the background. The viewer's eyes react to these soft contours as if light was glaring from the skin and materials of the subjects in the paintings. In his later work, no outlines or hard edges are visible at all as color blends into color to create form. Detail was often ignored in order to emphasize the color and movement created by rapid and powerful brush strokes, creating a textured surface quality that is called *painterly*.

Three subjects dominated Titian's imagination: events from pagan mythology, especially those involving Venus; portraits of important rulers and other figures from all over Europe; and religious subjects that called for great emotion, mood, or physical activity. Titian received honors from many parts of Europe in his long and productive life, and was almost princelike in his lifestyle. Like Michelangelo and Raphael, he was quite wealthy when he died. His work was as popular in Spain and Germany as it was in Italy, making him the most sought after artist of his time.

The figures in Titian's portraits almost always seem to have superhuman power, a quality which the artist wished to impart to his subjects. The *Doge Andrea Gritti* is no exception. A ruthless maritime ruler, his Venetian fleets dominated the shipping lanes of the trading world and made Venice a feared power. Yet he also was a patron of the arts, commissioning many religious, historical, and allegorical paintings from Titian. Startling changes in painting techniques can be noticed if Titian's Doge is compared to Bellini's (*See* p. 243). Although the same robes and caps are worn by both men, Titian disregards detail and uses slashing brush strokes to charac-

terize the physical strength of his subject. Edges are soft, suggesting movement, and a swirling motion is evident, even though the figure is sitting still. Both brush strokes and the turn of the head contribute to this strong feeling. The powerful hand that holds the robes is similar to the sculpted hand of Michelangelo's *Moses*. Bellini's fabrics and textures are very realistic, but Titian relies on brush strokes, deep values, and vivid colors to create a robust and individualistic figure rather than simply a likeness of the Doge.

Lush tones of red and gold abound in Titian's glowing portrayal of *Venus and Adonis*, one of several paintings he made of the same mythological subject. Venus is reluctant to let her lover Adonis depart to go hunting, warning him that certain animals are dangerous and can inflict great injury. The dogs strain at their leashes in their eagerness to hunt, and Adonis leaves, only to be killed by a wild boar that he had wounded. Titian's figures fill the space with their twisting bodies, yet their activity is controlled by the triangular composition that uses Adonis' head as the apex. The bodies of Venus, Adonis, and the dogs emerge from the deep shadows as Titian uses chiaroscuro to dramatize the imaginary event. At the left is the figure of the slumbering cupid.

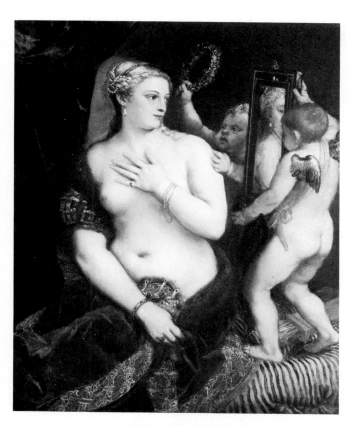

TITIAN. *Venus with a Mirror*, 1555. Oil on canvas, 124 × 105 cm. National Gallery of Art, Washington D.C., Andrew W. Mellon Collection

The painting of *Venus with a Mirror* was one of Titian's favorites, which he kept with him until he died. Painted when he was seventy-eight, the work was not easy for him to design. X-rays show that it was painted over two previous compositions, the first horizontal with two figures and the second of Venus with two cupids. The face and pose of the second were used in this final version. Titian made several variations of this subject as have many other artists. Again, the rich and glowing colors emerge from deep shadows as two cherubs are seen with the goddess of love. The painting epitomizes Titian's concept of feminine beauty—a concept that changes throughout history. The figures crowd the composition as if ready to burst out of the frame, but they are still confined within the borders of the canvas.

Titian's later work, like that of Michelangelo, moved him into the trends of Mannerism and on the verge of Baroque painting.

Titian, *Venus and Adonis, ca.* 1664. Oil on canvas, 107 × 126 cm. National Gallery of Art, Washington, D.C., Widener Collection.

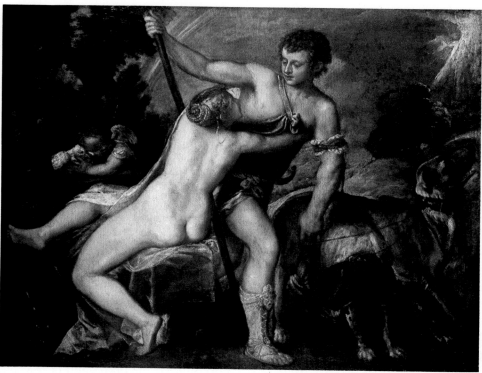

Mannerism

The period between the end of the High Renaissance and the emergence of the Baroque (from 1525 to 1600) has had several names, including the Late Renaissance, but the most used term today is *Mannerism*. Included in the term are several styles of painting and a variety of characteristics, each helping to form a bridge between the High Renaissance and the Baroque. Mannerism was originally a derogatory term applied to painters who had a formal, mannered style imitating various aspects of Raphael's and Michelangelo's. Today the meaning of the term has been broadened to include even the late work of both Michelangelo and Titian. Included are such features as crisp and frozen shapes, elongated bodies, distorted forms, peculiar perspective views, and very individual and expressionistic approaches to subject matter. Mannerism therefore is not a unified approach by several artists, but stresses unique approaches which are extensions of Renaissance styles. Such a mix of styles rather than a single dominance is comparable to the present art scene in its variety of visual expression.

Rosso Fiorentino (1494–1540) A dramatic difference exists between the sculpture-like figures by Michelangelo or the soft, painterly edges of a Venus by Titian and the crisp, hard edges of Rosso's figures. About 1520 a group of Florentine painters led by Rosso, shocked their fellow artists and the citizens of central Italy with such spidery forms as those in *Virgin and Child with St. Anne and Young St. John*. Rejecting many of the attributes of Renaissance painting, Rosso crowds figures into a tight composition with a hole in the center. St. Anne seems like a hag that is scaring the young Christ Child in Mary's arms. Perhaps she is foretelling Christ's suffering and death as young St. John, the future Baptist, lies deathlike in the corner. Two oversized angels hover nearby. The meaning is not clear, but Rosso's mystifying work certainly abuses the Classical devices of balance and harmony so essential to Renaissance art. The figures appear frozen in place yet active at

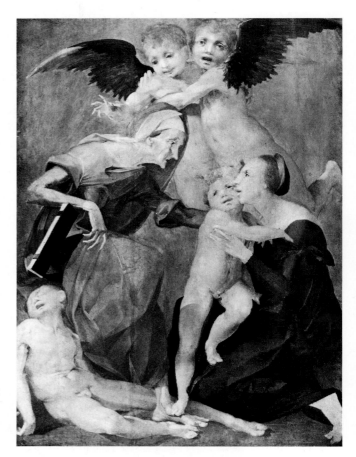

Rosso Fiorentino. *Virgin and Child with St. Anne and Young St. John*, 1521. Oil on panel, 161 × 119 cm. Los Angeles County Museum of Art, gift of Dr. and Mrs, Herbert T. Kalmus

the same time. Cloth is brittle, fingers and arms are long and thin. There is a disturbing quality about the work, especially after viewing the gradual evolving processes of Renaissance art and its emphasis on reality, shadow, and light. The colors also are unreal, featuring acid greens and yellows that are peculiar to Rosso's work. The artist later became court painter for François I of France and directed the decoration of the chateau of Fontainebleau. His style is but one of many in the Mannerist tradition which includes the work of the Italian painters Pontormo, Parmigianino, Agnolo Bronzino, Correggio, Tintoretto, and Veronese.

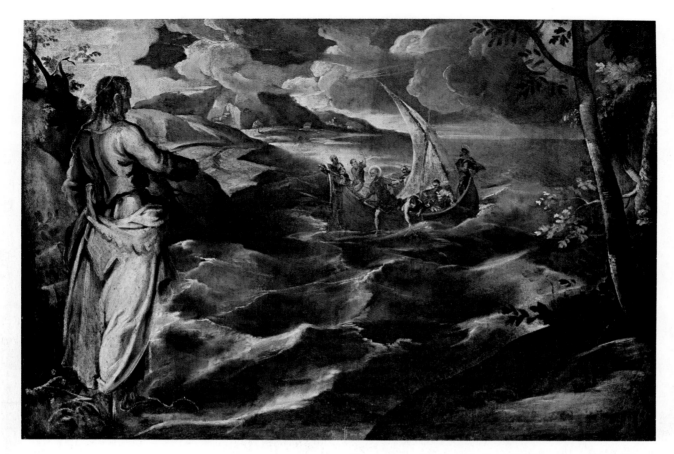

TINTORETTO. *Christ at the Sea of Galilee*, about 1580. Oil on canvas 117 × 169 cm. National Gallery of Art, Washington D.C., Samuel H. Kress Collection

Tintoretto (1518–1594) About the middle of the sixteenth century, two Venetian painters began to crowd into Titian's dominance: Jacopo Robusti, called Tintoretto and Paolo Caliari, called Veronese. Tintoretto (means "Little Dyer," so named because of his father's occupation) became the most dramatic painter of the sixteenth century, filling huge walls with canvases of soaring and hurtling figures. His subjects were mostly religious and sprang from a strong faith, a desire to communicate the incredible power of God, and the religious fervor of the Counter-Reformation. He would arrange small models on stages and even suspend some from wires to set the composition and see the foreshortening as it should be. He made small drawings of these arrangements and enlarged them enormously on his huge canvases. Tintoretto would first paint the bright colors and then add intense darks and highlights, producing the effect of a night scene illuminated with flashes of light. His brush strokes were less controlled than Titian's, causing the nineteenth century critic John Ruskin to accuse him of painting with a broom. Al-

though he painted constantly, much work was done for charity houses at a small salary, so that he died almost penniless.

Christ at the Sea of Galilee presents a Biblical narrative through the eyes of Tintoretto. Christ's disciples were in a boat on the Sea of Galilee when a sudden storm arose. As the boat was being tossed about, the men saw Christ walking toward them on the water. They were astounded and afraid, but Peter asked if he could walk to Christ on the water. Christ invited him and he stepped from the boat—the moment of natural and psychological tension that Tintoretto shows in his painting. The artist has created a powerful composition, placing Christ against the left edge of the canvas. Although Christ is important in the design, the center of interest is Peter as the viewer wonders "will he make it or not; and if not, why not?" The dominant hues of bluish-green are favorites of Tintoretto, and the elongated figures and flickering lights are features of much of his work. His student, El Greco, will carry these characteristics still further.

TINTORETTO. *Crucifixion*, 1565. Oil on canvas, 5.35 × 12.2 m.
End wall, Sala dell'Albergo, School of San Rocco, Venice

Tintoretto's masterpiece is the magnificent series of over fifty canvases in the School of San Rocco in Venice. For twenty-three years he labored for a small yearly salary to produce a monument that rivals Giotto's Arena Chapel and Michelangelo's Sistine Chapel in visual impact and sustained creative intensity. The largest canvas is the *Crucifixion* (12.2 meters long) which is overpowering in its visual effect. The foreground figures are over-lifesize and the upward thrust of the cross seems to crush Christ against the top border. Groups of soldiers, horses, disciples, and Mary are visually interlocked by their overlapping forms and the dramatic light which seems to emanate from the head of Christ. Tintoretto calls even more attention to Christ by having a great number of lines and shapes direct the visual movement toward the top center of the canvas. The use of unreal light counteracted the natural light used by Renaissance painters and placed the personal expression of Tintoretto in the Mannerist circle.

Veronese (1528–1588) Paolo Caliari was called Veronese because he came from Verona, some distance west of Venice on the mainland. While Tintoretto was concerned with turbulent and swirling light and action in religious scenes, Veronese emphasized the material beauty of marble, gold, textiles, and other materials of superb quality and great expense. Like other Mannerist painters, he was adept at using perspective to create startling effects—such as looking straight up at figures on a ceiling or looking upward or downward diagonally. He was so skilled at foreshortening that he had no trouble portraying figures in any conceivable location and position.

His interest in the luxurious quality of fabrics can be seen in *The Finding of Moses*. Although the event happened in Egypt over three thousand years earlier, Veronese contemporizes the scene by placing it in northern Italy (the Alps and a Tyrolian town are in the background) and peopling it with a sixteenth century prin-

PAOLO VERONESE. *The Finding of Moses*, 1570. Oil on canvas, 58 × 44.5 cm. National Gallery of Art, Washington D.C., Andrew W. Mellon Collection

cess and her court. The basis for the painting is the hiding of Moses by his mother when all first born sons were to be put to death by the Egyptian Pharaoh. The princess, out on her daily walk, finds Moses in a basket in the reeds by the river bank. She keeps the child as her own, and later he becomes the leader of the Hebrews, freeing them from Egyptian slavery. The flowing colors and spiraling, twisting figures are designed to lead the viewer's eyes to the face of the princess, even though the baby Moses is the reason for the painting. While Veronese leads the viewer's eyes along many paths, they always return to the face of the princess whose light complexion is set off by the dark foliage behind her. The arbitrary use of light, placed just where the artist wants it, is contradictory to the use of natural light so admired by Renaissance artists.

Painting *Christ and the Centurion* gave Veronese a chance to contrast the soft, flowing robes of Christ and his disciples with the metallic glint of Roman armor. Fabric and surface textures are again handled beautifully. The centurion, a Roman officer, is asking Christ to heal his daughter. His pleading face is the focal point of the composition and is placed against the void of the sky which isolates it for powerful, dramatic effect. The rest of the figures seem to jostle each other to get into the crowded picture, yet Veronese has skillfully allowed Christ and the Centurion to emerge as the dominant figures. Some figures are subordinated by softer values and grayer colors which push them back in the painting and separate them somewhat from the dominant figures.

The eye level is in the lower third of the painting. This feature and the intense look on each face enhance the dramatic impact of the moment Veronese has staged and lighted. Note too how Veronese fills all the little spaces—with a sword under the Centurion, a figure behind his right arm, and a dog next to his shadowed right hand. These three additions form a triangular pattern which adds depth to the painting.

PAOLO VERONESE. *Christ and the Centurion*, about 1570. Oil on canvas, 142 × 208 cm. William Rockhill Nelson Gallery of Art, Kansas City, Nelson Fund

Mannerism | 259

EL GRECO. *The Burial of Count Orgaz*, 1586. Oil on canvas, 4.86
× 3.61 m. San Tomé, Toledo, Spain

El Greco (1541–1614) Domenikos Theotocopoulos was born in Crete where he studied in the Byzantine tradition, then moved to Venice about 1560. He studied with Tintoretto, knew Titian and his work, and went to Rome to fall under the spell of Raphael, Michelangelo, and the central Italian Mannerists. About 1576 he went to Spain and settled in Toledo where he was nicknamed El Greco (the Greek) and where he spent the rest of his life. He continued to sign his name in Greek and never really gave up the Mannerist influences he absorbed in Italy. In the relative isolation of the Iberian peninsula he sharpened and developed these influences into a powerful

and unique visual expression. Featuring elongated distortion and a flickering light that is much more personal than realistic, El Greco's style was not fully appreciated until the latter part of the nineteenth century. Although his portraits are strong and express the psychological make-up of the sitter, his strength lies in his religious work. His Byzantine background, the Counter Reformation, and the Inquisition in Spain, all sharpened his religious sensibilities. El Greco's religious paintings are powerful personal statements which did not lead to the Baroque at all but were almost a whole style in themselves (*See* p. 50).

One of El Greco's most powerful works is *The Burial of Count Orgaz*, an oil painting on canvas that is mounted in the chapel of the church of San Tome in Toledo. It memorializes the earlier death of a Spanish nobleman (in 1323) whose life was so saintly that El Greco shows St. Augustine and St. Stephen coming down to help in the burial. The work is divided into two sections. The lower part is sixteenth century on earth, the upper is timeless and in heaven. The faces of the noblemen in attendance are portraits of El Greco's friends in Toledo. The artist even included himself in the group and his son in the foreground. The upward gaze of the priest at the right and the angel bearing the soul of Orgaz to heaven (his soul looks like a small doll, in the center) unite the lower with the upper part of the painting, where Christ sits on his heavenly throne. Surrounding him are Mary and John the Baptist, St. Peter and other apostles, disciples and believers, supported by crisp and frosty clouds that pile up in gigantic swirls. El Greco has stretched his figures to some extent, but will increase this distortion in later work. The light is not natural but seems to glow from within the figures themselves.

El Greco used greens, blues, silver-grays and blacks to create a visual statement about his adopted city in *View of Toledo* (*See* p. 30). Far from being realistic, the exciting landscape painting is an expressionistic statement of how El Greco felt about the place. It is mystical, glowing, painterly, and haunting. Tiny figures are merely specks on the canvas as light again seems to glow from within the painting rather than come from the sun.

El Greco painted many religious works for churches and hospitals in and around Toledo, but one of the finest examples of his later mystical style is the *Resurrection*. Christ soars effortlessly toward heaven, carrying the victory banner with him. He calmly observes the scene below where soldiers seem to be flung apart by the explosive power of His resurrection. The writhing movement and flickering lights and darks create a powerful and unified statement. Notice how the elongated figures and thin arms, hands, and legs fill most of the available space and draw the viewer's eyes up to the Christ figure with unrelenting magnetic force. The artist has made a personal statement, powerfully expressive, without using the conventional realism of Renaissance and Classical traditions. Physical reality does not exist in this late work. It must have been challenging for El Greco to work in such a manner—it is also one reason why his work is popular among many artists of the late twentieth century.

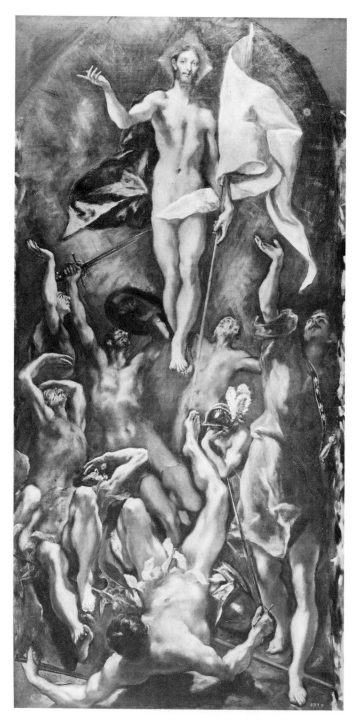

EL GRECO. *Resurrection*, about 1597–1604. Oil on canvas, 275 × 146 cm. Prado Museum, Madrid

BENVENUTO CELLINI. *Perseus and Medusa*, 1545–1554. Bronze, 6 m high. Piazza della Signoria, Florence

SCULPTURE AND ARCHITECTURE

Although painting was the most important medium during the late sixteenth century, several sculptors made excellent contributions to the art of the period. A slight change in style and an emphasis on luxurious elegance were characteristics of the work produced.

Benvenuto Cellini (1500–1571) Cellini's *Autobiography* is a book that gives us a vivid picture of life in sixteenth century Italy, including the sack of Rome through which the artist lived. Besides being an author, Cellini was an excellent goldsmith and a sculptor in bronze. His *Perseus and Medusa* stands in the Piazza della Signoria in Florence in an honored location. The heavily muscled figure of Perseus reminds one of Michelangelo's many powerful bodies. Perseus holds the severed head of Medusa, whose blood is turning to precious coral strands as it pours from body and head. These ornamental strands and the highly decorated pedestal add the luxurious touch to a Mannerist sculpture.

Giovanni Bologna (1529–1608) Coming to Italy from northern Europe, Jean Boulogne (renamed Giovanni Bologna in Italy) was the most original sculptor between Michelangelo and Bernini, thus bridging the time span between the Renaissance and the Baroque. His powerfully designed *Abduction of the Sabine Woman* was carved from a single block of marble. The muscular central figure carries away the Sabine woman as her father crouches in defeat. The three figures are interwoven in a spiraling composition that seems as difficult to unravel as the groupings in many of the Mannerist paintings. All sculpture until this time was made to be viewed from front, back, and profile, but Bologna's work has no front or back and viewers must constantly move around it to see the complete work. Parts of arms, legs, and heads seem to flail outward at various angles creating a feeling of violent action and tension. Comparing such a work with the rather static early Egyptian or archaic Greek sculptures will emphasize the skill and craftsmanship that were developed in the intervening centuries. The monumental sculpture displays all of Bologna's considerable skills and stands close to Cellini's *Perseus* in the Palazza della Signoria in Florence.

ANDREA PALLADIO. *Villa Capra (Villa Rotunda)*, begun 1550. Vicenza, Italy

Andrea Palladio (1508–1580) The only north Italian architect that ranks with Bramante (St. Peter's) and Michelangelo was Andrea Palladio from Vicenza. Many of the buildings in his hometown (palaces, town hall, and theater) were designed and built by him. Many structures in Venice, Padua, and other nearby cities also were his, but none are more influential than his villas or large country homes. The *Villa Capra* (called the *Villa Rotunda* because of its dome and central plan) uses Classic forms such as a flat dome like that of the Pantheon, Ionic columns, pediments, and arches. The large central cube has porches on four sides that enlarge the form to a more horizontal feeling of grace and stability. The building has the quiet elegance of Mannerism rather than the severe discipline of Renaissance architecture. In 1570 Palladio wrote and illustrated a book that contained his thoughts and ideas on architecture based on Classic ideals: a set of rules by which to build. It became the international guide for many builders up to the eighteenth century, including British and American architects, among them Thomas Jefferson (*See* p. 334). Some of the buildings seen in the next several chapters will illustrate the influence of Palladio on world architecture and the emergence of a style that bears his name—Palladian.

1400

Islamic world	Tomb of Timur, Samarkand (1405); Green Mosque, Bursa (1421)
China	Ming dynasty flowers; Classic blue-and-white porcelain; Forbidden city (1404–1420)
Japan	Muromachi period (1333–1573); Sumi-e painting; Gigakuji, Kyoto (Silver Pavilion)
Korea	Overthrow of Mongol rule and rise of Ui dynasty (1392–1910)
India	The Jami Masjid, at Alamadabad (1421)
S.E. Asia	Angkor falls to Ayutthya (1431); Sawankhaloke pottery; Chandi Sukuh built in Java
Europe	Joan of Arc (1412–1431); Prince Henry the Navigator of Portugal
Americas	Aztec. Mixtec, and Haustec cultures, Mexico; Inca unification of Andean area

1450

Islamic world	Moors driven from Spain (1492); Ottoman Turks take Constantinople (1453)
China	Ming dynasty; Overglaze enamels developed; Cloisonné work; Che and Wu painting
Japan	Muromachi period; Growth of "cha-no-yu" and related arts
India	Vasco da Gama reaches India, returns to Europe (1498)
Europe	Hapsburgs rule; Machiavelli; Spanish Inquisition (1478); End, Hundred Years War
Americas	Sun Stone (Aztec Calendar); Machu Picchu; Columbus; Cabot in North America

1500

ART OF OTHER CULTURES

When the Ming rulers reestablished control of China by ousting the Islamic Mongols in 1368, a wave of patriotic enthusiasm for "ancient" Chinese ways and arts inspired the construction of a new Imperial City at Beijing. Song architecture was duplicated in the construction and decoration motifs, rooftop ornaments, elevations, and symbolic use of Imperial blue and yellow coloration.

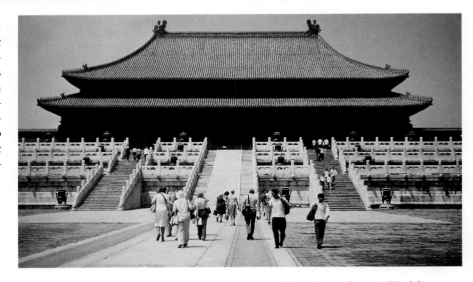

Forbidden City, about 1420. Ming dynasty. Beijing

The animal style of central Asia reached the kingdoms of Southeast Asia by way of both China and India. Thriving small kingdoms in Southeast Asia produced export pottery which was shipped to the Philippines, Borneo, and other islands in exchange for precious foods and raw materials. Interestingly, the animal bottle bears a great resemblance to the animal and human bottles of the Americas, made by the Colima, Nazca, and Mexican cultures.

Elephant Pot with Rider. 15th–16th centuries. Sawankhaloke, Siam. Stoneware, 14 cm high. Collection of L. C. Saunders, Hong Kong.

Two-headed Serpent, 15th century. Aztec or Mixtec. Mosaic, 44.5 cm long. The British Museum, London

The serpent is a popular religious image that spans cultures across the world and can be found in the iconography of American, Southeast Asian, Hindu-Javanese, Chinese, and Indian art. This one is of turquoise and shells, set on a wooden frame, and was probably a breast-plate from Monte Alban. Such work was exported by the commercial Pochetas into the country of the Mayas and elsewhere.

INDEPENDENT STUDY PROJECTS

Analysis

1. Mannerist painters often used elongated distortion in their paintings to emphasize personal feelings. Using a photograph as a start, sketch, draw or paint a group of people in elongated form. Or, arrange a slide show of your classmates in which you project their images on a slanted surface to distort the figures.

2. High Renaissance artists were greatly influenced by the art of Greece and Rome. Study one of the following projects and prepare an essay, oral or visual report:

 a) Find pictures of Renaissance paintings or sculpture that show direct influences of Greek and Roman body types.

 b) In one of Raphael's paintings, discover as many Classic influences as you can.

 c) Compare and contrast a Michelangelo sculpture with a Classic Greek sculpture.

3. Using illustrations from the text, list Italian Renaissance artists who stressed design in their work; those who emphasized emotion and feeling and those who balanced these two concepts equally.

Aesthetics

4. Renaissance artists used the human body to show perfection by stressing muscular development, sensuality, proportion and pose. Take photographs of students in gym classes or other sports activities to be labelled and used as illustrations for such concepts as loneliness, strength, thought, action, determination, dismay, exhaustion and exhiliration. Think of faces, legs, torso, hands, arms and backs as expressions of the feelings and tensions of the mind as well as the body.

5. Write an essay to compare or contrast two artists, one from the early and one from the high Renaissance. An essay might also compare or contrast the paintings of Raphael and Michelangelo; Michelangelo and Tintoretto; Titian and Bellini; Piero della Francesca and El Greco. Or compare the sculpture of Donatello and Michelangelo (their *Davids*) or the architecture of Bramante and Palladio.

6. Religious subjects became more natural during the Renaissance. These gradual changes can be noticed in both painting and sculpture. Write an essay comparing a religious painting of Giotto's with one of Raphael's, or other artists of distinctly different periods (Gothic and Renaissance, for example).

Studio

7. Renaissance artists developed scientific ways of showing perspective. Make a drawing of a simple building in your neighborhood or school ground using linear perspective. Look in a drawing book or encyclopedia, or ask your drawing teacher for help in establishing eye level, vanishing points, etc. Draw the same building using worms-eye perspective (looking up at it from below).

8. The portrait became important during the Renaissance. In addition to facial details, the subjects were often set in an environment that reflected the skills and interests of the subject. Make a self-portrait in which you not only represent yourself physically but also indicate personal aspects (family heritage, sports interests or professional aspirations). Use one medium (pencil, paint; clay) or create a collage (photographs, magazine cutouts) combined with drawing or painting.

9. Make comparative sketches of the exterior dimensions of several major buildings (St. Peter's Basilica, a Gothic cathedral, a Romanesque church, the Hagia Sophia, the Pantheon, the Parthenon and a large building in your own city). Make them to the same scale so that visual comparison is instantaneous. Use encyclopedias and other art books to research dimensions.

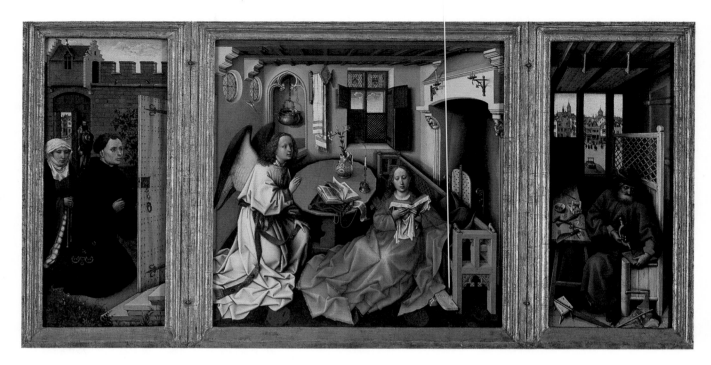

MASTER OF FLÉMALLE (Robert Campin). *Merode Altarpiece*,
about 1425–1426. Oil on panel, 64 cm high. The Metropolitan
Museum of Art, New York, The Cloisters Collection

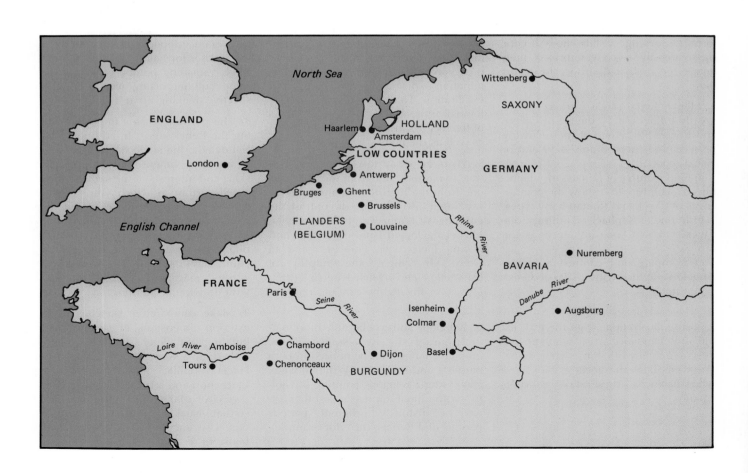

10 Attention to Detail:
The Renaissance in the North

THE CULTURAL SITUATION in Europe in the fifteenth and sixteenth centuries was complex. While Gothic architecture dominated northern Europe into the early sixteenth century, painting developed in various ways. As the last chapter demonstrated, many Italian Renaissance painters returned to the aesthetics and ideals of Classical antiquity. Northern Renaissance painters, who lived at the same time, moved in a different direction. They rediscovered nature and realistic ways to portray it.

Northern Renaissance art began with the realistic International style in Burgundy and then shifted to Brussels in 1430 when Philip the Good moved his capital there. The artistic tradition brought to this splendid court led to important changes in the painting of the Low Country cities of Bruges, Brussels, Ghent, Louvain, and Haarlem—the art centers which rivaled Florence, Siena, Rome, and Venice. As this chapter unfolds, refer back to the last one on the Italian Renaissance to compare and contrast the two parallel trends.

The Low Countries

The Master of Flémalle (Robert Campin) (1378–1444) One of the confusing aspects of early Renaissance painting in the Low Countries is the lack of accurate identification of many of the artists. Without signatures, names have been lost. Where definite similarities exist, several works can often be attributed to a single artist who is given a title such as "The Master of Flémalle," referring to his hometown or to one of his works. Art historians are not unanimous in their opinion, but it is generally thought that the Master of Flémalle was Robert Campin. But if there is doubt as to the name of the artist, there is no doubt that his *Mérode Altarpiece* is an early Renaissance masterpiece. So named because it was in

the Mérode family for many years, the central panel of the *triptych* is of the *Annunciation*. The event takes place in a merchant's home in Flanders and not in Nazareth or amid the luxurious surroundings so common with painters of the International style. The oil painting is filled with symbolism: the lilies for Mary's purity; the smoking candle, water pot, and towel for Mary's life and her son's work. Details are carefully observed and painted with equal vitality throughout the painting. Perspective is visually implied more than it is a scientifically accurate depiction of depth. Folds in the cloth are full, abundant, and crisp, almost too many for the quantity of material. (Compare these with the many folds in the sculpture of Claus Sluter.) The light is clean and crisp with careful attention to direct, diffused, and reflected light. This painting is a marvelous attempt at rendering interior space in a natural way and bringing a spiritually elevated event down to an earthly level, easily accepted by all who view it.

The two outside panels are constructed with hinges to close when the panels are not in use above an altar. In a closed garden on the left, the donors of the altarpiece (The Inghelbrechts from Mechelen) are shown viewing the event through a door left open behind the angel. The right panel shows Joseph in his carpenter's shop, surrounded by his tools, many of which are symbolic of Biblical events. Outside his window is a town (Nazareth?) which appears to be Flemish in its characteristics. Tiny people are even walking in the square. While most northern European painting had been done in miniature or as manuscript illuminations, Campin was among the first artists to work in large size, with some of his figures approaching lifesize. Those in the Mérode Altarpiece, however, are still rather small.

Campin could not have created such luminous detail with tempera paint. He used a new medium—oil

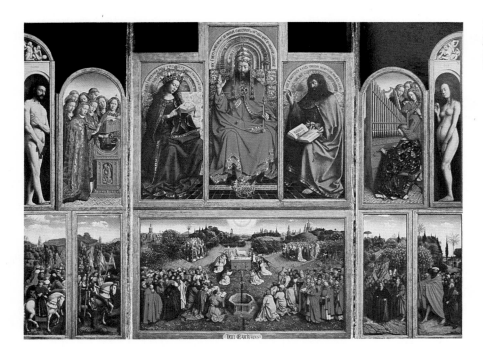

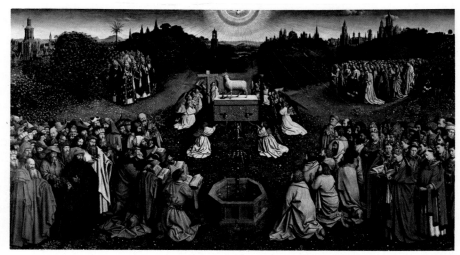

HUBERT and JAN VAN EYCK. *Ghent Altar-piece* (detail, *Adoration of the Mystic Lamb*)

painting. Over an underpainting of grayish tempera that was really a value drawing in darks and lights, oil colors were brushed in thin, transparent colored layers, one over the other until the desired richness was achieved. Because oil paints did not dry as rapidly as tempera, these colors could be blended to produce the delicately shaded folds in cloth and the carefully observed changes in light intensity. This new medium revolutionized painting and allowed artists to work with an unlimited range of values and colors and to use detail in a way not possible with tempera or fresco.

Jan van Eyck (about 1385–1441) The fascination with detail and the presentation of nature that was to be-

come the trademark of Northern European Renaissance painting is epitomized in the work of Jan van Eyck. Possibly one of the greatest painters to ever live, his contemporaries and fellow artists, confident of his greatness, showered him with unstinting praise. His detail is incredible, yet areas of his paintings are subordinated to direct attention to the most important parts. His understanding of light was far greater than that of his Italian contemporaries. Van Eyck excelled at portraying direct and diffused light, shadows falling on a variety of surfaces, and light's effect on the illusion of distance. Philip the Good, Duke of Burgundy, considered van Eyck the world's greatest artist. Van Eyck traveled for the Duke and even went to Italy where he met Masaccio and other

Florentine artists. He finally settled in Bruges in Flanders (Belgium) in 1430 and began to sign and date his works for the first time.

The greatest early Flemish masterpiece was *The Ghent Altarpiece* begun by Hubert van Eyck in 1425 and finished by his brother Jan seven years later. Art historians have spent much time trying to determine which parts were done by each, but the work largely reveals Jan's genius. The entire altarpiece is about five meters wide when the tryptic is opened, and the two wings are painted on both sides to be decorative even when closed. The entire bottom section across five panels tells a story from the Book of Revelation: *The Adoration of the Lamb*. Marvelous landscapes, animals, trees, people, fabrics, light, and air are handled with meticulous detail, as if each part were to be studied separately. Using the newly devised oil technique, van Eyck presents in glowing color a scene in Paradise (with Flemish buildings) in which the dove of the Holy Spirit sheds light on the enthroned Mystic Lamb (a symbol of Christ). The Fountain of Life pours its water into an octagonal basin and from there into a river in which jewels are seen. Prophets, patriarchs, and kings of the Old Testament are grouped on the left while apostles and saints are on the right. The top panels include Adam and Eve (the first almost lifesize nudes done in northern Europe), singing angels, and an incredibly detailed central panel of God the Father flanked by Mary and John the Baptist.

An interesting mixture of time and space is used by Jan van Eyck in his painting, *The Annunciation*, where he places the event of the angel Gabriel announcing the birth of Christ to Mary in a fifteenth century Gothic church. While such details as scientific perspective are not used accurately, but only felt, the artist creates a stage-like setting in which the viewer seems to be a fellow participant. Robes, building, windows, faces, and the floor are painstakingly detailed. Jewels in Gabriel's crown and robe reflect the light with amazing accuracy. More than simply a painting of an event, van Eyck fills the panel with symbolism. The lilies symbolize Mary's purity and her gesture is one of submission to the will of God. Words coming from Gabriel's mouth ("Ave Maria . . .") are answered by Mary's words which are upside down—to be read by God. Lilies on the angel's robe again symbolize Mary while many seeded pomegranates signify Christ's resurrection. From the top of the painting, on rays of light, the dove of the Holy Spirit descends to Mary, all in accord with the Biblical narration. Floor panels illustrate Old Testament events that foreshadow New Testament activities: David killing Goliath, Samson destroying the temple, and so on.

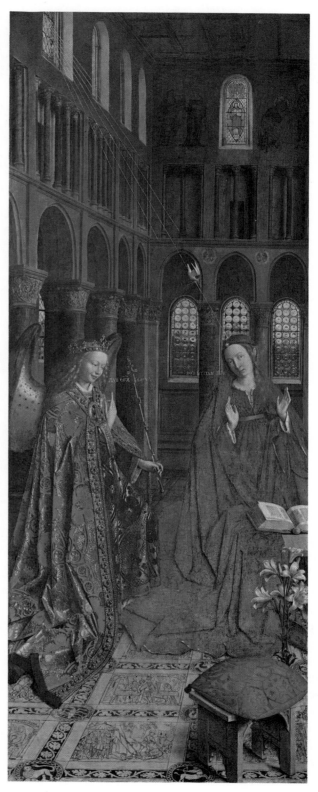

JAN VAN EYCK. *The Annunciation*, 1432–1436. Oil on wood, transferred to canvas, 92 × 36 cm. National Gallery of Art, Washington D.C., Andrew Mellon Collection

JAN VAN EYCK. *Arnolfini Wedding*, 1434. Oil on panel, 82 × 59 cm. National Gallery, London

One of van Eyck's best known paintings is the *Arnolfini Wedding*, the ceremony between Giovani Arnolfini (an Italian merchant living in Bruges) and Jeanne Cenami (an Italian born in Paris). Meticulous detail and incredibly realistic light share importance in the work to produce a painting of marvelous reality and unity. Light enters at the left and softly illuminates the metal chandelier, hard walls, soft fabrics, and flesh. All the detailed objects in the room have symbolic significance: the right hand is raised in the pledge of fidelity; the little dog is another symbol of fidelity; the clogs, cast aside, indicate the couple stands on holy ground; the peaches ripening on the chest are a sign of fertility; and the single candle (the nuptial candle) is lighted in the chandelier. The decorative signature on the wall above the mirror says (translated) "Jan van Eyck was here in 1434," attesting to his witness of the ceremony. The convex enlarging mirror shows the viewer not only the backs of the couple but also the front view of Jan and another person in a miniature composition.

Rogier van der Weyden (1399–1464) No painters could equal the color and light of Jan van Eyck, nor did they try. The third great artist of early Flemish painting was Rogier van der Weyden who worked on larger surfaces than van Eyck and infused his detailed religious works with drama and emotion. The large *Descent from the Cross* (probably part of a triptych) was painted for a church in Louvain in 1435. The setting (what one can see of it) is symbolic, taking place inside the sepulchre and not on a hill outside Jerusalem. Rather than use the natural light of van Eyck, Rogier lights each part carefully to allow one to see every wrinkle, tear, and detail, much like the evenly lighted treatment in Robert Campin's work. The strong emotional feeling expressed in each

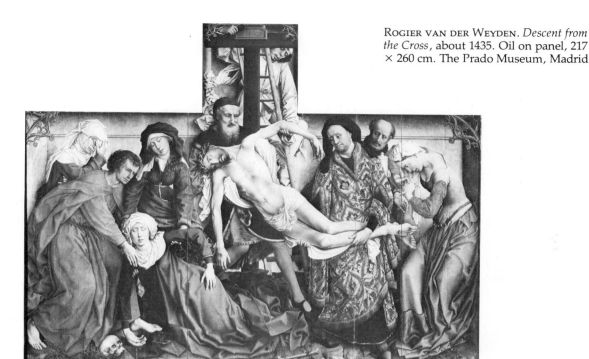

ROGIER VAN DER WEYDEN. *Descent from the Cross*, about 1435. Oil on panel, 217 × 260 cm. The Prado Museum, Madrid

face receives extra emphasis from the twisted and bending bodies. Notice how the limp s-curve of Christ's body is repeated in Mary's body in the foreground, her hand almost touching the skull of Adam which, by legend, was discovered when the hole was dug for the cross. The entire complex composition is balanced beautifully by grouping the figures carefully and allowing the almost horizontal body of Christ to tie the parts together. The crisp folds so noticeable in Campin's paintings are again evident in Rogier's work. Notice how close the viewer is to the drama on the stage, rather than watching the event from a distance as if outdoors. Rogier van der Weyden became the official painter for the city of Brussels in 1435 and had a strong influence on countless artists that followed.

Jan van Eyck had been one of the first northern European artists to paint portraits, which he did with his characteristic detail and light. But equally impressive are those of Rogier van der Weyden, his *Portrait of a Lady* being an excellent example. Exquisite line and delicate shading form the face which is set off by the beautiful white coif placed against a dark background. The folded hands are a familar gesture in such paintings, with the only bit of bright color being in the red belt which seems much too small for the figure. The aloofness of the expression eliminates an emotional response from the viewer and places emphasis on the design which, stark, simple, and cool, has a tremendous visual impact on the viewer's senses.

ROGIER VAN DER WEYDEN. *Portrait of a Lady*, about 1455. Oil on panel, 37 × 27 cm. National Gallery of Art, Washington D.C., Andrew Mellon Collection

HANS MEMLING. *Madonna and Child with Angels*, about 1480. Oil on panel, 59 × 48 cm. National Gallery of Art, Washington D.C., Andrew Mellon Collection

Hans Memling (1440–1494) Born in Germany, Hans Memling (also written as Memlinc) became a citizen of Bruges and probably studied under Rogier van der Weyden for a time. His work, quiet and serene compared to that of his Flemish contemporaries Hugo van der Goes and Geertgen Tot Sint Jans, was sometimes confused with that of Jan van Eyck, also of Bruges. He was the leading Flemish painter after van Eyck. His *Madonna and Child with Angels* is similar in theme to many works of this time, but his technique is superior. In the symmetrically balanced composition Mary and the Christ Child are flanked by two angels with musical instruments. One toys with the child, offering him an orange for which he reaches with one hand while ruffling the pages of the book with the other, both very natural movements for a child. There is the typical textural detail of the various fabrics, some rich brocades, others plain and smooth. Gothic sculptures flank a rounded arch through which one can see a medieval landscape with a castle and distant church. Every corner of the painting is carefully done and the light on each material (stone, wood, cloth, carpet, skin) is painted with knowledge and great skill.

Hieronymus Bosch (1450–1516) A Dutch painter of fanciful images and an incredible imagination, Hieronymus Bosch presents a world full of weird sights and puzzling symbols. His work is usually packed with tiny people, mostly naked, engaged in dozens of activities, almost as if ten or more paintings were crammed into a single frame, set in a fantastic landscape. Probably the most complex of his busy works is the strangely wonderful *Garden of Delights*, a huge triptych. The symbolism, complexity, and incredible detail of the three part story take a long time to read. The left panel is *The Garden of Eden*, where, amid exotic animals, plants, and landscape, God is introducing Adam to Eve. The right panel is a nightmare of indescribable tortures and portrays Bosch's idea of Hell, *The Garden of Satan*. Hundreds of figures are being tortured while the eggshell-human-tree trunk figure of Satan in the center supervises it all. Across the River Styx, a city burns with fire and dense smoke. The huge central panel, the *Garden of Delights*, is also a huge question mark. What does it all mean? Bosch's unending imagination and deft painting skill present a fantastic landscape populated with hundreds of light-pink, naked figures that are innocently parading, riding on various beasts, sitting on giant birds, swimming, bathing, and crawling in and out of gigantic eggs and other equally amazing forms. If one reads the entire story together, Bosch is revealed as a moralist: the left panel shows God's beautiful creation; the middle panel depicts humanity's constant search to satisfy its earthly desires with overindulgence and sin; this eventually leads to Hell, shown on the right. Although it is called a *Garden of Delights*, Bosch's work is a pessimistic look at humanity, with no chance of salvation shown.

Pieter Bruegel (1525–1569) Religious wars wracked Germany and the Low Countries (what is now Belgium and Holland) during the early sixteenth century. The Inquisition which spread into the area was answered by the Protestants who destroyed thousands of paintings, sculptures, and stained glass windows. Even the Ghent Altarpiece had a narrow escape in 1566. Amid this unsettling environment, Low Country painting began to discard the detail and reality of van Eyck and Rogier and to absorb the influence of Italian art. While searching for a definite direction, it was Albrecht Dürer of Germany who later provided leadership in the north.

The only Low Country master of the sixteenth century who was universally acclaimed was Pieter Bruegel. Born near Bosch's hometown in what is now Holland, his

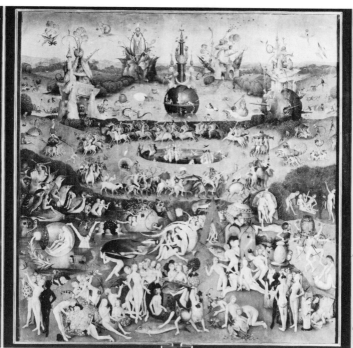

HIERONYMUS BOSCH. *Garden of Delights*. Triptych, about 1505–1510. Oil on panel, center panel 219 × 195 cm, each wing 219 × 97 cm. The Prado Museum, Madrid

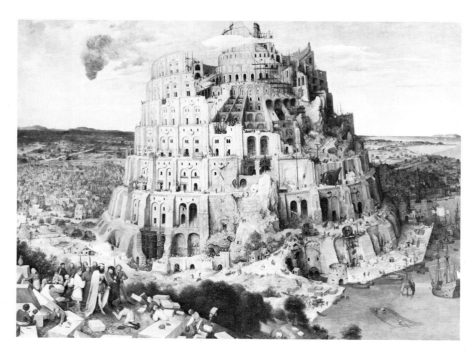

PIETER BRUEGEL. *The Tower of Babel*, 1563. Oil and tempera on panel, 113 × 155 cm. Art History Museum, Vienna

early work was greatly influenced by Bosch. A four year trip to Italy changed his outlook on painting as his later work contains larger figures which often have the monumentality of Giotto or Masaccio.

Bruegel fills his painting of the *Tower of Babel* with hundreds of tiny figures that contrast with the mammoth structure set into a far-reaching landscape. The event, re-

corded in the Old Testament, occurred when the people of Mesopotamia attempted to build a tower that reached to heaven. Bruegel had no idea of the squarish ziggurat structures of those people so he invented a huge round edifice, influenced by the Roman colosseum, that towers over the city. Bruegel displays his knowledge of various building techniques and tools. Boats and barges unload

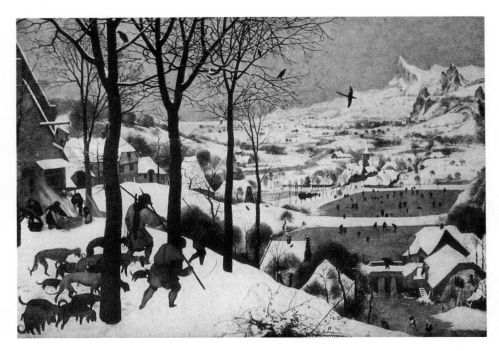

PIETER BRUEGEL. *Hunters in the Snow*, 1565. Oil and tempera on panel, 117 × 161 cm. Art History Museum, Vienna

materials which are carried up ladders and ramps to the work sites. As the mountainous structure rises into the clouds, more stone is being cut in the foreground. The story ends in the Bible when the pride of the people becomes so great that God cannot tolerate it and confuses their languages. The people cannot communicate and work has to stop. Bruegel emphasizes the work process, the huge scale of the tower, and the inevitable failure of the impossible task.

Bruegel depicted many Flemish parables and fables that illustrate the vanity of life and the shortcomings of the human race. The *Land of Cockayne* (*See* p. 29) shows a fool's paradise where food is ever present, ready and willing to be devoured. A roast pig runs around with a knife strapped to its back; pies are used as shingles on roofs; a roast chicken puts itself on a plate; and tables laden with delicious dishes never empty. The fools from all walks of life (peasant, cleric, soldier, and nobleman) have become slaves to their appetites and have lost the battle. The composition is radial, a device not often used in paintings. Bruegel brings the viewer close to his subject and repels the viewer from these gluttonous men—the didactic purpose of his painting.

Very few artists have captured the silent, cold crispness of winter the way Pieter Bruegel has in *Hunters in the Snow*, one of a series of paintings depicting the seasons of the year. He loved to paint peasants in their daily activities as well as at their special festivals. The world here

is covered with snow as the weary hunters trudge homeward, their dogs following dejectedly behind. The hunt has been hard work, not a jolly sport, but is part of the seasonal struggle of the peasants. Below the village on the hillside, skaters frolic on the frozen ponds. Alpine peaks, which Bruegel observed on his Italian trip, are shown in the distance, a depth that is felt more strongly because of the birds flying in the intervening space. The leafless trees march down the hill and help unite the foreground with the middle distance. Simple human activities and ordinary landscapes seem to achieve extreme importance and dignity in Bruegel's treatment. Humans and nature are bound together as a working unit.

The jovial activity of a country party is the subject of Bruegel's *Peasant Wedding* (*See* p. 22). Solid and rounded human forms fill the interior space as family, guests, musicians, and servers cram themselves around the table which slants diagonally into the composition. The bride is visually set off by the dark cloth behind her, but the groom is more difficult to find. In this and many of Bruegel's paintings, the viewer must look in all areas for surprises, such as the child in the foreground licking a plate clean. Although Pieter Bruegel lived in the city, he loved to witness the activities of the hard working and fun loving peasants. He became the first artist to paint the common everyday activities of the working people, for which he was nicknamed "Peasant Bruegel."

ALBRECHT DÜRER. *Self-Portrait*, 1498. Oil on panel, 51 × 41 cm. The Prado Museum, Madrid

at perspective techniques and on two trips to northern Italy he absorbed some of the Italian interest in color and form. Yet line always remained a dominant feature of his style. He admired the princely lifestyle enjoyed by Titian and other Italian artists and attempted to raise the status of art in Germany and the rest of northern Europe to an equally high level.

Dürer painted himself at different times in his life but his *Self-Portrait* done in 1498 is one of his best and one of the earliest such subjects painted. The influence of Italian portraiture appears in the casual pose and the landscape through the window. The costume is fifteenth century German, a flamboyant style that disappeared when High Renaissance Classicism reached north of the Alps. Although the pose is Italian, the linear quality is still German and distinctively Dürer's. Hair is not treated as masses but as individual lines—hundreds of them. Line is also evident in the clothes, the crisp folds and edges, and the faint outlines of hands and face.

Dürer is unsurpassed in the field of graphic arts. Printmaking techniques are discussed in Chapter 2 and should be reviewed to understand the incredible abilities Dürer possessed in both woodcut and copper engraving. In 1498 he concluded a series of fifteen woodcuts illustrating events from the *Apocalypse*, the Book of Revelation (last book in the Bible) which reveals the visions of St. John. They are extremely detailed and, where other printmakers worked with single lines, Dürer massed fine lines together to produce gray-valued areas that give his prints depth and shading. The cut lines are unbelievably fine for the woodcut medium and give the appearance of being pen and ink drawings.

These cut blocks could be inked and printed in presses (Gutenberg had already invented movable type in 1446) and sold for much more modest prices than the master's paintings. The market for these works was huge and Dürer became a wealthy artist and honored citizen in his home town of Nuremberg. Prints like his *Four Horsemen of the Apocalypse* (one of the finest woodcuts ever made) were used as wall decorations and above altars in middle class homes, or were pasted inside trunks and travel

Germany

Early fifteenth century German art was part of the International style and ignored the Italian use of Classic ideals because such Classicism was not part of their cultural heritage. The Italian use of nude figures and monumental forms, based on Greek and Roman art, were strange to the artists in northern Europe whose tradition lay in medieval expressionism and the use of line. German artists looked to Flanders for inspiration (van Eyck and van der Weyden were strong influences), but they were secondary to the Flemish in both technique and style. This situation changed in the early sixteenth century as German art moved to the forefront of northern European expression. German and Italian High Renaissance artists were contemporaries, yet in Germany the artistic momentum was short-lived. By the end of the century, there were no great artists to replace Dürer, Grünewald, Altdorfer, Cranach, and Holbein.

Albrecht Dürer (1471–1528) The leader of the German High Renaissance was Albrecht Dürer, an artist of gigantic ability in painting, woodcut, engraving, and drawing. Like his Italian contemporaries, he was adept

ALBRECHT DÜRER. *Knight*, *Death and the Devil*, 1513. Engraving. 25 × 19 cm. Los Angeles County Museum of Art, Graphic Arts Council Fund

ALBRECHT DÜRER. *Young Hare*, 1502. Watercolor with opaque white, 25 × 23 cm. The Albertina Museum, Vienna

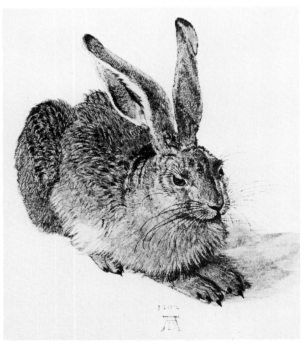

cases as worship aids for travelers (*See* p. 37). The four horsemen seen by St. John (war, pestilence, famine, and death) ride roughshod over helpless humanity. Dürer's line is put to the test as he includes fantastic detail in so small a woodcut. Notice how he uses it to give form to the figures and horses as well as to outline, shade, and indicate hair. Notice also the A-D monogram used by Dürer to sign his prints and often his paintings.

Another printmaking technique at which Dürer excelled was copper engraving; he was more skilled in this than Schongauer, the medium's first great master. *Knight, Death and the Devil* is one of three master prints made by Dürer from 1513 to 1514. (The other two were *Melancholia* and *Saint Jerome in His Study*.) The subject is a knight, which symbolizes the Christian warrior, sitting astride a magnificently drawn horse. The artist demonstrates his complete knowledge of animals and their forms. The brave knight fears no evil and rides gallantly ahead without paying attention to Death (with the hourglass) or the Devil (a monster of hideous form).

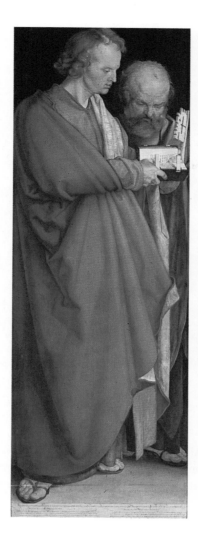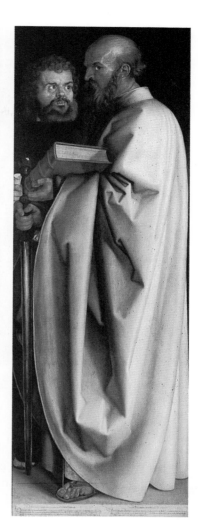

ALBRECHT DÜRER. *Four Apostles*, about
1526. Oil on panel, each part 215 × 76
cm. Pinakothek, Munich

Dürer used incised line to outline as well as crosshatch,
creating a fantastic variety of darks which appear to be
solid grays rather than linear pattern. He achieved a
chiaroscuro with line comparable to what the Italians did
with paint. Again, the monogram in the lower left corner
identifies the artist and the date of the work.

Albrecht Dürer loved animals and used them in many
of his prints and paintings. He owned several dogs and
traveled miles to see exotic animals not native to north-
ern Europe, often making drawings or watercolor
sketches of them. He kept these for reference, ready to
include in later works. In his *Young Hare*, a watercolor
sketch, he applied line with tender care to produce a
feeling of soft fur. His cabinet contained hundreds of
such animal sketches as well as watercolors of plants and
landscapes. Dürer was a master of watercolor, a medium
that at the time was used mostly for preliminary studies
which were often discarded. He kept them, however,
and was among the first artists to retain work done in
this medium.

Dürer's last major work is the powerful oil painting of
The Four Apostles, a diptych meant as the side wings of a
large triptych. The four figures of John and Peter on the
left and Mark and Paul (not really among Christ's apos-
tles who traveled with him) on the right were to flank a
Madonna and child with saints in the center. But since
the city of Nuremberg and Dürer had swung to Luther
and Protestantism by 1526, the central subject was not
acceptable. The solidness and weight of these figures are
more Italian than anything Dürer did. The faces emerge
from a darkly shadowed, flat background, and the light
creates marvelously full forms and folds in the cloth. Our
eyes are pulled up along these folds to the hands and ex-
pressive Germanic faces. Each part could easily stand
alone as a completed painting, but the two parts together
produce a balanced composition of powerful expression
and sculpturesque forms. The figures are crowded into
the required space, which creates tension and a feeling of
explosive energy, as if they are ready to burst from the
frame and proclaim their messages.

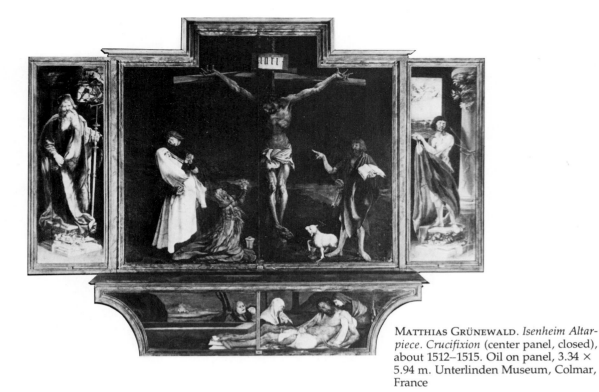

MATTHIAS GRÜNEWALD. *Isenheim Altarpiece. Crucifixion* (center panel, closed), about 1512–1515. Oil on panel, 3.34 × 5.94 m. Unterlinden Museum, Colmar, France

Matthias Grünewald (about 1465–1528) Although he was an excellent artist, Dürer's greatest contemporary was not a well-known figure. His real name, Mathis Niethardt Gothardt, was not known until this century, and because of popular usage the name Matthias Grünewald is still used. While Dürer was exploring the visual trails of the Renaissance, Grünewald was the last and most powerful of the expressive Gothic spirits. He painted only a limited number of works but his single greatest masterpiece is the *Isenheim Altarpiece*, done for the Hospital of St. Anthony in Isenheim, a small town near Colmar which today is in France. The painting is a complex polyptych, made of many opening panels and wings that were hung in two sets of paintings in front of a carved shrine to St. Anthony. When closed, the *Crucifixion* is seen, as in the illustration. As these panels are opened there are scenes of the *Annunciation*, the *Nativity*, the *Resurrection*, and various saints, painted in bright orange, red, gold, and blue; and finally the carved and gilded shrine appears.

The *Crucifixion* is the most dramatically powerful work ever done on the subject of Christ's suffering and death. Placed slightly off-center (to add to the tension and not to divide Christ's body when the panels open), the cross is seen as the cruelest means of death. The scarred body of the beaten Christ hangs as a broken figure, dangling from crossarms which are bent under the weight of the body and the world's sin. The pull of gravity is so strong that the fingers and hands are almost pulled apart. The bent head, bloody with the crown of thorns, seems ready to take its last breath. It is not a pretty sight and many people are repelled by it, but Grünewald is expressing the ugliness and weight of sin and how it made God's son suffer. The drama is intensified by the black sky that adds to the feeling of death, gloom, and sorrow. On the left, John is consoling Mary, according to one of Christ's last wishes, and Mary Magdalene is yet praying to her Lord for continuing forgiveness. John the Baptist is shown pointing to Christ as the Savior of the world, which was his role. Even though he had died prior to Christ's death, the Baptist was placed here to complete Grünewald's idea and his composition. The symbolic lamb with a cross is bleeding into the chalice, an often used symbol of Christ and his suffering and death. The two figures standing in the side panels are St. Sebastian on the left and St. Anthony on the right. Below the central panel, under a ledge, is a horizontal composition of the *Pieta*. Christ's body has been taken down from the cross and will soon be placed in the open sarcophagus.

The entire cycle of the altarpiece is a marvel of organization which reaches its climax in the resurrection scene, in the second set of panels, where Christ bursts from the

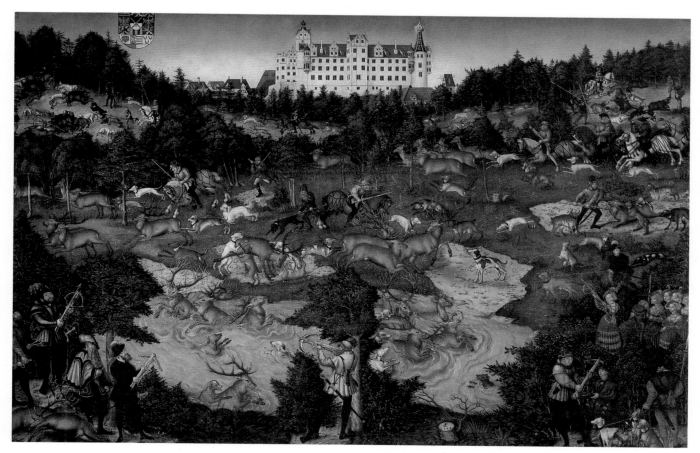

LUCAS CRANACH. *Hunting Party in Honor of Charles V at the Castle of Torgau*, 1545. Oil on panel, 111 × 175 cm. The Prado Museum, Madrid

tomb with the energy of an atomic explosion. While his crucifixion is awesome, Grünewald's resurrection is the most astonishing ever painted. A small study of the crucifixion scene was done prior to the large painting and is in the National Gallery in Washington, D.C. (*See* p. 75). It is interesting to note the changes made in the final work.

Lucas Cranach (1472–1553) A Protestant painter and friend of Martin Luther, Lucas Cranach (the Elder) painted several portraits of the leader of the Reformation. Both painter and architect, he became official painter for the Elector of Saxony at Wittenberg, where he and his two sons, Hans and Lucas (the Younger), were responsible for dozens of paintings. While Dürer traveled often to Italy, Flanders, and other parts of Germany, Cranach was provincial and remained at home, shunning the advances made in Italian and Flemish painting. He painted many nude subjects of Adam, Eve,

and various gods from ancient mythology, yet they all appear as naked German folk, posed in rugged outdoor settings rather than as Classic figures of Greek and Roman times. His work includes a number of hunting scenes such as *Hunting Party in Honor of Charles V at the Castle of Torgau*. Extremely complex in its composition, the painting illustrates hunting with crossbows and spears. Assistants and dogs are driving the stags into the open and to the pond in the foreground, where the Duke of Saxony, Emperor Charles V, and a knight (lower left) are waiting for the kill. Bear are being hunted in the upper left and upper right and above all towers the Castle of Torgau. Cranach has combined architecture, landscape, animals, and people in a writhing composition in which the viewer's eyes are constantly moving from one area to another, seeking a place to pause. Notice the other hunters, including women in the lower right. The painting is a documentary work, illustrating a contemporary event, and might be compared with today's photographs of hunting parties and their catches.

HANS HOLBEIN. *Sir Thomas More*, 1527. Oil on panel, 75 × 59 cm. The Frick Collection, New York

HANS HOLBEIN. *The French Ambassadors*, 1533. Oil on panel, 206 × 208 cm. National Gallery, London

Hans Holbein (1498–1543) One of the finest portrait painters of all times, Hans Holbein (the Younger) was born in Germany but found success in Switzerland and later in England. He moved to Basel, Switzerland when he was about thirteen and stayed there for eleven years, making occasional trips to Italy and France. He enjoyed great popularity in Basel where people appreciated his paintings, prints, murals, jewelry, and architectural designs. When the Reformation reached Basel in the mid-1520s, Holbein went to England where he became court painter to Henry VIII, painting many portraits of royalty and English contemporaries. Holbein's work provides a realistic image of sixteenth century clothing, hair styles, and general appearance.

Although Holbein painted religious works, portraits were his strength and the source of a very handsome income. His mature style (though he died at a young age) is characterized by extreme detail, a cool and objective likeness of his sitters, and a wonderful ability to describe fabrics with his brushes. Holbein painted a remarkable portrait of Sir Thomas More, the witty author and statesman who launched the English phase of Holbein's career. No one has painted velvet or fur more convincingly; yet More's face is beautifully rendered and draws the viewer's final attention, as it should. Set against a green drape and dark hat, the modeling of the features is brilliant, particularly the treatment of the eyes. The face is determined and dignified. One can almost sense that this man who wrote *Utopia* could not compromise his ideals—a quality that led to his clash with Henry VIII and his beheading.

Holbein painted four of Henry's six wives and traveled to the continent for his monarch, painting prospective brides. He not only painted the king several times but designed his jewelry, lavish clothes, weapons, and silverware. He also painted the king's heir, *Edward VI as a Child*, when the youngster was only two years old (*See* p. 27). Holding his rattle as a scepter and gesturing with a regal motion, the young prince is attired in royal clothing. It is the portrait of a king-to-be, not of a cuddly baby.

One of Holbein's greatest achievements is his double portrait, *The Ambassadors*. The French Ambassador to England, Jean de Dinteville, is on the left in a casual pose and is with his friend Bishop Georges de Selve. While both men are portrayed with Holbein's usual care and detail, the array of objects in the painting is fascinating. The objects are a virtual catalog of the two men's interests: eye glass, lute, celestial globe, Lutheran hymnbook, compasses, flutes, sundial, a crucifix, books, the usual

Oriental carpet, and others. The most astounding feature is the shape that seems to grow out of the frame at the lower left in the foreground. It is impossible to tell what it is until one looks at it from below, near the left corner of the painting. Hold the book at a flat angle and view the object from the lower left to see it. Viewed from the correct angle, a skull appears. The painting was perhaps made to hang over a doorway so that when people looked up, they recognized a skull. Perhaps this was Holbein's subtle way of indicating de Dinteville's morbid preoccupation with death.

Although England had not produced any painters of international stature, Holbein showed the world how the English looked and established a trend in portraiture that would be long-lasting in the island empire. His early death cut short a career that could have gone on to include portraits of Elizabeth I and her court.

England, France, and Spain

While the visual arts in England did not flourish during the Renaissance (as the dominance of the German-born Hans Holbein suggests), music and literature were developing broad foundations and local flavors. Madrigals and other songs were sung across the countryside while Francis Bacon and William Shakespeare exerted a strong influence on the literature and daily language of the English people.

In France, the International style, which originated in Burgundy, continued to set the tone in painting. Jean Fouquet (1420–1481), the most important artist of the fifteenth century, painted portraits and religious scenes but also continued to work on manuscript illuminations. Several anonymous artists produced altarpieces in parts of France but turned to Flanders and Burgundy, not Italy, for stylistic changes.

Jean Clouet (1485–1541) painted portraits (some of which may have influenced Holbein) but failed to reach a stature of major importance. While sixteenth century French painting lagged behind the rest of Europe (except England), French architecture enjoyed a period of exceptional growth. In spite of Francis I's sporadic wars with Charles V and his ill-fated attempts to control Flanders and parts of Italy, he and the French aristocracy built a group of opulent châteaux in the Loire River valley.

The château of Chambord is an excellent example. Started in 1519, it follows several Italian structures in concept and has a large central block with rounded towers, which contains numerous apartments. Wings on each side contain simple hallways which terminate in huge rounded fortress-like structures with conical roofs. The entire structure has a horizontal feeling from afar. From close up, however, the Gothic-style roof towers and the vertical elements on the exterior walls produce a vertical pull on the viewer's senses. Inside the central block is a marvelously intertwined stairway to the various apartments. It is constructed so that a person walking up the spiraling stairs can hear, but cannot see, persons coming down. The entire structure is a remarkable combination of styles: the bottom three stories are coolly Renaissance while the roof is flamboyant Gothic. This dramatic contrast is revealed first by covering the roof, then the lower three stories with a piece of paper.

Pierre Nepveu. Chateau of Chambord, begun 1519.

JEAN BULLANT. Château of Chenonceaux, 1520. View of bridge and gallery

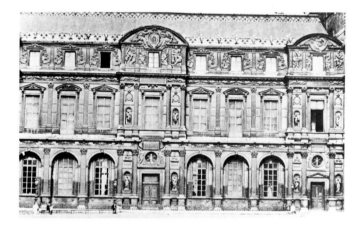

PIERRE LESCOT. Square Court of the Louvre, 1546. Paris

Another château that occupies one of the most interesting sites in the world is Chenonceaux. Constructed like a bridge across the river, huge rooms are placed atop the arched foundation and are situated directly over the water. The château is anchored to land on the left side, from which the entrance leads to huge landscaped gardens. Other châteaux dot the Loire landscape, including the one at Amboise, where Leonardo spent the last years of his life.

The Square Court of the Louvre in Paris is the first truly French Renaissance building and was designed by Pierre Lescot and Jean Goujon, the latter also furnishing the structure with sculptures and fine reliefs. A three story block, its large windows and steeply sloping roof are French additions to an Italian Renaissance idea. The sculptural details contrast with the Classical forms to produce a carefully balanced facade, both rich in detail yet more restrained than Gothic flamboyance. The windows on each floor receive different treatment, yet the stories are visually tied together with vertical pilasters and Corinthian columns. Originally part of the royal palace in Paris, it is today part of the magnificent museum of the Louvre.

Although Spain is in southern Europe, its architectural ties were with France, especially in the construction of *El*

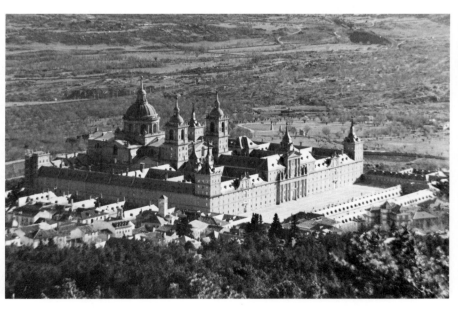

JUAN BAUTISTA DE TOLEDO and JUAN DE HERRERA. El Escorial, 1563–1584.

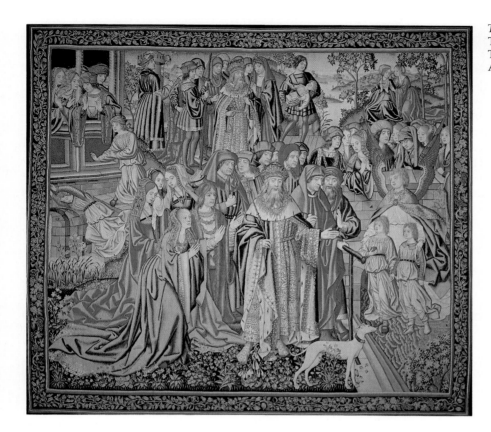

The Justice of the Emperor Trajan, 1510. Tapestry: wool and silk, 3.26 × 3.68 M. The Norton Simon Foundation, Los Angeles

Escorial. Philip II of Spain devoted much of the incoming wealth from the New World to stopping the spread of Protestantism in western Europe. His single greatest monument was the magnificent El Escorial, a building complex that expressed the unified Catholic spirit in Spain as it combined a secular palace and court with a church. Begun in the bleak Guadarrama Mountains in 1563, it is a huge square grid of interesting corridors and courtyards with the austere basilica at the center. Beneath the high altar lie eleven Spanish kings, including Philip II. The return to Classic simplicity, the visual balance, and the mathematical proportions put the stamp of Renaissance planning on the complex, which was called by Philip's contemporaries "the eighth wonder of the world."

Tapestries

The years between 1480 and 1520 witnessed the height of Belgian (Flemish) tapestry excellence. Tapestries had advantages over wall paintings in that they were portable, could be taken down and rehung elsewhere, added warmth to cold castle walls, and helped reduce echoes in stone-walled halls. The materials, dyed wools and silks, and even gold and silver threads added luxurious textures and colors to the interior environments. The process was lengthy and costly: from an idea sketch an artist would create a full-size painting on paper, called a cartoon, and from this the highly skilled weavers would set up their looms. The entire tapestry was woven on a huge loom, thread by thread. Such wall-hangings were found in every major castle and palace in Europe.

The Justice of Emperor Trajan is a marvelous tapestry from Brussels that shows the influence of the International style in the crowded scene and the careful detailing of fabrics and pattern. At the top left, the Emperor Trajan's young son accidently drowns a companion by pushing him into the Tiber River. At the top, the Emperor insists on carrying out the law and has his own son thrown into the river by the father of the drowned boy. Below, an angel reunites the two boys and presents them to Trajan and his court. Such themes of justice were often hung in court rooms and in palace collections. The entire scene, clothing, and setting are Flemish, although Trajan was an ancient Roman.

1500

Islamic world	Suleiman I on Turkish throne (1520); Ottoman conquest of Syria (1516)
China	Portuguese trade with China (1516); Ming dynasty; Chiu Ying, master painter (1520)
Japan	Muromachi period; Landscape painting; Zen garden at Ryoan-ji, Kyoto; Portuguese come
India	Mogul dynasty begins (1527); Portuguese defeat Islamic forces at Diu (1509); Goa (1510)
S.E. Asia	Portuguese capture Malacca (1511); Islamic power grows on Java; Majapahit decline
Europe	Anglican Church (1534); Martin Luther; Sir Thomas More; Magellan; Machiavelli
Americas	Cortez in Mexico; Balboa; Pisarro takes Peru (1533); Coronado in Southwest (1540)

1550

Islamic world	Battle of Lepanto (1571); Mosque of Suleiman (Blue Mosque) at Constantinople (1557)
China	Beijing is walled; Chinese novels written; Ming tombs begun; Macau is Portuguese
Japan	Momoyama period begins (1573–1614); Christianity banned; Castles; Himeji, Osaka, Nagoya, etc.
India	Humayan's tomb, Delhi; Tomb of Shar Shah, Bengal; Jesuit missions; Akbar rules
S.E. Asia	Spanish established at Cebu and Manila (1565)
Europe	Elizabeth I, England; Spanish Armada; Skakespeare; Knox; Bacon; Ivan is first czar
Americas	First English colony at Roanoke, Virginia, fails (1583)

1600

ART OF OTHER CULTURES

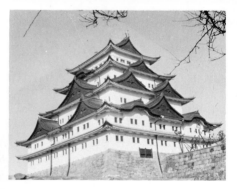

Nagoya Castle, exterior view. Momoyama period, Japan

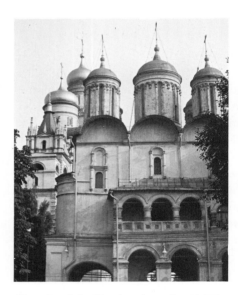

Church of the Twelve Apostles (1655) and Ivan's Bell Tower. Kremlin, Moscow

In 1480 Russia became independent of the Tartar rule which had been in control since 1230. Rulers Ivan III, Basil III, and Ivan IV (The Terrible) raised Russia to new heights of power in eastern Europe and built Moscow as a great Christian city, situated around the walled Kremlin palace. Each czar (king) had a special chapel built for his family's use. Since brick architecture had been prohibited under the Tartars, architects designed these tall towers with exaggerated domes as a reaction to the severity of foreign rule and as a statement of Russian and Orthodox nationalism. They are still synonymous with Russian architecture today.

Built for the warlords of feudal Japan, castles such as this one appeared during the short Momoyama era, marking the height of civil war activity in Japan. The strongholds utilized European ideas of fortification which were learned from the few Englishmen who happened to come to Japan as adventurers. Chinese and Japanese architectural practices and materials were combined with these medieval ideas. Only fire and bombs were able to destroy these elegant and military gems of architecture. This castle at Nagoya was rebuilt after World War II by following the original plans.

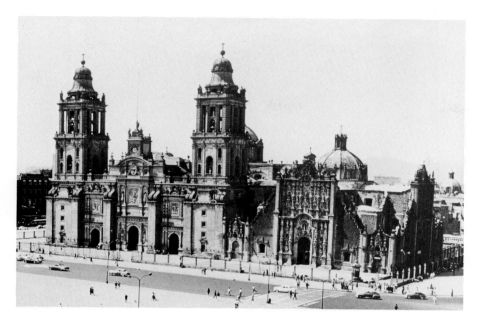

Cathedral of Mexico City, exterior view, begun in 1530 and completed in the late 1600s

Located on the Zocalo (huge main square in the center of Mexico City), the cathedral is constructed in architectural styles prevalent in Spain at the time—a combination of Renaissance and Baroque influences. The dome and square towers with rounded tops are influences from as far away as Italy, via Spain. The ornately carved facades are a Baroque influence from Spain. It is the largest cathedral in the Western hemisphere and once contained several million dollars worth of gold. A series of catacombs, containing Mexico's chief prelates, is located beneath the structure.

INDEPENDENT STUDY PROJECTS

Analysis

1. Write an essay on one of the following: The genre painting of Pieter Bruegel, A comparison of the realism of Jan Van Eyck and contemporary photography, A comparison of Renaissance architecture in France and Italy, or another subject of your own choice. Use this text and other art history books to research your subject.

2. If symbolism interests you, analyze the symbolism of Bosch, Dürer, van Eyck and Bruegel. Make a list of some of their visual symbols and what they might mean. In a report to the class, use drawings and charts of the symbols, isolated from their painted environments.

3. Fresco paintings were generally large and placed on the walls of buildings. Egg tempera and oil paintings were small and portable, and painted on wood panels. Write a paper or lead a discussion on how these facts might have affected patrons (those who commissioned artwork), buyers of art and the artists themselves. How might the size and technique have affected the artists' choices of subjects? Could *either* of these kinds of paintings be bought and sold?

Aesthetics

4. Grünewald's style of painting is called *expressionistic*. Research and write a definition of this term, and explain how Grünewald's art fits your description. Find the names of other expressionistic painters who lived in later years, and whose work might be found in other parts of this book.

5. The small size of most Northern Renaissance paintings is astonishing. Some artists even painted miniature portraits that were less than 10 cm high. Measure the dimensions of Van Eyck's *Arnolfini Wedding Portrait* or his *Annunciation* and plot them on a sheet of white drawing paper or butcher paper. Then outline and block in the basic parts. On a sheet of Kraft or butcher paper, mark the measurements of a painting by Holbein, Bruegel or Dürer. Place them side by side and discuss comparative size, amount of detail in the paintings, visual impact and the purpose of the paintings. Can purpose affect size? Why?

6. Study portraits by Holbein, Dürer, van der Weyden, Van Eyck, etc. in this and other art history books. Judging by what the artists show us about their subjects and using your imagination, write a description of the people portrayed.

Studio

7. The imagination of Bosch may suggest ways of showing your own thoughts, dreams or nightmares. Select a title for a composition (such as "Veggies in the Closet", "Garden of Electronics" or "Robotic Nightmare") and create a collage, drawing or wild combination of things.

8. Pieter Bruegel's paintings of the four seasons are known as a *cycle*. He painted his Flemish community in four settings (spring, summer, autumn and winter). You (and/or several classmates) could depict your own community, neighborhood or school in a series of four drawings, paintings, sculptures or photographs.

9. Northern European artists imitated nature by painting miniature worlds of their own. Using watercolor or colored pencils, make a tiny painting, no wider than 10 cm. Work from nature (grass, flowers, etc.) or from a still life, and keep everything in proportion. Try painting with egg tempera on a wooden panel or a piece of illustration board. Use egg yoke, water and powdered pigments as your medium, and the smallest brush you can find. (Then imagine using this exacting technique on a large altarpiece.)

SCANDINAVIA

ENGLAND

POLAND

● Oxford
Haarlem ●
● Bath
● Amsterdam
London ●
Delft ● Leiden ● Bremen
Utrecht ●
HOLLAND
Calais ●
● Antwerp
Brussels ● Cologne ● Würzburg
FLANDERS
GERMANY

Atlantic Ocean

Versailles ● Paris

BAVARIA
● Chambord
Munich ●
Staffelstein ● AUSTRIA ● Melk
Zwiefalten ● Salzburg ● Vienna
FRANCE
SWITZERLAND

Venice ●
Genoa ●
Florence ●
PORTUGAL ● Madrid
● Siena

SPAIN
Rome ●
ITALY
● Seville
Naples

Mediterranean Sea

11 Sunshine, Shadow, and Action:
Baroque and Rococo

THE WORD *Baroque* (Portuguese for grotesque or irregular) like Romanesque and Gothic was first used in a derogatory way. Eighteenth century Neoclassicists used Baroque to describe the flamboyance and unrestrained exuberance of seventeenth century art. Today the term is used to group together the art and architecture produced in Europe from 1600 to about 1780. In several countries the work done in the late part of the Baroque has been given the name *Rococo*. Although painting, sculpture, and architecture styles vary over this span of time, enough similarities exist in either appearances or artistic goals to group these works together under a single heading. Parallel developments in art, architecture, and music began in Rome, spread throughout Europe, and even reached the newly colonized Americas.

While Renaissance styles had been ordered and balanced, Mannerism had gone in another direction, emphasizing individual expression and style. The Baroque returned to Classicism in a way, but only as a basic form. The new emphasis in Catholicism was on the emotional rather than the intellectual. Art which emphasized emotions became more important than symbolic or literal interpretations. Drama therefore became vital. Emotional appeal, strong contrasts of dark and light, swirling movement, agitation, hugeness of forms, asymmetry, and intense warm colors were dominant. Large musical forms were explored (operas, cantatas, and symphonies) which often combined large choruses, full orchestras, and even actors. Paintings were also generally large and presented intense colors and powerful lights and darks. Big buildings, mostly churches and palaces, were filled with light, gold, color, and a feeling of brightness and airiness.

The balance of political power was also changing. Spain, Holland, Portugal, France, and England were colonizing many parts of the world. The wealth obtained in these operations generated new societies and established a middle class of well-to-do merchants, bankers, and tradespeople. At the same time, the dominance of Germany and Italy was waning. Science and mathematics were making great strides forward (Galileo, Newton, etc.), and the religious strife between churches of the Reformation and the Catholic church was quieting. Many of the architectural and artistic expressions of the Baroque were positive statements of confidence in Catholic doctrines and the future of religion. Based on this new, secure feeling, Rome again became the art center of Europe, with artists and visitors flocking there to view the wonders of antiquity and the great works of the Renaissance. They were also excited about the bright and shining works of contemporary Italians who were in the vanguard of the new Baroque movement.

The Catholic church again became a major patron of the arts; the newly designed buildings needed a new kind of painting that swirled with light and movement. Paintings were often done on ceilings and were incredible examples of complex vertical perspective. In Protestant countries (Holland, northern Germany, England, Switzerland, and Scandinavia) the churches did not make use of art in their sanctuaries because it looked too "Catholic." However, the new commercial middle class took up the slack in patronage and commissioned paintings for their homes and public buildings.

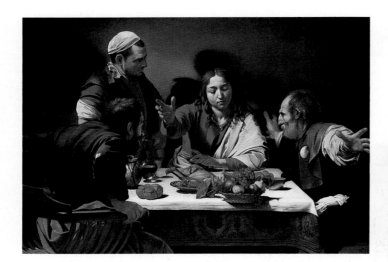

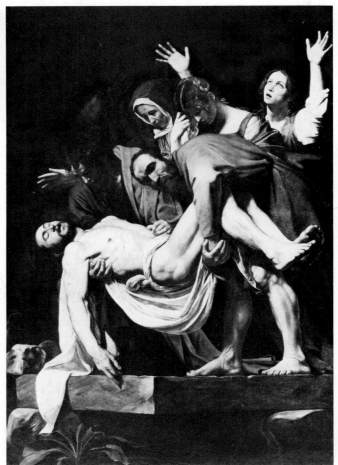

The Baroque in Italy

The transformation from Mannerism to Baroque took place in Rome near the end of the sixteenth century and gradually spread throughout Europe. Artists of this period were highly competent at drawing and painting the human figure from every possible angle, reproducing the most complicated perspective, and using color and value contrasts with ease. The Baroque direction was not different in subject matter or technique but in emotional content and dramatic lighting effects in both religious and secular paintings.

Caravaggio (1573–1610) While several artists were filling the ceilings of Rome's churches with colorful and energetic paintings of heaven, Michelangelo Merisi, called Caravaggio (after his hometown) became the first giant of the Baroque. He was considered a rebel against conventional society and met an early death (at thirty-seven) while running from the law. He often tried to shock his patrons by placing his religious figures in very common, earthly settings, such as Christ entering a darkened Roman tavern to call Matthew to become an apostle. For this reason churches sometimes refused his commissioned work. Caravaggio's extreme naturalism, intense value contrasts, hard painting style, and ability to use these three elements to create intense drama strongly influenced many artists. His usual large paintings on canvas, many still on church walls in Rome, had a significant impact on northern European art, where naturalism was already accepted.

Brilliantly lit by a single source of light, the subjects in Caravaggio's *The Supper at Emmaus* seem ready to move and carry out a director's orders. Taken from the Biblical account of Easter Sunday evening, Jesus talked with two of his followers as they walked to their home at Emmaus. When he sat down with them for supper, he blessed the food on the table, and immediately they knew who he was—their risen Lord. Caravaggio captures them at the moment of recognition. With Christ's hand over the meal in blessing, the man on the right throws out his arms in amazement while the man on the left shoves his chair away from the table in utter astonishment. Their servant looks on in disbelief. Set against a solid wall of dark values, the figures seem lit with a flood light as they surround the table, acting out the drama. They are nearly

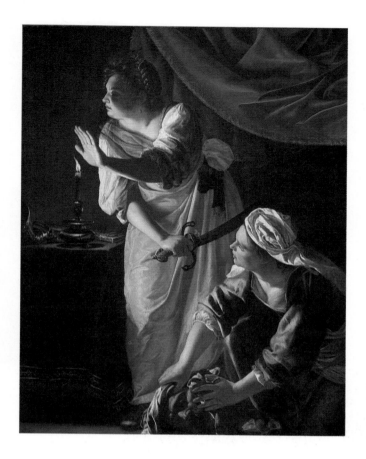

Artemisia Gentileschi. *Judith and Maidservant with the Head of Holofernes,* about 1625. Oil on canvas, 185 × 142 cm. The Detroit Institute of Arts

lifesize and each has facial expressions and hand gestures intensifying the dramatic impact. Caravaggio is a master of foreshortening, color, light, drama, and still life painting. Notice the exquisite basket of fruit, the roast chicken, bread and dishes on the table, all of which receive the same dramatic treatment as the human figures. Caravaggio was one of the earliest artists to paint still life subjects with such naturalism (even rotten spots on the apples) and made several small paintings containing only such objects.

In his painting, *Deposition of Christ* (bringing Christ down from the cross) Caravaggio has an ideal subject for his dramatic technique. A tightly composed group made up of three women, Joseph of Arimathea, and the apostle John ease the lifeless body to the ground, which is a huge stone slab projecting out from the canvas. Christ's limp hand and the corner of the winding cloth touch the slab, uniting it with the group of figures. Caravaggio places the eye level right at the top of the slab so that all the action takes place above the viewer, adding to the stagelike feeling. The black background intensifies the drama as the deep shadows eat into the group of figures, causing the lighter values to be even more powerful by contrast. The nearly nude figure of Christ contrasts with the various cloth textures; light contrasts with dark; life with death; hunched figures with erect; and horizontal direction with vertical and diagonal. Caravaggio is at his best.

The light plays most directly on Christ's body and highlights the faces of John and Joseph while the faces of Christ's mother and of Mary Magdalene are darkened in shadow. The light again strikes the face and uplifted hands of the third Mary at the top of the composition. The *tenebroso* together with the naturalistic style of Caravaggio creates an overpowering work. Since the figures are slightly over lifesize, viewers feel that they are watching the event take place before their eyes. The Flemish painter Peter Paul Rubens was so impressed with the work that he made a copy of it for himself.

Artemisia Gentileschi (1593–1653) Caravaggio's followers used his dramatic staging of events set against a plain dark background as part of their own style. Among them is one of the first woman painters in Western art to

make an important contribution to the art of her time, spreading Caravaggio's style to Florence, Genoa, and Naples. She was an apt pupil of her father's and other excellent teachers and by 1615 was a well known artist in Florence. She moved to Rome in 1620 and painted *Judith and Maidservant with the Head of Holofernes,* a popular subject from the Apochryphal book of Judith. The Babylonian army was besieging a Hebrew city when Judith surrendered herself to the enemy. Once in camp, she and her servant succeeded in finding the general, Holofernes, and beheaded him, causing the Babylonian army to retreat and lift the siege. The violence of the killing is overlooked by Gentileschi who instead dramatizes the start of the escape from the enemy camp. Using a candle as the single light source, she is able to emphasize deep shadows and brilliant lights. The tenebroso effect highlights the forms of the figures and the satiny gold material in Judith's robe, as the blacks from the background eat into the dark shadows of the figures. The maidservant is stuffing the head of Holofernes into a sack at the bottom of the painting. The foreshortening of the figures is handled beautifully as they are shown rushing to get their work done before they are detected.

GIOVANNI PAOLO PANINI. *Interior of St. Peter's, Rome*, 1746–1754. Oil on canvas, 154 × 197 cm. National Gallery of Art, Washington D.C., Ailsa Mellon Bruce Fund

Carlo Maderno (1556–1629) Although Carlo Maderno made important contributions to the style of Baroque architecture, such as the projection of parts of the facade from a flat surface, his work on St. Peter's in Rome brought him fame. In 1606 Pope Paul V commissioned him to extend one arm of Michelangelo's Greek cross plan to create a Latin cross plan. Moving the new facade far forward reduced the importance of Michelangelo's dome, which now cannot be seen except from a distance or from the papal gardens in the rear of the basilica. The new facade now has a heavy horizontal look because huge corner structures were added. Each, pierced with an arch and crowned with a clock, is a gateway to the Vatican properties behind. Maderno intended them to be the basis for massive towers that were never built because the foundations were not strong enough. The elements of the facade (windows, five doors, columns, and statues) are enormous in size, but because of the careful scale and design, they work together beautifully and do not seem excessively large. Only when comparing their size to a person standing by a column, does one realize how massive the parts and the whole are. (*See* p. 250.)

The newly lengthened arm of the cross gave Maderno a huge interior space to integrate with what Bramante had begun. A gigantic barrel vault is held up with squarish piers that are highly decorated and designed to appear light in weight. The broad nave seems even wider because of the huge archways that open into extremely large side aisles, which open again into chapels.

The entire width thus seems enormous in places. A painting by Giovanni Panini (done about 1750) helps one see the size and decoration of the *Interior of St. Peter's*. Baroque decoration can be seen in the richly-gilded, coffered ceiling, the piers of colored marble, and the sculpture added to painted spaces. Huge clear windows allow sunlight to flood the interior which is startling in its brightness compared to the somber majesty of earlier Gothic cathedrals. The scale is hard to believe. The parts fit together so beautifully and sizes are so carefully interrelated that at first glance the basilica does not seem large at all. But many steps must be taken before one reaches the high altar. The interior, from entrance to the end of the apse, is 192.6 meters long—longer than two football fields. Notice the size of the people in comparison to the sculpture or the thickness of the piers. To bring the scale into concrete dimensions, look at the *baldachin* over the high altar, under Michelangelo's dome. It is 28.4 meters high or about the height of a ten story building. Yet it is dwarfed by the hugeness of the open spaces and the massive size of the structure. Some of Maderno's efforts can be seen by studying the aerial view on page 292.

Gianlorenzo Bernini (1598–1680) One of the most influential artists of the seventeenth century and its most powerful sculptor was Gianlorenzo Bernini: sculptor, architect, painter, composer, and dramatist. With papal and secular commissions, he redesigned many areas of Rome and transformed them into the splendid sections still enjoyed today. His flair for drama placed him in the

GIANLORENZO BERNINI. *Ecstasy of Saint Theresa*, 1645–1652. Marble, about 3.5 m high. Cornaro Chapel, Santa Maria della Vittoria, Rome

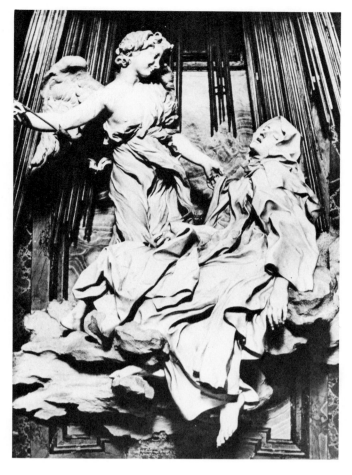

forefront of the Baroque and his new sculpture techniques influenced work for several centuries. The action in Renaissance sculpture had been restrained and contained within the figures themselves. Bernini's energy-charged figures make use of the space around them as part of the design. They reach into space and space enters into them. They appear much lighter than the bronze or marble from which they are made and often seem to float in swirling action above the earth.

Bernini's *David* should be compared to those of Donatello and Michelangelo which fully express the ideals of two previous periods of the Renaissance. Bernini's figure, though not as large as Michelangelo's, is agile and coiled like a giant spring, ready to swing into action. His intent eyes are on Goliath and he bites his lips together as he strains for the utmost strength. His armor has been shed and lies discarded at his feet, which gives Bernini a chance to show the muscular tension of a figure in violent action. The space around and in front of David seems to belong to the sculpture. Viewers often sense they should not remain in front of it as they will be in the way of a hurled stone.

All of Bernini's dramatic ability is brought into play in his *Ecstasy of Saint Theresa,* a marble grouping in a specially designed environment which becomes part of the sculpture. Placed in a little side chapel in the church of Santa Maria della Vittoria in Rome, the space is so small that the entire environment is difficult to grasp and defies photography. The part shown here is the sculpture itself (a small part of the total work) in which the youthful angel of love pierces the heart of Saint Theresa with a golden arrow. According to her vision, the pain was dreadful yet so sweet that she wanted it to continue forever. Saint Theresa, whose face is an exquisite picture of pain and ecstasy, floats on a marble cloud that seems suspended in air. Golden rods appear to be rays of light coming from above, a sensation that Bernini enhanced when he included a window (that lets in real light) and a vault that is painted with clouds, soaring angels, and the dove of the Holy Spirit.

GIANLORENZO BERNINI. *David,* 1623. Marble, 170 cm high. Galleria Borghese, Rome

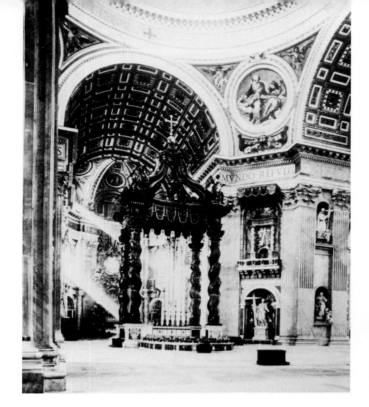

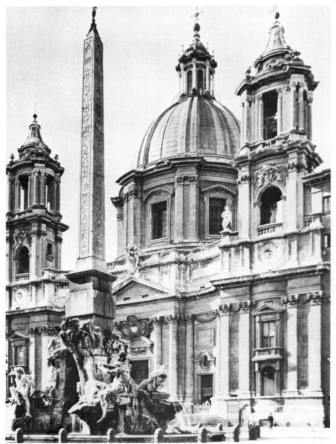

It is impossible to look at or visit St. Peter's without thinking of Bernini. Inside and out, his work is evident. Under his supervision, thirty-nine artists carried out his sculptural plans during several years of intense activity. Most of the sculptures are huge in size, but do not appear so because of the awesome scale of the building. Two huge masterpieces of Bernini's are focal points of the interior of the basilica, the *Chair of St. Peter* in the apse, and the baldachin under the dome. The baldachin is a magnificent structure of bronze that seems to be made of cloth, wood, and gold. Standing over the high altar, it is the centerpiece of the basilica with its spiral columns writhing into the air to support the towering canopy. The spiral columns are grooved and decorated with vines, leaves, and bees, the symbol of the Barberini family of which Pope Urban VIII was a member. Topped by the orb of power and a cross, the gigantic bronze work could only fit comfortably into a structure as gigantic as St. Peter's.

The gracefully curving arms that reach out from St. Peter's to enclose the magnificent piazza (often jammed with thousands of visitors and/or worshipers) were the final touches added by Bernini. Again the size is huge, with each wing containing a forest of columns standing four abreast with a huge sculpture above each column facing the piazza. An Egyptian *obelisk* stands in the

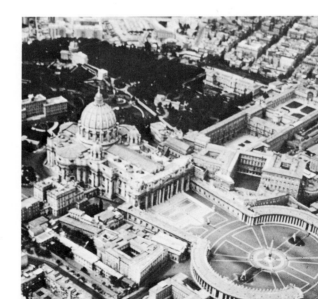

Aerial view of St. Peter's and surrounding area of Vatican

center flanked by two beautiful fountains. Although grandly Classic in its style, the curves are Baroque, and the huge colonnade is a splendid introduction to the glorious Baroque interior that awaits behind Maderno's facade. The aerial view of St. Peter's shows the Latin cross plan, the complete design of Bernini's colonnade, the Vatican gardens, and the surrounding structures.

Part of Bernini's contribution to Baroque art in Rome is the installation of sculpted fountains, many of his own design and work. Fountains had always been popular in Rome because of the water brought to the city via aqueducts, but Bernini wanted the supply to be available from sculpted sources. His most spectacular was the *Fountain of the Four Rivers* in the Piazza Novona, the site of an ancient Roman *circus*. An Egyptian obelisk stands atop a marble mountain, surrounded by four gigantic figures who represent four major rivers of the world (Nile, Danube, Ganges, and Rio de la Plata). Water is employed as part of the sculpture and emerges in dribbles, spills, spouts, ribbons, and jets. It is as if Bernini sculpted the water, the light, and the marble into a single unified and active composition.

Francesco Borromini (1599–1667) Borromini is a seventeenth century Italian architect who made a strong imprint on succeeding generations. His buildings are marvels of Baroque feeling and are noted for their facades which move in and out in great swags as though made of a plastic material. His Sant' Agnese in Rome is directly behind Bernini's *Fountain of the Four Rivers* as seen in the photograph. Borromini's design for Sant' Agnese combines Classic, Renaissance, and Baroque styles into a unified design which was adopted in other parts of Europe and even Mexico. The convex sculptural quality of the dome which rests on a high drum is repeated in convex features of the two corner towers. The central part of the facade has a concave surface which provides a gentle contrast to the dome. Notice the many places where features project out from or recede into the facade. The two corner towers are similar to those Maderno planned for St. Peter's but which were never built.

BAROQUE CEILINGS IN ROME

During the middle of the seventeenth century, several artists created illusionary paintings of tremendous complexity on the ceilings of some Baroque churches in Rome. Usually providing the worshiper with a glimpse into paradise above, the paintings are filled with figures that appear to be floating and soaring into infinity as if

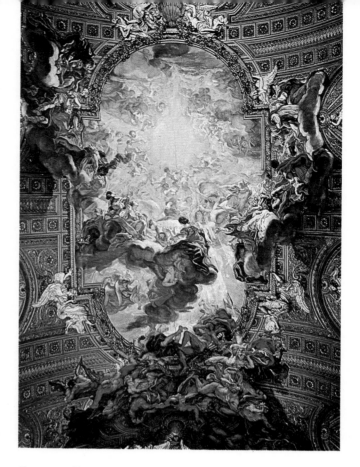

Giovanni Battista Gaulli and Antonio Raggi. *Triumph of the Sacred Name of Jesus.* Ceiling fresco, 1676–1679. Il Gesu, Rome

large balloons were cut loose to float heavenward. Some artists painted the church structure upward into space (beyond where it actually exists) to suggest even higher dimensions. The ceiling then became a brightly lit space crowded with soaring figures in vertical perspective. A mark on the floor indicated the exact spot from which the perspective was viewed most accurately. Several, like the barrel vault of the church of *Il Gesu,* contained *stucco* (plaster) figures in addition to the painting which gave the added illusion of figures tumbling out of the picture and into the realm of three-dimensional reality. Painted by Giovanni Battista Gaulli (1639–1709) with sculpture by Antonio Raggi (1624–1686) and directed by Bernini, the ceiling is highly gilded with a painted oval opening to the sky. Through this window one can look into heaven and can see various *Jesuit* saints. (Il Gesu is the burial place of Ignacious Loyola, founder of the Jesuit order). The same power that draws the faithful into heaven also casts out the unbelievers who tumble through the frame and seem ready to crash to the floor. The three-dimensional illusion is enhanced as the sculptures cast shadows on the sloping vault ceiling.

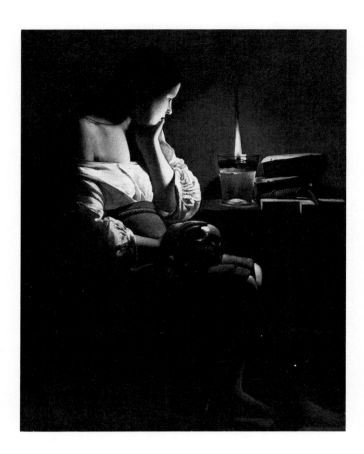

GEORGES DE LA TOUR. *Magdalen with the Smoking Flame*, about 1630–1635. Oil on canvas, 117 × 92 cm. Los Angeles County Museum of Art, gift of the Ahmanson Foundation

compositions, intense in their feeling. What seems like a *genre* subject at first glance (a farm girl sitting at a table, for example) becomes charged with emotion and takes on aspects of reverence in La Tour's silent but powerful treatment. His *Magdalen with the Smoking Flame* is one of four paintings he did of this subject. Set against a flat dark background and using a candle as the single source of light, La Tour builds a striking composition in which the forms are simple and monumental. His later paintings are even more simplified but this early work is done in his naturalistic style. Mary Magdalen was a symbol of the Catholic doctrine of the forgiveness of sins through penance, but this painting is more than just a picture of the saint. The figure personifies the life of contemplation and mortification, devoted to the love of God. Shown as a young woman who may still have to struggle with the temptations of the flesh, she is an image with whom the young Catholic girls of France could easily have identified. The skull is symbolic of vanity and the transitory existence of people on earth. The painting was discovered and identified in 1972.

Louis Le Nain (1593–1648) Another rediscovery of recent years is Louis Le Nain, one of three brothers who lived and painted together in Paris. All three painted genre subjects, centering their interest on the peasants of rural France and their daily activities. Barnyards, animals, hayfields, and farmhouses become the settings for paintings, and farmers are treated with such clarity and care that they seem almost saintly. Le Nain's religious paintings are infused with a simple, quiet, devotional quality which can be felt in *The Adoration of the Shepherds*. The pale, high-keyed sky provides a more general illumination than the dramatic light of Caravaggio or La Tour, and colors are therefore bright and clear. Set amid Classical ruins, the composition is triangular, similar to many of Raphael's works. The balance is almost radial as movement seems to lead to the centrally located Christ Child from all directions. The figures and animals are painted in a very natural way with one little angel and one of the shepherd boys looking away as if their attention were caught by some unseen activity to the left. The feeling is quiet, reverent, Classic, and fitting for the subject.

The Baroque in France

Although the influence of Carravagio and Bernini was felt in France during the seventeenth century, their extreme expression and enthusiasm were not comfortable to the French. Bernini spent some time in Paris at the request of the king but left without accomplishing much and returned to Rome. The French preferred a more rational and balanced approach and still do not call their seventeenth century style Baroque but rather the Style of Louis XIV. During this period France became the richest and most powerful country in Europe, and during the seventy-two year reign of Louis XIV the center of art began to shift from Rome to Paris where it remained until World War II.

Georges de La Tour (1593–1652) The influence of Caravaggio is unmistakable in the tenebroso and realism of Georges de La Tour. Well known in his own time, then completely forgotten, La Tour's work had drawn attention only recently. Only forty of his paintings are known to exist, yet he is now considered one of the important figures in French painting. Often using a candle as the only source of light, La Tour built dramatic night-time

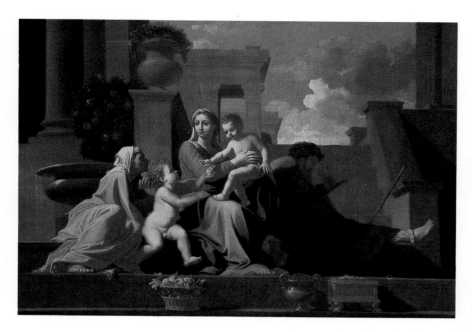

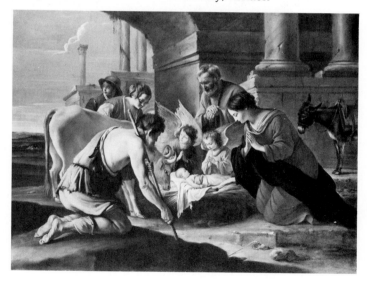

Nicolas Poussin (1593–1665) Even though he was the most important painter of France in the late seventeenth century, Nicolas Poussin spent most of his productive years in Rome. Unlike the Classic artists of the Italian Renaissance who wanted to revive Greek and Roman culture and art, Poussin used great imagination to show his contemporaries how Classic life may have been. He used the colored glazes of Titian but employed the simplified sculptural quality of Raphael. He stressed the elimination of unnecessary detail and put emphasis on composition, balance, and other qualities of Classical art which he loved. His approach to art was intellectual as he often constructed a model stage filled with wax figures so he could obtain the best balance and movement in his painting. But at other times he filled his paintings with swirling activity and strong brushwork, anticipating some of the French painters of the eighteenth century.

Poussin felt that subject matter was of great importance in painting and that it should be grand, heroic, or divine. His *Holy Family on the Steps* illustrates his theories of painting. The theme or subject matter is divine (Mary, Joseph, the Christ Child, Elizabeth, and John the Baptist); the setting is Classical; the composition is triangular; and the design is perfectly worked out. Poussin also includes some subtle symbolism, placing Joseph and his carpentry tools (the intellectual and working life) in the shadow of Mary and the Christ Child (the spiritual life). Asymmetrical balance is worked out carefully with Joseph's small highlighted foot balancing the larger light-valued masses of Ste. Elizabeth and her son John. The still life items on the lower step are also asymmetrically balanced. Every part is considered carefully and placed to attain a perfectly balanced composition. If any part were changed in value or moved to some extent, the feeling of comfortable balance would be destroyed. With all this attention on composition, Poussin is still able to subordinate Elizabeth, John, and Joseph with shadows and to center the visual emphasis on Mary and the Christ Child.

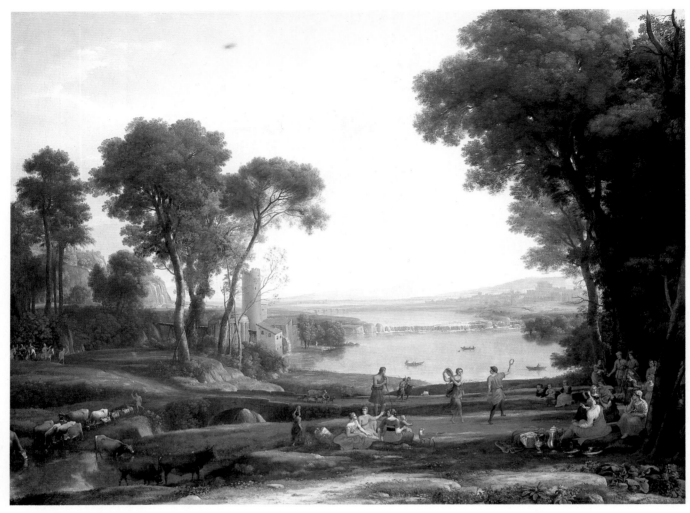

CLAUDE LORRAIN. *The Marriage of Isaac and Rebecca. (The Mill)*, about 1648. Oil on canvas, 149 × 197 cm. National Gallery London

Claude Lorrain (1600–1682) Claude Gellée was called Claude Lorrain because he came from the province of Lorrain; most art historians simply refer to him as Claude. Like Poussin, he went to Rome; however, he remained there and never returned to France. He spent much time in the Italian countryside making hundreds of ink and wash sketches which would later be used as subjects for studio paintings. *Wooded Landscape with Bridge* is an example (*See* p. 33). The bridge, trees, or cattle can be found in later works. Such recording of darks and lights in an immediate response to nature is later found in the nineteenth century English landscapists such as Constable.

Claude composed his landscapes as carefully as Poussin designed his figure paintings. In *The Marriage of Isaac*

and Rebecca, he used his typical arrangement to provide visual movement, with large trees in the foreground (at right) moving in an arc to several more trees in the middleground (at left) and then back into a spacious, sunlit countryside. The soft light creates the dreamy mood found in many of his landscapes. Claude did not enjoy painting figures and often paid fellow artists to paint them for him. Yet they are important to the paintings because they provide a scale by which to see the huge size of the trees and the vastness of the landscape. The painting has also been called *The Mill* because of the buildings in the middleground. The figures could be any group of people enjoying a party in the Italian countryside, but Claude gave the work a biblical title even though he was only interested in the landscape.

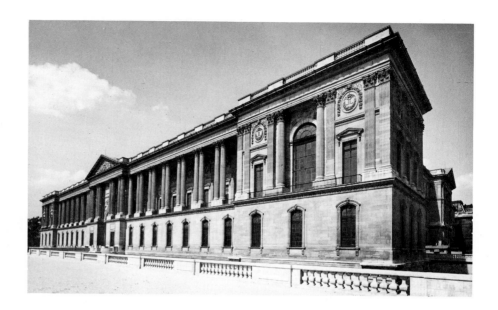

CLAUDE PERRAULT. East Facade of the Louvre, 1667–1670. Paris

THE ROYAL ACADEMY OF PAINTING AND SCULPTURE

When Louis XIV, the "Sun King," took control of the French government in 1661, several changes in art were initiated. Since he claimed that the king and the state were one, all art should glorify him. The appointment of "First Painter" went to Charles Le Brun who immediately became the art dictator of the country. The Classicism of Poussin became the "official art" of France, and an art school, The Royal Academy of Painting and Sculpture, was opened to train young artists in the correct style. This was an innovation since up to this time all artists had learned their techniques under the personal direction and in the studio of an older and well established master. With the new academy idea, art theory, science, a formal education, and traditional skills were taught. The French approach was dogmatic: rules and formulas were taught and the official style was the only acceptable approach. The Royal Academy became the model for later art schools, although many changes of emphasis were then encouraged. As popular as it was in France, the Academy failed to produce any great artists from its earliest classes.

ARCHITECTURE

While some churches were constructed in France during the Baroque period, the major contributions were made in secular architecture. The ultimate expression of the French Baroque (they called it Classic style) was the Palace of Versailles, but several major developments preceded it. The building of châteaux, begun during the

Renaissance, continued and under excellent architects became larger and more impressively grand. In 1665 Louis XIV wanted to finish the east facade of the Louvre and called the Italian master Bernini to design it. But Bernini's ambitious plans were too majestic for the French, who rejected them because their taste was determined by the Academy and its Classic ideals. Bernini returned to Rome and the commission was turned over to Claude Perrault (1613–1688), Charles Le Brun (1619–1690) and Louis Le Vau (1612–1670), with Perrault getting most of the credit. Often called The Colonnade, it marks a distinct victory of French Classicism over Italian Baroque. The Classic features of Corinthian columns, arches, pediments, and low severe lines are relieved somewhat by the French technique of protruding the central entrance and corner sections slightly from the facade. Such protrusions are called *pavilions*. The ground floor is treated as a podium upon which the columns rest. Although some columns are engaged and others are freestanding, the design of the facade is simple, elegant, and completely unified. It became the model for French architects for many years.

The severity was a bit too Classic for the elegant taste of Louis XIV and he decided to move his court (an entourage of 2,000 nobles and their ladies, 9,000 soldiers and 9,000 servants) to a gigantic palace set in beautifully landscaped gardens at Versailles, outside Paris. Around an existing hunting château built by the King's father, Louis Le Vau added two sets of rooms in the 1660s. In 1678 Jules Hardouin-Mansart added the fantastic Hall of Mirrors which is one of the most splendid rooms in all of Europe. Seventeen arched windows admit abundant

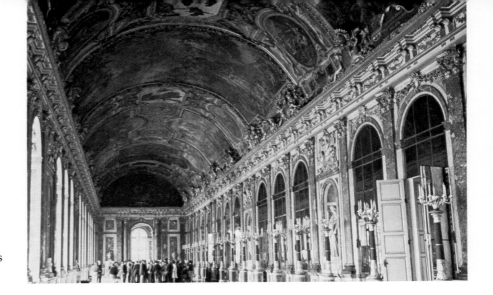

JULES HARDOUIN-MANSART and CHARLES LEBRUN. Hall of Mirrors, Palace of Versailles, begun 1678

sunlight that is reflected from seventeen mammoth mirrors which bounce light up to the highly decorated, vaulted ceiling. Charles Le Brun designed the gilt-touched interior which rivals any Italian Baroque interior in its richness and light. The exterior of Versailles by Le Vau and Hardouin-Mansart is more decorative than the east front of the Louvre yet has a quality of restraint that is echoed in the formal patterns developed in the vast gardens of the largest palace in the world. A chapel was built by Le Vau, and many rooms were added during the Rococo period, creating a huge and showy complex that exhibits a sometimes monotonous character in its exterior facades.

Among the most impressive Baroque buildings outside Versailles is the Church of the Invalides in Paris, built by Jules Hardouin-Mansart. Added to a home for disabled veterans and designed as a tomb for Napoleon and his family, parts of it recall earlier styles, but the vertical emphasis topped by a soaring dome is wonderfully French Baroque. The two-storied facade has graceful Corinthian columns that lead the viewer's eyes upward. The small pediment at the center is emphasized because of the treatment of the doorways below it and the drum of the dome behind it. The drum has paired columns (like St. Peter's) but the two immediately behind the pediment are recessed slightly. The dome it-

LOUIS LE VAU and JULES HARDOUIN-MANSART. Palace of Versailles. Aerial view, garden in foreground, 1669–1685

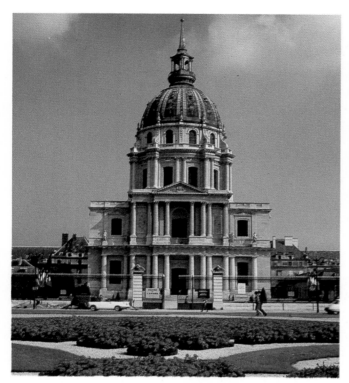

Jules Hardouin-Mansart. Facade, Church of the Invalides, 1676–1706. Paris

Christopher Wren. West facade, St. Paul's Cathedral, 1675–1710. London

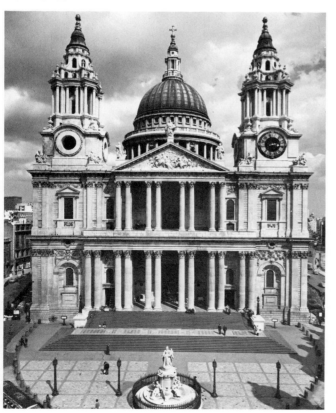

self is highly decorated, unlike previous domes, and is topped by a square *lantern,* another first. Although it has no concave-convex features such as the Italians were using, the facade has a pavilion similar to some other French buildings and an unmistakable French Baroque feeling.

The Baroque in England

Painting in seventeenth century England was not an important part of the local art scene. However, foreign artists (Rubens and van Dyck from Flanders) painted some of their finest work there. Music and poetry were still the major forms of artistic expression but several architects began to make important contributions. Handsome country houses and palaces were built by the Tudor kings and their noblemen. The work of Andrea Palladio, Italy's leading sixteenth century architect, exerted a strong influence on Inigo Jones (1573–1652) who went to Italy but was unimpressed by Baroque innovations. He designed many buildings in the *Palladian style* which the Italians had by now abandoned.

Christopher Wren (1632–1723) Christopher Wren was the right man in the right place at the right time. Following the disastrous London fire which leveled great portions of the city in 1666, Wren was instrumental in designing many of the major buildings that replaced those that were destroyed. His spires and domes help give London its characteristic look, but his most important structure is St. Paul's Cathedral. After several models and plans were rejected by the clergy, he arrived at a basically Gothic, longitudinal floor plan (Latin cross) with a very large choir. At the center of the exterior facade, two stories of paired Corinthian columns are topped with a decorated pediment, all of which stand forward like a French-styled pavilion. The corner towers are derived from Borromini's Church of Sant' Agnese and even have similar concave features. The beautiful dome (second in size to St. Peter's) is vertical in feeling and stands on a high, columned drum over the crossing. Its shape is attractive enough to have been copied many times in Europe and the United States (as in the Capitol in Washington). Although Wren drew on many sources for the design of St. Paul's, his finished work is a powerful Baroque statement. The interior is not as elaborate as Italian Baroque churches but has a restrained and simple elegance more in keeping with Anglican Protestantism. Wren's use of circles, arches, and framing to emphasize certain elements create a Classic feeling.

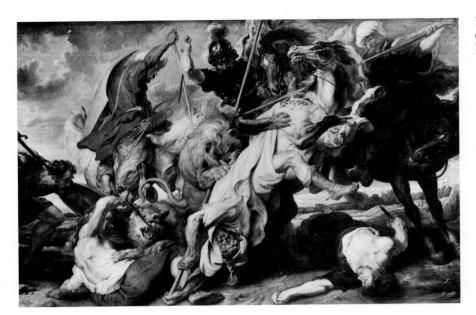

PETER PAUL RUBENS. *Lion Hunt*, 1616. Oil on panel, 246 × 372 cm. Alte Pinakotek, Munich

The Baroque in Flanders

While the northern part of the Low Country provinces (Holland) had gained their independence from Spain and had become a Calvinist (Protestant) and democratic country, the southern provinces (Flanders) remained under Hapsburg and Spanish domination, and Catholic. Little large-scale construction was begun so Baroque architecture is not abundant in today's Belgium, but painting is another story.

Peter Paul Rubens (1577–1640) While Bernini was filling Baroque Rome with sculpture, Peter Paul Rubens was flooding Flanders and the rest of Europe with magnificent Baroque paintings. Possessing enormous intelligence and an unending capacity for work, he produced an incredible number of paintings (over 2000). Disregarding the earlier Flemish painters who specialized in detail and a cool detachment from their subjects, Rubens turned to Italy for his inspiration and spent eight years studying the masterworks of Classic Rome, the Renaissance, Mannerism, and the Baroque. When he returned to Antwerp, he set up a painting workshop to keep up with his numerous commissions. He hired assistants (many of whom were established painters) to paint in still life objects, flowers, and landscapes. He generally painted the figures himself, but even these were often started by assistants. He would paint small studies on wooden panels and from these his helpers painted their sections on the large canvas or wooden panels while, from a large balcony in the studio, Rubens directed all of their work simultaneously. He often put the finishing glazes on the works and added his characteristic brush strokes—if the price was right. As his work was often huge in size (altarpieces and murals), the amount he charged his patrons was in proportion to how much work he did on it himself.

Rubens often picked up new patrons on his travels to other countries as a diplomat and confidential advisor who could write and speak six languages fluently. When he had first been in Italy, he met Velasquez from Spain and made sketches and small paintings of the sculpture and paintings of Leonardo, Raphael, Titian, Tintoretto, Veronese, Mantegna, and Caravaggio, among others. He even had assistants making sketches for him, so that when he returned to Antwerp he had a collection of thousands of ideas from which he would develop his personal style—one of swirling physical movement, marvelous color, and energetic brushwork—the epitome of Baroque painting.

From 1616 to 1618 Rubens painted a number of huge works that dealt with the theme of hunting exotic animals. Europeans were fascinated by lions, tigers, leopards, elephants, and crocodiles because they came from distant tropical countries and many noblemen had examples in their private zoos. Whenever Rubens got the chance, he would sketch them for future use in his hunting scenes, such as those he did for Emperor Maximillian. *Lion Hunt* is typical of this phase of Rubens' painting. It boils with violent activity as turning and twisting bodies of horses, lions, and humans are intertwined in a complicated knot. Rubens uses the straight lances and swords to stabilize the writhing composition and to lead the viewer's eyes back to the central

PETER PAUL RUBENS. *Castle of Steen*, 1635. Oil on panel, 131 × 230 cm. National Gallery, London

area. The eye level is quite low which increases the dramatic upward thrust of the action. The confrontation would explode out of the frame if the curved necks, arms, and heads did not direct the movement back to the center of the canvas. Each detail is charged with tension, and the foreshortening is handled with mastery. Never before had an artist used swirling action, color, and light with such complete authority and seeming ease.

Rubens set the stage for his painting of the ancient myth, the *Judgement of Paris,* in his favorite Flemish countryside (*See* p. 26). He shows the young shepherd, Paris, with Hermes beside him, about to hand the golden apple to the beauty contest winner, Aphrodite (Venus), who had won over the other two goddesses, Minerva and Juno. This decision eventually led to the Trojan War. Caught up in the swirling movement of the painting is Eris, the personification of discord and the instigator of the contest, who is seen in the billowing clouds. The three goddesses are carefully placed against dark values to show off their translucent flesh, a technique at which Rubens excelled. Notice how he shows all three views of the female figure, front, back, and side, in the painting. It is possible that Rubens' second wife, Helena, was the model for Aphrodite, the central figure of the three. Her delicate facial features and plump form were considered the epitome of female beauty at the time. Human skin is marvelously responsive to light and shadows and Rubens delighted in its texture and subtle changes in color and value. His painting technique called for a heavy impasto application of white paint where the light would strike the flesh; over this he added sufficient tinted glazes to get the translucent colors he wanted. His shadows are more thinly painted with darker values but still have glazes which produce mar-

velously colored, translucent shadows. His painting technique as well as his complex compositions would later influence Delacroix, Renoir, and other French painters.

In his later years, after a second stay in Madrid, Rubens' subjects became more serene and calm. Titian, whose work was much admired and abundant in the Spanish palace, became a strong influence. In his *Garden of Love,* Rubens pays a superb tribute to the joy of life and love (*See* p. 35). As a widower, he had recently married the young and beautiful Helena Fourment, with whom he is shown on the left. Four of Helena's sisters are shown also, some with their husbands, in a setting that is partly from Rubens' elaborate home in Antwerp and partly imaginative. Chubby cupids flit about the scene which is flooded with controlled light that strikes only where the artist wants it. Yet even in a scene where there is no evident action (all the people are stationary), Rubens still creates energetic visual movement as light plays over and reflects from the crinkled satin gowns and translucent flesh. It is a happy conglomeration of reality, Classical mythology, and Baroque material elegance—a portrait of happiness, and Rubens at his finest.

The *Castle of Steen* is a favorite painting of Rubens and one which he kept in his possession until his death. After he returned from Madrid he bought this country estate and moved from his palatial mansion in Antwerp. With tender care he portrays the Belgian landscape with its broad receding spaces flooded with afternoon light. His earlier landscapes had been turbulent and depicted nature's violence, but in his later years, Rubens chose to represent the quiet atmosphere surrounding his own country house. A hunter, wagon master, and castle occupy the shadowy lower left part of the scene, but the

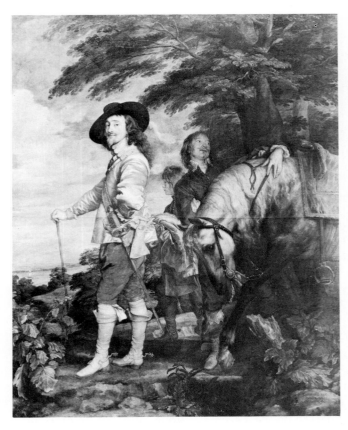

VIII. Van Dyck flattered his subjects, endowing them with aristocratic refinement, delicacy, and elegance. It is no wonder that he became a favorite of English noblemen. In his *Portrait of Charles I in Hunting Dress*, he creates the impression of regal splendor and dignity as Charles poses dramatically with his horse and servant in an outdoor setting. With apparent ease, he accents the shimmering mane of the horse and the satin shirt of the King as they glisten with light amid the shadows of the scene. In reality the King was short and lacked a handsome appearance, but one would never suspect it after looking at van Dyck's official portrait. His technique of placing the figure in an outdoor setting with large shaded trees, distant landscape, and cloudy sky became a standard treatment for portrait paintings when England finally developed her first native painters. Although a Flemish painter, van Dyck did much of his work in service of the English King, and when he died in London, he was buried there.

Frans Snyders (1579–1657) Although he was responsible for much of the still life painting in Rubens' works, Frans Snyders, like van Dyck, also painted many works of his own. Elaborate still lifes which emphasized the textural quality of fruits, vegetables, animals, and often the magnificent silver and gold vessels of the aristocracy were in great demand. Paintings, such as this huge *Still Life*, filled the walls of the Baroque Flemish homes of wealthy merchants and professional people. Opulence, reality, and material wealth are the true subjects of these paintings which are often overpowering in their size and dramatic, elaborate treatment. Here a woman toys with some birds as her son looks on, but they are not really important to the painting and were even painted by Snyder's friend Cornelius de Vos. A realistic portrayal

emphasis easily shifts to the vast expanse of fields and trees that seem to reach into infinity, finally uniting with the glare of the high-keyed sky.

Anthony van Dyck (1599–1641) Among the fine artists who painted for Rubens in his Antwerp workshop was Anthony van Dyck, already an accomplished painter when only seventeen. His early work was influenced greatly by Rubens, but when he went to Italy he fell under the spell of the work of Titian, Tintoretto, and Veronese. *Samson and Delilah*, painted after his seven-year stay in Italy, is a complex and involved composition which exhibits subtler values and a more sensitive color treatment than Rubens would have given the subject (*See* p. 62). The figures fill the space, which seems ready to burst from the energy and huge size of the people. The figure, robe, and coloring of Delilah have been influenced by Titian's work but the mood and intense actions are van Dyck's maturing and confident style.

There was no sense in competing with Rubens as a rival for the mural commissions of Europe. Instead, Anthony van Dyck turned to portraiture, at which he excelled. He went to England and worked as official court painter for Charles I, just as Holbein had done for Henry

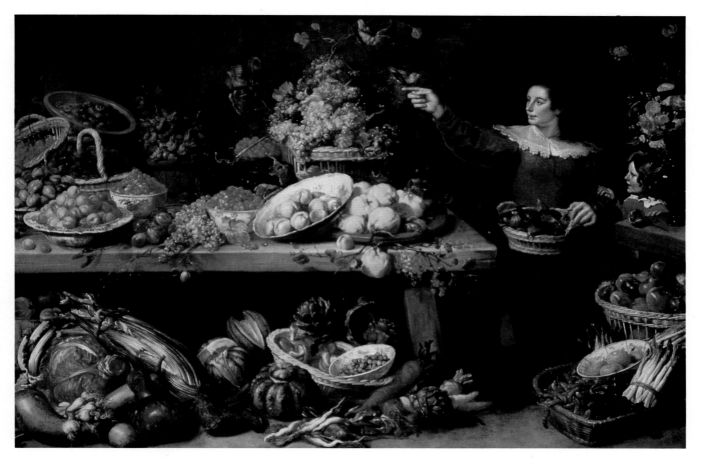

FRANS SNYDERS. *Still Life*. Oil on canvas, 152 × 250 cm. Norton Simon Foundation, Los Angeles

of nature is important. Grapes are dusty and translucent, peaches are complete with fuzzy skins, and cabbage is as crinkly as in everyday life. The dramatic light is controlled to create rounded forms and deep shadows from which certain parts are carefully highlighted and emphasized. All the characteristics of Baroque painting (light, shadow, movement, reality, and material magnificence) are used by Snyders in this overwhelming still life, just as Rubens and van Dyck used them in painting narrative works, mythological scenes, or portraits.

The Baroque In Holland

Holland, as stated earlier, became a separate country with its newly-won independence. This action brought about significant changes. Calvinistic Protestantism, which forbade the use of art in churches, predominated, and a democratic society replaced the monarchy and

aristocracy. Thus, three of the usual art patrons (the church, the court, and the nobility) were absent. Artists were thrust into the open market which completely revolutionized the role of the artist and art in the community. A prosperous country with new colonies and expanding commerce, Holland developed a large middle class who sought out artists to provide paintings for their homes. Even workers such as blacksmiths wanted to possess at least one painting rather than the woodcut prints which had usually been done for them. This immense demand for paintings (not sculpture) was met by a host of competent artists who painted what was wanted.

The early seventeenth century saw several painters working in the style of Caravaggio and La Tour (with tenebroso), but in a short time a Dutch style began to develop. The open market system of artists selling their work to individual patrons led to trade in art, a method of merchandising paintings through agents, galleries, or at fairs. So artists began painting subjects that were in demand, such as landscapes, seascapes, cityscapes, room interiors, naval battles, ideal country scenes, church interiors, cattle, parties, taverns, brawls, still

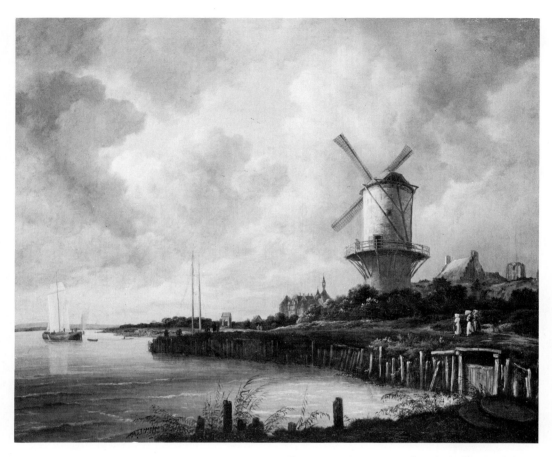

lifes, and portraits. At least forty artists could be included in a detailed study of Dutch Baroque painting, and they are sometimes grouped together and called "the little masters" to distinguish them from the great masters, Frans Hals, Jan Vermeer, and Rembrandt van Rijn. A look at a few of these "little masters" will suffice.

Jacob van Ruisdael (1629–1682) A master at portraying the Dutch landscape with its everchanging and powerful clouds was Jacob van Ruisdael. The drama of the sky has never before attracted the artist's attention to this extent. Usually placing the horizon line low in the painting (because Holland is so very flat) the emphasis naturally is forced to the huge sky which van Ruisdael fills with superb cumulus clouds. As in *The Windmill at Wijk by Durstede*, their light and dark values lead to brightly lit highlights on the ground which contrast sharply with the dark shadowed areas. Humans are often seen as small and insignificant in the vast panorama of nature and structures are often overshadowed by it. Here, however, the mill is emphasized against the turbulent sky as the mill and boats pause as if held in time for the viewer to see. Even the river runs smoothly and quietly in contrast to the active sky. Trees usually dominate the fore-

ground in van Ruisdael's work, but the mill is featured here. To drive or walk through the Dutch countryside is to experience the reality of van Ruisdael's painting. Most such landscapes were painted in studios after artists had made sketches of the scene on the site (See also p. 77).

Meyndert Hobbema (1638–1709). Two rows of tall poplar trees add linear perspective to Meyndert Hobbema's painting of the *Avenue, Middelharnis.* Again the eye level is low and the sky is huge, but the trees projecting into the clouds tie the two parts of the painting together. The rutted road attracts attention first but soon the viewer looks at fields, trees, figures, farm houses, a church, and a town. The same spotty light which illuminates just the right areas of this landscape is found in almost every contemporary landscape painting. Hobbema, his teacher van Ruisdael, and other Baroque landscapists, developed an overpowering feeling of space and depth in their work; yet at other times their landscapes featured a closer look at their environment.

MEINDERT HOBBEMA. *The Avenue, Middleharnis*, 1689. Oil on canvas, 104 × 141 cm. National Gallery, London

Pieter de Hooch (1629–1684) Fascination with detail characterizes the work of Pieter de Hooch who painted the immaculate interiors of Dutch homes. He also did several backyard exteriors. Drenched in sun, the three adults, with the little girl looking on, are enjoying a break in the day's activities: a smoke and a little refreshment. De Hooch seems to stop the clock for the viewer. This painting is a fleeting genre scene, captured for all time. Brush strokes are completely hidden in this and other small works where De Hooch depicts with great skill the texture of trees, crumbling bricks, and fabrics, the transparency of glass and liquids; and the gleam of metal. Painting in Delft, de Hooch was influenced by the greatest Dutch genre painter, Jan Vermeer.

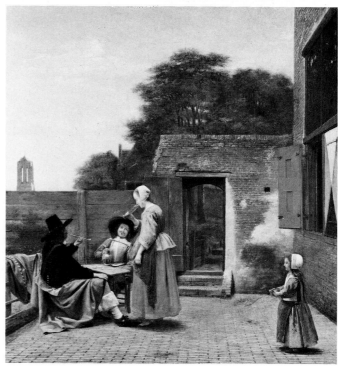

PIETER DE HOOCH. *A Dutch Courtyard*, 1660. Oil on canvas, 68 × 59 cm. National Gallery, Washington D.C., Andrew Mellon Collection

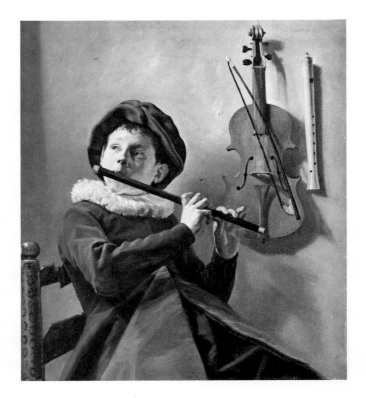

Judith Leyster (1609–1660) While most women artists until this time had the advantage of having artist fathers from whom to learn, Judith Leyster's father owned a brewery and she developed a style of her own. Although influenced by some Catholic artists in Utrecht who worked in the style of Caravaggio and by Frans Hals whom she knew well, her style is distinctive. Her genre subjects were similar to the rest of the "little masters": interiors, still lifes, and portraits. One of her best works, *The Flute Player*, is not only a portrait of a young boy playing his flute but a meditative mood painting—a mood established by the look on the young man's face. The composition is carefully balanced, using other instruments and the chair as visual elements. The controlled light entering from an unseen window on the left is a vital part of the painting. Although after her death her works were often attributed to other Dutch painters, Judith Leyster is receiving much current interest from museums, and her work is gaining new attention.

JAN STEEN. *The Feast of St. Nicholas*, about 1660–1665. Oil on canvas, 82 × 70 cm. Rijksmuseum, Amsterdam

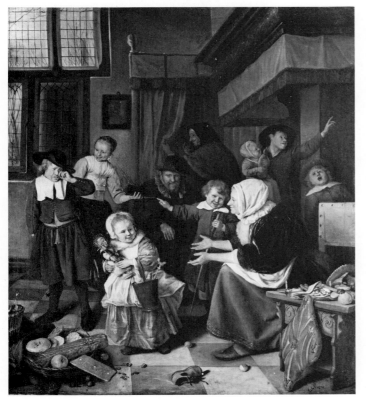

Jan Steen (1625–1679) While de Hooch and Vermeer present the immaculate order of Dutch interiors, Jan Steen shows another side: chaos, clutter, and humor. He enjoyed the unexpected and often crammed his canvases full with children, animals, drunken folk, and upset baskets. In the *Feast of St. Nicholas*, Steen visualizes a typical children's holiday. Some have been given candy and toys and are happy, another is crying because he is unhappy while others are making fun of him. Much family interplay is taking place in the warm room, but the child, clutching the statue of a saint, and her grandmother receive the most light and the most attention. Steen loved to portray older folks enjoying the pleasure of small children and this work is a warm example of his human interest. The loose shoe and spilled fruit are almost trademarks of the clutter in his paintings. A whole story could be written about the actions and appearances of all the family members and of their relationships to each other and to the scene, as Steen weaves a tender narrative of a children's festival for the viewer to enjoy.

Dozens of other artists could be included here but their work would seem repetitious. These examples show the content and variety of work done in Baroque Holland by an army of competent artists to meet the requirements of an art-hungry populace. There has probably never been such a concentration of excellent paint-

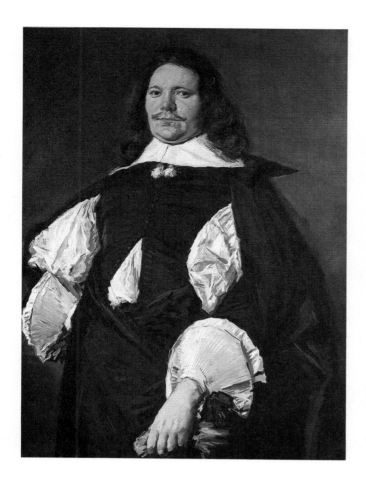

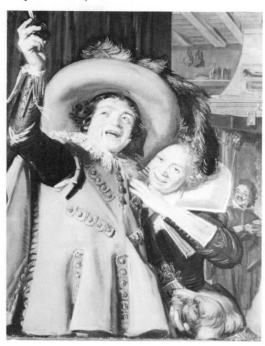

FRANS HALS. *Portrait of a Man*, 1660. Oil on canvas, 113 × 82 cm. The Frick Collection, New York

FRANS HALS. *Yonker Ramp and His Sweetheart*, not dated. Oil on canvas, 105 × 79 cm. The Metropolitan Museum of Art, bequest of Benjamin Altman

ers in such a small area in history except perhaps in Florence and Siena during the Renaissance. But three men stood out above the "little masters": Frans Hals, Jan Vermeer, and Rembrandt van Rijn.

Frans Hals (1581–1666) Frans Hals was brilliantly adept at portraiture. Developing a technique using slashing brush strokes, he captured the momentary smile and the twinkle of an eye with unerring accuracy. Although his painterly brush strokes remain visible and his paintings appear to have been done in minutes, Hals spent much time on them to get just the right instantaneous quality. This loose feeling is completely different from the tight and exact features in the portraits of Leonardo, Holbein or Dürer.

Hals' early commissions were for large group portraits which often resemble group photos made for yearbooks. Each person in the group paid an equal price and posed separately, and the artist tried to arrange them so they would not complain about their appearance. Such portraits were of shooting companies or groups of men who had fought together in Holland's war of independence. In individual portraits, however, Hals was able to capture the character of his subject with deft strokes of his

brush. Using a limited palette, his work seems almost monochromatic because often black and white were his chief colors. *Portrait of a Man* is typical of his robust style and the rich vitality of his work. The unknown subject stands before a flat dark background with his face, hands, and the light parts of his shirt receiving the highlighted emphasis. The face is finished in a controlled way but still has visible brush strokes. But the suit and cape are painted with typical Hals ferocity—almost slashed onto the canvas with energetic enjoyment. The fleeting smile, so difficult to capture even with a camera, is caught by Hals in almost all his work. It is not a grin, not a laugh, but the pleasant look of a beginning or fading smile (see another Hals portrait on title page).

Portraits of wealthy burghers provided an income, but Hals also liked to paint the common people, especially his good friends. In *Yonker Ramp and His Sweetheart*, Hals shows his friend, whom he painted often, in a happy scene at the local tavern in Haarlem, his home town. Hoisting his glass in a toast, the man is obviously enjoying his evening as he fondles his dog's muzzle with his left hand. His girlfriend cuddles as close as the broadbrimmed hat will allow, as if trying to get into the picture. The dashing brush strokes are appropriate to the

subject and add to the feeling of spontaneity and vibrant action. It is obvious that Hals enjoyed making this painting.

Although he sold many paintings and enjoyed excellent success as a portrait painter, Hals died penniless in a poorhouse. His career almost parallels the artistic development of his country. He flourished when Holland was growing and expanding her trade, but in the second half of the seventeenth century, interest in local artists was reduced as French painting was more in demand. Hals and many of his contemporary artist friends could find little work. After his death, agents were not able to sell his work at all, yet today there is a Frans Hals Museum in Haarlem that honors him and his vigorous painting.

Jan Vermeer (1632–1675) Even in his own day, Jan Vermeer of Delft was not well known, and after his death his name practically disappeared. In the eighteenth century, Sir Joshua Reynolds, a painter from England, saw a Vermeer painting in Holland and proclaimed it one of the greatest he had seen. Only during and after the nineteenth century was his work fully appreciated; today he is considered one of the finest Dutch painters. All that is known of him is found in the few luminous, tranquil paintings that exist. He worked in a slow and painstaking way, and until now, only thirty-eight paintings have been attributed to him. Only three of these are outdoor works, the rest are portraits or interior views. But what views they are. Carefully designed with figures and furniture, they feature light and realistic color.

Perhaps no artist until Vermeer's time perceived natural light and color with such awareness. It is thought that he used a *camera obscura* to achieve this absolute realism. This device, known already to Islamic scientists and used in sixteenth century Italy, was a box with a small opening on one side. The image seen through the opening was transferred to the back wall of the box, in reverse of the actual scene. With a mirror and lens attachment, the user could rectify the image and focus it. Some were large enough for the viewer to be on the inside. With such a device, Vermeer could observe that not everything one looks at in an interior scene is on the same plane or in equal focus. He also noticed that colors from one object or area are reflected in other parts of the room. Most northern artists had painted each object in absolute focus and were not aware of the reflected colors as they

painted each part precisely and individually. Look back at the work of van Eyck as an example.

A Woman Weighing Gold illustrates many of Vermeer's characteristics. The quiet interior is lit by a window on the left, and a soft light illuminates the figure and touches other objects with varying intensity. The chiaroscuro of the Italian Renaissance is fully realized in Vermeer's work. Notice the quality of the light that brushes the wall and how carefully Vermeer has observed it. The light bouncing off the clothing of the pregnant woman illuminates the objects on the table and reflects off the glass in the frame at the left. The design of the elements is carefully planned, and Vermeer often used a map or painting to back up his figures and provide a colored shape on the wall. The foreground objects, here a large rumpled cloth, are somewhat out of focus as the viewer's steady gaze centers on the woman. Notice how the light from the translucent window bounces off the pearls on the table and creates soft shadows elsewhere. Even in black and white, the grays are beautifully composed through a wide range of values. No other artist had been able to use the tones of color with such subtle distinction, and to indicate the light source and depth of the objects in the painting.

The comments about this small painting could almost be repeated for several other of Vermeer's subjects with interior views, but there is a distinguishing fact about this work. It is the painting on the wall. When one sees

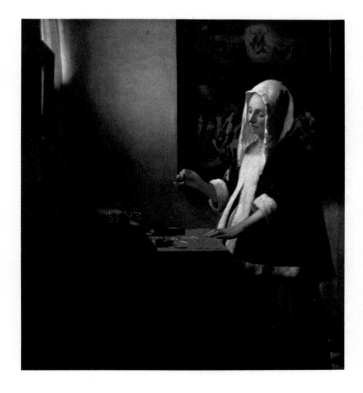

JAN VERMEER. *A Woman Weighing Gold*, about 1664. Oil on canvas, 42.5 × 38 cm. National Gallery of Art, Washington, D.C., Andrew W. Mellon Collection

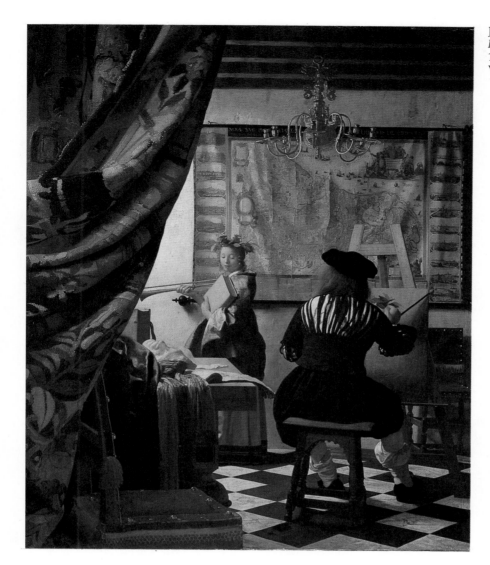

JAN VERMEER. *Allegory of the Art of Painting*, about 1665–1672. Oil on panel, 120 × 100 cm. Art History Museum, Vienna

that it is a scene of Christ on Judgment Day, weighing the souls of humanity, the weighing of pearls and gold in real life takes on another meaning. They represent earthly possessions which really account for nothing in the end. But that need not be depressing because Vermeer's woman is pregnant, about to bring new life into the world. In relation to the painting, her act is a celebration of life everlasting. Most of Vermeer's seemingly simple paintings can be viewed on two such levels.

This double significance also is true of Vermeer's later painting, *Allegory of the Art of Painting* (also called *Allegory of Fame* and at one time, *The Artist and His Studio*). The titles, none given by the artist, depend on one's interpretation of the symbolism, also not provided by the artist. It is now thought that the model represents Clio, the muse of history, looking at a table full of objects that symbolize other muses. The artist in a sixteenth century costume cannot be Vermeer . . . or is it? The map of Holland on the wall, surrounded by pictures of twenty cities, could symbolize that Holland is the center of world art and that the painter is the greatest creator. Whatever the meanings, this is a fine painting, again organized beautifully. Light is the most important ingredient. An unseen window on the left illuminates the model and the deep space in the work. Another source highlights the drapery in the foreground. The artist is in focus, but the foreground, the model, and her space are slightly out of focus. The colors that are closest to the light source are most intense. With all the complex elements Vermeer uses, the painting is still clear, cool, and orderly. In 1942 the painting was owned by Hitler who intended to make it the central jewel in a gigantic art collection he was confiscating from the countries that he captured.

Another Vermeer painting, *Officer and Laughing Girl*, can be seen in Chapter 2 (*See* p. 60).

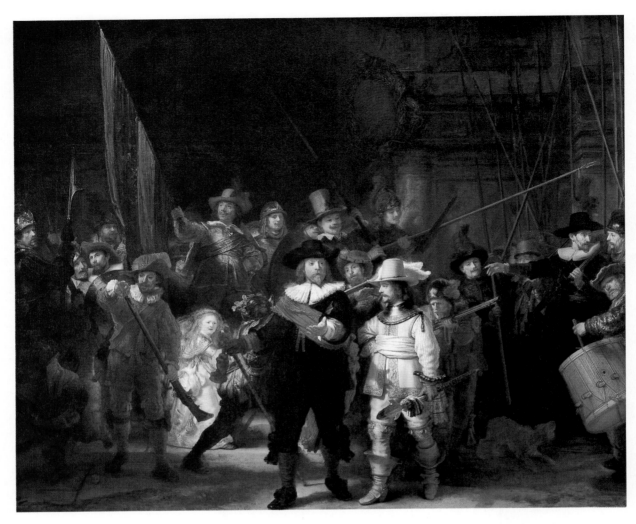

REMBRANDT VAN RIJN. *The Shooting Company of Captain Frans Banning Cocq (The Night Watch)*, 1642. Oil on canvas, 3.5 × 4.37 m. Rijksmuseum, Amsterdam

Rembrandt van Rijn (1606–1669) The greatest of Dutch painters, and one of the great geniuses of the art world, was Rembrandt van Rijn, the son of a miller whose business was located on the Rijn (Rhine) River in Holland. He was interested in painting early in his life, and when he moved from Leiden to Amsterdam in 1632, he was already a competent artist. His early portraits provided him with an excellent income, and when he married and bought a large house, he was seemingly well off. In several years his wife died; he managed his income so poorly that his wealth declined and commissions dropped off. His style of painting changed and became more personal and expressionistic, which further alienated him from the public. His son and his mistress took over his business affairs, as he became bankrupt. Yet through all this adversity, his work became stronger and more powerful. He was extremely prolific, leaving over six hundred paintings, three hundred etchings, and over two thousand drawings for the world to enjoy.

Rembrandt's very early work in Leiden was religious while his early paintings in Amsterdam were portraits which established his name as an artist. He, like many other Baroque artists, painted many self-portraits. One can actually note the progress and decline of Rembrandt's fortunes by analyzing his clothes and facial expressions in dozens of such works. Using a mirror to view himself, Rembrandt would often put on one of the costumes he loved to collect so that he could create a special mood. The *Self-Portrait* (*See* p. 28) was done in the late 1630s when the artist was just over thirty years old. His painting style was already well established, and he shows himself as a successful and well dressed personage of Amsterdam. The light is carefully controlled to highlight the face and collar and to shade the rest of the

figure. Like Rubens, Rembrandt used a heavy white impasto in the brightest areas and applied glazes over them and in the deep shadows to obtain the golden tones he desired. These light-valued passages emerge from the dark brown shadows as a brilliant use of chiaroscuro. Notice how the highlights on beads, buttons, and the band of the beret help direct the viewer's attention to the face where the eyes, which are always important to Rembrandt in expressing the inner feeling of the sitter, hold one's attention. Here they look confidently at the viewer and hide nothing.

As mentioned earlier, a popular type of painting in Holland at this time was the group portrait, which usually consisted of a number of people posed in a row or some other formal arrangement. Rembrandt accepted a commission to paint *The Shooting Company of Captain Frans Banning Cocq* and revolutionized the concept of group portrait painting. The huge painting is 3.5 meters high and the foreground figures are about life-size. He accepted equal payment from each member of the company, who expected to receive equal treatment, but Rembrandt wished to make a fine painting, not produce a stereotyped group portrait. He placed Captain Cocq (in black) in a central position and put his lieutenant at his side. But the rest of the men he placed at random to simulate natural action as if they were preparing for a parade. Some are in shadow, some in light, and some are almost completely hidden. A little girl (who looks amazingly like his wife Saskia) runs among the men and receives an ample dose of Rembrandt's mysterious light. He produced a superb painting. But naturally some of the men were disappointed in their portrayal, especially the man who could only see his eyes and the top of his head.

The painting at one time was brighter in color but oxidation of the colors and layers of soot had turned all the values darker, so it is now called *The Night Watch*. After World War II it was cleaned to reveal much richer color and detail, but the name has remained. It was larger also, but once when it was moved to a new location, someone cut a meter off the left side and about thirty centimeters off the right, so it could fit between two doors. The major alteration has drastically changed the composition and balance of the work but it remains a powerful, dramatic, and popular painting. The pulsating light bounces off several faces and provides a number of minor centers of interest, which lead the viewer to the two major figures in the foreground who seem to be stepping off the stage into the viewer's presence.

Chiaroscuro is evident in all of Rembrandt's work, but in *The Descent from the Cross* it almost becomes the dominant subject (See p. 24). In the shadows, an L-shaped composition develops with two bright areas of light. Figures seem to move about in the dark areas, and hands reach out to help with the task of bringing the dead Christ down from the cross. The subject has been treated many times but not with the force of Rembrandt's powerful design. Light seems to glow from the limp body and illuminate those close by, but it also skips across space and falls on the face and body of Christ's mother, Mary, who seems about to faint from the ordeal. The look of puzzlement on the face of Joseph of Arimethea as he looks up to the face of Christ is astonishing. The light is not natural but is Rembrandt's and it glows in an incandescent display of power. Rembrandt's numerous religious paintings are fascinating because his models were his Jewish friends and neighbors in Amsterdam. Other Marys and Christs have been Italians, Germans, or Flemings, but Rembrandt's are Jewish and as such, his features strike one as amazingly authentic.

Even in his etchings, of which he did hundreds, Rembrandt was able to use his favorite chiaroscuro. The etching process, discussed in Chapter 2, differs from engraving in that acid is used to eat the lines into the copper plates. In *St. Jerome in an Italian Landscape*, Rembrandt combines etching and drypoint to produce a print of rich value contrasts and excellent design (See p. 38). Although etching is basically a linear process, he has massed lines together to produce gray-valued passages from which St. Jerome emerges as a glistening white figure. The brightness is intensified by leaving lines broken and obliterated, suggesting a glare which eliminates detail. St. Jerome's lion stands in the shadow of the huge tree while a bridge, several tiny figures, and two marvelously drawn buildings make up the setting. But Rembrandt clearly leads the viewer's eyes back to the glowing figure of St. Jerome. During his bad years (he lost his house, art collection, and many of his own paintings to his creditors), Rembrandt produced many editions of such etchings which sold at small prices and helped to sustain him.

Although Rembrandt grew in disfavor as he alienated himself from those wishing to have portraits painted, he generally would not change his style to please his would-be patrons. His heavy impastos grew thicker and more sculpture-like, and his paintings glowed with powerful and dramatic light—a light too strong for the taste of most Hollanders. During this time he painted *The Polish Rider*, a work which is mysterious in its concept because its meaning is not known. Here a rider, dressed in the garb of a Polish mounted officer, rides a

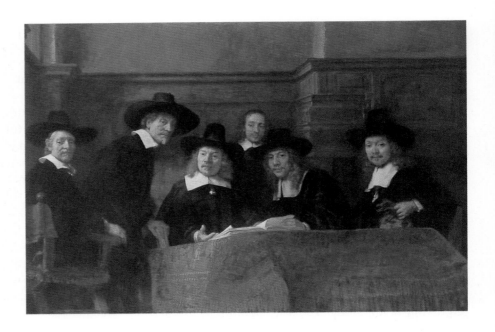

white horse through a shadowy valley. Perhaps the alert rider, like Dürer's subjects, represents the wary Christian riding through the dangerous and seductive world. The paint is buttered on in places with a palette knife which creates a sculptural quality when overglazes are applied. Again the light glows as it touches the rider and parts of his mount. Squint to see how the dark shadows of the background eat into both the horse and the rider; the two are thus united forever with the background as they become part of it yet also stand away from it.

REMBRANDT VAN RIJN. *The Polish Rider*, 1655. Oil on canvas, 146 × 135 cm. The Frick Collection, New York

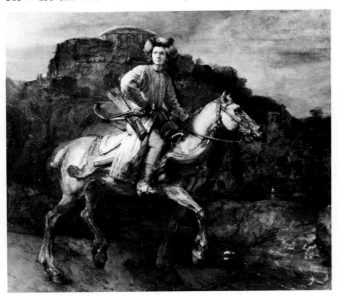

In Rembrandt's late years his work increased in power and personal expression, yet his commissions subsided while his self-portraits increased. Sometimes he painted friends who would pose as Biblical figures. But at the urging of close friends, he accepted one last group portrait commission, which he handled beautifully. *The Syndics of the Cloth Guild* is portraiture at its best—six times. The five seated figures were the officers of a trade union in Amsterdam while the bare-headed man in the background was their favorite steward whom they included at no cost to him. All faces are treated with individuality and concern as Rembrandt interprets the inner character of each, especially in the eyes. The life-sized figures are posed in a casual way (the man on the right even fondles a tiny dog) yet are dignified and at ease. The controlled light of the artist is evident as the book and the carpet on the table seem to glow with an internal light. Each of the five men who paid for the work received equal treatment and none is hidden as in *The Night Watch*. Here Rembrandt conformed to tradition and the desires of the group, yet he produced an exceptional painting. The eye level is kept very low because the painting was meant to hang over a large fireplace, above the viewer's eyes. The moment one looks at the work one is irrevocably involved. It is as if the noise of opening the door made the syndics stop and look up. Are they pleased or dismayed? Do all handle the intrusion in the same way? In a moment they will look down and continue their meeting, but for now Rembrandt has frozen them in time and space in his ever-glowing light.

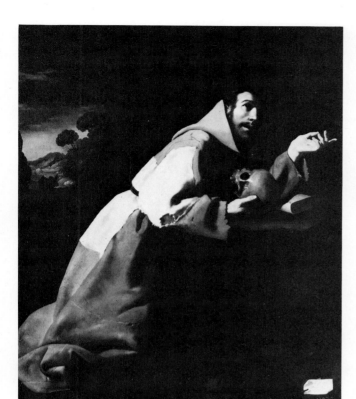

The Baroque in Spain

Spain, like England, produced little art during the Renaissance and relied on foreign artists like El Greco to create their visual images. Music and literature fared better, but not until the Baroque did Spanish artists come into their own. Jusepe de Ribera and Bartolome Esteban Murillo were among them, but the two leading names were Zurbarán and Velazquez.

Francisco de Zurbarán (1598–1664) Working in Seville, Francisco de Zurbarán developed a style reminiscent of Caravaggio and La Tour. Often single figures were placed against a solid, dark background and lit from a single source which produced dramatic cross lighting and emphasized the simple, basic forms. *St. Francis in Meditation* is a powerful statement with Caravaggio-like tenebroso. From the black background emerges the simple sculptural form of the saint, kneeling in prayer. The work is not psychological, as Rembrandt might have handled it, but is a simple, straightforward, and realistic portrayal. The strong diagonal movement is balanced by the landscape background, the skull, the book and gesturing hand, and the white paper in the foreground on which Zurbaran signed his name. All of these elements are used to stop the rushing diagonal movement and to contain it in the painting. Like Caravaggio, he also produced several still life paintings which were handled with the same dramatic light treatment. A beautifully designed still life by Zurbarán, with powerful lights and darks, can be seen on page 57.

Diego Rodriguez de Silva y Velazquez (1599–1660) The most important Spanish painter was also from Seville, but Diego Velazquez left in 1624 to become court painter in Madrid. For more than thirty years he painted with great realism the family and court of King Philip IV. He worked on a few religious subjects and several landscapes but concentrated on portrait and figure painting and was constantly concerned with design and composition. A protrait might often be worked on for several years until the design and likeness were satisfactory to him. His travels to Italy brought him in contact with Renaissance design and the work of Titian, whom he admired, and he was also acquainted with Rubens who visited Spain several times.

Although most of his work was portraiture, in 1634 he began work on a monumental canvas depicting the *Surrender of Breda* (See p. 26). The incident took place in Holland where Spanish troops under the direction of General Ambrosio Spinola received the keys to the city gates from the vanquished Dutch general, Justin of Nassau. The surrender saved the city of Breda after an eleven-month-long siege was lifted in 1624, only ten years before the painting was made. The Spaniards on the right are shown almost in portrait form (with Velazquez himself between the horse and the border of the painting) and appear gracious in victory. Their lances are upright and symbolize the pride and confidence of the victors. The ranks of the Dutch are more chaotic although they do not seem overcome with sorrow.

The huge horse helps to form an arc of visual movement around the life-sized central figures which stand forward clearly from the distant background. The soft light of the distance is sharpened up close and Velazquez uses it to define forms in a realistic way. But he controls the light carefully around the key central figures, playing light values against dark and dark against light as a means of contrast and emphasis. Although there are many figures and much action, Velazquez has designed the space carefully to keep all the elements in order and

Diego Velazquez. *Las Meninas (The Maids of Honor)*, 1656. Oil on canvas, 317 × 274 cm. Prado Museum, Madrid

under complete control. Even though Velazquez was not at Breda, the painting has a quality of intimacy and actual presence, as though the viewer were there to see it. Notice the folded paper in the lower right corner. It was meant for a signature that, for some reason, was never applied.

Velazquez's masterpiece is *Las Meninas (The Maids of Honor)* which is really a group portrait of the royal family. There are several interpretations of the scene, depending upon the viewer's point of view. It is probably meant as a king's and queen's eye view of the artist's studio. On the left is Velazquez himself, with brush and palette, working on a canvas about the size of this one. He is probably painting the little five-year-old princess Margarita who is being fussed over by her two ladies in waiting and who has just turned to look at her mother and father. Her playmates, two dwarfs, and her dog are in the corner, ready to entertain her. Two adult chaperons stand in the shadows behind the more brightly lit group, and a court officer stands silhouetted in the doorway. In the mirror next to the door are the blurred reflections of the king and queen. All the figures are placed carefully by the artist who used only the lower half of the canvas for them. But the space above, filled with paintings and a marvelous and subtle range of light and shadow, is important for the calm and spaciousness of the work.

If the top half of the painting is covered, the figures remain the same but are now crowded together in an uncomfortable way. Velazquez knew the importance of space in a painting—space that allows the figures to breathe and move without creating a sense of claustrophobia. The indirect light in the spacious studio contrasts with the direct light that strikes the figures in the foreground and bounces and reflects from a variety of materials. Like Vermeer, Velazquez was fascinated by the quality of light and used a complete range of values to suggest material and space. Spots, patches of color, and light are used to define the forms because line was seldom used by Velazquez in his work.

GIOVANNI BATTISTA TIEPOLO. Interior of Residenz Palace. 1751–1752. Fresco. Würzburg, Germany

The Early 18th Century in Europe

The eighteenth century was a restless age that witnessed great changes in every phase of European society. Industrialism was beginning, and established society was being challenged by ideas such as the rights and the dignity of the common people. Revolutions in America and France heralded the birth of modern democracy. Artists and their art reflected the confusion and complexity of the times, but no giants emerged to equal the Baroque standard bearers Caravaggio, Bernini, Rubens, and Rembrandt. Instead, musical giants such as Bach, Handel, Vivaldi, Haydn, and Mozart were the creative geniuses. The only new element to emerge in the visual arts was the Rococo style which centered in France, Germany, Austria, and Spain. An extension of the Baroque period, the Rococo substituted lighthearted gaity, charm, and wit for the grandeur of the Baroque. However, the strains of Classicism and Realism were not dead but only biding their time before they would appear again to dominate the art of the latter half of the century. Italy, England, and America were not enticed by Rococo lavishness but enjoyed a more dignified and serious extension of the Baroque.

In Italy, only Venice continued to produce artists that could rival those of France and who kept Baroque splendor alive for several more decades. The country was politically stagnant, but Venice, with its canals, lagoons, and romantic spirit, had become the first tourist center of the modern world, luring visitors from every corner of Europe. With Giovanni Battista Piazetta, Fran-

cesco Guardi, Giovanni Battista Tiepolo, and Antonio Canaletto leading the way, churches and homes were filled with vibrant paintings from this sudden burst of creative energy.

Giovanni Battista Tiepolo (1696–1770) The finest eighteenth century painter in Venice was Giovanni Battista Tiepolo. He did not confine his work to Venice but fulfilled commissions in northern Italy, Germany, and Spain where he died while working in the royal palace. Tiepolo's greatest achievements were his decorative ceiling frescoes which he painted with illusionary visual perspective, probably influenced by the Baroque ceiling painters of Rome. Enormous surfaces were covered, but the feeling was never heavy and dramatic but rather light and airy with figures floating freely and lightly in vast expanses of sky. Leaving Venice in 1750, Tiepolo took his two sons with him to Germany to work at the Residenz Palace of the Bishop of Würzburg. His stay was longer than expected because the admiring Bishop found other ceilings for him to decorate. The Residenz Hall ceiling, like other frescoes by Tiepolo, is a feast for the eyes rather than a vehicle for some profound message. Swirling forms, joyous color, and unbelievable perspectives are combined to create a painting that seems to dissolve the architecture and continue the view up to the sky. Saints, gods, and heroes of various times are seen cavorting through the heavens in one of the most sumptuous ceiling decorations ever painted.

But Germany's damp climate and harsh winters would not allow the fresco technique to be used year round and Tiepolo spent those cold months working on canvases with his oils. While in Würzburg he painted the huge *Adoration of the Magi* as an altarpiece (*See* p. 61). His free and slashing brush strokes are combined with vibrant colors and a mastery of drawing to produce a startling composition. Even this humble event, treated so tenderly by artists of the past, is made into a spectacular production by Tiepolo. Numerous figures are crowded into the vertical format, and the artist demonstrates his skill at painting fabrics of various materials, from the rich silks of the kings to the coarse homespuns of the shepherds. The cloths billow and fall effortlessly as they reflect the strong light which holds the composition together. Shadow and light are handled with surety and ease with the high-keyed emphasis naturally placed on Mary and the Christ Child. The figures do not seem confined by the frame but rather seem to extend beyond these limits where more action must be taking place. The strong light, contrasting darker values, quivering dark lines, and flecks of light scattered throughout characterize the sparkling and joyous work of Tiepolo.

Antonio Canaletto (1697–1768) A new style of painting emerged from several studios in Venice early in the eighteenth century—a style called *view painting*. Giovanni Antonio Canal, called Canaletto, could depict city views with incredible accuracy. Specializing in views of Venice, of which he painted dozens, he sold them to the wealthy travelers who were visiting in greater numbers every year. The perspective of Canaletto is so precise in many of his works that he probably made use of a camera obscura to project the correct lines and angles. His realistic portraits of cities were not confined to Venice, for he painted in many of the capitals of Europe. His accuracy and detail were so carefully painted that in Warsaw, for example, the central core of the city was rebuilt, after Nazi bombings, according to Canaletto's painting.

Works, such as *The Basin of San Marco*, are historically important because they provide an exact picture of places as they appeared in the eighteenth century and before the invention of photography. The Grand Canal is choked with various types of gondolas and boats on a typically busy day. The great landmarks of Venetian architecture are accurately detailed: The Doge's Palace in

Antonio Canaletto. *The Basin of San Marcos*, about 1740. Oil on canvas. Royal Collection, St. James' Palace, London

front of St. Mark's Basilica, the library on the left with the huge campanile behind it. All the buildings seen here are still in use. The huge Doge's state barge is tied up at its mooring in front of the palace. A viewer tends to be overcome by the profusion of detail yet Canaletto, conscious of design elements, placed the movable parts of the composition (figures and boats) in just the right places to provide scale, proportion, visual movement, contrast, and pattern *See* p. 55 for another fine example of Canaletto's architectural paintings.

Eighteenth Century France

The manners, dress, literature, and art of seventeenth century France had been dominated by the solemn figure of Louis XIV. In the eighteenth century, all stiffness was swept away as royalty and nobles lived in a make-believe world of charm and delight—as though on a perpetual holiday. Architecture in this newly found freedom retained the Classical exterior features begun in the Baroque, but the interiors of the new Parisian townhouses built by the courtiers were delicately decorated with scrolls, flowers, ribbons, shell forms, and other playful motifs. The Baroque had exploded into millions of glittering pieces which became the Style of Louis XV or the Rococo. The name Rococo is derived from the word *rocaille,* which referred to the fantastic Baroque garden grotto decorations made of decorative shells and pebbles.

The characteristic painting of the Rococo era was the *fête galante*—an elegant, courtly, romantic outdoor picnic attended by young men and women in delicate attire. The scenes were part of the impossibly sensual and unreal world in which French nobility moved. The real world was ignored as the aristocracy indulged themselves in lives of play-acting and make-believe. The art that was popular was an echo of this type of life—paintings commissioned to decorate elegant rooms and fancy boudoirs.

Antoine Watteau (1684–1721) The strongest French painter of the Rococo was born in Flanders shortly after it was annexed by Louis XIV. Influenced by the colorism of his countryman Rubens, Antoine Watteau created shimmering surfaces that sparkle with life and gaiety and capture the essence of the *fête galante.* He underpainted his canvas with a pearly color which combined white, pale blue, and rose. When this dried he would rapidly brush in the trees and background with thin washes of color. He then added the important figures in impastos

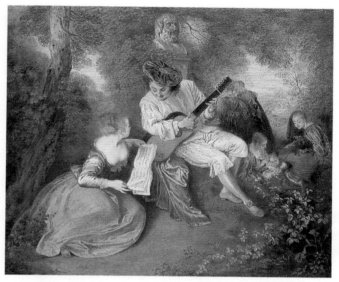

Antoine Watteau. *The Gamut of Love*, 1717. Oil on canvas, 51 × 59 cm. National Gallery, London

of jewel-like colors, again featuring rose, pale blue, pink, yellow, and white hues. He added glazes over these to create a warm, atmospheric effect through which the earlier colors gleamed with sparkling richness. His technique faithfully captures the sheen of wrinkled satin and silk, favorite materials of the French aristocracy.

Watteau enjoyed the performances of the itinerant Italian theatrical teams that work their way through France, and in *Italian Comedians* (*See* p. 58) he was able to show his mastery of drawing as well as his technique for painting shimmering material. In another of his works, *The Gamut of Love,* Watteau sets before the viewer a small playlet of the successive stages of love: courtship, marriage, and children. Poetic and playful courtship is the main theme as a costumed gentleman of the comic theater strums a few bars for his lady love. To the right and in the distance the viewer sees the same couple walking off together into the forest (marriage) and then again with several children (family). This is only one of several interpretations of the painting. The delicately lit scene and the shimmering surfaces are typical of Watteau's skillful handling of his subject matter and of his painting technique for setting on canvas the glittering and fanciful lives of his Parisian patrons. Like the *Italian Comedians,* it is a symmetrically balanced painting with a major pyramid shape centered on the canvas. There are also strong diagonal movements from corner to corner as Watteau used several traditional compositional techniques to attract the viewer to the center of interest. Amid the frivolity of the French Rococo, Watteau still used Classic principles to structure his compositions.

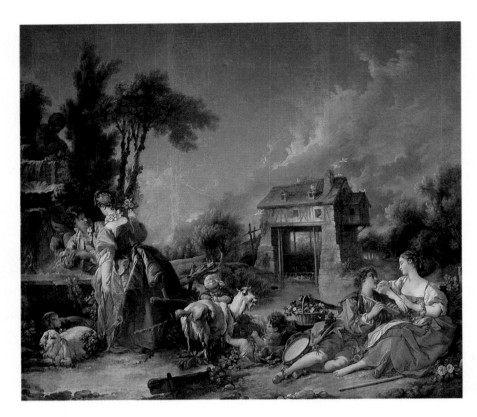

Francois Boucher (1703–1770) Most of the artists who painted the sensuously delicate and pretty decorations popular with the French nobility are forgotten, but because of his abilities as a designer and draftsman, Francois Boucher is well-represented in the world's museums. Boucher's friends compared his colors to "rose petals floating in milk" and his pink-fleshed nudes were in great demand. Many of his paintings dealt with mythological figures such as Venus, Diana, and countless nymphs and Muses. But he cared little about mythology and used these subjects to express his basic purpose—the painting of beautiful women. One of his largest works is *Pastoral Scene,* probably painted for Louis XV or Madame de Pompadour, mistress to the King and patron of Boucher. It typifies the nobility's fascination with rural life in an ideal form. Instead of doing hard and dirty work, the shepherds and shepherdesses are shown in intimate conversation as children and sheep complete the scene. Remarkably, the sheep in such paintings are ignored by their shepherds but never seem to wander away. The romantic setting of fountains and a mill house surrounded by feathery trees and backed by swirling clouds is just as ideal and perfectly pretty as the gorgeously costumed people. The pink skins (no sun tans here) and tiny delicate hands and feet are typical of the French Rococo paintings of figures.

Several years after the painting was finished, it was reproduced in the form of a tapestry.

Jean-Baptiste-Simeon Chardin (1699–1779) While Watteau and Boucher were glorifying the earthly pleasures of the French aristocracy, Jean-Baptiste-Simeon Chardin drew on his lower middle-class background for painting subjects. His still lifes of common cooking utensils and kitchen objects were simple and strong in composition and continued the tradition of French realism begun by Le Nain. Chardin also painted servants and household workers in monumental form, giving them simple dignity and stature. His genre subjects, done as simple, large forms against a plain and neutral background, were the exact opposite of the typical Rococo paintings of flamboyance and delicate grace. They symbolize the power in the common people who will shortly take control of the government from the pleasure seeking aristocracy. Chardin uses objects found in every kitchen and instills a quiet dignity in them. Compare *Still Life with Plums (See* p. 29), to the mammoth and complex still life of Frans Snyders (*See* p. 303). How powerful Chardin's simple forms are as they are placed against a neutral and solid background. While Snyders and his contemporaries were glorifying the material magnificence of their time, Chardin was glorifying the simple

foods and utensils of the common people. The triangular composition used so often by previous artists is used by Chardin to achieve a unified and powerful effect.

Chardin's figures were as powerful as his still lifes. Often using nurses, servants, and children as subjects, he retained their simplicity and painted them as monumental forms against a simple background. *The Attentive Nurse* is genre painting at its best. Heavy kitchen furniture, a delightful still life of ordinary items, and a charcoal heater on the floor are used for props. And what important task is the nurse performing? She is cracking a soft-boiled egg just removed from the pan. To paint such a person performing such a routine task with love and care adds importance to it, and Chardin was interested in getting the common people to realize their importance and worth to society. He abandoned the painting of silky textures for the coarse homespuns of the lower classes, and instead of delicate wrinkles his materials drape easily into heavy folds. The solidness, heaviness, and simplicity of his subjects contrast directly with the frailness, delicacy, and swirling of his contemporaries and their Rococo delights.

Jean-Honoré Fragonard (1732–1806) Working briefly under both Boucher and Chardin, Jean-Honoré Fragonard soon developed a style of his own which was acceptable to the art-buying nobility of France. His brush strokes were energetic and painterly, yet his subjects remained typically Rococo. His late work, following his flight from Paris during the Revolution, was more sedate and serious but he never regained his popularity and died in poverty.

The romantic setting and intimate pose of the figures in *The Happy Lovers* is typical of his work. The adoring looks of the beautiful young couple symbolize their evident affection. The dove being fondled by the young man is about to be set free, perhaps symbolizing their own search for freedom of spirit. Statues, flowers and pets were often used to complement Fragonard's figures which are delicately drawn and exquisitely painted. Trees, flowers, clouds and fabric seem to be made of the same soft, sweet substance.

He favored working with more serious subjects, but work such as this was popular among the French elite. However, the dream world of the French nobility would soon have to face the reality of political revolution and such paintings would certainly not be acceptable to the rising middle classes.

JEAN-BAPTISTE-SIMEON CHARDIN. *The Attentive Nurse*, 1738. Oil on canvas, 46 × 37 cm. National Gallery of Art, Washington D.C., Samuel H. Kress Collection

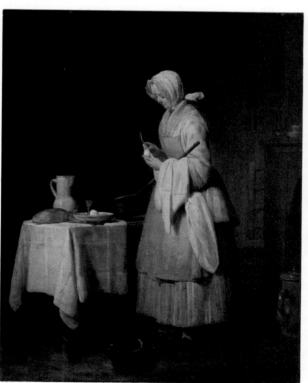

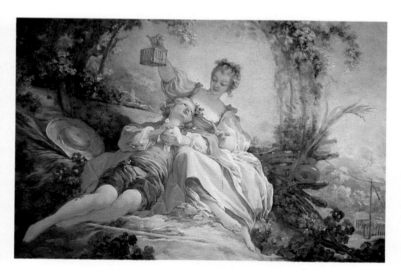

JEAN HONORE FRAGONARD. *The Happy Lovers*, about 1760–65. Oil on canvas, 90 × 119 cm. The Norton Simon Foundation, Los Angeles

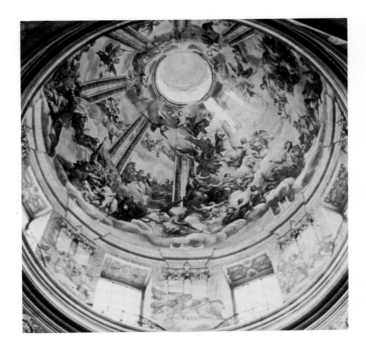

JACOB PRANDTAUER. Benedictine Abbey, begun 1702. Melk, Austria. Exterior and interior of dome

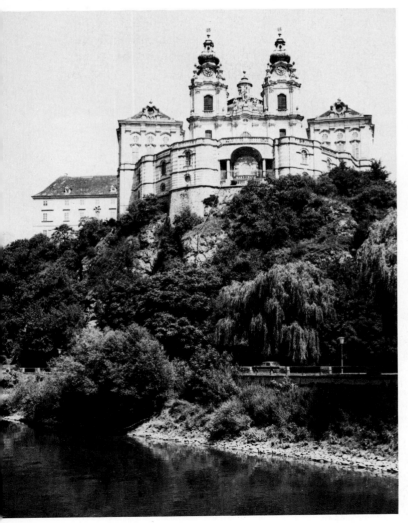

The Baroque and Rococo in Austria and Germany

While the Baroque style was developing in Italy, Flanders, Holland, Spain, and France, central Europe was engaged in the devastating Thirty Years War which ended in 1648. Not until the seventeenth century were Austria and Germany able to begin building projects of any great size. But when they started, the activity was tremendous. Combining the late Baroque styles of Italy and the French Rococo, architects filled the cities and countryside of Austria and southern Germany with structures that had exteriors of stately elegance and interiors of gilded light and swirling movement. Several examples will characterize the vitality that appears in the buildings of this era.

Jacob Prandtauer (1660–1720) Prandtauer chose a rocky cliff above the Danube River on which to erect the Benedictine Abbey at Melk. The imposing structure is dominated by an ornate dome and two magnificent bell towers, each topped with onion domes so familiar in the southern German and Austrian countryside. The exterior presents a powerful appearance with curved surfaces and superb detail while the interior is filled with gilded surfaces that allow little chance for eyes to rest. Light streams into the vast space from windows in the dome and darts from painted areas to gilded statues to carved surfaces, all intricately woven into a huge work of art alive with swirling visual activity.

Johan Michael Fischer (1691–1766) Church architecture in Bavaria (southern Germany) was dominated by the Asam brothers and by Johan Michael Fischer whose Benedictine Church at Zwiefalten is not his most famous but perhaps his most beautiful. The Church of Our Lady has a rather plain exterior that is quickly forgotten once the brilliant interior is experienced. Symbolizing the joyous spirit of the Counter Reformation, walls and ceiling erupt in color and swirling form. Only the stately side piers seem stable amid the floating sensation created by marble columns, brilliant frescoes, and carved statues. Flooded with natural light from many large windows, the interior seems to shout aloud in praise to God. Although some other churches of Bavaria and Austria may not be as carefully planned or as ornately decorated, the Zwiefalten interior is typical of hundreds of similar churches in this part of Europe.

Johann Lucas von Hildebrandt (1663–1745) The magnificent palace of the Upper Belvedere overlooking the city of Vienna was designed by von Hildebrandt. One of many European palaces placed in landscaped parks and designed after the plan of Versailles, the Upper Belvedere was built for Prince Eugene of Savoy as a summer residence. Von Hildebrandt adapted the central and corner pavilion features of French architecture, but his palace has a much lighter and more airy quality than the French structures. The attention to Classical features is noticeable at close range, but the overall feeling is of airy magnificence. Like the churches of the Austrian Late Baroque, the interior is light and alive with swirling visual movement.

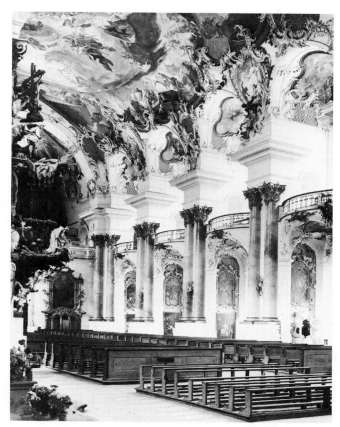

JOHANN MICHAEL FISCHER. Interior, Church of Our Lady, begun 1738. Zwiefalten, Germany

JOHANN LUCAS VON HILDEBRANDT. Palace of the Upper Belvedere, 1721–1724. Vienna

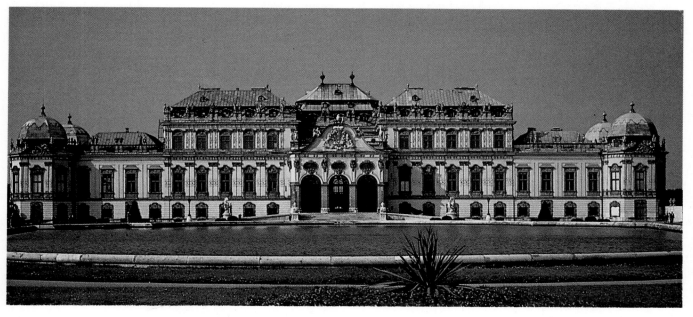

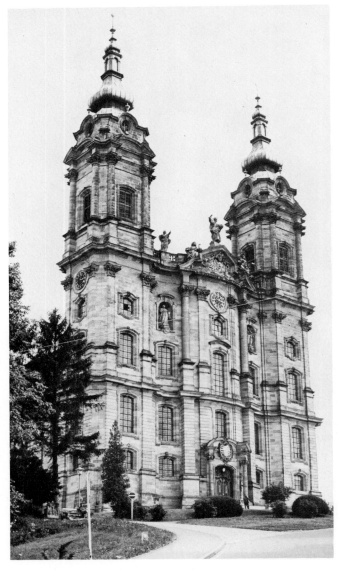

were on pilgrimages to important religious centers. Neumann's design includes a typically gorgeous interior and an undulating facade dominated by two tremendous towers, each intricately ornate and topped by an onion dome.

The Rococo style could not be any more elaborate than in these churches of Bavaria and Austria and could not be developed any further. The brilliant color and swirling movement create a sensation of agitated action which was bound to end when confronted by a cool and Classic reaction.

English Art in the 18th Century

English Rococo architecture contained none of the inventive spirit found in Germany and Austria but continued to reflect the influence of Christopher Wren and his Classic approach (the Palladian style adapted to England by Inigo Jones). Many churches, palaces, libraries, and large houses were built but most reflected previous continental or English styles. There were a few architects, some of them amateurs, who constructed buildings with Gothic or Classic Greek features, but these were not considered serious attempts at reviving earlier styles.

England had gone through a period of revolution in the seventeenth century and had become a country ruled by Parliament as well as a king. Colonization was expanding and England had become one of the dominant economic forces in the world. The increased wealth of the middle classes led, as it had in Holland, to an increased desire for painted portraits, a need which was met by three men who were the first important native artists in England. Their original approaches were much more serious than the frivolous lightheartedness of the French Rococo style, yet they were influenced by the painting techniques of the continental masters.

William Hogarth (1697–1764) The real founder of the British school of painting was William Hogarth whose satiric wit emerged in most of his work. Although he painted many portraits and argued long and loud that English painters were equal to those on the continent,

Balthasar Neumann (1687–1752) Neumann was the principal German architect of the Late Baroque, and his design for the Würzburg palace of the bishops is his masterpiece. The Residenz is quietly elegant on the outside, but sumptuously rich in the interior, featuring the ceiling frescoes of Tiepolo (*See* p. 315). The interior is a riot of splendid staircases, huge windows, ornamental statues, and curving surfaces. The central room, a thirty-three meter long space dominated by the Tiepolo ceiling, is so bright that a visitor has the sensation of being outdoors in the sunlight.

Neumann's most important church is the Pilgrimage Church of Vierzehnheiligen (Fourteen Saints) near Staffelstein. Such churches were constructed in rural areas to serve the needs of huge numbers of worshipers who

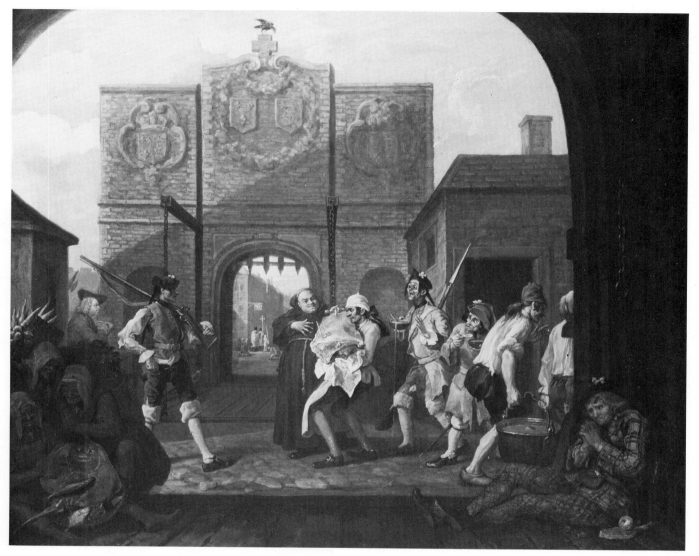

WILLIAM HOGARTH. *O, The Roast Beef of Old England*, 1748.
Oil on canvas, 79 × 95 cm. Tate Gallery, London

his fame was established by several series of narrative paintings which were made into engravings for mass distribution and sale to the common people. These works were moralistic cycles, dealing with such pertinent topics as problems in marriage, the degeneration of a middle-class English rogue, the distressing life of a harlot, political irregularities, or the results of alcohol abuse. In all of these series he criticized society and the moral quality of the upper classes. His work was naturally popular with the lower classes and his caustic wit knifed deeply into the heart of London society.

Hogarth's scathing satire can be felt in the painting, *O, The Roast Beef of Old England*, in which he took on England's traditional enemy, France, as the point of his attack. The scene occurs before the gate of Calais in France—a gate built by the English. The painting's main focus is the huge side of beef being delivered to an English eating house. The size seems so tremendous to the starving Frenchmen that they stumble about in utter disbelief and stare at it as if it was a mammoth gold nugget. The Catholic clergy felt the barb of Hogarth's Protestant wit as he shows the priest as the only overfed person among his starving French countrymen. Hogarth shows himself near the left border as he sketches the scene. Actually, he was arrested while sketching here and was imprisoned briefly as a spy. When he returned to England, he made this painting to get back at the French in his own way.

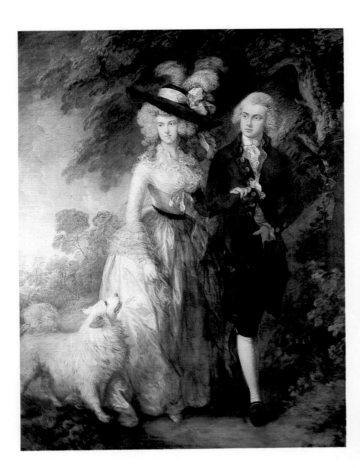

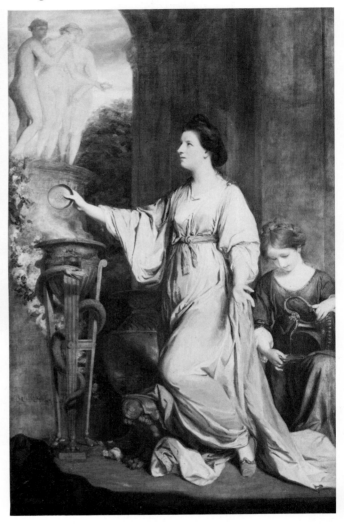

Thomas Gainsborough (1727–1788) Although he would rather have painted landscapes, Thomas Gainsborough became one of England's finest portrait artists. After his reputation was established with traditional paintings, however, he often would include large areas of open landscape as backgrounds for his subjects. His patrons were getting a bonus, almost two paintings in one. Before the invention of photography, marriage portraits were often painted, and the double portrait of young Squire William Hallett and his wife Elizabeth, called *The Morning Walk*, is probably Gainsborough's finest. Obviously influenced by the outdoor portraits of van Dyck, Gainsborough's figures walk with their dog through a park where feathery trees seem to move ever so slightly in the breeze. Carefully controlling the light and dark values, the artist skillfully places the light faces against dark foliage and balances them with splashes of light in other areas. Gainsborough's loose brush strokes masterfully catch the glint of light on rustling fabrics. Great care is taken to paint the faces accurately, but the rest of the surface shimmers with flashing brush strokes. Gainsborough's tendency to elongate the figures slightly always made his subjects seem regal and elegant. His

success can be counted in over one thousand portraits which he painted, this being one of his last.

After his reputation as a portrait artist was established, Gainsborough would reserve some time for his favorite landscape painting. Only a few of the hundreds he did were sold, the others he stored away or gave to friends. He was living in London and relied on his memory for many of the scenes such as *View of Dedham* (*See* p. 25). In his studio he would often arrange miniature landscapes of broccoli stalks, moss, rocks, and other materials to simulate nature and would paint from them. Figures, often included in his later work to establish scale or set the center of interest, included farmers

and farm children. Even though they were not accepted by contemporary London society, Gainsborough's landscapes are important because they greatly influenced later generations of English painters who made landscape painting the dominant subject matter.

Sir Joshua Reynolds (1723–1792) Unlike Hogarth and Gainsborough who stayed at home in England (Hogarth once got as far away as Calais), Sir Joshua Reynolds spent time traveling in Europe and living in Rome where he absorbed the influences of Renaissance and Classical painting and architecture. He returned to England and in 1768 helped to establish and become president of the Royal Academy, based on the example of the French school. Here he lectured on his theories of art, derived from his own intensive studies of the European art of preceding generations. The tremendous number of his portrait commissions created the need for assistants to stretch the huge canvases and start the background work. Often his figures were placed in Classical settings to enhance their nobility. In paintings like *Lady Sarah Bunbury Sacrificing to the Graces,* Reynolds created an artificial feeling as a contemporary woman seems to be living in past times. The huge size of his portraits and the grand settings he devised would often flatter the subject, making them seem more important than they actually were.

Painting in Colonial America

Americans during the 18th century were struggling to establish their cities and farmsteads in a land that was new and challenging, which left no time for the frivolity of the French Rococo, and there was not sufficient wealth to support artists of the stature of Gainsborough or Reynolds. Most of the artists were amateurs or at best were itinerant craftsmen with no formal art training but who worked from copies of European paintings. Art done by people with no formal education, called *primitive painting,* was mostly in the form of portraits. Early American *limners* were artists who, during the cold winter months, painted single or group portraits without the faces, and when spring arrived, would find patrons who wanted their faces filled in. Several artists came to the colonies from Europe to paint portraits which would later become the foundation for an American style. Far

surpassing the imports, primitives and the limners, were three fine American artists, the first to make an impact both here and in Europe.

John Singleton Copley (1738–1815) The early works of John Singleton Copley, such as his portrait of *Paul Revere,* were competent and often forceful despite his lack of formal training. Using his considerable natural talent, he developed his own style after carefully studying the paintings of the European artists who were working in America. Intuitively aware of color, light, and form, he was able to produce excellent portraits in which he could often penetrate the personalities of his sitters. The portrait of Paul Revere shows the famous silversmith and patriot in a moment of concentration. He holds one of his pitchers in his left hand and, with his engraving tools handy, seems to be wondering what type of design to work into the metal. A strong light is used to model the figure which is placed before a solid, dark background. The work is a serious study of the man; the composition is strong; the edges are hard; and the figure is solid—all of which are different qualities from those found in English and French painting of the same time. Copley went to Europe in 1775 to study with Reynolds and other European artists. Although his technical skills increased, his later work lost this fresh American approach and became softer and more English in character.

JOHN SINGLETON COPLEY. *Paul Revere*, 1768–1770. Oil on canvas, 89 × 72 cm. Museum of Fine Arts, Boston, gift of Joseph W., William B., and Edward H. R. Revere

Benjamin West (1738–1820) Born in the Commonwealth of Pennsylvania, Benjamin West left America in 1759, lived and painted in Rome for three years, and finally settled in London, never returning to his native land. He became an outstanding portrait and historical painter in England, and his style and work really belong in the study of English art. Adept at painting huge battle scenes, he was historical painter to King George III and became president of the Royal Academy of Arts when Sir Joshua Reynolds died. Of his many excellent portraits, one of his finest is that of *Colonel Guy Johnson* who was the English Superintendent of Indian Affairs in the American colonies. Handling the texture of various materials with great skill, West shows Colonel Johnson with an idealized Indian holding a peace pipe which contrasts with the Englishman's gun. In the background is a small scene of Indian family life near a huge waterfall, probably Niagara. The British were fascinated with the Indian, whom they called the "noble savage," and West painted this group from memories of childhood in the colonies. Notice how West has subordinated the other parts of the painting to place the emphasis on the Colonel. West's influence was very strong because American artists coming to England to study would always first stop to get his advice and often stayed to study with him in London. These included Copley, Gilbert Stuart, Samuel F. B. Morse, and Robert Fulton.

BENJAMIN WEST. *Colonel Guy Johnson*, 1776. Oil on canvas, 203 × 138 cm. National Gallery of Art, Washington D.C., Andrew W. Mellon Collection

GILBERT STUART. *Mrs. Richard Yates*, 1793–1794. Oil on canvas, 77 × 63 cm. National Gallery of Art, Washington D.C., Andrew W. Mellon Collection

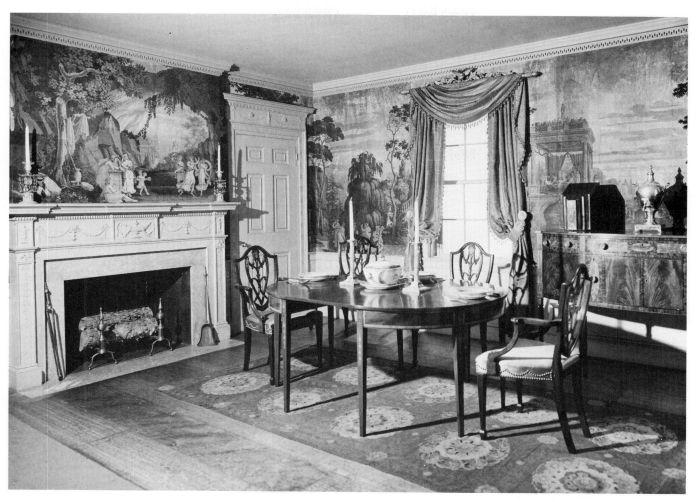

Dining room, from Salem, Massachusetts, about 1800. Attributed to Samuel McIntire. William Rockhill Nelson Gallery of Art, Kansas City

Gilbert Stuart (1755–1828)　The most inventive of early American painters was Gilbert Stuart who arrived in London in 1775, a penniless young student. After studying with Benjamin West for a time, he exhibited a portrait of a man on ice skates that became the sensation of the Royal Academy show in 1782. With his name established he accepted many portrait commissions at prices exceeded only by Reynolds and Gainsborough. Handling his income poorly, however, he returned to America in debt and spent the rest of his life painting the heroes of the new Republic, including the first president, George Washington. He did not like to flatter his subjects but painted them as he saw them. Most Americans liked this approach because patrons such as *Mrs. Richard Yates* wanted to see themselves as they really were. Stuart's brush strokes were strong and sure and his use of color, especially in the skin tones, was innovative and fresh, because he used almost every color to portray the living quality of flesh.

EARLY AMERICAN CRAFTS

An American dining room of about 1800 shows the decoration and furniture used in a fine New England home. The carvings over the mantel and on the doorway were probably done by Samuel McIntire who was one of the country's finest architects as well as a superb wood carver. The hand-blocked wallpaper came from Rococo France, but the simple lines of the Sheraton and Hepplewhite furniture begin to show the influence of European Neoclassicism and the Federal period in this country. But remember that the Rococo never really got a foothold in the United States because the country simply was not in any mood for make-believe and frivolity. Compare this room with the French paneled room on the next page.

French paneled room, about 1730. The furniture, about 1720–1750. The J. Paul Getty Museum, Malibu

PAUL DE LAMERIE. Sideboard dish and ewer, 1742. Silver dish 74 cm diameter; ewer 47 cm high. Los Angeles County Museum of Art, promised gift of Mr. and Mrs. Arthur Gilbert

Rococo Crafts

The swirling magnificence in the work of Bernini, Rubens, Watteau, and the imaginative Austrian architects of the early eighteenth century found itself reflected in the crafts of the period. The designers of furniture, clothing, silverwork, and chinaware were constantly seeking to express themselves in the most elegant fashion as they enriched their work with decorative features such as swirls, arabesques, curves, countercurves, flowers, leaves, shells, and other elaborate motifs.

The French paneled room is from Paris and dates from about 1730 while the furniture dates from 1720 to 1750. Most of the pieces are signed and dated by the craftspersons who made them. Each piece was carefully made and decorated for various members of the French nobility, yet their characteristic Rococo features are so alike that they blend easily together in this museum setting. Walls are of carved oak and composition material, painted cream and gilt. Tapestries are from original paintings by Francois Boucher and date from 1741 to 1760.

The commode to the left of the mirror, done about 1760, is by Joseph Baumbauer. It is of wood veneer with Japanese lacquer panels and gilt-bronze mounts. Adrien Delorme designed the commode to the right which copies the other. The clock, by Andre-Charles Boulle in 1720, is of wood veneer with inlaid tortoise shell and brass, decorated with gilt-bronze mounts. Charles Cres-

sent, who did much work for the king, created the large leather-topped table of kingwood and purplewood about 1725. The French Savonnerie carpet of about 1667 was in the collection of Louis XIV and lies on an eighteenth century parquet floor. Finally, Augustes Rex Meissen made the two vases on the left commode.

This silver side dish and ewer were crafted by Paul de Lamerie for clients in England. When the fork came into use at late seventeenth century tables, such tableware, used to wash hands, became obsolete. In the eighteenth century they returned to popularity but in a decorative rather than utilitarian role. The lavish designs on de Lamerie's pieces are in the new Rococo style which he pioneered (See p. 49).

The English woman's gown is of brocaded silk taffeta and features such Rococo decorations as delicate flowers and meandering vines. The added flower garlands are in Rococo s-curves and imitate the architectural decoration seen in many elaborate rooms. The fitted sleeves were in style from 1770 to 1785, so the gown can be dated by this one feature alone. The full dress is actually an overgown with large back pleats falling to the floor. It was designed with buttons and loops to hold it off the floor for outdoor walking.

MASTER GREGORY CHIZHEVSKI. *Royal Gates*, Church of the
Nativity of the Mother of God, 1784, Kiev, Ukraine, Russia.
Silver and silver gilt, 232 × 103 cm. Los Angeles County
Museum of Art, promised gift of Mr. and Mrs. Arthur Gilbert

The silver and silver-gilt Royal Gates are from The
Church of the Nativity of the Mother of God, a monas-
tery chapel in Kiev, Russia. They were made in the
monastery workshops and are attributed to Master Greg-
ory Chizhevski. Such gates were always located in the
center of the *iconostasis*, the wall-like screen which sepa-
rated the holy altar area from the congregation in an
Eastern Orthodox church. The wall was traditionally
decorated with painted icons and had three entrances,
with the Royal Gates being the central and most impor-
tant. The incredibly luxurious design includes six icons
in bas-relief, but the interlaced garlands of flowers and
leaves are the dominant feature.

The Royal Coach is from the collection in the Schoen-
brunn Palace in Vienna and reveals that even such
utilitarian items as this means of transportation received
elaborate Rococo decoration. Hardly a straight line can
be found amid the curves, countercurves, scrolls, and
swirls that embellish the carved surface of the coach.
Even the horses were trimmed to match the coach, as
feathers and elaborately tooled and bejeweled harnesses
were used to create a unified visual entity.

Royal coach. Schoenbrunn Palace Col-
lection, Vienna

Woman's gown, 1775–1785. English.
Brocaded silk taffeta. Los Angeles
County Museum of Art, gift of Mrs.
Delmar Lawrence Daves

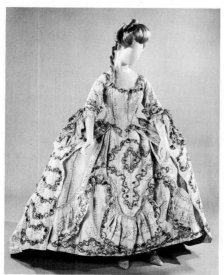

1600

Islamic world	Three empires comprise Islamic world: Ottoman, Safawi and Mughal
China	Qing dynasty begins (1644–1911); Emperor Kang-Xi sponsors the arts (1662–1722)
Japan	Tokugawa shoguns rule from Edo (Tokyo) (1603–1868); Ukiyo-e and Kabuki; self-isolation, 1640–1853
India	Mughals rule India; Shah Jahan builds Red Fort, also Jama Masjid and Taj Mahal
S.E. Asia	Dutch East India Co. established in Java, Phnom Phen, Malacca, Taiwan (early 1600s)
Europe	Cromwell controls England; King James version of Bible (1611); Bloodless Revolution
Americas	Spanish empire at apex; Jamestown, Virginia (1607); Pilgrims in Massachusetts (1620)

1700

China	Qing dynasty, Emperor Chinn Lung (1736–1796) dominates politics and art
Japan	Growth of merchant class and cities; Greatest period of Ukiyo-e production
India	British East India Company rules Bengal (1757)
S.E. Asia	Sack of Ayuthaya (1767) Thailand

1775

ART OF OTHER CULTURES

These three photographs indicate some of the international influences that characterized the art of the seventeenth and eighteenth centuries. All seem very much alike, as if made in the same kilns, but are from China, Japan, and France, thousands of miles apart.

China's ceramic artists reached a new level of aesthetic refinement during the Qing dynasty and the reign of Kang-Xi, producing porcelain decorated with cobalt blue which was in demand in Asia, Europe, and even America. The Japanese acquired ceramic skills from the Chinese-inspired Koreans and from the Chinese themselves. A group of Korean potters was actually kidnapped and taken to Japan in the late 1500s to make ceramics in the Chinese style.

Europeans tried for years to emulate Chinese porcelain before the secret use of kaolin and ball clays was discovered by a Jesuit priest in the 1700s. After that, French, English, German, and Dutch kilns produced fine white porcelain, often decorated with motifs and scenes inspired by the journals of Oriental travelers—a style known as *chinoiserie*.

Shouldered Vase, 17th century. Japan. Porcelain, enameled decoration, 20 cm high. Museum of Fine Arts, Boston, Edward S. Morse Memorial Fund

Sèvres Bowl, 1792. French. Porcelain, gold, and platinum decoration on black ground, 16.5 cm high. By Jacques Dieux. J. Paul Getty Museum, Malibu

Brush Pot, 1662–1722. Qing dynasty, Kang-Xi period, China. Porcelain, 22 cm diameter. Fung Ping Sham Museum, University of Hong Kong

HISHIKAWA MORONOBU. *Pleasuring on the Sumida River*, 1690. Ink and colors on gold paper, 93 × 244 cm. Los Angeles County Museum of Art

St. Paul's Church, Macau. Exterior view, about 1640

Artists at the Japanese capitol at Edo (Tokyo) depicted the daily activities of the rulers and businessmen on scrolls and folding screens. Such genre subjects as boating, eating, traveling the Tokaido road, or going to the theater became popular with the middle class. This trend eventually led to an art form known as *ukiyo-e*.

Japanese Christians, fleeing from Japan, built this church in the Portuguese colony of Macau on the south China coast. St. Paul's facade is a remarkable mixture of styles, incorporating elements of Neoclassic, Baroque, and *Platteresque* architecture. The sculptured work ranges from Renaissance images of Mary to reliefs in Oriental perspective of skeletons and birdlike creatures. The wooden church building itself burned during a typhoon in the 19th century, leaving only the masonry facade.

INDEPENDENT STUDY PROJECTS

Analysis

1. Study the three versions of *David* by Donatello (p. 232), Michelangelo (p. 247) and Bernini (p. 291). Compare and contrast the sculptures as they appear to you. Then compare and contrast their styles and the changing emphasis that artists placed on pose, movement, expression and emotion from the early Renaissance to the Baroque.

2. Study the Velasquez painting *Las Meninas*, and observe the many kinds of people represented. Write a few sentences, quoting what you think each person might be thinking at the moment that Velasquez stopped the action in the Spanish court.

3. Imagine that Rubens and Poussin meet toward the end of their careers and begin to discuss each other's work. Write a script for a television spot on how the conversation might proceed. Perhaps your script could be videotaped or tape recorded for presentation to the class.

Aesthetics

4. Write an essay on the use of light in painting. Compare and contrast the styles of Vermeer and Caravaggio as you research and explore this important aspect of painting. Why did each artist approach the use of light in a different way?

5. The influence of Baroque palaces spread over all of Europe and even influenced royal palaces in Asia and homes of the wealthy in America. Collect illustrations of some of these buildings from travel brochures, magazines and newspapers. Try to find and record the dates of their constructions.

6. Select several dozen slides of Baroque paintings, sculpture and architecture. Arrange a visual presentation, set to the music of Baroque composers (Vivaldi's *Concerti Grossi*, Bach's *Brandenburg Concerti*, Scarlatti's *Sonatas for Harpsichord*, Handel's *Messiah*). Try to coordinate theme, expressiveness, color, volume, lightness, heaviness, rhythm, pattern, etc.

Studio

7. Group portraits were popular subjects for Dutch Baroque artists. They might be compared to your school's group yearbook pictures. Using a yearbook group photograph as a guide, make a tempera painting or large drawing in the style of Rembrandt.

8. Hogarth's art was full of social criticism and political satire. In our own time, he might have been a political cartoonist. Use such a cartoon from your newspaper's editorial page as visual information, and make a tempera or watercolor painting that satirizes a contemporary political or social situation.

9. The genre paintings of Vermeer, Chardin, Hogarth and Le Nain made the common ordinary events of daily life seem noble and important, without being overly dramatic. Make a list of genre subjects from your own experience and environment. Think how each could be depicted so that it takes on new meaning and significance and make several sketches.

DENMARK

Liverpool
Manchester

Birmingham
ENGLAND *Stour River*
Cambridge
London
Brighton

Amsterdam
The Hague
NETHERLANDS
Arnhem
Berlin
GERMANY
Dresden
Ghent
Brussels
BELGIUM

Normandy
Paris
Barbizon
Fontainebleau
Seine River
Munich
AUSTRIA

Atlantic Ocean

Ornans
SWITZERLAND
Venice
Milan
FRANCE
ITALY

Guernica

SPAIN

Madrid

Mediterranean Sea

12 Three Opposing Views: Late 18th and Early 19th Centuries

WHAT IS CALLED THE *modern world* and *modern art* began in the late eighteenth century and is still developing. No real common denominator can be found for this two-hundred-year era, but people today still identify with the struggle against tyranny and the art and music of the late eighteenth century. Many significant changes occurred during this period. Organized religion lost its dictatorial hold, leading to secularization and to the two basic forces that shape lives today—social democracy and scientific progress. Social democracy originated in France under the philosophical leadership of Voltaire and Rousseau and had its first taste of success in America. Scientific progress was initiated in England during the Industrial Revolution and spread to all Western nations during the nineteenth century, becoming the basis for capitalism. Both revolutions continue; industrialization and democracy are the goals of people around the world.

With the new freedoms society became more mobile and unrestrained. Yet this same new freedom that tolerates a latitude of creative thought and art demands a self-discipline that is both frightening and stimulating. Without the restraints of monarchies and the church, humanity began a search for corporate and individual identity. People know more than ever about themselves yet are unsure. Artists, philosophers, and scientists are searching for new means of expression. Movements and countermovements crossed international boundaries and patterns that began in France quickly emerged in America and Italy. Today, Chinese concert halls echo with the music of Mozart and Beethoven. "Western" movies are filmed in Italy and rock concerts take place in Yugoslavia. Paintings for sale in England are bought via television satellite in Los Angeles. Architectural designs for urban structures are nearly the same in every major city in the world. This internationalization of art and cultures has closely paralleled the advances in communication and transportation that are gradually shrinking the world in terms of time-distance relationships.

Since the early nineteenth century, there have been no definite, large eras in art, such as the Renaissance or Baroque. Instead there are many artistic movements that probe new directions, react to former styles, or revive traditions. At first, national movements ("isms") lasted for many years; then for several; and now for one or two. In short, the single characteristic that unifies modern art is its diversity. This constant change can confuse the general public; movements happen too quickly to be understood. In such an atmosphere, art can become the province of an elite group rather than the expression of the people. But the great variety of styles only reflects the wide range of choices available to people in other areas of life. As these styles have become international in scope, modern art movements will be studied as an international language, not confined to the borders of a single country. Since the styles are so different, no person can possibly accept all with the same eagerness. In nineteenth century France, three distinct styles challenged the viewer: Neoclassicism, Romanticism and Realism. How different from the Rococo period with its one identifiable style and content. Today, however, the individual must choose from multiple styles.

Neoclassicism

From 1775 to 1815 the Western world was in turmoil, dominated by a series of upheavals rarely matched in history. The American colonies gained independence from England. The French went through economic and political crises that finally led to the dictatorship of

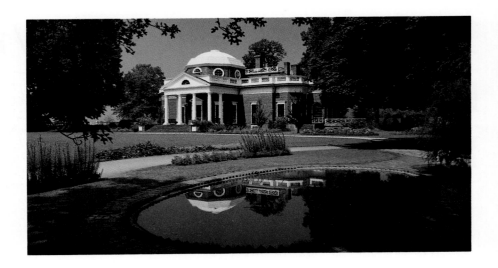

Thomas Jefferson. Monticello, 1770–1784. Charlottesville; Virginia

Napoleon Bonaparte. Napoleon unleashed a ferocious attack on Europe that eliminated many Baroque monarchies, dissolved the Holy Roman Empire, and threatened to conquer Russia and England. With Napoleon's collapse, some of the monarchies were restored, but they were doomed to future turmoil and eventual extinction.

Napoleon had likened himself to the Roman emperors and the art which he favored drew heavily on the Classical Roman styles. This *Neoclassicism* was not a passing fad but became a way of life in revolutionary times. Furniture, dress, painting, sculpture, architecture, and the crafts all relied on ancient Classicism for their motifs and forms. As a serious and lasting reaction to the frivolous Rococo, no-nonsense Neoclassicism became firmly embedded in the academies and was the official force in art well into the nineteenth century, on the continent, in England, and in America.

In 1738, Pompeii and Herculaneum (buried in 79) were uncovered, and artifacts and information gradually filtered into France and northern Europe. This, together with Napoleon's fascination with Roman history and styles, led to a general interest in Classic themes, history, and design. Rules of composition and design, based on an intensive study of Greek, Roman, and Renaissance art, were established in the academies, and art became as much a study as a personal expression. The art collections of the nobility became nationalized and belonged to the people. Great palaces, such as the Louvre, became museums and were opened to the public, who were often incensed at the aristocratic taste in art. After a period of adjustment, the public was allowed to view the art collections under certain restrictions which ensured the safety of the works.

ARCHITECTURE

Following the flamboyant and sensual architecture of the Baroque and Rococo, architects who fell in line with the Neoclassic doctrines went back in history to find examples from which to work. Classic simplicity and balance replaced the overworked surfaces of Rococo palaces and churches. Twisting and curling lines were replaced by straight ones, and frills were eliminated almost completely. Not only Napoleon's France was affected, but all the continent and even America were ready for a change from Baroque elegance to Neoclassic refinement and order. Several examples of the hundreds still standing will show how this revival of Classic design swept the Western world.

Besides being one of our early presidents, a politician, and the designer of the Declaration of Independence, Thomas Jefferson was also an architect. Influenced by the architectural writings of Palladio and the Roman structures he had seen in France, he designed his own home at Monticello and the first buildings at the University of Virginia at Charlottesville. Monticello is a two-story structure built along Palladian lines with a flat dome over the central space. Its portico and white-painted Doric columns and trim, which stand out from the red brick surface, became characteristic of an American style called Georgian. The noble simplicity of such architecture was attractive to the developing taste of America's growing middle classes.

Neoclassicism and its influence are evident in the United States Capitol as well as scores of public buildings constructed at this time around the world. The Capitol was begun as a Georgian structure, developed through a face lifting and enlargement by Benjamin La-

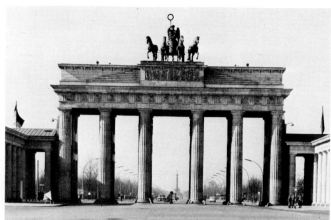

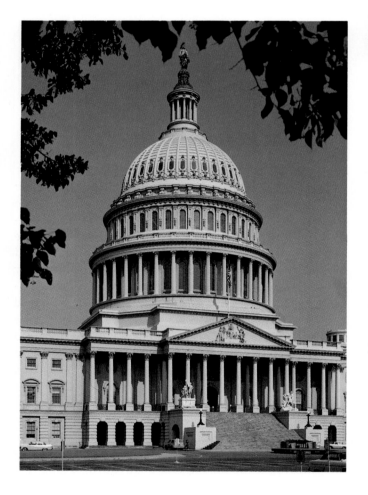

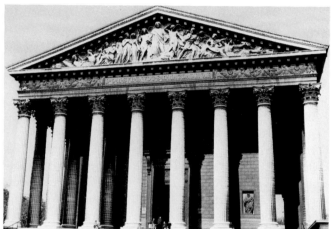

PIERRE VIGNON. Church of the Madeleine, 1806–1843. Paris

THOMAS U. WALTER. United States Capitol, 1851–1863. Washington D.C.

trobe and was completed as a massive, super-scale structure when Thomas Walter added the cast iron dome in 1863. Considering the many architects who worked on it, the building has a remarkable feeling of unity. The dome, raised on a high, columned drum, has an internal diameter of slightly over thirty meters and rises sixty-seven meters above the floor.

The columned Brandenburg Gate in Berlin was built by Karl Langhans along the lines of some Greek gateways. Topped with a four-horse Roman chariot, the gate has stood between East and West Berlin as a symbol of the divided city, although that was certainly not its in-

tention at the time of construction. A concrete wall in front of it was built by the Soviets to discourage free communication and movement between the two sectors of the city, following its division after World War II.

Paris has many fine examples of Neoclassic architecture, but none is better than the church of the Madeleine, designed by Pierre Vignon. The colossal structure is designed as a Roman Corinthian temple and took over thirty-five years to complete. The exterior follows Classic ideas completely, but the interior needed light and windows, so the necessary alterations were incorporated.

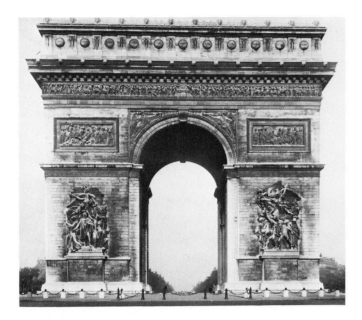

Erected to the glory of the "Grand Armee," the Arc de Triomphe de l'Etoile (Arch of Triumph of the Star) in Paris was one of Napoleon's numerous monuments. Following the example of Imperial Rome's triumphal arches, this ponderous structure by J. F. Chalgrin towers over surrounding structures and forms a focus for nearly a dozen boulevards that lead into the huge circular area containing the arch. The structure contains the eternal flame which honors France's unknown soldiers as well as a list of the campaigns and victories of Napoleon. At the other end of the magnificent boulevard, the Champs-Élysées, stands the Louvre and another dramatic arch of triumph. Others are scattered throughout Europe in many major cities.

From the banks of the Neva in Leningrad to the Spanish capital of Madrid, from Denmark to the city of Athens, many builders worked with the elements of Classic architecture (columns, arches, domes, pediments, simplicity, order and balance) to flood Europe with impressive Neoclassic cityscapes.

PAINTING

Jacques-Louis David (1748–1825) If any man was ever a dictator in the world of art, it was Jacques Louis David of France. He began painting under Louis XVI, but after the King's death under the guillotine, David was able to switch allegiance and become the most important artist under Napoleon. Most other Rococo artists could not make this change and fled Paris in self-imposed exile. David not only stayed but became a powerful and domi-

nant figure in art, designing clothing, uniforms, furniture, pageants, and painting the revolutionary leaders.

Although he began in the decorative style of Boucher and Fragonard, his ideas changed when traveling to Rome in 1775 where he studied and drew the Classic sculptures with infinite detail, establishing a style that was clean, crisp, and hard edged. He would not tolerate any evidence of brush strokes in his own work or that of his students. When he returned to Paris his allegorical paintings began to suggest the ideals of Classic republicanism, using Greek and Roman subject matter and showing parallels with contemporary French politics.

The Oath of the Horatii is a huge painting (though not as large as some of his later works) which uses a Roman story to establish strong passions for contemporary French unity. The Horatii brothers are chosen to defend Rome in battle against neighboring Alba, but one of their sisters is engaged to an enemy and one of the brothers is married to an Alban. The three brothers take an oath on the raised swords held by their father, Horatius, to defend Rome. Their sister, the betrothed Horatia, their mother, and one brother's wife are mourning, in attitudes of Classic grace, the inevitable result of such a battle. But Rome (like France) must oppose any threat to its unity, despite family interests.

Notice the drastic change in painting style. Every figure is painted with absolute clarity. Edges are hard and crisp, and the austere figures against the plain, neutral background seem almost frozen in action on a dramatically lit stage. Against a Classically arched setting, the feathery grace of Rococo drapery is replaced by the hard-as-steel, sculptural folds of Neoclassicism. Paintings such as this helped to establish the craving for independence and freedom from the oppressive monarchy. David dressed dummies in Roman costumes so he could study the drapery and had helmets made for him to copy. He finished the painting in Rome after begin-

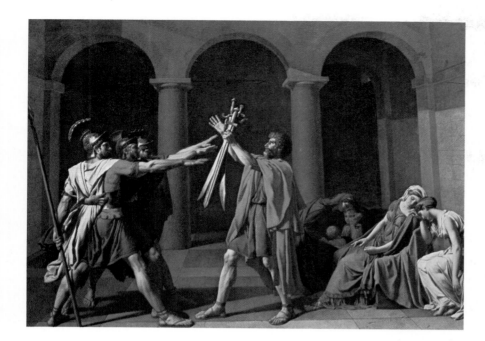

Jacques-Louis David. *Oath of the Horatii*, 1784–1785. Oil on canvas, 325 × 426 cm. The Louvre, Paris

ning it in Paris, and entered it in the Salon, the major yearly show of the members of the French Academy.

Because of his early work for the French nobility, David was imprisoned but escaped the guillotine. On his release he became interested in Napoleon as the man who might bring order out of impossible chaos. He painted some mammoth canvases glorifying the little Emperor and portrayed him as the central figure in elaborate pageantry. *Napoleon in His Study*, however, shows the leader alone and surrounded by details which reveal aspects of his identity to the people. David portrays him in his Sunday uniform with medals of the Legion of Honor and the Iron Cross of Italy, both orders which he created. The manuscript of the *Code Napoleon* is on the desk at which he had been working. The burnt-down candle, the writing materials, and the clock (the time is 4:13 a.m.) suggest that the Emperor has worked all night. Such flattery was well rewarded by the Emperor and the artist soon became his favorite. The chair in the painting was designed and dated by David and was delivered to Napoleon shortly before the painting was made. David often painted Napoleon but also worked on many other portraits, showing his sitters in Classic poses and dress. Unable to adjust to the Restoration of the Monarchy, David spent his last years in exile in Brussels.

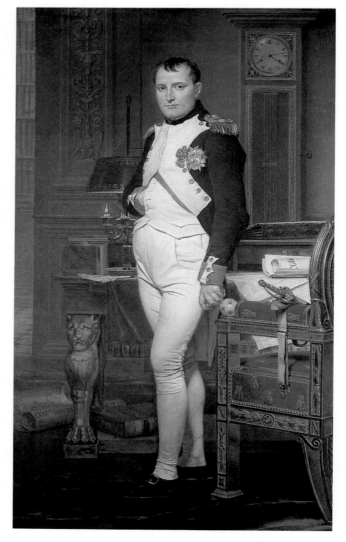

Jacques-Louis David. *Napoleon in His Study*, 1812. Oil on canvas, 204 × 125 cm. National Gallery of Art, Washington D.C., Samuel H. Kress Collection

Jean-Auguste-Dominique Ingres (1780–1867) David's best pupil and primary spokesman for Neoclassicism was Jean-Auguste-Dominique Ingres. A child prodigy, Ingres entered art school at eleven and began studying with David at seventeen. He was also an accomplished violinist and a close friend of many famous musicians. Although he never allowed his brush work to show, his style was much softer and more sensitive to texture and flesh than that of David. He lived and worked in Rome for eighteen years, and when he returned to Paris he became a staunch defender of Neoclassicism and its rigid rules and methods. Ingres considered himself a historical painter, yet most of his income came from his nude paintings and cool, Classic portraits (*See* p. 74). He was a marvelous draftsman and his portraits were carefully drawn before they were painted as exact likenesses. He was one of the last great portrait painters because that role was soon taken over by the camera, which became practical about 1840.

His cool, undramatic Classicism can be seen in the huge *Apotheosis of Homer*. In front of an Ionic temple, the blind poet is crowned by the Muse of epic poetry. The

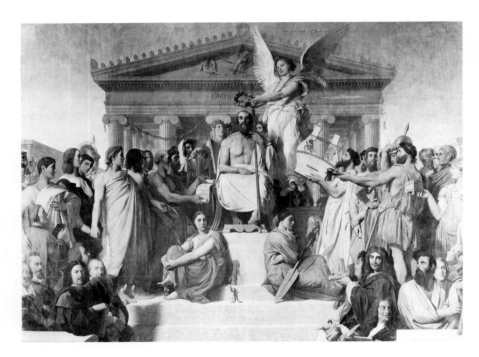

JEAN-AUGUSTE-DOMINIQUE INGRES. *Apotheosis of Homer*, 1827. Oil on canvas, 386 × 514 cm. The Louvre, Paris

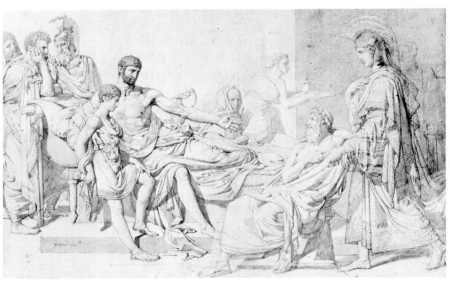

JEAN-AUGUSTE-DOMINIQUE INGRES. *Scipio and His Son with the Envoys of Antiochus.* Pencil on paper, 24 × 37 cm. Norton Simon Inc. Museum of Art, Pasadena

ELIZABETH VIGÉE-LEBRUN. *Therese, Countess Kinsky*, 1793. Oil on canvas, 135 × 99 cm. Norton Simon Inc. Foundation, Los Angeles

two female figures below him symbolize his two major works, the *Iliad* (by the sword) and the *Odyssey* (by the rudder). Ingres included among those present, figures whom he considered Classical geniuses from various periods, such as Phidias, Pindar, Aeschylus, and Apelles; Raphael, Leonardo, Fra Angelico, and Poussin. Making the list are writers such as Moliere and Shakespeare, but the composer Mozart, who was once included, was finally eliminated from the finished composition. His use of contemporary figures in a Classic setting is similar to Raphael's work in *The School of Athens*.

Ingres' fantastic ability to draw is evident in his paintings and drawings. In the Classic tradition, he would draw figures in the nude to make absolutely sure all the proportions were correct and then would add the clothing in intricate detail. *Scipio and His Son with the Envoys of Antiochus* is a pencil drawing of small size but immense ability. Shaded in some places to appear almost finished, yet barely outlined in other areas, the poses, attitudes, and drawing technique are handled masterfully. Ingres used this same care and skill in making his contemporary portraits. He carried on a run-

ning battle with the Romantic painters whose emotional treatment he could not tolerate. He detested the work of Rubens and called Delacroix (leader of the Romanticists) the devil incarnate. *See* page 32 for another of Ingres' drawings.

Elizabeth Vigée-Lebrun (1755–1842) One of the most successful of all women painters, Elizabeth Vigée-Lebrun studied first with her father and became an excellent portrait painter before she was twenty. At twenty-four she was called to Versailles to paint Marie Antoinette, stayed to become Painter to the Queen, and was elected to the Academy in 1783. When the Revolution broke out she went to Italy, Vienna, Prague, Dresden, and Moscow before returning to Berlin, London, and finally Paris again. Her career was a series of international triumphs as she received commissions everywhere she went. She was constantly busy during her long life and over eight hundred paintings have been identified as her work. Her published memoirs are an excellent account of travel and living during her lifetime. Her portrait of *Therese, Countess Kinsky* was painted in Vienna and is typical of a period when she was using landscapes as backgrounds for her sitters. Vigée-Lebrun was helpful in establishing the simple, high-waisted dresses of the Empire style shown here, replacing the elaborate gowns of the old monarchy. David was the instigator of this Classic style, but portraits such as this, with prominent people wearing such dresses, added to the importance of the change of style throughout Europe. Vigée-Lebrun's coloring was softer than that of David and Ingres and her poses more inventive. Even though she was not in sympathy with Napoleon and his Empire or with David and Ingres and their dogmatic approaches to painting, her beautifully drawn and painted portraits were typical of artists working through the turmoil of the turn of the century. She was more successful than most.

SCULPTURE

Jean Antoine Houdon (1741–1828) It would seem logical for sculpture to be as important to the Neoclassic movement as it had been in ancient Greece and Rome, but such was not the case. The best of several sculptors working during the turmoil in France was Jean Antoine Houdon, who started his work during the reign of Louis XIV and managed to adjust to the changing political philosophies and remain unscathed. Although Napoleon was not an admirer of Houdon, his work was greatly honored by the philosophers who founded the intellectual basis of the Revolution, Voltaire and Rousseau. In fact, Houdon made excellent likenesses of each. His work is anatomically accurate yet is not rigid in appearance because he was able to capture the personality of the sitter. In France, he sculpted Benjamin Franklin and Thomas Jefferson. Through them he was invited to the new country, the United States, in 1785 and carved the first president, George Washington, in marble. Houdon's brilliant realism can be seen in his bust of *Benjamin Franklin*. Although the drapery has Classic overtones, the sparkle of Franklin's wit is superbly expressed in both eyes and mouth. Although technically perfect, Houdon's work is charged with life and is not somber as many Roman sculptures. His sculpture seems about ready to spring to life.

JEAN ANTOINE HOUDON. *Benjamin Franklin*, 1780. Marble, 58 cm high. William Rockhill Nelson Gallery of Art, Kansas City

Romanticism

The Neoclassic style had begun as a protest against the Rococo style of the eighteenth century aristocracy but it soon dictated its own artistic taste to much of Europe. The academies in Paris and London were led by cautious men who stuck by tradition in their own painting and teaching—and it appeared as though Neoclassicism was here to stay. But there were other ideas stirring. Some independent-minded artists detested having to work within the Classic restrictions of form and proportion, and their feelings erupted into a full-blown movement called Romanticism. The name came from a widespread revival of interest in medieval stories known as romances—stories involving fictional heroes and great adventures of individual heroism and emotion. Rather than focus interest on ancient Greece and Rome as the source of all good design, the Romanticists dug into the Middle Ages and were fascinated with Africa and the Orient. It was individualism versus the system; emotionalism versus intellectualism; and rebellion against the academies.

Romantic poets such as Wordsworth, Shelley, Keats, and Byron exhibited a new freedom over the more stylized writings of Pope, Thomson, Gray, and Cowper. In music, Romanticism was championed by Beethoven and Schubert who composed greatly-expanded symphonies, contatas, and concertos. Italian tragic opera flourished and a new emotionalism generated excitement in the arts throughout Europe. Although Neoclassicism and Romanticism seem to be absolute opposites, they were both the product of rebellions against previous standards and this spirit of rebellion made them somewhat akin, at times almost interchangeable. Yet, looking back at the movements from a historical distance, one is able to notice characteristics which give each a separate sense of unity and style.

ARCHITECTURE

In architecture, England was the leader in Romanticism as many estates sprouted Gothic towers and medieval castle-like features. The foundation had been laid even

earlier as English architects seemed to worship the style of Palladio and continued to borrow ideas from his buildings. This eclectic attitude easily developed into massive borrowing from other times and cultures. What difference did it make if the buildings were not Classic and the lines were not clean? If they were interesting to look at (picturesque) and expressed an individualism, they were deemed worthy by the English.

Since there was no single model from which to work (Neoclassicism looked back only to Greece and Rome) no single architectural style developed. As emotion was important to Romantic painting, so mood and individual taste were guiding principles in architecture.

One of the most fascinating structures built was the Royal Pavilion at Brighton, designed by John Nash (1752–1835) who had earlier built Neoclassic homes in London. Built on the south coast of England, it was to be the summer home for the prince regent, later King George IV. Using existing structures as a beginning, Nash added and enlarged them to produce an Oriental fantasy, imitating Islamic domes and encasing chimneys in minaret-like forms. Interior spaces are styled after Greek, Egyptian, Chinese, and Gothic rooms, but the entire fun-filled structure has an overall unity even though it looks like it was transported to Brighton from India on some huge magic carpet.

After 1800, a revival of the Gothic style became very popular in England, basically because the English thought of it as *their* style. They wanted to be independent of Napoleon, Neoclassicism, or anything recalling France. So when the Houses of Parliament were to be expanded, Gothic was the unanimous choice. Sir Charles Barry (1795–1860) and A. Welby Pugin (1812–

John Nash. Royal Pavilion, begun 1815. Brighton, England

1852) were chosen as architects. The lacy feeling and perpendicular line found in Gothic cathedrals were translated into a gigantic public building. Dominated by the huge tower on the left (Victoria Tower), an octagonal central tower, and a clock tower on the right (Big Ben), the massive structure presents a formidable appearance as it hugs the bank of the Thames. Its Gothic feeling is so authentic that it easily blends with Westminster Abbey, a true Gothic structure that stands nearby. Europe is dotted with Gothic revival architecture as the result of the Romantic movement.

Sir Charles Barry and A. Welby Pugin. Houses of Parliament, 1836–1860. London

CHARLES GARNIER. Grand Staircase of
The Opera, 1874. Paris

CHARLES GARNIER. Grand Staircase of
The Opera, 1874. Paris

GIUSEPPE MENGONI. The Galleria Vittorio
Emanuele, 1861–1877. Milan

In France, the major building activity took place in Paris. And what activity it was! Great portions of the city were rebuilt, most of it under the direction of Georges Eugene Baron Haussman (1809–1891). Following Napoleon I's city plan, calling for boulevards radiating from the Arc de Triomphe, Haussman imposed a plan having all buildings of a similar style and a height of only six stories. This similarity, together with the planting of trees along the wide boulevards, gives Paris its familiar unity and striking beauty. The main boulevard, the Champs Elysees, cuts through Paris from the Arc de Triomphe to the huge gardens of the Tuileries and the Louvre.

Several large structures stand above the six-story limit imposed by Haussman. Some were already existing (such as Note Dame and the Church of the Madeleine) but others were new. The most striking of these new

buildings was the Opera, designed by Charles Garnier (1825–1898) and intended to be the central focus of the new Paris. The showy magnificence of the exterior was popular with the emerging industrial bourgeoisie who were gaining more power as the Third Republic developed. If the exterior seems a bit "overdressed" for the home of Neoclassicism, the interior is an incredible tribute to luxury and Baroque taste. The grand staircase cascades through a lobby space that is almost as large as the auditorium itself. Colored marble columns, gigantic sculptures, elaborate light fixtures, and decorative reliefs fill the space with a feeling of unnecessary magnificence. This type of showiness led later architects to seek a more quiet and disciplined approach to public building construction—except perhaps for the overly-decorated theaters and opera houses which dotted the continents of Europe and North and South America.

As nineteenth century architecture developed, new materials were incorporated as a result of the Industrial Revolution. While metal had been used in minor ways in the past, cast iron became a new and exciting material for architects. Cast iron frames held up the domes of the Royal Pavilion at Brighton. Some American and English buildings had decorative facades made of the new material, and the dome of the United States Capitol was of cast iron. Since it could be formed in any required shape, it was used to make arches and spans that could leap across large spaces. F. K. Brunel used it to construct suspension bridges in England, Joseph Paxton to provide the framework for the mammoth glass casing in his Crystal Place in London, and Henri Labrouste to build the huge National Library of St. Genevieve in Paris.

However, cast iron was affected by intense heat, and many such buildings were later destroyed in fires. Among those remaining is the Galleria Vittorio Emanuele, a shopping arcade designed in Milan by Giuseppe Mengoni and built in England and reassembled in Milan. It is actually a glass-covered shopping street, an early relative of today's enclosed shopping malls. Four separate arcades fan out from a domed octagon which tops a huge open space at the intersection. This was the largest and highest of its kind to be built in the nineteenth century.

A landmark familiar around the world is the Eiffel Tower, the symbol of modern Paris. Built by Alexandre-Gustave Eiffel as the central feature of the Paris Exhibition of 1889, it towers three hundred meters above the city. It rests on four pylons and four separate foundations and was the tallest structure in the world when it was completed. Still standing today, its elevators can hoist visitors to the very top to obtain an airplane-like view of this great city.

PAINTING

Color, emotion, content, and passion became key ideas in Romantic painting as they replaced the Neoclassic stress on line, intellect, form, and judgment. While Neoclassic painters had revered Raphael, Poussin, and the ancient Romans, their Romantic counterparts admired Rubens, Rembrandt, the Middle Ages, and the East. While only a few artists can be studied here, keep in mind that Romanticism was a widespread movement throughout Europe and the United States.

Francisco Goya (1746–1828) No painter worked in a style farther from Neoclassic ideals than Francisco Jose Goya y Lucientes of Spain. He traveled to Italy but was unimpressed by the Renaissance and Classic masterpieces and could not tolerate the restrictions that his French contemporary, David, imposed on artists. Instead, he preferred the work of Tiepolo who was working in the palace in Madrid. In 1786 Goya was appointed painter to King Charles IV and was responsible for the official portraits of the royal family. After a severe illness in 1792, he became totally deaf, a calamity that only strengthened his spirit and desire to communicate his feelings visually. He did large group portraits of the royal family and many individual portraits of Spanish nobility such as *Dona Isabel Cobos de Porcel*. The powerful study shows the Castilian woman dressed in a folk costume and posed in a way to emphasize her queenly

FRANCISCO GOYA. *Dona Isabel Cobos de Porcel*, 1806. Oil on canvas, 81 × 55 cm. National Gallery, London

beauty. The many Titian and Velasquez paintings hanging in the Spanish palace undoubtedly influenced Goya in his portrait techniques.

Goya's subject matter and style of painting changed throughout his life and covered a wide range. He painted delicate, sunny studies of Madrid's young people which were made into tapestries. Yet he also produced a series of etchings on the *Disasters of War* and a group of "black paintings" on the walls of his house that are awesome in their treatment of devils, witches, and cults. One of his most powerful and emotional works is the monumental *Third of May, 1808,* showing the execution of several Madrid rebels by French soldiers. By comparing the brush strokes, edges of color, emotional feeling, and sense of action with David's *The Oath of the Horatii (See* p. 337), the differences between Neoclassic and Romantic painting will become apparent. Done in 1814, just after the French left the country, Goya's dramatic painting is the first of its kind—a painting today called "social protest." It is not allegori-

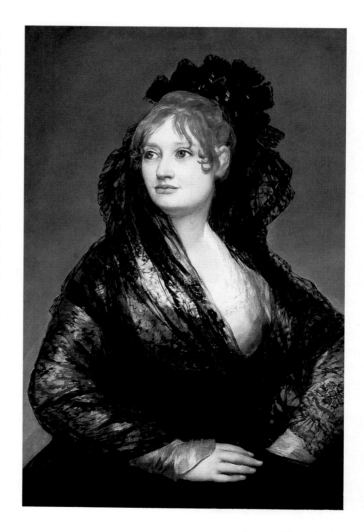

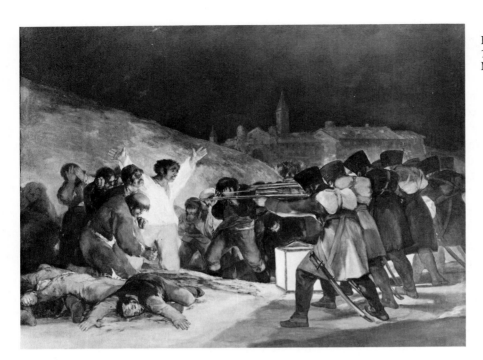

Francisco Goya. *Third of May, 1808*, 1814. Oil on canvas, 264 × 344 cm. Prado Museum, Madrid

cal, as battle scenes had previously been, but is an emotional portrayal of the event as the artist remembered it. The day before, on May 2, the Spanish rebels had attacked Napoleon's occupation force (*See* Goya's painting, p. 5). In retaliation, the French slaughtered a band of rebels in the streets of Madrid the following day. Here Goya shows the incredible inhumanity of human beings against others of their kind. He treats the French soldiers as a faceless monster with many legs whose bullets are cutting down his defenseless friends, some of whom wave wildly while others are already dead. Painted some time after the event occurred, Goya still captured its ferocity and gave it a startling sense of immediacy. The light comes from the huge paper lantern and adds to the eerie quality of the terrible event.

Goya made several series of etchings on a variety of subjects such as war, folklore, the follies of society, and bullfights. His range of expression was unmatched in his time and his powerful statements are still awesome to behold. He left Spain when the governments changed and died in France.

Theodore Gericault (1791–1824) The lifestyle of Theodore Gericault was pure Romanticism. He had little concern for his personal safety, loved to travel, always stood up for the less fortunate, and dedicated himself to an emotional life. He was successful in getting a painting exhibited in the Salon of the Academy when only twenty-one, a high honor. He lived and worked in Rome for several years but was only influenced by Michelangelo's muscular and dynamic figures and not his Classical surroundings. When he returned to Paris, he painted his only large canvas, the *Raft of the Medusa*, which clearly shows Michelangelo's influence and Gericault's treatment of Romantic and adventurous episodes. A government ship, the *Medusa,* was wrecked on the way from France to Senegal in 1816. The captain, who had obtained his office as a political favor, abandoned ship first, along with his crew, and the 149 passengers were crowded onto a raft to be towed by the lifeboat. The raft was eventually cut adrift and, after suffering extreme torments of starvation and thirst, only fifteen survivors made it to the African coast. It was a national scandal that shook the entire country. Gericault, always interested in humanity's struggle with nature, jumped into the subject with great enthusiasm. He interviewed the survivors, read the newspaper accounts, and made sketches and paintings of corpses and bodies at the morgue. He even had himself lashed to the mast of a small ship in a storm so he could *feel* the movement of the swells and the wind. Everything was done to make the painting realistic and authentic, but his Romantic spirit took him beyond realism. *Raft of the Medusa* is built around two pyramids, one of dead, dying, and tragic figures and the other of hope and struggle. (Later painters would reject such an obvious attempt at organization as being too Classical and orderly). Atop the second pyramid, several men wave clothing, trying to signal a distant ship, so small and

EUGENE DELACROIX. *Liberty Leading the People*, 1830. Oil on canvas, 259 × 324 cm. The Louvre, Paris

THEODORE GERICAULT. *Raft of the Medusa*, 1818–1819. Oil on canvas, 490 × 716 cm. The Louvre, Paris

far away it can barely be seen. But the gunboat *Argos*, finally came to the rescue. Storm clouds and high seas add to the feeling of futility and constant hope, in France's first great Romantic painting.

The painting was too gruesome to be easily accepted in France so Gericault took it on a tour to London and charged admission for the English to see it. The plan was financially successful, and Gericault was also able to meet the English Romanticists, especially Constable. When he returned to Paris, he worked on a series of psychological paintings, portraying the inmates of the city's insane asylum, whom he treated compassionately as mentally disturbed and not as outcasts to be ridiculed. He had a deep love for horses, both to ride and to paint. Following several falling accidents, he died in his early thirties, but is known as the founder of Romanticism in France.

Eugene Delacroix (1789–1863) After Gericault's untimely death, leadership of the Romantic movement passed on to Eugene Delacroix. He and Ingres were exact contemporaries and the leaders in their separate movements. Delacroix was as adventuresome and emotional as Gericault. Little but painting existed for him. He produced thousands of paintings, sketches, and watercolors. In his carefully kept journal, he recorded his feelings, thoughts, and plans for paintings and expressed an intense interest in the works of Shakespeare, Byron, Chopin (whom he knew well), Mozart, Michelangelo, and Rubens. He drew heavily on subjects

from literature, medieval history, the Crusades, and current events. *Liberty Leading the People* was inspired by the 1830 insurrection in Paris, a contemporary event. He painted the allegorical figure of Liberty, holding a tricolor French flag, leading the revolutionaries over the street barricades in Paris. Delacroix identifies himself with their cause by painting himself as the business man with the gun. While he glorifies the cause of the victorious revolt, he also shows the horror and violence of fighting. His theatrical feelings dictated the placing of the two dead figures in the foreground and blending allegory with reality. The huge painting was later purchased by the French government.

Two years after showing the painting, Delacroix made a trip to Spain and Morocco which changed his life. He experienced a way of life so different and living conditions so changed that he used the subject matter from this trip for many years. He was the first major painter in modern times to visit the Islamic world, and he sketched profusely. Having little time to paint and fearing the Islamic hostility toward portrayal of human forms, he returned to Paris with a trunk of sketches and a head full of exotic memories. Years later he painted harem scenes and figures in colorful costumes, introducing new and vivid hues into his palette. He painted a series of tiger and lion hunts (from sketches made of caged animals), all of which swirl with incredible activity and lush color (See p. 30). Compare *The Lion Hunt* with Rubens' painting of a similar subject to see why the Romantic artists admired his work. Raging animals, frightened horses, and furious hunters are knotted together in an interwoven composition. The eye travels in and out as it follows the curves and countercurves of men and beasts. Only the triangular format lends solidity to the composition and keeps the wild design under control. The slashing brush strokes, intense colors, and value contrast are fitting for such Romantic subject matter and point the way directly into the twentieth century. Photography was used by Delacroix in making studies of some subjects, and he became expert at using the newly invented cameras. He was also the subject for many photographs made by his friends, among them the world's first photographers.

SCULPTURE

One would be inclined to think that the revolutionary activities of France would have made perfect subjects for expressive sculptures, but this was not the case. Painting was still the most powerful visual means of Romantic expression. Several artists, however, were commissioned to create large works for new public buildings in Paris. Francoise Rude (1784–1855) created two grand sculptures for each side of the Arc de Triomphe, entitled *The Departure of the Volunteers in 1792* (See p. 336). The allegorical figure of a militant Liberty leads the massed figures off to battle for the glory of France. As in the Delacroix painting of a similar subject, the figures represent a cross-section of French society: workers, soldiers, businessmen, and young boys, united under the single driving force of Liberty. The massing of figures and congested movement are almost Baroque in feeling, but the contemporary context gives them Romantic overtones.

ENGLAND

Without a revolution or unifying political cause, English Romantic art developed in a very personal way. Two giants commanded center stage in England, both concerned with the drama and emotion contained in the elements of landscape and weather. John Constable glorified the green English countryside with its huge trees, gigantic, puffy clouds, and calm water. William Turner preferred to show the violent side of nature: storms, avalanches, fires, and the furious seas. Their interest in landscape, echoed in the poetry of Wordsworth, Shelley, and Keats, amplified Gainsborough's. Perhaps this obsession with nature was in part an aesthetic revolt against the Industrial Revolution which was gradually creeping from the heart of England's cities into the verdant countryside.

John Constable (1776–1837) John Constable was among the first painters to paint outdoors. He made dozens of quick studies on paper in which he tried to match, as closely as possible, oil colors with those of nature. Using them as guides, Constable would then construct a carefully designed landscape in his studio. He loved the English landscape and never left England to find subject matter for his work. He once said: ". . . water escaping from mill dams, willows, old rotten planks, slimey posts and brickwork—I love such things." In *The Hay Wain* he shows his skill in visualizing those things for the viewer. A red hay wagon is pulled through the Stour River near a typical English farmhouse close to Constable's home. Huge trees, flat fields, the stream, and Constable's beloved clouds are the subject of the painting. Look back to the Dutch Baroque painters like van Ruisdael to see where Constable first saw such dramatically painted skies. Constable was the first artist to paint water with such sparkling clarity and depth of shadow, an effect he achieved by adding touches of white to the canvas—touches which critics could not understand. While they liked his painting generally, they often made fun of his added whites and even called them "Constable's snow." This kind of criticism, based on a lack of knowledge of what the artist was trying to do, was the beginning of a rift between artists and the public—a rift which was later widened into a chasm when the independent work of the Impressionists came into the market.

The Hay Wain received more favorable acceptance in France's Salon of 1824 than in England. Delacroix saw it and was so impressed by the sky treatment and the fresh colors that he retouched his own entry at the Salon show and added colors and strokes more like those of Consta-

JOHN CONSTABLE. *The Hay Wain*, 1821. Oil on canvas, 129 × 185 cm. National Gallery, London

JOHN CONSTABLE. *Stoke-by-Nayland*, 1836. Oil on canvas, 128 × 169 cm. The Art Institute of Chicago, Mr. and Mrs. W. W. Kimball Collection

ble. English art was finally making an impact on the art world. *The Hay Wain* was one of six huge paintings that Constable did of subjects close to his home and were the first landscapes done in a size normally given to important historical subjects (*See* p. 75). His figures are small and belong to the environment, such as farmers herding animals, running barges, or riding wagons.

After the death of his beloved wife, Constable abandoned his more careful depiction of nature and painted with a great vibrancy and force reminiscent of his early sketches. *Stoke-by-Nayland* is a large studio painting with the immediacy and verve of an outdoor sketch. The colors are applied freely and the artist even mixed and spread some of them right on the canvas with his flexible palette knife. The spontaneous effect arises from the loose and rapid strokes and the elimination of detail. Since the critics could not fathom the white flecks of light in *The Hay Wain,* imagine their feelings about the wildness of this painting. The visual elements are similar in these two works, but Constable's technique, like Rembrandt's, changed drastically in later years.

JOSEPH MALLORD WILLIAM TURNER. *Snow Storm: Steam-Boat off a Harbor's Mouth*, 1824. Oil on canvas, 91.5 × 122 cm. Tate Gallery, London

Joseph Mallord William Turner (1775–1851) While Constable developed two styles, Turner developed three or more. Working in the traditional English landscape style at an early age, Turner was accepted into the Royal Academy at only twenty-four (in 1799) while his contemporary, Constable, was not admitted until 1829. Turner's earliest works were all in watercolor, a medium which he used all his life, producing about 19,000 watercolor paintings. He traveled to Europe and made sketching and watercolor painting trips all over the continent. His middle period paintings were of continental scenes as well as English subjects, and were set against backdrops of brilliantly colored, high-keyed skies of mist, sunset, and sunrise (*See Lake Geneva from Montreux*, p. 55). His later works are incredible compositions of swirling color and light. Turner enjoyed painting the pure movement of masses of color without representational meaning, although he usually had some eventual subject in mind. Study *Snow Storm: Steam-Boat off a Harbor's Mouth* first without looking for a subject. Just enjoy the swirling fog, steam, color, water, and movement. Violent action is achieved without portraying people or things. The colors and values swirl in a vortex that eventually centers on the mast of a ship which Turner added at the end. No one at that time knew anything of non-representational painting, so Turner added the representation of a ship, but the painting would be just as strong without it. Color and movement are the real subject. His work of this period anticipates the Impressionist movement. When Claude Monet spent time in London in 1870, the work of Turner had a profound impact on him, and through him, on the rest of the Impressionists. (*See* p. 59 for Turner's impression of *The Burning of the Houses of Parliament*.)

AMERICA

Romantic painting in the United States followed the general pattern of landscape painting in England. The painters can roughly be placed in two groups: those who painted in the East and those who traveled with the westward migration and painted the settling of the West. There were many artists in each group, but two will be studied as characteristic examples.

Thomas Cole (1801–1848) In the New England states, a group of painters, called the Hudson River School, worked in a landscape that was soon to be taken over by an expanding population. Their leader was Thomas Cole who was born in England, came to America at seventeen, returned to England to study painting and came back to America to paint. Many of his paintings depicted Classic ruins but most, such as *View on the Catskill, Early Autumn*, were painted in the studio from a series of sketches of the countryside. Like his English contemporaries, he added small figures that seem to enhance the grandeur and immensity of the landscape. Rustic beauty and ideal settings seemed to Cole to be the essence of America, and his Romantic approach was

THOMAS COLE. *View on the Catskill, Early Autumn*, 1837. Oil on canvas, 99 × 160 cm. The Metropolitan Museum of Art, New York, gift in memory of Jonathan Sturges by his children

GEORGE CALEB BINGHAM. *Fur Traders Descending the Missouri*, 1845. Oil on canvas, 74 × 92 cm. The Metropolitan Museum of Art, New York, Morris K. Jesup Fund

adopted by his friends and fellow artists like Asher Brown Durand and Washington Allston. Other men in the group, led by an adventuresome spirit, soon left New England for the Rockies and even South America.

George Caleb Bingham (1811–1879) While Cole was content to work in his beautiful New England, George Caleb Bingham followed the American dream to the West. Even though he studied painting in Germany, he grew up by the Missouri River and many of his paintings are based on events he saw happen there. Events of pioneering (not the violence and hardship but the quiet moments and genial activity) are what set Bingham's brush in motion. Politicians talking to people and asking for votes, Daniel Boone leading a band of pioneers through a gap, and the boat people of the rivers were his favorite subjects. In *Fur Traders Descending the Missouri*, Bingham eliminates the dangers of this kind of life and reveals the romance of drifting down a huge, quiet river in the early morning mist with a bale of furs for the market in St. Louis. It is idealized enough to make most viewers desire such work. A small black fox sits in the prow of the dugout canoe and visually balances the elegant composition. Bingham's work is mostly of genre subjects, illustrating the daily life of ordinary people involved in the westward expansion, but always adding his Romantic feelings and mood. Bingham became a politician in later life and gave up most of his painting activity.

Other Americans worked with images of America in their own terms. John James Audubon (1788–1851) painted the animals and birds of America; his work was made into colored engravings which became very popular in English homes. Albert Pinkham Ryder (1847–1917) achieved a mystical quality through subdued colors and an excellent sense of design. Many of his paintings were night scenes of marine subjects (*See* p. 430). Through these men and others, America was beginning to develop a foundation in the visual arts, although the painters still relied on Europe for schooling and for new and creative approaches to the arts.

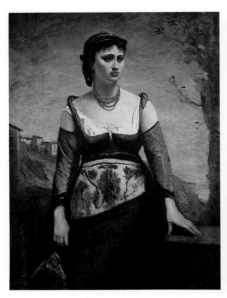

JEAN-BAPTISTE-CAMILLE COROT. *Agostina*, 1866. Oil on canvas, 133 × 98 cm. National Gallery of Art, Washington D.C., Chester Dale Collection

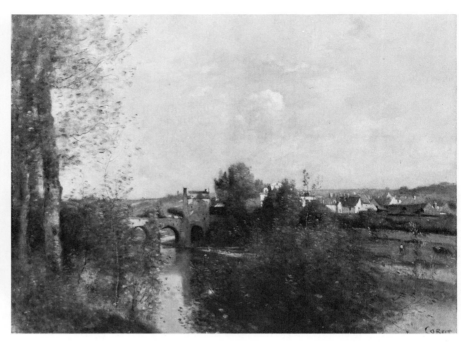

JEAN-BAPTISTE-CAMILLE COROT. *Seine and Old Bridge at Limay*, about 1870. Oil on canvas, 41 × 66 cm. Los Angeles County Museum of Art, Paul Rodman Mabury Collection

Realism

With the Neoclassicists trying to recall the glories of Rome and the Romanticists imagining great things, there was a group of painters that could not tolerate either extreme. They became known as Realists, a name applied to them in the 1840s. For them, history had no importance and imagination was for dreamers. Only what could be seen and experienced by the artists themselves was worthy subject matter and that had to be treated in as natural and realistic a way as possible. Gustave Courbet said, for example, that he could not paint angels, since he had never seen any. The Realists admired the work of the seventeenth century Dutch and Flemish naturalists, and artists like Vermeer and Le Nain were rediscovered and brought to light. Chardin and his genre subjects were finally appreciated. But the public and other artists could not understand this progressive Realist philosophy which glorified the working class and its activities. Realist painting lacked spirit, according to their critics, and therefore was not true art. Their work was not accepted by the Academy so these individualists organized a *Salon des Refuses*, or Exhibition of Refused Art, in Paris in 1863 and showed their work in a huge tent near the Academy.

It is difficult to understand the Academy's refusal of such conservative work. From today's historical perspective, their work does not shock or offend. Instead of the bright colors of Neoclassicism or the swirling color fantasies of Romanticism, the Realists looked at the green foliage, the blue sky, the earth colors of everyday clothing, the gray stones, and the brown earth and painted what they saw. They painted fact, not fiction. While the public was looking for meaning in the paintings they liked, the Realists gave them common, everyday scenes of people engaged in daily labor or conversation. This approach eventually inspired the impressionists who all began their painting careers in the Realist tradition.

Jean-Baptiste-Camille Corot (1796–1875) This fascination with painting real things in real light first appeared in the early work of Jean-Baptiste-Camille Corot of France. Studying and traveling in Italy, Corot was overcome by the clearness of the light and the harmony between humans and their environment. He painted this harmony in small sketches and larger works, often done on the spot. Notice the clarity of light and form in *View of Venice, The Piazzetta Seen from the Quai of the Esclavons*, in which even the title is factual (*See* p. 25). Corot painted what he saw—not the pageantry of the city nor a Romantic impression of it in a misty sunrise. Simplifying the detail to show what he absorbed at first glance,

Corot painted patches of color in flat strokes and used only a few high-keyed, closely related colors. His limited palette helps emphasize the unity of the scene. The huge, high-keyed sky intensifies the clear light and contrasting shadow. Corot includes figures but they are only part of the Piazzetta and do not tell a story, emphasize an emotion, or act as a distracting element. Corot treats the entire canvas in a detached way, as if he were taking a snapshot to send home.

At midstage of his career, Corot moved near the forest of Fontainebleau, near the village of Barbizon, and began painting dreamy landscapes of trees, rivers, and summery scenes in grayish tones. These paintings, done in his studio from memory or imagination, brought him great financial reward, even though they were not his best work. His vivid light was changed to a purplish-gray haze and his sure, blocky strokes were changed to whispy, soft touches—a complete transformation. These poetic paintings were very popular in America where they sold as fast as Corot could paint them. *Seine and Old Bridge at Limay* is from this period. Corot has included some structures in this work, though most include simply trees, water, sky, and perhaps a few small figures.

While he was turning out these whispy landscapes, and later toward the end of his career, Corot made another about-face. He returned to solid forms but used the figure as his theme instead of the buildings and landscapes of Italy. Few artists in history have had the ability to handle the figure and landscape with equal ease. His figures have a solid feeling and are strongly three-dimensional. His use of light was both dramatic and real, indoors as well as out. *Agostina* is a realistic portrait—no flattery, drama, romanticizing, or story telling. Rather, a standing peasant girl stares off into space. Corot seems as detached from the model as the model is from her world at the moment.

Jean Francois Millet (1814–1875) Although born of a peasant family in Normandy, Jean Francois Millet settled with his wife and fourteen children in the town of Barbizon and worked there for twenty years. In his early career he painted the normal Classic subjects and models, but his attachment to the soil emerged in his genre paintings of the peasants in France. Sowing seed, harvesting, plowing, and gleaning were all common activities to him and he painted them with complete understanding. He wished to present the farm workers as dignified humans, much as Chardin had done with servants in Paris. His painting of *The Gleaners* is a powerful treatment of simple workers and their daily tasks. Note how the three solid forms stand out in front of the sun-drenched background and how Millet has subordinated the main harvesting activity in the bright glare. The design is simple, powerful, and fitting for the subject. The light is strong and the shadows are deep. There is absolute realism in color, form, and simplicity. No embellishment or unnecessary glorification of the peasant women is shown but simply their hard, back-breaking labor as they pick over the field for any good grain the harvesting crew has left. The simple dignity of Millet's work had a direct influence on Vincent van Gogh's paintings.

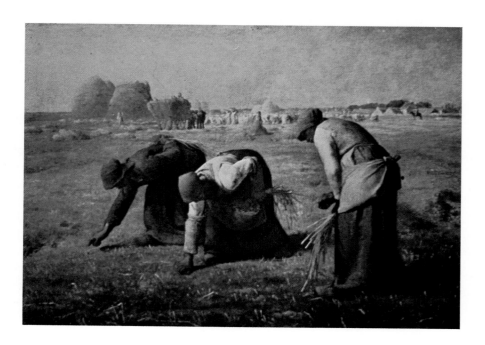

Francois Millet. *The Gleaners*, 1848. Oil on canvas, 53 × 66 cm. The Louvre, Paris

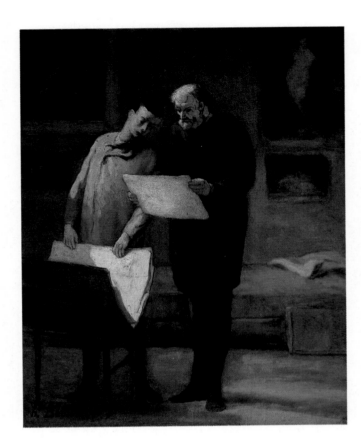

HONORE DAUMIER. *Advice to a Young Artist*, after 1860. Oil on canvas, 41 × 33 cm. National Gallery of Art, Washington D.C., gift of Duncan Phillips

man has brought a portfolio of his work for the older artist to see and criticize. In his earlier paintings, Daumier had used oil washes applied in a thin manner, but here the paint is heavy and the texture sure. The simplification of features enhances the solidness of the forms, as in Chardin's work. Daumier remained poor all his life and gave this painting to his good friend, Corot, who had provided a small cottage for him as a gesture of their friendship. He succumbed to his friends' persuasion to have an exhibition of his work only a year before he died; thus, he received a small amount of recognition while living. Blinded by overwork, Daumier simply could not paint the last year of his life.

Daumier's painting, *Third Class Carriage* is more in the breezy style of his caricatures, but still has a marvelous solidity (*See* p. 28). As in most of his work, Daumier deals with the public where he finds them—in their urban environment—rather than bringing them into his studio to pose for him. The thin washes of muted color allow the viewer to see the grid lines that Daumier used to enlarge his smaller sketch onto the canvas.

Honoré Daumier (1808–1879) The people of Paris knew Honoré Daumier as the greatest social caricaturist in their newspapers but they did not know about his paintings. In his four thousand lithographic drawings for the newspaper, he took pot shots at the Royalists, the Bonapartists, politicians of all types, judges, lawyers, and to some degree, the middle classes and their foibles. His biting satire led to some imprisonment, but he never tempered his brilliant caricatures. After the 1848 uprising in Paris, he began to paint in secret and only his wife knew about his work. A few close friends later found out and encouraged him to exhibit his paintings. His Realism featured people in the arts in Paris: artists, performers, musicians, circus workers, dancers, audiences and the common people in daily activities. He wanted to show the people of Paris how they looked to him. Although his painting technique was different from his lithographic drawings for the newspapers, some of the characteristics of his caricatures carried over into his paintings. *Advice to a Young Artist* is one of the first paintings to show people looking at art. Daumier's monumental forms are powerfully simple. A strong light from the left illuminates the figures and causes them to stand forward from the neutral background. The young

Gustave Courbet (1819–1877) The most effective spokesman for Realism was Gustave Courbet. He admired the work of earlier artists in museums and hoped he would be included someday. He is quoted as saying: "the art of painting should consist only in the representation of objects which the artist can see and touch," and this was the credo of Realism. Courbet's paintings were of events or things that he had seen and knew well. He associated himself with the working class and their search for their rights in French society. A social activist, Courbet found himself in constant trouble, not for his artistic statements but for his association with admitted Socialists.

In the Salon of 1850, Courbet exhibited *A Burial at Ornans,* a gigantic painting that is a masterpiece of Realism. There is no aristocratic funeral here or visualized soul being transported to heaven. Compare this work with El Greco's *Burial of Count Orgaz* (*See* p. 260). Courbet shows the people of his home town of Ornans attending the graveside funeral of a friend who remains nameless. Courbet depicts the pallbearers with the coffin on the left, the priest reading the Office of the Dead, the altar boys, the mayor standing by the dog, the gravedigger kneeling next to the open grave, the mourning friends,

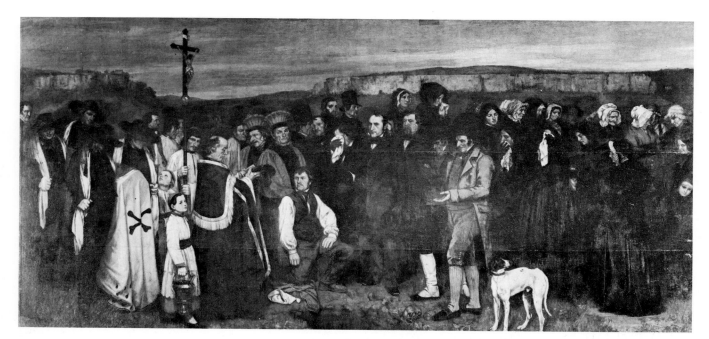

GUSTAVE COURBET. *A Burial at Ornans*, 1849–1850. Oil on canvas, 312 × 663 cm. The Louvre, Paris

GUSTAVE COURBET. *Still Life: Apples, Pears and Primroses on a Table,* 1871. Oil on canvas, 59 × 73 cm. The Norton Simon Foundation, Los Angeles

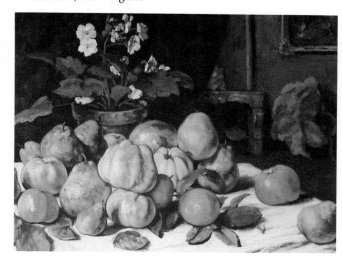

and the clergy. Ordinary people are painted doing ordinary things at a very sad time. The mood is somber and the figures and faces are solid and real. The crucifix reaches into the overcast sky, uniting it with the grouped figures below. If the scene is not ordinary enough, the dog certainly adds to the common, everyday feeling of the painting. The painting was so large that Courbet could not back up from it in his studio to see the overall effect, yet it is amazingly unified and the simple dignity of the peasants is captured superbly.

At the 1855 Universal Exposition in Paris, works by Ingres and Delacroix were prominently displayed, but the works of Courbet were rejected, including *Burial at Ornans*. Never one to stand still, Courbet, with the help of friends, built a special shed for an exhibition of his work alone, called the *Pavilion of Realism*. This became the first one-artist exhibition in history.

Courbet, like Corot, could handle landscapes and figures with equal ease, but he also had an opportunity to work on still lifes. After the revolution of 1870, he joined the Paris Commune which was responsible for tearing down the Vendome Column, a Napoleonic monument. He was put in jail for six months, during which time he painted still lifes with the same vitality he used on his figures and landscapes. *Still Life: Apples, Pears and Primroses on a Table* shows how solid the forms of fruit can be. All the experience gained in his earlier work was brought to this new subject matter. The piled up fruit rests comfortably on the table which is brightly lit from the left. The background seems flat and empty at first but

is filled with objects and subtle value contrasts, similar to some of Rembrandt's paintings. By contrast, the delicate primrose emphasizes the solidity of the fruit which is handled with simplicity and clarity.

Courbet was later charged a fee for rebuilding the Vendome monument. The sum was too immense for him to pay so he fled to Switzerland after all his belongings were sold by the authorities. He died there, in virtual exile.

Rosa Bonheur. *The Horse Fair*, 1853. Oil on canvas, 244 × 495 cm. The Metropolitan Museum of Art, New York, gift of Cornelius Vanderbilt

Rosa Bonheur (1822–1899) The first woman artist to receive the coveted cross of the French Legion of Honor was Rosa Bonheur, in 1865. She worked in sculpture as well as painting but the painting of animals brought her fame. She studied them carefully and went to slaughter houses to get parts that she could dissect. She sketched endlessly at horse fairs and cattle markets, often dressed as a man to avoid the harassment of attendants and spectators. Her life was dedicated to her painting and she became immersed in a feminist movement stirring in France. *The Horse Fair* is considered her masterpiece and was shown in the Salon of 1853. Based on many sketches done outdoors, the painting is alive with movement and tension. The horses are seen during an exercise period as trainers move them around to relieve their nervousness. They are not racing thoroughbreds but heavy work horses, some in pairs and others single. A horse fair was a common scene in France at the time and no deep significance or story-telling quality is implied. Sky and trees are treated naturally but are kept subdued. The visual movement is strongly horizontal from left to right, but the break in grouping in front of the white horses stops the movement from running out of the frame. Even though she was interested in light and handled it beautifully in her work, Rosa Bonheur did not join in the Impressionist experiments or the other artistic rebellions of the nineteenth century but remained an individualist in her work and life.

AMERICA

As the influence of Realism spread through Europe, young Americans traveling and studying in France in the 1860s were impressed with the works of Corot and Courbet. Bringing their impressions home with them, they became the foundation on which American Realism was built, and two men, Winslow Homer and Thomas Eakins, were the cornerstone of this movement.

Winslow Homer (1836–1910) From an early age, Winslow Homer knew he had to become an artist. Mostly self-taught, he began his professional art career by making wood engravings as illustrations for *Harper's Weekly.* He spent time during the Civil War as a field illustrator for the magazine, a position similar to today's photo-journalist or video camera operator. When the war was over, Homer began painting, and his training as a detailed wood engraver pushed him toward Realism with his oils. A trip to Europe in 1866 gave direction to his painting. He gleaned the following techniques from Corot and Courbet: the use of color and light under careful value control in clear tones, and the application of heavy paint to canvas. In *Croquet Scene,* Homer achieved marvelous clarity of light and used the dazzling sunlight to generalize and flatten details. Approaching the painting of light and color in terms of black, white, and gray values, his early paintings have the same flat shapes

WINSLOW HOMER. *Breezing Up*, 1876. Oil on canvas, 61.5 × 97 cm. National Gallery of Art, Washington D.C., gift of W.L. and May T. Mellon Foundation

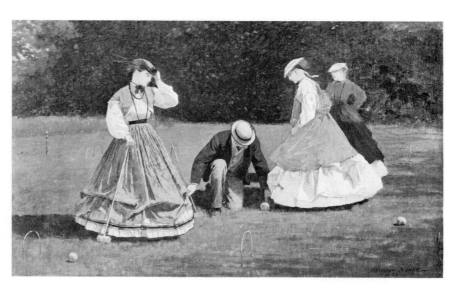

WINSLOW HOMER. *Croquet Scene*, 1866. Oil on canvas, 41 × 66 cm. The Art Institute of Chicago

and intense value contrasts as early Impressionist work. A sunny Sunday afternoon is frozen in time as the brilliant colors of the girls' dresses are locked in place against the variety of contrasting greens of grass and trees.

Perhaps Homer's most popular painting is *Breezing Up*, in which three boys are out sailing with a New England fisherman. Each is lost in his own thoughts as the small craft skips over the Atlantic. Perhaps they dream of captaining a larger vessel like the one in the distance that so beautifully balances the painting. Those who are interested in sports relate easily to Homer and his work.

About 1873, Homer became seriously interested in watercolor and has made a major contribution to the use of this medium. He used it first to make sketches for his oils but found that people liked them enough to purchase some of them. He spent time in England painting

the sea, fishermen and their wives, in oils and water-color. He was relaxed with his watercolors and they were fresh, spontaneous, and alive. *After the Hunt* is typical of these vivid statements (*See* p. 36). Two hunt-ers, with a deer already on board, help their dog back into the boat. The drawing is sure, the values are strong, and the contrasting, abstract quality of the background and water is a beautiful foil for the central figures. The transparency and luminosity of the medium are distinc-tive. Homer was the first American artist to exhibit and think of his watercolors as completed statements and finished works, rather than as sketches or preliminary studies for oil paintings. For this attitude toward the medium, he became the prime influence in the devel-opment of American watercolor painting.

Thomas Eakins (1844–1916) A more influential artist than Homer, Thomas Eakins is one of the finest painters America has produced. He went to Europe after study at the Pennsylvania Academy and returned with a dedica-tion to paint only realistic facts and not explore imagina-tion and sentiment. He taught drawing classes at the Pennsylvania Academy and was unwavering in his stress on realism and accuracy. This determination forced his resignation when he insisted that all students, females included, draw from nude male and female mod-els. While Homer was concerned with nature, Eakins was interested primarily in the figure. He painted many

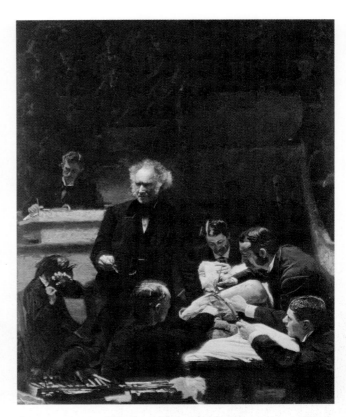

THOMAS EAKINS. *The Gross Clinic*, 1875. Oil on canvas, 244 × 198 cm. Jefferson Medical College, Philadelphia

THOMAS EAKINS. *The Biglen Brothers Racing*, 1873. Oil on canvas, 61 × 91.5 cm. National Gallery of Art, Washington D.C.

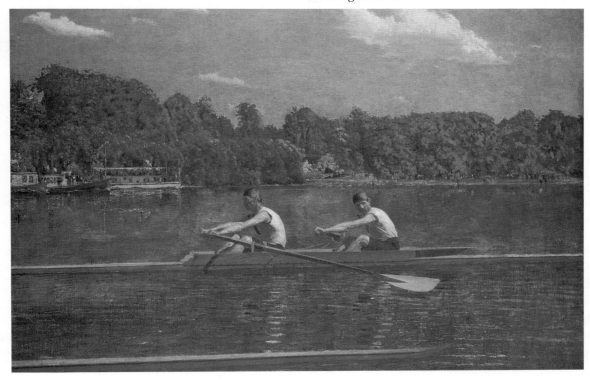

realistic portraits of friends and approached his subjects logically and with mathematical precision. His perspectives are accurate because they were measured and plotted mathematically before the painting began. Yet in spite of such a careful system of work, his paintings have a strength and naturalness that stems from a superb sense of observation and a grand joy in nature and humanity.

Eakins had an intense interest in sports and painted swimmers, baseball players, wrestlers, boxers, and oarsmen in sculls. His accuracy in portraying them was aided by his interest in photography which he used in his detailed study of the human body in action. Eakins was the first American to take multiple exposure photographs of a moving subject on a single piece of film, much like today's stop-action photography. His experiments along these lines were the first steps toward motion picture photography.

Eakins' most powerful painting (and perhaps his most controversial) is *The Gross Clinic*, painted for the Jefferson Medical College in Philadelphia. Dr. Samuel Gross, scalpel in hand, turns away from the beginning surgery to talk to the students. His noble portrait unites the students above with the operation below. Each face is a superb individual portrait, yet the grouping of surgeons forms a strong unit. The powerful surgical light focuses the viewer's attention on the operation by creating intense value contrasts. The students are painted in dim obscurity in the background. Each part is handled with absolute realism, yet Eakins instilled a sense of drama which heightens the painting's statement. The fierce concentration of the doctors creates tension, and as a final realistic touch, at the left, the mother of the young man on the operating table, whose leg is being cut into, hides her face in a gesture of intense grief. The scene seems spontaneous but was carefully calculated by Eakins who arranged the figures and the light to create the most dramatic impact on the viewers. His fellow Philadelphians did not like his work, feeling that the blood on Dr. Gross' hand was not necessary and made the painting too realistic and gruesome. Eakins had succeeded in his quest for Realism, but his public did not appreciate his mastery.

The Biglen Brothers Racing is a fine example of Eakins' outdoor painting. He shows his two friends poised at the start of a race, waiting for the gun to sound. His realism depicts sparkling water, deep shadows, bright sunlight and muscular tension, all perfectly integrated to make a complete and unified statement. This convincing outdoor subject was painted in Eakins' studio from sketches, photographs and his incredible memory.

WILLIAM HARNETT. *Old Models*, 1892. Oil. The Museum of Fine Arts, Boston

William Michael Harnett (1848–1892) The Realism of Corot, Courbet, Homer, and Eakins is a depiction of things as they appear in everyday life. William Michael Harnett placed every object in sharp focus, as if each were under a magnifying glass, and fools the viewer's eye into accepting them as real instead of painted. The French term "trompe l' oeil" (fool the eye) was applied to this type of painting; such painting done today is called "magic realism" or "super realism." Harnett devoted hours to each small part of his painting until it was superbly rendered, complete in every detail.

Harnett was mostly self-taught, and when his work started to sell, he went to Europe, hoping to improve his technique. But when his methods of work were condemned by his teachers, he decided to see if his way had any merit, and submitted a large still life (*After the Hunt*) to the Paris Salon in 1885. It was a rousing success and his name was established on two continents. Yet his fellow artists did not appreciate his work because it deceived the eye, which was not the purpose of art.

Usually his paintings had a general theme, such as in *Old Models,* where most of the objects are associated with music. Each item is drawn with great care, lit dramatically to show form, and colored accurately. Since the objects are all painted in actual size, the sense of reality is startling. While such refined techniques are not appreciated by all people, Harnett's work has gained importance with the development of magic realism in the 1960s and 1970s as a major direction in painting (See pp. 489–491).

Photography

It has been mentioned before that several Romantic and Realist artists were interested in photography as an aid in the study of action, form and light. Photography had its roots in the *camera obscura* of the sixteenth century. When combined with lithography (invented in 1798) to make a print from the image on the photo-sensitive ground glass, modern photography and a new art form were born. Nicephore Niepce of France produced the first print after an eight hour exposure (1826). Louis Daguerre of France (invented daguerrotype in 1837) cut the needed exposure time to twenty minutes, and Fox Talbot of England produced the first paper print (1835). There were those (including artists) who thought painting a dead art to be taken over by photography after 1839. Few early photographers thought in terms of art, however, being satisfied to simply make portraits and take pictures. The first creative photographers came from the ranks of painters, sculptors, and draftsmen in Britain and France. Once photographers realized that their cameras could portray the fascination of everyday life, the vitality of action, the beauty of form, the expressiveness of a situation, texture, pattern, and human relationships, they were on the way to creating a visual art of their own.

The development of photography parallels the changes in painting to some degree. Realism, Impressionism, and Expressionism are common to both fields. Painters learned from photographers and photographers took

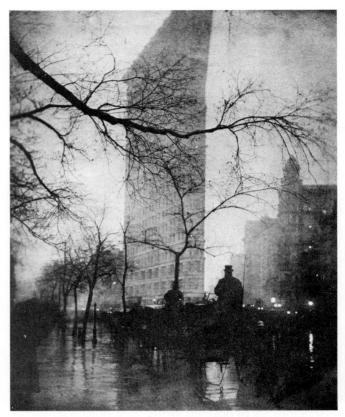

EDWARD J. STEICHEN. *The Flatiron Building*, 1909. Photograph. The Metropolitan Museum of Art, New York, gift of Alfred Stieglitz

hints from painters. What one developed, the other soon used. The Realists made extensive use of photography to learn how things really looked to an objective machine and piece of film. They learned about movement and muscles under stress, and for the first time in history they could catch action and stop it for study.

Photographers like Edward Steichen of America (1879–1973) followed the leadership of Henry Peach Robinson (1830–1901), Julia Margaret Cameron (1815–1879), and Oscar Rejlander (1813–1875) in thinking of photography as an art. Spanning a lifetime of fantastic technological developments in the craft of photography, Steichen began at an early age to appreciate the subtle qualities that could make photographs into art. *The Flatiron Building* is a fine example. There can be no doubt about its artistic merit as design and mood are balanced as if rendered with a brush. All the knowledge gained by the Realist painters (about light, massing of tones, shapes running into each other, and the flattening of forms in the absence of light) are explored in this one superb photograph, which is used here to illustrate photography in the Realist tradition. Photography will be discussed again in twentieth century American art where Steichen made many more fine contributions.

Crafts

The late eighteenth and early nineteenth centuries saw a trend in crafts away from the ornamental Rococo to a more refined Neoclassical feeling. The desk by David Roentgen (1743–1807), a German working in Paris, is built like a bit of Neoclassic architecture. Twelve fluted Doric columns rest on a Classic platform and support the rectangular desk which has the appearance of a concert hall. Lines are clean and strong, the arches are flattened, and the simple decoration is Classic in motif and used sparingly. The gilt-bronze relief is by another artist, working in Paris. The change is drastic from the characteristic Rococo furniture seen in the previous chapter and it is apparent that David's influence was strong. The desk of veneered mahogany was made in Germany with the gilt-bronze mounts added in Paris. It is equipped with secret drawers and elaborate mechanical fittings. Chairs, clocks, and porcelains of the time received the same simplified treatment with Classical features borrowed from Roman architecture and objects found in the uncovered cities of Pompeii and Herculaneum.

The *Cuckoo Egg* is a tiny clock by Michael Perkhin Fabergé of Russia who constructed a series of Imperial Russian Easter Eggs about 1900. Made of gold, enamel, pearls, and diamonds, it illustrates the Romantic return to a Neo-Baroque craftsmanship. Meticulous in its exacting detail, the egg is really a large piece of elaborate jewelry designed to satisfy the Romantic whims of Russian nobility.

DAVID ROENTGEN. Cylinder Top Desk, about 1785–1790. Mahogany veneer with gilt-bronze mounts. The J. Paul Getty Museum, Malibu

MICHAEL PERKHIN FABERGÉ. *Cuckoo Egg,* 1900. Gold, enamel, pearls and diamonds, 20 cm high. Los Angeles County Museum of Art, lent by Mr. and Mrs. Bernard Solomon

1775

Islamic world	Delhi sultanate; Court supported painting schools
China	Weakening of Qing dynasty; Blue-and-white porcelain
Japan	Doors remain closed to Western world
India	First British governor (1784)
S.E. Asia	Bangkok is Thai capital (1782); Penang founded by British (1786); Singapore founded
Europe	French Revolution; Mozart; Beethoven; Napoleon at Waterloo (1815); Sir Walter Scott
Americas	American Revolution (1775–85); Constitution (1789); Simon Bolivar (1822) and S. American independence

1825

Islamic world	Delhi Sultanate, to 1857; Suez Canal opened (1869)
China	Opium War (1839–42); British found Hong Kong (1841); Trade with U.S. and Europe (1844)
Japan	Perry opens trade (1853); Emperor Meiji "restores" Japan in 1868
India	British rule extended
Europe	Victoria in England; Italy unified under Victor Immanuel; Bismarck unifies Germany
Americas	U.S. Civil War; U.S. peace with Mexico (1847); U.S. buys Alaska (1867); Susan B. Anthony

1875

ART OF OTHER CULTURES

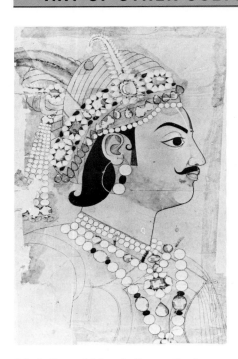

Sahab Ram. *Maharaja Pratap Singh.* India, Rajput style, Jaipur school, about 1780. Ink and colors on paper, 61 × 36 cm. Los Angeles County Museum of Art

Portraits had not been a common subject matter for Islamic artists until the 17th century when some of the interpretations of Islamic law were altered. The use of repeated textures and ornaments, along with heavy use of line is a carry-over from earlier Mughal painting. This work was painted at Jaipur in Northern India, where the local court painters developed a regional style based on the Imperial style of larger sultanates.

The Japanese adapted Chinese ink painting techniques to their own temperament and life style. In this work, a minimum number of brush strokes have been used, but the result is full of suggested detail. This *sumi-e* painting style developed before the Edo period but reached a high level in the 18th and 19th centuries. Paintings with such a free and unrestrained appearance gave European artists new ideas about the boundless limits of visual expression.

Sengai. *Jittoku Scroll.* Japanese, 1751–1837. Ink on paper, 88 × 31 cm. Los Angeles County Museum of Art, gift of Mrs. Vicci Sperry

Royal craftspersons continued to develop their metal-working skills long after they ceased production of bronze castings (*See* Chapter 4). Court tastes dictated elegance and precision, two standards easily met by this pair of noble leopards. Copper medallions were fitted over the ivory sculptures in a rigid stylization of the leopard's spots.

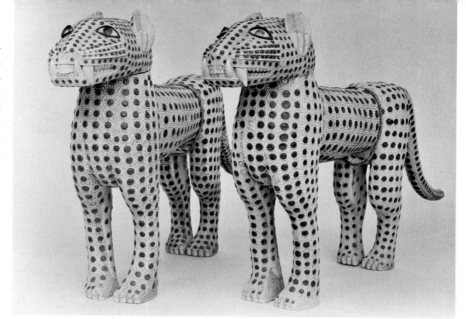

Two Leopards. Nigeria, Benin Kingdom, 19th century. Ivory and copper, 79 cm long. British Museum, London

INDEPENDENT STUDY PROJECTS

Analysis

1. Outline the features of Neoclassic, Romantic and Realistic art. Use some visual method (chart, graph, photographs, etc.) to compare styles, methods, emphases, techniques, influences, roots, and other features.

2. Research the Neoclassic architecture of Thomas Jefferson. Write a report tracing the roots of his style, and include the work of Andrea Palladio and Robert Adam. List examples of Jefferson's work that still exists.

3. Think of yourself as an art history teacher, and make up a list of five questions each concerning a Neoclassic, Romantic and Realist painting of your choice. Word the questions so the responses will reveal the major differences between the three painting styles.

4. To get firsthand glimpses of the thoughts and ideas of nineteenth century artists, consult Robert Goldwater's book *Artists on Art.* Read what the Romantics thought of the Academy and of academic art, and also what some artists thought of the work of their contemporaries. Write an interview with these artists and record or videotape the conversation.

Aesthetics

5. Using a painting by Ingres and one by Delacroix, explain the differences between Neoclassicism and Romanticism. Make this a written essay, a visual presentation with slides or prints, or a video documentary program, taped from a script which you prepare.

6. If you are interested in music, arrange to play recordings of Classical (Haydn, Mozart) and Romantic (Beethoven, Chopin, Brahms) compositions. Discuss the features of each and how their styles compare with the paintings of the period in form, mood, movement, color, feeling, style, emphasis, etc.

7. Does Realism lean more toward Classicism or Romanticism, or can it go in both directions? Why do you think so? Include some aspects of Renaissance thinking in your answers, and write a page describing your personal opinions.

8. If you lived in the nineteenth century, with which of the three major painting styles would you feel most comfortable? Write several paragraphs explaining your answer.

Studio

9. Many American buildings have been influenced by Neoclassic or Romantic styles. Photograph elements of architecture in your community that reflect these influences and arrange a photo essay.

10. Make three small tempera or acrylic paintings (about 23 × 38 cm) of the same subject (from a still life or photograph). Paint one as a Neoclassic work, one as a Romantic painting, and one in the style of Realism. Use the characteristics of color, edges, texture, movement, light, brushstrokes and composition described in the text to help you decide on the way you will work.

11. Using a fine-tipped black marker and a piece of frosted acetate, trace the outline of the major figures and objects in a painting by Delacroix and by David (or other Romantic and Neoclassic painters). Project each of these images on large sheets of drawing paper and trace the lines with a heavy marker. Try to make the two images about equal in size. Notice the differences in line direction, visual movement, major directional orientations, composition, balance, etc. Discuss your findings. Then, experiment with the linear images (fill in with flat color, overlay one on the other, invert and paint as an abstract, etc.).

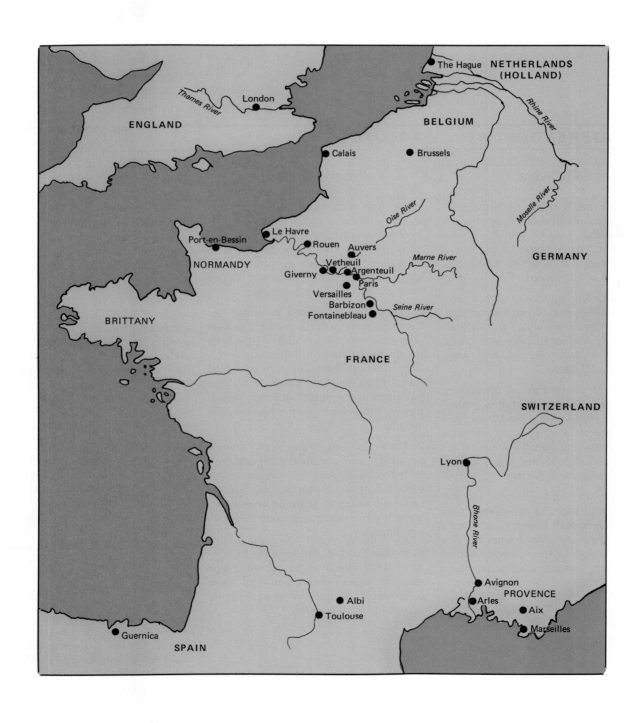

13 A New Way of Seeing: Impressionism and Post-Impressionism

WHILE ALL THE ELEMENTS of Impressionism were known prior to 1860, they were brought together by a group of people who changed the way artists and others look at their environment. Their departures from the Renaissance and Classic ways of describing space and form opened the doors for twentieth century artists to invent new ways of painting in personal styles, using innovative techniques.

Impressionism

All the Impressionist painters began as Realists, with interest in natural color and landscapes which they painted outdoors. Like Courbet and Corot, they painted people and things as solid, colored objects. But they soon realized that the color of light had a tremendous effect on the color of the object they were painting. The color of the atmosphere changed the appearance of the object in front of them at different times of the same day.

Some earlier artists, like Vermeer, Rubens, and Delacroix, had worked with colors reflecting into other colors. The Impressionists revived this concern. Working in the sunlight, they also noticed the effect that bright light, mists, and haze had on the color of water, grass, trees, and clouds. Where previous painters recorded the color of objects as they assumed them to be, the Impressionists painted color as they saw it—bright, glaring, and high-keyed with colored light even penetrating the shadows. Sometimes solid form was lost in the glare of bright light or the mistiness of a summer morning. The Impressionists wanted to express an instantaneous impression, not a detailed analysis. By facing a scene (indoors or out), closing one's eyes for a moment, and then opening them for a "one second exposure," one grasps what the Impressionists wanted to paint—a momentary glimpse of nature. Claude Monet described his goal in painting as "instantaneity." Artists approached this problem in different ways, and the Impressionists were never really united as a cohesive group either in style or in their approach to painting. Yet their subject matter was color and light (not people and trees) and their objective to capture an instantaneous glimpse of nature.

Impressionism is the first artistic revolution since the Renaissance and the first universal style to originate in France since Gothic times. Naturally, such a new way of painting could not be accepted easily by the public—or by other artists—and early sales were few and far between. But with great perseverance the few people involved survived and gradually built up a following throughout Europe, especially in the United States and even in Russia. Impressionism lasted only about fifteen years as the artists then took off in different directions.

Incredibly, the movement was not stopped by the Franco-Prussian War (1870–1871), the Siege of Paris (1871), or the putting down of the Commune of 1871. The artists simply left Paris for the countryside and returned when things had calmed down. They then brought their sparkling, high-keyed colors and dazzling light to the environs of Paris. Upon returning, Monet explained his new style. He did not paint trees or fields but simply the colors he saw—a little blue square, an oblong of pink, a streak of yellow or green dots. The difference between his approach and Corot's, for example, is that Corot painted trees, flowers, and sky while Monet painted the greens, blues, and yellows that he sensed.

The name Impressionism was first used in jest when Claude Monet exhibited a work called *Impression-Sunrise* in an 1874 show at the studio of the photographer, Gaspard Nadar (*See* p. 131). The painting colored streaks and blobs on a pale blue ground that represents

363

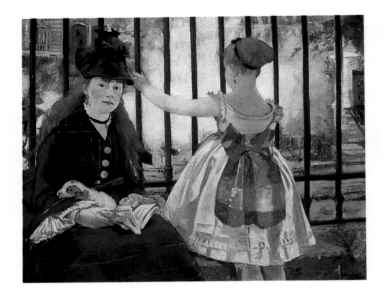

EDOUARD MANET. *Gare Saint-Lazare*, 1873. Oil on canvas, 93 × 115 cm. National Gallery of Art, Washington D.C., gift of Horace Havemeyer in memory of his mother, Louisine W. Havemeyer

Manet's paintings were "as flat as playing cards." Even in his *Gare Saint-Lazare*, done in mid-career, there is a flatness that is fascinating. Look at the girl's face. It is too flatly painted if the viewer looks at it with Renaissance eyes. There are no dark shadows or depth, no chiaroscuro, no form of roundness. The light source is probably directly *behind* the artist, not to the side as in most previous paintings. No black was added to make the few shadows that exist in the painting. What form exists is achieved by changing color slightly or lightening a value here and there.

The format of the painting is like a snapshot of a young woman and girl at the train station (*gare* is French for station). The peculiar composition, with the vertical bars dominating, is fresh and startling. The little girl looks through the bars at a train which has passed by, leaving a cloud of steam in its wake. (Manet worked on the large canvas outdoors to capture the light-through-steam effect.) The girl on the left was one of Manet's favorite models, and she looks at the viewer with de-

what a person sees when looking momentarily into a sunrise over a harbor. The works of the group were derisively called *impressions* and not paintings. The title stuck, although several Impressionists did not like it. Among others who were included in the first exhibition of this group were Edgar Degas, Camille Pissarro, Alfred Sisley, Paul Cezanne, Auguste Renoir, and Berthe Morisot. Not all stayed in the movement as some became involved in other approaches to painting; and missing was Edouard Manet who became their first leader.

Edouard Manet (1832–1883) Trained as a traditional painter, Edouard Manet traveled through Europe at an early age and was particularily attracted to the paintings and the brushwork of Diego Velazquez and Francisco Goya of Spain. Like them, Manet felt that the message of the artist was the brush strokes and patches of paint on the canvas, not the subject matter that they represented. Manet wanted the viewer to look *at* his paintings and not through them like through some magic window into a deep, secondary space. He did not want to compete with the camera in a race for reality, but wanted to make paintings that could be enjoyed for their own sake, for their color and arrangement, and for the fact that they were paintings and not imitations of nature.

His early work had a flatness new to the world of painting and difficult for his contemporaries to understand. In this flatness and candid approach to design, Manet was influenced by Japanese woodcuts that were popular imports in France. His friend Courbet said that

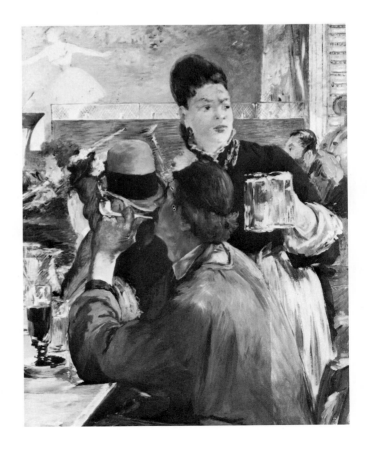

EDOUARD MANET. *The Waitress*, 1878. Oil on canvas, 98 × 77 cm. National Gallery, London

tached interest. She will soon drop her head and go on reading as her finger in the book's pages suggests. The puppy in her lap (one of the most appealing ever painted) sleeps in complete contentment. The candid, off-hand appearance is greatly enhanced as all four sides of the canvas seem to have been "cropped," much as one would "crop" a snapshot. The work's occasional unfinished look also contributes to this effect. Manet's work here is different from the Realism of Corot and vastly different from the Neoclassicism of David and Ingres.

Toward the end of his short life, Manet left the flat and even patches of color of his earlier work and adopted the looser, longer strokes and vibrating color of the Impressionists. *The Waitress* was painted in Manet's studio as the woman (a real waitress at the Café de Bock in Paris) posed for him. The unposed arrangement again produces a snapshot effect of an instantaneous glimpse into the cafe—as if the door were opened for a second and one looked quickly inside. Notice the directional brushwork in the material and on the hands and arms. Patterns of light values make the painting sparkle with light. The indefinite character of the people in the cafe, of the band, and of the dancer on stage are truly impressions of the scene rather than a factual representation. Everything seems to quiver with excitement as sparkling light transforms an everyday subject into a delightful event.

Although Manet did not seek it, initial leadership in the Impressionist movement was entrusted to him. He was older than the others, and they respected him and his philosophy of painting. At his death, the unofficial leadership passed into the capable hands of Claude Monet.

Claude Monet (1840–1926) It is fitting that Claude Monet, after Manet's death, became the leading force in the Impressionist movement. As a result of his long life and constant search for new ways to express himself, Monet bridged the span from the Realist world to the contemporary world of abstraction. Monet loved to work outdoors and to directly confront the environment he was painting. Born in Paris, his father, a grocer, soon moved to Le Havre on the coast of Normandy, where the boy's interest in light, water, and atmosphere became intense. He studied with a fine outdoor landscape painter, Eugene Boudin, and learned the fundamentals of Realist painting. His early work reflects this training but also shows an early fascination with light. In *Argenteuil*, Monet expresses this interest with a high-keyed palette, particularly in the large portion of sky and the reflecting water. He used flat patches of color in the foreground rather than try to imitate the textures of the place. The heavy visual weight of the darker masses on the right is balanced by the single white sail on the left, a device which Monet used often in his early outdoor paintings to give his seemingly unbalanced compositions a sense of stability.

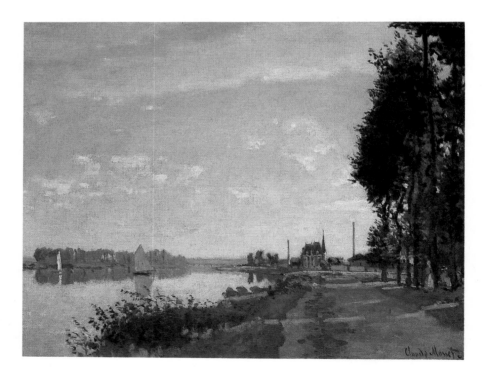

CLAUDE MONET. *Argenteuil*, 1872. Oil on canvas, 50 × 65 cm. National Gallery of Art, Washington, D.C., Ailsa Mellon Bruce Collection

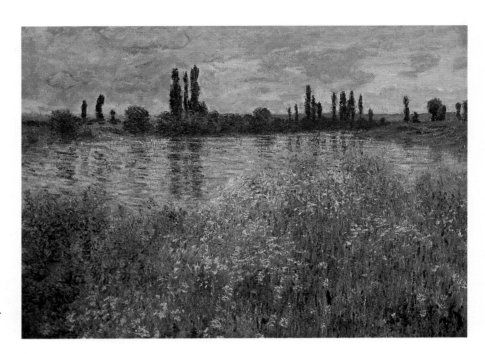

CLAUDE MONET. *Banks of the Seine, Vetheuil*, 1880. Oil on canvas, 73 × 100 cm. National Gallery of Art, Washington, D.C., Chester Dale Collection

In a short time, a drastic change occurred in Monet's work, as seen in *Banks of the Seine, Vetheuil*. The flat brush strokes of *Argenteuil* gave way to a shimmering effect in which the entire surface vibrated with color and light. The sky, water, and flowers were handled with similar short strokes of color, laid side by side. Where previous painters had mixed their colors to the desired hue and then brushed them on the canvas (mixing yellow and blues to make green, for example), Monet took dabs of yellow and put them next to dabs of blue and did not smear them together. Instead he lets the viewer look at them as they are; from a distance, the colors blend into a shimmering green. This technique, called *optical mixing* or the applying of *broken color,* was the basis for Impressionist theories of color and light. Of course, the public had difficulty comprehending and ridiculed such work.

Form and line disappear in Monet's paintings. Notice how the foreground flowers blend into the water which blends into the trees. There are no definite edges or contours to anything. Monet saw the world in movement with light flickering on moving things. He emphasized instantaneous glimpses of nature. Edges blend and disappear; colors melt into each other, outlines do not, and things of substance become merely light and color.

Monet carried this technique further in his painting of the *Rouen Cathedral, West Facade, Sunlight.* The more he painted outdoors, the more he realized that colors were constantly changing with the moving of the sun or the interruption of clouds or haze. To analyze those changes, he decided to paint a single subject at different times of the day, at different times of the year, under different illumination. He did it with haystacks and again with the west facade of the Rouen Cathedral. Here was a heavy, massive surface, built and carved of stone. Yet under Monet's skillful handling, one no longer sees the stone and carving but only the light and color reflected from different surfaces. Monet recorded these considerable light and color changes on the church in more than thirty canvases. Some are bold with heavy paint, others are so pale and smooth that from close up the cathedral features cannot be seen at all. But by standing back or squinting, the bluer, darker colors take on the feeling of shadows and the features seem to materialize as if coming out of a fog. Monet helps one see such massive structures in a new way.

Monet also discovered that shadows are not black or simply darker tones of a color, as Renaissance and Baroque painters had shown them. Colors are in the shadows too; they do not leave an object just because it is in shadow. Monet also realized that shadows are a lessening of light intensity and can be painted by adding opposite or complementary hues to the colors of the objects. Thus, he added blues to create the shadows on warm-colored (red to yellow) surfaces; the deeper the shadows, the darker the blue became. Scientists studying the physics of light were finding out the same things. Under Monet's brush, the viewer began to see the cathedral and the environment in an exciting way.

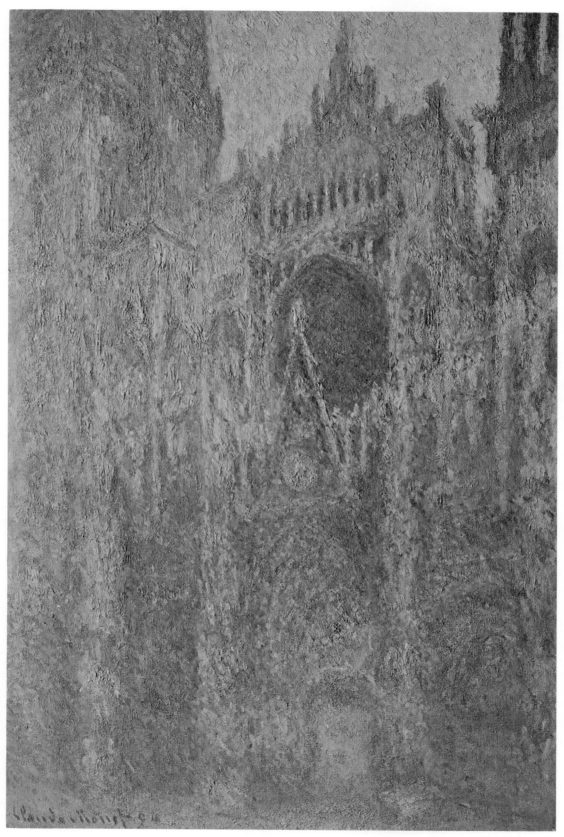

CLAUDE MONET. *Rouen Cathedral, West Facade, Sunlight,* 1894.
Oil on canvas, 100 × 66 cm. National Gallery of Art,
Washington, D.C., Chester Dale Collection 1962

A trip to England caused Monet to experience a different light, one often diluted by fog or solid clouds. It also gave him a chance to experience the works of Constable and Turner. In the *Houses of Parliament, Sunset,* the heavy, solid forms of Britain's government buildings dissolve under Monet's brush and color. Purples, oranges, reds, and pinks are laid side by side on the glittering surface. The sparkling water becomes jabs of color while the buildings are soft, longish strokes of purples and blues. This painting has a similar feeling to his *Impression-Sunrise* painted almost thirty years earlier, but the technique is now completely refined and perfectly expresses Monet's vision (*See* p. 528 and p. 131).

More than any other Impressionist, Monet stuck by the early credo of the group: to transcribe visual sensations as experienced at a certain time and place. His work was finally accepted in the United States and Europe, and his long life allowed him to enjoy some financial security. He spent his final years at Giverny, where he developed beautiful Japanese-styled gardens and found a perfect subject for his Impressionist statements: the shimmering, reflecting surface of ponds on which floated water lilies, flowers, and pads. The breaking up of color and light through the reflective surfaces was an absolute joy for him to paint, and the lily ponds provided Monet with a motif on which he spent the last energies of his life. His final works bordered on abstraction and were a foretaste of things to come, as Monet quietly worked and developed his personal language of art.

Camille Pissarro (1830–1903) Camille Pissarro worked both in Paris and in the surrounding countryside. Although he was born in the West Indies, he came to Paris when twenty-five, determined to be an artist. He was a bit older, but a good friend of the other Impressionists, often buying their work to keep them from starving. He also let many of the young, struggling artists live on his property in the country and painted side by side with them. He was especially helpful to the young Paul Cezanne. Pissarro was adept at capturing the feeling of a place through color and mood and often made one sense its atmosphere and even the time of year or day. His favorite subjects, which he handled with tremendous competence, were scenes of the streets of Paris as viewed from second or third story windows. In *Place du Theatre Francais* the viewer seems to be looking over Pissarro's

shoulder, out the window and down onto the street below. The shimmering light and color of the hustle-and-bustle of a city street are felt immediately. People, horses, and carriages seem to move as the tiny spots and dashes of color seem to melt and dissolve. The viewer has to look through some leafless branches to see part of the scene—a device Pissarro used often to heighten the sense of movement and sparkle. Pissarro, like Monet, wanted to obtain an instantaneous sensation of the scene before him and succeeded remarkably in his many refreshing and bright street scenes.

Pierre Auguste Renoir (1841–1919) The first contact Pierre Auguste Renoir had with painting was a job in a porcelain factory, copying the nudes of Boucher onto porcelain. His interest in painting women and the nude figure stayed with him throughout his career, which stretched well into the twentieth century and which progressed through several developmental stages. He and Monet were primarily responsible for the exploration and definition of the Impressionist techniques.

In his first period he was interested in the bright, cheerful effects of light and air, which typified Impressionism. For the 1877 Impressionist group exhibit (their third), Renoir painted the ambitious *Moulin de la Galette*, which is the very essence of Impressionism. Renoir, always interested in painting people, depicts a Sunday afternoon outdoor dance in a popular district of Paris, the Montmartre. Beautiful people (Renoir never shied from words like "beautiful" or "pretty") are enjoying conversation and dancing, and the viewer is caught up in the effervescence that he felt and painted. Flickering light filters through the trees and speckles the people with bits of sunshine as they move about the scene. In

CAMILLE PISSARRO. *Place du Theatre Francais*, 1898. Oil on canvas, 72 × 93 cm. Los Angeles County Museum of Art, Mr. and Mrs. George Gard de Sylva Collection

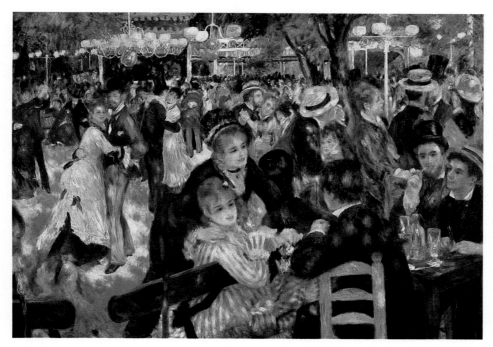

PIERRE AUGUSTE RENOIR. *Moulin de la Galette*, 1876. Oil on canvas, 131 × 175 cm. The Louvre, Paris

PIERRE AUGUSTE RENOIR. *In the Meadow*, 1892. Oil on canvas, 81 × 65 cm. The Metropolitan Museum of Art, New York, bequest of Samuel A. Lewisohn

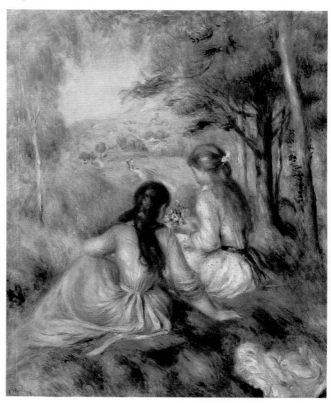

this delightful interplay of light and shadow, Renoir uses no black paint, but all shadows are tinged with blue. The darker the value, the deeper the blue mixed with other colors. During the first part of Renoir's career, he painted portraits, still lifes, landscapes, and figures in a fantastic surge of creativity.

During his second phase Renoir gave up the transient effects of Impressionism and painted solid, carefully defined forms, after restudying the great masters. In his third period, he tried to unite his first two by combining the formal balance and solidity of the traditional approaches with the shimmering effects of Impressionism. *In the Meadow* was painted during this time. The figures are placed carefully in a landscape. They are shaded (using cool colors for shadows) to produce solid, rounded forms, yet the two figures blend softly into their surroundings. Edges on the two girls are non-existant. Renoir has developed a soft, longish brush stroke that is characteristic of his later work. Broken color and optical mixing are used with these strokes to create a soft, subtle, and gently shimmering painting style.

In his fourth and final period, there is an exaggeration of this soft brushwork and the use of more intense colors, but the solidity remains. Whatever the period, joy never leaves Renoir's work. His fingers crippled with arthritis at the end, this most joyful person still painted happy figures in sun-filled landscapes that in no way let one sense his pain.

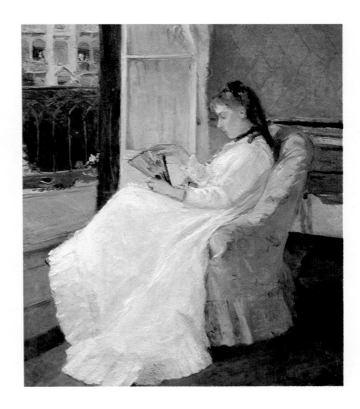

BERTHE MORISOT. *The Artist's Sister at a Window*, 1869. Oil on canvas, 55 × 46 cm. National Gallery of Art, Washington, D.C., Ailsa Mellon Bruce Collection

Berthe Morisot (1841–1895) A grand-daughter of Fragonard and sister-in-law of Manet, Berthe Morisot worked and exhibited with the Impressionists yet developed her own style. She was accepted into Salon shows early in her career but abandoned the huge competitions to exhibit with the Impressionists. She posed for many of her friends and in turn painted many of them. *The Artist's Sister at a Window* expresses completely Morisot's philosophy of painting. The subject is feminine and the treatment is delicate. The girl sitting by an open window, who seems to day dream while looking at her fan, creates a mood of loneliness. The application of color in flat patches reflects Manet's early influence on her work. Yet Morisot's design and composition, influenced by studying masterpieces of the Louvre and of Corot, are more solid than the off-hand, unposed look of many Impressionist works.

Edgar Degas (1834–1917) Although Edgar Degas differed in many aspects from the Impressionists, he was eager to exhibit with them and did share their interest in off-hand subjects and candid glimpses of people in action. Beginning with a traditional schooling in art under one of Ingres' pupils, Degas was a master of line and drawing and was reluctant to abandon it in favor of Impressionism's soft contours. He approached his work with intellectual curiosity and was concerned about design and the positioning of people and objects to achieve his desired instantaneity and candid look. In portraits, he was the only Impressionist to be concerned with the

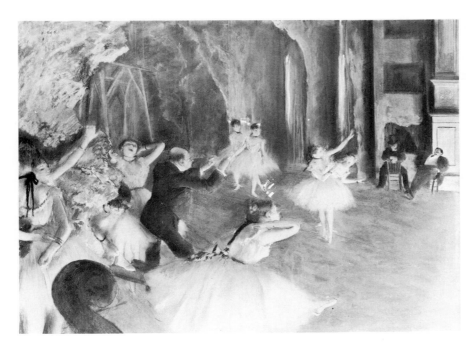

EDGAR DEGAS. *Rehearsal on the Stage*, 1874. Pastel on paper, 53 × 72 cm. The Metropolitan Museum of Art, New York, bequest of Mrs. H. O. Havemeyer, The H. O. Havemeyer Collection

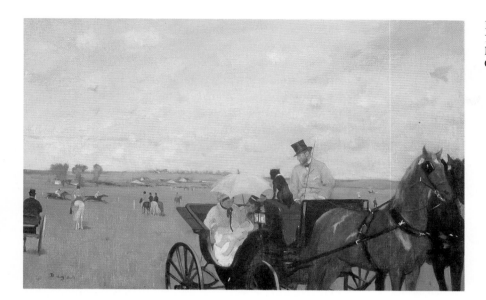

EDGAR DEGAS. *Carriages at the Races*, 1873. Oil on canvas, 36 × 54 cm. Museum of Fine Arts, Boston, Arthur Gordon Tompkins Fund

unique qualities of the sitter and was able to capture the person's true character. He was an excellent amateur photographer and worked with Edward Muybridge's and Thomas Eakins' studies of the human body and horses in motion, applying their results to his own unique presentation of the figure in his painting. He had American relatives in New Orleans and visited there in 1872 when he painted portraits of many of them as well as paintings of his family's cotton business (*See* p. 58).

Degas liked to paint in series, that is, many paintings exploring the same theme over a long period of time. One subject which he explored in great detail and in hundreds of paintings, drawings, and pastels was the ballet. These works combined all his interests: the instantaneous glimpse of figures in action; the indoor, controlled lighting, often coming from below as in footlights; and the view from peculiar vantage points, such as from wings, balcony boxes, or from below the stage. All of these features were used by Degas to enhance his candid glimpses of dancers working at their craft. *Rehearsal on the Stage* is done in pastels and is one of many pastels and paintings in Degas' unending portrayal of the ballet. He was not as much interested in the final performance as in the daily routine of practice and work—the constant search for perfection. The director is working with his ballerinas as stage hands relax and watch. The softness of the costumes are contrasted with lines and edges on figures and in the background. While Degas' soft blending of costume into background is an Impressionist technique for showing light bouncing off of form, Degas, as a line around a foot or down a leg suggests, only uses softness to express action or to describe

the material. His clustering of figures to one side or in one corner is balanced by open spaces and perhaps the careful placement of a separated figure or two. No matter how unbalanced or casual his groupings seem, they are always calculated to produce an asymmetric balance which produces a feeling of immediacy and non-planning. Using this medium, which is as much drawing as painting, Degas conveyed the color and excitement of the ballet with more assurance than he could with oils.

Another theme that Degas covered completely in a series was racetrack activity. Horses had always interested him and the combination of these beautiful animals and the jockeys, owners, and crowds at the races provided another wonderful arena for his deft touch. He treated them with a marvelous sense of design. *Carriage at the Races* was painted outdoors in response to his association with the Impressionists and was exhibited in their initial show in 1874. He did not use their loose brush strokes and optical mixing to achieve an airy effect but instead used a carefully selected, high-keyed palette of pearly softness. Vibrating greens, pinks, yellows, blues, and grays contrast with the crisp, darker tones of horses and the carriage. The combination definitely produces an outdoor feeling. His informal composition is derived from his interest in the Japanese Ukiyo-e wood block prints circulating in Paris. The off-center placement of the carriage and the horses which run out the bottom of the frame, as if cropped for some special effect, add to the feeling of a momentary glimpse of the scene. The composition is visually balanced by the partial carriage at the left edge.

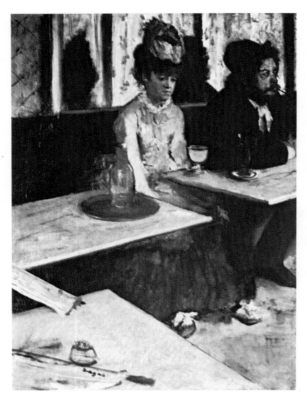

EDGAR DEGAS. *Glass of Absinth*, 1876. Oil on canvas, 92 × 68 cm. The Louvre, Paris

MARY CASSATT. *Woman Reading*, 1878. Oil on canvas, 79 × 63 cm. The Norton Simon Foundation, Los Angeles

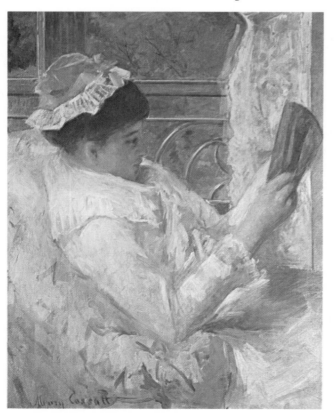

While Renoir saw the happy side of Parisian social life, Degas was not enchanted by what he saw. His *Glass of Absinth* shows a couple who have been sitting and drinking too long at their table. They no longer talk to each other but stare blankly at the activity in the cafe. At first, the painting has a snapshot quality and seems to lack formal composition. It seems as though Degas (or the shutterbug) almost missed the subjects. Yet the more one looks, the more one realizes that everything works perfectly to attain that feeling. The zig-zag of the empty tables increases the sense of brooding and confusion. Diagonals slant in many directions and even seem to extend forward from the picture plane, drawing the viewer into the scene. The milky green glass of absinth becomes Degas' center of interest and the purpose for the painting.

As seen before, Degas worked a great deal with pastels rather than oils, and was the first artist to exhibit them as finished works instead of preliminary sketches for paintings. As his eyesight weakened, he also spent much time working on sculptures because he enjoyed feeling the solidness of the forms and the action which they expressed—the same action he formerly put into his paintings. His mastery of several media (oils, pastels, pencil, and sculpture) indicate that he was a multi-talented artist.

Mary Cassatt (1855–1927) Mary Cassatt was born in Philadelphia and after studying art at the Pennsylvania Academy, left for Paris against the wishes of her parents. While working in a traditionalist's studio, she was drawn to the work of the Impressionists, especially Degas'. She found in his solid design and superb draftsmanship, the directions she wanted to take. Although influenced and helped by him, Cassatt never imitated him and developed a style that combined the informal subject and composition of the Impressionists with her personal desire for precision and definition.

Mothers and children were Mary Cassatt's favorite subjects, and she is unmatched in her ability to express, in both oils and pastels, the mutual love between the two. *Sleeping Baby*, a delightful pastel, combines a seemingly casual glimpse into a nursery with a carefully designed composition (*See* p. 33). The center of interest is the tender touching of faces of the mother and her child. Arms, legs, and darker values direct eye movement to this center. Like Degas, Mary Cassatt used line along legs and arms to strengthen the design and to add solidity to the figures. Yet the loose pastel strokes and high-keyed colors are features of the Impressionists with whom she exhibited.

JAMES ABBOTT MCNEILL WHISTLER. *Arrangement in Gray and Black No. 1: The Artist's Mother*, 1871. Oil on canvas, 115 × 161 cm. The Louvre, Paris

In *Woman Reading*, Mary Cassatt uses soft edges and high-keyed colors to describe a soft, feminine subject, yet the detail and careful treatment of the face of her sister Lydia and the bright color of the ribbon attract the viewer's eyes to the center of interest. The dark book visually balances the composition which again combines the looseness of Impressionism with the more solid design of traditional painting.

Mary Cassatt was well respected among her peers in Paris, but was not recognized at home in Philadelphia, a dilemma which caused her to remain in Europe. But she was tremendously influential in getting several American families to buy the paintings of her Impressionist friends. As a result, museums and private collections in the United States have superb collections of their work. She also became an excellent printmaker in the etching and aquatint media. Her interest in Japanese Ukiyo-e prints influenced the crispness, clean design, and simplicity of arrangement in her prints.

James Abbott McNeill Whistler (1834–1903) While Winslow Homer was busy in the United States, another American, James Abbott McNeill Whistler moved to Paris in 1855, and four years later went to London where he worked the rest of his life. While in Paris he knew Courbet, Manet, and Degas but as an Impressionist he never adopted their broken color or the sunlit effects. Instead, Whistler often worked in grays and blacks, blending his colors so carefully that he could obtain a wide range of hues and values with his limited palette. He was strongly influenced by Japanese prints and for a while included Oriental motifs and objects in his paintings. By the late 1860s Whistler returned to portraiture as a means of expression in which he wanted to combine a realistic likeness of the sitter with an excellent sense of design to produce a solid painting—a quality lacking in many portraits. In this attempt he looked to the simplification and stark arrangements of Degas and of the Japanese woodcut. An example is his best known work, *Arrangement in Gray and Black No. 1: The Artist's Mother*, commonly known as *Whistler's Mother*. The portrait of the delicate woman is very realistic and is placed against a carefully designed background of vertical and horizontal rectangular shapes, which really dominate the painting. Whistler's title was meant to convey his purpose of producing a designed arrangement. He used the flat color areas of Manet but not his brush work. Instead, Whistler used thin glazes of color to build up his subtle grays. Every item in the painting is an integral part of the design, including the drapes, the pictures on the wall

JAMES ABBOTT McNEILL WHISTLER. *Nocturne in Black and Gold: The Falling Rocket*, 1874. Oil on panel, 60 × 47 cm. The Detroit Institute of Arts

(the complete one is one of his own etchings), the floor, and the placement of his mother's hands.

In order for the public to see his paintings as designs as opposed to representational pictures, Whistler used titles that recall musical compositions, such as "arrangements," "symphonies," "harmonies," or "nocturnes." In 1877 he exhibited a work done two years earlier that caused him many problems. The painting, *Nocturne in Black and Gold: The Falling Rocket*, caused a furor when exhibited in London. An impressionistic view of sky rockets bursting in the English night, it swirls with muted colors and dark shadows, punctuated with vivid flecks of color. It is a symphony of color, tones, accents, and dark passages. It is Turner's "tinted steam" in dark values. But the noted English art critic John Ruskin, defender of traditional Realism, used his biting satire to remark that Whistler was "flinging a pot of paint in the public's face." Whistler could not let the challenge go and sued Ruskin for libel. After a lengthy trial where he tried in vain to explain to judge and jury what he was trying to express in his painting, he won the trial but was awarded only one farthing in damages. This work as well as several others is a foretaste of the Abstract Expressionist movement that followed World War II in America.

Whistler, like fellow American Mary Cassatt, was adept at the etching medium and produced many superb prints in which the delicate line of the etching needle is used with absolute mastery (*See* p. 389). And like Mary Cassatt, Whistler never really achieved proper recognition for his abilities in his home country, although he was greatly admired in Europe.

There were many other artists in Europe and America who followed the lead of the French Impressionists by experimenting with color, light, and air. Eventually many of them moved in different directions to continue the trend that would blossom into the intellectual "isms" of the twentieth century.

Auguste Rodin (1840–1917) Sculpture during the eighteenth and nineteenth centuries had not been as important as painting and architecture as a means of visual expression. Houdon was an outstanding sculptor, and Daumier and Degas made original and delightful works which were almost unknown while they lived. But during the years of Impressionism, when color and light were all important, Auguste Rodin burst on the

scene with magnificent sculptural forms—solid and enduring. He made use of the off-handedness and instantaneity of Impressionism, transforming them into powerful, three-dimensional forms. While Rodin's sculptures can be favorably considered with those of Donatello, Michelangelo, Bernini, and Sluter, they were so individual and personal that no followers imitated them.

Rodin's best works were cast in bronze but were first formed with his hands in clay, plaster, or wax. He loved the immediacy of these materials which he could manipulate, push, stab, and form. Often they were left seemingly unfinished because his statements had been made—much as the Impressionist paintings may seem unfinished yet are complete. He experimented with figures in action, accidental effects, and feelings of spontaneity and tension. Often the surface of his bronzes shimmer with light reflecting from his fingerprints and the rough surfaces which he likes—a sparkle of light akin to that of Impressionist paintings.

Like the Impressionists, Rodin's work was not popular with critics and the public because it was not smooth, finished, and beautiful. He planned a gigantic work, the *Gates of Hell* (which he never finished) that would have

rivaled Michelangelo's Sistine Ceiling in the amount of effort expended. Models were made, but because of frequent interruptions he was never able to complete the task. His famous *Thinker* was to be a small part of the entire monumental design (*See* p. 40). In 1884 he was commissioned by the city of Calais to produce a monument honoring six heroic citizens of 1347 who had saved the city. During that year, the city was under siege by King Edward III of England and was to be destroyed. The six burghers (city council members) came to the King, dressed in sackcloth with ropes around their necks, offering their own lives to spare the city. Rodin's monumental sculpture shows the men as they were preparing to see the king. He worked for two years on models of faces and bodies to express the feelings of tension, anguish, and dedication and succeeded superbly. The figures are grouped to be seen from all sides with the rough drapery contrasting with the muscular bodies, taut limbs, and tragic faces. Each figure is treated individually, but its placement in the group produces a marvelous visual interaction. Rodin wanted his *Burghers of Calais* placed at street level so the people could interact visually with the figures. At first the magnificent work was refused because the figures did not look heroic in

the traditional sense and were not placed on pedestals. (Rodin despised the traditional heroic sculpture of all-conquering generals on rearing horses.) His statement was honest, expressive, and incredibly powerful, and in 1924 it was finally placed in position in the square at Calais. Several other castings have been made and are located in various museums.

Most of Rodin's works were never completed and others were rejected by the patrons who had commissioned them. His *Balzac* was finally put in place in 1939, long after the artist's death. The sculpture of the French author is a massive form that is both powerful and expressive. Rodin wanted to show the author at the moment he conceived a new creative idea for a novel. Balzac (whom Rodin did not know) is shown in his bathrobe, striding about his house, mentally working on an idea for a book. The huge figure seems to be a mass of drapery with an unbelievably powerful head thrusting out of the folds. Again, the original concept was not appreciated by the patrons who wanted something more refined and traditional, but Rodin would not compromise his ideas. Viewed from below, the figure is overpowering and is the summation of Rodin's sculptural expression.

AUGUSTE RODIN. *Balzac*, 1897. Bronze, 281 cm high. Norton Simon Inc. Foundation, Los Angeles

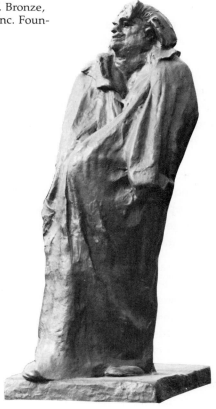

AUGUSTE RODIN. *The Burghers of Calais* 1884–1886. Bronze, 216 cm high. Musee Rodin, Paris

PAUL CEZANNE. *Mont Sainte-Victoire*, about 1904. Oil on canvas, 71 × 92 cm. Philadelphia Museum of Art, George W. Elkins Collection

Post-Impressionism

As the nineteenth century closed out, Impressionism had run its course as the "new direction in art." Renoir, Degas, and Monet continued their work but were exploring new aspects of their styles and had abandoned many of the early goals of Impressionism. The artists who based their work on the color theory and techniques of Impressionism but painted separately, developing their own unique styles, are loosely grouped together and known as Post-Impressionists. They worked contemporaneously with many of the Impressionists, once used their techniques, but could no longer subscribe to their instantaneous glimpses of nature and their seemingly unplanned canvases. They looked for something much more permanent and substantial or, as Paul Cezanne put it: ". . . something solid and durable, like the art of museums." In this respect they wished to combine the color and light of Impressionism with the design and composition of traditional painting—much like Renoir's goals in his latest period of work.

Two directions emerged among these artists: Cezanne and Seurat sought permanence of form and concentrated on design; van Gogh and Gauguin emphasized emotional and sensuous expression. If these directions sound familiar, it is because they reflected the earlier nineteenth century movements of Neoclassicism and Romanticism, of design and expressionism.

The development of Impressionism had freed artists from traditional painting techniques and the Renaissance concepts of space and form. Building on this new freedom, Post-Impressionism produced a variety of styles upon which succeeding artists might expand. It set the stage for the extreme range of individual expression that characterizes art in the twentieth century.

Paul Cezanne (1839–1906) Paul Cezanne was the leading painter of the late nineteenth century in France and one of the most influential artists in Western painting. Although he worked for a short while in Paris, he spent most of his life in relative seclusion in his hometown of Aix. His early work was Romantic, using Delacroix as his model, and he applied his colors in juicy, thick passages. In the early 1870s he met Pissarro and adopted the Impressionists' high-keyed palette, exhibiting with them at their first exhibition in 1874 and again at their third showing. All of his submissions to the Salon were rejected except one, in 1882. According to the standards of his time, he was a failure.

While the Impressionists used light to show the time of day or season, Cezanne's light seems permanent and all-encompassing. It illuminates colors and subjects, and shadows are often non-existent. Cezanne's prime concern was with what happened on the flat canvas. He did not want his paintings to imitate the realistic three-dimensionality of nature but to remain as flat canvases with paint on them. If the painting was of utmost importance, then he should be able to move objects and adjust relationships of color and form to produce the best design possible, even if it meant distortion and change. He discarded the traditional forms of perspective (aerial and lineal) and painted every part of the canvas with equal intensity—foreground, middleground, background, and sky. This led to compressing of space (which was what he wanted) so that the canvas remained visually flat yet the colors seemed to indicate depth. And on that flat surface, Cezanne worked out the elements of his design. His mature style can best be discussed while looking at his paintings.

Near the town of Aix is a large mountain that dominates the landscape—*Mont Sainte-Victoire* (Mount Saint Victory). Cezanne painted it often and explored his developing techniques and painting concepts, using it as his subject. In the version shown here, the mountain is in the background as houses and trees fill the valley in front. Cezanne built up his painting by applying paint in flat, squarish patches or planes of color. Some of these planes may seem to be houses or trees but were meant to be planes of color. The intensity of the colors remains

PAUL CEZANNE. *Still Life with Apples and Peaches*, 1905. Oil on canvas, 81 × 101 cm. National Gallery of Art, Washington, D. C., gift of Eugene and Agnes Meyer

strong throughout so that the sky seems as close to the viewer as the foreground. Space is compressed into a nearly flat plane even though the clouds, mountain, trees, and buildings recede. Colors and values are distributed over the picture plane to produce a visual balance. The whole painting reads as a mountain-dominated landscape yet is built up of relatively equal, small, squarish, flat, abstract planes of color that unify the composition.

Earlier in his life, Cezanne painted many portraits, but his sitters often complained of extremely long sessions and many quit before the paintings were finished. Cezanne's approach to painting required hours of looking to make sure of the placement of color and value and its relationship to the private environment of the canvas. How different from the instantaneous approach of the Impressionists. But when sitters would not tolerate the long hours of posing, Cezanne began working with still lifes, where his patient and tedious working process often caused fruits to spoil before the painting was finished. He finally had to resort to using wax fruit and vegetables in his set-ups. His still lifes were carefully designed and made use of brilliant color.

Still Life with Apples and Peaches is an excellent example. At first glance, the painting appears to be a simple still life with fruit and a few ceramic pieces, but, like all of Cezanne's art, it is carefully designed. The rich colors glow from the canvas as the warm hues of the fruit con-

trast with the cool hues of the surroundings. Rather than add black to the peach color to create a feeling of form, Cezanne used flat patches of gradually changing color to produce roundness. This careful selection of adjacent colors made his painting process lengthy. He used patches of color to build up form while the Impressionists had used them to dissolve form. Blues are distributed throughout the painting as are touches of pink, yellow, and orange. Lines are either painted on the canvas or occur as breaks in value or color. Notice how many lines seem to flow diagonally from upper right to lower left (cloth and table). In order to balance that strong diagonal movement, Cezanne introduced countermovement from the lower right to the upper left in several lines and in the cloths. But more important, notice the slanting of the pitcher, the distortion of the bowl, and the arrangement of the fruit that add to the countermovement and balance the design. Every brush stroke, color change, and line has a purpose in the painting. The visual movement from object to object and the rhythm established with color and value accents produce a typical Cezanne painting of perfect control, careful design, and brilliant use of color. The tilting of some objects or the distortion of others seemed natural to him since the design of the painting was most important, not the imitation of the original still life. If distortion produced a better design, it was the artist's privilege or even requirement to distort.

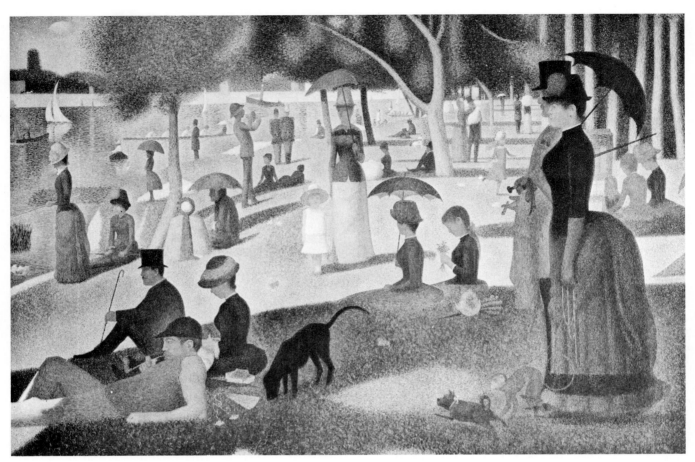

GEORGES SEURAT. *Sunday Afternoon on the Island of La Grande Jatte*, 1884–1886. Oil on canvas, 206 × 307 cm. The Art Institute of Chicago, Helen Birch Bartlett Memorial Collection

Georges Seurat (1859–1891) Georges Seurat pursued a permanence of design similar to Cezanne's but used a completely different approach in his painting. His methodical and scientific techniques were extremely mature for a young man who died when only thirty-two. His technique influenced several Impressionists who were much older than he. Combining knowledge gained from the developing fields of photography and the physics of light and color with the experiments of the Impressionists, Seurat painted magically sunny pictures in his large studio. Following many sketches in oils, charcoal, and crayon to determine color, light, placement, and forms, he carefully began work on his final canvases (*See* p. 33).

Seurat's largest and most impressive work is *Sunday Afternoon on the Island of La Grande Jatte*. After forty preliminary color studies, Seurat placed each figure with careful thought. He applied his bright colors in tiny dots, each about the size of a pencil eraser. From a distance, the viewer's eyes visually mix these dots together (like the dots in the color printing process) to create the vast array of hues and values which make up the painting. For example, red dots placed next to yellow dots appear as an orange area. This technique, given the name *pointillism* or Neoimpressionism (for obvious reasons), is similar to the placing of tessarae in a mosaic. The result is a grainy, delightfully uniform surface which sparkles with light and color. The people of Paris, enjoying a Sunday afternoon in the park, are carefully arranged, either sideways or frontally, and are almost Egyptian in their formality. Seurat placed figures or landscape features according to a mathematical formula similar to that which the Greeks used in their designs and structures. He was certainly trying to make his compositions and designs more solid than the fleeting glimpses of the Impressionists.

Even in *Port-en-Bessin, Entrance to the Harbor*, Seurat's design is carefully worked out. One of a series of landscapes painted around Port-en-Bessin in 1888, it shows a fleet of sail boats both inside and outside the harbor entrance. Again, hundreds of thousands of points of color

GEORGES SEURAT. *Port-en-Bessin, Entrance to the Harbor,* 1888. Oil on canvas, 55 × 65 cm. Museum of Modern Art, New York, Lillie P. Bliss Collection

are applied to build up the surface and develop the final color range. The flickering light and grainy look are appropriate to the subject of summer at the seashore. It is said that Seurat walked around an area for a long time, looking for just the right view to fit his design formula, before he started making sketches and painting studies of the final scene. With this series of works, he began experimenting with the inclusion of a painted border of compatible colors around the subject. In the rest of his work, during his few remaining years, he made these borders more important parts of his compositions.

Henri de Toulouse-Lautrec (1864–1901) Born in Albi to one of the noble families of France, Henri de Toulouse-Lautrec broke both legs when fourteen, and because they did not develop properly, he remained a dwarf. Since he could not participate in his family's active social life, he learned to paint and went off to Paris to live in the Montmartre area where he spent much of his time in the cafes, cabarets, and theaters. He drew caricatures and portraits with great skill but liked to portray dancers and circus people rather than the wealthy patrons who might pay well. In his quick, sketchy style, as in the drawing of *Jane Avril,* his dancer-friend, he was able to capture the character of his subject in a few rapidly applied lines. Lautrec created the same feeling of spontaneity in his paintings, although they often took a long time to finish. Thin washes of color are often used in

HENRI DE TOULOUSE-LAUTREC. *Jane Avril,* 1892. Oil on cardboard, 68 × 53 cm. National Gallery of Art, Washington, D. C., Chester Dale Collection

Henri De Toulouse-Lautrec. *At the Moulin Rouge*, 1892. Oil on canvas, 121 × 141 cm. The Art Institute of Chicago, Helen Birch Bartlett Memorial Collection

combination with a sure, dark line which was an extension of his drawing technique. Many of his paintings are of the night life of Paris, which he saw from "elbow height" (as he himself said). *At the Moulin Rouge* reveals the influence of his friend Degas as the composition recalls *The Glass of Absinth*. A group of his friends are clustered around a table in the cabaret. Lautrec and his much taller cousin can be seen crossing the canvas in the background. The diagonal table and the woman at the right seem to move forward from the picture plane and bring the viewer into direct relationship with the scene. The lighting from below gives the woman an eerie appearance and lends a feeling of evil to the rest of the scene. Lautrec's presentation of his lifestyle and social environment was as realistic as that of Daumier and just as biting in its comment. He knew it well, painted and drew it with gusto and lived it fully, dying of alcoholism when only thirty-seven.

Lautrec was the first artist to produce modern posters for commerical purposes. His caricatures adorned advertisements for many of the cafes and cabarets of the Montmartre, Paris' theater district and artists' quarters. In the discussion of printmaking in Chapter 2, his lithograph *L'Estampe Originale* is shown (*See* p. 39). It is a lithographic print of a printmaker producing an original lithograph. However, most of his prints of dancers were used to advertise their performances and were pasted on the kiosks of Paris—the billboards of the time. Notice in the print, Lautrec's use of strong, black line and flat areas of lighter color. He moved freely from one medium to another: painting, drafting and printing. Although he enjoyed painting, he did not consider his work worthy of display, and at his early death, many fine works, not seen before by his friends, were found in his studio.

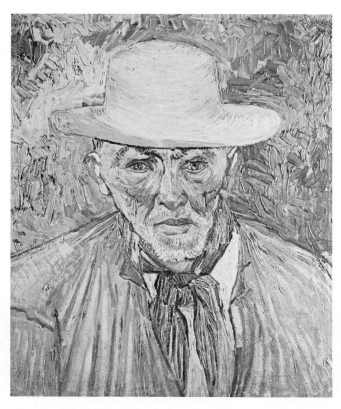

Vincent Van Gogh. *Portrait of a Peasant*, 1888. Oil on canvas, 65 × 54 cm. Norton Simon Inc. Foundation, Los Angeles

Vincent Van Gogh (1853–1890) The first great Dutch painter since the seventeenth century, Vincent van Gogh did not start out as an artist. He worked for art dealers in The Hague, London, and Paris, was a language teacher in England, an evangelist in Brussells, and a missionary to coal miners in Belgium. His love for humanity and life directed him to these pursuits. At times he was vital and exuberant while at other times depressed and melancholy. During several sieges of mental depression, he even admitted himself to sanitariums for help and rest. Van Gogh began painting when he was twenty-seven and worked feverishly for only ten years before suicide ended his tragic life. As with Cezanne, he was considered a failure by his contemporary standards, selling only a single painting while he was alive. Yet today he is considered one of the world's more important artists.

One of the most fascinating aspects of his short career is his correspondence with his brother Theo, who was an art dealer in Paris. Van Gogh fully explained his reasons, techniques, and/or feelings about each painting as he worked on it. These letters provide a unique insight into the creative processes of a deeply serious painter. Van Gogh spent most of his painting years in France, had few friends, and devoted himself fully to his painting. His early work was traditional in technique, dark in

value and somber in color. But once he saw the work of the Impressionists, his colors brightened and his brush strokes became visible, until his paintings jumped alive with brilliant color and a textured surface never seen before. Rather than use the soft strokes of Renoir or the dots of Seurat, van Gogh jabbed at his canvas with vigorous strokes, applying paint in thick impasto. In the short ten years of production, he left over eight hundred drawings and an equal number of paintings.

Van Gogh was not satisfied with merely painting a scene or a person. He felt he had to say something about the subject, himself, or about his own emotional involvement with the subject. Artists who express their feelings and emotions through their work are called *expressionists*. Van Gogh began this movement which was later given the logical title, Expressionism.

In his portraits, van Gogh used radiant, vibrating colors to immortalize his subjects or, as he said, to give them "something of the eternal which the halo used to symbolize." *Portrait of a Peasant* shows his late portrait style. Sizzling color is applied with choppy strokes to build up a textural surface. In the light of southern France, he used complementary colors (orange against blue, yellow against blue-violet, and red against green) and a contrast of warm against cool to create a visual vibration that at first might seem shocking. Notice the cool green of the eyes that seem to burn back into the canvas and the cool touches in the warm and rugged face. Van Gogh liked to paint his peasant friends and admired the peasant subjects of Millet, whose work he sometimes imitated. His ribbons of pure color produce a vibration and style which draw viewers into his personality. After looking at a number of his works, viewers often

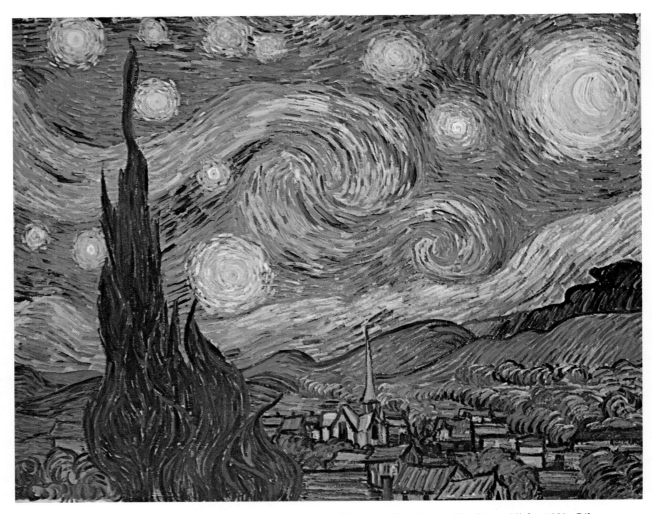

Vincent Van Gogh. *The Starry Night*, 1889. Oil on canvas, 74 × 93 cm. Museum of Modern Art, New York, Lillie P. Bliss Bequest

feel that they know van Gogh quite well—an ironic circumstance because he had few friends in his lifetime. Notice the signature "Vincent" in the upper left corner.

The Starry Night is the direct opposite of the cool and calculated paintings of Seurat, van Gogh's contemporary and friend. Although he tried to work in Seurat's pointillistic style for a time, the all-consuming passion of this painting is more in keeping with van Gogh's character. Although it is planned and balanced, it has a feeling of gushing spontaneity—as if the brush took control of the artist. The subject of a village at night, resting peacefully under the stars could have been treated quite differently, but van Gogh turns the scene into a writhing turmoil of activity. The stars not only glow in the dark sky but move violently, perhaps noisily, as they churn through

the universe. The writhing movement from left to right is halted by the moon which lends stability to the sky and sends the viewer's eyes back into the picture. The snakelike vertical cypress tree also stabilizes the scene but adds its own writhing movement. The jabbing brush strokes, across the town, trees, and hills, produce a unifying effect over the entire surface. At times the painting seems more like a textured tapestry than a painting on canvas. The curling rhythms indicate a rapidly done painting, probably produced in a creative burst of activity. This provocative work forces the viewer to confront the question, "What is he trying to reveal about the night?" One can look at Seurat's work with a detached feeling, but van Gogh's demands a commitment, a sensitive and thoughtful response.

PAUL GAUGUIN. *Ia Orana Maria*, 1891. Oil on canvas, 113 × 87 cm. The Metropolitan Museum of Art, New York, bequest of Samuel A. Lewisohn

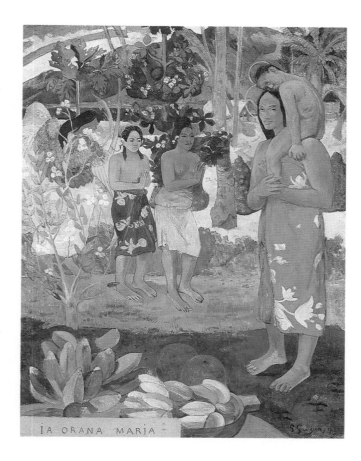

Paul Gauguin (1848–1903) Although he had no formal training in art and was a very successful stockbroker, Paul Gauguin became intensely interested in painting in his late twenties. At first he painted for relaxation but soon was accepted in the Salon show in 1876 and was buying the work of the Impressionists. He was drawn into their group, exhibited with them in 1879, studied and painted with Pissarro, and could no longer suppress his desire to paint. In 1883 he quit his job and a few years later could no longer support his family, who left for his wife's homeland of Denmark. He was convinced that European urban society was incurably sick and began a wandering search for a more favorable way of life among honest and hard-working people outside the cities. He lived in the villages of Brittany (the most remote region of France) at several different times, on the island of Martinique, in Arles (with van Gogh) on Tahiti, back in Brittany, and finally in the Marquesas Islands where he died in poverty. In his painting, he rejected the formlessness of Impressionism, the traditional Western style of naturalism, and realistic portrayal. What was left for Paul Gauguin? He wanted to return to a primitive style of art with simple forms and symbolism rendered in a decorative and stylized way. Like Egyptain, medieval, and Oriental artists, he outlined his shapes and even used Egyptian poses in several of his paintings. He flattened form into decorative shapes and combined brilliant colors to express his feelings. His color combinations were innovative as he used purples with oranges, and bright blues with yellow greens.

The decorative, symbolic quality of Gauguin's work is appropriate to his subject matter of Tahiti and the South Seas. He went to these French territories to learn a simple and more meaningful lifestyle from the natives. Although he adopted native ways and took a native wife, he was always a sophisticated Parisian living in Tahiti. His painting style and colors were already established in his Normandy paintings, and Tahitian influence on his work was very small. But the natives and their colorful surroundings fill his canvases with a fascinating beauty.

One of his earliest Tahitian paintings is *Ia Orana Maria*, translated as "We Hail Thee Mary." Here Gauguin combines the two elements of his own cultural background; Christianity and Oceanic influences. A native woman and her son have haloes as if they are Tahitian versions of Mary and the Christ Child. Two women stand nearby in an attitude of worship, their poses copied from a photograph of a Javanese temple relief. Hidden in the colorful surroundings is a protective angel. Thus, Gauguin incorporates colorful and symbolic forms with a Tahitian setting to produce a unified painting. His symbolism is completely personal, distinct from the feelings and religious convictions of the Tahitian natives. Gauguin made this work to sell in Paris to support his stay in Tahiti.

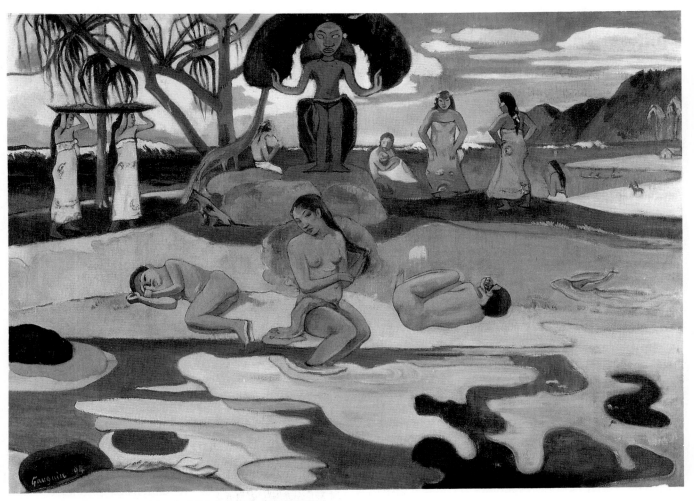

PAUL GAUGUIN. *The Day of the God (Mahana No Atua)*, 1894.
Oil on canvas, 70 × 90 cm. The Art Institute of Chicago, Helen
Birch Bartlett Memorial Collection

In *The Day of the God*, a young native mother and her
two children are near the water while a huge image of a
god towers over them. Almost as in an Egyptian register,
a line of other natives perform their daily task in the
background. The water takes on a decorative pattern as
Gauguin outlines brilliant colors in peculiar, flat shapes
which are repeated in the sky. He has again combined
Tahitian subject matter with his decorative symbolism
and exotic colors to produce a handsome design.

Gauguin spent much of his time in Tahiti producing
woodcuts for sale in Paris, often cutting his designs into
the wood from crates that had brought him new art
supplies from France. The subjects were similar to those
in his oil paintings, but the flat quality of his painting
style was easily adapted to the creation of powerful block
prints which often were colored with the help of stencils.

Symbolism

A group of young painters in Paris looked to Gauguin
and his symbolic paintings as their model. Calling them-
selves Symbolists, the group used the name *Nabis*, the
Hebrew word for prophet. They found several older
Romantic artists who fit into their pattern of symbolic
painting and tried to include them in their group. Al-
though these recognized Romantic artists worked with
their own subjective imagery and denounced the objec-
tive realism of traditional styles, they did not become
deeply involved with the Nabis. The visionary elegance
of Gustave Moreau (1826–1898) inspired the Nabis.
Another solitary figure whom they admired was Odilon
Redon (1840–1916) whose haunting imagination pro-
duced personal works that were disturbing and some-
times tormented.

An excellent printmaker in both the lithography and
etching media, Redon also worked in oils and pastels.

PIERRE BONNARD. *The Breakfast Room*, 1930–1931. Oil on canvas, 160 × 114 cm. The Museum of Modern Art, New York

ODILON REDON. *Profile and Flowers*, 1912. Pastel on paper, 70 × 55 cm. McNay Art Institute, San Antonio, Texas

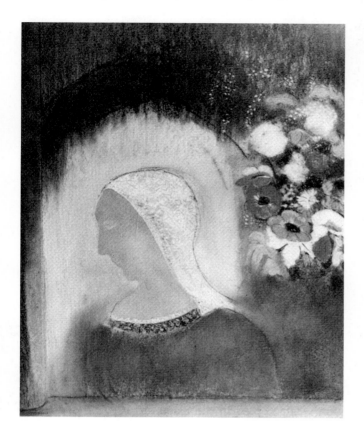

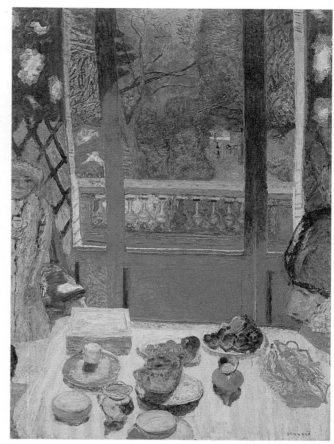

He often made pastel studies of flowers alone or combined them in some mysterious way with ghostlike profiles. Redon enjoyed the poetry of Edgar Allan Poe and Baudelaire and often created drawings and paintings to visualize their poems. His works could almost be called "visual poems," and his dreamlike pastel *Profile and Flowers* fits this category. The face and flowers do not have a specific meaning but are products of Redon's private imaginative world. In his own words, he wanted "to make improbable beings live." The brilliantly colored flowers have no scent and body but are a metaphor for the blossoming of a dream, full of mystery and suggestion. Such is the essence of Symbolism.

In 1884, Redon and Seurat organized The Society of Independent Artists as a rival group to the Salon and as a place for the non-traditional artists to show their work. Such shows, although they gave the independents a chance to exhibit, only alienated them farther from the conservative public and the art critics. Similar groups or brotherhoods, like the Nabis, emerged in France, Ger-

many and especially in England during the nineteenth century, each bringing together artists who were of similar convictions but who were outside the traditional mainstreams of art.

The most important artists included in the Nabis were Edouard Vuillard (1886–1940), Aristide Maillol (then a painter, but better known for later sculpture, see next chapter) and Pierre Bonnard (1867–1947). Their paintings were of intimate indoor subjects like people in the kitchen, eating lunch, feeding the baby, or simply visiting. Hence, they called their style *intimism*. Their warm colors and soft contours created a mood often suggesting a meaning beyond the simple depiction of the scene. Bonnard's work, such as *The Breakfast Room*, seems to be Impressionism brought indoors, but on second look, has color and value intensities more personal than realistic. It also has a more decorative and planned approach than the casual glimpses of Impressionism. Yet these painters owed a great debt to Impressionism for freeing them from traditional styles and realistic form and leading them toward personal expression, soft contours, optical mixing, and casual views.

EDVARD MUNCH. *Girls on a Bridge*, between 1904 and 1907. Oil on canvas, 80 × 69 cm. Kimbell Art Museum, Fort Worth, Texas

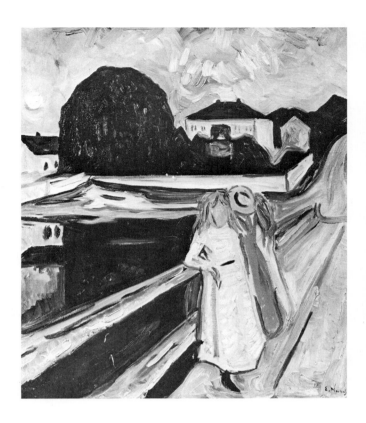

The Beginnings of Expressionism

The pessimistic views of European society reached intense proportions in the work of a few men near the turn of the century. In Belgium, James Ensor (1860–1949) filled his canvases with grotesque, masklike faces to express the hypocracy and the depraved condition of contemporary society. Others also followed the direction set by Goya, van Gogh, and Gauguin by expressing their personal dissatisfaction with their cultural environment through painting.

Edvard Munch (1863–1944) Edvard Munch was a Norwegian artist whose thoughts of tragedy and death dominated his many paintings and prints. He infused many works with a feeling of imminent tragedy such as that expressed in *Girls on a Bridge*. The composition of strong diagonals (recalling Degas' *The Glass of Absinth*) and dark, foreboding shapes is characteristic of his work. The textured brush strokes remind one of van Gogh but the overall mood is typical of Munch's work. The faceless figures are unidentifiable and incapable of accepting one's pity or help as they stare into the dark depths of the river below. Munch weaves a psychological drama but makes no comment and offers no relief. This work is more than a picture of people on a bridge, such as the Impressionists or Corot might paint. As can be imag-

ined, the paintings of Ensor and Munch created uproars wherever they were shown, and both were influential in the formation of German Expressionism, as it developed in the twentieth century.

Pablo Picasso (1881–1974) Pablo Picasso came to Paris from Spain as a young man in 1900, and like Ensor, Munch, and van Gogh was affected by the tragic mood that urban society was generating. His early work has been called his Blue Period because he painted beggars, derelicts, and poor families with a predominately blue palette. The color fits the mood of the paintings, such as *The Tragedy*, composed entirely in blue tones. Sadness is expressed by the color, by the attitudes of the figures, and by the mysterious sea close by. Although Picasso's name weaves itself into the fabric of many aspects of twentieth century art, his early work in Paris coincided with the beginnings of Expressionism.

Henri Rousseau (1844–1910) A customs official of France (a "Douanier"), Henri Rousseau gave up his government job at middle age and took up painting. Nicknamed "Douanier" by his friends, his goal was to paint the world around him with absolute realism, in the style of Ingres—but without any formal art training this was impossible. Instead, he presents an enchanted

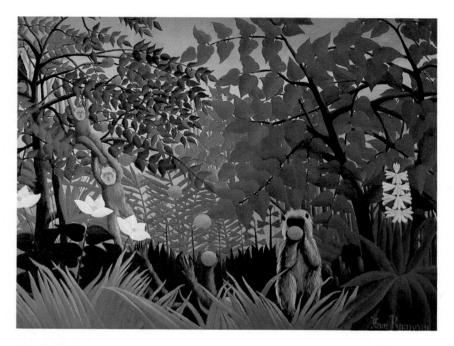

HENRI ROUSSEAU. *Exotic Landscape*, 1910. Oil on canvas, 130 × 162 cm. The Norton Simon Foundation, Los Angeles

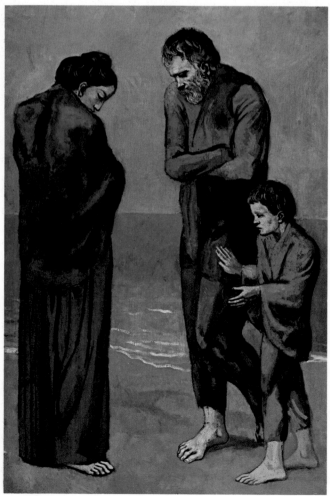

world of forests and tropical jungles filled with exotic flowers, fantastic animals, and an occasional person or two. He was admired by many of his fellow artists and by succeeding generations of painters for his unique qualities: directness of vision, innocence of technique, and his naive spirit. His *primitive* style was born of technical limitations but his honesty, hard work, and psychological sophistication produced paintings of great enchantment. *Exotic Landscape*, one of his many jungle paintings, contains crystal clear visualizations of incredible leaves, monkeys, flowers, and fruit. Every leaf is carefully drawn and painted to weave a dense and impenetrable jungle. Painted in the last year of his life (after thirty years of painting), it illustrates clearly the imaginative realism of primitive painting. Rousseau visited zoos and botanical gardens to gather visual notes for his paintings. Although he had been to Mexico, it is doubtful he saw such jungles there. The rhythmic beauty of his concepts was lost on the public who considered him an untrained novice and laughed at his magical portrayals with outright indignation. In their derision, they overlooked the naive honesty and dreamlike expression of this delightful artist.

PABLO PICASSO. *The Tragedy*, 1903. Oil on wood, 105 × 69 cm. National Gallery of Art, Washington, D. C., Chester Dale Collection

1875

China	First Sino-Japanese War (1894–1895); Boxer Rebellion against the West (1899–1900)
Japan	Meiji Restoration brings Western ideas and technology (1868–1912)
India	Gandhi
S.E. Asia	U.S.A. in Philippines (1898); British control Malay States; King Chulalongkorn in Thailand
Europe	Victoria's Golden Jubilee in 1875; Apex of European colonization (1876–1914)
Americas	Reconstruction ends in U.S. (1877); Edison; Emily Dickinson; Spanish American War (1898)

1900

ART OF OTHER CULTURES

This ideal knight's castle is a romantic reproduction of a medieval design. Located in one of the most beautiful spots in the lower Alps, it was constructed by King Ludwig II of Bavaria in the late nineteenth century.

Schloss Neuschwanstein (Neuschwanstein Castle), Bavaria, Germany, 1869–1886

Susuki Harunobu. *Drying Clothes.* Japan, Edo period, 1767. Color woodcut. Philadelphia Museum of Art

This woodcut was not made in the late nineteenth century but such prints were a major influence on the French Impressionists and Post-Impressionists. Oriental perspective is very different from traditional Western linear perspective (*See* discussion in Chapter 4). Patterns of leaves, calligraphy, clothing, and proportions are distinctly different from the naturalism of Western art, as are the use of bright flat color areas and decorative motifs. These and other aspects of Oriental art appealed to the artists as they experimented with ideas of color, line, light, and subject matter. As chinoiserie was the product of Chinese influence in Europe two hundred years earlier, Impressionist and Post-Impressionist artists were excited by the presence of Ukiyo-e prints in Europe.

While the Impressionists and Post-Impressionists in France were working with new forms of visual communication, many painters in the United States were following the westward expansion of our nation. Artists like William Keith (see others on pages 429–430) were painting the Western landscape for Easterners who stayed at home but wondered what the West was like. They saw it through the romanticism of these visual interpreters.

WILLIAM KEITH. *Yosemite Valley,* 1875. Oil on canvas 102 × 183 cm. Los Angeles County Museum of Art, bequest of A. T. Jergins

Analysis

1. Analyze a painting by Cézanne and one by Renoir. Write several sentences about how each artist used the design elements of line, shape, color, texture, space, value and form (or how they were *not* used). Then write several sentences to point out their use (or non-use) of the design principles of balance, contrast, movement, emphasis, unity, pattern and rhythm.

2. Write a one-sentence summary of the painting styles of Seurat, Toulouse-Lautrec, van Gogh, Gauguin, Redon, Bonnard, Munch and Rousseau. Start each sentence the same way: ''In his paintings, Vincent van Gogh . . . ,'' for example. Tell what the artist tried to say to us and/or what techniques he used to communicate his ideas.

3. James Abbott McNeill Whistler made this etching, *Black Lion Wharf,* of the waterfront in Glasgow, Scotland. It is very different in style and technique from his paintings. In an essay, compare and contrast it with *Nocturene in Black and Gold,* indicating stylistic differences as well as technique, emphasis, mood, etc. This small (15 × 21 cm) etching is in the collection of the Metropolitan Museum of Art, Harris Brisbane Dick Fund.

Aesthetics

4. Impressionist and Post-Impressionist artists were trying to communicate different things with their paintings. Briefly state what each (Monet and Cezanne, for example) were trying to do in their work. Then indicate which of the two results you like better and explain why. You may wish to illustrate your work with photocopies, sketches, slides or prints.

5. You are a young Italian painter of the High Renaissance and through a time-warp are dropped into Paris in 1890. What are your feelings and sensations, impressions and resentments about the city, the art scene, the forms of visual expression and the role of the artist? Compare your experiences with what was going on back home in Florence during the Renaissance.

6. Movements like Impressionism and Post-Impressionism often developed outside the mainstream of art and were usually isolated from the critics and the public. Discuss the advantages and disadvantages of this situation. Should one or both sides make compromises to reach a mutual and happy union? Or should such artists continue independently? Theoretically, which might produce better art?

Studio

7. The dot patterns of Seurat's painting use the same principle that modern printers used in recreating the color photography in this book. If you examine any color reproduction with a magnifying glass, you should only find four colors of ink—the three primary colors and black. Using these four colors of tempera paint, experiment with dot patterns to see if you can recreate a full-color image.

8. The soft edges of Impressionistic painting and the lack of sharp contrasts are characteristic of the style. Try one of these experiments: (1) Paint or draw a simple scene in tempera or pencil: if using tempera, go over the work and soften all the edges by overpainting; if drawing, smudge or erase until edges are soft. (2) Photograph outdoor scenes, but purposely set the lens *slightly* out of focus to blur the image. The results can give you an insight into Impressionistic images—often best viewed from a distance or with squinted eyes.

9. Cézanne's ''building blocks of color'' made everything in nature into geometric solids. Cut sheets of various colors of construction paper or colors from magazines into small squares and rectangles. Then make a small collage of one of Cezanne's paintings using only those pieces. Viewed from a distance, the colors and patches should produce an image similar to that of the original painting.

10. Impressionist sculpture (Rodin, Degas, Renoir, etc.) creates a feeling for form without providing all the detail. Using clay or wax, make a sculpture of an animal that gives a feeling for its shape, surface texture or character without adding detail. Try to do the same for a human figure, i.e., a dancer, athlete, student, mother.

HENRI MATISSE. *The Red Studio*, 1911. Oil on canvas, 180 × 219 cm. The Museum of Modern Art, New York, Mrs. Simon Guggenheim Fund

14 Intellect, Emotion, and Imagination: A Half Century of "isms"

THE QUALITY OF REVOLUTION, which reared its head in the work of the Impressionists and Post-Impressionists, roars into all-out war in the early twentieth century. An observer, watching the development of art from the Gothic era to the turn of the century, could have predicted this outcome. Each "school of art" had merged into succeeding styles until no new movements seemed possible. The Renaissance style merged into Mannerism and the Baroque, then into Rococo. Neoclassicism was a reaction to the fanciful Rococo and then Romanticism reacted to it. Realism emerged as a natural outgrowth of the development of photography and as an objective outlet for artists who could not conform to Classic or Romantic thought. Impressionism grew out of Realism and the variety of Post-Impressionist styles picked up the trends of Classicism, Romanticism, and Realism and pushed them still further. The art of the twentieth century, as confusing as it appears, is based again on the Post-Impressionists' developments. By remembering where its roots were nourished, this art will become a bit easier to comprehend.

The mainstream of nineteenth century Western art was filled with artists who painted a realistic and often sentimental representation of the world around them. The public wanted this style and its conservative ideas controlled the Salon. But both Impressionism and Post-Impressionism, though ridiculed by established critics and the public, had already eliminated the traditional concepts of form, space, color, and shape. Artists in the *avant-garde* now assumed the right to determine these important aspects of painting in their own ways, not according to nature or traditional Renaissance concepts. Their task was not easy because the critics (who

wrote about art) and the public (who listened to the critics) were shocked, startled, and disgusted by the avant-garde's art. The road ahead of them was not easy.

The "isms" that multiplied in the twentieth century are too many to list or to classify here. In addition to several major "isms," there were many obscure movements, perhaps joined by only a few members. While these "ism" labels organize the tremendous variety of twentieth century art, most artists cannot be exclusively identified with one "ism." Most were involved with several movements during their lifetimes. During previous generations, major movements in art lasted for a half century, a century, or more. In the twentieth century, a typical "ism" might be over in ten years or less, so an artist, such as Picasso or Matisse, might experiment in six or eight "isms" during his career. In this chapter, artists will be placed in one movement for convenience of listing, although they usually participated in many styles.

Three main currents of art developed out of Post-Impressionistic painting and they will organize the styles in this chapter: Expressionistic Art, Abstract Art, and Fantasy Art. In each of these areas, artists can work in realistic or *non-representational* ways—or somewhere in between. Expressionistic art stresses the artists' emotional attitudes toward the world and themselves. Abstract art emphasizes the structure of art—the organization of line, form, space, and color. Fantasy art displays the workings of the imagination and the dream-like inventions of the mind. These three aspects—feeling, design, and imagination—appear in most works of art. Without each, a work of art lacks an important ingredient. Yet artists, like viewers, usually identify more fully with one of these main currents over the others.

HENRI MATISSE. *Beasts of the Sea*, 1950. Paper on canvas (collage), 296 × 154 cm. National Gallery of Art, Washington, D. C., Ailsa Mellon Bruce Fund

Expressionistic Art

The terms Expressionistic or Abstract art refer to an attitude or philosophy of art rather than to a style because artists of many styles can be expressionistic or abstract in their work. It is difficult to group artists according to style in the twentieth century as each was trying to develop an individual style different from all other artists. But certain characteristics do group artists together for the sake of organization and study.

THE FAUVES

Between 1901 and 1906 there were several exhibitions in Paris of the work of Cezanne, van Gogh, and Gauguin. Young artists, seeking direction for their visual expression, were greatly impressed by the freedom, color, and individual character of this work. A number of these men, considering themselves to be the avant-garde, scheduled a show of their work in 1905 in Paris. The walls exploded with violent color, bold distortion, and vigorous brush strokes. The artists had filled their canvases with raw, bright, hot colors that sizzled. One shocked critic described the art as the work of "wild beasts," not of sane humans. The French word for wild beasts is *Fauves*, and the revolutionary artists accepted the title with pride; their work was thus called Fauvism. Today their art does not seem radical, but to the French who had been startled by van Gogh and Gauguin, Fauvism was outrageous. Emphasis on vibrant color held the group together, and when in a few years they each moved off in different directions, the movement was dissolved. The Fauves expressed their emotions through distorted color as they splashed still lifes and figures with exaggerated hues. Warm colors became red-hot and cool hues were pushed into icy cold. But the hot, vibrant hues received the most attention and often attained added zest by their contrast with vivid cools. This development would have made Gauguin very happy. Green and blue faces, orange skins, purple eyes, and bright red hair would have been too much for van Gogh, but the Fauves brushed on their vivid colors with reckless abandon. Included in the group were Andre Derain, Raoul Dufy, Maurice de Vlaminck, Albert Marquet, Georges Rouault, and their spokesman, Henri Matisse.

Henri Matisse (1869–1954) Although he was being schooled for the practice of law, Henri Matisse soon felt the urge to paint—a feeling that completely changed his life. He began working in the Impressionist style and copied the works of the older masters in the Louvre, but when the exhibition of 1905 in the Salon d'Automne was hung, Matisse featured several shocking works amid the "wild beasts." His use of intense colors and ability to simplify complex subjects moved him into the forefront of Fauvism. He wanted to express himself with simple color and shape rather than with shading and perspec-

HENRI MATISSE. Chapel of the Rosary of the Dominican Nuns, 1948–1951. Vence, France

tive. Six years after the Fauves exploded on the art scene, Matisse painted *The Red Studio*, which summarizes his artistic goals. The dominant color of red is used for walls, floor, and many of the pieces of furniture. The flattened effect is enhanced by the lack of shadow and value changes, as Matisse tried to attain a two-dimensional feeling. On the wall are a number of his Fauvist paintings from the previous few years. The simplification of plants, statues, and furniture is a foretaste of his later style, but at this point, the reddish color and yellow lines are dominant features. Renaissance painting concepts are almost completely eliminated and a personal, decorative quality emerges.

Matisse's powers of observation and simplification were so fully developed that he could look at a complicated subject for a period of time and then draw it with his beautiful, singing, simple line. Of course, this is much more difficult to do than it looks, and few artists have ever done it as well as Matisse.

Although Matisse worked in sculpture and took a fling at Cubism, flat shapes and sinuous line continued to dominate his work. In his later years he experimented with *collage*—pinning and pasting brightly colored flat shapes on contrasting backgrounds. When finally confined to his bed by illness, he used his simplified collage technique with powerful results. In 1950 he assembled one of his most beautiful collages, *Beasts of the Sea*. As in all his latest work, he cut directly from colored sheets of paper and did not outline first with pencil. From the hundreds of colored scraps lying about his bed and studio, this charming work emerged. It is a memory of a visit to the South Seas, made twenty years earlier. By looking carefully, as if into a lagoon, one can see

simplified symbolic shapes that recall sea plants, coral, sea animals, fish, water, land, and sky. Matisse has arranged his cut-outs like a series of small enameled panels. The usual pastel colors of water, sky, and underwater forms are heightened to vivid hues which more accurately convey Matisse's feeling for the place. These colors, often contrasting and dissonant for greater impact, produce a visual excitement that could not be generated by a realistic representation of the underwater scene.

In 1943 Matisse suffered a severe illness and was cared for by the Dominican nuns in the southern French village of Vence. To express his appreciation for their help, he designed, financed, and built a wonderful chapel for them. Hundreds of preparatory drawings reveal that he started with many complex ideas for the design which he simplified to this final form. The chapel is white, inside and out, with the only color coming from light entering through yellow, blue, and green windows, casting ever-changing patterns on the floors and walls. The wall decorations are simple and linear, and are fired in black on the white tile. Matisse designed the altar, windows, wall decorations (St. Dominic is shown here), crucifix, candelabra, and even the vestments for the officiants. He provided the nuns with a beautiful and uncomplicated environment for prayer and worship.

To many, the work of Matisse has a childlike quality enhanced by its seemingly simple character. Yet such simplicity is extremely difficult to accomplish, and his freshness is the result of a marvelous ability to look at a complex subject and reduce it to its simplest elements using line and colored shapes. His simplicity, therefore, is the result of extreme sophistication.

RAOUL DUFY. *Golfe Juan*, 1927. Oil on canvas, 84 × 101 cm. McNay Art Institute, San Antonio, Texas

MAURICE DE VLAMINCK. *Still Life with Lemons*, 1907. Oil on cardboard, 51 × 65 cm. Norton Simon Inc. Foundation, Los Angeles

Maurice de Vlaminck (1876–1958) Many of the Fauves worked together at the beginning of the movement, and Maurice de Vlaminck and Andre Derain were friends and professional athletes who turned to art as a means of expression. Vlaminck's *Still Life with Lemons* was painted two years after the exhibition which started the Fauves on their way. The bold strokes of paint and the common objects in the set-up are not startling, but the color certainly is. Warms are heightened in intensity until they are shockingly hot while the cool shadows are also intensified. Placing such complementary hues together creates a sizzling visual sensation, alive with colors pushed past their normal relationships. After the dissolution of Fauvism, Vlaminck continued to use heavy impastos but subdued his colors and painted wintry landscapes of the French countryside. In many he used a painting knife to smear on his colors with great gusto.

Raoul Dufy (1877–1953) After trying to work with the solid feeling of Paul Cezanne, Raoul Dufy soon developed his own *calligraphic* style that was both charming and colorful. Splashing his canvas or watercolor paper with broad, flat areas of intense color, he used smaller brushes to draw delightful linear figures or landscape elements over them. One of his favorite areas to paint was the southern coast of France where the vivid blues of the Mediterranean sea constrast with bright rooftops and trees. In *Golfe Juan*, Dufy places a sizzling red tree trunk and hot red rooftops in opposition to intense blue water and sky and bright green trees. He accents these spontaneous color areas with joyful calligraphic lines that sometimes outline things and at other times ramble on their own, describing leaves, flowers, buildings, or decorative elements. He enjoyed using his cheerful means of expression to paint horse races, garden parties, regattas, and concerts. It is said that he would listen to an orchestra play and would close his eyes and see crimson, rose, or other colors. He painted a scribbled outline of a violin lost in a wave of burning, heavenly blue, as response to his feelings when hearing Mozart's music.

Georges Rouault (1871–1958) Georges Rouault was a devout Catholic who used his paintings to express his deep concern over the immoral conditions of poverty and war. Art and the church had been separated from each other for many generations, but Rouault did not attempt to heal the breach. Instead, his expression was of a personal nature, deeply rooted in his religious background and his fascination with medieval life and religion. His early paintings were of various religious subjects, done in traditional styles. He also spent some time

GEORGES ROUAULT. *The Old King*, 1937. Oil on canvas, 77 × 54 cm. Museum of Art, Carnegie Institute, Pittsburgh

GEORGES ROUAULT. *Head of Christ*, undated. Oil on panel, 59 × 48 cm. Los Angeles County Museum of Art, bequest of David L. Loew in memory of his father Marcus Loew

working in a stained glass studio—an experience which helped shape his mature painting style. He met Matisse and for a while worked with the Fauves, enjoying their unrestrained use of color. But by 1911 his work turned darker and more subjective as he expressed his indignation at the evils around him: prostitution, injustice, poverty, and corruption. He became a marvelous printmaker during this time and was able to combine his feelings with many new technical devices in several series of prints.

Rouault's numerous depictions of Christ were often limited to tragic faces as his *Head of Christ* illustrates. While Matisse insisted that his entire composition expressed his feelings, Rouault felt that his "passion" was "mirrored upon a human face." Despite Rouault's outlook, his favorite impasto technique, broad brush strokes, and massive black lines all aid his personal ex-

pression. Since Grünewald, no artist has expressed the tragedy, humility, and suffering of Christ with such conviction and feeling. In such works, Rouault was leaning more toward German Expressionism than toward Fauvism.

Heavy black lines (which recall the lead in stained glass windows) are used to cage brilliant colors in Rouault's *The Old King*, one of his later works. If one thinks of the troubles of Kings David or Solomon in the Old Testament, this sorrowful monarch could be either of them. Glowing colors are separated by heavy lines which also control eye movement and outline the half figure, separating it from the background. Rouault, using a technique vastly different from Impressionism successfully combines his interest in medieval art and religious concepts with a personal, dynamic form of visual expression.

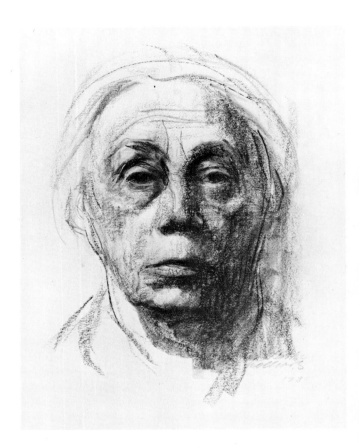

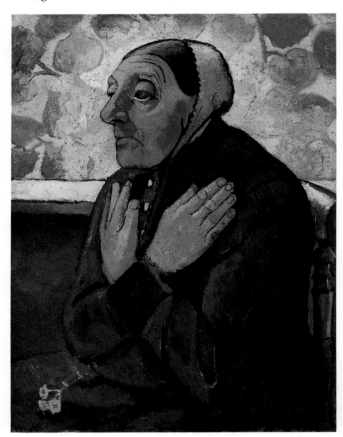

KÄTHE KOLLWITZ. *Self-Portrait*, 1934. Charcoal on paper, 43 × 34 cm. Los Angeles County Museum of Art

PAULA MODERSOHN-BECKER. *Old Peasant Woman Praying*, about 1905. Oil on canvas, 76 × 58 cm. The Detroit Institute of Arts, gift of Robert H. Tannahill

GERMAN EXPRESSIONISM

Before various groups in Germany were organized to promote individual expression in the arts, several solitary artists were setting the stage for action.

Paula Modersohn-Becker (1876–1907) Paula Modersohn-Becker was one of the most important German artists of her day and a main precursor of Expressionism. She traveled often to France to see the work of Gauguin and van Gogh, introducing Gauguin's simplified forms, exotic color, and use of line to Germany. *Old Peasant Woman Praying* is a dramatic study of a German farm woman in an ancient attitude of worship. Although her earlier work was more realistic, this portrait shows her personal feelings about such people and is reminiscent of both Gauguin and van Gogh. Such features as yellow skin, heavy-lidded eyes, a prominent nose, and a melancholy look caused the Nazis to confiscate this "ugly painting" in 1937 as "degenerate art." Most German Expressionistic paintings suffered a similar fate and were later sold by the government to collectors and museums outside the country.

Käthe Kollwitz (1867–1945) Käthe Kollwitz was one of the most powerfully emotional artists of this century. She worked in Berlin most of her life and was evacuated in the bombings of 1943. Her etchings, woodcuts, lithographs, and drawings express her feelings about old age, hard work, war, motherhood, and death. She used the working class people as her models even though she was married to a prominent Berlin doctor. Her *Self-Portrait*, one of many she did, was drawn with charcoal pencil when she was sixty-seven years old. The taut expression and lined features bear witness to a long and difficult life as she handles the eyes and mouth with special emphasis. The contrast of shadow and line is used effectively to produce a feeling of form and volume. Yet the artist used very little detail, emphasizing instead the broad planes and the stark, powerful drama of the human face.

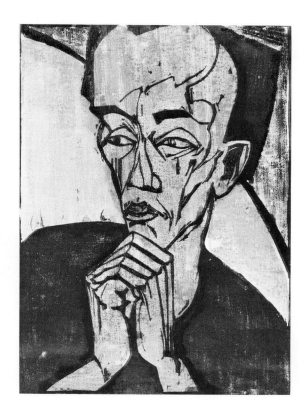

ERICH HECKEL. *Portrait of a Man. (Self-Portrait)*, 1919. Color woodcut, 46 × 31 cm. The Museum of Modern Art, New York

Throughout history, Germanic people were inclined toward Expressionism and their visual art was generally more involved with personal feelings than with mathematical perfection and composition. It is logical then, as the colorful explosions of Fauvism were taking hold in France, that Germany would develop comparable movements. A small brotherhood called Die Brücke (The Bridge) was formed in Dresden in 1905, the same year the Fauves first showed in Paris. They were ardent admirers of Munch, van Gogh, and Gauguin and emphasized violent color and distortion of features in their paintings and powerful and somber woodcuts as they cried out against the economic and social conditions in Germany prior to World War I. They studied subequatorial African art in depth, especially the expressive masks and carvings, and tried to include some of those characteristics in their paintings.

ERNST LUDWIG KIRCHNER. *The Street*, 1913. Oil on canvas, 121 × 91 cm. The Museum of Modern Art, New York

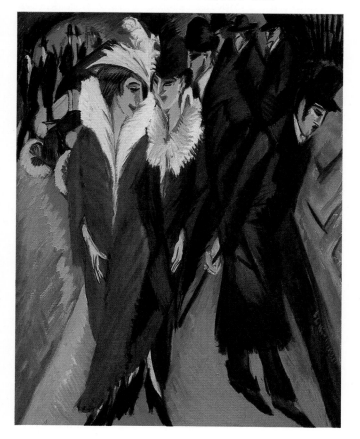

Ernst Ludwig Kirchner (1880–1938) The early leader of Die Brücke was Ernst Ludwig Kirchner who tried through several methods and styles to express his feelings. He insisted that "art depends on inspiration and not on technique," as his group vehemently rejected academic training in art and all the traditional forms of expression. In his early paintings, such as *The Street*, he worked in flat color areas with bright hues and heavy black shapes. The tension and agitation of the street are expressed by sharp, angular shapes and vivid, acid colors. There is isolation and loneliness even in such crowded conditions. His woodcuts were powerful statements in black and white but often included several background colors (*See* p. 37).

Erich Heckel (1833–1970) Erich Heckel was both painter and printmaker, and his powerful woodcuts caused a revival of interest in German printmaking. *Portrait of a Man* could almost be thought of as a psychological portrait of German Expressionism. The face is emaciated and appears to be apprehensive and neurotic. The inked wood (the black areas) is printed over painted color areas: face and hands of olive green and background of blue and brown. The angular cuts and shapes produce a feeling of agitation and conflict, certainly not of calm and composure. Notice how Heckel's sharp angles echo those used by Kirchner in his painting.

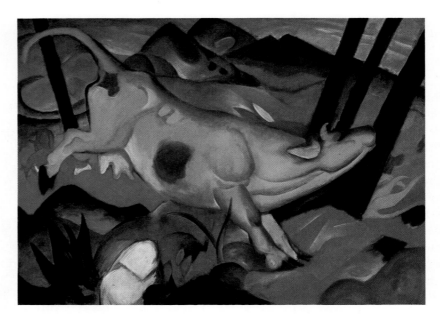

FRANZ MARC. *The Yellow Cow*, 1911. Oil on canvas, 141 × 189 cm. Solomon R. Guggenheim Museum, New York

EMIL NOLDE. *Masks*, 1911. Oil on canvas, 73 × 77 cm. William Rockhill Nelson Gallery of Art, Kansas City

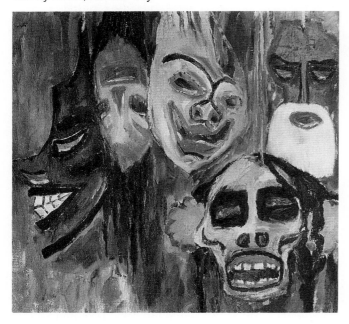

revived avid interest in the woodcut and other graphic means of expression.

Among the many other Expressionist groups spawned in Germany prior to World War I was a small important group of artists who called themselves Der Blaue Reiter (The Blue Rider). Centered in Munich from 1911 to 1912, it included three important painters: Franz Marc (known for his beautiful animal paintings), the Swiss Paul Klee (*see* later in this chapter) and the Russian Wassily Kandinsky. They were not social revolutionaries as members of Die Brücke had been but were strong individual artists who exerted a powerful influence as twentieth century art unfolded.

Franz Marc (1880–1916) While Franz Marc painted many kinds of subjects, his animal paintings are of major importance. Not since the ancient cave painters had an artist specialized in painting animals to this extent. Marc used brilliant color in a symbolic and arbitrary way, combining it with shape and rhythm to dramatize the integration of all creatures in nature. There probably has never been a more joyful cow than the one cavorting in his work *The Yellow Cow*. Placed into the rhythmic flow of an equally colorful landscape, the happy creature fills the picture with powerful movement and active shape. The movement generated by the animal seems to charge the environment with equal excitement. Marc and Kandinsky were leaders of The Blue Rider and were responsible for giving the name to the group. His death during World War I cut short a very promising career for this dynamic German artist.

Emil Nolde (1867–1956) Emil Nolde was a bit older than the rest of the members of Die Brücke and remained in the group for only two years. Like Rouault, he painted many religious themes, but his slashing brush strokes and garish colors were not pleasing to the public. His grotesque faces, as seen in *Masks*, show his interest in primitive societies and cultures and his desire to relate them to his contemporary time. He used these faces to show personal contempt for immorality, greed, avarice, lust, and hypocricy as it appeared in his society.

The group broke up in 1913 but in those few years had exerted considerable influence on public taste and had

Wassily Kandinsky (1866–1944) Wassily Kandinsky was born in Moscow but attended art school in Munich, after first obtaining a Russian law degree. He is credited with painting the first completely abstract (non-objective) painting about 1910. He returned to Russia but was soon back in Germany, teaching at the *Bauhaus*. His early paintings were similar in feeling to those of the Fauves, with recognizable houses and trees painted in vivid colors. Gradually he simplified and abstracted these features until only shape, color, and line were left, features which were not reminiscent of any recognizable subject matter. He titled these paintings with musical terminology such as "Improvisation 9" or "Composition No. 138." Kandinsky explained that improvisations were "unplanned and spontaneous expressions of inner character, non-material in nature." Such works as *Open Green* seem to be a meaningless assortment of astonishing colors and lines, arranged in a haphazard, spontaneous way—a joyful happening in color and line. The whole canvas seems to explode as if a cannon had fired a resounding shot. Certain kinds of lines and various colors had personal meaning to Kandinsky as he wrote that to him "blue is soft and round while yellow is sharp." He developed his own personal language of color and shape which he used to express his feelings. His later work was more geometric and more carefully organized but just as non-objective and his influence became very strong in the Abstract Expressionist movement following World War II. Often the colors seem dissident and clashing, as sounds clash in the musical compositions of his friend, Igor Stravinsky.

Oskar Kokoschka (1886–1980) While related in spirit to the artists of Die Brücke, Oskar Kokoschka shunned such organized groups. This Austrian painter used portraits and figures as his subject and never became non-objective in his expression. His painterly brush strokes and vivid color tied him to the German Expressionists but his restraint kept his figures recognizable rather than symbolic of twentieth century evil or corruption. Most, however, have a somber quality and a mood of uneasiness. *Frau Erfurth* is an elderly lady, blind in one eye and crippled with arthritis. These are visable characteristics. But Kokoschka also shows us her sinewy determination and an inner strength which she uses to overcome her afflictions and to smile in spite of them.

WASSILY KANDINSKY. *Open Green*, 1923. Oil on canvas, 98 × 98 cm. The Norton Simon Foundation, Los Angeles

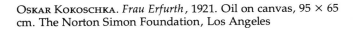

OSKAR KOKOSCHKA. *Frau Erfurth*, 1921. Oil on canvas, 95 × 65 cm. The Norton Simon Foundation, Los Angeles

MAX BECKMANN. *Baccarat*, 1947. Oil on canvas, 119 × 100 cm. William Rockhill Nelson Gallery of Art, Kansas City

Max Beckmann (1884–1950) Max Beckmann started out in the traditional mainstream of art but, following World War I, began painting his nightmarish expressions of decadence and the tragedy of the human condition. Bright, raw colors are outlined with hard, black lines as Beckmann allows one to see the puppet-like figures of humanity dehumanized by social conditions. *Baccarat* was painted in Amsterdam because Beckmann (like many German artists of the time) had to flee Nazi Germany when he was officially labeled "degenerate." His last three years were spent in the United States. His symbolism and style are personal and often unexplainable. It is difficult to explain the man with the sword in an otherwise tranquil casino setting. Yet most of his characters seem ominous and/or evil which is part of Beckmann's symbolic vocabulary.

Amedeo Modigliani (1884–1920) Amedeo Modigliani was born in Italy but spent most of his life painting in Paris. Although his early work was influenced by Toulouse-Lautrec, he soon developed a unique style based on the elongated distortion of African sculpture, the design and brushwork of Cezanne, the sketchy line and flat shapes of Matisse, and his innate Italian interest in portraiture. He was an excellent draftsman, and as *Gypsy Woman with Baby* shows, he was able to simplify human features into a dignified and simple statement, often recalling the Italian Mannerist distortion and elongation (*See* also the work of El Greco). His portrait sculptures are reminiscent of African masks in their elongated forms and stylized features (*See* p. 129). Although many outside influences can be found in Modigliani's work, his final expressions are completely unique in their design and emotional content.

AMEDEO MODIGLIANI. *Gypsy Woman with Baby*, 1919. Oil on canvas, 115 × 73 cm. National Gallery of Art, Washington, D.C., Chester Dale Collection

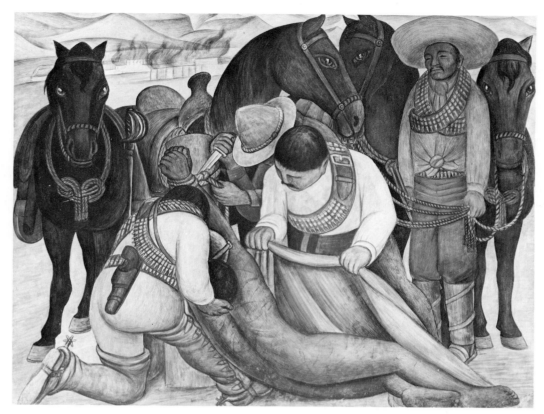

DIEGO RIVERA. *Liberation of the Peon*, 1931. Fresco, 188 × 241 cm. Philadelphia Museum of Art

EXPRESSIONISM IN THE AMERICAS

Although American artists following 1910 were familiar with Fauvism and German Expressionism, they were very slow in adopting any part of the movements into their own work. Mexican artists, however, spurred on by the fall of dictator Porfirio Diaz and their new freedom of expression, developed a national style "of the people" that typified the spirit of the Revolution. Combining the simple, solid feeling of Pre-Columbian figures and the powerful colors and forms of European Expressionism, walls and ceilings in Mexico City began to bloom with vibrant murals depicting the history of the country, the oppression of the common people, and the immoral excesses of the ruling class. The works often took on political overtones that were sometimes too strong in their personal passions for proper use as public murals. Many ceilings and walls in major Mexican cities are covered with the powerful visual statements of the three finest painters while Jose Guadalupe Posada flooded the streets with woodcuts and engravings depicting the atrocities of the government and the rulers of the country. Social protest and art were synonymous in Mexico for several decades.

Diego Rivera (1886–1957) Diego Rivera studied in Paris and worked in many of the current styles emerging in the early years of the century (*See* p. 53). He knew Picasso, Matisse, and the rest of the avant garde in Paris but returned to Mexico in 1921 to become actively involved in its politics. Influenced by the simple, outlined forms of Gauguin and his own cultural heritage of Mayan and Aztec sculpture, Rivera developed a powerful and unique painting style. The figures, such as those in *Liberation of the Peon*, are solid, bulky, and rounded, much like those of Giotto. Folds in cloth are heavy and simple, and figures are shaded in the traditional way to create a feeling of roundness and dimension. Rivera revived the fresco technique, which had not been used extensively for centuries, and put his ideas on public walls for all to see. This example is a strong social protest against the inhumanity of the landowners toward their peons. Saved from torture and certain death, this scarred, beaten, and bound slave is receiving tender care from his benevolent rescuers. Many huge walls in Mexico and the United States carry the powerful messages of Diego Rivera (*See* p. 448). His unique style was also used effectively in easel paintings (*See* p. 78).

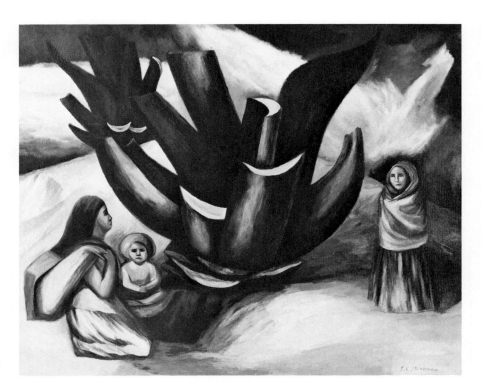

José Clemente Orozco. *Mexican Landscape*, 1930. Oil on canvas, 76 × 94 cm. Los Angeles County Museum of Art, gift of Charles K. Feldman

José Clemente Orozco (1883–1949) Beginning with the fresco technique, José Clemente Orozco later used more modern materials to fill walls in Guadalajara and other cities with his statements. Even more powerful than the work of Rivera, Orozco's murals are dramatic and political and were often commissioned by revolutionary governments. His oil painting *Mexican Landscape* is a dramatic easel painting that features his powerful style. The forms are well rounded, like those of Rivera, but are painted with slashing brush strokes and greater contrast of values, thus creating a more dramatic impact on the senses. Even this small canvas has the visual impact of a large mural because of the monumentality of the forms. The dominant feature is the huge maguey plant which is a major source of food, drink, cloth, rope, and other items for the desert people of Mexico. It seems as though these quiet, solitary figures are patiently waiting for more growth to sustain them a little longer. The background is treated with abstract shapes that place visual emphasis on the plant and the three human figures. Many painters from around Mexico and the United States worked on the mural commissions of Rivera and Orozco and brought this Expressionistic style back to their homes, incorporating much of it in their personal work.

David Alfaro Siqueiros (1896–1974) David Alfaro Siqueiros spent many years of his life in prison because of his revolutionary ideas and political connections. He worked with Rivera and Orozco on many mural projects and during the last twenty years of his life was the only surviving member of the great triumvirate. With the development of new painting materials and modern constructive techniques, Siqueiros was able to design murals of incredible dimension and powerful, emotional impact. A huge structure in Mexico City, the Polyforum Cultural Siqueiros, is covered inside and out with mammoth murals of acrylic paint on asbestos-cement panels and sculptured steel. Although the building is home for many cultural arts, the main feature is a gigantic floor, wall, and ceiling mural of incredible complexity entitled and dealing with the theme, *The March of Humanity on Earth and Toward the Cosmos.* It is overpowering to the senses, especially when accompanied with programmed lighting and sound. The exterior is a duodecagon, like a multicolored diamond, with over 11,000 square meters of painted surface. Each of its twelve huge facets contains a sculptured mural covering 274 square meters and ranges in subject matter from *Christ the Leader* (shown here) to *Atom as A Triumph of Peace over Destruction.* Also included are

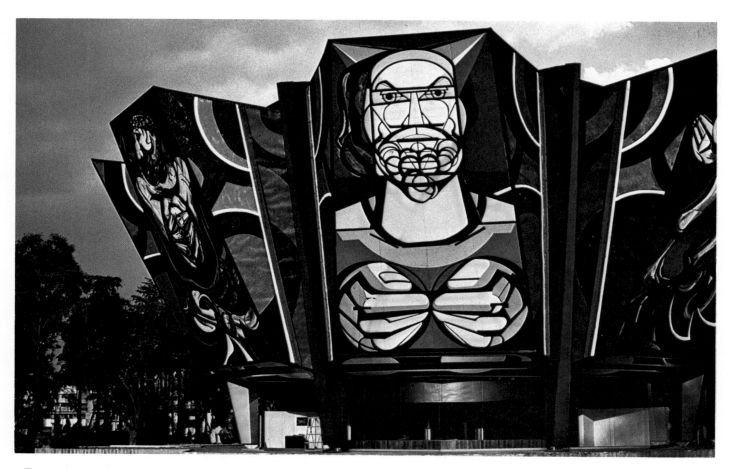

David Alfaro Siqueiros. Exterior, Polyforum Cultural
Siqueiros, 1974. Acrylic enamel on asbestos-cement and steel,
15 m high. Mexico City

Moses, the dance, the circus, flight, music, and mingled races, all presented with vivid colors and surging lines to present a gigantic outdoor gallery for the people of Mexico. Siqueiros' powerful, Expressionistic statements can also be seen in Chapters 2 and 3.

Abstract Art

Expressionistic artists were primarily concerned with the psychological and social drama of life and expressed their feelings in symbolic and/or personal ways. Artists working with abstraction were mainly concerned with the design on the canvas and how the various parts related to each other. Cezanne had believed and established that the canvas is and remains a flat surface when covered with paint. For him, a painting is not an imitation of nature but is canvas and paint. Correspondingly, the artist is not a camera that records nature but is a designer of pictorial space. The creative imagination of the painter determines how the space is used. It may be covered with a realistic representation (like a Corot), with non-objective or non-representational arrangements (like a Kandinsky), or with many combinations in between these extremes. To a certain extent, all painting is abstraction. No matter how realistic it looks, it is still not real but is an abstracted representation of the original model or landscape.

Degrees of abstraction or realism are dependent upon the way the artist sees the environment or envisions ideas and concepts. Most artists try a number of ways of expression before settling on one. Each finally works in a style that is comfortable, useful, and best expresses his or her visual communication. Twentieth century painters explored many avenues of expression for varying lengths of time, and almost all who were so inclined in 1910 tried their hands at Cubism.

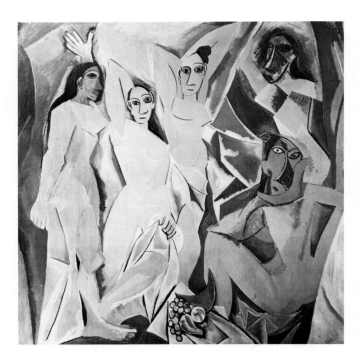

PABLO PICASSO. *Les Demoiselles d'Avignon*, 1907. Oil on canvas, 242 × 236 cm. The Museum of Modern Art, New York, acquired through the Lillie P. Bliss Bequest

CUBISM

Cubism was begun in 1907 by Pablo Picasso who was joined shortly by his good friend Georges Braque. Basing their philosophy of art on Paul Cezanne's ideas and their technique on his way of building up the surface with small squarish brushstrokes, they launched a new way of seeing and painting the world. Cubism is primarily concerned with surface design and pushes emotion and personal feelings out of consideration. What Picasso began in 1907 set the minds of creative artists on fire with ideas and possibilities undreamed of several years before. The creativity of the artists became all-important.

Pablo Picasso (1881–1974) Pablo Picasso casts a long shadow across the art of the twentieth century. A creative innovator of ideas and techniques and a master of many styles, he was constantly searching and changing during his long lifetime. Born in Spain and an excellent painter at nineteen, he moved to Paris to spend most of his years in France. His early "blue period" paintings were Expressionistic (*See* p. 387) and were followed by a more gracious "rose period" in which circus themes were explored.

The beginning of Cubism burst onto the twentieth century art scene with Picasso's painting *Les Demoiselles d'Avignon (The Maids of Avignon)* in 1907. Sketches reveal that Picasso began his painting with several other figures included in an interior setting. But what the viewer now sees are five fractured, nude figures and a small still life. As Picasso worked, he became aware of the relationships of shapes and colors to each other, and these relationships became more important than the figures. For six months he worked and reworked his design on the large canvas, and never really finished it completely. In an attempt to give his work a primitive feeling (like a Gauguin) he pushed the figures to a nearly Egyptian concept, especially the one on the left. He depersonalized the two central figures by giving them generalized faces. His introduction to geometrical African masks made such a strong impression on him that the faces of three of the nudes were overpainted with masklike features, adding to the discordant quality of the work. These newly introduced, sharp angles caused him to rework the entire surface, repeating the angular features of the masks in the figures and the related background. This interplay of geometric shapes led to Cubism.

The five women seem to be shocked at some unexplained sight, and such an emotional reaction is part of Picasso's link to Expressionism. Later, Cubism will entirely reject any emotional content and rely completely on interlocking, geometric surface arrangements. *Demoiselles* is therefore not a Cubist painting but is the painting that started the entire Cubist movement. The work does not show a view of people in the world but a milieu of its own of angular shapes and muted colors, a visual world that is difficult to explain with words. Cubism was given its name by critics who saw the hard edges and geometric shapes and nothing else. The unlovely ladies of Avignon had started a revolution.

Picasso took a fling at Fauvism but soon began to work with Georges Braque in developing true Cubism. Big, flat shapes were replaced by small, crisp facets and nearly monochromatic hues because bright hues would detract from the design. Picasso's painting of the art dealer *Daniel-Henry Kahnweiler* is an example of how Braque and Picasso both worked at this time. The features of the sitter are broken apart and reassembled in a new and unique way. Facial features, hands, and still life objects can be discerned, but it seems that if one looks away, they also will dissolve in a shattering pattern of translucent, geometric shapes. This mature style of Cubism is classic in its lack of emotion and concentration on the principles of design. It was later called *Analytical Cubism*

PABLO PICASSO. *Three Musicians*, 1921. Oil on canvas, 204 × 188 cm. Philadelphia Museum of Art, the A. E. Gallatin Collection

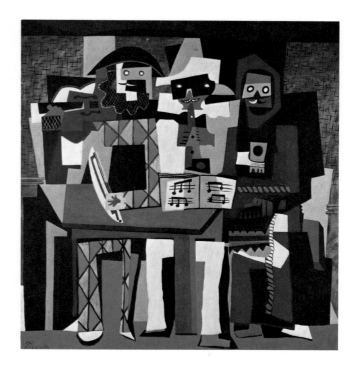

by art historians who saw an attempt to break apart or analyze the subject and view it from different perspectives simultaneously.

After World War I, the work of Picasso changed radically as one style blended into many others. His wonderful *Three Musicians* is painted to look like a huge collage of interlocking flat shapes and colors. After Picasso and Braque developed their collage technique, both artists moved on to creating paintings which appeared to have collaged papers in them but which were actually painted. They had begun to interchange reality (pasted papers) with simulation and played tricks on the viewer's senses. Recognizable images emerge again in this work as one can seen three figures: a Pierrot and a Harlequin from Italian comedic theater, and a Franciscan monk making music on a violin, a clarinet, and a zither. This unlikely trio is thrust forward from a

neutral background as the three happily play on their instruments. The color, shapes, and textures create a pleasant and happy composition, locked together as tightly as a finished jig-saw puzzle.

Following a 1917 trip to Italy where he saw many of the works of Giotto and Piero della Francesca, Picasso developed a way of painting monumental figures in a rather Classic style. His subjects seem to be a race of giants, painted in a solid, sculpture-like, monochromatic representation. He was working on these rather realistic paintings at the same time he was painting the flat, colorful shapes in his *Three Musicians*. The lightning changes in his style after Cubism are too many to study here, but one work must be included. It is his most powerful painting and one of the most devastating social protest pictures ever composed. Picasso painted *Guernica* as a commission for the Spanish government to exhibit at the Paris Exposition of 1937. The protest was against the massive April 1937 Nazi Luftwaffe bombing of the small Basque town of Guernica. The Spanish Fascists had hired the German airforce to completely destroy the village which was a center of resistance in the ongoing civil war. The painting becomes a powerful protest against the inhumanity of people against their kind—a

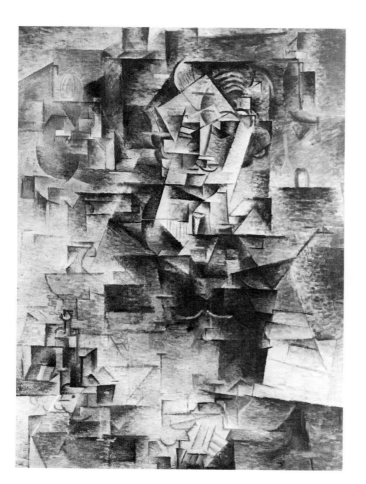

PABLO PICASSO. *Daniel-Henry Kahnweiler*, 1910. Oil on canvas, 101 × 73 cm. The Art Institute of Chicago, gift of Mrs. Gilbert W. Chapman

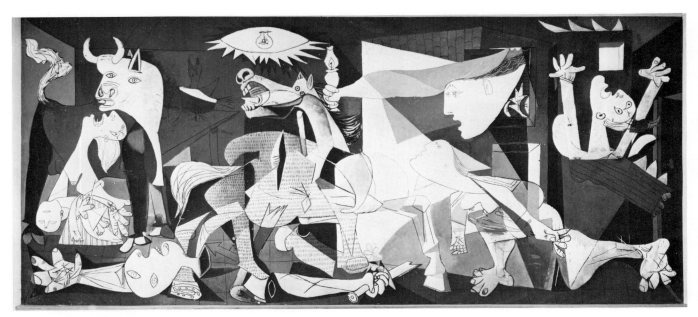

PABLO PICCASO. *Guernica*, 1937. Oil on canvas, 3.50 × 7.76 m.
Prado Museum. Madrid.

universal expression of emotion and shock. Picasso used a system of symbols drawn from Spanish folk culture and Christianity rather than present a realistic, Goya-like protest. By using flat, symbolic figures he was able to express extremes of suffering not possible in realistic representation. The people are all-important as actual destruction is shown only in a flaming building and some crumbling walls. A mother rushes screaming from a burning house, her arms flailing in the air. Agonized heads and arms reach out desperately from crumbling wreckage. At the left a mother holds her dead child and shrieks toward the heavens. The bull, a Spanish symbol of human irrationality, surveys the scene of carnage. The screeching horse is perhaps symbolic of Spain's torment yet it and other symbolism are never explained by the artist. The sun is mechanized with a light bulb, and textures simulate the newspaper write-ups that described the tragedy to a shocked world. Pain, agony, and chaos are everywhere, yet the design is solidly held together by a triangular composition. A broken sword symbolizes the absolute defeat of the people and the end of all hope. But out of the handle of the sword a flower grows, and hope is still alive. Picasso painted the enormous canvas in black, white, and gray to place the visual emphasis on the message as well as to develop a somber mood. *Guernica* combines Expressionism and Cubism in a mighty voice of protest and is Picasso's most dramatic work.

Although he painted continuously for the rest of his long life, most of his efforts were recapitulations and expansions of earlier styles and ideas. His prolific output is absolutely astounding and future historians will have to determine which works will live on as the best examples of his later years.

Georges Braque (1882–1963) Georges Braque worked closely with Picasso in developing the vocabulary of Cubism. As a result, many experts cannot tell some of their work apart during the analytical phase of the movement (1911–1912). The two artists next began adding actual bits of real objects to their canvases: newspaper clippings and headings, pieces of rope, bits of wallpaper, and even sand. Called collage (from the French word for glue or paste), they added a note of realism to the designed pictorial space. Following World War I, Braque worked on a series of figure paintings but finally settled on the still life as his basic subject. Using the fractured planes of Cubism, Braque carefully structured his space, abstracting from the set-ups to create beautiful designs. In *Still Life: The Table*, he uses several typical Braque techniques. The table top is tilted forward (more dramatically than anything Cezanne did) so that it becomes a background shape for the objects which often seem about to slide off the inclined surface. The viewer sees each object from a separate vantage point, something a camera cannot do. One can see into the top of

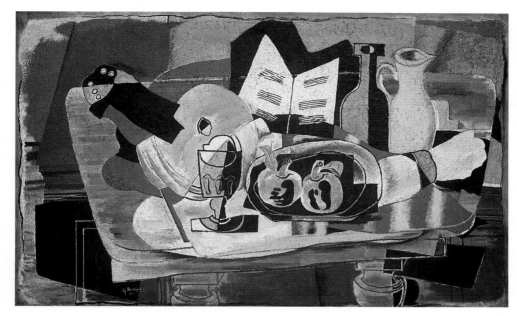

Georges Braque. *Still Life: The Table*, 1928. Oil on canvas, 81 × 131 cm. National Gallery of Art, Washington, D.C., Chester Dale Collection

Juan Gris. *Breakfast*, 1914. Pasted paper, crayon and oil on canvas, 83 × 59 cm. The Museum of Modern Art, New York, acquired through the Lillie P. Bliss Bequest

one bottle but not into that of its neighboring flask. The viewer looks down on the dish with the apples. The wine glass is seen straight on and in perspective at the same time: a characteristic called *simultaneity*. Notice how lines from the contour of one object can be found continuing in another place, causing the shapes and lines to weave a tight pattern over the surface. Colors and textures are brighter and more developed than in earlier Cubist paintings, as Braque's personal style is used to compose a sophisticated design based on simple objects.

Juan Gris (1887–1927) Juan Gris was born in Madrid but moved to Paris in 1906, living near Picasso, his Spanish countryman. He worked with Braque and Picasso in the analytical phase of Cubism and developed with them the technique of collage and Synthetic Cubism. The artists were no longer destroying the object but were trying to emphasize it again—to put it back together or synthesize it. In 1912 Picasso glued some wallpaper to one of his paintings, thus mixing reality (the paper) with illusion (the painting). Braque and Gris enlarged on this technique and Gris' work, *Breakfast,* is an excellent example. Wallpapers, simulated wood-grained paper, newspapers, and labels are adhered to the canvas. Their patterns are sometimes drawn and painted over and at other times are left alone to expose their authenticity. As in Braque's *Still Life,* the surface of Gris' table is vertical and still life objects are drawn onto it, each seen from a different vantage point. The design is carefully worked out so that unity is achieved through

balance, pattern, and movement. While Picasso worked in many styles during succeeding years, Braque and Gris remained active with their Cubist techniques the remainder of their lives.

Fernand Leger (1881–1955) Fernand Leger was among the many painters who were influenced by Cubism. First working in a kind of facet style, he soon became intrigued with the application of painting to his industrial environment. His industrial landscapes were the first of their kind as he even transformed humans into metal-like creatures. Using hard edges and often outlining shapes with heavy black lines, Leger changes geometric shapes into three-dimensional forms by his careful shading technique. In *The City*, the elements of urban industrialization are fractured and reassembled, including such features as lettering, stairs, scaffolding, people, poles, windows, structures, and machinery parts.

Marcel Duchamp (1887–1968) Marcel Duchamp created what was probably the most controversial painting of any artist working under the influences of Cubism. Although his *ready-mades* and the nonsense art of his *Dada* period would make him better known in the art world, his *Nude Descending a Staircase* brought him

LYONEL FEININGER. *Zirchow VII*, 1918. Oil on canvas, 81 × 101 cm. National Gallery of Art, Washington, D. C., gift of Julia Feininger

quickly to the attention of the public. Like many of the European and American artists during the first decade of the twentieth century, Duchamp exhibited his painting in the famous Armory Show in New York in 1913. It was America's first chance to see Cubism, Fauvism, Impressionism, and Post-Impressionism in a single exhibition—and the result was predictable. America's artists (even those who exhibited in the show) were appalled at how far they were behind the Europeans in their expression. America's public, used to seeing realistic representation, was absolutely irate. Although the Armory Show interested several art buyers in emerging twentieth century European styles, the general public was alienated by the artists and their new forms of communication. Duchamp's painting was the primary target of critical attack. Calling it "an explosion in a shingle factory," one critic forever made the painting famous and provoked the public into general derision of the entire show. Duchamp had fractured the movement of a figure as it descended the stairs, and the shapes *are* very shingle-like in their character. But Duchamp presents not one image but an entire series of movements, stopped in successive stages of action—similar to the result of stop-action or strobe-light photography. While viewers today understand that Duchamp

was painting motion, the public in 1913 could not comprehend his form of art and out of ignorance, laughed at the result.

Lyonel Feininger (1871–1956) Although he was born in New York, Lyonel Feininger spent a large portion of his productive life in Germany where he went to study music but instead became a cartoonist. His serious paintings, however, were the result of his interest in Cubism. He knew the members of *Die Brücke* and joined the *Blaue Reiter* to exhibit with them. Sailing ships and cityscapes were his favorite subjects and his faceting style included a Cubist technique called *contour continuation*. Edges of many shapes are continued outward until they hit the border of the canvas, creating new shapes as they intersect. In *Zirchow VII* these shapes are distinguishable because of contrasting values but the artist's subtle use of color changes makes such paintings glow with light as if the shapes were illuminated prisms. Notice how each facet is shaded to give it a feeling of form, yet together they do not create a literal representation of a church. Feininger's crisp design style is particularly appropriate for his urban subject matter.

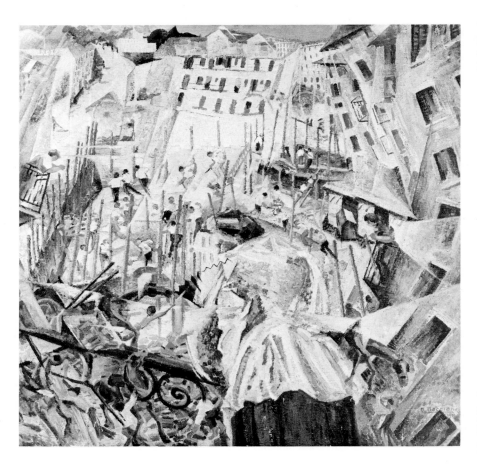

UMBERTO BOCCIONI. *The Noise of the Street Penetrates the House*, 1911. Oil on canvas, 100 × 100 cm. Lower Saxony National Gallery, Hannover, Germany

UMBERTO BOCCIONI. *Unique Forms of Continuity in Space*, 1913. Bronze, 111 cm high. Museum of Modern Art, New York, acquired through the Lillie P. Bliss Bequest

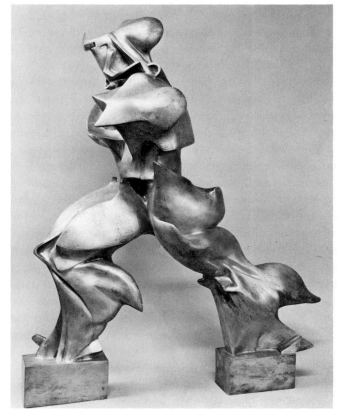

FUTURISM

During the first decades of the twentieth century, an Italian movement called *Futurism* was initiated by writers and soon picked up by the avant garde artists. Their interest was in the mechanized advancement of society and the destruction of all symbols of the past (museums, academies, and large cities) because they held up progress. Thankfully, this phase of their program was not successful. Their favorite word was "dynamism" by which they meant to show the "lines of force" which characterize various objects. The sense of movement generated in Duchamp's *Nude* was basic to Futurism.

Umberto Boccioni (1882–1916) The young leader of Italian Futurism, Umberto Boccioni died in an accident during World War I, and the movement died with him. In *The Noise of the Street Penetrates The House*, Boccioni combines the angular facets of Cubism with a tilting of planes to create a chaotic scene, filled with agitation and motion. People are working and children are playing as other people watch from balconies in a congested urban atmosphere of noise and confusing activity. Boccioni's finest achievement, however, was in sculpture. His

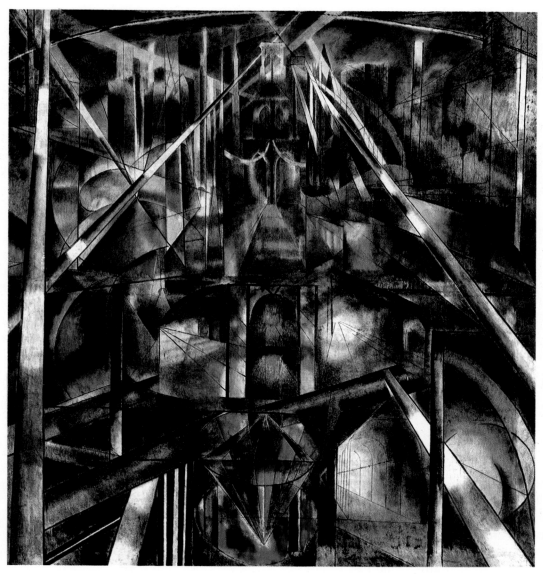

JOSEPH STELLA. *Brooklyn Bridge*, 1917–1918. Oil on canvas, 214 × 194 cm. Yale University Art Gallery, New Haven, Connecticut, collection of Société Anonyme

Unique Forms of Continuity in Space is a charging male figure caught in several aspects of walking at the same time. It is Duchamp's *Nude* in three dimensions. According to Boccioni, "motion and light destroy the materiality of bodies" and his sculpture goes about proving it. The forms seem to have been shaped by rushing air, whose currents seem to extend beyond the sculpture itself and also to penetrate the form in other places. Solid forms and space are merging and interlocking, causing the negative volumes to be as important as the positive. In this respect, Boccioni's figure recalls Bernini's *David*, and other Baroque sculpture, which interacts dynamically with its surrounding space. Yet Boccioni's work combines abstract rather than representational forms to produce a human-like result in vibrant movement.

Joseph Stella (1877–1946) Joseph Stella came from Italy to the United States when twenty-five but returned to his homeland when Futurism was in its developmental stages. His painting of the *Brooklyn Bridge* is a visual song of praise to a structure that was considered an industrial and engineering triumph. Such glorification of industrialization is a positive expression of twentieth century technology and is the opposite of German Expressionism, which saw such mechanization as dehumanizing. Towers, cables, and beams of light were all woven together with distant skyscrapers, tunnels, and water to create a dynamic vision of interlocking space, light, form, and color.

KASIMIR MALEVICH. *Suprematist Composition: White on White*, 1918. Oil on canvas, 80 × 80 cm. The Museum of Modern Art, New York

SUPREMATISM

Analytical Cubism broke objects and figures apart and assembled them in facets that almost hid them from recognition. Although recognizable elements remained, it followed that someone would soon produce a painting without any representational features, in other words, a total abstraction. Kandinsky did it first in 1910 and shortly after, a Russian artist, who had combined Cubism and Futurism with fascinating results, made the transition from abstract to non-objective painting in a single jump. Kasimir Malevich (1878–1935) proclaimed a new style which he called *Suprematism* when he exhibited a white-painted canvas containing a black square. The square represented nothing at all and demonstrated his theory that art "must leave behind all dependence on motif." Kandinsky's non-objective paintings were expressions of his feelings, but Malevich's expressed nothing. He limited his shapes to rectangles, circles, triangles, and crosses. No shading was permitted as everything was to appear perfectly flat. Five years later he produced *Suprematist Composition: White on White*, which was as abstract as he could get. The white square floats delicately and freely on a slightly different white background. The transition from figure to non-figure was completed.

CONSTRUCTIVISM

Constructivism was mainly a Russian movement brought to Moscow by Vladimir Tatlin after he saw the collages and constructions of Picasso in France. At first it was a form of sculpture that involved making abstract human figures of non-traditional materials such as cardboard, sheet metal, plastic, and wire. When Naum Gabo (1890–1966) returned to Moscow in 1917, he began constructing completely abstract works, some even containing motors to produce vibrations. His *Linear Construction*, done entirely in transparent plastic with plastic threads, changes the concept of sculptural volumes. Remember how Analytical Cubism allowed one to see several parts of an object at the same time? Gabo allows the viewer to experience such simultaneity in his sculptures. It is difficult to see what is sculpture and what is not, as volumes of space and of solid are not discernible. Every step one takes around the sculpture provides a different set of relationships. Volume is no longer mass surrounded by empty space as in Michelangelo's *David*. Space is no longer emptiness, but space and volume become one and the same.

NAUM GABO. *Linear Construction*, 1942. Plastic with plastic threads, 35.5 × 34.5 × 9 cm. Tate Gallery, London

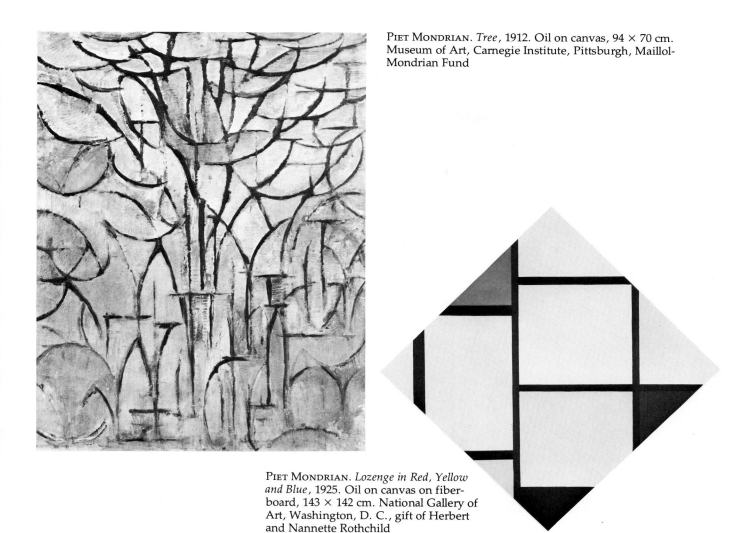

PIET MONDRIAN. *Tree*, 1912. Oil on canvas, 94 × 70 cm. Museum of Art, Carnegie Institute, Pittsburgh, Maillol-Mondrian Fund

PIET MONDRIAN. *Lozenge in Red, Yellow and Blue*, 1925. Oil on canvas on fiberboard, 143 × 142 cm. National Gallery of Art, Washington, D. C., gift of Herbert and Nannette Rothchild

DE STIJL (THE STYLE)

Interestingly, the roots of modern Expressionism can be traced to the Dutch artist, Vincent van Gogh, and the coldly intellectual approach to design to another Dutchman, Piet Mondrian (1872–1944). Coming from a tradition of Realistic painters (father and uncle), Mondrian traveled to Paris and back several times and rapidly changed styles from Realism to Impressionism, Post-Impressionism, and Cubism. He was gradually flattening his natural forms and reducing them to linear patterns as in the *Tree*. Natural color has been nearly eliminated as grays and blacks take over, and natural objects are reduced to lines. Returning to Holland, Mondrian led in the development of a non-representational style, called *De Stijl*, Dutch for *The Style*. He restricted his design to vertical and horizontal black lines and his colors to the three primary hues (red, blue, and yellow) plus black, white, and gray. By doing this, all possibility of representation was eliminated. *Lozenge in Red, Yellow and Blue* is one of about twenty of his paintings that are square and made to stand on one corner. It is an exercise in visual balance as the three primary colors are distributed around an imaginary center point. There is no center of interest, but the viewer's eye must see the whole design at one time. Every space is a different size; each line is a different thickness; and each "white" space is a different value of very light gray. The lines establish rhythms and the various values and hues create a sense of depth. Careful calculations and mathematical precision are essential to such a dehumanizing style of art. "But art," as Mondrian said, "systematically eliminates the world of nature and man." The basic precept of De Stijl—the complete reliance on design and the elimination of all feeling and emotion—was the exact opposite of Expressionism.

BEN NICHOLSON. *1964 (Lussios II)*, 1964. Oil on carved board, 50 × 41 cm. On loan to the Hirshhorn Museum, Washington, D. C. The Museum of Modern Art, New York, gift of H. S. Ede and the artist

Mondrian had no direct followers, although several Americans worked with vertical and horizontal shapes (*See* Chapter 15), and advertising and industrial artists made use of the concepts he had fostered. Yet the purist principles of Mondrian and of Malevich found a new voice in the exacting compositions of Ben Nicholson (1894–), an English sculptor and painter. Using rectangles and circles, he assembled shallow reliefs of wood and other flat materials and tinted them slightly. Painted Relief *1964 (Lussios II)* was part of an ongoing series of experiments with these basic materials and ideas. Some flat shapes seem to float above others in such works which are carefully balanced designs with no room for emotion. Viewing an exhibit of Nicholson's work, one is amazed that he could find so many variations on this theme and yet not repeat his designs.

Sculpture

There were no sculptural developments that closely paralleled Post-Impressionism or Expressionism even though these movements in painting were based somewhat on the interest in Sub-Equatorial African sculpture. Most of the sculptors received an early academic training, and while some adhered to more Classic traditions, others began to depart from them and stretch into more innovative and experimental areas.

Aristide Maillol (1861–1944) Starting his art career as a painter with the Nabis, Aristide Maillol soon felt more at home in three-dimensional art. He admired the simple strength of early Greek sculpture, and his female figures tend toward such Classicism. Sculptures such as his

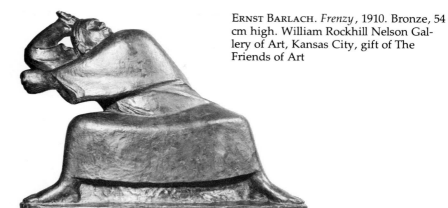

ARISTIDE MAILLOL. *Summer*, 1910.
Bronze, 163 cm high. National Gallery of
Art, Washington, D. C., Ailsa Mellon
Bruce Fund

ERNST BARLACH. *Frenzy*, 1910. Bronze, 54
cm high. William Rockhill Nelson Gal-
lery of Art, Kansas City, gift of The
Friends of Art

WILHELM LEHMBRUCK. *Seated Youth*,
1917. Composite tinted plaster, 103 cm
high. National Gallery of Art,
Washington, D.C., Andrew W. Mellon
Fund

bronze *Summer* have a calm and self-sufficient sense of harmony that a bustling twentieth century world cannot destroy. While Rodin had emphasized movement, his fellow Frenchman Maillol emphasized a static balance and feeling of serenity in his full-formed figures (*See* p. 53).

Wilhelm Lehmbruck (1881–1919) Wilhelm Lehmbruck was a German sculptor who came to work in Paris and was influenced by the expressive quality of Rodin and the Classic balance of Maillol. He combines these tendencies with a fascination for Gothic distortion to produce a highly personal style. *Seated Youth* is an angular, elongated piece that shows how this combination was used by Lehmbruck to produce expressive figures. By such severe distortion, the emaciated figure hardly has any mass but seems to be a network of thin solids encompassing a series of enclosed spaces. Lehmbruck worked in clay (as Rodin and Maillol had done) but rather than cast his work in bronze, he cast it in a composite mixture of pulverized stone and plaster or cement. Thus he could work in clay and still have a rough finish to his sculpture.

Ernst Barlach (1870–1938) Ernst Barlach was a German Expressionist sculptor whose simple, strong style was the result of a visit to Russia and of contact with the peasants and beggars and their folk art. He carved in wood but also cast bronzes, such as *Frenzy (Der Berserker)*, which expressed basic human emotions such as anger, fear, wrath, or grief. The large forms, simply sculpted, produce powerful works when combined with such elemental human traits. Often the figure is locked to the base and not cut free from the block, which seems to add weight and substance to the finished form. Notice how heavy *Frenzy* seems compared to *Seated Youth* through which air moves almost unimpeded.

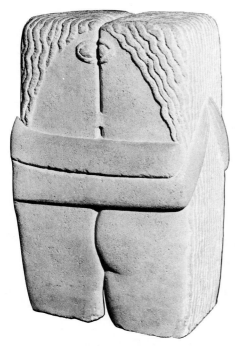

CONSTANTIN BRANCUSI. *The Kiss*, 1912. Limestone, 58 cm high. Philadelphia Museum of Art, Louise and Walter Arensberg Collection

CONSTANTIN BRANCUSI. *Bird in Space*, 1928. Bronze, 138 cm high. The Museum of Modern Art, New York

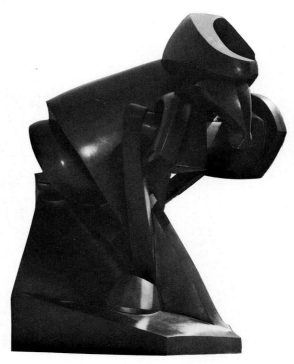

RAYMOND DUCHAMP-VILLON. *The Large Horse*, 1914. Bronze, 150 cm high. Los Angeles County Museum of Art, gift of Anna Bing Arnold

Constantin Brancusi (1876–1957) Constantin Brancusi, a Rumanian who came to Paris in 1904, got involved in the Abstractionist movement and incorporated such theories into his sculpture. He was a friend of Modigliani and induced him to work in sculpture also for a while. His limestone carving, *The Kiss,* shows his interest in simplification and elimination of detail, a characteristic of African art that he admired. He cherished the basic upright shape of the block of stone, considering it a strong and primitive form, and carved as little as possible in it. In such works as this, Brancusi was returning to the primitive sculptures of the past but with a touch of sophistication. Many of his later works stressed simplicity to the extent that they became abstract pieces of art, either based on the oval egg form or the soaring, vertical bird motifs—thus making Brancusi the first sculptor of abstract forms to completely eliminate normal representational reference and to emphasize the form itself. His *Bird in Space* is not a sculpture of a bird but of the essence of sensation of flight made visible and touchable. The high polish on the surface reflects surrounding space and objects and almost eliminates the form itself, uniting it with its environment.

Raymond Duchamp-Villon (1876–1918) The older brother of Marcel Duchamp, Raymond Duchamp-Villon died at an early age after showing great early promise as a sculptor. First working with the facet phase of Cubism, he soon developed a way of combining industrial forms from technology with the natural forms of animals. *The Large Horse* is a dynamic sculpture in which the tense forms of a rearing horse have become mechanized and translated into pistons, rods, and turbines—a sculpture of "horsepower" rather than of horseflesh.

Jacques Lipchitz (1891–1973) Born in Lithuania, Jacques Lipchitz worked in Paris during the Cubist period and spent the last thirty-two years of his life in the United States. He sculpted relief panels that were three-dimensional versions of Cubist still lifes but soon began to develop his sculptures in the round. Working with plasticine (a synthetic claylike material), he formed his works with his hands, later to be cast in bronze. *Figure*, typical of his Cubist-like transformations of human elements to geometric forms, is a disturbing sculpture whose eyes stare at the viewer from an oval cavity. The forms used in the body are not representational but are simply interlocking forms which suggest upraised arms, torso, and legs.

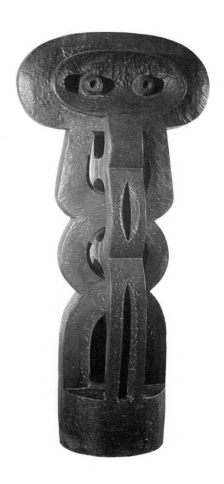

JACQUES LIPCHITZ. *Figure*, 1926–1930. Bronze, 119 cm high. Norton Simon Inc. Foundation, Los Angeles

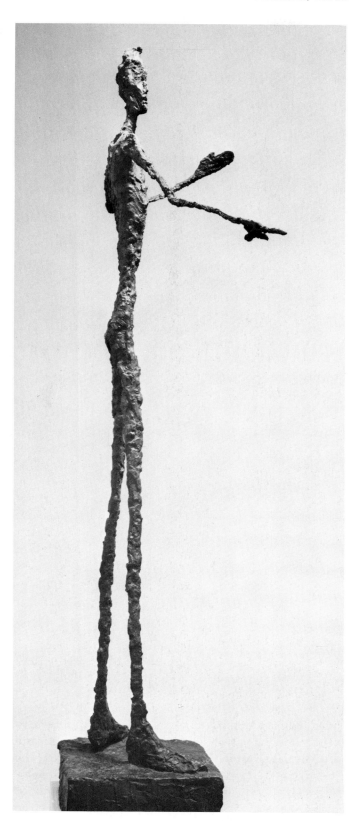

Alberto Giacometti (1901–1966) Alberto Giacometti was a Swiss sculptor who worked in Italy for several years before going to Paris to become involved with the Surrealist movement (*See* later in this chapter). After 1934 he started to work on a series of figure sculptures whose emaciated and elongated forms were first formed in plaster over a wire *armature*. The stick-thin figures, such as *Man Pointing*, have come to be recognized as a powerful symbol of the loneliness and alienation of humanity in this century. The personal symbolism and expressive quality of his figures place Giacometti in the realm of Expressionism even though he was not formally associated with any of the groups or brotherhoods.

From this wide range of sculptural expression grew the varied trends of three-dimensional expression in the later part of the century. With the advent of new materials and techniques, all of the former examples will seem rather traditional in comparison to the sculpture of the 1960s and later.

ALBERTO GIACOMETTI. *Man Pointing*, 1947. Bronze, 179 cm high. The Museum of Modern Art, New York, gift of Mrs. John D. Rockefeller

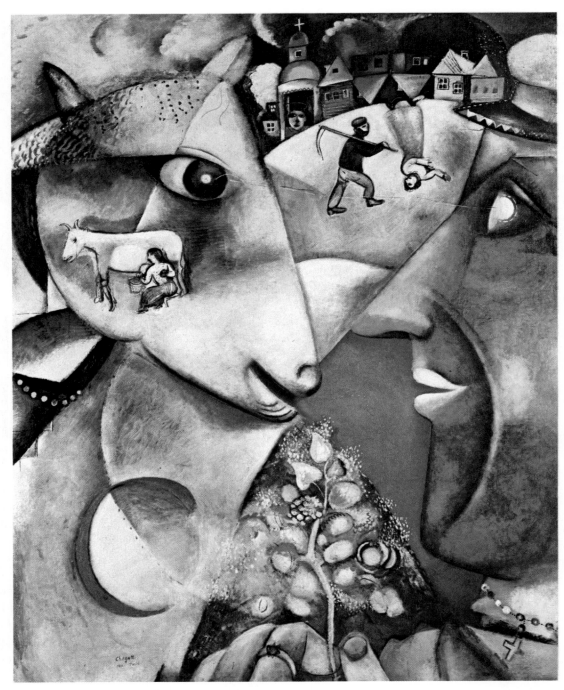

MARC CHAGALL. *I and the Village*, 1911. Oil on canvas, 192 × 151 cm. The Museum of Modern Art, New York, Mrs. Simon Guggenheim Fund

Fantasy Art

Like Expressionistic and Abstract art, Fantasy art springs from an earlier tradition. Greek mythology, the demons and monsters of the Middle Ages, the imagination of Bosch, the hideous nightmares of Goya, and even the personal symbolism of Munch, Redon, and Rousseau were attempts to visualize the fantasy world of human imagination. Although twentieth century citizens pride themselves in technology and scientific approaches, the world of psychological fantasy became the subject for the expressive work of many painters. Starting with individual artists, it was not long before groups such as the Dadaists and Surrealists were organized to

GIORGIO DE CHIRICO. *The Nostalgia of the Infinite*, 1911. Oil on canvas, 136 × 65 cm. The Museum of Modern Art, New York

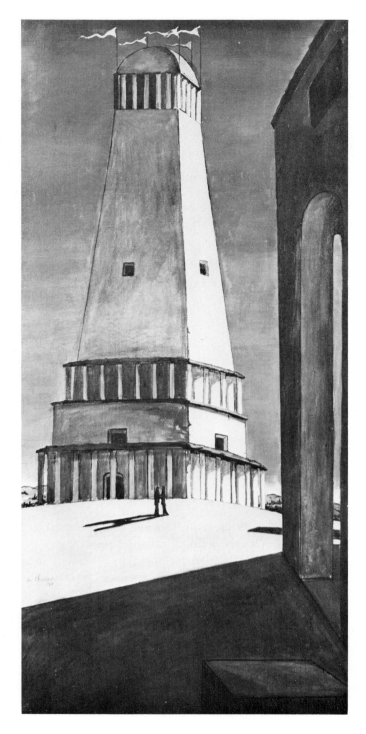

proclaim their philosophies in word as well as in paint. Their paintings often seem to be visualizations of their inner thoughts and an artistic parallel to the psychological probings of Sigmund Freud.

Marc Chagall (1887–1985) Marc Chagall was born in Russia but spent most of his life in France and the United States. Like Kandinsky and the Constructivists, he left his homeland for good after 1920 when the political climate was no longer conducive to personal expression and freedom of thought. Chagall's style is based somewhat on Cubism with its fractured planes, but his concepts and presentation are purely personal. His main subject is the Russia he remembered, a Russia of villages and fun-loving peasants, folklore, and fairy tales. Reality is mixed with happy remembrances and the result is a delightfully personal style that has charmed viewers in countries around the globe. In *I and the Village*, the cow dreams happily of a milk maid, lovers are on their way to the field (one right side up, the other upside down), the village street has several upside down houses, and a green-faced man holds a fantastic plant as he views the entire scene. Dreamlike memories, Jewish proverbs, and Russian folk tales are re-woven to create a new tapestry of Chagall's private thoughts. The viewer need not be discouraged by failing to understand the symbolism because Chagall himself says: "I do not understand them at all. They are not literature. They are only pictorial arrangements of images which obsess me." He has painted fantastic murals and ceilings, designed stage settings, produced lithographs and etchings, and created imaginative stained glass windows, all in his own personal style.

Giorgio de Chirico (1888–1978) Giorgio de Chirico was an Italian artist, born in Greece, who studied in Athens and Munich before coming to Paris in 1911. He showed no interest at all in Impressionism, Cubism, or Fauvism but produced a series of disturbing cityscapes which are crisp, clean, and altogether strange. Most of them, such as *The Nostalgia of the Infinite*, have buildings of tremendous solidity that are lit from the side so that long shadows are cast. Small figures produce a feeling of loneliness and despair because they appear to be the last beings left in the otherwise deserted city. Often an unexplained shadow creeps in from the side, a shadow without an object to cast it. Vast spaces and large flat areas of little texture create a sensation of impending doom. The Surrealist painters admired such early works of de Chirico who changed his style in later years to more traditional approaches and failed to live up to his early promise as an experimenter and leader in personal expression.

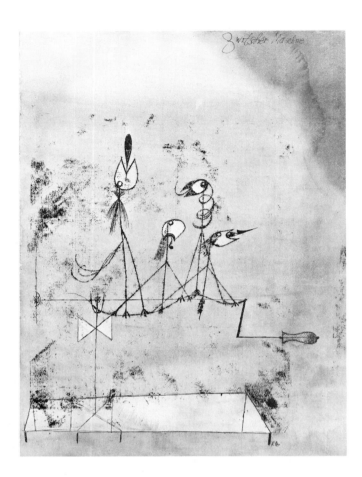

PAUL KLEE. *Twittering Machine*, 1922. Watercolor, pen, and ink on paper, 41 × 30 cm. The Museum of Modern Art, New York

JEAN (HANS) ARP. *Birds in an Aquarium*, 1920. Painted wood relief, 25 × 20 cm. The Museum of Modern Art, New York

Paul Klee (1879–1940) Paul Klee was a Swiss-born artist who was trained as a violinist and who spent most of his life in Germany. He settled in Munich in 1911 and joined Der Blaue Reiter while working in near poverty. His small watercolors, etchings, and drawings were done on his kitchen table while his wife gave piano lessons. He later taught at the Bauhaus and was a close friend of Kandinsky. Always interested in children's art, he developed a style which combined his personal wit with a childlike vision of the mysteries of life to create poetic statements of a very personal nature. Most of his work has a happy quality, such as the *Twittering Machine*, a delightful exercise in imagination. If the handle is cranked, perhaps bird sounds will be produced. Or is Klee trying to tell viewers something about their insane urge to create machines to do everything—even to make mechanical bird sounds? Or perhaps humanity's trust in natural things is not valid and machines can do everything. Klee supplies no answers. He only tickles the viewers' imaginations and sets them thinking—after they first smile a bit at his art and at themselves.

DADA

During World War I, a group of artists and writers gathered in Zurich to organize a protest against the complete degradation of European society as well as the monstrous destruction of such a war. Their protest took the form of nonsense poetry made of words snipped from pages and allowed to arrange themselves when dropped on the table. The name Dada originated from this nonsense attitude toward conventional language. Their protest also hit hard at traditional art forms which they ridiculed—even the avant garde artists of a few years earlier. Branches of Dada sprang up in New York (under the leadership of Marcel Duchamp), Berlin, Cologne, Hanover, and Paris as their anti-art doctrines spread across Europe and America. Artists used their personal styles to create spur-of-the-moment works but the message was the same: All European culture was decadent and void of meaning. Marcel Duchamp displayed his "ready-mades" which were found objects such as typewriters, bicycle wheels, or toilets and did not alter them at all, giving them fascinating titles. The Dada

movement created chaos in the art world, among the public, and even in its own ranks as members joined and left hurriedly and could not get along well with each other for any great length of time.

Jean (Hans) Arp (1887–1966) Jean (Hans) Arp was born in Strasbourg, a city which at times was German (his name was Hans) and at times French (his name was Jean). He made collages by cutting bits of paper and floating them to the floor where their accidental arrangement was made permanent by gluing them to a sheet of paper. Such unplanned work was a protest against both the design quality and the emotional expression of previous styles of art. He began cutting random bits of wood with a band saw, gluing them together, and adding paint to create relief sculptures which sometimes suggested visual images, such as *Birds in an Aquarium*. His *biomorphic* shapes are often whimsical in themselves or when put together spark viewers' imaginations to perceive whimsical scenes.

Max Ernst (1891–1976) Max Ernst was a German artist who made extensive use of collage techniques as well as working with oils. He was associated with the Dada movement in his earlier years, but spent much of his life in the United States working with the elements of Surrealism. His painting *La Mer (The Sea)* allows one to view the sea and shore confrontation through Ernst's own eyes and inner vision. Sand, water, and waves can be seen—or can they? Is that a sun and clouds above or a ball floating on water? Ernst presents a seascape of his own making, seen with unconventional eyes.

Kurt Schwitters (1887–1948) Kurt Schwitters was a scavenger who gathered junk items from everywhere to include in his art. The German artist did not portray these objects in paintings but glued them to a ground and added some paint to make pictures with them—*assemblages* that were partly three-dimensional. Works such as *Construction for Noble Ladies* might contain ticket stubs, candy wrappers, announcements, and bits of broken toys, wheels, boards, and assorted trash. Schwitters became the ultimate Dada master, using the refuse from a society he was demeaning to recycle into

KURT SCHWITTERS. *Construction for Noble Ladies*, 1919. Mixed media assemblage of wood, metal and paint, 103 × 84 cm. Los Angeles County Museum of Art

JOAN MIRO. *Women at Sunrise*, 1946. Oil on canvas, 38 × 61 cm. William Rockhill Nelson Gallery of Art, Kansas City

works of art for that same society to see. Viewers were of course disgusted at the sight of it, but the message was delivered.

As steam ran out of the Dada movement, its members began to work in varying styles and to proclaim different messages. In the rather peaceful years following the war, other movements would replace Dada, with Surrealism being the first and most direct descendant.

SURREALISM

Andre Breton was the instigator of Surrealism in 1924, but he was not even an artist. As a writer, he followed the Dada philosophy of allowing things to happen naturally in his work rather than put words together in a logical way. His emphasis on a dream world, word-association games, and unconscious writing was carried into the visual world by artists like Max Ernst and Hans Arp. In 1925 the first Surrealist group exhibition took place in Paris, featuring artists like Ernst, Arp, de Chirico, Klee, and Picasso. Another painter who would later form the heart of the Surrealist movement was Joan Miro while Rene Magritte, Salvador Dali, and Yves Tanguy would join in a few years. The work of these men was called Surrealism because they were getting "beneath the realistic surface of life" or into a dream world of unreality.

Early Surrealist work began with such chance techniques as rubbing a pencil over a paper placed on boards to see what the grain would suggest. Ernst used this technique and also spread paint at random on canvas and squashed it with paper to see what the resulting shapes and textures would suggest. Such techniques were visual extensions of Breton's unconscious writing and, like Dr. Rorschach's psychological ink-blot tests of 1921, were exercises in responding to and interpreting

visual data freely. Later extensions of this approach developed into sophisticated presentations of logical or recognizable subject matter in very illogical situations or in weird associations. Much of later Surrealism developed around personal symbols which were unexplained by the artists. For example, Salvador Dali presents green giraffes that are fully ablaze or limp watches draped over a table, but he never tells the viewer what they mean.

Joan Miro (1893–) Joan Miro charms the viewer with his Spanish wit and delightful menagerie of impossible animals and people. He uses black lines and flat shapes of red, yellow, blue, black, and white that often seem cut from paper and glued to the canvas. In *Women at Sunrise*, the shapes are suggestive of people, animals, and a rising sun, but at other times his shapes and lines are purely abstract and suggest nothing. His biomorphic shapes seem to float on a soft background and when they overlap become transparent or create another shape. In his later years, Miro also turned to abstract sculpture, using plastic and ceramic as his media. He also worked extensively with fibers, creating huge woven tapestry murals that repeat the colors, shapes, and lines of his paintings (*See* p. 45). His joyful expressions of life are contagious because viewers of his work in any media are caught up in his zest for living and his clever sense of humor.

Salvador Dali (1904–) Another Spaniard, Salvador Dali became the most famous Surrealist because of his flashy lifestyle when in New York and his work in the motion picture industry. His personal painting style, influenced at first by Picasso and Miro, soon developed into a magical presentation of incredible draftsmanship and three-dimensional space. *The Persistence of Memory*, perhaps his best known work, is a very small painting of

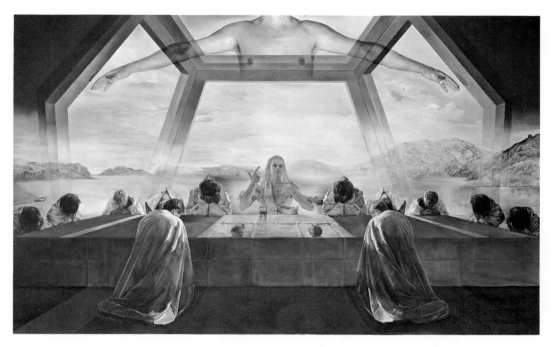

SALVADOR DALI. *Sacrament of the Last Supper*, 1955. Oil on canvas, 167 × 267 cm. National Gallery of Art, Washington, D. C., Chester Dale Collection

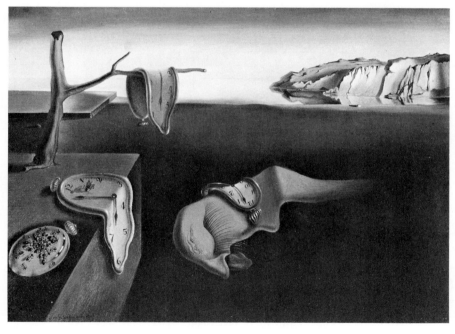

SALVADOR DALI. *The Persistence of Memory*, 1931. Oil on canvas, 24 × 33 cm. The Museum of Modern Art, New York

soft objects that represent things which are usually metallic and solid. He said that he got the idea for the painting while eating soft cheese. The limp watches, gigantic ants, and a partial face on a plain of immense depth are all startling objects, even today. They are placed in a natural setting with the rocky cliffs of Spain in the background. These cliffs and other private symbolism occur often in Dali's work. Dali uses exacting realism in every part of his paintings because, unlike Miro, he claims to "hate simplicity in all its forms," thus rejecting abstraction and any other simplified form of art.

Later in his life, Dali began painting religious subjects with his unique style and symbolism. The *Sacrament of the Last Supper* has many features similar to the deep-spaced *Persistence of Memory*, but the subject matter is entirely different. It at first recalls da Vinci's *Last Supper* in Milan, but upon closer examination Christ's body is translucent and a partial, symbolic torso is suspended in the air above the table. The floating segment of the

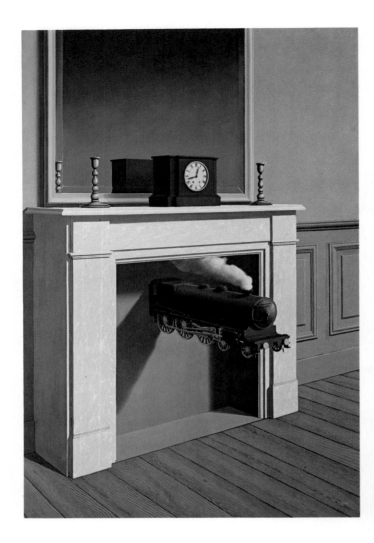

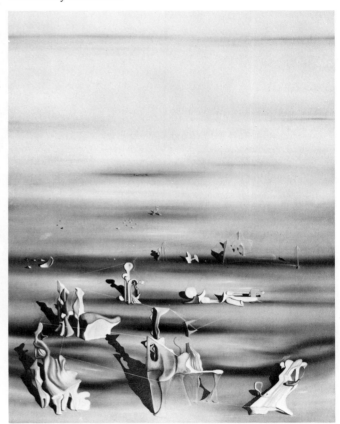

Rene Magritte. *Time Transfixed*, 1939. Oil on canvas, 146 × 97 cm. Art Institute of Chicago, Joseph Winterbotham Fund

Yves Tanguy. *The Furniture of Time*, 1939. Oil on canvas, 116 × 89 cm. The Museum of Modern Art, New York, James Thrall Soby Collection

dodecahedron (12-sided figure) is a symbol of the universe. The detail and painting technique are wonders of craftsmanship, and the composition is designed and carried out meticulously, very unlike the first Surrealistic paintings. The image, as in all Surrealist work, leaves the viewer with more questions than answers.

Rene Magritte (1898–1967) Rene Magritte was a Belgian artist who developed his own witty style of Surrealism based on absurd combinations of realistically painted objects. These juxtapositions both amuse and puzzle the viewer. In *Time Transfixed* a partially realistic scene of a crisp, clean, and detailed room is combined with a steaming train emerging from the fireplace. Each element is distinct but, as in Dali's art, the total work raises more questions than answers. Often, Surrealist artists themselves do not know their motives for such improbable combinations.

Yves Tanguy (1900–1955) Yves Tanguy was a French artist who developed a unique approach to Surrealism, placing three-dimensional biomorphic forms in fantastically deep space. Everything seems to be taking place on another planet peopled by strange creatures where all is seen in a cold blue light as if surrounded by a dreadful gas. Tanguy produced scenes such as *The Furniture of Time* without the benefit of formal art training, simply using his imagination and intuition. The carefully modeled forms and shadows hint at reality, but the forms themselves are like nothing ever seen on earth, except in the mind and paintings of Tanguy.

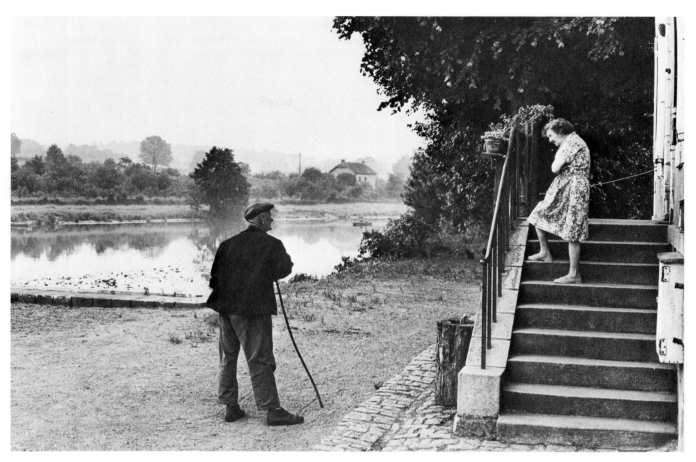

HENRI CARTIER-BRESSON. *Woman on Stairway Talking to a Man with Cane.* Silver print. The Detroit Institute of Arts, Michigan State Council for the Arts Exhibition Fund

Photography

While painters were experimenting in many directions, photographers attempted to keep pace but were limited in what their camera could do. As painters delved into abstraction, photographers continued to work with humanity and nature, and the public (which did not understand abstraction) became increasingly appreciative of the work of photographers. Travel in foreign countries, two world wars, and the publication of magazines like *Look, Life,* and *National Geographic* gave photographers plenty of opportunity for reportage—an area in which they excelled. Creative photographers searched for ways to interpret the everyday life of the world's peoples—human relationships, ugliness, poverty, tragedy, sympathy, love, joy, and the entire texture and emotion of humanity.

Henri Cartier-Bresson (1908–) became one of the finest reportage photographers, covering wars, travels, occupations, and the underground operations in France. He worked on several movies and had a one-man show

of his photographs in the Museum of Modern Art in New York. *Woman on Stairway Talking to a Man with Cane* is an excellent example of the human quality in his work. As carefully constructed as a fine painting, it has superb contrasts, excellent aerial perspective, balance, and the touch of human interest that sparks it to life.

The work of Edward Steichen (*See* p. 358) and Alfred Stieglitz (1864–1946) dominated the American scene. Stieglitz will be mentioned further as he affected the course of American art when he opened his New York studio for exhibitions of avant garde painters, sculptors, and photographers. In 1902 he organized a group called Photo-Secession which was dedicated to advancing photography as an art form. Others during the period included Ansel Adams (1902–1984) (*See* p. 501), Cecil Beaton (1904–1980), Werner Bischof (1916–1954), Peter Henry Emerson (1856–1936), Dorothea Lange (1895–1965), Arthur Rothstein (1915–), Paul Strand (1890–1976), and Edward Weston (1886–1958).

1900

Middle East	Syria divided, French and English (1920); Partitioned: Lebanon, Syria, Israel, Egypt (1948)
Islamic world	Islamic empires disintegrated (1918); Turkey united (1919); Oil promises new wealth
China	End of Qing dynasty (1911); Republican period; Japanese invasion; Peoples Republic (1949)
Japan	Russo-Japanese War (1904); Meiji period ends (1912); Hirohito; World War II (1941–1945)
India	Independence (1947), three states formed: Indian Union, Pakistan, Burma
S.E. Asia	Burma becomes independent; Malay Federation (1948); Indonesia rejects Dutch rule (1945)
Europe	World War I (1914–1918); Bolshevik Revolution; League of Nations; Freud; Hitler; World War II
Americas	World War I; Wright Brothers; Radio; Television; Stock Market Crash; World War II

1950

ART OF OTHER CULTURES

Europeans became aware of the art of Africa in the early twentieth century. While they did not understand the complex religious and mystical reasons for the creation of symbolic images, reliquary figures, or ornamental appendages, artists such as Picasso and Modigliani became fascinated with the simplified and exaggerated forms. Calling them "abstract" was a Western interpretation of the stylization and religiously symbolic statements of these images. The African craftsperson's use of geometric forms, linear patterns, disregard of traditional proportions, and personal coloration gave Europeans ideas which were later adapted into Cubism, Expressionism, Fauvism, and the work of the Nabis. A part of the left arm of this figure is missing (it is removable) and a recessed part of it was used as a reliquary for the "magic" charge.

Atop the head is carved a totem mask.

Early in the 20th Century, a distinctive Canadian painting style developed. Led by the *Group of Seven*, austere Canadian landscape subjects were explored and painted with bold color and flat patterns. The impetus for this visual treatment came from a show of Scandinavian art, seen by members of the group in a Buffalo, N.Y., show (an unplanned cross-cultural influence). The first exhibition of this group was held in Toronto in 1920, and these seven artists influenced Canadian painting until the group disbanded in 1933. The work of two members of the group is shown below.

Ancestor Figure. Suku tribe, Kwango River Area, Zaire Republic. Wood, 38 cm high. Collection of Carl K. Provost, Houston

FRANKLIN CARMICHAEL. *Mirror Lake*, 1929. Watercolor on paper, 44 × 54 cm. The McMichael Canadian Collection, Ontario, Gift of Mrs. R. G. Mastin

Analysis

1. Line is an important element of art; it can be found and used in many ways. Dufy and Rouault both used line as a major part of their work, but in no ways are their paintings alike. Analyze their work (look for other examples also) and write several paragraphs discussing their uses of line and its importance in their work. How would their paintings look *without* line?

2. Make three columns with headings of Classical (design oriented), Emotional (romantically oriented) and Balanced (in design and emotion). Then place the name of each artist studied in this chapter under one of the three headings. Base your decisions on their work as illustrated in this chapter.

3. Color is a major dynamic art element in painting and its uses are many. Arrange a slide (or print) show and discussion, comparing the role of color in the work of the Fauves, in the work of Cubist painters and in the work of German Expressionists.

Aesthetics

4. You are a young American painter in 1913 and are visiting New York. You stop in to see the Armory Show (see p. 409) and are astonished and excited by the work of the Impressionists, Post-Impressionists, Cubists, Fauves and Expressionists. In which style would you feel most comfortable? Why? Which artist in that movement could easily become your "inspirational leader?" Why?

5. Study and analyze *Guernica* by Picasso and *Third of May* by Goya. Both are powerful social statements, resulting from events that occurred during the artists' lives. Compare and contrast the content, style, use of color, purpose, size, visual impact, symbolism and your personal reaction to each work.

6. These four facial sculptures represent four contrasting styles, concepts and uses. Write an essay on one of the following ideas:

a) What effect did work such as the first two sculptures have on the last two?

b) Which are realistic and which are conceptual? Why?

c) Compare and contrast the African sculpture with Picasso's work.

d) Compare and contrast any two of the faces.

e) What features do you find common to all four sculptures? Explain.

Studio

7. "Facet Cubism" used flat geometric planes, much like the facets of a cut gem. Make a drawing of an apple or pear, using only triangles of various sizes and shapes to indicate the changes in light and form. You may do this as a line drawing, tempera painting or collage of different values of the same color.

8. Surrealism often visualized strange dreams or peculiar sensations or concepts. Experiment by making a dream painting in tempera or acrylic. Look at the styles of the Surrealists to get ideas of your own. You may also cut whole images and objects from magazines and arrange them into a fantasy collage developed around a single theme.

9. Paint a nonobjective composition in the style of Kandinsky. Remember that no recognizable objects can be included in the work. Give it a title which adds to its nonobjectivity. Include the use of the principles of design, but still try to make the painting free-wheeling and open.

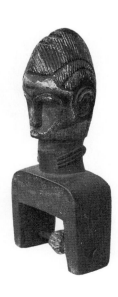

PABLO PICASSO. *Woman's Head*, 1909. Cubism. Bronze, 41 cm high. The Museum of Modern Art, New York

CONSTANTIN BRANCUSI. *Mademoiselle Pogany*, 1931. Abstractionism. Marble, 44 cm high. Philadelphia Museum of Art, gift of Mrs. Rodolph M. de Schauensee

Aphrodite, 2nd century B.C. Greek, from Armenia. Bronze, 30 cm high. The British Museum, London

Head of Figure, 20th century. Bauli, from Africa. Ornament for a pulley. Wood, 25 cm high. Collection of Joseph Gatto

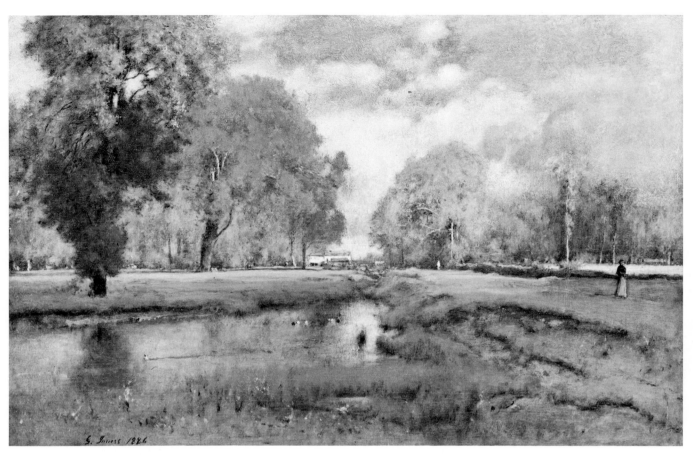

GEORGE INNESS. *October*, 1886. Oil on panel, 51 × 76 cm. Los Angeles County Museum of Art, Paul Rodman Mabury Collection

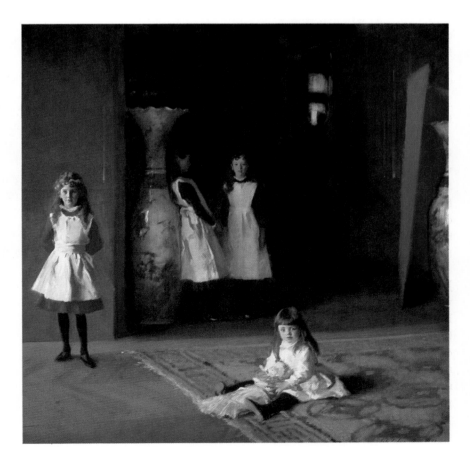

JOHN SINGER SARGENT. *Daughters of Edward D. Boit*, 1882. Oil on canvas, 211 × 211 cm. Museum of Fine Arts, Boston, gift of the daughters of Edward D. Boit

15 Exploring the Soul of Our Nation: American Art (1900–1950)

NO ONE BORN IN AMERICA in the early twentieth century could possibly envision the changes of the following several decades. The invention of automobiles, airplanes, movies, television, and a multitude of other scientific advances would change the country's (and the world's) lifestyle. A depression would stagger the economy and two world wars would be fought. Art was bound to reflect such dramatic changes. At the turn of the century the European public bristled at Impressionism and Post-Impressionism while the American public considered the rather soft pastels of Mary Cassatt as outrageous splashes of color. The American public was far more provincial in its taste but would soon be rudely awakened to art across the Atlantic. Eventually, after World War II, American artists became recognized as leaders and innovators by their contemporaries around the world.

Closing out the nineteenth century, painters like Mary Cassatt and James Abbott McNeill Whistler were still working in Europe while Winslow Homer and Thomas Eakins were painting the American scene and laying the foundations for the twentieth century artists. Several other artists were concluding their life's work as the twentieth century dawned, and they too were forming the basis for the new era in painting.

John Singer Sargent (1856–1925) John Singer Sargent was born in Europe of American parents and worked both in this country and Europe. He was a master portrait painter and also produced dozens of brilliant watercolors. Although many of his portraits were more formally arranged, his *Daughters of Edward D. Boit* is a masterful portrait painting of the four girls. Sargent painted the daughters of his artist-friend with the crisp and juicy brush strokes that characterize his portraits. Influenced by Velazquez in technique, color, and the casual arrangement of his figures, Sargent was the last of the fine portrait painters because the camera would now record family growth and personal appearance. Notice the large blue and white Japanese vases and the magnificent use of shadow and light which Sargent always handles with great ease. His flashy style and elegant portraits earned him many wealthy clients on two continents.

George Inness (1825–1894) George Inness admired the work of the Hudson River School painters when only a boy and went to Europe to study and be influenced by the landscapes of Corot, Courbet, Constable, and Turner. His gentle landscapes reflect his quiet personality, and while other American artists surpassed him in drama and imagination, Inness' landscapes were faithful to nature. The general effect of a place was always more important to him than the specific details. *October* is typical of the gentle moods he created. The muted colors and values of all are massed together to produce a definite feeling of place and time, in a statement that lacks specific details.

Albert Bierstadt (1830–1902) Born and trained in Europe, Albert Bierstadt's paintings usually reflect his interest in the Alps and other European locales. His landscapes of the American Rockies were dramatic to the point of often seeming to be staged especially for his dramatic lighting. Bierstadt accompanied surveying expeditions to the Rocky Mountains and made numerous sketches and photographs. His large paintings, like *The Rocky Mountains*, were composed from such sketches and painted in his New York studio. He romanticized

ALBERT BIERSTADT. *The Rocky Mountains*, 1863. Oil on canvas, 186 × 307 cm. The Metropolitan Museum of Art, New York, Rogers Fund

ALBERT PINKHAM RYDER. *Moonlight-Marine*, 1870–1890. Oil on wood, 29 × 30 cm. The Metropolitan Museum of Art, New York, Samuel D. Lee Fund

the West to look the way Easterners wanted it to look. His mountains were higher and more craggy, the gorges deeper, the reflections sharper, the waterfalls higher and the dramatic light sharper and clearer. Many critics claimed that he made the West look like the Swiss Alps with buffalo and Indians. He adds crowds of Indians and horses to the vast panorama and even shows his camera at the lower left. Such scenes soon drew people from the canyons of New York City to the new and glorious canyons of Western America.

Other painters also worked in a realistic style to capture the immensity and ruggedness of the American West or the serenity of the landscape of the Eastern seaboard. With those just mentioned, they established the basis for later American landscape painting. Among them were John Frederick Kensett, Frederick E. Church, Thomas Moran, Eastman Johnson, Frederic Remington, and Charles Russell.

Albert Pinkham Ryder (1847–1917) Albert Pinkham Ryder was a mystical figure in the world of art. Although he painted poetical landscapes, seascapes, and religious subjects, he rarely left his crowded apartment in New York but used his vivid imagination. He often painted all day and walked the streets at night, constantly

ROBERT HENRI. *Snow in New York*, 1902. Oil on canvas, 81 × 65 cm. National Gallery of Art, Washington, D.C. gift of Chester Dale

searching the sky for the visual effect of clouds, moonlight, wind, and rain. He sailed to Europe several times, not to study the art of the museums or to meet his contemporary artists, but to closely observe the sea and its movement, color, rhythms, and texture in various lighting conditions. In paintings such as *Moonlight-Marine*, Ryder carefully designed the large shapes and eliminated all detail as he created a mood in color, value, and texture. He often worked with thick layers of paint over long periods of time so that today some of his paintings are deeply cracked and checked. Mood was most important as he developed such paintings in his studio. He once said: "What avails a storm cloud accurate in color, if the storm is not within?" The storm is here, and the moonlight crackles as if it were lightning. Ryder's world is a dream world, based on remembered realities.

The American Scene

Photography eliminated most of the portrait commissions for artists but they were still in demand as illustrators, often sent to sketch events for newspapers or magazines. In 1908 eight of Philadelphia's illustrators banded together to put on an exhibition of their paintings, calling themselves *The Eight*. They were Expressionistic painters, trying to communicate their feelings about American life. They presented various aspects of city life in images of crowds, slums, clogged streets, ragged children, new bridges, circuses, sports events, clowns, and sunny afternoons. As their down-to-earth realism was exaggerated and often became expressions of ugliness and poverty, The Eight were jeeringly called "The Ashcan School." Their personal portrayals of America's urban life were not appreciated by the newly emerging middle class, the general public, or the National Academy of Design, who hesitated to call such Social Realism art. America had always favored Realism, but such visual social statements were disturbing. The public preferred gentle cows in a sunset or a beautiful

girl in a Grecian robe presenting a laurel wreath to some handsome winner. The Eight were more interested in the streets of New York and Philadelphia.

Robert Henri (1865–1929) Robert Henri, who pronounced his name "Hen-rye" to be as American as possible, became the leader of The Eight. He led by example and by teaching, urging his students and colleagues to paint the city and its people as they saw them and as they felt about what they saw. His own style used broad, juicy brush strokes in a direct way, much in the manner of Manet, Goya, and Hals. But he encouraged his students to paint in their own way and to expand the tradition of American Realism begun by Eakins. *Snow in New York* is one of many snow-clogged cityscapes which he painted in his broad, freely-brushed style. It is moody and clearly reflects Henri's knowledge and feeling about New York in winter. It is not the joyful snow scene of calendar painters but the cold, everyday, hard working reality of urban winters. Henri's great skill at rapidly brushed portraiture was exceptional, but portrait painters were becoming an endangered species. His studio became a regular meeting place for The Eight as well as other young and aspiring artists whom he encouraged and helped.

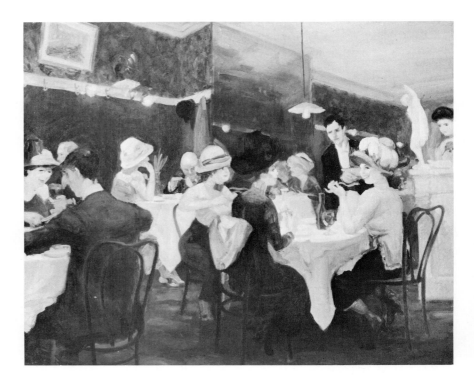

John Sloan (1871–1951) John Sloan was one of the most talented among The Eight and believed that a work of art need not have beautiful subject matter to be valid. The city subjects could be beautiful or ugly, but the beauty of the painting was in the work itself, not in the subject. Sloan enjoyed painting any city scene and set up his easel in any street. People sitting on the steps, women drying their hair on a rooftop, or a woman hanging out her Monday's washing on a line could all become subject matter for Sloan's creative mind. *Renganeschi's Saturday Night* is simply a scene in an urban restaurant, rapidly brushed on canvas by an observant artist. No academic artist of the time would consider this subject matter but Sloan filled the room with joy and delight. His work was slow to sell, but he continued to paint because he understood life in the city, fully enjoyed the people and their daily activities, and found pleasure in the pursuit.

William Glackens (1870–1938) Admiring the work of the Impressionists, William Glackens sailed to Europe to study their paintings and technique. He enjoyed painting the entertainers, vaudeville acts, and their audiences in New York. He painted his wife and her friends in everyday clothes, doing such common chores as housework and shopping. The public again preferred their subjects wearing fancy clothes and partying, so few of Glackens' works sold. *Family Group* is a vividly colored, Impressionistic treatment of family members sitting in a parlor. Glackens was greatly influenced by Renoir at this

stage of his painting as he gave up his monochromatic palette and the dark colors of Henri and introduced more joyful color into his work. Most of Glackens' work is of indoor scenes such as living rooms, kitchens, parlors, motels, theaters, and restaurants while other members of The Eight worked more with outdoor subject matter.

George Bellows (1882–1925) George Bellows was the youngest member ever elected to the National Academy of Design (twenty-six years old) and was also a prize student of Robert Henri. He was a tall, young man and an exceptional high school athlete who loved to draw. In New York, he earned extra money by playing semi-pro baseball on weekends, and his interest in sports led him to paint several boxing scenes of bouts in New York's private clubs. But he also loved to paint the unbelievable clutter and congestion of New York's East Side slums where thousands of immigrants shouted in languages he could not understand. The whole scene excited him immensely. He painted scenes of naked boys swimming in the East River, dock workers, smoky saloons, and huge horses. *Cliff Dwellers* is a clever title for a painting of the tenement dwellers of New York City. Bellows took the mass confusion of elements and organized a simple composition of darks and lights, eliminating much of the detail of the actual scene. The activity in the painting is intense and varied yet is handled with care and compassion by an artist who felt keenly the confusion and needs of these people.

WILLIAM GLACKENS. *Family Group*, 1910–1911. Oil on canvas, 183 × 213 cm. National Gallery of Art, Washington D. C., gift of Mr. and Mrs. Ira Glackens

GEORGE BELLOWS. *Cliff Dwellers*, 1913. Oil on canvas, 100 × 105 cm. Los Angeles County Museum of Art

JOHN MARIN. *Singer Building*, 1921. Watercolor on paper, 67 × 54 cm. Philadelphia Museum of Art, The Alfred Stieglitz Collection

JOHN MARIN. *Sunset, Casco Bay*, 1936. Watercolor on paper, 54 × 67 cm. Wichita Art Museum, Kansas, the Roland P. Murdock Collection

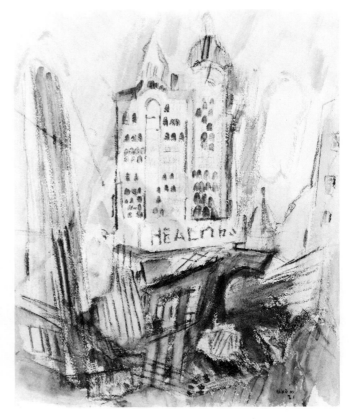

The original exhibition of The Eight also included: George Luks, Everett Shinn, Maurice Prendergast, Ernest Lawson, and Arthur B. Davies (Bellows was not part of the group). Although they had no more group shows for themselves, members of The Eight were responsible for organizing The Armory Show of 1913, which changed the entire character of American art (*See* p. 409).

The Influence of Abstraction

If The Eight had trouble with Americans' accepting their efforts as art, a small group of Abstract painters had a greater struggle. Looking to Europeans like Matisse and Picasso for ideas and directions, American Abstractionists met massive public ridicule. While the Europeans had seen the gradual development of Abstraction, Americans could not comprehend the sudden differences and wanted more reality in art rather than less. But Abstraction persisted, and Americans, wishing to be part of the movement, had to go to Europe to learn and to be appreciated. In America there was one stronghold for the young experimenters—the studio of master photographer Alfred Stieglitz. He admired the work of Cezanne, Rodin, Brancusi, and Picasso and encouraged

young American Abstractionists, showing their work in his New York studio.

In 1913 the New York Armory Show, as stated earlier, opened American eyes to the European art scene. Despite negative public reaction, several perceptive patrons began buying the work of the European avant grade. American artists then realized that they either had to change direction or be eliminated from the art scene by their European contemporaries. Following World War I, American artists flocked to France and worked hard to attain a stature comparable to that of the French artists. The work of Americans Lyonel Feininger (*See* p. 409) and Joseph Stella (*See* p. 411) were known on both continents, and many of the European experimenters spent the years after World War I in American cities. Gradually the attitude of provincialism in this country changed, and Abstraction became an important element in American art, though not fully accepted by the public.

John Marin (1870–1953) John Marin studied to be an architect but after a trip to Europe, where he worked with Whistler, he returned to paint and exhibit in the Armory Show. He was among the first Americans to experiment with Abstract art, and his paintings have a Cubist feeling, in which soft lines break up the larger

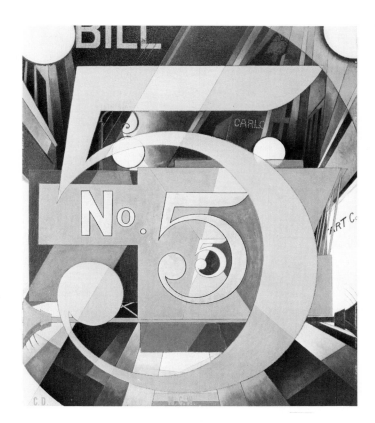

CHARLES DEMUTH. *I Saw the Figure Five in Gold*, 1928. Oil on composition board, 91 × 75 cm. The Metropolitan Museum of Art, New York, The Alfred Stieglitz Collection

shapes. Much of his work, such as *Singer Building*, explores cityscapes, although he later concentrated on Maine landscapes and seascapes. He often painted in watercolor so he could work quickly in his own personal shorthand style, which expressed a sense of agitation and excitement. His paintings explode with color, line, and a dynamic geometry that seems in constant motion. He said once that he could see and feel the "warring of great and small buildings in the city . . . and hear the sound of their strife." He once compared his brisk painting style to a golf game—the fewer strokes, the better. Although his paintings seem quickly done, they were carefully thought out before his brush first touched paper.

Charles Demuth (1883–1935) Charles Demuth was born in Pennsylvania and after studying in Philadelphia, went to Paris. His early works were mostly Cubistic watercolors of delicate, beautifully drawn houses, landscapes, grain elevators, acrobats, and circus performers. Later he painted in oils and worked on a series that he called "posters" although they were not meant for that purpose. One was *I Saw the Figure Five in Gold*, based on a poem which his friend William Carlos Williams had written. Both the poem and the painting recall a shrieking fire engine tearing through the darkened city streets on a wet night. The name of the poet "Bill" and "Carlo" appear in the Cubist design along with the roaring number five. The painting became Demuth's best known work.

Max Weber (1881–1961) Max Weber was born in Russia and studied in Paris but became an American citizen and a good friend of Stieglitz. For a long time his work was so *eclectic* that it seems he painted like everyone in Europe—everyone except Max Weber. *Rush Hour, New York* was painted in 1915, shortly after the Armory Show, and is in the style of the Italian Futurists (*See* Boccioni's painting, p. 410). His message about the city is the same as Marin's, but his style is not as original. He later developed an Expressionistic style of his own and gradually received more favorable treatment from his contemporaries and the critics.

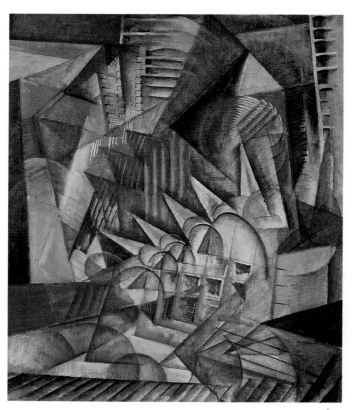

MAX WEBER. *Rush Hour, New York*, 1915. Oil on canvas, 92 × 77 cm. National Gallery of Art, Washington D. C., gift of Avalon Foundation

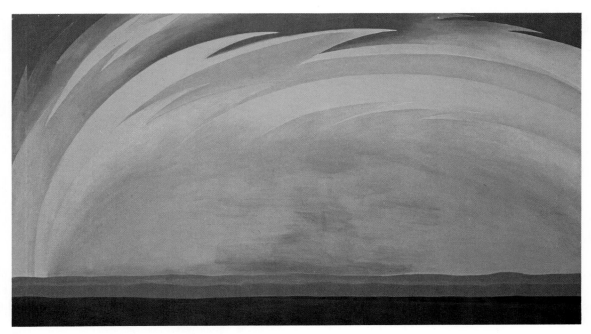

Georgia O'Keeffe. *From the Plains I*, 1953. Oil on canvas, 122 × 214 cm. McNay Art Institute, San Antonio, Texas

Stuart Davis. *Something on the Eight Ball*, 1954. Oil on canvas, 142 × 114 cm. Philadelphia Museum of Art, Beatrice Pastorius Turner Fund

Georgia O'Keeffe (1887–1986) Georgia O'Keeffe was born in Wisconsin and studied and taught in Chicago, Virginia, and South Carolina before working with the schools in west Texas. Her early representational work did not satisfy her, and she began making abstract drawings of land forms from memory. These sketches came to the attention of Stieglitz who admired them and gave her a one-person show in his studio in 1917. Their friendship developed into a marriage in which both artists grew in stature together. Her earlier subjects were gigantic close-up paintings of flowers or flower parts. She said: "I'll make them big like the huge buildings going up. People will be startled; they'll have to look at them." Nature's abstract forms always pleased her and when Stieglitz died, she returned to her beloved desert landscape and settled in New Mexico. *From the Plains I* is a powerful and dramatic work that captures the austere and quiet vastness of the plains. The painting is in yellow, red, and orange hues which adds a hot and savage feeling to a flat land where no monumental mountain breaks the horizon line but where the horizon line itself becomes monumental.

Stuart Davis (1894–1964) Stuart Davis was a student of Robert Henri and showed several Realistic paintings (and even sold one) in the Armory Show. But his exposure to Cubism, Fauvism, and the rest of European experimentation had such an impact upon him that he never painted or saw the world in the same way. The abstract style he developed formed the bridge between

BURGOYNE DILLER. *Second Theme*, 1937–1938. Oil on canvas, 76 × 76 cm. The Metropolitan Museum of Art, New York, George A. Hearn Fund

values. The possibilities of such interesting arrangements are endless and more important, the Geometric Abstractionists demonstrate the beauty of mathematical precision and the comfortable feeling of predictable arrangements of interlocking shapes and lines.

Charles Sheeler (1883–1965) Charles Sheeler worked with another kind of precision. After going through several phases and styles, he found himself close to the thinking and design of the great and cool Renaissance designers, such as Raphael and Piero della Francesca. Instead of people, however, Sheeler used machinery, buildings, and manufactured products as his subject because he enjoyed their geometric lines and solid structure. His intense interest in photography led him to believe that light is the great designer. His carefully composed paintings, such as *City Interior*, combine the structure of abstraction with a realistic presentation of subject matter. As precisely put together as Burgoyne Diller's abstraction (and equally as free of emotion), this painting combines interlocking darks and lights, verticals, and horizontals, and lines and shapes. While several Americans painted the cities and the industrial scene with similar careful attention to design and detail, Sheeler was better than most. These artists are loosely grouped together and called The Precisionists.

European Cubism and American Abstract Expressionism later in the century. From a series of experiments in color and shape, Davis finally developed a style of hard edge abstraction that was clean, colorful, and personal, and which sizzled with life and a jazz beat (a type of music which he loved). Often reflecting the words, numbers, shapes, and colors of urban life, congestion, and advertising, works such as *Something on the Eight Ball* are bright, joyful, and carefully composed. He had the rare ability to reduce the complexities of his urban environment to rhythmic and electric designs which matched any work by Leger, Feininger, Matisse, or Mondrian. His unique paintings have the appearance of flat cut-outs of brightly colored paper, of interlocking strips overlaid with parts of words and numbers. Davis' titles are personal and are not literal references to the paintings. Each work is to be enjoyed as seen, not as a mystical configuration. Davis worked with his powerful abstractions well into the second half of the twentieth century.

Burgoyne Diller (1906–1965) Burgoyne Diller developed a style of abstraction based on the work of Mondrian. Working with vertical and horizontal lines, shapes, primary colors, right angles, and asymmetric composition, Diller designed his works according to the principles of Geometric Abstraction. *Second Theme* is as carefully constructed as any of Mondrian's compositions, as Diller used a varying width of line, negative spaces of varying sizes and shapes, and contrasting colors and

CHARLES SHEELER. *City Interior*, 1936. Oil on fiberboard, 56 × 69 cm. Worcester Art Museum, Massachusetts

MARK TOBEY. *Broadway*, about 1936. Tempera on Masonite
board, 66 × 49 cm. The Metropolitan Museum of Art, New
York, Arthur H. Hearn Fund

ARSHILE GORKY. *The Liver is the Cock's Comb*, 1944. Oil on canvas, 182 × 248 cm. Albright-Knox Art Gallery, Buffalo, gift of Seymour H. Knox

Mark Tobey (1890–1976) Mark Tobey started his career as an illustrator and portrait painter. After settling in Seattle to teach art, he traveled to China in 1934—a trip which completely changed his life and art. He studied Oriental brush drawing and was convinced that the Western and Eastern art worlds should be combined. To help accomplish this end, he invented what he called "white writing," a white calligraphic line drawn on a dark background (the reverse of Oriental writing). Many of his white line paintings were completely abstract, being just joyful and pleasant calligraphy. Others, such as *Broadway*, were linear drawings that recall the noise, congestion, and visual clutter of the large cities. The viewer senses bustling people, blinking signs, towering buildings, and rushing cars in crowded streets, and enjoys the overall network of squiggly lines. Tobey has woven a textured fabric of all the elements of a city street which conveys the rhythm and excitement of the city. Both Sheeler and Tobey looked at American cities, but each wished to express his findings in different ways— one with hard, tight, and mechanical precision, the other with a loose, calligraphic, and Oriental quality.

Arshile Gorky (1904–1948) Coming to America from Armenia when he was sixteen, Gorky became the pioneer of an American artistic revolution later called *Abstract Expressionism*. He worked his way through various early phases and "isms" and was particularly interested in Surrealism. Yet his major contribution was in developing a unique style of abstraction founded on his personal feelings and inner thoughts. His work is sometimes based on the abstracting of representational objects, but the development of shapes and colors is so personal that one cannot often recognize them and is forced to view the work without recognizable symbols. The shapes, lines, and colors in *The Liver is the Cock's Comb* are organic (not geometric) and appear to be floating and turning in congested space. They seem almost human, but soon the resemblance vanishes and only shapes, lines, and colors remain. This sensation comes and goes, leaving one with ambiguous feelings. Each viewer must interpret the result in his or her own way. Gorky does not provide a clue, nor does the title help. His titles, like those of Stuart Davis, are personal and were perhaps pertinent when the work was finished.

WALT KUHN. *The Blue Clown*, 1931. Oil on canvas, 76 × 64 cm. Whitney Museum of American Art, New York

The American public was still more interested in representational paintings and made little attempt to understand the language and meaning of the Abstractionists. Thus, the artists worked in isolation, receiving encouragement from each other and from a small but growing element of society comprising patrons, museums, and galleries.

America Rediscovered

The American art establishment made a giant swing from Realism to Abstraction following the Armory Show, but the public did not join in this change of attitude. They were still confused by Abstraction and felt more comfortable with Realism. Many artists were ready to satisfy their needs. Because they painted the farmlands and the cities of America in a realistic way, some of them were called American Scene painters. Each had an individual style, but the message was the same: America is vast, beautiful, abundant, lonely, crowded, and full of honest, hard working people.

Walt Kuhn (1880–1949) Walt Kuhn fits into several periods of American art since he was one of the organizers of the Armory Show and also painted until mid-century. He could not change his painting style to adapt to the modern Abstractionism as others did even though he met the leading members of the avant garde in Europe. However, after his return to New York, his work took on a heightened use of color and a feeling of greater solidity. He continued to work realistically, painting dramatic studies of clowns and circus performers. He had worked in circuses himself and painted his subjects with knowledge and compassion. He would catch his models, like *The Blue Clown*, in off-duty moments and in moods of reflection. He was able to portray their sense of dignity and pride, of sadness and loneliness, as well as the feeling of continuing drama in which they lived and worked.

Edward Hopper (1882–1967) Edward Hopper was one of Robert Henri's most talented pupils. He sold a single painting at the Armory Show but continued to work at his own brand of Realism, despite a trip to Europe and the increasing importance of Abstractionism in America. He was sensitive to human emotions and was acutely conscious of the loneliness of life in the big cities. He painted America from the inside out, concentrating on its feelings rather than the visibly evident. He closely observed the sadness of cheap hotel rooms, empty diners, cool nights, lonely people, and cheerless houses. *Nighthawks* is a powerful and dramatic portrayal of loneliness. Hopper traveled from place to place and made mental notes of what he saw, later to put them together to express his feelings on American life. Most of his carefully structured designs deal with American cities but are treated in a different way from those of Sheeler or Tobey. The massive and simplified forms of houses and buildings take on a monumental quality, and the large open spaces are strongly suggestive of emptiness and loneliness. His strong light is always garish and piercing as it exposes its subjects as if putting them under a glaring spotlight (*See* p. 64 and p. 449).

Charles Burchfield (1893–1967) One of Americas most independent artists, Charles Burchfield developed a unique style of painting. Working mostly in watercolor, he progressed through several distinct periods and stages, beginning with an imaginative approach to painting nature. In the thirties, he worked in the realistic

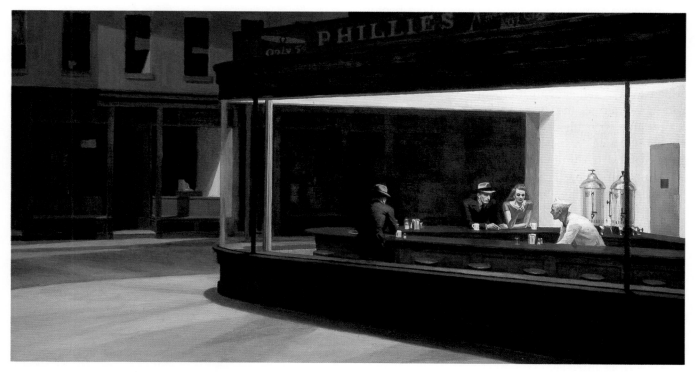

EDWARD HOPPER. *Nighthawks*, 1942. Oil on canvas, 76 × 152 cm. The Art Institute of Chicago, Friends of American Art Collection

CHARLES BURCHFIELD. *Sun and Rocks*, 1950. Watercolor on paper, 102 × 142 cm. Albright-Knox Art Gallery, Buffalo, New York

style of the American Scene painters and painted the cities and farms of mid-America. But he was not satisfied and returned to nature as his subject, interpreting it in his own unique way. *Sun and Rocks* is a landscape one has never seen, but which Burchfield felt and heard. His own feelings about landscape painting reveal his attitude in this painting: "You cannot experience a landscape until you have felt all its discomforts. You have to fight mosquitoes, be slapped by stinging branches, fall over rocks and skin your knees, be stung by nettles, scratched by grasshopper grass and pricked by brambles . . . before you have really experienced the world of nature." Burchfield did not paint pretty landscapes but the ruggedness and power, the sounds and heat, the harshness and eternal joy of nature—the vibrating pulsations of growing things.

Thomas Hart Benton (1889–1975) Thomas Hart Benton also developed a unique painting style and limited his subject matter to the history and activities of typical midwestern farmers—subjects he knew best. Sun-burned farmers, sturdy horses, and furrowed fields appealed to him rather than the people of Paris or New York. He tried all the avant garde styles but only felt comfortable with his own brand of Realism. *The Kentuckian* illustrates a historical subject (which he loved to paint) and his unique style of painting (which no one imitated). There is a slight distortion of humans, plant life, and nature, but the strongly-lit forms, deep shadows, and simplified design create a realistic image filtered through a personal style. Benton was the leader of a group of midwestern artists known as the Regionalists because they developed independent styles and limited their subject matter to the regions in which they lived.

Grant Wood (1892–1941) Grant Wood was another of the Regionalists or painters of the American Scene. Benton was from Missouri and Wood from Iowa. Several trips to Europe interested Wood in the exquisite detail of the early Flemish masters rather than the bombastic abstractions of Paris. His paintings, such as *Stone City, Iowa*, reflect this fascination with detail, but again it is filtered through a Midwestern imagination to produce trees and hills that are smoothly rounded and expertly trimmed to perfection. His work is painstakingly de-

THOMAS HART BENTON. *The Kentuckian*, 1954. Oil on canvas, 93 × 52.5 cm. Los Angeles County Museum of Art, gift of Burt Lancaster

GRANT WOOD. *Stone City, Iowa*, 1930. Oil on wood panel, 77 × 102 cm. Joslyn Art Museum, Omaha, Nebraska

BEN SHAHN. *Handball*, 1939. Tempera on paper over composition board, 57 × 80 cm. The Museum of Modern Art, New York, Abby Aldrich Rockefeller Fund

signed, drawn, and painted to present a clean and crisp world of farmers, farms, countrysides, and people—an idealized American Scene.

The third artist of the mid-American scene was John Steuart Curry (1897–1946) of Kansas who developed a slightly different style but still dealt with Midwestern farm life as his main subject matter.

Social Realism

During and immediately following the Great Depression of the early 1930s, the United States was in a period of mass unemployment, hard times, and near social panic. Outside influences, such as totalitarianism, socialism, and communism cast threatening shadows over the country. In reaction to this nightmare situation, many American artists rejected the fashionable Abstraction, dismissed the Realism of Benton, Wood, and Burchfield (who lived away from the cities' problems) and painted real, recognizable subjects. These Social Realists attacked the dehumanization of industrial and urban life and tried to use their means of visual communication to turn the country around. Led at first by Ben Shahn, Moses Soyer, Reginald Marsh, Philip Evergood, and Peter

Blume, the banner was later picked up by artists like Jacob Lawrence, Jack Levine, and George Tooker. Their belief that painting must describe and express the people, their lives, problems, and times sums up the aesthetic philosophy of the Social Realists.

Ben Shahn (1898–1969) Ben Shahn grew up in a Brooklyn slum, studied art in Paris, and was the early leader of Social Realism. His hatred for injustice in any form led him to visually criticize and comment on the judicial system, racial injustice, and the plights of migratory workers and miners. His eloquent voice was heard and seen by millions. His work as a photographer, muralist, and printmaker during America's rebuilding years gave him a variety of media with which to communicate. Paintings such as *Handball* do not simply show American young people playing games but indicate the tragedy of unemployment and the waste of human resources as men must spend their time idly. Shahn was a master at using empty space to symbolize loneliness. He could have treated this subject as a joyful, active, fun-filled sport, but the viewer feels at once that this was not his intention.

Reginald Marsh (1898–1954) Reginald Marsh painted the people of the streets during the 1930s. His subjects included crowds in the tenements, on the steps, in the streets, and at parks, beaches, and theaters. His sketchy style, somewhat reminiscent of Daumier's, was the result of numerous pen and ink sketches he made for himself and for newspaper cartoons. *The Bowery* captures the crowded living conditions and the congestion of life in parts of New York in the 1930s. Marsh's use of color, values, and swirling movement creates a feeling of agitation and restlessness, even if his figures are relaxed and sleeping. The softness of his edges is drastically different from the harder edges of Shahn, Lawrence, and Tooker.

Jacob Lawrence (1917–) Jacob Lawrence learned his art in Harlem during the 1920s in a government sponsored workshop. After his first exhibition (when only twenty-one), he began several series of paintings about the heritage of his people and the black struggle for equality. His angular, hard-edge style is appropriate for subjects that show struggle, hardship, and clashing ideologies. *Juke Box*, like most of his paintings, tells a story. A lonely woman leans against the juke box, listening sadly to its music. Has her husband left her? Is she remembering better times? Why is she alone in such a large room? Why aren't others enjoying the music or why isn't she enjoying it? All the answers to such questions could be possible narratives that Lawrence allows the viewer to make up.

JACOB LAWRENCE. *Juke Box*, 1946. Tempera on paper, 74 × 54 cm. Detroit Institute of Arts

GEORGE TOOKER. *Government Bureau*, 1956. Egg tempera on
gesso panel, 49 × 75 cm. Metropolitan Museum of Art, New
York, gift of George A. Hearn Fund

George Tooker (1920–) George Tooker carried the
banner of Social Realism, with Lawrence, into the Post-
World War II period. He painted the decline in the qual-
ity of life in the growing cities by emphasizing chilling
loneliness and alienation. A prison-like environment
seems to engulf city-dwellers in their subways, stations,
offices, and governmental agencies. In his *Government
Bureau*, he shows the plight of a depersonalized hu-
manity confronting a faceless bureaucracy. The bleak ar-
chitectural setting and the evident repetition of forms (the
same male figure appears three times) intensifies the
scene's impact and eerie feeling of hopelessness.

Each of the four artists shown here, as well as several
dozen others, communicated their ideas and feelings
about American society in different styles, but the mes-
sages still got across. Causes for social protest are
numerous, and artists who feel part of them can usually
find a medium and an audience for their personal com-
munication.

Sculpture

American sculptors during the first half of the twentieth
century worked mostly in traditional ways and media
but with ever increasing interest in simplifying the fig-
ure. Several began to work with new materials and in
new ways, and set the stage for the unbelievable
sculptural activity of the second half of the century. The
sculpture scene in New York after the turn of the century
took on an international flavor with artists flocking to
America where the artistic and political freedom was en-
ticing. Some came as children and others as established
sculptors, and included William Zorach (1887–1966) from
Lithuania, Elie Nadelman (1882–1946) from Poland,
Gaston Lachaise (1882–1935) from France, José de Creeft
(1884–1974) from Spain, and Alexander Archipenko
(1887–1964) from Russia. Earlier sections featured the
work of other foreign-born Americans working during
this period: Naum Gabo (*See* p. 412), Jacques Lipchitz

ALEXANDER CALDER. *Lobster Trap and Fish Tails*, 1939. Painted steel wire and sheet aluminum, about 257 × 292 cm. The Museum of Modern Àrt, New York

(*See* p. 416) and Hugo Robus (*See* p. 72). Other American sculptors included Paul Manship (1885–1966), Malvina Hoffman (1887–1960), John Storrs (1885–1956), and Gutzon Borglum (1867–1941) who carved the presidents at Mount Rushmore. Many sculptors working before the middle of the century produced their major works in the fifties, sixties, and seventies, and they will be presented in the last chapter.

Frederic Remington (1861–1906) Frederic Remington was a painter and sculptor of the great westward expansion. His cowboys, Indians, and horses were impressive studies of the life, joys, tribulations, and hardships of the Old West. Although known primarily for his paintings, Remington began sculpting in bronze about 1895 and produced many fine pieces before he died in 1906. Sculptures such as *The Outlaw* show his supreme knowledge of horses, cowboys, and their movement, based on countless hours of sketching and painting. Remington's work was traditional in concept because of its realism, but the action and subject matter were strictly American to the point of nostalgia.

FREDERIC REMINGTON. *The Outlaw*, 1906. Bronze, 57.5 cm high. Los Angeles County Museum of Art, William Randolph Hearst Collection

ALEXANDER CALDER. *Sow*, 1928. Wire construction, 43 cm long. The Museum of Modern Art, New York, gift of the artist

Alexander Calder (1898–1976) Alexander Calder was among the first Americans to begin working with abstract forms in space. He moved to Paris in 1926 and began creating an imaginative menagerie of animals from wire and scraps of other materials. Like whimsical drawings in space, *Sow* and other three-dimensional, linear animals and circus performers delighted visitors to his studio. The light and airy feeling of his space drawings was carried into more technical constructions called *mobiles*, which hung suspended from a single point. *Lobster Trap and Fish Tails* is a buoyant assemblage of shapes that is balanced so carefully that a single breath of air sets the sculpture in motion. It was constructed so that every movement produced a change in the visual configuration—with the possibilities being endless. Although this sculpture has a suggested subject matter, most of his mobiles were completely non-objective. Calder also produced many standing sculptures which he called *stabiles*, such as the steel *Black Widow* (See p. 41), and was an early innovator in the avant garde of twentieth century sculpture.

Richard Lippold (1915–) As aware as Calder of the possible uses of modern metals, Richard Lippold created constructions much more calculated than Calder's. *Variation Number 7: Full Moon* is made of metal rods and threads that suggest a source of bursting light. The tension of the stretched wires and the rigidity of the stiff rods are so carefully balanced that if one element were removed the entire structure would collapse. The shimmering, three-dimensional construction is literally woven together in space like a gigantic knitting problem.

RICHARD LIPPOLD. *Variation Number 7: Full Moon*, 1949–1950. Brass rods and nickle-chromium and stainless steel wire, 303 cm high. The Museum of Modern Art, New York, Mrs. Simon Guggenheim Fund

Henri Matisse. *Warrior Costume and Design for "The Song of Rossignol,"* 1920. Design: pencil on paper, 42 × 22 cm. Costume: wool, felt, velvet and silk

Although Henri Matisse was discussed in the previous chapter, his active life lasted until 1954. This design and costume for the Russian Ballet Company are shown to display another aspect of Matisse's art, for like most of his contemporaries, he was involved in many media during his life. This design was done for a one-act opera put on in Paris in 1920. Matisse designed the sets and costumes for the show and supervised sewing and construction. When necessary, he painted on the costumes, as the hand-painted black lines on the border of this tunic. Matisse envisioned the warrior as a ferocious being. It is interesting to note the degree of international cooperation in this production: The director was Serge Diaghilev (Russian); the score was written by Igor Stravinsky (Russian), based on a tale by Hans Christian Andersen (Danish), with sets designed by Matisse (French). The arts know no physical boundaries. Derain, Braque, Gris, Miro, Picasso, and Rouault also designed sets and costumes for the Russian Ballet for programs in Paris.

After establishing a name for himself in Mexico, Rivera (*See* Chapter 14) was invited to paint murals in San Francisco, Detroit, and New York. It was his first real encounter with American life and the mechanization of Detroit, and he was impressed by its bigness, noise, and constant action. He painted the courtyard from top to bottom with industrial and scientific scenes. The two large figures on this wall at the top represent the Caucasian and Mongol races (Indian and Black races are represented on the North Wall). The hands represent work and building. Small panels at upper left and right illustrate the pharmaceutical and chemical industries. The long, thin panel suggests underground strata and the fossils of the earth. The main panel deals with Detroit's automotive industry—the final chassis and body assembly line. An incredible amount of activity is crammed into the space, but machinery dominates humans, just as Spaniards dominate natives in Rivera's murals back home in Mexico.

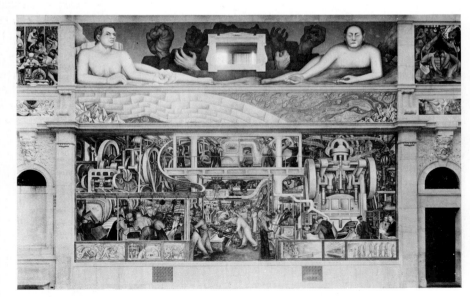

Diego Rivera. *South Wall, Detroit Institute of Arts' Garden Court*. Fresco mural, 1932–1933

Analysis

1. There are several types of subject matter that seemed to appeal to American artists during the first half of the century. Identify them, and list three or four paintings and artists under each category. Explain why American artists were interested in these subject areas.

2. If there are murals in your library, post office or school done during the thirties and forties, find out who painted them and in what medium. Write a description of them: explain subject matter, symbolism and style. You can film, videotape or photograph details and parts to prepare a visual presentation.

3. Read the discussion of the Edward Hopper painting on page 64. Using any of Hopper's paintings in the text or another work from another source, analyze his use of the elements and principles of design as outlined on page 64.

Aesthetics

4. What differences can be noted in the landscapes of Inness and Bierstadt? What underlying philosophy in the treatment of subject matter and of expression determined these differences?

What was each trying to say in his work? Are they alike in any way? Which do you like better? Why? Write a one page paper answering these questions.

5. Select one work of art that gives you a feeling for each of the following eras of American history, and explain the relationship: Roaring '20s, The Great Depression, The New Deal, World War II, The Fabulous '50s or other topical subject you may wish to add to the list. How have the artists captured that feeling and communicated it to you? Which did it most successfully, in your opinion? Why?

6. For the purpose of this problem, the McLaughlin painting has been turned on its side, because the shapes and design of the two works are then almost alike. In which style do each of these paintings belong? What was each artist attempting to communicate? How are these two works alike? How are they different? Which do you like better? Why?

Studio

7. Cut out flat shapes from colored paper and arrange a collage similar in style, color and format to the paintings of Stuart Davis. How did he project meanings or themes into his work? Can

you do that also? Do not imitate one of his paintings—only use his type of surface arrangement and exciting use of shape and color.

8. Study the work of Naum Gabo, and then make a sculpture with string, wood and nails. Look elsewhere for other examples of his work. Or, after looking at examples of Calder's mobiles, create a similar kinetic sculpture. Observe the principle of balance, and work carefully to keep the work neat in appearance.

9. Use tempera paint to work in the style of one of the members of "The Ashcan School." Remember what they were trying to portray in the American scene and choose a contemporary subject to paint. You may wish to look up the other members of the group not shown in the text and work in a style similar to theirs.

10. Make a painting in the distinctive style of Grant Wood, John Marin, Burgoyne Diller, Mark Tobey or Charles Burchfield. Use contemporary subject matter where appropriate.

John D. McLaughlin. *Untitled*, 1955. Oil on masonite, 97 × 81 cm. Los Angeles County Museum of Art.

Edward Hopper. *Manhattan Bridge Loop*, 1928. Oil on canvas. Addison Gallery of American Art, Andover.

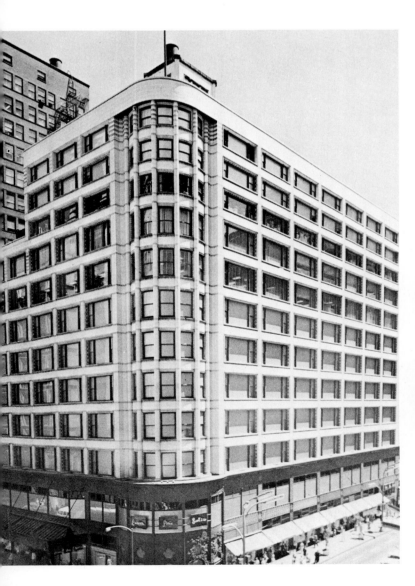

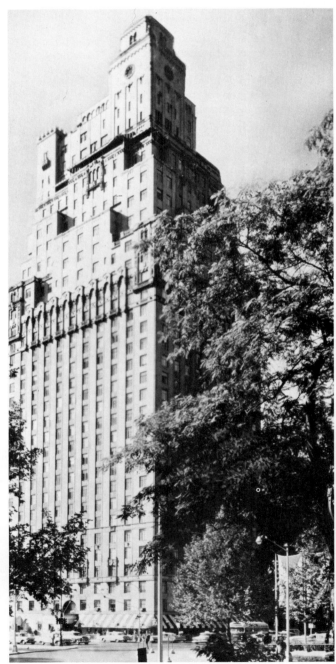

Emery Roth. St. Moritz Hotel, 1928. New York City

Louis Sullivan. Carson Pirie Scott Department Store, 1899–1901; enlarged 1903–1904. Chicago

The American Search for Excellence: 20th Century Architecture

THE DESIGN AND CONSTRUCTION of structures for shelter have reflected and met the needs of cultures from the earliest times. Greeks used open-air spaces; Romans needed interior spaces; Gothic architects met the need for worship space. Architects have continued to satisfy current requirements, embellishing and designing their products to suit the styles of the times. The new forms of Western architecture that appeared around the turn of the century were built to meet the needs of an industrial nation: commercial buildings, factories, industrial complexes, and high-rise structures that made the best use of constantly dwindling land space. Materials and building techniques developed for such a growing construction industry were soon adapted to smaller and more specialized buildings such as houses, apartments, and churches.

Into the 20th Century

The previous chapters provided glimpses of architectural developments, but the surge in construction during the twentieth century is unparalleled. European cities developed their plans and character over centuries while American cities underwent fantastic growth and development in less than a century. Often their planning suffered because of the rapid transition from a rural to an urban society. Wood and stone had been the major building materials, and cast iron had been used to some degree, but these materials had severe limitations. The Chicago Fire of 1871 destroyed the center of the city, and in the rebuilding process, steel was brought into use for the first time. The steel frame, composed of vertical and horizontal beams riveted together, created a structure that was incredibly solid, rigid, and strong, held together by the tensile strength of the steel instead of the enormous weight of building stone. In such steel-frame structures, the walls do not bear the weight of the floors above and are simply curtains of material that enclose interior space. Buildings took on a gridlike appearance which echoed the rectangular structure of the steel that supported it. Traditional arches and post and lintel elements were reduced to merely ornamentation as steel became the primary support. High-speed, efficient elevators helped make the construction of high rise buildings more feasible.

Louis Sullivan (1856–1924) Louis Sullivan was one of the earliest architects to use steel construction. His Wainwright Building in St. Louis still stands, but a more revolutionary work was his Carson Pirie Scott Department Store, built in Chicago in 1901. The feeling of columns is almost eliminated and the grid-pattern of steel structure is evident, with large windows used on every one of the ten upper floors. The traditional heavy cornice and heavy window detail were eliminated. All ornamentation is eliminated except over the front doors at the rounded corner. The stark simplicity (at a time when decorative Art Nouveau was in vogue) heralded the beginning of modern architecture in America—a development that would influence the entire world.

Emery Roth (1873–1950) Emery Roth came to America from Hungary, and after working for several firms in Chicago and New York, opened his own office in New York in 1903. Although he used steel construction and *curtain walls*, he continued to incorporate elements of Neoclassic and Romantic decoration and materials. The St. Moritz Hotel in New York City (1928) demonstrates his sense of style and graceful proportions. The vertical feeling of steel structures is evident, but decorative

motifs and set-backs at the upper floors provide relief from a sense of severity and add a touch of elegance.

Antoni Gaudi (1852–1926) Antoni Gaudi worked in Barcelona, Spain and developed a unique architectural style, centered around organic forms and the Art Nouveau style. His Casa Mila, an apartment building, is an excellent example of this. In 1883 he took over the design and construction of the colossal Church of the Sagrada Familia (Sacred Family) in Barcelona. It is not finished yet because construction has been slowed considerably since his death. The four gigantic towers seem to grow from the structure as their organic forms reach toward the sky. Gothic windows can be seen below, but the formed concrete structure seems to ooze and flow on the surface. By squinting one's eyes, the Gothic feeling emerges as if its details were lost in an Impressionist painting. Other facades (there are three) are in completely different architectural styles, and only the huge interior is planned to be uniform in style.

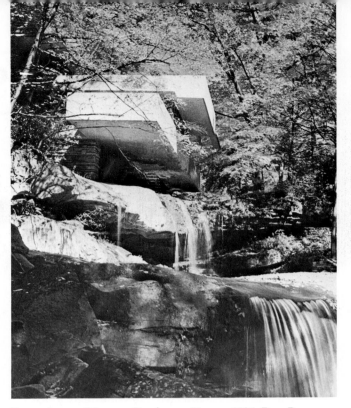

FRANK LLOYD WRIGHT. Kaufmann House, 1936. Bear Run, Pennsylvania

ANTONI GAUDI. Church of the Sagrada Familia, 1883–1926–now. Barcelona, Spain

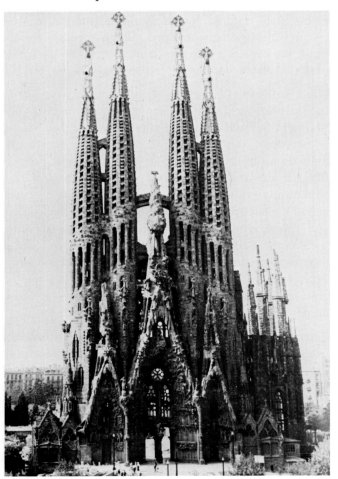

Frank Lloyd Wright (1867–1959) Frank Lloyd Wright was an individual genius, developing his own style and disregarding conventional construction. His primary concern was to develop a compatible relationship between the structure and its location so the building seemed to grow out of its environment. One of his earliest revolutionary designs was for the Robie House in Chicago (1909). He disregarded the traditional plan of enclosed rooms with doors and allowed one room to flow into another space, separated only by partial walls, and let exterior space flow into interior space. There is an overall horizontal feeling to his houses which rest comfortably on their sites. Roofs here are *cantilevered* and seem to float without supports as they reach out from the cubic forms of the house. There are Japanese influences in the simplicity of forms and the honest use of materials because Wright had been favorably impressed by the design of the Japanese Pavilion at the Chicago World's Fair in 1893.

In 1936 Wright designed and built one of the most original living spaces—The Kaufmann House at Bear Run, Pennsylvania. Cantilevered terraces that stretch out over a stream and waterfall echo the form and color of the natural rock terraces below. Stone, wood, color, shape, form, and line are used by Wright in a perfect marriage of structure and site.

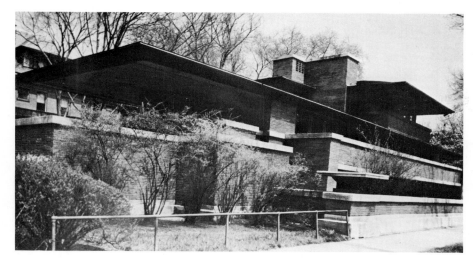

FRANK LLOYD WRIGHT. Robie House, 1909, Chicago

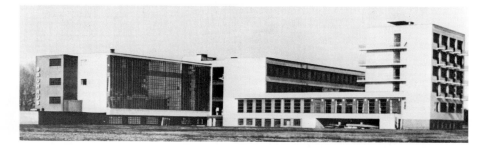

WALTER GROPIUS. Bauhaus, 1928. Dessau, Germany

Wright's commercial designs were few in comparison with his houses and smaller structures. His Guggenheim Museum in New York (1959) again shows his individuality as the round structure encloses a sloping ramp that uncoils around a large open space (See p. 19).

The International Style

After World War I, a style of architecture emerged in Germany, Holland, and France that was so similar that it was tabbed the *International Style*. It was the forerunner of contemporary architecture and the mass production building techniques of today. As a style, it eliminated all ornamentation, prohibited the use of natural materials (wood or stone), and sought to produce a structure that appeared light in weight—without traditional architectural mass. The result was a boxlike structure of steel, reinforced concrete, and glass—the only materials that could provide the light appearance, flat surfaces, and thin walls. The new buildings enclosed volumes instead of creating masses. Such buildings were influenced by Cubism and its emphasis on planes; by Frank Lloyd Wright and his innovative use of materials; and by the group of abstract painters known as *De Stijl,* and their leader Piet Mondrian (See p. 413).

Walter Gropius (1883–1969) Walter Gropius was an early practitioner of the International Style and a powerful influence on twentieth century art and architecture. Much of this influence was generated through an art school called *The Bauhaus* which he took over in Germany in 1919. Bringing together great teachers from many countries, it stressed the industrial and mechanical art processes as they related to painting, sculpture, architecture, crafts, printmaking, and other art forms. Students of the Bauhaus influenced art in many countries for many years. In 1925 Gropius moved the school from Weimar to Dessau and designed the new buildings himself. The main building is a huge glass box with flat planes of concrete and glass, supported by a steel grid, which is not visible. Such gigantic walls of glass were used in construction until the 1970s when the energy crisis caused second thoughts. Heating and cooling could be done much more efficiently if window space were cut down; thus, much architecture of the eighties has smaller windows and larger areas of masonry or concrete for better fuel efficiency.

Other architects working in the International Style included Gerrit Rietveld and Ludwig Mies van der Rohe in Europe, Richard Neutra, R. M. Schindler, and Purcell and Elmslie in the United States.

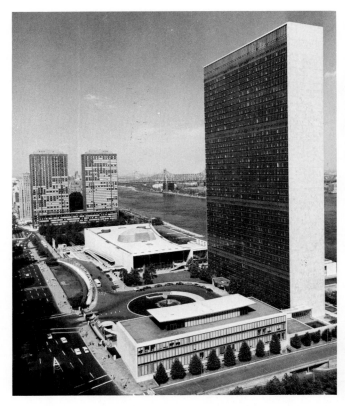

WALLACE K. HARRISON. United Nations Secretariat Building, 1950. New York City

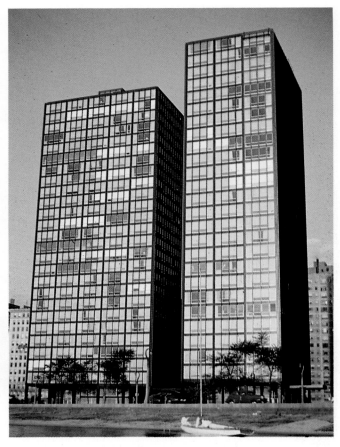

LUDWIG MIES VAN DER ROHE. Lakeshore Drive Apartments, 1951. Chicago

THE SKYSCRAPER

American cities (mainly New York, Philadelphia, and Chicago at first) became the settings for towering skyscrapers that made efficient use of steel, concrete and glass construction, and drastically changed the skylines and urban landscapes of this country. Under the influence of the International Style, ornamentation such as Roth added to the St. Moritz Hotel was eliminated, and structures became clean and lacking much individual identity. New York required set-backs on the upper stories to allow sunlight to reach the streets of their concrete canyons, setting some limitations on the creativity of the architects.

Wallace K. Harrison (1895–1981) Wallace K. Harrison's skyscraper was the first that had a simple shaft without changes or set-backs from top to bottom. The Secretariat Building of the United Nations in New York (1947–1950) was designed by a firm of architects under Harrison's direction. From then on, most huge projects required teams of architects and draftspersons to complete such unbelievably complex designing. The build-

ing has a grid of glass and steel on the wide sides and unbroken marble panels on the ends. All service units (elevator machinery, water towers, air conditioning equipment) are on the roof, hidden from view by the structure's extended walls.

Ludwig Mies van der Rohe (1866–1969) Ludwig Mies van der Rohe had worked in Europe, and like other architects and artists of Germany, left in the thirties because of Hitler's closed attitude toward modern art. He settled in Chicago. He designed many building complexes in and around the city, but among his best known are the Lakeshore Drive Apartments, constructed in 1951. The two buildings are set at right angles to each other to allow the most light to strike each apartment and are prime examples of the International Style in high rise construction. His simplified forms usually have slight detailing on windows and employ dark colors for the metal parts. The windows here, for example, may all seem alike, but every fourth metal division is a bit wider, adding a sense of subtle rhythm to the surface.

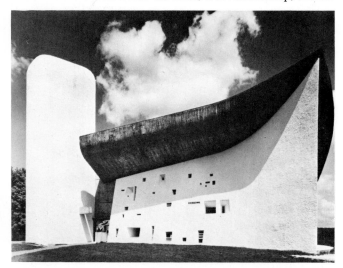

Le Corbusier. Notre-Dame-du-Haut, 1955. Ronchamp, France

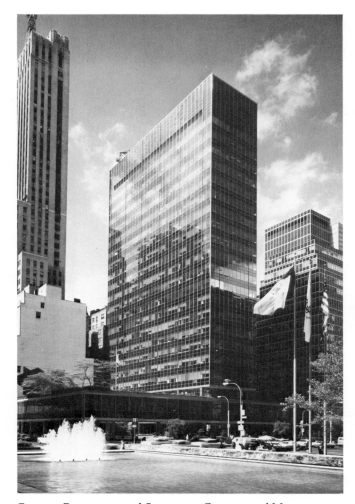

Gordon Bunshaft, and Skidmore, Owings and Merrill (New York). Lever House, 1951–1952. New York

Gordon Bunshaft (1909–) Chief designer for Skidmore, Owings and Merrill, Gordon Bunshaft was responsible for the next development: the all glass exterior of the Lever House in New York, a design that (like Gothic architecture) seems to defy gravity. The reflective glass tower and the two-story horizontal unit are supported by pylons above the street level, allowing foot traffic to circulate into a partially shaded open court. The structure itself occupies only about half of the total site, leaving room for the pleasant court and eliminating the feeling of congestion and crowdedness that is present in many urban streets. The Lever House (1951–1952) is sheathed in green-tinted glass that reflects clouds, sky, sun, and the surrounding environment. It was so successful in appearance and function that it was the model for hundreds of glass and metal skyscrapers built around the world during the following quarter of a century.

Counter Currents

When World War II concluded, architects began looking for new ways to provide spaces for human activities. The regimentation of the International Style seemed too confining for many of them who dared to try new approaches.

Le Corbusier (Charles-Edouard Jaenneret) (1887–1965) Le Corbusier was a Swiss-born architect who grew up on the International Style. Yet he was one of the first to deviate from its principles after the war. He had been an instrumental part of the team that designed the United Nations building, but the concept of Notre-Dame-du-Haut (1955) was completely different. Built on a hilltop near Ronchamp, France, the pilgrimage chapel abandons every aspect of the International Style. Using his favorite construction material, reinforced concrete, he has formed an organic sculpture, not a shoe-box building. The floor plan is even irregular, and the walls slope, slant, and bend while the roof flares, curves, and twists as if alive. Wedge-shaped windows are irregular and of different sizes, and light floods hidden chapels from recessed skylights. Around every interior turn there seems to be a surprise. Built for worship by a small number of townspeople, the interior holds about fifty people, but the outdoor seating area can accommodate over ten thousand religious travelers.

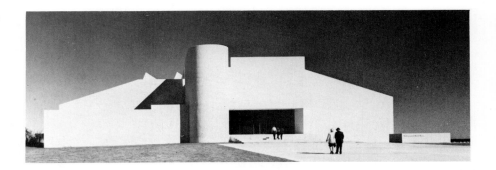

Philip Johnson. South Texas Museum, 1972. Corpus Christi, Texas

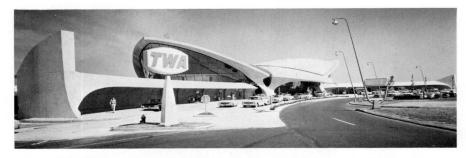

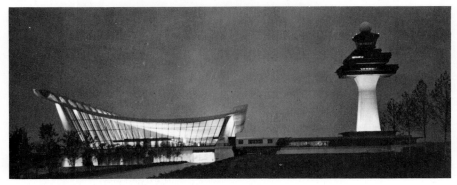

Eero Saarinen. Trans World Airlines Terminal, John F. Kennedy International Airport, 1962. New York. Dulles International Airport Terminal Building, 1962. Washington, D.C.

Philip Johnson (1906–1987) When designing the South Texas Museum in Corpus Christi, Texas (1972), Philip Johnson incorporated the Classical features of balance and simplicity. The structure appears to be a white marble sculpture from this side, although there are windows that face the bay on the other side. Inside the all-white structure are galleries, halls, an auditorium, and offices. Skylights light the upper galleries of the textured concrete form, giving a hint of the new brute tendencies of powerful form which will be seen in later architectural design during the century. The work stands as a white monument against a dark blue sky and is intriguing in its simple statement.

Eero Saarinen (1910–1961) Eero Saarinen was involved in the construction of many beautiful structures, but his involvement in several air terminals alone would make

him important. As the air age was thrust upon the world after World War II, existing facilities were soon overtaxed, yet most new facilities failed to equal in quality and design the advances made in the aircraft themselves. Saarinen's sculptured, organic structures were the exception as they almost seem capable of flight themselves. The Trans World Airlines terminal in New York (1962) has curves that flow like air currents and suggest cloud shapes in their sculptural contours. His magnificent terminal for Dulles International Airport outside Washington D.C. (1962) makes use of mobile lounges to get passengers to planes. In the structure, there is nothing left of traditional building design. Sixteen pairs of slanting concrete pillars support the enormous, hammock-shaped roof which tilts to one side. No interior supports mar the vast enclosed space. With great window walls, the roof seems suspended from the sky

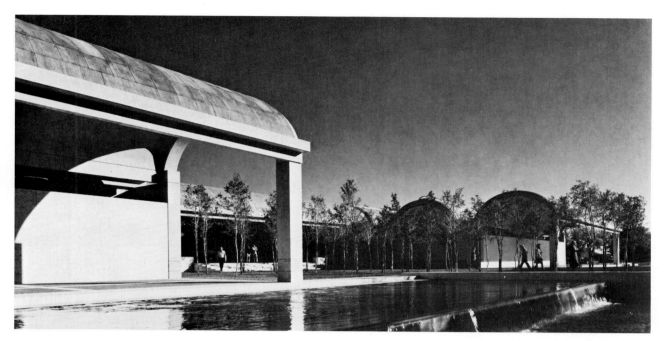

LOUIS I. KAHN. Kimbell Art Museum, 1972. Fort Worth, Texas

and the entire building has a floating appearance. Both air terminals are dynamic structures, perfectly expressive of their intended use.

Louis I. Kahn (1901–1974) Louis I. Kahn was an admirer of Le Corbusier and studied his work intensively, but his solutions were original and had a strong influence on his contemporaries. One of his finest designs (and also his last) was the Kimbell Art Museum in Fort Worth, Texas (1972). The main entrance, shown here, is a tree-filled patio, flanked by two open arched vaults and reflecting pools. Vaults are used to roof the entire structure, providing a powerful sense of unity throughout. Natural light is admitted through long slits located in the vaults and diffused inside by a series of baffles (adjustable panels that deflect light) to provide superior lighting for the paintings. The structure is a work of art itself, designed to accommodate other works of art.

R. Buckminster Fuller (1895–1983) R. Buckminster Fuller sought to make use of inexpensive, easily manufactured materials in his constructions. Innovative buildings such as the United States Pavilion at Expo 67 in Montreal make use of his geodesic dome. This one is a bubble fifty-two meters high and 78.5 meters in diameter. Thick struts, joined with knot joints, carry the weight and hold up an inner net on which 2000 acrylic caps are mounted. Motors at the joints react automatically to sunlight and shift blinds and a ventilating system to control the interior climate. The building is

R. BUCKMINSTER FULLER. United States Pavilion, Expo 67, 1967. Montreal, Canada

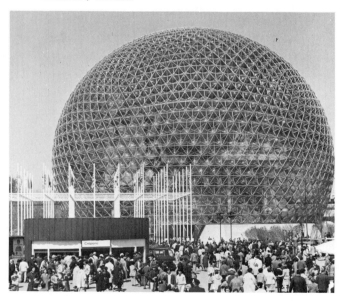

demountable, reusable, cheap, and can have parts of it replaced. Could it be an indication of future building styles and techniques? Fuller dreamt of a vast dome over Manhattan Island—an enclosed environment in which the climate could be controlled by the occupants of the city. World fairs and Olympic games tend to spawn creative architecture, but too often many of the structures are not practical for normal urban needs and fail to be compatible with existing urban structures.

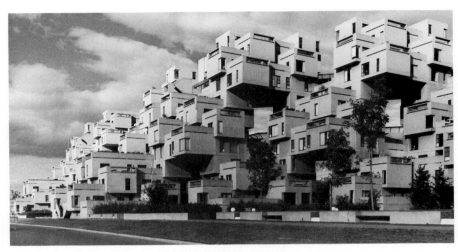

MOSHE SAFDIE. Habitat (at Expo 67), 1967. Montreal

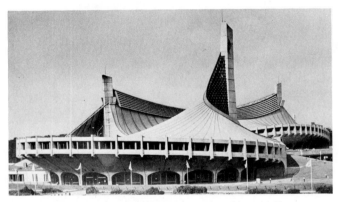

KENZO TANGE. Olympic Halls, 1964. Tokyo Yoyogi, Japan

Kenzo Tange (1913–) Kenzo Tange has designed an amazing variety of buildings in Japan during the post-war years and incorporates inventive solutions in his major structures. Leading a team of engineers and architects, Tange designed the Olympic Halls in Tokyo for the 1964 Summer Olympic Games. The roof of the larger hall in the rear is a steel net suspended from cables stretched between two enormous concrete pylons. It has an insulated, lightweight lining inside and is painted outside to reflect the heat. Its curvature does not present a flat surface to the wind, and natural light is admitted through the louvered band which runs between the two pillars. The smaller hall is a basketball arena designed in a circular form. This roof is suspended from a single pillar at one side and is of the same roofing material as the larger structure. An underground building with offices, training facilities, and dressing rooms connects the two fascinating structures.

Moshe Safdie (1938–) Moshe Safdie has created some of the most unique and practical urban dwelling units yet conceived. Working mostly in his native Israel,

Safdie completed a dramatic structure when he finished Habitat for Expo 67 at Montreal. Mass-produced, precast, one-piece concrete units (each a complete apartment) were transported to the sight and stacked like gigantic building blocks by huge cranes. Individual families can order different sizes and different interior arrangements, and each floor has a play area for children. The uniformity of usual apartments was avoided, and a new housing concept was developed. It is remarkable how much this contemporary structure resembles the earliest towns of Mesopotamia or the early pueblos of the Southwestern United States.

Paolo Soleri (1920–) Paolo Soleri has designed incredible mushroom-shaped cities to be placed in desert areas, but they are much more imaginative than practical. Called "Arcologies," they are envisioned to house all the necessary requirements for survival in one immense unit. Perhaps from such dreaming and planning will evolve practical solutions for the struggle for usable living space.

Bertrand Goldberg (1913–) Bertrand Goldberg devised another solution for urban dwelling when he built Marina City in Chicago (1965). In two round, 177-meter-high towers, Goldberg has located 900 apartment units and eighteen stories of parking garages. Another incorporated structure contains offices, banks, shops, halls, restaurants, theater, post office, railway station, retail, and service establishments—a self-contained city. The simple cylindrical forms are enhanced by the rippling patterns produced by the balconies on each apart-

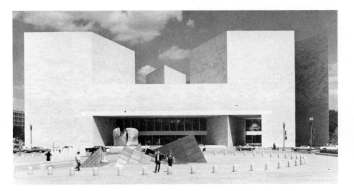

I.M. PEI. East Building, National Gallery of Art, 1978. Exterior view. Washington D. C.

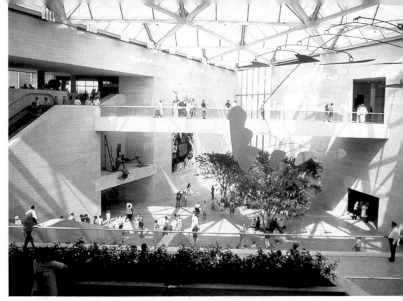

I.M. PEI. East Building, National Gallery of Art, 1978. Interior view

BERTRAND GOLDBERG. Marina City, 1965. Chicago

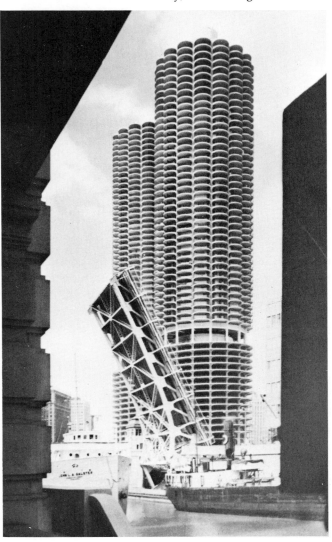

ment. Rapidly increasing prices of land have forced builders to reach up instead of out in order to provide living space for people who wish to live close to city centers. These towers are at the edge of Chicago's Loop and even feature a marina for occupants who can dock their own boats when not in use on the river.

I.M. Pei (1917–) I.M. Pei has designed many hotels and government structures in America, but one of the most dramatic is the East Building of the National Gallery in Washington D.C., 1978. Built to house part of the nation's great collection of art as well as a huge research library and working facilities, the building occupies a wedge-shaped site on Washington's Mall. The white marble structure shows a completely different face in each direction: this view has no windows; other walls have all windows; and the huge pie-shaped section on the right rises like a white sliver when viewed from certain angles. The solid, faceted planes do not prepare one for the marvelous open spaces inside. A mammoth skylight allows natural light to flood the interior, and from various angles, one can look out at the wide vistas of the mall and government buildings. The interior space is enhanced by sculptures (including Calder's gigantic mobile) prepared specifically by the artists for the spaces where they are located. The East Building is another work of art designed to hold art—a perfect relationship between the form of the structure and its intended function. The sculptural forms in the foreground are part of a fountain of twenty-four jets and a skylight system for the underground concourse that connects the East Building with the older structure.

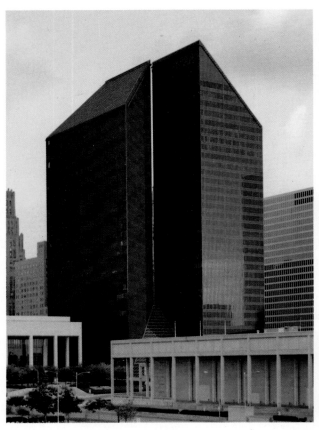

PHILIP JOHNSON/JOHN BURGEE. Pennzoil Place, 1976. Houston

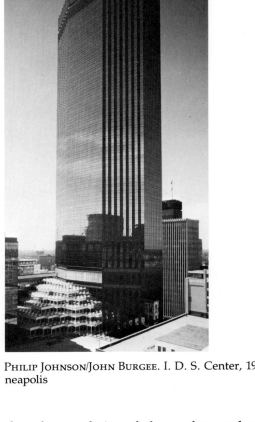

PHILIP JOHNSON/JOHN BURGEE. I. D. S. Center, 1972. Minneapolis

Philip Johnson (1906–)/John Burgee (1933–)
Many of today's architectural firms are built around two or more top architects as well as a group of engineers, accountants, and designers. Philip Johnson and John Burgee are responsible for some of the most advanced thinking in major projects in the country since they do not specialize in glass boxes but in using different solutions for different clients. Pennzoil Place in Houston (1976) is a dramatic example of such new direction. The two towers are separated by a ten-foot space and their tops are tapered at forty-five degrees. The glass wedge at the bottom provides a gigantic lobby which has a well-lighted but climatically controlled atmosphere. The dark color together with the unique shapes and the slit of air space, which changes as one moves around the building to view it, produce a daring new outline on the Houston skyline—like a gigantic minimal sculpture.

Another Johnson and Burgee masterpiece is the towering I.D.S. Center in Minneapolis (1972). Again, the usual box form was avoided as the glass shaft rises like a molded sculpture above the city. The vertical set-backs alter the regularity of the surface and add dramatic shadows and sharp contrasts to the structure. The glass and steel covered courtyard allows light to enter the pedestrian levels and brings the outdoors inside all during the year, even in coldest winter. Such projects are going up around the country and in every major city in the world so that New York and Chicago no longer have the only dramatic skylines in the world. The American skyscraper has come of age and is a common sight on every continent—its twentieth century architectural contribution to world culture.

Wallace K. Harrison (1895–1981)/Max Abramovitz (1908–) Wallace Harrison and Max Abramovitz teamed up to produce many beautiful industrial and commercial structures. The Corning Glass Center in Corning, New York (1951) is designed as a public relations center and as a production unit for the corporation's glass products. Production buildings are the core, but also included are conference rooms, a library of books relating to glass production, a glass museum, and a Steuben glass-blowing building where visitors can

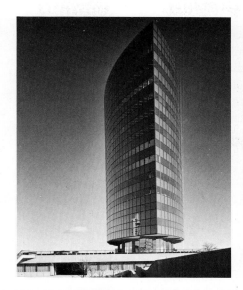

Harrison and Abramovitz. Phoenix Mutual Life Insurance Company, 1965. Hartford, Connecticut

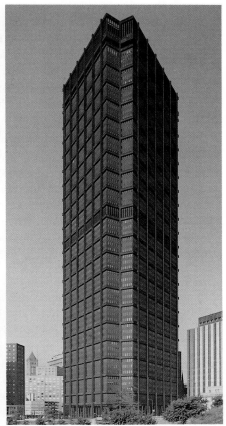

Harrison and Abramovitz. Corning Glass Center, 1951. Corning, New York

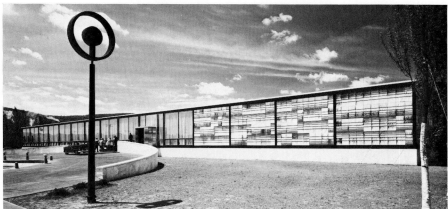

Harrison and Abramovitz. United States Steel Corporation, 1970. Pittsburgh

watch master craftspersons work with individual projects. Few industries can have their facades designed to make use of their own products. The architects used glass in abundance. Plate glass, glass tubes, glass fabric drapes, and on the right side, photo-sensitive glass placed over concrete blocks. From a distance, this section appears to be of marble.

In designing the Phoenix Mutual Life Insurance Building in Hartford, Connecticut (1965), the architects developed the unique shape called a lenticular hyperboloid (a distorted, lens-shaped form) which produces a powerful sculptural form. The form developed from a functional need: some offices had to be close to elevators while clerical and support help needed to be out of the main traffic pattern. The way the company's office routine and management was set up required this kind of shape. "Form follows function" is an old architectural adage, and it is carried out beautifully here in Hartford. The sculptural form rises from a four-story square structure at ground level. The cantilevered walls seem to float over the slender base, adding a feeling of lightness as the slick, smooth, shiny, glass curtain walls reflect the Connecticut sky and the urban environment.

Harrison and Abramovitz continued to work with new forms and techniques when they designed the United States Steel Corporation building in Pittsburgh (1970). The equilateral triangular shape had its wind resistance reduced by cutting out the sharp corners. The dark color of the grid pattern arises from the use of Cor-Ten steel which forms a permanent protective coating as it rusts (oxidizes) and turns to a rich purple-brown color. The exterior curtain wall is also Cor-Ten steel and the glass is bronze-tinted. The outside grid is made of hollow sections and contains water that will circulate and on very hot days helps cool the steel and reduce expansion. Anti-freeze will keep it from freezing in winter, and the water system helps fireproof the structure. The sixty-four-story tower seems to hang suspended inside the open framework and float over the two-story, open lobby at the base.

Emery Roth and Sons (1903–) This firm has been responsible for over 125 Manhattan skyscrapers built since World War II. Emery Roth and sons Julian and Richard played a big part in the Pan Am Building, World Trade Center, Citicorp Center, and some excellent hotels in the city. One Hundred Constitution Plaza (1964) was the first structure completed in Hartford, Connecticut's ambitious urban renewal program. A large landscaped area of pedestrian walks, lawns, and plantings surrounds the building. It is sheathed in gray-tinted glass with panels of glass on baked enamel backing between floors. Anodized aluminum vertical mullions (rigid supports between windows) reach from the third story to the roof. The strong vertical feeling is softened by the horizontal panels and the irregular reflections of the surrounding structures.

Marcel Breuer (1902–1981) Marcel Breuer provided excellent architectural designs for a wide range of structures around the country. The IBM General Systems Division Office and Manufacturing Facility at Boca Raton, Florida is an on-going project. Begun in 1967, the complex continues to grow with additional buildings added every few years as the company expands. The horizontal layout was essential to traffic and use patterns so a large land area was necessary. Sand was quarried out to leave several lakes which provide landscaping, water supply, cooling material,

MARCEL BREUER and ASSOCIATES. Campus High School, 1977. Boston

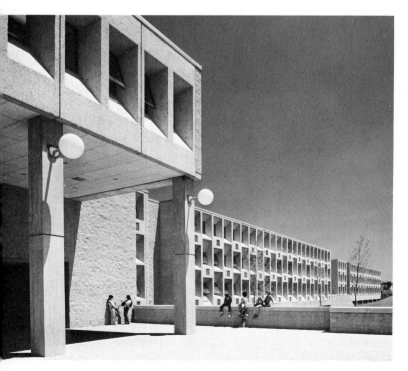

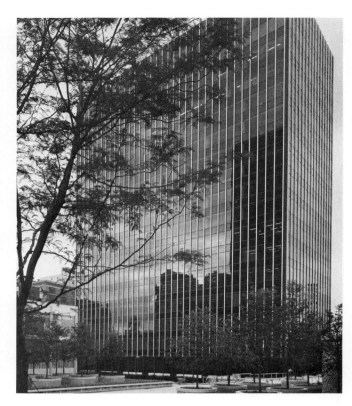

EMERY ROTH and SONS. 100 Constitution Plaza, 1964. Hartford, Connecticut

and firefighting water. The deeply modeled facade panels are of precast concrete, often formed elsewhere and brought to the construction site. They are decorative and provide a fascinating pattern, but they also are load-bearing structures and support the upper stories and the roof. They create interesting shadow patterns, and the canopies provide shade from the hot Florida sun.

Campus High School in Boston (1977) is part of a unique educational complex in an inner-city neighborhood. This unit of precast concrete panels is the first part of a 5000-student high school, but on campus will also be a primary school, retail and office buildings, adult school, community center, parking facilities, low rise housing, and landscaped open space. The facility is open sixteen hours a day and is a focal point for community activities. Designed to draw people of all ages into the urban core area rather than disperse them, the center hopefully will aid urban renewal, racial integration, and provide educational excellence. Such architectural farsightedness is extremely helpful in solving one aspect of twentieth century urban problems.

After his retirement, Marcel Breuer's younger partners continue his work, with the firm of Gatje, Papachristou, Smith.

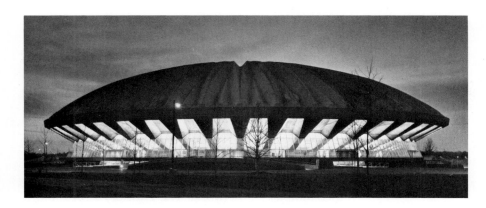

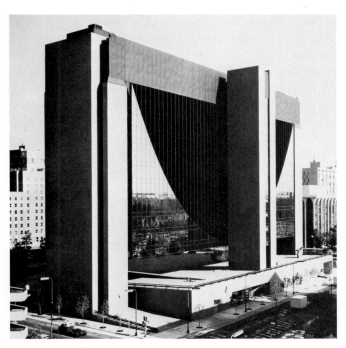

GUNNAR BIKERTS. Federal Reserve Bank of Minneapolis, 1973

THE AMERICAN LOOK: CONTEMPORARY ARCHITECTURE

There are many contemporary architects who are advocating new types of construction that will change the face of urban areas. Buildings are being suspended over valleys or have their service elements (pipes, ducts, tubes, etc.) exposed on the exterior of the structure. New materials are constantly being tried, such as aluminum sprayed muslin, plastic sheeting, metal and plastic grills, precast and exposed aggregate panels. During the seventies and eighties, no type of architecture is being tabbed as typical of the times. Instead, creative architects are going in different directions, with each problem being solved in an individual way.

Gunnar Bikerts (1925–) Gunnar Bikerts has successfully used a concept that has intrigued architects for years. The offices of the Federal Reserve Bank of Minneapolis are actually suspended from cables. Two gigantic towers are 95 meters apart with suspension cables hanging between them. The office section, sheathed in double glass, is attached to the cables and hangs about 12 meters above the plaza level. The glass is tinted to show the location of the cable, but the curtain wall has no structural significance. The elevators are in the towering shaft that stands alongside. The solid structure below is part of an underground building that houses storage for valuables and securities so the building is in two parts: a secure area for valuables and a separate office tower—an ingenious solution to a unique problem.

Wallace Harrison (1895–1981)/Max Abramovitz (1908–) The largest edge-supported concrete dome in the world was designed by Wallace Harrison and Max Abramovitz for the University of Illinois Assembly Hall at Urbana. The structure presents a dramatic appearance, and the construction and engineering were just as dramatic. The sections of the concrete roof were cast and stressed and then lowered into place to lean against a gigantic ring at the top of a steel tower erected in the center of the structure. When completed, the tower was removed, leaving an inverted saucer about 122 meters in diameter resting only on the concrete outer edge of another saucer which is embedded in the earth. This lower saucer forms the seating area and is pierced with open spaces for windows. The engineering problems involved in supporting a thin, nine centimeters, corrugated, 4,400-ton dome on the edge are enormous, but were successfully met by creative design.

The world's landscape is being dotted with such ingenious architecture, made possible by pre-stressed and reinforced concrete, able to span enormous areas.

Skidmore, Owings and Merril (1939–) The firm of Skidmore, Owings and Merril has been a positive force in twentieth century architecture since their Lever House of 1952. Among their innovative structures is the Sears Tower (1974) in Chicago, the tallest and largest private office complex in the world. The 110-story structure has step-back construction that fits the interior requirements of the Sears, Roebuck and Company offices. The geometric modular office units are 23 meters square and have no columns, allowing for individualized office arrangements. The step-backs at various levels simply reflect terminations of some of these 23-meter-square vertical tubes. Black aluminum and bronze-tinted glass provide a distinctive exterior which is set off from surrounding structures by a landscaped plaza. The distinctive architectural form punctuates the sky over Chicago, producing a dramatic center for the high-rise skyline.

THE SPORTS LOOK

In America, some architects are involved in creating gigantic spaces for sport—either indoors, under incredibly large steel domes (such as Seattle's Kingdome, New Orlean's Superdome, or Houston's Astrodome) or outdoors. Baseball and football stadiums are being designed to hold huge crowds and the variety of configurations is amazing. Some stadiums are designed to convert from one sport to another during various seasons while others, such as the Harry Truman Sports Complex in Kansas City, are built as two arenas using common parking spaces. With such large crowds, pedestrian and vehicle movement is critical. The architects here used circular ramps to get people in and out of the stadiums and a system of roadways providing internal and exit routes to surrounding highways to move vehicular traffic. When such vast open spaces are available, the problem of movement can be solved more easily.

As leisure time increases in the world's major cities, spectator sports become more popular and demand for such arenas increases. Olympic games also require the construction of gigantic sports facilities and living quarters, which hopefully can be converted to good use by the sponsoring cities once the games are over.

KIVETT and MYERS. The Harry Truman Sports Complex, 1972. Kansas City

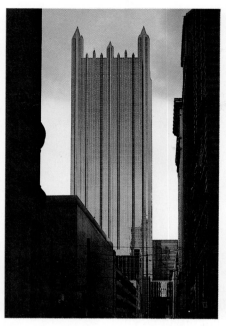

John Burgee Architects *with* Philip Johnson. *AT&T Corporate Headquarters, 1985. New York City*

John Burgee Architects *with* Philip Johnson. *PPG Place, 1984. Pittsburgh*

John Burgee Architects *with* Philip Johnson. *Transco Tower and Park, 1985. Houston, Texas*

POST-MODERN ARCHITECTURE: EMPHASIS ON DIVERSITY

Philip Johnson (1906–1987) maintained his influence through several periods of American architecture. The rectangular glass boxes of international design were left behind when he and John Burgee joined forces and developed the "late modern" style of the 1970's (see page 460). The name of the partnership was changed in the 1980's to John Burgee Architects *with* Philip Johnson, but their *Post-Modern* influence remained important.

Johnson continued to reflect his architectural heritage by combining historically important details with contemporary materials and design. Some of these aspects are literal and others are interpretive, but the results are definitely Johnson and Burgee. In New York City, the AT&T Corporate Headquarters building is a thirty-seven-story pink granite building, topped with a distinctive broken pediment. The entrance is through a sixth-story arch and colonnaded base, to a lobby 100 feet above the ground—a design which allows a ground level loggia or seating arch similar to those found in Renaissance Italy.

PPG Place in Pittsburgh is a Gothic-styled tower in glass—an appropriate reflection of the company's principle product and its longevity in the industry. The task of adapting monolithic stone construction to glass would seem insurmountable but was carried off with style and success.

John Burgee Architects *with* Philip Johnson. *PPG Place, 1984. View from Market Square, Pittsburgh*

The design detail (regular set-backs, verticality, mirror glass in two colors, simple square crown, etc.) of the Transco Tower in suburban Houston creates a feeling of monolithic solidity apart from the glass-dominated skyline of the Texas metropolis. All of Johnson and Burgee's buildings reflect a characteristic attribute of their clients and project an individualized approach to architectural excellence.

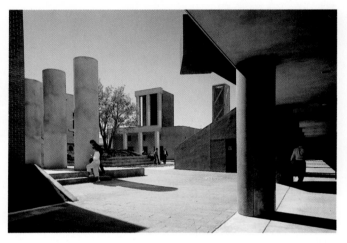

New York City and Chicago are no longer the only centers of American architectural design as they once were. Post-Modern architectural firms are building beautiful structures in many major cities, especially in the West Coast urban centers of Seattle, Portland, San Francisco and Los Angeles. Nor are the established firms of renowned architects getting all the contracts. Architecture is undergoing a renaissance that again makes it a major art form, and the results are visually exhilerating.

Post-Modern architects have shunned the glass-box ideal and are treating materials, ideas and concepts with daring and personal conviction. The skyscraper is no longer a tall box, but an organic form with curves, arcs, set-backs, crowns and wonderfully adaptable materials. Architects are not constructing monuments but are reflecting client interest and personal daring to interpret space as aesthetically pleasing volumes. Designs are being manipulated in new and exciting ways.

Frank O. Gehry and Associates, of Los Angeles, typifies this attitude. His buildings are designed to capture the essence of their purpose. The architecture of the Loyola Law School reflects the classic Greek source of our legal system. Its spaces seem to tie the contemporary urban structures to their ancient Greek counterparts—across geography and time. Gehry's California Aerospace Museum also reflects the building's purpose. Angles and planes seem to barely contain the dynamic action that the word *aerospace* implies. Its spaces are contained and intimate but the overall structure is bursting with energy.

The dynamic surge of Post-Modern architecture is not limited to a few designers. Instead, many architectural firms across the country are reaching for new concepts and ideas and are dotting the urban American landscape with exciting structures.

There is not room for a complete listing of important firms and examples of their work, but the following names should be considered important in the late 1980s. Leading architects often change partners or major partners retire from active roles, and firm names change to reflect this aspect of contemporary design. In addition to those firms already discussed in previous pages, we might add the following and one or two of their important buildings:

Michael Graves: Portland Public Services Building, Oregon

Pietro Belluschi: Bancorp Tower, Portland; Pan Am Building, New York City

Chris Simons with Chester L. Lindsey: Columbia Seafirst Center, Seattle

Zimmer Gunsol Frasca (ZGF): Koin Center, Portland

Hugh Stubbins & Associates: Citycorp Building, New York City; Pacwest Center, Portland

Gatje Papachristou Smith: Broward County Main Library, Fort Lauderdale; Richard B. Russell Power Plant, Savannah River, Georgia

Swanke Hayden Connell: Trump Tower, New York City

EMERY ROTH and SONS. Palace Hotel (architectural rendering), 1980. New York City

Nicollet Mall. Minneapolis

ARCHITECTURAL PRESERVATION

In recent years, as skyscrapers create more look-alike skylines all over the world, it has become apparent that America must preserve its distinctive architecture or each city will lose its individual character. The inhabitants of many cities are refurbishing old structures, redecorating houses, and saving old buildings that are worth the effort and funds to do the job. Some structures are being transformed from manufacturing centers into shopping areas and restaurants in an effort to preserve the feel of the city. Conversely, some shopping centers are incorporating or are being converted to office and industrial space. Finally, some shopping streets have been transformed into pedestrian malls to eliminate auto traffic. Such projects, like the Nicollet Mall in Minneapolis, preserve existing architecture and often incorporate some new structures in the process. This one includes the I.D.S. Center seen earlier in the chapter.

Emery Roth and Sons (1903–) This firm approached a similar problem from another angle. The Helmsey Palace Hotel complex (1980) makes use of a new tower but will coordinate it with the Villard House, an 1882 townhouse in New York. The house is designated as an historical landmark and cannot be moved or destroyed so it has been incorporated into the master plan. Entrance to the luxury 1050-room hotel-apartment tower is through the elegant historic house. Some of the valuable walls and decorations will be used in the offices and public rooms of the new structure. The bronze and glass tower forms a dramatic backdrop for the Villard House, but nearly 100 years separates the two constructions. The horizontal banding of the tower and the dark ridge on the corners create a contained feeling that ties it visually to the older structure. The top 10 floors of the tower are given over to 108 one- or two-bedroom rental apartments, which combine with a multi-purpose service structure.

CROSS-CULTURAL ARCHITECTURAL INFLUENCES

Architects today are not necessarily confined to their native lands but cross international boundaries and oceans to design their structures. Canadian architects have worked in Los Angeles and Mexico City. American designers have constructed buildings in Japan, China, Singapore and Europe. Major architects from several countries have built in Hong Kong and South America. They bring their own cultural influences to bear on the architectural styles of the world community. Like painting and sculpture, contemporary architecture reflects an integrated international style that is responsive to individual requirements. The following examples provide an insight into contemporary international design.

Japanese architect Arata Isozaki (1937–) designed the Museum of Contemporary Art in downtown Los Angeles. The site and purpose each posed specific problems that were solved with a distinctive and practical structure. Its use of color and a feeling of intimacy exemplifies many contemporary medium-sized buildings.

Many American architects are responsible for innovative designs overseas. Emery Roth and Sons continue to exert a major influence with structures in Malaysia, Singapore, China, Australia and the United Arab Emirates. Two examples of their planning are shown here, with architectural renderings showing buildings in planning and process in the Orient. Selegie Road Commercial Center in Singapore is a multi-purpose structure containing four stories of office space, three retail shopping levels around a seven-story atrium, and a three-level parking garage. It is located in a fashionable tourist district and is only one of many buildings designed by this firm for Singapore.

The China World Trade Center occupies a large area in downtown Beijing. Hotels, convention center, display areas, office space, retail outlets and parking are combined in a dramatic multi-purpose complex. Emery Roth and Sons is one of several American architectural firms designing buildings in China. This firm has also pioneered extremely tall, high-rise construction, having built the World Trade Center in New York City. They are developing plans for a 125-story office building in mid-town Manhattan, that will be the tallest building in the world.

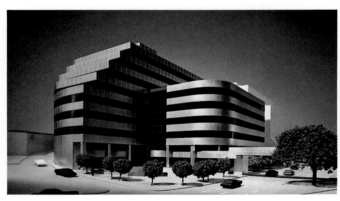

Arata Isozaki. Museum of Contemporary Art, 1986. Los Angeles

Emery Roth and Sons. Selegie Road Commercial Center, 1986. Singapore

Emery Roth and Sons. China World Trade Center, in planning, 1985. Beijing, China

468

Analysis

1. One of the basic teachings of architectural design is "Form follows function." Write a paper on this topic. First, discuss the meaning of the statement. Then choose three buildings in your community and discuss whether their use is reflected in their design. Does their form follow their function, or not? Explain.

2. The preservation of architectural examples is important for a sense of heritage. If we destroy all evidence of a fifty-year period, we eliminate that part of our visual heritage. Discuss the possibility and practicality of saving architectural works in your community. Which ones should be chosen for preservation? What criteria should be·used? What purpose should they have? How can such areas be organized? Many major cities are working on such projects: among them are Denver, Boston, Philadelphia, Baltimore and Minneapolis. Write to their chambers of commerce for information on these projects, and use their brochures to help you analyze your own historical and environmental situation.

3. Invite an architect in your community to speak to your class on city planning in your area, or on the firm's attitude toward architectural preservation versus urban renewal programs. Or, conduct an interview with an architect and tape the conversation. Be sure to have questions ready ahead of time.

Aesthetics

4. The photograph of a part of the city of San Francisco shows several interesting architectural features. Based on this photo, discuss: 1) The people of San Francisco take pride in their older architecture; 2) San Francisco's architecture reflects the progressive attitude of the people of the city; 3) San Francisco is a city of many architectural styles; 4) The skyline of San Francisco presents a unique appearance.

5. Twentieth century architecture seems to have lost its nationalistic or ethnic character. Based on the photos on these pages or other sources, defend or refute that statement. Then add a paragraph telling how you feel about architecture reflecting ethnic heritage. Should we consider it or not?

6. The most recently completed office building, church or public building in your community is probably the product of building techniques such as curtain walls, cantilevering, steel skeletons and other innovations. Visit the building and speak with the contractor, owner or architectural firm responsible for its leasing. (Do not forget to have questions planned and to make appointments to speak to people.) Report your findings to the class. Include information about function, finances, structural principles, aesthetics, environmental impact, landscaping, the community and possible significant impact on future architectural projects in the vicinity.

Studio

7. Architectural details often reveal a designer's appreciation and admiration of previous building styles and insure a continuity in building design. Take your sketchbook or camera on an architectural tour of your community. Sketch (or photograph) architectural details (window treatments, doorways, cornices, pediments, columns, rooflines, domes, etc.). Prepare a display of your findings and label each item with a few sentences telling: 1) name and/or location of the example; 2) the architectural influence that is evident (Greek, Classicism, French Renaissance, for example). Look in this book or other architecture books to find the earliest possible examples of similar details.

8. Make drawings to redesign an old section in your community. Consider such ideas as: 1) preservation of important structures; 2) adding new buildings (what style and size should you consider?); 3) total environmental scheme. Use ground plans (layout) and elevations (sketches) to show and explain your thinking. Photographs, sketches, and/or models can be used effectively in an oral or written presentation or in a television documentary.

9. Use lightweight cardboard, glue, tape and paint to design a model of a single building or an architectural complex (possibly a group project). Build it up from a ground plan, and consider vehicular and pedestrian traffic, use of land, environmental considerations, form and function, materials and landscaping. Use your imagination and plan a community of the twenty-first century, if you wish. If possible, visit a university architectural department or an architect's studio to see how architectural models look before you begin on your own design; or refer to a book on architectural design or model building.

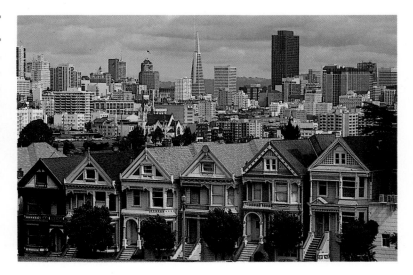

City Skyline. San Francisco, California

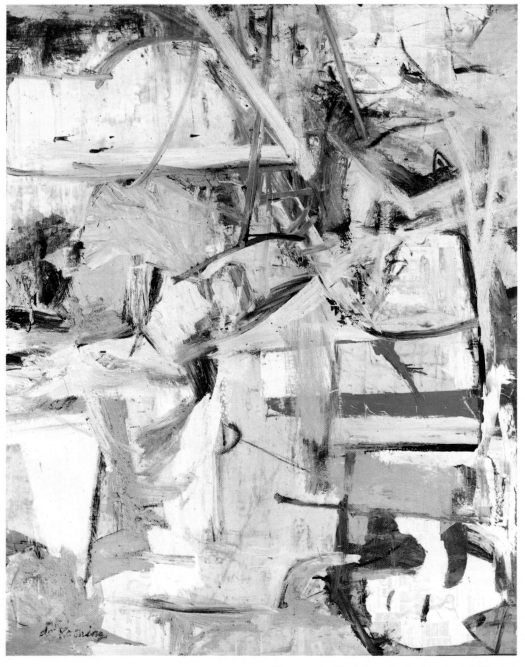

WILLEM de KOONING. *Easter Monday*, 1956. Oil and newspaper
transfer, 244 × 188 cm. The Metropolitan Museum of Art,
New York, Rogers Fund

17 New Concepts and Materials: Art from the Fifties to the Present

As wars have a tendency to do, World War II completely disrupted the European art scene and in the confusion, Paris lost its position as the art center of the world. That honor and responsibility shifted instead to the relative newcomer to Western art—the United States and the city of New York. What happened to art in the next three decades was astounding. Change and innovation became key words. Artists took flings at every conceivable method of communicating ideas, from absolute realism to pure subjectivity, to trying not to communicate anything at all. The fifties, sixties, seventies and eighties saw more changes in styles, techniques, materials, and messages than in a thousand previous years. The basic purposes of art did not change but the methods of making art and the artists of America did.

Realism persisted, but experimentation was rampant and popular styles sometimes lasted only several months as art dealers began merchandising art and artists as stylish commodities, similar to clothes and automobiles. The chaos in the art world reflected the impatience, confusion, and the searching inquiry of the world at large. Uncharted territory was searched, change was encouraged for the sake of change, individualism became a fetish, and newness was cherished. There is no way of knowing what directions and which artists will stand the test of time and be included in the art history books of the next generation. A cross-section of today's art, a few artists, and the major movements (mostly American) will be presented. Some styles were beyond the comprehension of the general public, but as Jackson Pollock once said: "The modern painter cannot express his age, the airplane, the atom bomb, the radio in the old forms of the Renaissance or any other past culture."

Abstract Expressionism

With absolute dynamic fury, a movement called *Abstract Expressionism* exploded in New York following World War II. Based on the freedom of individual expression, it got its title because it was abstract (emphasizing shape, color and/or line with no recognizable subject matter) and expressive (stressing emotions and individual feelings more than design and formalism). The style found its roots in Kandinsky and the more recent work of Gorky, but artists went off in individual directions and developed personal styles and techniques. The movement lasted about fifteen years, but during that time revolutionized the art world because it became immediately popular among artists around the globe. America had become the art leader of the world and remains so today. Artists from Europe, fleeing totalitarian restrictions and some even purged from Hitler's Germany, had settled in New York and began teaching. They and their students were the instigators of Abstract Expressionism or *Action Painting* as it was often called.

Willem de Kooning (1904–) Willem de Kooning came to America from Holland. After painting realistically for many years, he jumped into Abstract Expressionism with vitality, enthusiasm, and emotion. His slashing brush covered large canvases with color and action which became his non-objective subject matter. The apparent spontaneity of his art was often the result of many days of work which produced paintings of overall strength and compositional texture. In *Easter Monday*, de Kooning used newspaper transfer and oils as the media of the non-objective work. His huge paintings were

471

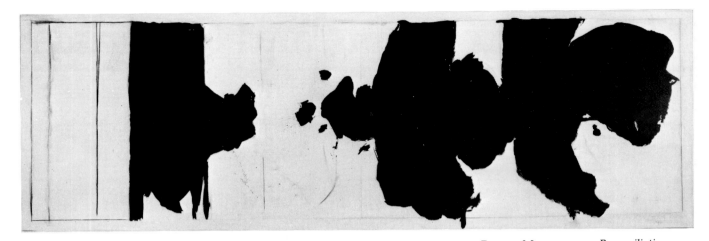

ROBERT MOTHERWELL. *Reconciliation Elegy*, 1978. Acrylic on canvas, 305 × 924 cm. National Gallery of Art, Washington D. C., gift of the Collectors Committee

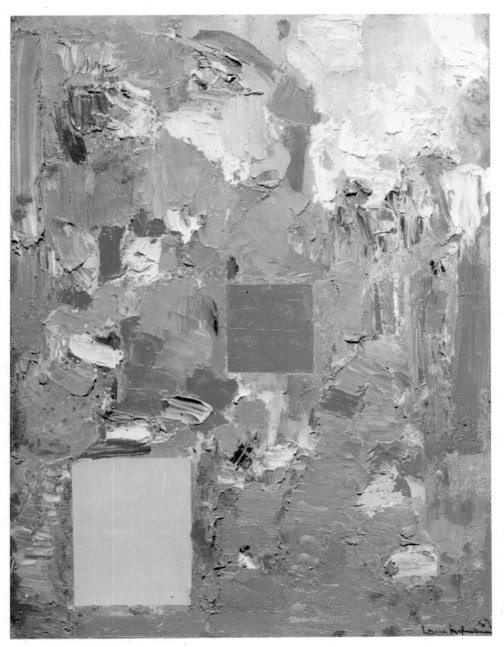

HANS HOFMANN. *Flowering Swamp*, 1957. Oil on wood, 122 × 91 cm. Hirshhorn Museum and the Smithsonian Institution, Washington D. C.

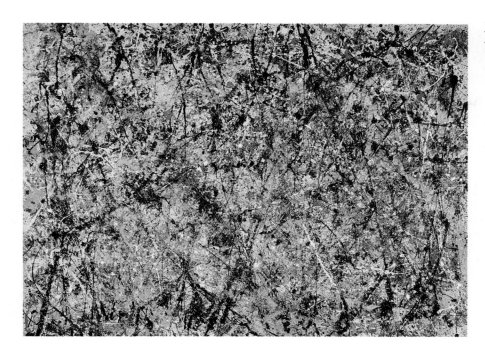

JACKSON POLLOCK. *No. 1, 1950* (*Lavender Mist*). Oil on canvas, 224 × 304 cm. National Gallery of Art, Washington D. C., Ailsa Mellon Bruce Fund

often frantic and violent—features that are evident here in the slashing quality of the brushwork. The emphasis is on the act of painting as part of the subject matter, and for this reason such work was called Action Painting. Some letters of the alphabet appear in de Kooning's work. He used them often as part of his huge swinging-motion paintings (*See* p. 75).

Robert Motherwell (1915–1991) Robert Motherwell does not use the slurred brush strokes of de Kooning but rather keeps a firm clarity to the outline of his freely formed shapes. Usually his paintings have flatly painted, delicate hues which are intensified because of the white backgrounds and powerful, bold, black shapes. *Reconciliation Elegy* is the 1978 extension of a series of paintings begun in 1949, reflecting the horror and destruction of the Spanish civil war. The brooding black shapes suggest a mood of anguish and a sense of doom. Usually his gigantic canvases are laid flat on the floor and the artist walks on them during the designing and painting process.

Hans Hofmann (1880–1966) Hans Hofmann came to New York from Germany and Paris to become one of America's most influential art teachers. He is best known for his canvases of heavily applied, brilliant color which seem to have some magical intensity. In paintings, such as *Flowering Swamp*, Hofmann painted several colored rectangles which seem to float over the background of softly brushed but heavily built-up colors, here suggestive of water and flowers. Most of his work does not have such representational aspects; however, the two rectangles immediately dismiss any idea of reality and orient the viewer to Hofmann's brand of abstraction. While de Kooning's canvases are often violent, Hofmann's often have a sense of serenity and visual balance.

Jackson Pollock (1912–1956) Jackson Pollock progressed through a realistic style and an abstract period before beginning (in 1946) his series of drip paintings, a working technique which completely freed him from the use of traditional brushes and opened the door to Abstract Expressionism. Laying his canvas on the floor of the studio so he could walk around on it or above it, he literally put himself into his work. With a can of paint in his hand, he moved about freely, dripping, spilling, and throwing the color with apparent abandon Pollock's paintings were not haphazard, however. He was the force behind the paint's movement. While he could not control the paint, he completely engaged himself in the process of creation to release both the creativity within him and the possibilities within the paint. The final work can thus be viewed as an interchange between the "will" of the paint and the inner forces of the artist.

Pollock's *No. 1, 1950* (*Lavender Mist*) is a complex interweaving of color and line which produces an overall web of fascinating texture. Although Pollock intended this work to be flat in appearance, as if all the color were right on the picture plane, overlapping lines of various values and colors give an indication of depth as if some lines are floating above others. Perhaps this unanticipated depth and the rhythm created by the thicker,

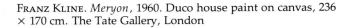

FRANZ KLINE. *Meryon*, 1960. Duco house paint on canvas, 236 × 170 cm. The Tate Gallery, London

darker lines suggest the ways in which Pollock's subsconscious interacted with and in some sense determined the flow of paint (*See* p. 31).

Franz Kline (1910–1962) Franz Kline painted the buildings and people of New York in a representational style until 1949 when he began to refine his style to a vigorous, slashing form of abstraction. At first his forms were derived from urban structures but soon he expressed himself freely without such visual ties to representative subject matter. In works like *Meryon,* he found he needed larger-sized canvases and less color to project his images of the energy of the city and contemporary life, and he began using gigantic slashes of black and white. He liked to tack unstretched canvas to a wall or to the floor and use large house painting brushes to apply house paint in powerful and energetic vertical and horizontal strokes.

Lee Krasner (1908–1984) Lee Krasner progressed through realism and small abstractions to eventually feel the need for much larger sized canvases to fully contain her expressions. She was a powerful influence in the development of Abstract Expressionism, although she maintained her independence on the fringes of the movement. Occasional changes in style always seemed to produce stronger statements based on her previous expressions. In 1954 when she was working on her brilliant collages, such as *Shattered Light,* she was actually tearing up old paintings to create dynamic new images. The resulting surfaces, rich in texture, color, movement, and overall unity, are noisy and joyous and are vibrant, unique, and personal expressions. She was married to Jackson Pollock until his tragic death in an auto accident in 1956.

Mark Rothko (1903–1970) Born in Russia, Mark Rothko was an early abstractionist who in his early development worked somewhat in the style of Arshile Gorky. He soon developed a style based on soft edges and blending colors. His expression was not the harsh and slashing furor of Kline or de Kooning, but a subtle and serene expression of a hushed and brooding mood. As his work became more simplified, the sizes of his canvases became larger and the color less contrasting and less intense. He limited his large, rectangular shapes, as in *Blue, Orange Red,* to only two or three. The hazy edges seem to give the feeling of shapes floating and vibrating in and out of the background color. When standing in front of a huge Rothko canvas, one almost has the feeling of floating along with the shapes, a sensation that would be explored by the color-field painters and the expanded-field painters of the 1960s. His final works were done mostly in grays and blacks as color, so important earlier, was completely abandoned.

LEE KRASNER. *Shattered Light*, 1954. 86 ×
122 cm. Collection of the artist

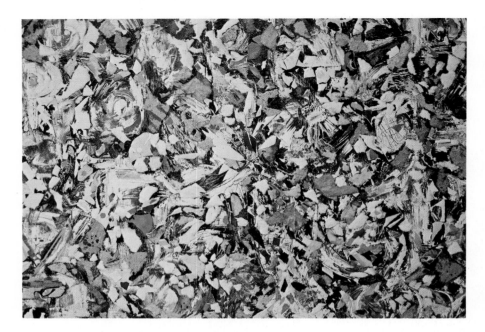

MARK ROTHKO. *Blue, Orange, Red*, 1961.
Oil on canvas, 231 × 206 cm. Hirshhorn
Museum and The Smithsonian Institu-
tion, Washington D. C.

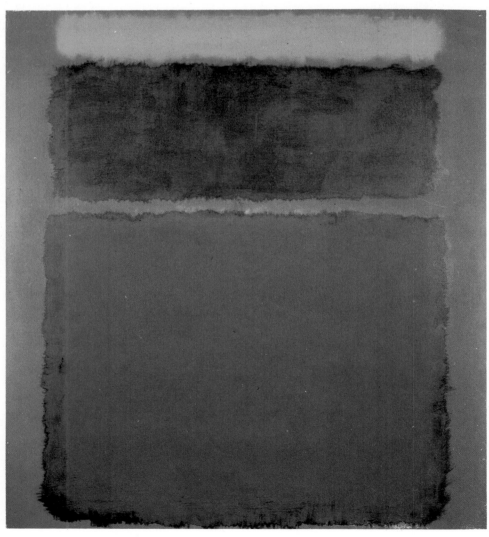

RICHARD DIEBENKORN. *Cityscape I*, 1963. Oil on canvas, 153 ×
129 cm. San Francisco Museum of Modern Art

LARRY RIVERS. *The Sitter*, 1956. Oil on canvas, 131 × 119 cm. The Metropolitan Museum of Art, New York, gift of Hugo Kastor

Richard Diebenkorn (1922–) Richard Diebenkorn was part of the second generation of Abstract Expressionists, many of whom abandoned complete reliance on undisciplined abstraction and returned to representational subjects and figurative painting but with expressionistic overtones. Combining reality and the expressionistic power and technique of the Abstract Expressionists, Diebenkorn developed a method of personal expression that relied on design but was still emotional in feeling. *Cityscape I* shows the influence of Abstract Expressionism in the brush strokes and reliance on flat shapes, but the design is structured and not accidental or undisciplined. The muted colors are arranged in flat planes with soft edges. Often figures were included in his work, and they also were treated as soft-edged planes rather than rounded forms.

Larry Rivers (1923–) Larry Rivers is another second generation Abstract Expressionist who developed an individual style based on the earlier movement but incorporated recognizable images. In *The Sitter*, he uses thin washes of oil color combined with skilled draftsmanship to fuse Realism and Abstract Expressionism into a single, unified painting. Some areas are as loosely painted as a de Kooning, but others are designed and drawn carefully. He combines the freedom of one style with the discipline of another to create his own personal statements. His work, like that of Diebenkorn's, was instrumental in bringing order out of the chaos that was developing in the later stages of the Abstract Expressionist movement, when even some critics could no longer tell the difference between the work of an accomplished painter and the slashes of a rank amateur.

Pop Art

As a reaction to intellectual and subjective Abstract Expressionism, a number of artists during the early sixties burst on the art scene, working with the common, everyday environment as their subject matter. Their subjects were often Coke bottles, beer and soup cans, comic strip characters, and hamburgers—things so

common that the attitude was dubbed *Pop Art*. It was not really a style because the artists worked in many directions; instead it was an attitude toward art and toward genre subjects that were actually reminders of supermarkets, movies, TV, and the comics. Abstract Expressionism had been a movement of undisciplined emotions, wildly exciting action paintings, slashing brush strokes, and hazy edges. Pop Art responded with hard edges, almost no brush strokes in many styles, extremely careful preparation and drawing, and an impersonal attitude toward the work and the subject. It also stressed simplicity. Emanating from nineteenth century Dadaism and Marcel Duchamp, it also was based on frustration with the art establishment and a delightful sense of wit, satire, and humor.

Robert Rauschenberg (1925–) Robert Rauschenberg acted as the bridge between Abstract Expressionism and Pop Art when he fastened to his abstract canvases such mundane objects as license plates, street signs, and men's clothes. He called them *combine paintings,* and like Picasso and Braque, was mixing reality

with abstraction. Rauschenberg, however, used the entire objects, not simply scraps. He combined everything imaginable (silk-screened images, transfers, prints, objects, painting, stuffed birds, and automobile tires) to create the visual sensation he desired. That sensation was often difficult for the public to comprehend as they were not used to looking at such a chaotic mixture of materials. Titles, such as *First Landing Jump*, probably did not help either. But the artist makes the viewer look at ordinary things in a different context. One is used to seeing tires on automobiles, not in "paintings." Pop artists want the viewer to see the commercial environment in a new way, and by juxtaposing usually unrelated materials, Rauschenberg has succeeded.

Jasper Johns (1930–) Jasper Johns used many Abstract Expressionist painting techniques, but his subject matter was as common as the American flag, targets, numbers, beer cans, flashlights, and maps of the United States. In paintings, such as *Numbers in Color*, Johns presents things one has often looked at but seldom seen in detail. Here he shows numbers, but he also made paintings of maps and flags—common things often overlooked but which he forces the viewer to look at. The colors are complementary (blue and orange) and cry out for recognition as they seem to vibrate forward and backward into the canvas. The overall effect is one of texture and pattern, but within that context, the individual numbers are the subject matter.

Roy Lichtenstein (1923–) Roy Lichtenstein became one of the stars of Pop Art. Like others of the group, he wanted to play on the slick, multiple images of commercial art, its mechanical techniques, and its glossy colors. The images were blown up to gigantic size by some artists: super hamburgers, mammoth ice cream sundae sculptures a meter and a half high, or huge boxes of Brillo pads. Lichtenstein made giant cartoon-like paintings, even simulating the Ben Day printing dots used to color the Sunday comics. Paintings, such as *Masterpiece*, look like they are cut from the comic page, but try to imagine this one 138 centimeters high. Often he poked gentle fun at the melodrama of the comics and the national fascination with them. Some of his works had verbal messages while others did not, but his slick, machine-like style remained the same for years. It was fun and art at the same time—an art that brought Abstract Expressionism to an abrupt halt.

Andy Warhol (1930–1987) Andy Warhol and Pop Art go hand in hand; it is hard to imagine one without the other. He zeroed in on American mass production and its boring repetitions. The consumer goes into the supermarket and sees hundreds of cans of Campbell's soup—instantly recognized and found in nearly every market and home in the country. Warhol painted *100 Cans* in a boring, unexciting way—just the way they are lined up on the market shelves. He even used the mechanical silk screen process to apply paint to canvas and had other people do the work. This is how impersonal he became with the medium. Warhol's depictions of Campbell's cans also include a series of paintings of huge, individual soup cans. They hung in the same gallery in a row to simulate the supermarket experience (*See* p. 39). Also known for his images of Marilyn Monroe and other personalities, Warhol created them by using the same printmaking process he had used for the cans.

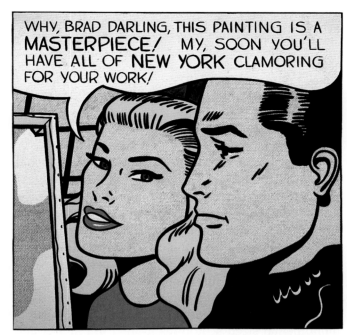

Roy Lichtenstein. *Masterpiece*, 1962. Oil on canvas, 138 × 138 cm. Collection of Leo Castelli, Inc.

Andy Warhol. *100 Cans*, 1962. Oil on canvas, 182 × 132 cm. Albright-Knox Art Gallery, Buffalo, New York, gift of Seymour H. Knox

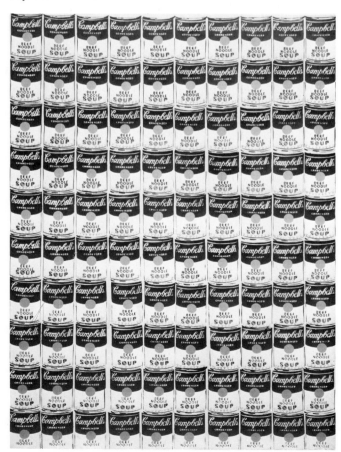

Claes Oldenburg (1929) Claes Oldenburg worked with various sculpture media to help the viewer see the manufactured environment with new eyes. He enlarged ordinary household objects, such as a three-way electrical plug, to enormous size (*See* p. 41). He also developed the technique of *soft sculpture* which added a surrealistic effect to his work. *Falling Shoestring Potatoes* is of painted canvas stuffed with soft kapok. The colors are rather realistic, but the entire "sculpture" is soft to the touch and sags humorously as it hangs limply from the ceiling. It would be startling in its soft form if it were actual size, but this sculpture is almost three meters high. Oldenburg enjoys designing ordinary forms (such as combs, trowels, and typewriter erasers) and producing them as monumental sized sculptures located in outdoor and indoor settings. Again, fun and art are united, and the viewer is forced to look at the work and wonder: Do people make too much of the commercial environment, and the industrialized surroundings? Are these things the twentieth century heroes?

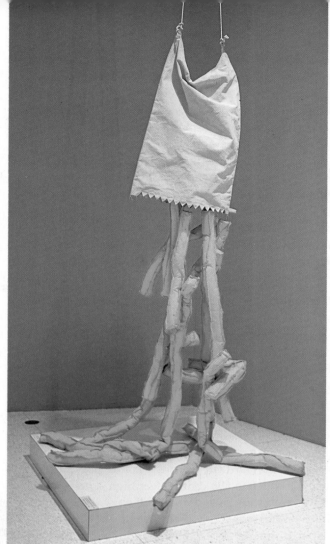

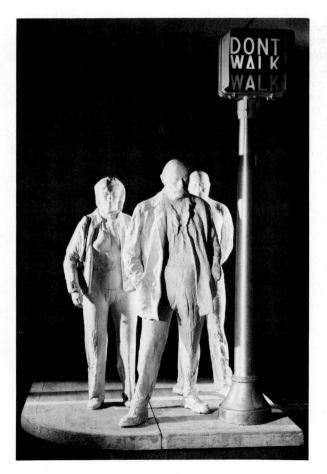

George Segal (1924–) Concerned with the same everyday sculptural subjects as Claes Oldenburg, George Segal used a different medium. Beginning his career as a painter and student of Hans Hofmann, he soon started using plaster to form people in everyday activities. In works like *Walk, Don't Walk*, Segal dips surgical gauze in plaster and wraps it around the person posing for him. Each section of the fast-drying plaster is cut off as soon as it dries, and the parts are assembled to make a hollow cast of the person. The ghostly white figures are startlingly real, especially when placed in a setting with real props, such as the street sign. There is nothing amazing or dramatic about the figures or their poses; they are simply realistic slices of American life—people going about their everyday jobs and routines.

BRIDGET RILEY. *Fall*, 1963. Acrylic emulsion on hardboard, 141 × 141 cm. The Tate Gallery, London

Op Art

Many artists have been fascinated by visual illusions and some have played tricks on the viewer's eyes. But twentieth century *Op Art (Optical Art)* makes use of scientific principles to create the sensation of movement on the picture plane. There are no focal points or traditional centers of interest in an Op Art work, but over-all organization creates the proper effect. Sometimes color makes the eye detect movement in and out, and at other times lines or shapes do. Op art is carefully calculated and meticulously presented. Its hard edges and smooth surfaces make it as different from Abstract Expressionism as possible.

Bridget Riley (1931–) Bridget Riley worked on pure Op paintings in England for many years, creating surfaces that seem to undulate before the viewer's eyes. By fixing one's gaze steadily in one place, shifting one's eye movement, or moving the work a bit, the image itself will move. Works such as *Fall* are capable of producing a dizzy sensation in some viewers. Riley's surfaces seem to wriggle and one cannot make the sensation stop, especially when confronting the work in its actual size.

Victor Vasarely (1908–) Victor Vasarely, the Hungarian-born leader of the Op movement in America, worked with geometric shapes and brilliant colors, after

VICTOR VASARELY. *Vega-Kontosh-Va*, 1971. Tempera on panel, 65 × 65 cm. Los Angeles County Museum of Art, gift of Mr. and Mrs. Donald Winston

RON DAVIS. *Plane Sawtooth*, 1970. Polyester resin and fiberglass, 152 × 356 cm. Albright-Knox Art Gallery, Buffalo, New York, gift of Seymour H. Knox

starting his studies in black and white. He plays tricks with the viewer's eyes as his surfaces seem to bulge in or out in either subtle or unbelievably abrupt bubbles. He achieved such effects by changing the size of shapes or the width of lines and strips, as in *Vega-Kontosh-Va*. Vasarely used thin layers of oil paint and crisp, hard edges to produce his effects, which he does not wish to call paintings. He created fantastic illusions of optical space and depth. His experiments have formed the basis for an illusionistic movement in art at the beginning of the eighties.

Richard Anuskiewicz (1930–) Richard Anuskiewicz was another American leader in the Op Art movement. His paintings are so carefully constructed with line and color that they produce sensations of the same shape both advancing and receding. His work is brilliant, balanced, and optically stimulating and makes use of the incredibly exact placement of lines, shapes, and colors (*See* p. 36).

Ron Davis (1937–) Ron Davis began using contemporary materials (acrylics or polyester resins with fiberglass) to create astonishing works of optical illusion. His colors, necessary to produce the various values in *Plane Sawtooth*, are fused to the rear surface of the fiberglass. The work is absolutely flat, not dimensional, and is cut from a sheet of fiberglass. Its unframed, irregular shape, when placed on the wall, adds dramati-

cally to the illusion of three-dimensionality. Even when the viewer gets close to the wall, it is difficult to visually flatten out the illusion as it is so convincing. Some parts seem shadowed, others transparent, and the viewer's eyes, accustomed to looking at three-dimensional objects, cannot separate the illusion from reality.

The emphasis on illusionism in the early eighties is based on the work of these Op artists and of others such as Larry Poons, Peter Young, and Alexander Lieberman. Still others, who worked with optical principles for a while but went into other directions as the sixties and seventies unfolded, are found in other pages of this chapter.

Color Field Painting

It is neither easy to label some of the other movements of the sixties and seventies nor to fit the artists into only one category. Most artists tried their hands at several styles until they found a comfortable means of expression. Mark Rothko's large and flat color statements led into a style that used only flat fields of color, involving no emotion and no mathematical calculations or geometry. It relied solely on color and has been called *Color Field Painting* but also has been labeled Post-Painterly Abstraction, Classical Abstraction, and Hard-Edge Painting.

Joseph Albers (1888–1976) Joseph Albers became the teacher of many Color Field painters when he came to America from Germany in 1933 and began a long series of studies based on the interaction of color. Using the square as a motif, he demonstrated the qualities of color and how they interact when placed next to each other or near other colors. *Homage to the Square: Glow* illustrates the format and design of his experiments with color. In most the squares are placed as they are here, but with different colors and combinations the visual results vary. Here, the intensity of the central hue causes that square to come forward and float over the others. Albers published his fascinating studies in a book titled *Interaction of Color* in which he defines his research and explains his findings (*See* p. 74).

Barnett Newman (1905–1970) Barnett Newman was part of a movement to produce art totally void of any visual or geometrical associations. His color fields are often huge and might be separated by a single wide or narrow line of contrasting or similar hue. His and other artists' desire to reduce the content of the painting to virtually nothing has caused the work to be called *Minimal Art*. It has also been called *Cool Art* because of its non-emotional quality and its characteristic precision which is the direct opposite of the hot and emotional Abstract Expressionism. Newman's *Adam* is a large canvas of two

KENNETH NOLAND. *Yellow Half*, 1963. Oil on canvas, 175 × 175 cm. Albright-Knox Art Gallery, Buffalo, New York, gift of Seymour H. Knox

elements, a dark-valued reddish-brown color field divided by bright red lines (seen here as lighter gray). It has no specific or hidden meanings, and the shapes are not rectangular or perfect. It is the most minimal statement that Newman could make at the time. He wants the viewer to look at the work and see *it* (not any suggestive subject matter or geometrical organization), and to perhaps think inwardly, much as the Oriental priest who looks at a blank wall and meditates.

Artists like Ad Reinhardt out-minimalized Newman later by painting a solid canvas of only black and painting it so smoothly that no brush strokes would show—the ultimate minimal statement.

Kenneth Noland (1924–) Kenneth Noland studied with Albers and worked in Washington, D. C., away from the New York scene where most of the country's art activity was taking place. He continued the Color Field

emphasis on the dominance of the canvas over subject matter or design. He started painting concentric circles on unprimed canvas, which caused a staining process and made the circles seem to pulsate and float. He then moved to gigantic, inverted chevrons of bright colors, each made up of several stripes placed against a darkly painted canvas. At first they were symmetrical, as in *Yellow Half*, but soon he moved the point to one or the other sides. He has more recently painted huge canvases of horizontal stripes of flat color, floating against vast white fields—producing the effect of flat landscapes. He was also one of the first artists to work on *shaped canvases*, eliminating the rectangular shape and working with diamonds and triangles.

Ellsworth Kelly (1923–) Ellsworth Kelly worked with pure color in large flat shapes. Large is an apt word because often his simple designs of only two intense colors and several geometric shapes would be mural-sized—over three meters high and five or six meters wide. Kelly got his training in Paris where he studied with the constructionists, artists who worked abstractly with basic geometric shapes. He often used acrylic paints to attain the hard, perfect edges of his shapes. Such precision, essential to the concept and style of Hard-Edge painting, is possible only with the use of masking tapes and thinned pigments. *Blue Curve III* is part of a series of works based on shaped canvases and curved shapes. The edge of the intense blue color appears to bulge forward from the diamond-shaped frame but in reality is perfectly flat.

Frank Stella (1936–) Frank Stella carried the shaped canvas still farther. His geometric designs make use of the unframed edges as part of the painting. In *Protractor Variation*, the interior lines and shapes repeat the curved and flat edges of the canvas itself. The colors are extremely varied, compared to the paintings of the previous few artists, and are carefully chosen to cause visual movement. What appear to be white lines are really narrow negative areas of unpainted canvas between the brightly painted shapes. During an earlier period of his development, Stella used these unpainted lines against a solid color field as the main element of the painting, as in *Star of Persia II*. His early works are almost monochromatic but his protractor series often combine

Frank Stella. *Zolder XXII*, 1982.
Mixed media on etched magnesium,
198 × 204 × 36 cm. Courtesy, Leo
Castelli Gallery, New York City

Gene Davis. *Moroccan Wedding*, 1973. Acrylic on canvas, 228
× 155 cm. McNay Art Institute, San Antonio, Texas, gift of
Mrs. Harry C. Hanszen

flourescent paints and metallic colors that are jarring to
the visual senses. His work in the seventies calmed
down in color but he began making constructions of
fabric and metal that were as much sculpture as paint-
ing. His experimental techniques in the eighties led
him to design works such as *Zolder XXII*, which is
painted with several media but is not on canvas or
paper. Instead, Stella etched wide strips of magnesium
to provide a slight surface texture to which the paint
can adhere, and bent them into sculptural configura-
tions. He continues to work at the forefront of contem-
porary painting and wall sculpture.

Gene Davis (1920–1985) Gene Davis was a Hard-Edge
painter who disregarded the large flat areas of the Color
Field artists and began working with colored strips or
lines. His meticulously crafted canvases of acrylic paint
are colorful, vivid, and carefully controlled. The width of
each color and its intensity is balanced across the surface
to present a unified, rhythmic pattern of lines and colors.
Moroccan Wedding was done with the aid of masking
tapes, but all feeling of a painted surface is eliminated
because of the smooth application of paint. As with
other minimal artists, Davis gives the viewer no subject
to contemplate and makes the surface as unpainterly and
machine-like as possible—linear and minimal perfec-
tion. As Frank Stella once said: "What you see is what

you see." In 1972 Davis painted a mammoth stripe
painting much larger than a football field on the parking
surface in front of the Philadelphia Museum of Art. He
used nineteen kilometers of masking tape and 1800 li-
ters of epoxy paint. It was a gallery work placed in a
non-gallery context, and now cars drive and park on it,
and people walk, roller skate, and bicycle over it, be-
coming part of the work.

Enlarged Field Painting

Environmental art has existed for a long time, having its
roots in the great Baroque churches that wrapped the
worshiper in color, form, and light. Monet's huge lily
pond paintings surrounded the viewer as did the
American cycloramas of the middle and late nineteenth
century. As stated earlier, after World War II, painters of
all types gradually enlarged their work until their can-

vases were almost mural size (compare painting sizes on the previous few pages with those on some nineteenth century pages). Huge canvases can fill a wall in a museum or public space, making the painting an important aspect of the interior environment and drawing the viewer into active visual participation with the work. Artists began opening up space in their work by leaving large portions painted white or as natural canvas. Such space did not seem vacant but became active open space, creating a feeling of air in which the viewer could almost float. Some artists designed three or four canvases to work together on three or four walls, acting as a total environment. Mark Rothko's huge, soft-edged canvases provided the impetus for the Enlarged Field painters. They were Color Field artists but made use of improvisation and accidental happenings with color rather than planning every part of the painting ahead of time.

Adolph Gottlieb (1903–1974) Adolph Gottlieb was an Abstract Expressionist whose work became larger and larger. He wanted to develop a workable set of symbols in his art and evolved a way of combining two opposite shapes: a disc, which is calm and geometric, and another form of ragged edges, breaking out of any containment. People have labeled them "bursts" and "blasts." Although Gottlieb did not mind other readings of his powerful work, he only wanted to make the two opposite shapes work together as a unit. *Rolling II* illustrates these two visual symbols with the roundish shapes always floating over the irregular ones. Notice that the round shapes have soft edges, made by staining the raw canvas and creating a pulsating sensation of forward and backward movement. The powerful black shapes are reminders of Klein's slashing black strokes, but by combining them with the round shapes, Gottlieb has produced a completely different and personal statement.

ADOLPH GOTTLIEB. *Rolling II*, 1961. Oil on canvas, 185 × 231 cm. Los Angeles County Museum of Art, estate of David E. Bright

Sam Francis (1923–) Sam Francis uses freely applied thin colors which he pours onto the canvas and allows to spread, stain, and overlap, creating luminous transparent layers. In earlier work, such as *Basel Mural*, the shapes are clustered in the top part of the gigantic canvas. Later the vivid color blobs are arranged around the edges of the canvas, almost slipping out of sight. In both arrangements, the white area acts as a powerful, sparkling, positive area of vibrant space. The drips, blobs, lines, stains, and bright colors add to the intensity of the unpainted areas which seem to be space through which one can move. Some of these environmental works by Francis are enormous, over ten meters wide, and enwrap the viewer in sparkling white space.

SAM FRANCIS. *Basel Mural*, 1956–58. Oil on canvas, 398 × 600 cm. Norton Simon Museum, Pasadena

Helen Frankenthaler (1928–) Helen Frankenthaler is one of the major contributors to Enlarged Field painting with her huge abstract canvases of luminous color. Works like *The Bay* were painted on the floor where unprimed canvas was stapled to make it taut. She works in a spontaneous way, pouring and spreading, pushing and flowing the stains and paints on the canvas. What starts as the top may end up being a side or the bottom of the work. Part of the unstretched canvas may be cut off to change the shape or the dimensions. Working in such a spontaneous way is difficult for many artists. Frankenthaler allows her feelings to play some part in determining which way a color is spread. She still works with fields of color, not by pre-planning the structure of the canvas, but by engaging in a spontaneous and exciting activity.

Morris Louis (1912–1962) Morris Louis based his images on the physical movement of color across unprimed canvas. He poured diluted acrylic paint on the canvas and by tilting, let it run until it produced superimposed veils of color. Sometimes the shapes were linear (running from top to bottom) while others, such as in *Point of Tranquility*, spread in different directions. The overlap-

HELEN FRANKENTHALER. *The Bay*, 1963. Acrylic resin on canvas, 205 × 208 cm. The Detroit Institute of Arts, gift of Dr. and Mrs. Hilbert H. DeLawter

MORRIS LOUIS. *Point of Tranquility*, 1958. Synthetic polymer on canvas, 258 × 343 cm. Hirshhorn Museum and Sculpture Garden, Smithsonian Institution, Washington D. C.

ANDREW WYETH. *Christina's World*, 1948.
Tempera on gesso panel, 82 × 121 cm.
The Museum of Modern Art, New York

ping, transparent shapes create a feeling of depth on the huge flat surfaces. Although the work is spontaneous and unplanned, the working process is delicate and careful, especially on such a gigantic surface. As each color is applied and the canvas tilted to spread the paint, the tilting must be controlled, stopped, and shifted to another angle until the supply of color is even and in a satisfactory shape and location. This painting is a soft, gentle explosion of color that seems to float like colored smoke in the white space of the canvas. It is a painting done completely without a brush stroke.

New Realism

American interest in realistic art never really disappeared from the scene, and in the seventies a revival of interest began in California and spread rapidly throughout the country. The movement goes by various names *(Super Realism, Photorealism, New Realism, Hyper-Realism)* with artists using commercial art techniques of airbrush, photography, spray, or anything else that helps produce realistic images. Based on genre art and the Pop painting of the fifties, New Realism led directly into the Illusionistic paintings of the early eighties—paintings which astound the viewer with mind-boggling illusions of reality (*See* Chuck Close's *Self-Portrait*, p. 506).

Andrew Wyeth (1917–) Andrew Wyeth is not a part of the New Realism movement because he has painted in his own realistic way throughout the various isms and developments of twentieth century art. His style is natural and easy as he portrays his natural environment in Pennsylvania and Maine. He works primarily with the natural landscape or portraits of his neighbors, using the exacting egg tempera medium. His work is a continuation of the American Scene painting but has a universal appeal. He works from energetic and emotional sketches to a finished product that seems absolutely real but which is based on abstract structuring and design. In paintings, such as *Christina's World*, he paints in the vast spaces and background first then adds the figure over it. The girl was a crippled neighbor of Wyeth's and her family's farm, shown in the painting, is next to his in Maine. The painting, like many of Wyeth's works, creates a mood in addition to being a realistic presentation. He is able to capture a moment in time and a feeling of place, enriched by a touch of the universal experience with life, people, and place. He raises commonplace subjects to levels of importance and dignity with immense skill.

James Rosenquist (1933–) James Rosenquist worked as a billboard painter and in the sixties, began to create paintings on canvas of billboard proportions. In

JAMES ROSENQUIST. *Nomad*, 1963. Oil on canvas with plastic and wood, 214 × 532 cm. Albright-Knox Gallery, Buffalo, New York, gift of Seymour H. Knox

TOM WESSELMAN. *Still Life No. 25*, 1963. Oil and assemblage on composition board, 122 × 183 × 10 cm. Rose Art Museum, Brandeis University, Waltham, Massachusetts

his king-sized works, such as *Nomad*, he uses many techniques employed by commercial and industrial artists, and he mimics the advertising style of art. His work has the feeling of Pop Art in its common subjects, but he combines many such images into one framework. Here the viewer can see (from left to right) part of a detergent box, two pairs of ballerinas' legs, a redwood picnic table and bench, a gigantic billfold, spaghetti with meatballs and olives, part of a lightbulb, a microphone, and a patch of grass with a stake in it. He has also included a real plastic trash bag and a pile of sticks he used to mix his paints. The impression is one that may be in the viewer's mind after watching a dozen television commercials or zipping by several advertising billboards.

Tom Wesselmann (1931–) Tom Wesselmann paints contemporary still lifes of huge proportions, blowing up ordinary bottles, cans, and food products to outlandish size. *Still Life #25* is typical of his treatment of subject matter and his commercially-oriented style. Each product and item is carefully portrayed in heroic size. The crinkled foil is real, but everything else is painted. Wesselmann, like Rosenquist, uses airbrushes, sprays, photographs, slides, and any other devices that help produce the desired image. He treats his subjects with cool detachment and unemotional objectivity. In more recent work, he is working in a more simplified way with larger images and is incorporating parts of nude female figures and/or gigantic smoking cigarettes, all done in his characteristic slick, commercial style.

Richard Estes (1936–) Richard Estes is a master of the urban scene. His buildings, windows, and vehicles sparkle with the brilliance and clarity of a rain-washed day. People are generally absent or are an insignificant part of the scene, but they are not needed as the shine and reflection of chrome and glass surfaces produces plenty of life and interest. Working directly from photographs and slides, colors, shadows, values, and reflections are painstakingly reproduced. As in *Drugstore,* the result is a cool, impassionate look at the city; a matter of fact photographic representation of a place. Estes' attitude is derived from Pop Art, but his technique and style are much more sophisticated.

Duane Hanson (1925–) Duane Hanson produces lifesize, colored models of human beings that are dressed with clothes and surrounded with actual things. The result is so lifelike that viewers often gape and giggle in unbelief and amusement. His three-dimensional New Realism is flawless and almost frightening at times. From plaster casts of people, polyester and fiberglass models are created which are tinted in natural colors. He works with ordinary people and even himself. In *Self-Portrait with Model* he surrounds the realistic sculptures with props which heighten the reality even more. His people and arrangements appear so real and ordinary that some viewers walk right past Hanson's work without realizing they are sculptures and not living people—the ultimate compliment to a superrealist artist.

RICHARD ESTES. *Drugstore*, 1970. Oil on canvas, 113 × 152 cm. The Art Institute of Chicago

DUANE HANSON. *Self-Portrait with Model*, 1979. Polyester and fiberglass, lifesize. Courtesy of the artist

HENRY MOORE. *Sheep Piece*, 1972. Bronze, 568 cm long. Hertfordshire, England. Courtesy of the artist

Sculpture

Sculpture during the second half of the twentieth century took gigantic steps in the use of new materials, techniques, concepts, and directions. The direction of its development is even more varied than that of painting. Contemporary sculpture reflects the excitement and innovative work of artists using these new techniques and materials.

Henry Moore (1898–1986) Henry Moore bridges late nineteenth and mid-twentieth century sculpture with his tremendous amount of work and uncommon skill. Into the late seventies, the master English sculptor was producing imaginative works in bronze and marble. *Reclining Figure Single Leg* of 1977 is an example (*See* p. 72). Almost all his abstracted works are based on the various forms of the human figure. His early work was only slightly abstracted compared to the rounded, simplified forms of his later years. *Sheep Piece* is a monumental bronze work of two interacting forms, reminiscent of two sheep huddling against a storm. Moore placed this casting in a sheep pasture where it

seems to belong, but the powerful, smooth, rounded forms would be just as comfortable in front of a skyscraper or in the courtyard of a museum. The tremendous body of work produced by the artist and its placement in locations around the world, has made Moore's work easily recognizable and universally appealing.

Barbara Hepworth (1903–1977) Barbara Hepworth was another English sculptor who worked with simplified forms, either in wood, bronze, or marble. In *Assembly of Sea Forms*, she used a traditional material (marble) but produced a contemporary effect by grouping the pieces to make the completed arrangement. But the arrangement may be changed again and again, always producing another complete effect. When a viewer walks around the group, the relationships between each part and the whole change also. Hepworth has carved marble into the essence of sea forms: rocks, caves, eroded forms, pebbles, and cliffs. The simplified units relate perfectly to each other in form and color and unite to produce a marvelous group sculpture.

Louise Nevelson. *Homage to the World*, 1966. Wood, 273 cm high. The Detroit Institute of Arts

Barbara Hepworth. *Assembly of Sea Forms*, 1972. White marble, tallest form 85 cm high. Norton Simon Inc. Foundation, Los Angeles

Louise Nevelson (1900–) Louise Nevelson experimented in the forties with all media and by the fifties found that her best expression was in wood. She filled boxes with found scraps, boards, and pieces of old Victorian houses and arranged them in various configurations, some small and some huge, such as *Homage to the World*. By painting everything a flat black (later she made them white and even gold), she unified the many different parts of the work. This gigantic assemblage is an environmental sculpture as it occupies two walls of a room. In recent years Nevelson has created an entire chapel of wood, painted white, in the inside of a skyscraper in Manhattan. This is a total environment of benches, walls, altar, and vestments, much like Matisse's. She continued to work with wood into the seventies, but also added Cor-Ten steel, lucite, and aluminum to her list of materials, producing gigantic outdoor as well as indoor works. A square in New York City is named for her and contains seven mammoth steel sculptures, up to twenty-one meters high. It is an exterior environmental group of huge proportions. She continues to experiment and work into her eighties.

Isamu Noguchi (1904–) Isamu Noguchi has produced an amazing variety of sculptures in various materials. Born of Japanese-American parents, he spent his early years in Japan and then two years working with Brancusi in Paris. He later studied in China and Japan and worked in London and Mexico. His international background has led to works of international feeling and acceptance. One of his recent sculptures, *Great Rock of Inner Seeking*, is carved from granite and weighs eight and one-half tons. Like much of his work, it has a primeval feeling and seems closely related to traditional Japanese garden art and Zen Buddhist contemplation. Some of the textures were made in nature, some by the drill that severed the stone from its parent mass, and some by Noguchi. The cooperative effort is a magnificent and powerful form, exciting in its simplicity and solemn and quiet in its implications. Like Nevelson, Noguchi has also designed some environmental spaces (Detroit's Civic Center Plaza and the Sculpture Garden at Jerusalem's Museum of Art) and also children's playgrounds and stage sets.

David Smith (1906–1965) David Smith was one of the first American sculptors to weld steel into sculptural forms. His work in a locomotive plant and automobile factory gave him the skills and personal experience to work with metals himself. In the late fifties and early sixties he developed a series of powerful images based on cubes of various sizes and proportions welded from stainless steel. The hollow forms were assembled in a variety of combinations and burnished to produce a slightly textured surface. These reflective planes on his geometric structures pleased him because "the surfaces were lightened and unified with the atmosphere." He titled the twenty-eight-piece series *Cubi*, of which the illustration is *Cubi XXIII*. Smith was in a highly productive period of his life when he died in an automobile accident.

DAVID SMITH. *Cubi XXIII*, 1964. Stainless steel. 439 cm long. Los Angeles County Museum of Art, Contemporary Art Council Fund

Len Lye. *Grass*, 1965. Stainless steel wire in wood, motorized, 91 cm high, including base, Albright-Knox Art Gallery, Buffalo, New York, gift of Howard Wise Gallery

New Directions

It is difficult to summarize the sculpture of the sixties and seventies because the variety of work and the experimental attitude defy classification. Gigantic projects were undertaken by artists in cooperation with heavy industry. Movement became more important and sculptors worked with materials and motors to create sculpture that moved—*Kinetic Art*. They used lights, sound, computers, and electricity to bring sculpture to life, uniting science, technology, and art. Videotapes, light, sound, cinematography, and animated film became the language of a new art form called *Intermedia*. Artists devised environments in which the spectators must participate. Some artists used earth moving equipment to gouge designs in the western deserts, to build circular jetties into lakes, or to rearrange earth into mounds (much as American Indians had done in the Ohio Valley many years ago). This phenomenon is known as *Earth Art*. Other artists developed a kind of art based on expressing in words, diagrams, or ideas, concepts which they had in mind but never intended to carry out—*Concept Art*. Others worked with laser beams, spanned huge valleys with curtains, sprayed plate glass, or worked on mammoth ceramic projects. The combining of technology and art opened up new areas which artists had never explored before. Art, and particularily sculpture, was moving in new directions that were a far cry from carving wood, painting canvas, or casting bronze.

Len Lye (1901–) Len Lye came to America from New Zealand, via England and Canada, and was always interested in motion. He became an instigator of Kinetic Art or art that involves actual movement. His kinetic sculptures move by air currents (like Calder's mobiles), by spectators who turn cranks or initiate the movement, or by electricity. His works were mostly in metal, such as *Grass* which is made of fine stainless steel wires inserted into a wooden base. It is attached to a motor programmed to tilt back and forth causing the wires to sway (as seen here), giving the impression of grass waving in the breeze. Lye taught an Intermedia program in New York, and his students are leaders in experimental and technological art at the present time.

LUCAS SAMARAS. *Mirrored Room #2*, 1966.
Wood and mirror, 2.44 × 3.03 × 2.44 m.
Pace Gallery, New York

DAN FLAVIN. Untitled, 1975. Daylight, warm fluorescent light,
wall #1—30 × 244 cm: wall #2—86 × 244 cm. Leo Castelli
Gallery, New York

Lucas Samaras (1936–　) Lucas Samaras has a strong interest in constructing environments and his *Mirrored Room #2* is a prime example. On a wooden framework he mounted mirrors inside and out so that when a spectator moves into the mirrored environment, there is a sensation of being suspended in space. The endless sparkling environment fragments one's vision and tricks one's senses in a delightful way. The exterior is also covered with mirrors and reflects and blends into the surrounding environment of the room in which it is placed.

Dan Flavin (1933–　) Dan Flavin works with fluorescent light as his medium. Forming glass tubes and filling them with gas, he designs light environments by filling walls, floors, or ceilings with his work. His untitled, two-wall arrangement of circular tubes is an example. While some light artists create chairs or ladders, Flavin concentrates on abstract environments. Here the circles of glowing glass can be seen, but at other times they are hidden and the light is indirect. Such light sculptures are best viewed in a darkened environment to sense the original glowing character envisioned by the artist.

Judy Chicago (1939–　) Judy Chicago works in many directions with her art but is always involved with advancing the cause of women's rights. Her monumental work is a gigantic triangular arrangement of place settings called *The Dinner Party*, of 1979. Each setting, designed in glazed ceramic and set on an embroidered and/or hand woven cloth, represents one of the great women of history. The ceramic tile floor is designed to supplement the ambitious table settings. She worked on much of the project herself but needed the help of many volunteers and employees to complete the task. Earlier she painted a *Reincarnation Triptych* which expressed the dynamic characteristics of three women whose lives had influenced hers. *Virginia Woolf* consists of acrylic paint sprayed on canvas, on which the artist used stencils to control the sprayed pattern. Around the border (as in each of the three canvases) is a forty-word statement about Virginia Woolf. Chicago's ideas are expressionistic as they are stimulating and based upon her personal philosophy of life. They are not part of a contemporary movement.

Judy Chicago. *The Dinner Party*, 1979. Ceramic with hand woven cloth, each side about 25 meters long. Courtesy of the artist.

Judy Chicago. *Virginia Woolf*, 1973. Sprayed acrylic on canvas, 152 × 152 cm. Courtesy of the artist.

ROBERT IRWIN. Untitled, 1968. Acrylic on Plexiglas (with lights), 152 cm diameter. Los Angeles County Museum of Art, gift of The Kleiner Foundation

LARRY BELL. Untitled, 1971. Coated glass/2 panels, each 274 × 153 × 1 cm. Los Angeles County Museum of Art, gift of the Burt Kleiner Foundation

Robert Irwin (1928–) Robert Irwin also involves light in his work but often combines it with plexiglass panels. In this untitled work from 1968, he suspends a large plexiglass disc (152 centimeters in diameter) about a half meter from the white wall. The disc is sprayed with acrylic paint and appears to be a whitish, bulging form rather than a flat shape. Four lights are directed at the shape which casts four overlapping shadows on the wall. The disc, lights, shadows, and the wall are all an integral part of the work. If the lights go off, only the disc remains. When standing directly in front of the disc, it is impossible to separate it from the shadow pattern on the wall as Irwin plays yet another trick on the viewer's sense of sight.

Larry Bell (1939–) Larry Bell began his art career as a painter, but soon began incorporating mirrors in his paintings. He moved into sculpture in 1964 when he began putting together aluminized glass cubes which partly reflected their surroundings. In 1970 he began a series of huge glass arrangements, some of which were large enough to be considered environments. This untitled work of 1971 consists of two panels of coated glass sprayed so delicately that the transition from clear glass to mirrored image is imperceptible. When walking past this work, the viewer occasionally sees his or her reflection but at other times sees through the clear glass. Visual stimulation of the viewer's senses is achieved here with mirrors and glass, not with lights and shadows.

Sebastian (1947–) Sebastian is a young Mexican artist who has produced transformable sculptures that the spectator can manipulate to change configurations. Again, the viewer becomes a participant in the work. Sebastian builds a small workable model from cardboard then enlarges it and produces a full-sized version in wood or metal. *Eugenlita* is made in highly polished silver to reflect the surroundings. Such intricately designed works are overwhelming in their complexity and technical skill. Hinged in dozens of places, the original squarish form can be opened and folded out to create a variety of new forms, of which three are shown here. None of the new forms seem to relate to the original cube except in the reflecting planes of silver. Sebastian's other works of different materials are often painted with acrylics to define the planes. His architectonic structures are enjoyable to manipulate and innovative in concept, and illustrate the wide degree of personal expression possible with familiar materials.

ROCKNE KREBS. *Day Passage*, 1971. Argon, helium-neon lasers, mirrors; environment space 30.46 m, L-shaped corridor. Los Angeles County Museum of Art (with Hewlett-Packard Corporation)

SEBASTIAN. *Eugenlita*, 1979. Silver, various sizes, depending on configuration. Three views. Courtesy of Rutherford Barnes Collection, Denver, and the artist

Rockne Krebs (1938–) Rockne Krebs delves into a kind of art that may be popular in the next century—that of using laser beams. While most of the world's population has never even seen a laser beam, Krebs uses them to create his visual statements. Since lasers shine into infinity without spreading, he has designed laser projects to illuminate a linear pattern over large urban centers, thereby creating a gigantic light show. On a smaller scale, he designed an installation at the Los Angeles County Museum of Art in 1971 that involved several lasers and mirrors to bounce the beams back and forth. *Day Passage* was constructed in an L-shaped space with the technological assistance of Hewlett-Packard Corporation who loaned several scientists to the artist for the project. Today, light shows with lasers are becoming more common, and artists will be working with advanced technology to incorporate this medium into their working vocabulary.

CHRISTO. *Running Fence*, 1972–1976. Nylon and cable, 540 cm high, 38.5 km long. Sonoma and Marin Counties, California. Courtesy of the artist

Christo (1935–) Christo was born in Bulgaria but has woven his artistic creations across several parts of the American landscape. He enjoys wrapping things like huge buildings, bridges, and part of the Australian coast (which he has wrapped and tied in plastic). He has spanned Rifle Gap in Colorado with a gigantic orange curtain, and in 1976 completed *Running Fence*, a 38.5 kilometer nylon curtain which snaked across Marin and Sonoma counties in California. The logistics and planning are a major part of such a four-year project. Public officials, scientists, environmentalists, artists, townspeople, farmers, construction workers, engineers, clothmakers, and seamstresses must be coordinated and convinced that the project is worthwhile. It cost three million dollars to put together (money which the artist had to raise himself) and stood for several days before it was dismantled. The only part of such art that remains is a huge book which documents every part of the project, and a picture, such as this one, which the artist released for this book. Christo is continually working on ideas for wrapping his favorite structures, such as the Reichstag in Berlin or Pont Neuf, a bridge across the Seine in Paris.

Donald Judd (1928–) Donald Judd represents sculptors interested in proportion and mechanical excellence. In his feelings about materials and finishes, he is like the minimal painters. His sculptures bear the imprint of Classicism in their proportions, careful design, and simplicity. Ten identical quadrangular cubic masses of stainless steel and laminated plastic make up *Stack*. The simple and undecorated forms are attached to and become part of the wall, and seem to float between ceiling and floor. The highly polished surfaces are as carefully formed and finished as pieces of jewelry. Judd conceives the ideas for his work and often has master craftspersons execute his designs. Decoration or color are not needed in such work where the forms are perfect and the relationships need not be altered. Even amid the experimentation and searching of the artists of the seventies and eighties, Judd reaches back and ties contemporary art to the Classic ideas of Greece.

DONALD JUDD. *Stack*, 1969. Stainless steel and laminated plastic, about 3.5 m high. The Detroit Institute of Arts

RED GROOMS. *Ruckus Rodeo*, 1980 (detail of part of work). Multimedia sculpto-pictorama, almost life size. Fort Worth Museum of Art, Texas

Red Grooms (1937–) Red Grooms does not work like any other living artist, although he was an abstract expressionist in his early years. He calls his papier-mâché environments "sculpto-pictoramas," and they completely involve the viewers as they walk through the colorful installations. He combines sculpture, construction and painting to produce work that overflows with detail, exaggerated perspective, verbal and visual puns and burlesque figural renditions. When walking into an installation like *Ruckus Rodeo*, the viewers become part of the work and can almost *hear* the noise of the crowds. Grooms spend an average of four months on each work, with some taking a year to complete. The artist is also involved in making films, watercolors, prints, oils, drawings, bronzes and mechanized constructions.

Roy Lichtenstein (see page 479) and **Jasper Johns** (see page 478) continue to expand their ranges of visual expression and are shown here as typical examples of the way contemporary artists grow and change. While new styles and techniques (*Graffiti Art, Post-Painterly Abstraction, New Image Painting, Post-Minimalism, Post-Modernism,* and a variety of re-runs, such as *Art Deco, Neo-Expressionism, Earth Art,* etc.) are constantly bombarding our visual senses, the established artists shown in this chapter are quietly adjusting, refining, and changing their styles to maintain their dynamic leadership in contemporary American art. New names also appear (Jonathan Borofsky, Susan Rothenberg, Audrey Flack, Eric Fischl, Julian Schnabel, Robert Cottingham, etc.) and by combining their work with that of older and more established artists, we have in the late 1980s an aesthetic mix that creates a visual environment unparalleled in its variations of techniques, methods of presentation, and means of expression.

ROY LICHTENSTEIN. *WomanI II*, 1982. Oil and magna on canvas, 204 × 142 cm. Courtesy, Leo Castelli Gallery, New York

JASPER JOHNS. *In The Studio*, 1982. Encaustic and collage on canvas, with objects, 182 × 122 × 10 cm. Courtesy, Leo Castelli Gallery, New York

501

ANSEL ADAMS. *Half Dome, Merced River, Winter Yosemite Valley*, 1971. Silverprint, 38 × 49 cm. The Detroit Institute of the Arts

Photography

In recent years, Photography has been gaining ground in its attempt to be recognized as a fine art medium. Museums have been exhibiting the work of historically important photographers as well as contemporary artist-photographers. Color work and experimental darkroom techniques have added new dimensions to the medium so that personal expression is even more possible. Photographers like Ansel Adams (1902–1987) have continually portrayed the American landscape with skill and good taste, in the tradition of the scenic painters. *Half Dome, Merced River, Winter Yosemite Valley* is dramatic in its contrasts, wonderful in its clarity and detail, and as carefully composed as an excellent painting. Wynn Bullock (1902–) works as close to his subjects as many superrealist painters. His silverprint, *Leaves and Cobwebs,* is delicate and powerful at the same time. The focus, editing of material, value contrasts, and composition are beautifully controlled and sensitively handled. No other artist, regardless of media, could portray the subject with any more skill than this.

WYNN BULLOCK. *Leaves and Cobwebs*, 1968. Silverprint, 19 × 23.5 cm. The Detroit Institute of the Arts

GENE GILL. *Untitled*, 1978. Serigraph, 61 × 81 cm. Courtesy of the artist

Printmaking

Experimental printmaking takes on many forms, and contemporary printmakers are exploring new avenues all the time. Innovations with color, tools, materials, and techniques have captured the imagination of many contemporary artists and have propelled printmaking into a major means of expression. The serigraphs of Gene Gill may provide a glimpse into the new techniques. His untitled print is screened on several sheets of plexiglass, mounted one over the other so that every time one changes position in front of the frame, the design changes slightly. The moire effect is unavoidable in such movement as the participating viewer becomes part of the creative process by moving to change positions and therefore change the appearance of the print.

Crafts

Fabrics, fibers, weaving, ceramics, jewelry, leatherwork, enameling and other crafts have become important art forms in the hands of superb craftspersons. Important craft exhibits are displaying work that is not made for utilitarian purposes but which is designed as art—that

OTTO NATZLER. *Bottle*, 1984. Ceramic, with blue-green reduction glaze, 31 cm. high. Courtesy of the artist.

503

is, to be appreciated for its aesthetic appeal. For example, Kay Sekimachi creates woven structures that are more sculpture than cloth. Yet Otto Natzler has continued to work in traditional ways with ceramics, developing innovative glazes to put on classically shaped bottles.

Conclusion

The second half of the twentieth century is a time of probing, experimentation, and searching in every field of endeavor, including art. Because some artists resent galleries and other people's making money from their art, they have devised kinds of art that cannot be sold or resold (such as Christo's fence or Krebs' laser displays). Kinetic artists have even designed works that shake themselves to pieces while Earth Artists allow nature to erode their work away. Concept art cannot even be seen! With all the experimentation, reaching, searching, exploring, and new technologies, other artists are perfectly content to work in traditional ways with traditional materials. As the beginning of the book suggests, people see and feel differently about the same things (some expressionistically and some objectively) and express themselves differently. The excitement of contemporary art is in its diversity. Each person cannot appreciate all of it but can try to understand the artists and their traditional or experimental expression. All have something to say, and if their work is honest and comes from their heart, it is valid expression, regardless of style. The viewer's job is to recognize styles, enjoy the expressions, and to read the visual communication of the world's artists to the best of his or her ever-growing ability.

KAY SEKIMACHI. *Amiyose III*, 1971. Clear nylon filament, quadruple and tubular weave, 165 cm high. Courtesy of the artist

1950

Middle East	British leave Suez Canal Zone (1954); Egypt seizes Suez Canal (1956)
China	Cultural Revolution (1965–1968)
Japan	Japan-U.S.A. Peace Treaty (1951); Beginning of economic boom (1950)
Korea	Korean War (1950–1953)
Europe	Warsaw Pact (1955); Common Market (1957); Sputnik (1957); Vatican Council (1962)
Africa	17 African countries achieve independence after 1957
Americas	Kennedy assassinated (1963); Hydrogen bomb (1954); Einstein dies (1955); Laser (1960)

1965

Islamic world	Domination of oil production (OPEC); World importance; Islamic state in Iran (1979); Iran-Iraq War (1980s)
Middle East	Six-Day War (1967); Beirut, Lebanon, turmoil (1980s)
China	Cultural Revolution ends (1968); Peoples Republic in United Nations (1971); Tourism (1979); Westernization (1980s)
India	Republic of Bangladesh established (1973); New government under Rajiv Gandhi (1985)
S.E. Asia	Vietnam War ends (1973); Unrest continues
Europe	Solzhenitsyn; Expansion of Common Market; U.S.S.R. liberalization (late 1980s)
Americas	First heart transplant (1967); Man on moon (1969); First orbiting space lab (1973); Space Shuttle (1980s)

1980

Art of Other Cultures

Regardless of nationality, ethnic background, or geography, there is a kind of internationalism in contemporary art. Artists all over the world work with the same materials and have access to books and reproductions of each other's work. Traveling shows expose the work of Asian artists to Australians and New Yorkers alike. And artists themselves are mobile, traveling to other continents to see what is being done and talking over philosophies with artists who live thousands of miles apart. Mizufune is a contemporary Japanese printmaker working in a traditional medium but incorporating many new techniques. The result is a print that has the heavy textural quality of an oil painting and could have been done by an experimental printmaker on any continent.

R. MIZUFUNE. *White Night*, 1973.
Woodcut, 51 × 61 cm. Collection of
M. M. Shinno, Los Angeles

INDEPENDENT STUDY PROJECTS

Analysis

1. Write an essay, comparing and contrasting the purposes, styles and techniques of one pair of artists from this list: Willem de Kooning and Joseph Albers; Jackson Pollock and Mark Rothko; Kenneth Noland and Sam Frances; Duane Hanson and Richard Estes; Larry Bell and Red Grooms.

2. Many contemporary artists continually go through periods of transition in their work. Trace a well-known established artist (Donald Judd, Larry Rivers, Frank Stella, Jim Dine, Robert Rauschenberg, Roy Lichtenstein, Andy Warhol, Tom Wesselman, etc.) through fifteen years of development by researching magazine articles on him or her. Use the *Readers Guide to Periodic Literature* or a cumulative index of various art magazines for sources. Your librarian can help you with this project.

3. The huge paintings of Chuck Close are superb examples of Super Realism in the late seventies. This portrait of *Kent* is so photographic that the limited depth of field allows only the eyes and everything within a centimeter of that plane to be in sharp focus. All else is slightly or more out of focus. Close paints realism exactly as the camera sees it. His technique involves a thorough knowledge of photography, color reproduction processes, color printing processes and painting techniques. How would you compare this work to the painting of a Renaissance realist such as Leonardo? Compare it with the portraits of Rembrandt; with the Neoclassic realism of Ingres; with the realistic portraits of Eakins; and with the Impressionist style of painting. Write a paper describing your comparisons. Although the realism of Chuck Close may seem astounding in this reproduction, it must be experienced in actual size (256 cm high) for its full impact.

Aesthetics

4. Write a paper or lead a class discussion on how an artist's visual statement can be interpreted in a variety of ways, or in ways which the artist never intended. Are such interpretations valid? Cite examples from this chapter or other sources. Should artists be disappointed if their original intent is not evident to a viewer who might see something completely different in the work? How can this question be approached with respect to poetry, films, novels and speeches?

5. Two- and three-dimensional contemporary art has many experimental directions. Which direction do you like best? Which contemporary artist appeals to you the most? Explain your reasons for your answers. Write a paper or make an oral presentation in person or on videotape.

6. Imagine yourself a young Renaissance artist who drops into a contemporary gallery in New York, London, Los Angeles or Paris. If you were a student of Raphael's, how would you feel? Which artists might you enjoy? What aspects of twentieth century art could you identify with? What types of art would be very disturbing to you? Explain why. Could you ever become comfortable in the twentieth century? Why or why not?

Studio

7. Make a tempera or acrylic painting in the style of one of the following artists: 1) Roy Lichtenstein (use a current, simple comic style and colored dots); 2) Andy Warhol (repetition of forms—use stencils); 3) Frank Stella (protractor series); 4) Richard Estes (use your own photograph); 5) Jackson Pollock (drip painting); 6) Morris Louis or Helen Frankenthaler (flowing shapes); 7) Franz Kline (big black slashes); or another artist of your choice. Use your own design, but the work in that artist's style.

8. Use materials of your own choice (not necessarily those of the artist in whom you are interested) and make a sculpture in the style of Henry Moore, Louise Nevelson, Isamu Noguchi, Red Grooms, Donald Judd, David Smith, Claes Oldenberg, George Segal or another artist. If you wish, your work can be much smaller than the work shown in this chapter.

9. Using the work of Robert Rauschenberg (page 478) or Jasper Johns (page 501) as a model, make a combine painting that includes one or more actual objects as well as painting on a flat surface. Design the piece so the objects and painting work together as a unified statement. Use heavy cardboard, Masonite or plywood as the ground, and acrylics as the painting medium.

CHUCK CLOSE. *Kent*, 1971. Acrylic on canvas, 256 × 228 cm. Art Gallery of Ontario, Toronto

Pronunciation Guide for Artists' Names

Italicized syllables are accented

Abramovitz, Max ah-*bram*-oh-vits, max
Adams, Ansel *ad*-ums, *an*-sul
Aeschylus *ess*-key-luss
Aguilar, Rosalie *ah*-gwee-lar, *rose*-ah-lee
Alberti al-*bear*-tee
Altdorfer, Albrecht *ahlt*-dor-fur, *ahl*-brekt
Angelico, Fra an-*jay*-lee-coe, frah
Anuskiewicz, Richard an-*nus*-ku-witz, *rich*-ard
Archipenko, Alexander are-chee-*peng*-coe, al-ex-*and*-er
Arp, Jean (Hans) arp, zhahn (hahns)

Baciccio, Giovanni Battista Gauli bah-*kee*-chee-oh, jo-*vahn*-ee bah-*tee*-stah *gow*-lee
Balogna, Nicolo da bah-*lone*-yah, nee-*koh*-loh dah
Barlach, Ernst *bahr*-lock, airnst
Becker, Paula Modersohn *bek*-ker, *pawl*-uh *mah*-der-sohn
Bellini, Giovanni bel-*lee*-nee, jo-*vahn*-nee
Bernini, Gianlorenzo bair-*nee*-nee, jee-ahn-low-*rents* oh
Bertoldo bair-*told*-oh
Bierstadt, Albert *beer*-staht, *al*-bert
Bischof, Weiner *bish*-off, *why*-ner
Boari, Adamo boh-*ah*-ree, ah-*dahm*-oh
Boccioni, Umberto bought-she-*oh*-nee, oom-*bair*-toe
Bologna, Giovanni boh-*loh*-nyah, jo-*vahn*-nee
Bonheur, Rosa bon-*err*, *roh*-zah
Bonnard, Pierre boh-*nahr*, pee-*air*
Borglum, Gutzon *bore*-glum, *gutz*-un
Borromini, Francesco bore-oh-*mee*-nee, fran-*sess*-coe
Bosch, Hieronymus bosh, heer-*ahn*-ni-mus
Botticelli, Sandro bought-tee-*chel*-lee, *sand*-roe

Boucher, Francois boo-*shay*, fran-*swah*
Boudin, Eugene boo-*den*, oo-*zshen*
Boudogne, Jean boo-*dawyn*, zjahn
Bramante, Donato brah-*mahn*-tee, doe-*nah*-toe
Brancusi, Constantin bran-*coo*-see, *con*-stan-tin
Braque, Georges brahk, zjorzj
Bresson, Henri Cartier bre-*sohn* ahn-*ree* car-*tyay*
Breton, Andre breh-*ton*, ahn-*dray*
Breuer, Marcel *brew*-er, mar-*sell*
Bronzino, Agnolo brahn-*zee*-noh, ag-*noh*-loh
Bruegel, Pieter *bree*-gl, *pee*-ter
Brunel, F. K. brew-*nell*, F. K.
Brunelleschi, Filippo brew-nell-*less*-key, fee-*leep*-poh
Bullant, Jean boo-*lahn*, zjahn
Buonarroti, Michelangelo bwoh-nay-*roh*-tee, mee-kel-*an*-jay-loh

Cambio, Arnolfo di *cam*-bee-oh, are-*nohl*-foe dee
Campin, Robert cahn-*pen*, roh-*bair*
Canaletto, Antonio can-ah-*let*-toe, an-*toe*-nee-oh
Caravaggio car-ah-*vah*-jyoh
Cassatt, Mary cah-*sat*, *mair*-ee
Castagno, Andrea del cas-*tahn*-yo, ahn-*dray*-ah dell
Castelfranco, Giorgione da cah-stell-*frank*-oh, jor-*joh*-nay dah
Cellini, Benvenuto chel-*lee*-nee, ben-vay-*noo*-toe
Cezanne, Paul say-*zahn*, pawl
Chagall, Marc sha-*gahl*, mark
Chalgrin, J. F. shal-*gren*, J. F.
Chardin, Jean Baptiste-Simeon shar-*den*, zjahn bah-*teest* see-may-*on*
Chirico, Giorgio de *key*-ree-coh, *jor*-jyoh day
Christo *kriss*-toe
Cimabue chee-mah-*boo*-ay

Clouet, Jean *cloo*-eh, zjahn
Copley, John Singleton *kahp*-lee, jahn *sing*-ul-ton
Corbusier, Le core-boo-zee-*ay*, luh
Corot, Jean Baptiste Camille ko-*roh*, zjahn bah-*teest* kah-*mee*-yuh
Correggio koh-*red*-jyoh
Courbet, Gustave koor-*bay*, goo-*stahv*
Cranach, Lucas crah-*nak* (soft) , *loo*-kahs
Creeft, Jose de krayft, hoe-*zay* day

Daguerre, Louis dah-*gehr*, loo-*ee*
Dali, Salvador *dah*-lee, *sahl*-vah-door
Daumier, Honore dough-mee-*ay*, oh-noh-*ray*
David, Jacques Louis dah-*veed*, zjahk loo-*ee*
Da Vinci, Leonardo dah-*vin*-chee, lay-oh-*nar*-doh dah
Degas, Edgar duh-*gah*, ed-*gahr*
Delacroix, Eugene dul-la-*krwah* oo-*zhen*
Derain, Andre duh-*ren*, ahn-*dray*
Diebenkorn, Richard *dee*-ben-korn, *rich*-ard
Dieux, Jean-Jacques dee-*yuh*, zjahn zjahk
Donatello doh-nah-*tell*-oh
Duccio *doo*-chyoh
Duchamp, Marcel doo-*shahn*, mar-*sell*
Dufy, Raoul doo-*fee*, rah-*ool*
Dürer, Albrecht *dur*-er (*deer*-er), *ahl*-brecht

Eakins, Thomas *ay*-kins, *tahm*-us
Eiffel, Alexandre-Gustave *eye*-fel, al-ex-*andr*, goo-*stahv*
El Greco el *greh*-koh
Ernst, Max airnst, max
Estes, Richard *ess*-tuss, *ri*-chard

Faberge, Michael Perkhin fah-bair-*zjay*, *my*-kel *pair*-kin

507

Fabriano, Gentile da fah-bree-*ah*-noh, jen-*teel* dah

Feininger, Lyonel *fine*-ing-er, *lye*-oh-nell

Fiorentino, Rosso fyor-en-*tee*-noh, *rah*-soh

Fischer, Johann Michael *fish*-er, *yoh*-hahn *my*-kel

Flavin, Dan *flay*-vin, dan

Fouquet, Jean foo-*kay*, zjahn

Fragonard, Jean-Honore fra-go-*nahr*, zjahn oh-no-*reh*

Frankenthaler, Helen frank-en-*tahl*-er, *hell*-en

Gabo, Naum *gah*-boh, naum

Garnier, Charles gahr-*nyay*, shael

Gaudi, Antoni *gow*-dee, *ahn*-toe-nee

Gauguin, Paul go-*gen*, pawl

Gellee, Claude zhuh-*lay*, kload

Gentileschi, Artemisia jen-ti-*less*-key, ar-tay-*mee*-zee-ah

Gericault, Theodore zhay-ree-koh *tay*-oh-dor

Ghiberti, Lorenzo gee-*bair*-tee, loh-*ren*-zoh

Ghirlandaio gear-lan-*dah*-yo

Giacometti, Alberto zjah-coe-*met*-ee, al-*bear*-toe

Giotto *jot*-toe

Gorky, Arshile *gor*-kee, *ar*-shil

Gothardt, Mathis Niethardt *got*-art, mah-*tis* nee-tart

Gottlieb, Adolph *got*-leeb, *ay*-dolf

Goujon, Jean goo-*zjahn*, zjahn

Goya, Francisco *goy*-ah, fran-*sis*-coe

Gris, Juan grease, *hwahn*

Gritte, Andrea grit, ahn-*dray*-ah

Gropius, Walter *grow*-pee-us, *wall*-ter

Grünewald, Mathias *groon*-eh-valt, mah-*tee*-ahs

Guardi, Giovanni Battista Francesco goo-*are*-dee, jo-*vah*-nee bah-*tees*-tah fran-*chess*-koh

Hals, Frans hahls, frahns

Haussmann, Georges Eugene ohs-*mahn*, zjorzj oo-*zjehn*

Henri, Robert *hen*-rye, *rah*-bert

Hiroshige, Utagawa hear-oh-*shee*-gah, oo-tah-*gah*-wah

Hobbema, Meyndert *hob*-buh-mah, *mine*-dert

Holbein, Hans *hole*-bine, hans

Hooch, Pieter de hoak, *pee*-ter duh

Horunobu, Susuki hor-oo-*noh*-boo, soo-zoo-key

Houdon, Jean Antoine oo-*don*, zjahn an-*twahn*

Iktinus *ick*-tee-nus

Ingres, Jean Auguste-Dominique engr, zjahn oh-*goost* doh-min-*eek*

Jans, Geertgen Tot Sint yahns, *gert*-gun toat snt

Jones, Inigo jones, *in*-ee-go

Kallikrates kal-i-*crate*-ees

Kandinsky, Wassily can-*dins*-key, *vahs*-i-lee

Kashani, Maqsud kah-*shah*-nee, *mahk*-sood

Keahbone, George *key*-ah-bone, george

Kirchner, Ernst Ludwig *kear*-kner, airnst *lood*-vig

Klee, Paul clay, pawl

Klimt, Gustav klimt, *goo*-stahf

Kokoschka, Oskar coh-*cosh*-cah, *oss*-kar

Kollwitz, Käthe *kahl*-wits, *kay*-teh

Labrouste, Henri lah-*broost*, ahn-*ree*

Lachaise, Gaston la *shez*, ga ston

Lamerie, Paul de la-muh-*ree*, pawl duh

Langhans, Karl *lahng*-hahns, carl

La Tour, George de la-*toor*, zjorzj duh

Lautrec, Henri de Toulouse low-*trek*, ahn-*ree* duh too-*looz*

Le Brun, Charles luh-*brun*, sharl

Leger, Fernand le, zjeh, fair-*nahn*

Lehmbruck, Wilhelm *lame*-brook, *vill*-helm

Le Nain, Antoine luh-*nain*, an-*twahn*

Lescoth, Pierre lay-*koh*, pee-*air*

Leyster, Judith *lie*-stir, *you*-deet (jew-*dith*)

Lichtenstein, Roy *lick*-ten-stine, roy

Limbourg lin-*boor*

Lipchitz, Jacques *lip*-sheets, zjahk

Lippi, Filippo *lip*-pee, fill-*lip*-poe

Lorenzetti, Ambrogio loh-ren-*zett*-tee, am-*broh*-jyoh

Lorenzetti, Pietro loh-ren-*zett*-tee, pee-*ate*-roh

Luks, George looks, george

Lysippus lie-*sip*-us

Maderno, Carlo mah-*dair*-noh, *car*-loh

Magritte, Rene mah-*greet*, ren-*ay*

Maillol, Aristede mah-*yahl*, ah-riss-*teed*

Malevich, Kasimir *mal*-uh-vich, kas-i-mear

Manet, Edouard ma-*nay*, eh-doo-*are*

Mansart, Jules Hardouin mahn-*sar*, zjool are-doo-ehn

Mantegna, Andrea man-*ten*-ya, ahn-*dray*-ah

Marin, John *mair*-in, jahn

Marquet, Albert mar-*keh*, al-*bair*

Martini, Simone mar-*tee*-nee, see-*moh*-nay

Masaccio ma-*saht*-chee-oh

Matisse, Henri mah-*teess*, ahn-ree

Medici Lorenzo de *meh*-di-chee, loh-*ren*-zo day

Meissen, Augustus Rex *mice*-en, aw-*gus*-tus rex

Mengoni, Guiseppe men-*go*-nee, jiss-*sep*-ee

Metzinger, Jean *met*-zin-gair, zjahn

Michelangelo mee-kel-*an*-jay-loh

Michelozzo mee-keh-*loht*-soh

Millet, Jean Francois mee-*lay*, zjahn fran-*swah*

Miro, Joan mee-*roh*, *zjoh*-ahn

Modigliani, Amedeo moh-dee-lee-*ah*-nee, ah-may-*day*-oh

Modrian, Piet *mown*-dree-ahn, peet

Monet, Claude moh-*nay*, kload

Moreau, Gustave mo-*roh*, goo-*stahv*

Morisot, Berthe moh-ree-*zoh*, bairt

Moronobu, Hishikawa moh-roh-*noh*-boo, hish-ee-*kah*-wah

Munch, Edvard moonk, *ed*-vard

Murillo, Bartholome Esteban moo-*ree*-yoh, bar-toh-loh-*may* ess-tay-bahn

Nadar, Gaspard nah-*dahr*, gass-pahr

Neutra, Richard *noy*-trah, *rich*-ard

Niepce, Nicephore *neep*-chee, *neess*-eh-for

Noguchi, Isamu noh-*goo*-chee, is-*sah*-moo

Nolde, Emil *nohl*-day, eh *meel*

Oldenburg, Claes *old*-en-berg, klahss

Orozco, Jose Clemente oh-*ross*-coh, ho-*say* cleh-*men*-tay

Palladio, Andrea pah-*lay*-dee-oh, an-*dray*-ah

Panini, Giovanni Paolo pah-*nee*-nee, jo-*vah*-nee pah-*oh*-loh

Parmigianino par-mi-*jee*-ah-*nee*-noh

Peale, Raphaelle peel, *rah*-fay-ell

Pei, I.M. pay, I.M.

Perrault, Claude pear-*oh*, kload

Perugino pay-roo-*jee*-noh

Phidias *fid*-ee-us

Piazzetta, Giovanni Battista pee-ah-*zet*-tah, jo-vahn-ee bah-*tees*-tah

Picasso, Pablo pee-*kahs*-oh, *pah*-blow

Pierro della Francesca pee-*air*-oh *dell*-ah fran-*chess*-kah

Pissarro, Camille pee-*sahr*-oh, cah-*meal*

Pollock, Jackson *pah*-lock, *jack*-sun

Pontormo pohn-*tore*-moh

Posada, Jose Guadalupe poh-*sah*-dah, ho-*say* hwah-dah-*loop*-ay

Poussin, Nicholas poo-*sahn*, *nick*-oh-lahs

Prandtauer, Jacob *pran*-tower, *yahk*-ob

Raggi, Antonio *rah*-jee, an-*toe*-nee-oh

Rapheal rah-fa-yell

Rauschenberg, Robert *rau*-shen-berg, *rah*-bert

Redon, Odilon re-*don*, oh-dee-*lon*

Rembrandt van Rijn *rem*-brant van rhine

Renoir, Pierre Auguste ren-*wahr*, pee-*air* oh-*gust*

Ribera, Josepe de ree-*bay*-rah, zhoo-*say*-pay day

Riemenschneider, Tilman *reem*-en-shny-dr, *till*-mahn

Rietveld, Gerrit *reet*-velt, *gair*-it
Rivera, Diego ree-*vay*-rah, dee-*ay*-goh
Robbia, Luca della *roh*-bee-ah, *loo*-kah *dell*-ah
Rodin, Auguste roh-*dan*, oh-*gust*
Roentgen, David *rent*-gun, *day*-vid
Rouault, Georges roo-*oh*, zjorzj
Rousseau, Henri roo-*soh*, ahn-*ree*
Rude, Francoise rood, fran-*swahz*
Ruisdael, Jacob van *rwees*-dahl, *yah*-cob van

Saarinen, Eero *sahr*-in-en, *ear*-oh
Safdie, Moshe *sahf*-dee, *moh*-shuh
Samaras, Lucas sah-*mah*-rus, *loo*-kus
Sekimachi, Kay seck-i-*mah*-chee, kay
Seurat, Georges suh-*rah*, zjorzj
Signorelli, Lucca see-nyoh-*rell*-ee, *loo*-kah
Sisley, Alfred *sizz*-lay, *al*-fred
Siqueiros, David Alfaro see-*kayr*-ohss, *day*-vid al-*far*-oh
Sluter, Claus *sloo*-tr, *clah*-oos
Soleri, Paolo so-*lair*-ee, pah-*oh*-loh
Staël, Nicholas de stahl, nee koh *lah*, duh
Steen, Jan stain, yahn
Steichen, Edward *sty*-ken, *ed*-word
Stieglitz, Alfred *stee*-glits, *al*-fred
Stravinsky, Igor strah-*vin*-skee, *ee*-gor
Suger, Abbot shoo-*gehr*, *a*-but

Tange, Kenzo *tan*-gee (hard), *ken*-zoh
Tanguy, Yves tan-*gee* (hard), eve
Tatlin, Vladimir *tat*-lahn, *vlad*-i-meer
Theotocopoulos, Domenikos thay-oh-toe-*coe*-poo-loss, doe-*may*-nee-coss
Tiepolo, Giovanni Battista tee-*ay*-poe-loe, jo-*vah*-nee bah-*tees*-tah
Tintoretto (Jacopo Robusti) tin-toe-*ret*-toe, (*yah*-coe-poe roe-*booss*-tee)
Titian (Titiano Vecelli) *tish*-un (tee-tsee-*ah*-noh vay-*chell*-ee)
Toledo, Juan Bautista de toe-*lay*-doe, wahn baw-*tees*-tah day
Toulouse-Lautrec, Henri de too-*looz* low-*trek*, ahn-*ree* duh

Uccello, Paolo oo-*chell*-loh, *pah*-oh-loh

van der Goes, Hogo van der *goose*, *hoo*-go
van der Rohe, Ludwig Mies van der *roe*-ay, *lood*-wig mees
van Dyck, Anthony van *dike*, *an*-toe-nee
van Eyck, Hubert van *ike*, *hoo*-bert
van Eyck, Jan van *ike*, yahn
van Gogh, Vincent van *go*, *vin*-sent
Vasarely, Victor va-sah-*rell*-ee, *vic*-tor
Vasari, Giorgio va-*sah*-ree, *jor*-jyoh

Vau, Louis voh, loo-*ee*
Velazquez, Diego Rodriguez vay-*lass*-kess, dee-*aye*-goh rod-*ree*-gess
Vermeer, Jan vair-*mair*, yahn
Veronese (Paolo Caliari) vay-roe-*nay*-zay, (*pah*-oh-loh cal-ee-*are*-ee)
Vigee-Lebrun, Elizabeth vee-*zhay* luh-*brun*, uh-*lee*-zah-bet
Vignon, Pierre vee-*nyon*, pee-*air*
Villon, Raymond Duchamp vee-*yohn*, ray-*mohn* doo-*shahn*
Villon Jacques vee-*yohn*, zhahk
Vlaminck, Maurice de vla mehnic, moh-*riss* duh
Vos, Cornelius de voss, cor-*nay*-lee-us day
Vuillard, Edouard vwee-*yahr*, eh-doo-are

Warhol, Andy *war*-hole, *an*-dee
Watteau, Antoine wah-*toh*, an-*twahn*
Weyden, Rogier van der *vee*-den, roh-*jair* van der
Wyeth, Andrew *why*-eth, *an*-drew

Zorach, William *zohr*-ahk, *will*-yum
Zurbaran, Francisco de *zoor*-bah-ran, fran-*sis*-coe day

Pronunciation Guide for Places and Terms

Abu Simbel *ah*-boo *sim*-bell
Aegean ee-*jee*-un
Aix eks
Amboise am-*bwahz*
Amiens ah-mee-*en*
Angkor Thom *ang*-core tahm
Angkor Wat *ang*-core waht
Arc de Triomphe de l'Etoile ark duh
 tree-omf duh leh-*twahl*
Arezzo ah-*retz*-oh
Argenteuil ahr-zhahn-*tuhye*
Ashurnasirpal ash-er-*naz*-er-pahl
Asuka ah-*soo*-kah
Avignon ah-veen-*yohn*

Baalbek *bal*-beck
Babylonia ba-bi-*loh*-nee-ah
Barbizon bahr-bih-*zone*
Basel *bah*-zel
Bayeux bah-*yuh*
Beijing bay-*jing*
Benin ben-*een*
Bokhara boh-*cahr*-ah
Bologna boh-*loh*-nyah
Borobodur bor-oh-boh-*duhr*
Breda *bray*-dah
Bruges brooszh

Calais cal-*ay*
Casale cah-*sah*-lay
Chambord shan-*boar*
Chartres shartr
Chateau sha-*toe*
Chateaux sha-*toes*
Chenonceaux shen-ahn-*soh*
Cheops *chee*-ahps
Chichen Itza *chee*-chen *eet*-zah
Colmar *coal*-mahr
Cologne coh-*lone*
Cordova cohr-*doh*-vah
Cyclades sick-*lay*-dees

Dada *dah*-dah
Deir el Bahari dayr el bah-*hah*-ree
Der Blaue Reiter dehr *blah*-way *right*-er

De Stijl day *shteel*
Die Brücke dee *broock*-eh
Dijon dee-*zjohn*
Doge *doe* szhay (soft)

El Castillo el cas-*tee*-yoh
Epidauros eh-pee-*dow*-rus
Euphrates you-*fray*-tees

Flemalle fleh-*mahl*
Fontainebleau fahn-tin-*blow*
Francais frahn-*say*

Gare Saint Lazare gahr sen lah-*zahr*
Ghent gent (hard g)
Giverny zhee-ver-*nay*
Giza *gee*-zah (hard g)
Gudea goo-*dee*-ah
Guernica *gair*-nik-ah
Guilin gwee-*lin*

Hagia Sophia *hah*-zhee-ah soh-*fee*-ah
Han Dynasty han *dye*-nas-tee
Heliopolis hee-lee-*ahp*-oh-liss
Herculaneum her-cue-*lay*-nee-um
Holofernes hoe-*loh*-fer-nays
Hue hway

Ife *ee*-fay
Il Gesu ill *jay*-soo
Invalides in-vah-*leed*
Isenheim *eye*-sen-hime
Isfahan *iss*-fah-hahn

Jericho *jer*-ee-coe

Kamakura kah-mah-*koo*-rah
Karnak *kahr*-nack
Kiev key-*eff*
Knossos *knoh*-sohs
Kyoto *kyoh*-toh

La Grande Jatte lah grahnd zjaht
Lascaux lass-*coe*
Las Meninas lahs men-*een*-yahss

Le Havre luh hahv
Leiden *lye*-den
Les Demoiselles d'Avignon lay
 dem-wah-zell dah-veen-*yohn*
Loire River lwahr
Louvain loo-*vahn*
Louvre loovr

Madeleine mah-duh-*layn*
Maesta mah-*aye*-stah
Magi *may*-jigh
Mamallapuram mah-mah-lah-*poor*-um
Mantua *man*-too-ah
Masada mah-*sah*-dah
Medici *meh*-di-chee
Mesopotamia mess-oh-poh-*tay*-mee-ah
Mohenjo-daro moh-*hen*-joe *dah*-roh
Monreale mohn-ray-*ah*-lay
Monticello mahn-ti-*sell*-oh
Montmartre mon *martr*
Montreux mahn-*truh*
Mont Sainte Victoire mohn sen
 vik-*twahr*
Moulin de la Galette moo-*lahn* duh lah
 gah-*lett*
Moulin Rouge moo-*lahn* roozjh
Mughal *moe*-gull
Mycenae my-*see*-nee

Nanzenji Temple nan-*sen*-jee
Nara *nah*-rah
Navajo *nah*-vah-hoh
Naxos *nahx*-ohs
Nevers neh-*vair*
Nijo nee-joe
Nineveh *nin*-eh-vuh
Notre Dame noh-*trah* dahm
Nuremberg *noor*-em-burg

Oaxaca wah-*hah*-cah
Osaka oh—*sah*—kah

Padua *pa*-doo-ah
Paestum pie-*aye*-stum
Pagan *pah*-gahn

Palazzo Ducale pah-*laht*-zoh doo-*kahl*-eh
Palazzo Publico pah-*laht*-zoh *poo*-blik-oh
Palazzo Vecchio pah-*laht*-zoh *veh*-key-oh
Parthenon *pahr*-then-ahn
Penang pen-*ang*
Persepolis per-*seh*-poh-lis
Piazza della Signoria pee-*aht*-zah *del*-lah *seen*-yor-*ee*-ah
Piazza Navona pee-*aht*-zah nah-*voh*-nah
Pieta pee-aye-*tah*
Pisa *pee*-sah
Poitiers pwah-*tyay*
Pompeii pahm-*pay*-ee
Port en Bessin port ahn bes-*ehn*
Poseidon poh-*sigh*-dun
Prado Museum *prah*-doh

Qing Dynasty ching *dye*-nas-tee

Reims reemz
Renaissance ren-eh-*sahnss*
Rijksmuseum *rikes*-myoo-zee-um
Ronchamp roh-*shahn*
Rouen roo-*ahn*

St. Apollinare in Classe saint ah-pahl-in-*ahr*-ay in *klahss*-ay

Sainte Chapelle sent shah-*pell*
St. Denis sahn duh-*nee*
Sakkara (Saqqara) sah-*kahr*-ah
Salisbury *sals*-burr-ee
Samothrace *sam*-oh-thrace
San Francesco san fran-*chess*-coh
San Rocco san *rock*-oh
Santa Maria del Carmine *san*-tah mah-*ree*-ah del cahr-*mee*-nay
Santa Maria della Grazie *san*-tah mah-*ree*-ah *del*-lah *graht*-see-ay
San Vitale san vih-*tahl*-ay
San Zavier del Bac san *hahv*-yair del bahk
Sawankhaloke kiln sah-*wahnk*-ah-lock kill
Schoenbrun *shayn*-broon
Scythia *sith*-ee-ah
Segovia seh-*goh*-vee-ah
Seine River sen
Seto *see*-toe
Seville seh-*vee*-yah
Sforza *sfort*-sah
Sfumato sfoo-*mah*-toe
Shekwan *shek*-wahn
Siena see-*en*-ah
Staffelstein *stah*-fell-stine
Stanza della Segnatura *stahn*-zah *del*-la seg-nah-*too*-rah
Sumer *soo*-mur
Sumerians soo-*mair*-ee-uns

Tabriz tah-*breeze*
Taj Mahal tazh mah-*hahl*
Tenochtitlan teh-*nok*-tit-lahn
Teotihuacan *tay*-oh-tee-*hoo*-a-can
Thebes theebs
Todai-ji toe-dah-ee jee
Toledo toe-*lay*-doe
Topkapi *top*-cap-ee
Torgau *tohr*-gow
Tuilleries *twill*-er-ees

Uffizi Gallery oo-*feet*-see
Ur er
Urbino oor-*bee*-noh

Vendome vahn-*dome*
Versailles vehr-*sigh*
Vetheuil veh-*twahl*
Vezelay ves-eh-*lay*
Vicenza vee-*chen*-zah
Vierzehnheiligen *fear*-tsayn-*high*-li-gen

Wijk by Durstede wike by *duhr*-sted-eh
Worms warmss
Würzburg *wirts*-burg

Xian *chee*-an

Zhou Dynasty chow *dye*-nas-tee
Zwiefalten *tswee*-fahl-ten

Glossary

(Correct Pronunciation of Difficult Words is Indicated)

*Indicates proper cultural name and/or style

Italics indicate emphasis or accent in pronunciation

Aborigine Indigenous or native inhabitants as differentiated from an invading or colonizing people.

Abrade To scrape or rub off.

Abstract Expressionism A 20th century painting style that features large scale works and expression of feelings through slashing, active brush strokes.

Abstraction A work of art that emphasizes design and a simplified or systematic investigation of forms. The subject matter may be recognized or may be completely transformed into shape, color, and/or line.

Acropolis The citadel of a Greek city; its highest point, containing temples and public buildings.

Aerial Perspective A method of creating the illusion of distance by representing objects further away with less clarity of contour and in diminished color. Also called *atmospheric perspective*.

Aesthetic (es-*thet*-ik) Pertaining to the philosophically pleasing, beautiful, and emotional nature of man; also, a pattern of thinking so oriented.

Aesthetics (es-*thet*-iks) The description and explanation of artistic phenomena and aesthetic experience by means of psychology, sociology, ethnology, or history.

Agora (ah-*go*-rah) Greek word for assembly; the square or marketplace that was the center of public life in an ancient Greek city.

Aisle The long, narrow space on each side of the nave of a church, usually between a row of columns and the outer wall. Often referred to as "side aisles."

Alabaster A fine-grained gypsum or calcite (like marble) often white and translucent (though sometimes delicately tinted) used for sculpture and architectural columns.

Allegorical Symbolic of truths or generalizations about human nature.

Altar A structure on which to place or sacrifice offerings to a deity.

Altarpiece A painted and/or sculptured work of art that stands above or at the back of the altar. It usually represents visual symbols of the Mass or depicts the saint to whom the chapel is dedicated, and may contain scenes from his or her life. See **retable** and **reredos**.

Ambulatory (*am*-byoo-lah-tor-ee) Any passageway around a central space. A place for walking around the apse of a church, often a continuation of the side aisles; also, a covered walkway around a cloister.

Amida (ah-*me*-dah) The Buddha of the Western Paradise, particularly popular in 11th century Japan. Pictured with short curly hair, elongated ear lobes, long arms, and an *urna* on his forehead.

Amphitheatre A double theatre or closed arena, such as the Roman Colosseum; An eliptical or circular space surrounded by rising tiers of seats.

Amphora (am-*for*-ah) A storage jar having an egg-shaped body, a foot, and two handles, each attached at the neck and shoulders of the jar.

***Anasazi** (ah-nah-*sah*-zee) "The Ancient Ones"; Early pueblo-dwelling peoples of the plateaus of the American Southwest.

Anatomy The structure of the human body (or of animals or plants). Anatomical drawing often shows such structural details as muscles and bones.

***Andean** (an-*dee*-an) Region of the Andes mountains of western South America, and the mountain-oriented highland culture of indigenous people there.

***Angkor** (ong-*kore*) Ancient Khmer temple complex in NW Cambodia and center of the ancient Khmer kingdoms from the tenth to thirteenth centuries.

Animal Style Artistic practice of making objects in the shape of or with motifs based on animals; specifically refers to a tradition of art among the nomads of Eastern Europe and Central and Northern Asia.

Animism The religious or spiritual attribution of conscious life to natural objects; the belief in the existence of spirits separable from bodies.

Anthropomorphic (an-thro-po-*more*-fik) Refers to giving human characteristics to non-human objects or beings. Many Egyptian and Brahmanic gods were animals in the form of humans.

***Apache** (ah-*patch*-ee) Tribe of Native Americans inhabiting the American Southwest, artistically distinguished by their coiled basketry, large beaded womens' collars, and decorated fine leatherwork.

Apollo Greek god of the sun, prophecy, music, medicine, and poetry; artistically significant as a model of physical beauty, dignity, and serenity.

Apostle In Christian usage refers to the twelve followers of Christ who spread his teachings throughout the Mediterranean world. The apostles of Buddha are known as "lohan."

Apse A large semi-circular (or polygonal) area at the choir end of a church. Usually contains the altar. May also be found at the ends of transepts or at the ends of smaller chapels.

Aqueduct (*ak*-wee-duckt) An artificial channel for carrying water from a distance.

Arabesque (*air*-uh-besk) Intricate and fanciful surface decoration generally based on geometric patterns and using

512

combinations of flowering vines, tendrils, etc.

Arcade A series of arches and their supports (columns). When placed against a wall and used mainly as decoration, the result is called a "blind arcade."

Arch An architectural construction (semi-circular or pointed) built of wedge-shaped blocks (voussoirs) to span an opening and usually supported by columns or piers. A corbeled arch is made by overlapping layers of stones, each one projecting slightly farther over the opening than the one below it. A building dependent upon arches for its structure is said to be "arculated."

***Archaic** (ar-*kay*-ik) Referring to the early phase of an artistic development; specifically applies to the span of ancient Greek art, prior to the Classical period.

Architecture The art and science of designing and erecting buildings.

Architrave (*arch*-i-trave) The main horizontal beam at the bottom of an entablature, resting on the capitals of columns. Often made of several lintels to stretch the length of the building.

Archivolt The concentric moldings above the arched openings in Romanesque and Gothic churches, often decorated with sculpture; also, the underside of an arch.

***Art Nouveau** (art new-*voh*) Abstract style in European and American arts from the 1880s to 1930s characterized by the use of undulating waves or flames, flowerstalks, and flowing lines.

Artifact Object, usually simple, that reveals human workmanship and modification.

Artisan A person manually skilled in making a particular product; a craftsperson.

Artist An individual who professes and practices the manipulation of materials in executing the concepts of his or her imagination. One who reflects the aesthetics and technology of his or her era and a cultural "editor" of the environment.

***Ashanti** (ah-*shahn*-tee) A people and former kingdom of West Africa, artistically significant in their use of highly stylized and simplified fertility dolls as well as their mud-built houses with foundations ornamented with curvilinear patterns.

***Asoka** (ah-*show*-kah) First Indian Emperor and Buddhist enthusiast responsible for the origins of Buddhist art, 274–236 B.C.

Assemblage A work of art composed of fragments of objects or materials originally intended for other purposes.

***Asuka** Early Japanese capital city and name of the first Buddhist cultural period there (538–645), artistically significant for importation of Korean and Chinese sculpture and architecture.

Atlantes Supports or columns in the form of carved male figures.

Atrium (*ay*-tree-um) The inner court of a Roman house, open to the sky. Also, the enclosed (but open to the sky) courtyard in front of the main doors of a basilica or church.

Attic Pertaining to Attica, a region of Greece, and the artistic style developed there in pre-Classical times; also, the story above the main colonnade of a building.

***Avaloketisvara** (ah-vah-lok-eh-*tesh*-vah-rah) The merciful Bodhisattva of Buddhism, manifested in Chinese culture as Guan Yin, the Goddess of Mercy; known to the Japanese as *Kannon*.

Avant-garde (ah-vant-*guard*) A style of 20th century art; also, any style of contemporary art in any period of time, being the newest form of visual expression and the farthest from the traditional ways of working.

Axial Describing a building plan that has a strong emphasis along one direction.

***Ayuthaya** (ah-*you*-tee-ah) Early Thai kingdom, founded 1350, artistically distinguished by its free mixing of Burmese, Khmer, and Ceylonese styles.

***Aztec** People and kingdom of ancient central Mexico, noted for their advanced civilization before their conquest by Cortes in 1521, artistically distinguished by their large temple-oriented cities.

Azulejos (ah-jew-*lay*-os) Glazed pottery tiles, usually painted in bright colors and floral or other patterns, used in Spanish Portuguese, and Hispanic architecture.

Balance A principle of design that refers to the visual equalization of elements in a work of art. There are three kinds of balance: symmetrical (formal); asymmetrical (informal); and radial.

Baldachin (bal-dah-*cheen*) A fixed canopy of wood, stone, fabric, etc. over an altar, throne, or doorway. Sometimes it can be portable as when it is over a movable statue during a parade or procession.

Balustrade A row of short pillars or columns topped by a railing.

***Bamara** (bah-*mar*-ah) A tribe of west Africa, particularly in Mali.

***Ban Chiang** (bahn cheng) Site of prehistoric burial grounds in northeast Thailand believed to be the oldest remains yet discovered of Bronze Age civilization. Distinguished by a fine grade of earthenware, with very thin hand-built walls and curvilinear slip decoration.

Baptistry An area in which the Sacrament of Baptism is administered either within an area of a church or as a separate building.

***Baroque** (bar-*oak*) A period and style of European art (17th century) which emphasized color and light. Work was characteristically exuberant, large, filled with swirling lines, and required emotional involvement; also refers to any highly ornate style.

Barrel Vault A semi-cylindrical ceiling spanning an open room, such as in Romanesque churches.

Basketry The art of making wickerwork objects by methods of plaiting stalks, cane, rushes, etc.

Basket Weave Technique of forming a fabric wherein double threads are interlaced to produce a checkered pattern, similar to that of a woven basket.

Bas Relief (*bah* ree-*leef*) A low, partially round sculpture that emerges from a flat panel.

Basilica (bah-*sill*-ee-ka) Roman civic building of rectangular form, whose ground plan was divided into nave, side aisles, and apse, and approached through a narthex. In Christian architecture, a church building similar in shape was the major worship form from the 3rd to 8th centuries.

Batik (ba-*teek*) A coloring or dying process using a wax stencil to protect design areas from coloration by dying of cloth or paper.

***Bauhaus** A German art school, begun in 1918, that stressed science and technology as major resources for art and architecture. Many modern concepts of design were originated at the Bauhaus which affect contemporary artistic ideas.

Bay A rectangular division (compartment) or a building, marked off by consecutive pairs of piers, columns, or other supports. Large stained glass windows were put into the bays of Gothic cathedrals. The size of Chinese and Japanese temples is measured in terms of the number of bays along the facade.

Bema (*bee*-mah) The raised sanctuary or chancel space in an early Christian or Eastern Orthodox church. In a synagogue, the elevated pulpit from which scripture is read.

***Benin** (beh-*neen*) A people and former kingdom of Nigeria, artistically distinguished by their fine-quality bronze castings of the 16th and 17th centuries.

Bible The collection of sacred writings of the Christian religion that includes Old and New Testaments or that of the Jewish faith which contains only the Old Testament.

Biomorphic Shape Artistic stylization suggested by organic forms.

Bishop A spiritual overseer of a number of churches in a diocese of Greek, Roman Catholic, and Anglican Church organizations. See **Cathedral**.

*****Blue-and-white** A general term for the underglaze cobalt decorated porcelain ware produced in China beginning in the Yüan dynasty. Cobalt produces the blue color, often of various intensities depending upon quality and thickness, and the white is the color of the kaolin body itself. Also, any pottery which seems to duplicate the style of such Chinese ware.

Bodhisattva (bode-he-*saht*-vah) A Buddhist saint, one who has compassionately refrained from entering eternal enlightenment (nirvana) in order to minister to the needs of mortals.

Bond Pattern of alternating the directions of individual bricks or stones in a masonry wall.

Brahma (*brah*-mah) The Indian creator-god of the Hindu trinity; the ultimate basis of all existence; the universal self.

*****Brahmanism** (*brah*-mahn-izm) Orthodox Indian religion adhering to the pantheon of the Vedas, stressing the preeminence of Siva, Indra, and Vishnu as well as the practice of sacrifices and ceremonies.

Buddha (*boo*-dah) Gautama Siddhartha, founder of Buddhism, c.563–483 B.C.; also any Buddhist sage who has achieved enlightenment in accordance with the teachings of Gautama.

*****Buddhism** (*boo*-dizm) Religious belief based on the teachings of Gautama Buddah that suffering is inherent in life and that one can be liberated from it by mental and moral self-purification. Hinayana Buddhism stresses individualistic faith and a simple iconography. Mahayana Buddhism evolved in the 2nd century under the teachings of Nagayana, stressing a complex understanding of the five eons of time, the four levels of creation, and the role of saints or Bodhisattvas.

Burnish To polish leather-hard clay with a smooth object, rubbing to seal the porous surface of the clay; also, any such rubbing on any material.

Buttress A massive support built against a wall to receive the lateral thrust (pressure) exerted by a vault, roof, or arch. See **Flying Buttress**.

Caliph (*kay*-liff) Title of an Islamic ruler, functioning in both religious and secular affairs.

Calligraphy The art of beautiful writing or printing; fine lettering of elegance, often thought in the West as being similar to the grace of Oriental writing.

Campanile (camp-uh-*neel*-ee) A bell-tower either attached to a church or freestanding nearby.

Campo Santo A cemetery, from the Italian word for "holy field".

Cancello (can-*chell*-oh) A latticed screen or grille separating the choir from the nave.

Candi (*john*-dee) Javanese commemorative structure, temple, or shrine.

Canopy An ornamental, rooflike covering, placed above a statue, tomb, niche, or altar.

Cantilever A horizontal projection, canopy, balcony, or beam balanced and supported with a fulcrum.

Canvas Surface of woven linen or other fiber on which an artist applies paint, and the most common ground or support for an oil painting; also, any painting executed on such material.

Capital The top element of a column, pier, or pilaster, usually ornamented with stylized leaves, volutes, animal, or human forms. The entablature rests on capitals in Doric, Ionic, and Corinthian orders.

Caricature A drawing, painting, or sculpture of a person that exaggerates selected characteristics of the subject, such as a prominent chin or large eyes. Often humorous.

Cartoon A full-scale drawing from which a painting or fresco is made. Also, a simplified humorous drawing.

Carving The subtractive process of sculpture in which parts of a block are cut or chisled away, leaving the finished work.

Caryatid (care-ee-*ah*-tid) A support or column in the form of a human figure, usually female. See **Atlantes**.

Casting A method of reproducing a three-dimensional object by pouring a hardening liquid or molten metal into a mold bearing its impression.

Castle A fortified habitation, primarily used for defense, composed of a central dungeon, or keep, and outer defense works.

Catacombs Underground burial places made up of passageways and niches for holding the sarcophagi. Some catacombs contained chapels and meeting rooms of the early Christians.

Cathedral The main church of a diocese, containing the *Cathedra*, or Bishop's chair. See **Bishop**.

Celadon (*sell*-a-don) Pottery glaze characterized by a pale-green to bluish-green color, derived from iron, popularly used during the Sung dynasty in China and later in Korea and Thailand; also, ware covered with such a glaze.

Cella (*sell*-ah) The main rectangular room of a temple containing the image of a god, goddess, or cult deity.

Centaur (*sen*-tower) A creature of Greek mythology with the head and torso of a man and the body and legs of a horse.

Center of Interest The area of a work of art toward which all visual movement is directed. It is the visual focal point of the work.

Centering A wooden framework to support a stone arch or vault during construction.

Ceramics Objects made of clay and fired in a kiln; also, the art of producing such objects.

Chaitaya (*chah-ee*-tee-ah) A Buddhist sanctuary.

Chakra (*chock*-rah) Iconographic wheel that symbolizes the first sermon of Buddha and the progression of the law.

*****Chan** (john) Buddhist sect emphasizing contemplation and meditation, self-discipline, and the teaching that the Buddha is inherent in all things. Known in Japan as Zen.

Chancel (*chan*-sell) The space kept for the clergy and the choir in a church, between the nave and the apse. It is usually separated from the nave by steps, a railing, or a screen.

*****Cha-no-yu** (cha-*know*-you) The "way of tea"; a prescribed ceremony for appreciating the process of making and drinking tea, connected with Zen meditation. This ceremony has inspired the creation of utensils and art objects to be used and appreciated during the tea-making process.

Chateau (shat-*oh*) A French castle or large country house.

*****Chavin** (chow-*veen*) Mother culture of Andean cultures, dating from about 500 B.C., centered in the Peruvian highlands.

Chedi (*jay*-dee) A tiered, pointed, spirelike Thai pagoda.

Cherub One of an order of angelic beings, often visualized in European art as a winged child.

*****Cheyenne** (shy-*enn*) A tribe of North American natives of the north central plains that created unique silverwork in the 1870s; noted for its fine leatherwork.

Chiaroscuro (key-ah-ross-*kyoo*-roh) A technique for modeling forms in painting by which the lighted parts seem to emerge from surrounding dark areas. Strong contrast of dark and light values in a painting.

*****Chilkat** (*chill*-cat) A band of Tlingit Indians of southern Alaska, artistically unique in their woven, twined, and plaited blankets in symbolic bear and other animal patterns.

*****Chimu** (*chee*-moo) An urbanist culture of Andean peoples, reaching a zenith of creative activity about 1200, noted for their heavy adobe architecture on terraced sites, their use of interlocking fish

designs, and stirrup pottery vessels in representations of birds and humans.

***Chinoiserie** (chee-nwa-*sree*) Style of European arts and crafts growing from a fanciful and idealized concept of "exotic" China based on travelers' accounts and isolated objects of Chinese art.

Choir The part of the church in which the service is sung, usually the apse; also, a group of trained singers.

***Chola** (*cho*-la) Dynasty of Indian rulers powerful from 846–1279, artistically distinguished by excellent graceful bronze castings, mostly notably of the Nataraja.

Chops In Chinese art, the signature seal of the artist stamped on the work.

***Churrigueresque** (chur-*ig*-er-esk) Extravagantly ornamented architecture of Baroque Spain and the Hispanic world, characterized by abundant and indiscriminate use of decorative motifs, twisted columns, and complex ornamentation.

Cire Perdue (sear per-*dew*) Method of casting molten metal into a cavity originally filled with a wax model. The resulting casting is an exact replica of the wax original.

Classical Relating to form regarded as having reached its greatest standard of excellence before modern times, i.e. Classical Greek or Classical Inca architecture.

Classicism The practice of using stylistic elements and/or myths derived from the Greek Classical period.

Clay Fine-grained earth, chiefly composed of aluminum silicate and formed by natural water deposition which is plastic, easily formed, and becomes hard and brittle upon treatment by high heat (firing).

Clerestory (*clear*-story) The upper section of a wall (windowed or open) used for lighting and ventilation; also, the upper story of the nave of a church building.

Cloisonné (kloy-soh-*nay*) Technique for setting colored glass, stones, or enamel between thin strips of metal on a metal surface.

Cloister A covered walkway or ambulatory around an open court or garden. Usually, a colonnade faces the garden, allowing light to enter.

***Cochise Culture** (ko-*cheese*) Ancient Southwest native American society noted for unfired clay pottery.

Codex (*ko*-decks) A manuscript in book form, often with pages arranged in an accordion-fold, as distinguished from a scroll.

Coelanoglyph (koh-eh-*lan*-oh-gliff) A low-relief carving set into a flat panel, below the surface as distinguished from a bas-relief.

Coffer In architecture, a square, rectangular, or polygonal recess in a ceiling to reduce the weight of the structure.

Coiling To build up with concentric rings.

***Colima** (ko-*lee*-ma) Culture of Western Mexico, artistically distinguished by superior free-hand molded clay vessels in animal and human forms, some with stirrup handles.

Collage A technique in which the artist glues materials such as paper, cloth, or found materials to some type of ground.

Colonnade A series of columns, usually supporting lintels or arches.

Color An element of design that identifies natural and manufactured things as being red, yellow, blue, orange, etc.

Column An upright post, bearing the load of the upper part of a building. It consists of a base, a shaft, and a capital. An engaged column is half a column, attached to a wall, and non-weight bearing.

***Commanche** (ko-*man*-she) Native American tribe of western Texas and New Mexico, artistically distinguished by its tipis, leather boots, clothing, and elaborate beadwork.

Complementary Colors Any two colors that are located opposite each other on a color wheel. When mixed together they will tend to subdue the intensities and produce a grayed hue. When placed side by side, they produce optical vibrations.

Composition The ordered arrangement of the elements (colors, shapes, lines, etc.) in a work of art, usually according to the principles of design.

Concept Art A style of art in which the artist expresses the idea concept of a proposed work of art in verbal or diagram form. The actual work will probably not be carried out.

***Confucian** (kun-*few*-shun) System of social interaction based on the teachings of Confucius (551–479 B.C.) who preached reforms of Chinese society during the Zhou dynasty. Stress is on order and loyalty; personal virtue; devotion to family and to the spirits of ancestors and justice.

Contemporary Art Refers to the art of today; the methods, styles, and techniques of artists living now.

Content The subject matter in a painting or other work of art.

Contour A single line or lines that define the outer and often the inner edges and surfaces of objects or figures.

Contrapposto (kon-tra-*pohs*-toe) Technique of sculpting a human figure in a pose that shows the weight of the body in balance. With weight on one leg, the shoulders and hips counterbalance each other in a natural way so that the figure does not fall over. Developed in the late Greek period.

Contrast A principle of design that refers to differences in values, colors, textures, and other elements to achieve emphasis and interest.

Cool Colors The hues on one side of the color wheel which contain blue and green.

Coptic Native of Egypt; descended from ancient Egyptians.

Corbel (*kore*-bell) An overlapping arrangement of stones, each layer projecting a bit beyond the row beneath it; also, a bracket of stone, wood, or brick projecting from the face of a wall which may support a cornice or arch.

Corinthian One of the Classical styles of architecture of ancient Greece (4th century B.C.) that features tall, slender columns topped with ornate capitals decorated with stylized acanthus leaves.

Cornice (*kor*-niss) Any projecting ornamental molding along the top of a building, wall, arch, etc.; also, the topmost projecting part of an entablature in a Classical Greek building.

Course Rows of stones or bricks that form a horizontal layer of a wall.

Crafts Works of art that generally have a utilitarian purpose, including ceramics, macrame, leatherwork, metals, weaving, fabrics, jewelry, furniture, basketry, etc.

Craftsperson One who fabricates useful and well-designed objects of quality, durability, and function. **Craftsmanship** implies the skillful practice of this process.

Cromlech A circle of monoliths, usually enclosing a type of altar.

Crossing The area of a church where the transept intersects the nave. Sometimes a dome or tower is built over this area, further emphasizing it as the focal area of the worship space.

Crucifix A representation of a cross with the figure of Christ's crucifixion placed on it.

Cruciform (*crew*-see-form) In the shape of a cross; usually a floorplan of building in such an arrangement.

Crypt (kript) A vaulted space below ground level, usually beneath the raised choir or apse of a church, or under a temple or shrine.

Cubism A style of art in which the subject is broken apart and reassembled in an abstract form, emphasizing geometric shapes.

Cult Magic Mystic practices of a system of religious beliefs and rituals.

Culture Elements that add to the aesthetic aspects of life, enriching it with beauty and enjoyment; also, a society or civilization marked by distinctive concepts, habits, skills, implements, and art forms.

Cupola (*coop*-oh-lah) A rounded con-

vex roof on a circular base; a dome of small size.

Curtain Wall A wall that carries no weight other than its own; a non-structural panel set between weight-bearing pillars in a building.

Dagob (duh-*gobb*) A small stupa-like architectural form which symbolically represents the commemorative function of the Buddhist stupa.

Dais (*day*-ahs) A raised platform, usually at one end of a long room.

Dao See **Taoism.**

***Dayak** (*die*-yak) Coastal and Highland people of Borneo, known for their bold graphic designs in painting and carving.

***Delftware** Blue-and-white faience pottery made in the Dutch city of Delft, inspired by Ming porcelain, which reached a peak in quality and production between 1650 and 1750; also, a term generally applied to any such European-produced blue-and-white china.

Deva Raja (day-va *rah*-jah) A god-king; the concept in Javanese and Southeast Asian culture that the ruler is an earthly counterpart of a divine being, usually Siva or Buddha.

Diaper (*die*-uh-per) Decorative unit or motif, often abstract or symbolic, repeated to create intricate surface decoration.

Dibutsu (*die*-boot-sue) Japanese name for Buddha.

***Ding Zhou** (ding jshoo) Region of Henan and Hebei provinces of China, producing non-Imperial pottery, especially during the Song dynasty, decorated with typical dark brown free-flowing floral designs; also pottery made there.

Diocese See **Bishop.**

Diptych (*dip*-tik) A pair of wood, ivory, or metal panels (large or small) usually hinged together, with painting or carving on the inside surfaces. Usually placed over an altar.

Distort To deform or stretch something out of its normal shape.

Doge (*doe*-jshay) Italian word for the chief magistrate in the former republics of Venice and Genoa.

Dolmen A grouping of huge, uncut stones, set on end and covered with a large single stone, apparently used by neolithic peoples as a burial altar.

Dome A hemispherical or beehive-shaped vault or ceiling over a circular opening. May be elevated further by placement on a drum. If placed over a square opening, the transition to a round shape is made by use of pendentives in the four corners.

***Doric** The earliest of the classical style of ancient Greek architecture, characterized by sturdy columns that have no base, and are terminated by simple, undecorated capitals.

Dormer A window placed vertically in a sloping roof, and with a roof of its own.

Dragon Legendary animal usually represented as a monstrous winged and scaly serpent or lizard, with a crested head and enormous claws. Symbolic to the Chinese of Imperial power.

***Dravidian** The people, language, and culture of much of South India, often regarded as the native people of the subcontinent.

Dress To prepare stone for architectural purposes by carving or decorating.

Drolleries The marginal designs, usually whimsical or fanciful, found on medieval European manuscripts.

Drum The cylindrical wall supporting a dome; also, one of several sections composing the shaft of a column.

***Dvaravati** (dvar-ah-*vaht*-tee) Earliest known period of Thai Buddhist culture and art, flourished 6th to 11th century.

Earthenware Vessels of a coarse nature made from low temperature clay. Commonly left unglazed.

Earth Works Large formations of moved earth, excavated by artists in the surface of the earth, and best viewed from a high vantage point.

Easel Painting Any kind of painting done in a studio (on an easel) which can be transported from place to place. Not painted directly on a wall, such as a mural.

Eclecticism The practice of using compositional elements or artistic styles derived from a variety of sources.

Edge A linear separation between two color areas; also, the outer contour of a shape or form.

***Edo** (ay-doe) Japanese capital city (Tokyo) and name often given to the rule of the Tokugawa shogunate (1615–1867), significant as a period when Japan essentially closed itself to the outside world.

Egg Tempera See **Tempera.**

Element The graphic devices with which the artist works, such as line, shape, color, texture, etc.

Elevation The external faces of a building; also, a side or front view of a structure, painted or drawn to reveal each story with equal detail.

Ellipse A curved line that is drawn to produce an oval shape with specific geometric proportions.

Elongated Stretched out lengthwise; drawn in a way as to exaggerate height or length.

Embroider To ornament textiles with stitching of colored thread or other fine material.

Emphasis A principle of design by which the artist or designer may use opposing sizes, shapes, contrasting colors, or other means to place greater attention on certain areas, objects, or feelings in a work of art.

Enamel Powdered colored glass that is fused by heating to a ceramic or metal ground; a work of art created by this method. Overglaze enamels are applied over previous glazes.

Encaustic A method of painting on a ground, with colors dissolved in hot wax; also, a work of art produced by this technique.

Engaged To be partially set into a larger mass; not fully free-standing.

Engaged Column See **Column.**

Engraving The process of incising lines into a surface to create an image; also, a print made by inking such an incised surface.

Entablature The upper part of an architectural order, being the part placed above the columns, usually consisting of architrave, frieze, and cornice.

Entasis (*en*-tah-sis) The subtle convex swelling of a Classical Greek column shaft.

Epistle A message; In Christian usage, one of the letters of the apostles that make up twenty-one books of the Biblical New Testament.

Espadaña (es-pah-*dahn*-ya) A gable wall on the facade of a building whose curved top extends above the roof line; characteristic of Spanish and Hispanic architecture.

Etching A technique in which a metal plate is incised by acid through needle-thin scratches in a waxed coating. It is inked and printed on paper; also, the print made by this process.

Eucharist (*you*-cah-rist) From the Greek word for "thanksgiving:" the Sacrament of the Lord's Supper. Also, the consecrated bread and wine used in this sacrament; also, the sacrament itself.

Evangelists The four writers of the Gospels in the New Testament: Matthew, Mark, Luke, and John, frequently visualized by their respective symbols of an angel, a lion, a bull, and an eagle.

Export Ware Objects made expressly for the tastes of a foreign market; in ceramics, shapes and designs may be made to order which are alien to the native aesthetics of the producing craftspersons.

***Expressionism** Any style of art in which the artist tries to communicate strong personal and emotional feelings to the viewer. Written with a capital "E", it refers to a definite style of art, begun in Germany early in the twentieth century.

Eye Level A horizontally drawn line that is even in height with the viewer's eye. In perspective drawing and painting, it can be the actual distant horizon

line, but it can also be drawn in a close-up still life.

Facade (fah-*sahd*) The front of a building.

Faience (fay-*ahns*) Opaque low-firing colored ceramic glaze; also, earthenware decorated with such glaze.

Famille Rose (fa-*meal* rose) Chinese porcelain decorated in the Qing dynasty under European influence, utilizing a mixture of opaque whites to paint scenery of courtile, birds, flowers, etc.

Famille Verde (fah-*meal vehr*-dee) Chinese porcelain developed in the Qing dynasty, decorated with overglaze enamels, principally greens and weaker reds and yellows.

Fan Vault A complex vault with radiating ribs, characteristic of late English Gothic (perpendicular) architecture.

***Fates, Three** The goddesses Clotho, Lachesis, and Atropos, in Greek and Roman mythology, who were believed to be able to determine the course of human life.

Fauvism (*foe*-vism) A style of painting which used brilliant colors for expressive purposes, in France of the early 20th century.

Feldspathic Crystalline silica-based minerals used in the formulation of high-firing ceramic glazes.

Ferroconcrete See **Reinforced Concrete**.

Fertility Capability to produce abundantly; the successful breeding and reproduction of the species.

Fetish An object to which magical powers are ascribed; a good luck charm.

Field The area in which a design, decoration, or painting is applied.

Filigree (*fill*-i-gree) Ornamental openwork of thinly hammered ribbons of metal; the process of making such openwork; also, any delicate design resembling delicate work.

Finger Weaving Technique of forming fibers, rushes, cornhusks, and bark into fabric by twining, plaiting, and braiding without a loom.

Flamboyant Decoration or style characterized by waving curves suggesting flames; also, any ornate style in a flashy or resplendent style. Specifically, a decorative architectural style of mid-13th century Europe stressing curving tracery in flamelike patterns.

Flash-firing Method of firing coarse pottery in an open pit with highly combustible fuel, much like a bonfire.

***Flemish** Characteristic of Flanders (Belgium); usually refers to the culture of this area from the 14th to 17th centuries.

Flint A very hard quartz or silica stone.

Fluting The shallow, rounded concave vertical grooves in the shaft of a column.

Flying Buttress A supportive structure consisting of a tower buttress and a flying arch which spans the side aisles and supports the upper wall of the nave of a Gothic church.

Folk Art Objects made by the common people with a combined goal of being functional and pleasing to the eye.

Foreshortening A method of drawing or painting an object or person that is not parallel to the picture plane so that it seems to recede in space, giving the illusion of three dimensions. Parts get smaller as they recede in space.

Forge To shape metal by hammering heated pieces with directed blows of a mallet or other driving tool.

Form An element of design that is three-dimensional and encloses volume, such as a cube, sphere, pyramid, cylinder, or free-flowing volume. Also, in metalworking, to shape metal with hammered strokes.

Formalism Stylization based on traditionally accepted forms.

Format The shape, size, and general composition of a work of art or publication.

Fortress Church A strongly fortified worship building in which Christianity faced military threats from local opponents.

Forum A central gathering place for the people of a town, particularly of ancient Rome. A place for judicial and public business.

***Franciscan** Monastic order founded in 1209 by Francis of Assisi; peaceful proselytizers of native coastal Indians who built missions each a day's walk apart along the southern California coast as stations for their work in the late 18th century.

Friar A brother or member of one of four Mendicant Roman Catholic Orders—Franciscan, Augustinian, Dominican, and Carmelite.

Free Form Not having prescribed geometric proportions.

Fresco A method of painting in which pigments suspended in water are applied to a thin layer of wet plaster so that the plaster absorbs the color and the painting becomes part of the wall.

Frieze (freeze) Any horizontal band, decorated with moldings or patterns, either painted or carved, usually at the upper end of a wall; specifically in Greek architecture, the middle layer (plain or carved) of an entablature.

***Fu-nan** (foo-nahn) Ancient Southeast Asian empire (c100–525), typified by their worship of Harihara, their early sculpture of Buddha and Vishnu, and their use of canals to drain the rice lands of Cambodia.

***Futurism** A style of painting (in Italy, early 20th century) which emphasized the machine-like quality of "modern" living.

Gable A triangular or shaped piece of a wall at the end of a ridged roof; called a pediment in Classical Greek architecture.

Gallery A story over the aisle and open to the nave through an arcade in Christian church architecture. Also, a contemporary commercial enterprise that exhibits works of art for sale.

***Gamelon** (*gam*-eh-lahn) Javanese orchestra incorporating bronze gongs, wooden xylophone-like chimes, drums, and wind instruments. Used to accompany puppet and human theatrical performances.

***Gandhara** (gahn-*dar*-ah) School of earliest Buddhist sculpture in the Indian province of Bactria distinguished by the use of Hellenistic and Persian anatomical representation. Also known as the Indo-Greek or Greco-Buddhist School.

Ganges Civilization (*gan*-jeez) Society of the Indo-Gangetic plains of northern India from about 1500 B.C., noteworthy for the evolution of the Vedic writings fundamental to Brahmanic religion.

Gautama (gow-*tah*-mah) The historical Buddha, Sakyamuni. See **Buddhism**.

Genre (*jsahn-ra*) Referring to the common, ordinary; also, a type of localized art.

Genre Painting The representation of subjects and/or scenes from everyday life.

Geodesic (jee-oh-*des*-ik) A form of geometry (solid) which forms the basis for structures built of interlocking polygons.

Geometric Referring to mechanical, human-made shapes such as squares, zig-zags, circles, spirals, checkerboard patterns, bands, and the like; also, a period of ancient history when decorative motifs of such patterns were commonly used on pottery (i.e., Geometric Greek pottery).

Gesso (*jess*-oh) A mixture of finely ground plaster and glue that is often spread on a surface prior to painting.

Guilding A covering of gold leaf over inexpensive or perishable materials.

Glaze In pottery, the thin coating of minerals which provides the glassy coloring and waterproof gloss for the final ware. In painting, a transparent mixture of a small amount of color dissolved in a large amount of the vehicle (such as linseed oil mixed with turpentine in oil painting) that changes the hues of previously painted surfaces.

Gopuram (*go*-poor-um) Elaborate pyramidal tapered gateway towers typical of South Indian Hindu temple architecture.

Gospel In Christian usage, the story of Christ's life and teaching, as found in the writings of the first four books of the New Testament.

***Gothic** Style of art in Europe of the 12th-15th centuries, emphasizing religious architecture and typified by pointed arches, spires, and verticality.

Gouache (gwash) Any opaque water-soluble paint or opaque watercolor.

***Great Pueblo** Era of Southwestern American Indian culture (1050–1300) marked by large communities of multi-storied buildings and the first appearance of polychrome painted pottery in the region.

***Greco-Buddhist** See **Gandhara**.

Greek Cross A cross with four arms of equal length.

Grid-iron Something consisting of a network, i.e., a street pattern or the regular divisions of a decorative surface.

Groin The sharp edge formed by two intersecting vaults.

Groined Vault A vault formed by the intersection (at right angles) of two barrel vaults of equal size so that the groins form a diagonal cross.

Ground The surface on which a painting is made.

Guan Yin (gwahn yin) The Chinese Buddhist goddess of mercy, an interpretation of the Indian Bodhisattva Avaloketisvara. A compassionate goddess, benevolent to children, and protective of sailors.

Guilds Independent associations of artisan-manufacturers and bankers in Renaissance Florence. The Italian word is *arti*, from which the word "art" comes.

***Gupta** (*goop*-tah) Ruling dynasty (320–600) synonymous with the golden age of Indian art, artistically significant for its Indianization of Buddhist images, the evolution of Mahayana Buddhist iconography, and the digging of early cave temples (Chaitya).

Gypsum (*jip*-some) White calcium sulphate mineral, useful as a painting pigment.

***Haida** (*high*-dah) Coastal Indians of British Columbia, artistically known for their symbolic and abstract wood carvings, totempoles, and plank houses.

Halo The circle of light shown around the head of a saint or of a holy person; also used to identify the divinity of a god. Also known as a *nimbus*.

***Han** (han[d]) Second longest Chinese dynasty (206 B.C.–221 A.D.), divisible into a number of phases. Artistically typified by aristocratic tomb art; sophisticated silk, lacquer, glazed ceramics; and clay models of architecture and daily use objects.

Handbuilt Ceramic objects formed without the use of a potters wheel, typically using slabs or coils of clay to construct vessels.

***Haniwa** (*hahn*-ee-wah) Late neolithic culture of the Japanese Tumulus Age (300–700), named for the typical sculptured cylinder-like clay tomb guardian figures found at burial sites of the period; also, the sculptures of humans, architecture, and animals made during the period.

Hanuman (hahn-oo-*mahn*) Mythological king of the monkeys in the *Ramayana*, responsible for Rama's successful recovery of his kingdom.

Hard-edge Refers to a style of art in which the artist uses crisp, clean edges and applies the values and colors so they are even and flat.

Harmika (har-*meek*-ah) The small railed balcony surmounting the dome of a stupa.

Hatching The use of parallel lines to create shading. When lines are overlapped at angles to each other, the technique is called crosshatching.

***Heian** (*hey*-on) Long-lived Japanese dynasty (794–1185) named for the new capital city at Kyoto. The later phase (894–1185) is known as the Fujiwara period. Significant for the establishment of Amida Buddhist sects, aristocratic refinement at court, and the flowering of the arts.

***Hellenistic** Era of Mediterranean culture influenced by the Greek world following the conquest of Alexander the Great.

Heraldic Relating to coats of arms and family crests or emblems.

Hieroglyphs (high-row-*gliffs*) Characters in the picture-writing system of many ancient cultures which utilize pictures or symbols representing sounds, words, or ideas.

***Hindu** (*hin*-doo) The dominant cultic religion of India, acknowledging a pantheon of earth spirits, the foremost of which are Brahma (the creator), Vishnu (the Preserver), and Siva (the Destroyer).

***Hispanic** (hiss-*pan*-ick) Pertaining to Spain or its people throughout the world.

***Hohokam** (ho-*ho*-kahm) Ancient Southwestern American culture (100–1400) developing from contacts with Mexico, typified by their use of irrigation canals, and artistically marked by red-on-buff pottery, the use of copper, and fine textiles and stonework.

***Hopi** (*hoe*-pee) A pueblo-dwelling people of the Shoshone group of Arizona, considered the finest Indian weavers. Their pottery of ancient times was decorated with abstract stylized animals. Modern distinction is in repoussé silverwork and turquoise and shell settings.

Horizon Line The division between earth and sky, as seen by an observer.

Hours, Book of A book for private devotions, containing the prayers for the seven canonical hours of the Roman Catholic Church. Often executed in illuminated manuscript form.

***Huaxtec** (*wahx*-tec) Warlike culture of Northern Veracruz which peaked between 600 and 900 but survived through Aztec times. Artistically noted for miniature and large sculptures of human and anthropomorphic gods.

Hue The attribute of a color that gives it its name. The spectrum is usually divided into six basic hues: violet, blue, green, yellow, orange, and red.

Humanism The renewed interest at the beginning of the Italian Renaissance in the art and literature of antiquity. Also, any concern with the study of humanity and its writings and activities.

Hypostyle (*hip*-oh-stile) A building having a roof or ceiling supported by rows of columns; used to describe a hall constructed of many columns; also, a row of columns.

***Iban** (*eh*-bahn) Tribe of coastal rice farmers in Northern Borneo, artistically distinguished by their stilted communal long houses, finger weaving, and fine basketry.

***Iberia** (eye-*beer*-ee-ah) The European peninsula composed of the Spanish, Portuguese, and Basque peoples.

***Ibibo** (*ee*-bee-bo) An African tribe of the Nigeria region, artistically noted for their ritual wooden masks.

***Ica** (*ee*-ka) Coastal people of Southern Peru, noted for their thin polychromatic pottery in the tradition of the Nazca culture, 1200–1500.

Icon (*eye*-kahn) A religious image or likeness; in the Eastern Orthodox religion usually a panel painting of a saint or of Christ.

Iconoclasm (eye-*kahn*-oh-klasm) Destruction of images or icons; Historical examples include the Iconoclastic Controversy (8th–9th centuries), the Protestant purges (16th–17th centuries), the Tang repression (845), and the Japanese persecution of Christians (1580–1640).

Iconography (eye-kahn-*aw*-graf-ee) The system of symbolic elements in a work of art; the system of symbols traditionally used to identify a deity, illustrated by pictures or other visual representations; also, the study of symbols and their meanings.

Iconostasis (eye-kahn-*aw*-stah-sis) A

decorated screen (often of icons) in Eastern Orthodox churches, separating the main part of the church from the sanctuary.

Idealization The representation of objects or people in a stylized and perfected way, often following a preconceived model. Greek and Indian gods were idealized human forms.

Idiom (*id*-eum) A style or design peculiar to a specific place or time.

Idol A representation or symbol of a deity used as an object of worship.

***Ife** (*ee*-fay) African civilization of the Nigerian coast, flourishing 1200–1500.

Ikebana (ee-kay-*bahn*-ah) Japanese art of flower arranging, using flowers and other organized objects to depict mood and movement.

Illumination Colored illustrations, often containing gold and silver, that decorated manuscripts in medieval times in Europe.

Imari (ee-*mar*-ee) Porcelain produced in the Arita region of Kyushu Island, Japan, decorated with underglaze blue and overglaze red enamels. Often gilded.

Impasto (im-*pass*-toe) A thick, heavy application of paint, with either brush or knife.

Imperial Art Objects of beauty and high value produced by workers hired by a ruler or his court; usually the finest products become the property of the "crown" for use at court, or as royal gifts.

Impress To push into; in ceramics, patterns are made in soft or leather-hard clay by pressing with textured tools, stamps, or chops.

Impressionism A style of painting begun in France about 1875. It stresses a candid glimpse of the subject, spontaniety, and an emphasis on the momentary effects of light on color.

***Inca** (*ing*-kah) Ancient imperialist Peruvian culture (1200–1532) unifying many local cultures of the Andes and ruled by a king (inca). Artistically noted for their encouragement of native traditions and their expert construction of fortified cities.

Incise To cut into a surface with a sharp tool.

***Indo-Greek** See **Gandhara**.

Indra (*in*-druh) King of the Vedic gods of India, personification of the Aryan warrior, and the god of thunder and the atmosphere.

***Indus Valley Civilization** Sophisticated early civilization of Northern India and Pakistan, probably influenced by Mesopotamian cultures, flourishing about 4000–1500 B.C., distinguished by their water-worship, grid-iron pattern streets, and early bronze casting.

Inlay To set one material into recessed areas of another substance; to decorate with such insertions.

Intaglio (in-*tahl*-ee-oh) A printmaking technique which transfers ink from areas beneath the surface (etched, engraved, or scratched) onto paper, resulting in a print.

Intensity The strength, brightness, or purity of a color. The more intense the color, the less it is weakened with admixtures of neutrals or its complementary color.

***Ionic** (eye-*ahn*-ik) Classical Greek style of architecture, characterized by slender columns with fluted shafts and capitals decorated with scroll-like devices (volutes).

***Iroquois** (*ear*-oh-coy) Native people of Northeastern America whose hunting and fishing economy produced significant carved-bone tools, masks, carved, painted wooden weaponry, and bark canoes.

Islam (is-*lahm*) Religious faith based on belief in Allah as the sole deity, as revealed to the prophet Muhammad (570–632); also, the civilization based on that Arabic faith.

Ivory Hard white dentine substance of the tusk of elephant, hippopotamus, walrus, and narwhal; also, an article made of that substance, usually by carving.

Jade Highly valued opaque to translucent stone, usually nephrite or jadite; known to the Chinese as "Yu"; also, a carved object made of such material.

***Jain** (jane) Indian religion following the teachings of Vardhamana Mahavira (6th century B.C.), based on a doctrine of peace, harmony, and non-violence.

***Jalisco** (hah-*lees*-ko) Ancient culture of West Mexico more attuned to Peruvian and Hohokam influences than other Mexican cultures. Thrived 100–300. Artistically known for ceramic figures of natural proportion in brown and gray clay.

Jamb The upright piece, forming the side of a doorway or window frame. In Romanesque and Gothic cathedrals, the jambs were the location for tall, sculptural figures.

Jesuit (*jeh*-zoo-it) Member of the Roman Catholic "Society of Jesus," founded by Loyola in 1534 and responsible for much of the spread of Christianity in the post-Reformation period.

Jesus Christian Son of God and Savior of the world (4 B.C.–30 A.D.) whose teachings stressed peaceful co-existence, salvation based on His dying for humanity's sins, and a resurrection to eternal life. Also known as The Christ.

Jewelry Objects of precious materials, usually metals and gems, worn for personal adornment.

Jōmōn (joe-*mahn*) Neolithic hunting society of prehistoric Japan (7000–200 B.C.), artistically typified by rope-designed pottery and clay fertility dolls.

Judaism The Jewish religion, characterized by belief in one God and by a religious life in accordance with Scriptures and rabbinic traditions; the Hebrew culture.

Judeo-Christian Culture originating with Biblical Abraham and continuing through the periods of prophecy into the Christian era; the common culture shared by Christians and Jews and their heritage of religious and societal values.

Jun (chun) Chinese celadon ware and kiln site in Henan Province, typified by glazes of lavender and greenish blue, frequently splashed and suffused with purple and crimson, produced by copper which has been reduced in firing.

Kabuki (kah-*boo*-key) Popular Japanese drama, both tragic and comic, involving highly costumed male actors.

Kachina (kah-*chee*-nah) Small dolls or figures made by Pueblo Indians which represent the gods and are used to teach religion.

Kamakura (kah-mah-*koo*-rah) Military government in Japan (1192–1338) with a capital city at Kamakura, whose arts reflect military austerity and the growth of Buddhist salvation sects.

Kannon (can-on) Japanese equivalent of the Bodhisattva Avaloketisvara and the Chinese Guan Yin. The goddess of mercy.

***Karen** (*care*-en) Tribal hill people of Tibeto-Burman stock living in North Thailand, Laos, and Burma, noted for their embroidered clothing and handicrafts.

Keep The massive central tower of a castle, and the final point of defense; also, a tower-like fortress.

***Kenyah** (*ken*-yah) Tribal people of Borneo, artistically noted for fine basketry.

Keystone The topmost stone in an arch, and the last stone to be placed in the construction of the arch; the stone which balances the gravitational forces pulling on the arch.

***Khmer** (cmer) Ancient kingdom and people of Cambodia, emerging as a distinct cultural group in the 6th century, climaxing in the 12th century with the construction of huge god-king temple complexes at Angkor and Angkor Thom.

Kiln (kill) An oven capable of controlled high temperatures in which clay objects are fired or baked; also, the complex of a pottery-producing site, including workshops, studios, and firing chambers.

Kinetic Art Any three-dimensional art that contains moving parts, that can be set in motion either by air currents or some type of motor. Also may refer to art in which changing light patterns are controlled by electronic switches.

***Kiowa** (*kigh*-oh-wah) Nomadic tribe of the Oklahoma region noted for fine leather garments ornamented with beadwork.

Kiva (*kee*-vah) Subterranean chamber ceremonially used by Southwestern American Indians as a worship center; Kivas were square in early phases of Pueblo culture and round during the Great Pueblo era. Roofs are low and slightly domed.

Koran (koh-*rahn*) Sacred writings as revealed by Allah to Mohammed, and the foundation of the Islamic faith.

Kore (*core*-ay) A female figure, a clothed sculpture in archaic Greek art.

Krater (*cray*-ter) Tall, wide-mouthed vase, usually of earthenware, in ancient Greece and Rome. It had two handles and was used for mixing water and wine.

Kraton (kray-*tahn*) An Islamic royal palace complex.

Kris (crease) An Islamic dagger with a wavy blade, held with a decorated pistol-grip handle. Commonly associated with Southeast Asia and Javanese arts.

Krishna (*krish*-nah) Hindu god and incarnation of Vishnu, the Preserver.

Kufic Script (*koo*-fik) An early Arabian writing form, used in the region south of Babylon.

Kutani (koo-*tah*-nee) Kiln site and name of Japanese 17th century porcelain richly decorated in overglaze enamels in patterns of birds, plants, landscapes, and textiles.

Kylix (*kigh*-lix) An ancient Greek two-handled shallow wine cup, often with a stem and foot.

Lacquer (*lack*-er) A durable natural resin which, when applied in many thin layers over a base of clay, wood, cloth, or basketry, forms a tough and permanent object. Objects so made are called lacquer or lacquerware.

Landscape A work of art that shows the features of the natural environment (trees, lakes, mountains, etc.)

Lantern A small dome, usually with windows around its drum, built atop a larger dome or on a roof to allow light to enter the structure.

***Lao** Hill tribe people of Indo-China, noted artistically for colorful patchwork stitchery and heavy silver jewelry.

Latin Cross A cross in which the vertical member is longer than the horizontal one.

Leather-hard Stage in the drying process of a clay object when designs are carved and impressed, handles and other appliques added, and coatings of colored clay slips applied.

Line An element of design that may be two-dimensional (pencil on paper), three-dimensional (wire), or implied (the edge of a shape or form).

Linear Perspective A system of drawing or painting to give the illusion of depth on a flat surface. All parallel lines receding into the distance are drawn to one or more imaginary vanishing points on the horizon in such a work.

Lintel Horizontal structural member that spans an opening between two walls or posts.

Lithography A printmaking process in which a flat stone, previously marked with a greasy substance (either a special ink or crayon) that will retain the ink, is charged with ink, placed against paper, and run through a press, producing a print known as a lithograph.

Live Rock Stone carved where it is found in nature; rock still in its original location.

Local Color The color of an object seen in white (or natural) light and free from reflected colors and shadow.

Lokeshvara (low-kesh-*vahr*-ah) The Khmer equivalent of the compassionate Bodhissatva Avaloketisvara (See **Guan Yin** and **Kannon**). Depicted with a turban and four arms that carry a lotus, a rosary, a flask, and a book.

Longhouse Communal dwelling for an entire tribe in Borneo. The front half of the structure is a common verandah, and the back half is divided into individual dwellings for each family.

***Long Shan** (loong shahn) Neolithic Chinese culture (c3000–1600 B.C.) of Gansu province, artistically typified by thin black pottery made with a potter's wheel and burnished by hand.

Loom A frame or device in which yarn or other threadlike material is woven into fabric by the crossing of threads, called weft, over and under stationary warp threads.

Lost-Wax Process See **Cire Perdue.**

Lotus Variety of water lily popular in Egyptian, Hindu, and Buddhist iconography as a symbol of purity.

Low Relief A surface that has only slight variations between the highest and lowest parts. Bas-relief is sculpture of low relief on a wall, and a coelanoglyph is a sculpture of low relief carved into a wall surface.

Lunette (loo-*net*) A semi-circular area, such as the space at the end of a vaulted room or over a door, niche, or window. When it is over the portal (main door) of a church, it is called a tympanum.

Lustre (*luss*-ter) An irridescent metallic ceramic glaze or surface on glass; may be created intentionally or may occur when pieces are buried in certain soils for long periods of time.

Madonna Mary, the mother of Jesus Christ.

Madrasah (mah-*drahs*-ah) A style of mosque using an enclosed courtyard but open to the sky.

Maesta (my-*ays*-tah) An altarpiece with a central panel representing the enthroned Madonna adored by saints. From the Italian word for "majesty."

Mahayana (mah-hah-*yan*-ah) See **Buddhism.**

Majolica (mah-*yall*-ikah) Earthenware with an opaque low-fired tin enamel glaze, ornamented with colors of mineral oxides.

Manchu (*mahn*-chew) See **Qing.**

Mandala (*mahn*-dahl-uh) A mystical geometric design, symbolizing a supernatural understanding of the universe. Called a "mandara" in Japan.

Mandorla An almond-shaped outline enclosing the full figure of a person endowed with divine light, usually Christ.

Mannerism A style and period of European art (16th century) notable for its deliberate reaction against the balance of High Renaissance art. It is characterized by subjective expression, distortion of the figure, peculiar placement of figures in the composition, exaggerated perspective view, and a crisp and harsh treatment of light and shadow.

***Maori** (*mou*-ree) Native peoples of New Zealand, artistically distinguished by totemic carvings, shellwork, and finely-plaited house walls.

Mask A false image, often ascribed with supernatural powers, worn during rituals in animistic societies.

Masonry Stone or brickwork in architecture; also, the pattern of bricks laid vertically or horizontally by courses to build up a wall.

Mass The physical bulk, weight, and density of a three-dimensional object; also, the celebration of the Eucharist in a Christian Church.

Mastaba (mah-*stah*-bah) A rectangular Egyptian tomb of mud brick and masonry with sloping sides and a flat top. It covered the burial chamber.

Mat (matte) A dull or non-reflecting surface. Also, a cardboard frame surrounding a print, drawing, watercolor, or photograph.

***Mauryan** (*moo*-ree-un) Early Indian kingdom, founded by Chandragupta Maurya about 322 B.C., uniting India for the first time. Artistically distinguished

by the evolution of the stupa and the Ashokan pillar.

Mauseoleum A magnificent and stately tomb.

***Maya** (*my*-uh) Ancient Classical civilization of Eastern Mexico and the Yucatan, 300–800). Artistically distinguished by colored frescoes, excellent weavings, iconographic sculpture, and boldly illustrated codices.

Medallion Tablet or panel in a wall or window bearing a figure in relief, a portrait, or a symmetrical ornament.

Medium A material used by an artist and often implying the technique of using that material. Plural is **media**. Also, the solvent which carries pigments in suspension in a paint.

Megalithic Consisting of huge undressed stones, usually arranged by prehistoric man.

Megaron (*meg*-a-rahn) In Minoan and Mycenaean culture, a large rectangular space with a hearth at the center and four columns supporting the roof. The main hall or room in palaces or houses of these early Greek cultures.

***Meiji** (may-jee) Japanese era (1868–1912) of enthusiastic learning from the West.

Mei-ping (may-ping) Shape of a tall Chinese vase typified by a gently tapering body toward a broad shoulder and a short narrow neck.

***Melanesia** (mel-ahn-*ee*-shiah) Cultural area of the South Pacific, east of Fiji, artistically distinguished by painted wooden images, totemism, and the tribal arts of New Guinea.

Menhir (*men*-ear) A single upright undressed monolith, usually of prehistoric origin.

***Meo** (meow) Hill tribe people of Northern Thailand, Laos, and Burma, artistically noted for their fine embroidery and heavy textured silverwork.

***Meso-America** The cultural areas of Central America and Mexico.

Metallurgy The science and technology of working with metals.

Metope (*met*-oh-pee) The carved or plain areas between the triglyphs in the frieze of a Doric building.

***Micronesia** (my-crow-*nee*-shiah) Islands of the Pacific north of the Equator and east of the Philippines which produce colorful weavings.

Minaret (min-ar-*et*) A tall, slender tower attached to a mosque from which the muezzin calls people to prayer.

Minimal Art Usually a wood or metal sculpture (but also a painting) using flat areas or planes in what seems a simple, geometric composition. Also, any non-representational art form using very simplified forms and colors.

Mishima (mih-*shee*-mah) A Korean technique of applying colored slip into textured or etched surfaces of leather-hard pottery, developed during the 12th century. Resulting decorative patterns are exposed after the excess slip is scraped away and the piece is glazed and fired.

***Mission Indians** Native tribes of Southern California who were served by missions of San Diego, San Gabriel, and San Fernando, noted for their soft-coiled baskets and fine featherwork.

***Mission Style** Architectural tradition of the Southwest United States, inspired by Franciscan-built churches and dormitories, typified by thick white adobe walls, arcaded or pillared verandahs, curvilinear gable walls, and unglazed red tile roofing.

Mixed Media A two-dimensional art technique that uses more than one medium, for example, a crayon and watercolor work.

***Mixtec** (*mix*-teck) Ancient Mexican culture in the Puebla and Oaxaca region, flowering in the 6th–7th centuries but contemporary with Toltec and Aztec peoples. Significant artistically for their immense pyramid at Cholula and their fine manuscripts painted on animal skins.

Mobile A balanced construction with moving parts, suspended from above, and moving freely in the air currents. May be set in motion by a motor. Invented by Alexander Calder in 1932.

***Mochica** (moh-*cheek*-ah) Coastal South American culture noted for fine pottery and adobe pyramidal temples (500 B.C.–900 A.D.).

Modeling The forming of a three-dimensional form in a soft substance such as clay or wax. Also, the effect of light falling on a three-dimensional form, delineating its form by means of shadow and light. Also, representing this three-dimensionality of forms in a painting by means of light and dark values.

***Mogollon Culture** (*moh*-gull-on) First ancient American culture of the Southwest to produce fired clay objects, from about 200 B.C.–1400 A.D.; influential on later Pueblo cultures.

Mohammed (moh-*hahm*-ed) Prophet and founder of the Islamic faith who lived in Arabia (570–632).

Mold The hollow form into which molten materials (gold, lead, plaster, etc.) are poured to create a cast sculpture.

Molding An ornamental strip that gives variety to the surface by creating light and shadow.

***Momoyama** (mo-mo-*yahm*-ah) Exuberant and vital Japanese shogunate (1573–1615) which was the pinnacle of the Samurai culture, Zen-inspired arts,

and political unification. Era of castle construction and use of feudal armament.

Monastery Living quarters for monks.

***Mongol** See **Yuan**.

Monochromatic One color; refers to colors formed by changing the values of a single hue by adding the neutrals (black, white, and grey).

Monolith A large single block of stone used in architecture or sculpture; also, a structure made of such large stones.

Monotype Any of several printmaking techniques where the image printed is unique and not able to be reproduced.

Montage A composition composed of several pictures, usually pasted together; also, a painting that has that appearance.

***Monte Alban** Classical Mexican civilization (200–500) of Zapotec origins, artistically distinct for burial urns in forms of gods; also, the sacred urban and necropolis center of many later Mexican civilizations.

Monumental A work of art that is huge in size, often displayed in public squares. By extension, it refers to the quality of a work of art that may be small in actual size but has the characteristics and feeling of a huge work.

***Moorish** Referring to the Moors, the Islamic rulers of Spain (710–1492), particularly their architecture, typified by the use of arches, stucco, tile roofing, and polychromatic majolica.

Mosaic A work of art consisting of pieces of colored marble or glass (tesserae) embedded in a layer of adhesive material.

Mosque (mahsk) An Islamic temple or place of worship.

Mother-of-pearl The hard, pearly, iridescent substance forming the inner layer of a mollusk shell, used in inlay work in jewelry and furniture.

Motif The main subject or idea of a work of art, such as landscape or still life; also, the two- or three-dimensional configuration repeated in a pattern.

***Mound-builders** Early native Americans of the Middle West and Southeast who formed large earthen burial mounds and fortifications, thus creating the first earth works in America (100–1000).

Movement A principle of design referring to the arrangement of parts in a work of art to create a slow to fast movement of one's eye through the work. Also, a style, school, or artistic thought and practice, i.e., the Impressionist movement.

***Mudéjar** (mood-ay-yar) The style of Moorish architecture.

Mudra (*moo*-druh) A ritual gesture which grew out of a simple gesture of the Buddha, symbolizing mystical power or action in mime or dance.

Muezzin (moo-*zeen*) See **Minaret.**

***Mughal** (*moh*-gull) Islamic empire in India, founded by Baber in 1526 and flourishing until 1857. Also spelled Mongul.

Mullion A vertical member separating two areas of a window.

Mural A painting on a wall, usually large in format.

***Muromachi** (mur-oh-*motch*-ee) Japanese shogunate (1338-1578) whose capital city was Kyoto, characterized aesthetically by the growth of Zen-related concepts of simplicity, restraint, subtlety, and artforms such as ikebana, sumi-e, and the cha-no-yu.

Muses The nine sister-goddesses of Classical Greek mythology who presided over learning and the arts. There were Muses for epic poetry, history, love poetry, music, tragedy, sacred song, dance, comedy, and astronomy.

Muslim (*muz*-lim) A believer in the Islamic faith.

Mysticism A spiritual discipline of communion and unity with the divine often achieved through meditation or trancelike contemplation.

***Nabis** (nah-*bee*) A small group of French artists who painted (1889–1899) in a style of flat bold colors and were unconcerned with naturalism.

Nāga (*nah*-gah) Divine serpent in Hindu mythology representing water spirits, guardians of cisterns and sacred water; a favorite motif in Thai, Indian, and Southeast Asian Hindu art.

Nandi (*nahn*-dee) The mythological bull upon which Siva rides; hence, a symbol of Siva's fertility and reincarnation powers.

***Nara** (*nah*-rah) City whose name is attached to the early Buddhist Japanese era (646–794), subdivided into the Hakuho (646–710) and the Tempyo (710–794). Artistically significant for Chinese-style architecture, iconographic Buddhist sculpture in the Tang style, and the inculcation of Confucian and Buddhist ideals.

Narthex A porch or vestibule, sometimes enclosed, preceding the main entrance of a church.

Natarāja (nah-tah-*rah*-jah) "Lord of the Dance" aspect of Siva who dances the Nataraj in the frenetic art of eternal reincarnation; a popular motif in Hindu sculpture.

Naturalism The suggestion, in a work of art, of the direct observation of a scene or of a figure; also, an Italian Renaissance concept of interest in the world of nature, including exploration of it scientifically.

***Navajo** (*nah*-vah-hoe) A tribe of American Indians, related to the Pueblo group of Southwestern United States, artistically noted for their unpainted pottery, use of the true loom in weaving outstanding blankets and rugs, and excellent hammered silverwork.

Nave The central section of a church where the congregation assembles. In a basilican plan, the space extends from the main entrance to the apse or the crossing. Usually, the nave is flanked by side aisles.

***Nayarit** Mexican culture of Western coastal Mexico, culturally distinguished by the creation of ceramic figures of exaggerated features.

***Nazca** Coastal culture of Peru, noted for thin polychrome pottery produced from 100–1200.

Necropolis (nay-*crop*-oh-liss) A cemetery of an ancient city.

Negative Space The area around the objects in a painting, sometimes called the background.

***Neoclassicism** A style of art in 19th century France that was a reaction to Baroque. It was derived from the art and culture of ancient Greece and Rome and imitated its architecture and fascination for order and simplicity. Also, any revival of Classical ideas in the arts during any later period.

***Nestorian** (nest-*or*-ee-an) Sect of Christianity following the teaching of Nestorius (d.451) that the divine and human aspects of Christ are separate.

Neutral A color not associated with any hue, such as black, white, and gray; a neutralized color made by combining complementary colors to produce a grayish hue.

***Nevers** (neh-*vehr*) Center of French faience manufacture, originally established by Italian potters about 1565, typified by large plates decorated with engraving-like scenes and rich borders.

***N'gere** Tribal people of Nigeria, noted artistically for ritual masks.

Niche (nitch) A recess in a wall, usually intended to hold a statue.

Nimbus See **Halo.**

Nōh (know) Classical Japanese drama, originating in the 14th century and derived from temple dances; the stylized presentation by two richly costumed actors performing against no scenery.

***Nok** Ancient Nigerian civilization of about 500 B.C., noted for their large sculptural figures.

Non-objective Art Art that has no recognizable subject matter, such as trees, flowers, or people. The actual subject matter might be color or the composition of the work itself.

Non-representational Art See **Non-objective.**

Obelisk (*ah*-beh-lisk) A tapering four-sided shaft of stone (usually one piece) topped by a pyramidal form, typical of Egyptian art. Sometimes called "Cleopatra's Needles."

***Oceania** Geographic region comprising the islands of the Pacific, artistically characterized by totemic and mystic sculptures of perishable materials; the general use of bright colors and fetishes.

Oculus (*ah*-cue-lus) A circular opening in a wall or in the top of a dome, from the Latin for "eye."

Odalisque (*oh*-dah-lisk) Any reclining female figure used as the subject for a painting or sculpture, from the French for "harem slave."

Oil Paint Opaque mixture of pigments dissolved in linseed oil using turpentine as a solvent, applied to a gessoed panel or canvas ground.

***Olmec** (*ohl*-mek) Mother culture of ancient Mexico (2000 B.C.–700 A.D.), centered in the Gulf coastal area, noted for the construction of the sacred city of Monte Alban and for the buildings and sculptures at La Venta.

***Oneida** (oh-*nigh*-dah) An Iroquois tribe that moved to the Wisconsin area (1822–1827) where they became noted for fine silverwork.

***Op Art** A style of art that confuses the visual senses by generating optical vibrations or ambiguous or undulating spatial relationships.

Oracle Bone Large, usually flat, mammal bones or tortoise shells upon which prehistoric Chinese shamen drew picture messages. When heated the bones cracked, revealing the response of the mystic forces, and then were interpreted by the shamen, acting as the voice of god, or oracle.

Order An architectural system based on the prescribed style of column and entablature, such as the Greek Doric, Ionic, and Corinthian. Also, the organization of the parts of a work of art.

Overglaze Design or color applied onto a piece of ceramic after it has been glaze fired, usually made permanent by firing to a low temperature.

Overlapping Planes A perspective technique involving the placement in a flat composition of one object in front of another, thus creating an illusion of depth.

***Paekche** (*pahk*-shay) Ancient kingdom of Southwestern Korea (18 B.C.–663 A.D.) noted for their adoption and promotion of Buddhism and associated Chinese-style aristocratic arts.

Pagoda (pah-*go*-dah) Circular or octagonal structure built to preserve relics, commemorate unusual acts of devotion,

act as an omen of good fortune, or as a water tower. Based on the Indian stupa, the form was modified when introduced to China in the 3rd century and again when introduced into Japan in the 6th century. Usually built of an odd number of stories.

Painterly Style or **Painterly Quality** A technique of painting in which forms are depicted by patches of color rather than by hard and precise edges. Brush strokes are left visible as part of the surface of the painting.

Painting A picture or other image composed of applied colors; the art or occupation of producing such works.

Painting Knife A small, shaped blade made expressly for applying paint to canvas, creating a textural surface.

Palette A board or flat surface on which a painter places (and mixes) the supply of paint to be used. Also, the typical group of colors that a particular artist (or school of art) uses.

Palette Knife A small spatula used for mixing colors on the palette and for cleaning paints from the palette. It may be used as a painting knife.

Palisade A raised earthen embankment held in place by closely set posts which act as a retaining wall.

***Palladian** Architectural style based on Renaissance motifs revived and altered by Andrea Palladio (1518–1580) which typify the buildings of Georgian England and British colonies in Asia and America.

***Pallava** (*paul*-ah-vah) Southeast Indian kingdom flourishing about 600–750, artistically distinguished by their rock cut freestanding temples.

Pantheon Greek for "all the gods"; therefore, a temple dedicated to all the gods. Specifically, the round-domed structure built in Rome in 25 A.D.

***Paracas** (pah-*rock*-us) Ancient culture of south-coast Peru, noted for excellent thin sculptural pottery, often in human form.

Paracas Necropolis Ancient Peruvian culture named for burial mounds which yielded weavings of superb quality.

Paradigm (*pair*-ah-dime) An exceptional example or outstanding object, representative of an entire group of similar pieces.

Parchment The treated skin of a lamb or goat, processed to make a smooth, flexible surface for manuscript writing and illumination.

Passion The suffering of Jesus Christ during the last week of His earthly life.

Pastel A chalky, colored crayon. Also, a chalky, light-valued color.

Patina (pah-*tee*-nah) The thin surface coloration on an old object or metal sculpture, resulting from natural oxidation or from the careful treatment by heat, chemicals, or polishing agents.

Pattern A principle of design in which combinations of lines, colors, and shapes are used to show real or imaginary things. Pattern may also be achieved by repeating a shape, line, or color.

Pediment The triangular area over the entablature in Classical Greek architecture, formed by the ends of a sloping roof and the cornice.

Pendentive (*pen*-den-tiv) A triangular piece of vaulting springing from the corner of a rectangular area to support a round or polygonal dome. Usually four pendentives spring from the four corners of a crossing to support the dome.

Pentateuch (*pen*-tah-took) The first five books of the Old Testament containing early history and law of Judeo-Christian culture.

Permutation Complete change in the nature of a constituent mineral in a ceramic glaze during the firing process.

Perspective The representation of three-dimensional objects and space on the flat surface to produce the same impression of distance and relative size as that received by the human eye. **Aerial** or **atmospheric perspective** creates the illusion of distance by muting color and blurring detail as objects get farther away. **Linear perspective** employs sets of parallel lines getting closer together in the distance until they merge as an imaginary vanishing point on the horizon. **Overlapping planes** create distance by placing objects in front of other objects. **Worm's eye perspective** creates a feeling of majesty and distance by looking up at subject matter from a low point in the composition.

Petroglyph (*pet*-row-glif) A carving on rock, usually of a stylized image or message in such images.

Phoenix (*fee*-niks) Legendary bird which rises in youthful reincarnation from its own ashes of destruction. Regarded by the Chinese as emperor of all birds and as an emblem of beauty.

Pictograph A drawing or painting stylizing or simplifying a real image; picture-writing, thus the basis of hieroglyphics and ideographs.

Picture Plane The flat surface which the artist uses as a starting point for a painting. It is not the paper or canvas itself but an imaginary flat plane that the artist uses as a visual reference and which is at the same level or depth as the surface itself.

Pier (peer) Massive vertical masonry pillar that supports an arch, vault, or other kind of roof. Also used under pendentives to support a dome. A square area in a Gothic church marked by a pier at each corner is known as a "bay."

Pieta (pee-ay-*tah*) The scene of Mary holding and weeping over the body of the dead Christ, her son. From the Italian word for "pity."

Pigment A dry powder that supplies the coloring agent for paint, crayons, chalk, and ink.

Pilaster (pee-*las*-ter) A rectangular engaged column, sometimes decorative but at other times used to buttress a wall.

Pillar Any vertical architectural member, such as a column, pier, or pilaster.

***Plains Indians** Semi-nomadic horsemen of the Western Mississippi basin, including the Blackfoot, Crow, Sioux, Cheyenne, Arapaho, Kiowa, and Comanche tribes. Artistically significant for excellent leatherwork, bone and horn carving, and symbolically decorated rawhide tipis.

Plane A flat surface that can be measured by length and width (two dimensions).

Plastic The quality that describes material that can be shaped or manipulated, such as clay or wax; flexibility. Also, the three-dimensional quality (roundness) of an art work. Also, any of a number of synthetic materials with various physical characteristics.

***Plateresque** (plat-ter-*esk*) A rich, ornate style of decoration resembling overdecorated silverwork, typical of the Spanish Baroque era.

Plaza A public square or assembly space.

Plinth The base of a building, column, pedestal, or wall which is usually marked on top by a molding.

Pointillism A style of 19th century French painting in which colors are systematically applied to canvas in small dots, producing a vibrant surface.

Polychrome Several colors rather than one (monochrome).

***Polynesia** (pahl-en-*nee*-shia) Scattered island group of the East Pacific with an artistic tradition characterized by the use of perishable materials and shells, and by large mystic sculptures in wood and stone.

Polyptych (pah-*lip*-tik) An altarpiece or devotional painting consisting of more than three panels, joined together.

***Pomo** (*poh*-moh) Native American tribe of central coastal California, regarded as the finest basketmakers in the world, although their other arts are not highly developed. Typical of their baskets are fine, water-tight weaving, and ornamentation with polychromatic feather work.

***Pop Art** A style of art in the 1950s that used popular, mass-media symbols (such as a Coke bottle) as subject matter, treating them in both serious and satirical ways.

Porcelain (*pour*-sell-in) Fine white clay, made primarily of kaolin; also, an object of such clay which is hard, translucent, sonorous, non-porous, and usually very thin. Porcelain may be decorated with mineral colorants under the glaze or with overglaze enamels.

Portal A door or gate, usually of importance or large in size. In Gothic cathedrals, there were usually three portals in the main facade.

Portico (*pour*-tee-ko) A porch with a roof, supported by columns and usually having an entablature and a pediment.

Portrait The image of a person's face, made of any sculptural material or any two-dimensional medium.

Positive Design A pattern or image created by painting or carving.

Positive Space The objects in a work of art as opposed to the background or space around the objects.

Post and Lintel The oldest and simplest way of building an opening: two vertical members (posts) support a horizontal beam (lintel) above them, creating a covered space. The structure can be part of a wall or can be freestanding.

Poster A form of graphic art, created for the purpose of making a public announcement.

***Post-Impressionism** The style of late 19th century French art that immediately followed the lead of the Impressionists. Paul Cezanne was a leader of this style, which stressed more substantial subjects than those of the Impressionists and a conscious effort to design the surface of the painting.

Potter's Wheel A weighted horizontal disc which revolves on a vertical spindle, upon which clay is symmetrically shaped by a potter as the wheel spins.

Pottery Ceramic ware made from clay that is shaped while moist and soft, and made hard and brittle by firing; also, coarser ware so made.

Prang A tiered, rounded spire, used in Thai architecture.

***Pre-Columbian** The culture of Meso-America and South America prior to the European colonization period initiated by Columbus' voyage of 1492.

Primary Colors The hues from which all other spectrum colors can be made: red, yellow, and blue (in painting): red, green, and blue (in light waves).

Primitive The native arts of any culture, usually on a less sophisticated level than that of modern times; a culture before it adopts the ways of another. Also used to describe the art produced by untrained or naive artists.

Print A multiple impression made from a master plate or block, produced and printed by the artist (or under his/her supervision)

Printmaking The art of producing prints.

Proof The trial prints produced by a printmaker prior to making the final edition (completed set of prints).

Proportion A comparative size relationship between several objects or between parts of a single object or person. In figure drawing and painting, the correct relationship between the size of head and body.

Prototype An original model on which other similar objects are patterned; the first in a series; a piece which inspires future creations.

***Pueblo** A communal dwelling consisting of groups of continuous flat-roofed stone or adobe houses; native American culture of the Southwestern United States typified by their use of such dwellings and artistically noted for their excellent slip-painted pottery, loom woven clothing and blankets, and kachinas.

Pylon (*pie*-lahn) The huge entrance structure for an Egyptian freestanding temple, formed by a pair of square tapering piers with a flat top and no connecting lintel. From the Greek word for "gateway." Also significant pillars in contemporary architecture.

Qibla (*key*-blah) A niche in the inner wall of a mosque, facing toward Mecca.

Qin (chin) Short-lived Chinese dynasty (221–206 B.C.) responsible for the unification of China, artistically noted for the standardization of Chinese writing and the unification of the Great Wall.

Qing (ching) Final dynastic era of China (1644–1911) also known as the Manchu because of the foreign ruling family. Artistically responsible for few innovations in the major arts, although new forms of ceramic decoration evolved and production of trade goods expanded as a result of contacts with European traders.

Quatrefoil (*kwa*-trah-foil) A four-lobed form used for ornamentation.

Quetzalcoatl (kwet-sah-*kwah*-tel) Meso-American god representing the dual forces of nature as a bird (sky) and serpent (earth) combination. Called the Feathered Serpent.

Radial Balance A design based on a circle, with features radiating from a central point.

Rama (*rah*-mah) The king and hero of the Ramayana epic and one of the incarnations of Vishnu (the Preserver).

Ramayana (rah-mah-*yah*-nah) Hindu epic tale of King Rama and his wife Sita, teaching morality and worthy human behavior. Known in Thailand as the "Ramakien."

Ravane (rah-*vah*-nah) Mythological demon-king, depicted with multiple heads and arms in Hindu iconography.

***Realism** A mid-19th century style of art based on the belief that the subject matter should be shown true to life, without any stylization or idealization.

Reduction Stage in the firing process of glazed ceramics resulting in insufficient oxygen for combustion, causing chemical changes in the oxides in clay and glaze.

***Regency** The period during which George, Prince of Wales, ruled England in the stead of his father (1811–1820), typified artistically by a taste for exotic Indian and Chinese motifs in art and architecture.

Register One of a series of horizontal bands which are placed one above the other, usually a format for painting. Commonly used in Egyptian tomb painting, medieval church sculpture, Aztec codices, and manuscript illumination.

Reinforced Concrete Building material composed of concrete with rods or webs of steel embedded in it; ferroconcrete.

Relief Sculptural surface which is not freestanding but projects from a background of which it is a part. High relief or low relief describes the amount of the projection. *See* **Bas Relief.**

Reliquary (*reh*-li-kweh-ree) A container for religious relics.

***Renaissance** A revival or rebirth of cultural awareness and learning: specifically in Europe, a period of time (about 1400–1600) following the middle ages that featured an emphasis on human beings and their environment, on science and on philosophy, all of which directed the interest back to the culture of ancient Greece and Rome.

Rendering The careful and complete drawing or painting of an object, place, or person to make it appear realistic.

Repousse (ree-*pooh*-say) To hammer or press sheet metal from the reverse side to raise up a shaped or ornamented pattern; a piece of metalwork so made.

Representational Any artistic style in which objects or figures are easily identified.

Reredos (*rear*-dahs) An ornamental facing or screen of stone or wood covering the wall at the back of an altar; a hanging of velvet or silk for the same purpose.

Resin (*rez*-in) Tree gum substance used to waterproof unglazed fired pottery by rubbing it into the porous surface.

Retable (ree-*tay*-bull) A large orna-

mental wall behind an altar with shelves or frames enclosing decorated panels.

Rhythm A principle of design that indicates a type of movement in an artwork or design, often by repeated shapes, lines, or colors.

Rib A slender projecting arch, used as support in Romanesque and Gothic vaults. In late Gothic, the ribs are often ornamental as well as structural, forming lacelike patterns.

Ribbed Vault a vault constructed of a system of self-supporting ribs and a web of thinner material, filling the spaces between the ribs.

Ritual A formal procedure or act in a religious observance.

***Rococo** (roh-*koh*-koh) A late Baroque style (about 1715–1775) that can be described as pretty, private, and often erotic and effete; also, any such elaborate or overdone phase in any culture.

***Romanticism** A style of art that emphasizes the personal, emotional, and dramatic aspects of exotic, literary, and historical subject matter. Specifically, a European style from the mid-18th century onward.

Rosary A string of beads used as a memory aid in the recitation of prayers in any religion; specifically refers to a series of prayers to the Virgin Mary, aided by such a device.

Rosette A circular decorative element, suggestive of a flattened rose.

Rose Window A circular window with stone tracery radiating from the center and a characteristic feature of Gothic church architecture.

Rotunda A round building or interior hall, topped by a dome.

Roundel A circular decorative element.

Rustication (russ-tee-*kay*-shun) A surface of massive stonework, having a rough contour with deep joints, with a resultant appearance of strength and solidity.

Salon (sah-*lahn*) A reception room. Also, an exhibition of the works of living artists, and specifically, the annual exhibition of French art in Paris.

Samurai (*sah*-moo-rye) A member of the feudal warrior class of medieval Japan.

Sanctuary A sacred or holy place, usually enclosed within a temple or church building, often housing an altar and other worship aids.

Sarcophagus (sar-*cough*-u-gus) A stone coffin, often elaborately carved.

Saturation Also called Intensity. The measure of the brilliance and purity of a color. Saturation decreases as the hue is neutralized.

Scale The relative size of an object when compared to others of its kind, to its environment, or to humans themselves.

School Artists who have a similar philosophy and style or who work under a common influence.

Script Written or printed lettering.

Sculpture A three-dimensional work of art.

***Scytho-Parthians** (*sith*-oh-*paar*-thee-uns) Ancient nomadic peoples of Southeast Europe and Central Asia before 100 B.C., artistically significant for their development of the Animal Style.

Secondary Colors Orange, green, and violet: hues produced by the mixing of equal parts of two primary colors.

Section A diagram of a building, showing how it would look if it were cut open on a vertical plane.

Secular Non-religious.

Sepia A warm dark-brown color.

Sepulchre (*sep*-uhl-ker) A place of burial; a tomb.

Serape (sehr-*ah*-pee) Shawl or vest worn in Hispanic cultures.

Seraph (*sehr*-ahf) An angel; a celestial being.

Serigraphy (sehr-*ig*-raff-ee) A form of printmaking using stencils attached to a porous screen of silk through which the ink is forced. Also called silk screen printing.

Serpentine (*sir*-pen-teen) Mineral with a dull green color, composed of magnesium silicate, usually with a mottled appearance closely resembling jade; also, a winding, snakelike line or design.

Sfumato (sfoo-*mah*-toe) A slight blurring of the edges of figures and objects in a painting, creating a hazy feeling and creating aerial perspective.

Sgraffito (skrah-*fee*-toe) The process of scratching lines into the surface of a work of art to expose the surface underneath.

Shade A low-valued color, made by adding black to a hue.

Shading Graduated variations in value, often used in painting to give a feeling of volume, form, and depth.

Shaft The main part of a column, between the base and the capital, which may be plain, fluted, or twisted.

***Shailendra** (shy-*lynn*-druh) Buddhist kingdom of ancient central Java (700–850) artistically noted for the construction of the ten-layered cosmic mountain stupa at Borobudur.

Shaman (*shah*-mun) A priest who uses magic to cure the sick, predict the future, or control nature.

***Shang** Bronze-age culture in northern China (about 1600–1027 B.C.), artistically distinguished by their fine ritual containers made by the cire-perdue process.

Shape An element of design that is an enclosed space, having only two dimensions. Shapes can be geometric (triangular, square, etc.) or organic (free form, with curving and irregular outlines).

***Shingon** (*shin*-gone) Sect of Japanese Buddhism, and the major esoteric philosophy of Japan.

Shinto (*shin*-toe) Native religion of Japan, marked by veneration of nature spirits.

Shogun (*show*-gun) A generalissimo; military rulers who controlled Japan beginning with the Kamakura era, leaving the Emperor as a figurehead.

***Shoshone** (show-*show*-nee) Native American tribe of the Central Basin; a basket-making group of nomadic seed-gatherers.

Side Aisle The arcaded walkways on either side of the nave of a Christian church.

Sikhara (*sick*-ah-rah) The tall curved roof of an Indian sanctuary.

Silk Screen See **Serigraphy.**

Sinicization (sin-uh-siz-*ay*-shun) The process of acquiring Chinese culture.

***Sioux** (soo) Native Americans of the Plains, living in tipis and artistically noted for colored and beaded leatherwork, silversmithing, and quillwork.

Sita (*see*-tah) Legendary wife of the epic-king, Rama.

Siva (*see*-vah) The third member of the Hindu trinity and controller of great destructive and procreative powers. Also known as Bhairava (The Frightful); Nataraja (Master of the Dance); and Vinadhara (Master of the Arts). Represented with one of two wives (Parvati or Uma); with Nandi (the bull upon which he rides); as a man with a third eye; or as a phallic symbol known as a *lings* (which looks like a fire hydrant).

***Six Dynasties** Era of political turmoil in China (256–589) during which various dynasties ruled parts of China, and Buddhism from India became well established, especially in the sculpture of the Northern Wei (about 400–550).

Sketch A quick drawing that catches the immediate feeling of action or the impression of a place or situation.

Slip A thin mixture of clay and water, used both as a clay glue and as a paint on leather-hard ware.

***Song** (sung) Chinese dynasty (960–1127 in the North, continuing until 1279 in the South) during which Chinese aesthetics reached a zenith of sophistication, notably in architecture, painting, and ceramics.

Space An element of design that indicates areas in a painting (positive and negative); also, the feeling of depth in a two-dimensional work of art.

Spandrel A space between two arches and a horizontal molding or cornice above them.

Spectrum Bands of colored light, created when white light is passed through a prism; the full range of color.

Sphinx (sfinks) A creature of Egyptian art with the body of a lion and the head of a man. In Greek mythology, a monster with the winged body of a lion and the head of a woman.

Sprigging The attaching of pre-formed leather-hard clay ornaments to a larger form; usually ornaments are plant forms, human or animal bas reliefs, or geometric bands.

Squash Blossom Popular motif among Southwestern native American silversmiths, resembling an open trumpet-like flower and representing abundance.

***Sri Vijaya** (sree-vih-*jigh*-ah) Ancient Hindu-Buddhist kingdom of Southeast Asia (8th–13th centuries) stretching from Java to Southern Thailand, significant for early bronze images and as a Buddhist monastic center.

Statue A freestanding sculpture.

Stele (*stee*-lee) An upright slab, bearing sculptured or painted designs or inscriptions. From the Greek for "standing block."

Stencil A method of producing images by cutting openings in a mask of paper, wax, or other material so that paint or dye may go through the openings to the material beneath. Used in serigraphy, batik, and ceramic decoration.

Still Life A group of inanimate objects arranged to be painted or drawn; also, a painting or drawing of such an arrangement.

Stirrup Handle Hollow, looplike handle resembling in shape the inverted U-shaped metal holder for a horseman's foot. Common in Pre-Columbian pottery.

Stoa (*stow*-ah) A large porch or covered colonnade in Greek architecture. Used for a meeting place, walkway, or place for small businesses and offices.

Structure The compositional relationships in a work of art; also, a building.

Stucco Any of several types of plaster used for decorative cornices, moldings, or ceilings; also, a cement coating for the exterior of a building.

Stupa (*stew*-pah) A reliquary structure based on the Vedic funerary mound which represents the Buddhist cosmic mountain and commemorates sacred places, events, or people (especially Buddha and Buddhist monks).

Stupa-temple Burmese modification of the Buddhist monument, incorporating a worship space underneath the bell-shaped stupa.

Style The distinctive characteristics contained in the works of art of a person, period of time, or geographic location.

Stylization The simplification or generalization of forms found in nature to present a personal and more decorative feeling in a work of art or lettering.

Stylobate (*sty*-low-bate) The immediate foundation for a row of columns, often set on a foundation.

Subject That which is represented in a work of art.

Subtractive Sculpture Sculpture formed by cutting away excess material from a block, leaving the finished work.

***Sui** (swee) Short-lived Chinese dynasty (581–618) during which Buddhist art and architecture evolved into a more Chinese and less Indian style.

***Sukothai** (*soo*-koh-tie) Early Thai kingdom (1238–1349) during which national architectural and sculptural styles became established; the golden age of Thai Buddhist sculpture and ceramics.

Sultan A local Muslim sovereign; a ruler of both secular and Islamic aspects of society.

Sumi-e (soo-mee-ay) Japanese black ink painting on white paper in the Chinese style.

Superrealism A 20th century style of painting that emphasizes photographic realism. Many times the objects are greatly enlarged yet keep their photographic appearance.

Support The material in a painting upon which the work is done (canvas, panels, paper, etc.)

***Surrealism** A style of 20th century art in which artists combine normally unrelated objects and situations. Scenes are often dreamlike or set in unnatural surroundings.

Sutra (*soo*-trah) Buddhist scripture.

Symbol A form, image, sign, or subject representing a meaning other than its outward appearance.

Symmetry A formally balanced composition.

***Tang** (T'ang) Classical Chinese dynasty (618–906) whose cosmopolitan character encouraged the growth of new ideas. Artistically significant for the development of the pagoda form, for glazed and unglazed tomb figures and other pottery masterpieces, the final Chinese influence on Buddhist sculpture, and sophisticated ink paintings.

Tao (*dah*-oh) The Chinese philosophy regarding the relationships of nature and its forces, based on the teachings of Lao zi in 6th century B.C.; means "The Way"; Taoism.

Tapestry A wall hanging of textile fabric painted, embroidered, or woven with colorful ornamental designs or scenes.

Tapestry Weave A plain, or basket-weave fabric in which the weft threads are compressed so as to completely cover all warp threads.

***Tarascan** (tah-*rass*-kan) A culture of West Mexico that maintained independence during the reign of the Aztecs, significant for its claywork.

Tatami (tah-*tah*-mee) Rice-straw flooring mats, 90 × 180 cm, about 5 cm thick, used in Japan.

Tattoo An indelible mark or design fixed upon the body by production of sores or insertion of pigment under the skin. From the Tahitian word "tatu" for "a mark."

Technology The understanding and systematic use of materials, tools, and processes.

Tempera A waterbased paint whose vehicle is egg yolk. Some commercially made paints are called tempera, but are actually gouache.

Tenebroso (ten-eh-*broh*-soh) A late 16th century Italian painting technique which exaggerated strong contrasts of light and dark.

***Teotihuacan** (tee-oh-*tee*-hwah-kahn) Classic Mexican civilization (about 350–850) and sacred city of temple pyramids, typified by the use of colored frescoes of gods, symbols, and human subjects.

Terra Cotta Baked earth-red clay, used in ceramics and sculpture. Often glazed, it is used in both architectural decoration and tableware.

Tessera (*tess*-ah-rah) (pl. tesserae (*tess*-ah-ree)) Bits of colored glass or stone used in making mosaics.

Texture The element of design that refers to the quality of a surface, both tactile and visual.

***Thai** (tie) Ancient and contemporary people of the Chao Phaya basin, emerging as a culturally distinct group in the the 13th century, artistically distinguished by their Buddhist architecture, sculpture, and mosaics.

Therianthropic (thear-ee-an-*throp*-ic) The combination of human and animal forms into one being, such as a centaur or sphinx.

Theriomorphic (thear-ee-ah-*more*-fik) Having the form of an animal, such as a god taking the form of a jaguar or falcon.

Thrust A strong, continued pressure, as the outward force exerted by an arch or vault that must be counterbalanced by buttressing.

Thunderbird A mythological bird of

North American Indian culture, responsible for thunder, lightning, and rain; depicted in a stylized geometric pattern with outstretched wings.

***Tiahuanaco** (tee-a-*wan*-ah-ko) Andean culture which united the region's various cultures (about 900–1200).

Ting A Chinese three-legged vessel made of clay, lacquer, or bronze, for ceremonial purposes.

Tint A light value of a hue, made by adding white to the original color.

Tipi (*tee*-pee) Conical, rawhide dwelling consisting of groups of buffalo hides stretched over a framework of poles, its base diameter ranging from 12 to 30 feet. Characteristic dwelling of the Plains Indians of America.

Tokonoma (toh-koh-*noh*-mah) An alcove in a Japanese interior, wherein are placed single objects of beauty for appreciation.

***Toltec** (*toll*-teck) A warlike people of semi-nomadic origin who unified northern Mexico about 947. Their capital at Tula is characterized by a temple with a pyramidal base and columns of atlantes.

Tone The modification of a color (hue) through the addition of neutrals.

Torah Jewish religious literature.

Torii (tore-ee) The freestanding gateway at the entrance to a Japanese Shinto temple, consisting of two upright posts supporting a curved lintel, with a straight crosspiece below.

Totem (*toe*-tem) An animal or natural object which symbolizes a clan or family.

Totempole A tall post or pillar carved with the heredity marks, emblems, or badges of a tribe or clan, functioning as a type of family tree.

***Totonac** (toe-*toe*-nack) Classic Mexican civilization of Veracruz (100–1000) typified artistically by the great religious pyramid temple center of El Tajin and light-hearted terra cotta sculpture.

Tracery Ornamental stonework in a decorative pattern with a lacelike effect; a decorative interlacing of lines suggestive of such stonework.

Transept The part of a cross-shaped church at right angles to the long nave, usually with one arm on each side of the crossing.

Transitional A style of art in which influences and tastes are changing from an established practice to a distinctly different form.

Transmutation The conversion of one element into another; a process in the firing of some specialized ceramic glazes.

Trefoil A three-lobed form or ornamentation.

Triforium (try-*for*-ee-um) An arcade, often blind, below the clerestory of the nave in a Gothic church.

Triglyph (*try*-gliff) A group of three vertical ridges alternating with a plain metope in the frieze of a Doric Greek building.

Triptych (*trip*-tik) An altarpiece consisting of three panels, joined together. Often the two outer panels are hinged to close over the central panel.

Triumphal Arch A monument built to commemorate a great victory, with an open vaulted passageway through it. Also, in the Christian church, the large arched opening that separates the chancel (apse) from the nave of the church.

Trompe-l'oeil (tromp l'oy) A type of painting that is so realistic (in form, color, size, and lighting) that the viewer may be convinced that what he sees is the actual subject and not a painting. From the French for "fool the eye."

True Arch A round arch that actually supports the weight of a wall as opposed to a blind arch which is a surface motif in a wall.

Truss An assemblage of structural members forming a rigid framework under a roof; also, used in bridge design.

Turret A small tower which may be functional or ornamental, at the outside angle of a larger structure.

Twining To wind or twist.

Tympanum (*tim*-pan-um) A carved or decorated space over the door and under the arch of a Romanesque or Gothic church facade.

Ukiyo-e (oo-key-*oh*-eh) Japanese pictures of the "floating world" pleasure district of Edo. These were first made in paint but were more commonly produced in editions of polychrome woodcuts. They are the unique creation of the Edo period.

Unity A principle of design that relates to the sense of oneness or wholeness in a work of art.

Urna (*earn*-ah) The third eye of Buddha, iconographically depicted as a curl of hair on the forehead.

Ushnisha (ush-*neesh*-ah) The knot of hair at the crown of Buddha's head or a bulge in the back of his skull which symbolically represents his wisdom.

Value An element of design that relates to the lightness and darkness of a color or tone.

Vanishing Point An imaginary point or points on the eye level toward which parallel lines recede and where they will eventually meet in perspective drawing and painting.

Vault An arched roof or covering made of brick, stone, or concrete. A barrel vault or tunnel vault is semi-circular. A corbelled vault is made by having each course protrude a little beyond the course below it until the two sides meet. See **Groined Vault.**

***Vedas** (*vay*-dahs) Sacred writings of Hindu philosophy, including the hymns to nature (Sanhitas); ethical and moral writings (Brahmanas); treatises on metaphysics (Aranyatas); and the quest for truth (Upanisads). Formulated during the centuries before 600 B.C. giving the name "Vedic Era" to the previous millennium.

Vehicle The binding agent in paint that holds the pigment together and forms a film that adheres to the support or ground.

Vellum A fine parchment made from calfskin, and used for writing, manuscript illumination, and book binding.

Vishnu (*vee*-shnoo) The preserver god of the Hindu trinity, often incarnated as the mild and benevolent Krishna.

Volute (voh-*loot*) A spiral ornament, resembling a rolled scroll.

Voussoir (voo-*swahr*) Wedge-shaped stone block used in the construction of an arch.

***Walkabout** An initiation ritual for Australian aborigines entering adulthood, involving survival skills against nature.

Ware A general term for pottery, particularly that made for export or sale; by extension, anything made for sale or barter.

Warm Color A hue in the red to yellow range in the spectrum.

Wash A thin transparent layer of paint; also, a thinned mixture of solvent and paint.

Wat (what) A Thai or Laotian temple; a Khmer pagoda.

Watercolor Any paint that uses water as a medium, including acrylic, gouache, casein, tempera, and transparent watercolor. In a more restricted sense, a paint which has gum arabic as a vehicle and water as a medium (called transparent watercolor or aquarelle). Also, a painting done with this paint.

Wattle-and-daub A building technique for filling in walls between structural members using a fabrication of poles interwoven with slender branches, reeds, etc., and imbedded with mud.

***Wayang Style** (*why*-yong) Indonesian painting of figures which duplicates the flat side views of local shadow puppets; also, relief carving in a form similar to the wooden puppets of local plays. While this style originated in the Hindu-Javanese kingdoms, the plays (Wayang) are part of Islamic culture as well.

Web The thin masonry surface between the ribs of a vault.

***Wei** (way) Name of a number of dynastic eras in China between 220 and 535, controlling various regions of the country, artistically distinguished by early Buddhist sculptures in the Gandharan style.

Westwork The western facade of a medieval European church that includes the main entrance and usually several towers.

Wheel-thrown Ceramic objects made by forming clay on a spinning disc, producing a symmetrical round form. See **Potter's Wheel.**

Woodcut A relief print made by cutting a design into the flat surface of a block of wood and applying ink only to the raised surface.

Wood Engraving A relief print made from a design cut into the end grain of a hardwood block and applying ink only to the raised surface.

Xia (*she*-ah) Ancient Chinese culture (1500–1200 B.C.) typified by the evolution of oracle bones on which pictographic symbols were inscribed as messages to the gods; Hsia.

Yamato (ya-*mah*-toh) The cultural area of old Japan, being the plain where Nara, Kyoto, and Osaka are located.

Yamato-e (ya-*mah*-toh-ay) Japanese style painting, an indigenous response to Chinese brush painting, typified by Japanese genre subjects in a delicate linear style.

***Yang Shao** (yang show) Neolithic culture of central China (about 7000–1600 B.C.), typified artistically by handbuilt terra cotta pottery with impressed designs or slip-painted spiral motifs.

***Yaqui** (*yah*-kee) A tribe of Uto-Aztec Indians of Sonora, Mexico.

***Yayoi** (*yah*-yoy) Agricultural society in pre-historic Japan (200 B.C.–300 A.D.) typified artistically by thin-walled, footed pottery.

***Yuan** (*you*-un) The Mongol dynasty of Chinese history which controlled all of China (1279–1368), artistically significant for the development of blue-and-white porcelain, an infusion of Central Asian culture, and a revival of Tang artistic practices.

***Zapotec** (za-*poh*-tek) Ancient Mexican people in the Valley of Oaxaca (wah-*hah*-kah) (about 200–1000) centered at Monte Alban, typified by their architecture of stuccoed and painted temples and pyramids.

Zen Buddhist sect emphasizing contemplation and meditation, self-discipline, and that the Buddha is inherent in all things. More commonly known by the Japanese spelling (Zen), it originated in China as Chan.

***Zhou** (zhoh) Chinese dynasty (1111–256 B.C.) typified artistically by elaborate cast bronze ritual vessels and sophisticated jade carving; Chou.

Ziggurat (*zig*-oo-rat) The high temple platform, built of mud brick, of Sumerian and Assyrian architecture. Usually built in the form of a truncated stepped pyramid with ramplike stairways leading to the sanctuary at the top.

***Zuni** (*zoo*-nee) Tribe of Southwestern Native Americans, artistically distinguished as the finest of Pueblo silversmiths and typified by their use of turquoise.

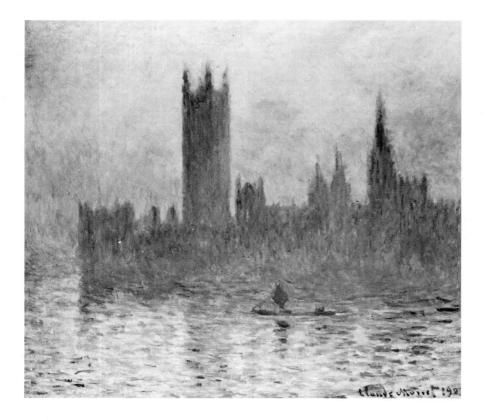

CLAUDE MONET. *The Houses of Parliament, Sunset*, 1903. Oil on canvas, 81 × 93 cm. National Gallery of Art, Washington, D.C., Chester Dale Collection 1962

Bibliography

There are literally hundreds of books on the shelves of libraries and bookstores that offer both general and detailed information about art and art history. Some are technical while others feature many pictures; some are written for art specialists, others for the general public. The authors found the following books useful in preparing the text, but by all means explore school, university (if accessible), and public libraries for more information.

ART HISTORY

Bazin, Germain. *The History of World Sculpture*. New York Graphic Society, Ltd., Greenwich, Connecticut. 1968

Davies, Elton M. *Art and Cultures of Man*. International Textbook Company, Scranton. 1972

Dorra, Henri. *Art in Perspective*. Harcourt Brace Jovanovich, Inc., New York. 1974

Elsen, Albert E. *Purposes of Art*. Holt, Rinehart Winston, Inc., New York. 3rd ed. 1972

Encyclopedia of World Art. 15 vols. McGraw-Hill Book Company, New York.

Feldman, Edmund Burke. *Varieties of Visual Expression*. Prentice-Hall, Inc., Englewood Cliffs. 1972

Goldwater, Robert and Treves, Marco, eds. *Artists on Art*. Pantheon Books, New York. 1972

Great Ages of Man series. 16 vols. Time-Life Books, New York. 1970

Great Museums of the World series. 16 vols. Newsweek Book Division, New York. 1968

Harris, Ann Sutherland and Nochlin, Linda. *Women Artists: 1550–1950*. Alfred Knopf, Inc., New York. 1976

Hartt, Frederick. *Art: A History of Painting, Sculpture, Architecture*. 2 vols. Prentice-Hall, Inc., Englewood Cliffs and Harry N. Abrams Inc., New York. 1976

Janson, H. W. *History of Art*. Prentice-Hall, Englewood Cliffs. 2nd ed. 1977

Knobler, Nathan. *The Visual Dialogue*. Holt, Rinehart and Winston, Inc., New York. 1971

Murray, Peter and Linda. *The Penguin Dictionary of Art and Artists*. Penguin Books, Ltd., New York. 4th ed. 1978

Osborne, Harold (ed). *The Oxford Companion to Art*. Oxford, Clarendon Press, England. 1970

Time-Life Library of Art. 28 vols. Time-Life Books, New York. 1967

Wasserman, Burton. *Exploring the Visual Arts*. Davis Publications, Inc., Worcester. 1976

SPECIFIC TIME PERIODS OR STYLES

Canaday, John. *Mainstreams of Modern Art*. Simon and Schuster, New York. 1959

Charles-Picard, Gilbert. *Larouse Encyclopedia of Archaeology*. Chartwell Books, Inc., Secaucus, New Jersey. 1977

Clark, Kenneth. *The Romantic Rebellion*. Harper and Row, New York. 1973

Cogniat, Raymond. *The Century of the Impressionists*. Crown Publishers, Inc., New York. 1967

Cooper, Douglas. *The Cubist Epoch*. Phaidon Press, Ltd. London. 1970

Copplestone, Trewin (ed). *Movements of Modern Art* (Series). *Expressionism*. Hamlyn Publishing Group, London. 1970

Davidson, Marshall B. *Artist's America*. American Heritage Publishing Co., New York. 1973

Eliot, Alexander. *Three Hundred Years of American Painting*. Time, Inc., New York. 1957

Goldwater, Robert. *What is Modern Sculpture?* The Museum of Modern Art, New York. 1969

Jacobs, Jay. *Great Cathedrals*. American Heritage Publishing Company, New York. 1968

Johnson, Charlotte Buel. *Contemporary Art*. Davis Publications, Inc., Worcester. 1973

Ketchum, Richard M. (ed). *The Horizon Book of the Renaissance*. American Heritage Publishing Company, New York. 1961

Kranz, Stewart. *Science and Technology in the Arts*. Van Nostrand Rhinehold Co., New York. 1974

Kurtz, Seymour. *The World Guide to Antiquities*. Octopus Books, Ltd., London, 1975

Ruskin, Ariane and Batterberry, Michael. Discovering Art series. *Greek and Roman Art. Seventeenth Century Art. Nineteenth Century Art. Twentieth Century Art. Art of the Early Renaissance. Art of the High Renaissance. Prehistoric Art and Ancient Art of the Near East. Art of the Middle Ages*. McGraw-Hill Book Co., New York. 1973

Wasserman, Burton. *Modern Painting*. Davis Publications, Inc., Worcester. 1970

ARCHITECTURE

Allsopp, Bruce and Booker, Harold and Clark, Ursala. *The Great Tradition of Western Architecture.* Oriel Press, London. 1966

Cook, John W. and Klotz, Heinrich. *Conversations with Architects.* Praeger Publications, New York. 1973

Copplestone, Trewin (ed). *World Architecture.* Hamlyn Publishing Group, London, and McGraw-Hill, New York. 1963

Fleming, J., Honour, Hugh, and Pevsner, Nikolaus. *The Penguin Dictionary of Architecture.* Penguin Books, New York. 1974

Fletcher, Banister. *A History of Architecture.* Athlone Press, London. 1975

Grand Tour series. 12 vols. HBJ Press, Boston, 1978
Man series. Newsweek, Inc., New York. 1971

Hamlin, Talbot. *Architecture through the Ages.* G. P. Putman's Sons, New York. 1953

Hofmann, Werner and Kultermann, Udo. *Modern Architecture.* The Viking Press, New York. 1970

Jordon, R. Furneaux. *A Concise History of Western Architecture.* Thames and Hudson, London. 1969

Norwich, John Julius (ed). *Great Architecture of the World.* Random House and American Heritage Publishing Co. New York. 1975

Wonders of Man series. 18 vols. Newsweek Book Division, New York. 1971

CRAFTS / PHOTOGRAPHY

Charleston, Robert J. *World Ceramics.* Paul Hamlyn, London. 1968

Gernsheim, Helmut. *Creative Photography.* Bonanza Books, New York. 1962

SPECIFIC CULTURES

American Indian Art: Form and Tradition. A Dutton Paperback, New York. 1973

Ashton, Robert and Stuart, Jozefa. *Images of American Indian Art.* Walker and Company, New York. 1977

Batterberry, Michael. *Chinese and Oriental Art.* McGraw-Hill Co., New York. 1973

Cervantes, Maria Antonieta. *Treasures of Ancient Mexico.* Crescent Books, New York. 1978

Donadoni, Sergio. *Egyptian Museum, Cairo.* Newsweek Books Inc., New York. 1969

Emmerich, Andre. *Art Before Columbus.* Simon and Schuster, New York. 1963

Feder, Norman. *American Indian Art.* Harry N. Abrams, New York. 1973

Freestone, Colin S. *The South East Asian Village.* George Philip and Son, London. 1974

Jordan, Paul. *Egypt, The Black Land.* Phaidon, Ltd., Oxford. 1976

Kelemen, Pal. *Art of the Americas, Ancient and Hispanic.* Bonanza Books, New York. 1969

Nicholson, Irene. *Mexican and Central American Mythology.* Paul Hamlyn, Ltd., London. 1967

Sickman, Laurence, and Soper, Alexander. *The Art and Architecture of China.* Penguin Books, New York. 1968

Smith, Bradley. *Mexico, A History in Art.* Doubleday and Company, Inc., Garden City, N.J. 1968

Smith, Bradley and Wan-go Weng. *China. A History in Art.* Doubleday and Company, Inc., New York. 1972

Steward, Desmond. *The Pyramids and the Sphynx.* Wonders of Man series. Newsweek, Inc., New York. 1971

Sullivan, Michael. *The Arts of China.* (Revised). University of California Press, Berkeley. 1977

Whiteford, Andrew. *North American Indian Arts.* Golden Press, New York. 1970

Willett, Frank. *African Art, An Introduction.* Praeger Publishers, Inc., New York. 1971

Willetts, William. *Foundations of Chinese Art.* Penguin Books Ltd., New York. 1967

Williams, C.A.S. *Outlines of Chinese Symbolism and Art Motifs.* Dover Books, Inc., New York. 1976

Wissler, Clark. *Indians of the United States.* Anchor Books, Doubleday, Inc., Garden City. 1966

INDIVIDUAL ARTISTS / MUSEUM CATALOGUES

Many books on individual artists and museum catalogues from various specialized exhibitions can be found. Museum libraries and bookstores are well stocked with such publications.

Index

Acknowledgments

A book of this nature would not have been possible without the help of a great number of people in offices scattered throughout the world. I thank them all for their help, consideration, and patience, especially those located in foreign countries who undoubtedly had less trouble with my English than I with their native tongues.

I am especially indebted to the following museums and collections: Albright-Knox Gallery (Alba Priore); Art Institute of Chicago (Linda Cohn); Art Museum of South Texas; Baltimore Museum of Art (Nancy Press); Boston Museum of Fine Arts (Dan Henry); Dallas Museum of Art (Carol Robbins); Detroit Institute of Art (Karen Serota); The Frick Collection (Martha Hackley); J. Paul Getty Museum (Roberta Stothart); Hirshhorn Museum and Sculpture Garden; Huntington Library and Art Gallery; Indian Art Center of California (John Degatina); Joslyn Museum of Art; Kimbell Art Museum (Shirley Spieckerman); Los Angeles County Museum of Art (Myrna Smoot); McNay Art Institute (Alison Wenger); Metropolitan (N.Y.) Museum of Art (Fredd Gordon); Museum of Modern Art, New York (Claudia Bismark); National Gallery of Art, Washington (Ira Bartfield); Natural History Museum, Los Angeles (Bill Mason); Norton Simon Foundation; Norton Simon Museum of Art at Pasadena (Sara Campbell); Philadelphia Museum of Art; Solomon R. Guggenheim Museum; Texas Memorial Museum (Lyman Bilotta); Whatcom Museum of History and Art; Whitney Museum of Art (Anita Duquette); and the William Rockhill Nelson Gallery of Art (Deborah Stavin).

Also, the Albertina Museum, Vienna; Alte Pinakotek, Munich; Archaeological Museum, Athens; Archaeological Museum, Heraklion; British Museum and British Library, London; Commissione de Architettura Sacra, Vatican; Fung Ping Shan Museum, Hong Kong; Hermitage Museum, Leningrad; Kunsthistorishes Museum, Vienna; Lateran Museum, Rome; National Gallery, London; National Museum, Stockholm; Ohora Museum of Art, Kurashiki, Japan; Prado Museum, Madrid; Rijksmuseum, Amsterdam; Sarawak Museum, Kuching; Tate Gallery, London; University of Singapore Museum, Singapore; Unterlinden Museum, Colmar; and the Vatican Museum, Rome.

Examples were supplied from the following private collections: Bowen and Paré, Hong Kong; Leo Castelli, New York; Joseph Gatto, Los Angeles; Carl K. Provost, Houston; Mr. and Mrs. David Kohl, Hong Kong; Mr. and Mrs. L. C. Saunders, Hong Kong; Mr. and Mrs. David Schollard, Hong Kong; and Thomas Jefferson University, Philadelphia.

My grateful thanks to the many artists who provided both permission and illustrations of their latest work, including Judy Chicago, Christo, Chuck Close, Claire Falkenstein, Gene Gill, Duane Hanson, Willem de Kooning, Lee Krasner, Henry Moore, Bridget Riley, Larry Rivers, Sebastian, and Kay Sekimachi. Both the Pace Gallery and Leo Castelli Gallery provided material for this book. Dr. Henri Dorra gave permission to use several of his excellent diagrams which add to the book's clarity.

Many other organizations were most helpful in providing photographs, documentary information, and support for which I am grateful. They include: the embassies of Belgium, Egypt, India, France, Federal Republic of Germany, Greece, China, and Spain; the tourist offices of Great Britain, Egypt, Australia, Austria, Italy (ENIT), Greece, Japan, Mexico, the Netherlands, Turkey, Belgium, and the Philippines. Also, the following firms: AC & R Public Relations, Air France, Air Egypt, American Institute of Architects, Copyright Agency of the USSR (VAAP), Emery Roth and Sons (architects), Fratelli Alinari, Harcourt Brace Jovanovich, Inc., Harrison and Abramovitz (architects), Houston Chamber of Commerce, Philip Johnson/John Burgee (architects), Kansas City Chamber of Commerce, Lufthansa, Marcel Breuer and Associates (architects), New York State Commerce Department, Photographie Giraudon (Rene Faille), Scala/Editorial Photocolor Archives, South East Asia Ceramic Society, and the United Nations.

I express my special thanks to those who went out of their way to help, encourage, and express interest in the book as it developed. To Dave Kohl, who supplied many visuals and the basic text for Chapter 4. His knowledge and friendship are deeply appreciated. To Bernie Thorsch, whose China trip added some necessary visuals. To Jane Kohl, who typed the final manuscript meticulously and with concern. To Davis Publications, who for so long have supported art education and who eagerly and consistently supported this project. To Penny Darras-Maxwell for her keen interest and excellent graphic design. And, to my wife, Georgia, whose patience, editorial assistance, and helpful suggestions are most appreciated.

I thank you all!

GERALD F. BROMMER

Los Angeles, California
August, 1987